SINCE 1888

SINCE 1888

THE BRITISH & IRISH LIONS

THE OFFICIAL HISTORY

CLEM THOMAS AND GREG THOMAS
WITH ROB COLE

VSP

CONTENTS

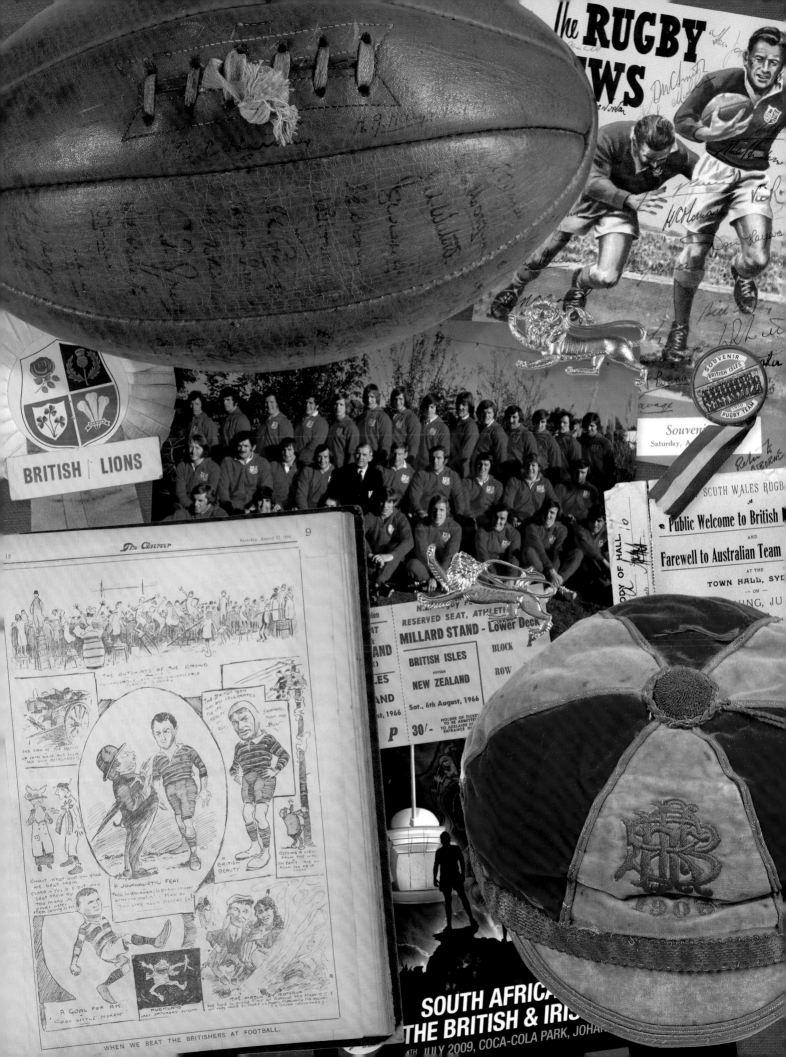

THE LAST GREAT RUGBY ADVENTURE

Since The British & Irish Lions first toured in 1888, the Lions tours have become established as the greatest tours in rugby. Cherished by players and supporters alike, they hold a special place in hearts and minds across the globe. Indeed, as my predecessor Gerald Davies so eloquently put it, they are 'the last great adventure – one team, one philosophy, one jersey'.

Although each Lions tour creates its own mark on the history of the Lions, the 1888 tour was the inspiration for the Lions and the reference point for all future tours, setting the values and behaviours that define what it means to be a Lion and what is required to represent the best of the best.

I was fortunate enough to be a part of Lions history in 1974 on the 'Invincible Tour' to South Africa and have witnessed first-hand what it means to be a Lion. Those who are fortunate enough to be selected feel that it is the pinnacle of their rugby career, they value and respect the Lions concept.

This book, first written by former Lion Clem Thomas, encapsulates the history and the magic of the Lions. His son, Greg, who himself toured with the Lions twice as Head of Media and Communications, took over and carried on his labour of love.

The Lions are rare, they are special, they represent all that is good about rugby values and friendship. It was a privilege to be a Lion and it is an honour to still be involved as Chairman.

We are looking forward to our next tour to New Zealand in 2017 for the next episode of this wonderful adventure.

Tom Grace
British & Irish Lions Chairman

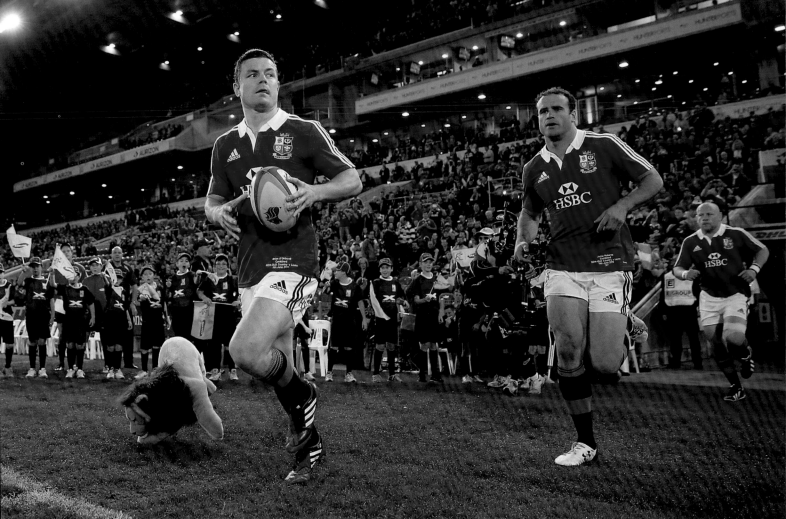

PRIDE AND TRADITION

It is with great pride and privilege that I welcome you to the latest edition of the *The British & Irish Lions: The Official History*, a book created by a former Lion, Clem Thomas, that captures the essence of the wonderful traditions of the Lions while at the same time providing key details and records of all the tours.

The Lions are unique and incredibly special, not just to me as a former player but also to the legions of British and Irish rugby fans. It is an amazing seven-week adventure every four years and logically – in the crowded world of professional sport – it probably shouldn't work, but it does: with excitement building and building as each tour nears.

I can remember the 1997 tour as my first real memory of the Lions and how special the tours were. The 1993 tour was not that widely covered, certainly by today's standards, but in 1997 I remember watching the matches from South Africa as the whole tour, including the midweek matches, coincided with my exams. I was 17 at the time and was trying to study while keeping a sharp eye on the tour. The broadcasts made it easy to follow but if someone had told me I would be on the next tour to Australia in 2001 I would have laughed at them. I just had no thought at the time that could be possible, but I guess it is funny where life takes us.

When that moment came and I knew I had become a Lion I was at home in Dublin. The phone rang and it was tour manager Donal Lenihan and there it was, selection for the 2001 tour to Australia. It was a crazy moment and one I will never forget. I was very excited and so were my family. There had been a lot of speculation about the tour squad and my name had been mentioned as a possible tourist. I was honoured just to be considered but to have it confirmed by Donal was simply amazing.

I have often been asked if it is the pinnacle of a player's career to be selected as a Lion and it is an interesting question given playing for your country is also very, very special. But the Lions are unique and further reward for your talent – you become recognised as one of the best 35 or so players in Britain and Ireland. So, yes, it is. From a playing point of view the standard is also much higher, so much so that I relished the training. You looked forward to it and enjoyed it as you were amongst the best of the best – the calibre of players around you in every position is unmatched which pushed me to excel.

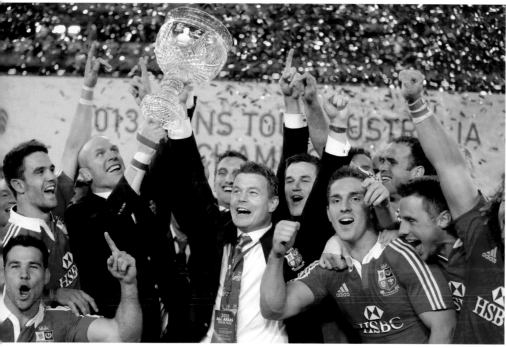

I was lucky to have played on four Lions tours and have some wonderful memories from all of them. Of course as a competitive athlete the rugby does stand out for me and I will never forget my first Test on the 2001 tour in Brisbane. We played at the Gabba, the famous cricket venue, and I scored a try but I felt it was my overall performance that I was most proud of, helping the team to win. And that sums up what the Lions spirit is all about, touring with fellow countrymen but also a new group of mates from Wales, Scotland and England, and wanting to do well as a group.

I will also never forget the support that day. For some reason we could not warm-up outside on the field and we had to make do with getting ready in the dressing sheds. We ran out into a wall of noise created by a red sea of Lions supporters – it was amazing and frankly felt like a home game. The Wallabies were shocked and could not believe the support the Lions enjoyed on tour.

Looking back I think the tours I took part in were better prepared each time. We definitely learned from each previous tour, especially after the wake-up call of 2005. We did things better in 2009, on and off the field, and retuned to the basics in a sense to ensure the rugby was front and centre. We shared hotel rooms and had to play more matches and front up more often – it was harder but it paid off.

Indeed we were so unlucky in 2009 not to have the series go to a third Test decider against the 'Boks, who were world champions at the time. That series was brilliant to be a part of, the rugby was fast, physical and hard. Then in 2013 the preparations improved again and I felt we were on a par with the southern hemisphere in this respect. We beat the Wallabies and the Lions won a series for the first time since 1997.

Of course my time as a player is now over and the baton has been passed to the next generation. However, I know that each and every player who pulls on the famous red shirt, just like myself, will honor the tradition and heritage that comes with it.

Here is to many, many more years of The British & Irish Lions...

Brian O'Driscoll

MILESTONES

In the words of two-time tourist Gerald Davies, an expedition with the Lions 'is the last great rugby adventure'. Having evolved from an unsanctioned journey into the unknown dreamed up by a handful of entrepreneurs to become the pinnacle of any British or Irish player's career, it's little wonder that the history of the Lions' exploits is rich, varied and endlessly fascinating...

NEW ZEALAND & AUSTRALIA, 1888

Principally an unsuccessful money-making exercise and not recognised by any of the Home Unions, the forerunner of future Lions tours was organised by the England Test cricketers James Lillywhite, Alfred Shaw and Arthur Shrewsbury. No Tests were played, with 19 club and regional fixtures scheduled in New Zealand and 16 in Australia between April and October. They also played 19 games of Aussie Rules and a cricket match. The trip was tinged with tragedy when England international and tour captain Robert Seddon drowned in a boating accident on the Hunter River in Maitland, New South Wales.

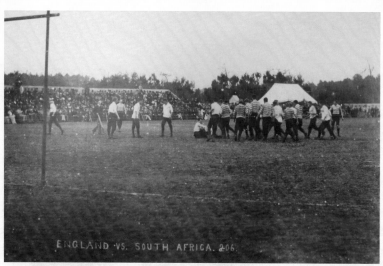

▲ Action from the 1891 tour of South Africa, where the tourists, captained by Scotland's Bill Maclagan, recorded an astounding 20 victories from 20 games

SOUTH AFRICA, 1891

Sanctioned by the RFU, a 21-man squad set sail in response to an invitation from the Western Province Rugby Football Union. Captained by Scottish three-quarter Bill Maclagan, the tourists cut a swathe through South Africa, conceding only one point as they notched 20 consecutive victories – 17 in provincial games and three in the Test matches to register the Lions' first unblemished record. The opening Test in Port Elizabeth was South Africa's inaugural international fixture. Lightning-fast Blackheath and England centre Randolph Aston proved the tour's star turn with 30 tries, including scores in the first and third Tests.

SOUTH AFRICA, 1896

The first squad to boast an Irish international contingent, including five players who had won the Home Nations Championship earlier in the year, the tourists were captained by English forward and 1891 tourist Johnny Hammond. The itinerary featured 17 provincial games and four Tests, the first three of which the Lions won comfortably. The fourth match in Cape Town, however, went the way of the home side courtesy of a converted try from Hull-born half-back Alf Larard – a first Test win for South Africa and a first international defeat for the Lions.

AUSTRALIA, 1899

The fourth and final tour of the 19th century, the 1899 squad provided Australia with their first international opposition. With players selected from all four Home Unions, the tour party was arguably the first to fully justify The British & Irish Lions name, although the Antipodean press persisted in erroneously dubbing the visitors 'the English football team'. Captained by 1896 tourist Rev. Matthew Mullineux, the team received an unexpected rude

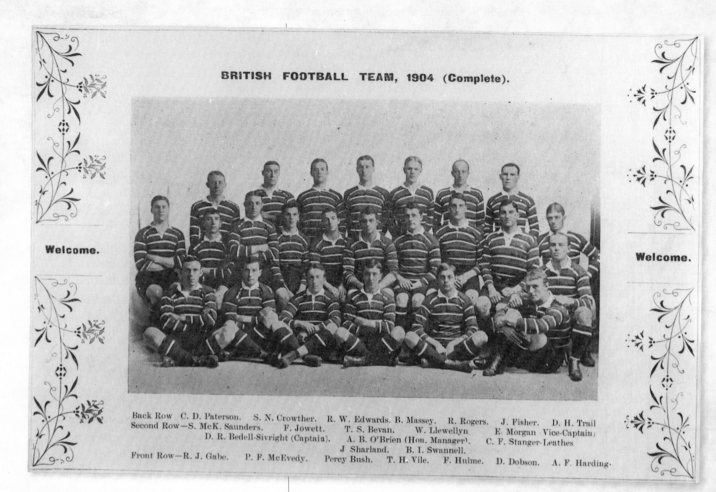

BRITISH FOOTBALL TEAM, 1904 (Complete).

Welcome.

Welcome.

Back Row C. D. Paterson. S. N. Crowther. R. W. Edwards. B. Massey. R. Rogers. J. Fisher. D. H. Trail
Second Row—S. McK. Saunders. F. Jowett. T. S. Bevan. W. Llewellyn. E. Morgan Vice-Captain)
 D. R. Bedell-Sivright (Captain). A. B. O'Brien (Hon. Manager). C. F. Stanger-Leathes
 J Sharland. B. I. Swannell.
Front Row—R. J. Gabe. P. F. McEvedy. Percy Bush. T. H. Vile. F. Hulme. D. Dobson. A. F. Harding.

awakening in the first Test at Sydney, going down 13–3. They recovered to register three successive victories and take the series 3–1.

SOUTH AFRICA, 1903

The Lions had lost just once in 40 matches on their two previous tours to South Africa but their third trip was to be a chastening experience as they failed to win a single Test and won only 11 of their 19 provincial fixtures. The respective captains of England, Ireland and Scotland – Frank Stout, Alf Tedford and Mark Morrison – all made the trip but, after the first two Tests were both drawn, the Springboks were 8–0 winners in Cape Town in September – the first Test in which the South Africans wore their famous green jerseys – to claim their first series victory over the tourists.

AUSTRALIA & NEW ZEALAND, 1904

Establishing a template which would endure until the 1970s, the tourists scheduled Tests against both Australia and New Zealand and enjoyed contrasting fortunes either side of the Tasman Sea. The Australian leg yielded 14 wins from 14 fixtures, including comprehensive victories in the three Tests against the Wallabies. The embryonic All Blacks, playing only their second international, provided sterner opposition and claimed a 9–3 success in Wellington. The tour was notable for the first sending-off in Lions history. Oxford University and England forward Denys Dobson was ordered off the field for 'dissent' in the match against Northern Districts in Newcastle, promoting a 20-minute delay as the Lions team walked-off the pitch in furious protest.

▲ The 1904 tourists enjoyed stunning success in Australia but fell short against the emerging All Blacks in New Zealand, losing 9–3 courtesy of two tries from Duncan McGregor

NEW ZEALAND & AUSTRALIA, 1908

This was a tour blighted by politics after Scotland and Ireland refused to sanction the trip which they deemed to be designed solely to stave off the rise of rugby league down under. The 'Anglo-Welsh' Lions of 1908 endured a torrid time on their travels and were beaten seven times in 23 provincial fixtures. Although they claimed a 3–3 draw against the All Blacks in Wellington, they were hammered 32–5 in the opening Test in Dunedin and dismantled 29–0 in Auckland to surrender the series.

▲ A ticket to the public welcome for the 'British Rugby Team' in 1908 – which also doubled as a farewell event for the Wallabies side departing to tour the UK – at Sydney Town Hall

ARGENTINA, 1910

It was a unique year for the Lions in 1910 with two squads dispatched to foreign shores. The first to depart was a 20-man party captained by England's John Raphael, which headed to Argentina in late May for a six-match tour. Billed as the 'English Rugby Union Team', the squad actually boasted three Scotsmen and was undefeated, beating the Pumas 28–3 in a one-off Test in Buenos Aires. It was Argentina's maiden international match and at No. 8 for them was Barry Heatlie, the former Springbok skipper, who was facing the Lions for a record 17th time.

SOUTH AFRICA, 1910

Previous differences resolved, Irish and Scottish players returned to the Lions fold in 1910 and, to cement the rapprochement, Ireland prop Tommy Smyth was appointed captain. The Newport club provided a record seven players. For the first time the itinerary included a fixture in Bulawayo against Rhodesia, a match which was won 24–11, but the tourists struggled in South Africa itself. Just as they had done seven years earlier, they lost the Test series 2–1.

SOUTH AFRICA, 1924

The Lions were back in action after a 14-year hiatus precipitated by the First World War and headed to South Africa, led by England stalwart Ronald Cove-Smith. For a third successive visit, the tourists came up short in the Test series, losing 3–0 but saving a degree of face with a 3–3 draw with the Springboks in Port Elizabeth. It was the first tour during which the squad were contemporaneously referred to as 'Lions', the name inspired by the heraldic motif on the players' ties.

ARGENTINA, 1927

An expanded itinerary featuring four Tests awaited the tourists 17 years after their first journey to South America. The Lions proved too strong for their hosts, scoring 298 points and conceding just nine. The Tests were all played at the Estadio GEBA in Buenos Aires, the tourists opening up with a comprehensive 37–0 triumph to set what was a one-sided tone for the series. England centre Ernie Hammett top scored for the Lions in their four international victories, amassing 40 points as the Pumas were overpowered and outclassed.

NEW ZEALAND & AUSTRALIA, 1930

For the Lions' first Australasian adventure for 22 years, the selectors approached more than 100 players before enough accepted their invitation. England forward Doug Prentice eventually led a 29-man tour party. A 6–3 victory in the first Test in Dunedin against the All Blacks, who were in fact playing in white to avoid a clash with the navy blue-shirted Lions, boded well but the team were beaten in their

subsequent three internationals in New Zealand. They also fell short in the standalone Test against the Wallabies, losing 6–5 in Sydney in late August.

ARGENTINA, 1936

The third and to date final Lions tour of Argentina, the 1936 tourists were led by stylish England half-back Bernard Gadney and marched imperiously through Argentina with 10 victories in 10 outings which included a 23–0 success in the only Test against the Pumas. So dominant were the tourists they averaged 40 points per fixture and conceded one solitary try, which came in the game against the side from Belgrano Athletic Club in Buenos Aires.

SOUTH AFRICA, 1938

The final tour of the pre-war era, the Springboks were fresh from series victories against New Zealand and Australia the previous year and were world champions in all but name. The first Test at Ellis Park went the way of the hosts with a 26–12 victory, while the second in Port Elizabeth, dubbed the 'Tropical Test' because of the stifling heat, also saw a South African victory. The Lions however rallied for the climax of the series and, with a record eight Irish players in the starting XV, they claimed a 21–16 win at Newlands, their first Test victory in South Africa in 28 years.

▲ A postcard depicting the 1950 Lions arriving in New Zealand to ecstatic greetings from the locals

NEW ZEALAND & AUSTRALIA, 1950

Sporting their now iconic red shirt to avoid a repeat of the kit clash of 1930, the Lions kicked off the Test series against the All Blacks with a morale-boosting 9–9 draw in Dunedin. Narrow losses in Christchurch, Wellington and Auckland followed but solace was on hand during the Australian leg of the tour in the shape of a 19–6 win over the Wallabies in Brisbane and a 24–3 triumph in Sydney. Wales and Llanelli full-back Lewis Jones made history when he was called up as a mid-tour replacement, becoming the first ever Lion to fly to his destination.

SOUTH AFRICA, 1955

One of the most entertaining tours of any era, the 1955 Lions, led by Ireland's Robin Thompson, gave the Springboks an almighty scare but ultimately had to settle for a share of the Test series. A dramatic 23–22 victory in the first game in Johannesburg was followed by defeat in Cape Town but the tourists edged

ahead again with a 9–6 win in Pretoria. The hosts had not lost a series on home soil for 59 years and preserved their proud record with a 22–8 success in the fourth and final Test in Port Elizabeth. Teenage Ireland wing Tony O'Reilly was the standout performer for the Lions with 16 tries.

AUSTRALIA, NEW ZEALAND & CANADA, 1959

A fourth successive tour to feature an Irish skipper in the shape of Leinster hooker Ronnie Dawson, the squad played an incredible 33 fixtures in three different countries. The Australian leg of the tour resulted in a 2–0 triumph for the Lions in the Test series but they went down 3–1 in New Zealand against the All Blacks. Their 9–6 win in Auckland was, however, the side's first success against

➤ A vintage souvenir pin badge celebrating the 'British Isles Rugby Union Team'

the Kiwis since 1930. The squad stopped off in Canada on the way home, playing sides representing British Columbia and Eastern Canada, while Tony O'Reilly scored a remarkable 22 tries, taking his total Lions tally to a record-breaking 38.

SOUTH AFRICA, 1962

The Lions fought fire with fire in 1962 and dispatched a massive pack to South Africa to arm wrestle the Springboks. The tactic earned the tourists a 3–3 draw in the first Test at Ellis Park but narrow defeats in the next two matches were followed by a bludgeoning loss in Bloemfontein in the climax of the series. The tour began with fixtures in Rhodesia and ended in East Africa and in the squad's 21 provincial matches they were only beaten by Northern and Eastern Transvaal.

AUSTRALIA, NEW ZEALAND & CANADA, 1966

What was to ultimately be a tour to forget began encouragingly enough with a two-Test win over the Wallabies but the Kiwi instalment of the trip – the first to include a dedicated coach in the party – was marred by foul play and bad blood and the Governor General of New Zealand was asked to mediate between the two captains. The intervention did the Lions little good and for the first time they were whitewashed by the All Blacks. The sense of gloom was only compounded when they suffered an embarrassing defeat to British Columbia en route back to the UK.

SOUTH AFRICA, 1968

The record books testify that the Lions lost the Test series 3–0 against the Springboks, the second game in Port Elizabeth finishing 6–6, but it was nonetheless a tour of note. Cardiff prop John O'Shea became the first Lion to be sent off for foul play after throwing a punch against Eastern Transvaal, while Mike Gibson became international rugby's first substitute when he replaced Barry John in the Test in Pretoria. Ireland full-back Tom Kiernan scored 35 points in the Tests, the only other Lion to trouble the scorers being Willie John McBride with a try.

NEW ZEALAND, 1971

Billed as standalone visit to New Zealand, the tour actually began with two provincial games in Australia, the first of which was lost to Queensland. But it was across the Tasman Sea that the tourists, led by John Dawes and coached by Carwyn James, achieved immortality. Beaten 4–0 by the All Blacks just five years earlier, they won the first Test 9–3 in Dunedin and the third 13–3 in Wellington before clinging on for dear life in Auckland to secure a 14–14 draw which sealed the series 2–1. After 67 years and seven tours, the Lions had finally toppled the All Blacks. It remains their only triumph to date in New Zealand.

▼ Fly-half Barry John was the standout player during the Lions' 1971 triumph over the All Blacks. So superlative were his performances that the New Zealand press dubbed him 'The King'

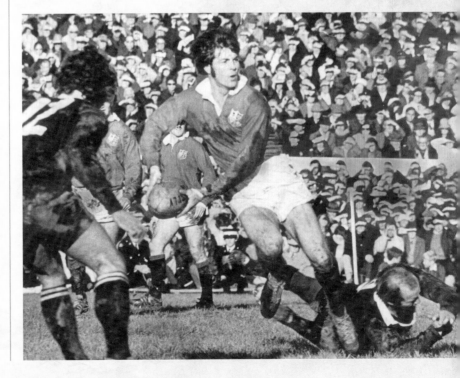

▲ Despite the best efforts of New Zealand's Bevan Wilson, Dougie Morgan touches down for a try during the fourth Test of the 1977 tour, although it wasn't enough to stop the Lions from slipping to a 10–9 defeat

SOUTH AFRICA, 1974

Famed for Willie John McBride's legendary '99' call, a rallying tactic to dissuade the South Africans from trying to intimidate his squad, the tourists were unbeaten in all 22 games. In winning the Test series 3–0 they became the first side in the 20th century to scalp the Springboks in their own backyard. The first three Tests all went to the visitors, but they were controversially denied a series and tour clean sweep in Johannesburg when the referee allegedly signalled time four minutes early and the game prematurely finished deadlocked at 13–13.

NEW ZEALAND, 1977

The All Blacks had waited six years for the chance to exact revenge for their 1971 series defeat and although the two sides were closely matched, it was the Kiwis who restored national pride. Beaten 16–12 in Wellington in the opener, Phil Bennett's side kept the series alive with a 13–9 success in Christchurch. The last two Tests were bridges too far and New Zealand ended 3–1 winners. The Lions broke new ground at the end of the tour with a Test against Fiji, surprisingly losing 25–21 in Suva.

SOUTH AFRICA, 1980

Captained by England's Grand Slam-winning skipper Bill Beaumont, this was the first of the modern, curtailed tours with only 18 matches. It went ahead despite opposition from the British Government and the sporting boycott of the apartheid era in South Africa. The Lions won all 14 of their provincial fixtures, but injuries took their toll and they were outmuscled in the opening

three Tests. Pride was salvaged with a 17–13 win over the Springboks in Pretoria in the final game.

NEW ZEALAND, 1983

There was little to redeem the 1983 tour from a British and Irish perspective as the Lions found themselves out of their depth in New Zealand. All four Tests were lost – as were the provincial fixtures against Auckland and Canterbury – and the sombre mood of the trip was encapsulated in the final match, the tourists leaking six unanswered tries at Auckland's Eden Park as the All Blacks recorded a comprehensive 38–6 win. It remains the Lions' heaviest defeat in any fixture.

AUSTRALIA, 1989

The first visit to Australia alone since 1899, the tour down under was condensed to 12 fixtures and climaxed with Finlay Calder's side making history when they became the first squad to lose the opening Test and go on to win the series. Beaten 30–12 in Sydney, the tourists bounced back seven days later to edge it 19–12 in Brisbane. They went on to clinch a 2–1 triumph in Sydney, dramatically carving out a 19–18 victory courtesy of a Ieuan Evans try which famously came after a mistake from David Campese.

NEW ZEALAND, 1993

Ian McGeechan became the first man to coach the Lions twice when he took up the reins four years after masterminding victory over the Wallabies. England supplied a record 17 of the final 34-man squad and had 11 players in the starting XV when the Lions levelled the Test series at one apiece with a muscular

▲ The 1989 Test series against Australia was particularly fractious and saw tempers flare on both sides on several occasions

➤ Alan Tait, Matt Dawson and Neil Jenkins celebrate the Lions' victory in the first Test of the 1997 tour of South Africa

20–7 win in Wellington. The All Blacks recovered their accustomed composure in time for the tour denouement, however, and emerged 30–13 winners at Eden Park to take their ninth series against the visitors.

SOUTH AFRICA, 1997

The first tour of the professional era and also the first in post-apartheid South Africa. The Lions selected six former rugby league players and named England lock Martin Johnson as captain to take on the reigning World Cup champions. The opening Test at Newlands was clinched 25–16 thanks to tries from Alan Tait and Matt Dawson. It took a heroic defensive effort, and Jeremy Guscott's iconic drop goal, to secure a nerve-jangling 18–15 triumph in Durban a week later to clinch a first series win in Africa for 23 years. The tourists were demolished in the third Test, but it scarcely seemed to matter to the delighted fans who had flocked to every game.

AUSTRALIA, 2001

The advent of the 21st century saw the Lions turn to a foreign head coach for the first time when they appointed the then Wales coach, Graham Henry. The Kiwi's tenure began brightly with a record 116–10 demolition of Western Australia. The three-Test series kicked-off with a 29–13 win for the visitors at the Gabba, but tensions within a disparate squad grew as the tour unfolded and the next two international matches were lost. It was the first time the Wallabies had defeated the tourists in a series.

NEW ZEALAND, 2005

Sir Clive Woodward took a record 44-player squad, plus a 26-strong management team, to New Zealand, but not before the Lions had played their first true international on 'home' soil against Argentina at the Millennium Stadium. Sadly, the Lions' unprecedented numbers failed to overwhelm the All Blacks. They lost

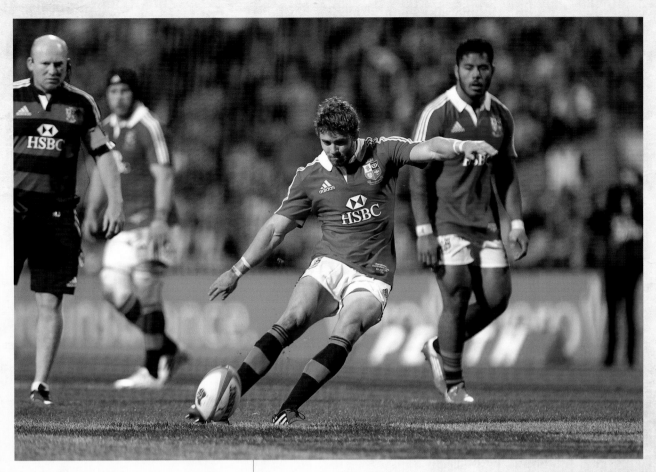

their captain, Brian O'Driscoll, to a spear tackle a mere two minutes into the first Test in Christchurch and lost the match 21–3. It was the closest they got to the Kiwis and heavy defeats in Wellington (48–18) and Auckland (38–19) followed to send a chastened group home with the dubious distinction of being the first squad in 22 years to have lost all their Tests on tour.

SOUTH AFRICA, 2009

The Springboks were once again world champions and made no secret of the fact they were still smarting from their experiences in 1997. Even the fabled tactical acumen of Ian McGeechan, coaching the tourists for an unprecedented fourth time, could not prevent them exacting their revenge. The 'Boks took the first Test in Durban, but the Lions seemed to have kept their hopes alive in Pretoria with the match

level at 25–25 as it moved into injury time. Then up stepped Morne Steyn to knock over a monster penalty to win the match and the series. The Lions had some consolation as they won the third Test 28–9 in Johannesburg.

AUSTRALIA, 2013

For the second time in Lions history a New Zealander took charge of the team. After a ground-breaking opening game against the Barbarians in Hong Kong, Warren Gatland took his 37-man squad down under in search of a first series success in 16 years. They narrowly edged the first Test 23–21, lost in Melbourne by a single point seven days later, but saved their best performance of the tour for the third game to demolish the Wallabies 41–16 in Sydney. Full-back Leigh Halfpenny kicked 21 points in the ANZ Stadium to take his tour tally to 114.

▲ Leigh Halfpenny makes it 11 successful kicks out of 11 in the match against Western Force in 2013. The Welshman was in imperious form throughout the tour and was named player of the series

1

THE GENESIS OF THE LIONS

As the world continues to spin further and further into the 21st century in an age of ever expanding technology, it is hard to fathom that the wonderful institution of The British & Irish Lions began way back in the latter stages of the 19th century.

A time when air travel was still a dream for the Wright brothers, mobile phones and the internet were implausible, and when many sports that we have come to love and cherish were in their early genesis and being spread around the world following the beat of the British Empire, an empire that by 1922 held sway over about 458 million people – one-fifth of the world's population. To this day Britain retains sovereignty over many territories, including sporting arch-enemies Australia and New Zealand, with South Africa having become a republic in 1961.

What we have come to so look forward to every four years is, surprisingly, the direct result of plans hatched by three cricketers, Shaw, Shrewsbury and Lillywhite. These visionary entrepreneurs had all experienced pioneering cricket tours to Australia and dreamt of further fame and fortune in distant lands. These first Lions 'tourists' were actually paid on a tour not sanctioned by the rugby authorities.

Since that fateful tour the make-up of the Lions, their name and the shirt they have played in have all varied through time but with each passing decade the 'brand' has become stronger. Today Lions tours draw huge crowds and TV audiences and generate millions of pounds in revenue.

Such a colourful and intriguing past, littered with success and failures, has developed a tradition so strong that in the modern era of professional rugby the Lions remain the last bastion of rugby touring. Fans revel in the deeds of famous Lions who have worn the red shirt. Pubs the length and breadth of England, Wales, Scotland and Ireland are open forums for amateur selectors. Supporters scrimp and save to make the journey south with their heroes to be a part of 'the sea of red', as the hordes of Lions fans are affectionately known.

Little did Messrs Shaw, Shrewsbury and Lillywhite know what they had started. From such humble beginnings would grow a rugby institution that in 2013 celebrated 125 years of touring trials and tribulations. May there be many more.

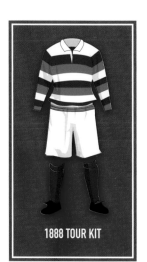

1888 TOUR KIT

1888
WANTED: A PROFESSIONAL TOURING TEAM

Captain: Rob Seddon (Swinton and England), Andrew Stoddart (Blackheath and England)
Squad Size: 22
Manager: Arthur Shrewsbury (England)

Tour Record:	P 35	W 27	D 6	L 2	F 292	A 98
In New Zealand:	P 19	W 13	D 4	L 2	F 82	A 33
In Australia:	P 16	W 14	D 2	L 0	F 210	A 65

Dear Sir,
It has been decided by Messrs Shaw, Shrewsbury and Lillywhite to take out a team of Rugby Union football players to Australia next March, returning in September. The grounds have been secured in all the principal places. The rules of the

Victorian Association differ somewhat from Rugby Union, the number of players being twenty-a-side... The greater number of matches will be arranged against clubs playing the Rugby Union rules. Six or eight matches under Victorian Rules will be played but these will not be until late in the tour, thereby giving every opportunity to the team of witnessing games played under these rules as well as practising them. I am desired by Shaw, Shrewsbury and Lillywhite to ask if you will form one of the team, in which case I shall be happy on their behalf to communicate terms to you, which I am sure will prove satisfactory.

Yours sincerely,

Mr Henry Turner

P.S. If you know, amongst your circle of friends, anyone whom you think would be likely to take the trip, I should esteem it a favour if you would kindly send me his name and address. Should prefer international players, if possible.

And so the message was sent out to a handful of carefully selected players to join what is now accepted as the first tour made by what became The British & Irish Lions. The game of rugby may have officially been declared 'open' in Paris on 26 August 1995 by the International Rugby Board (IRB), but as the letter above shows the first overseas tourists were paid for their time and effort even 125 years ago. The 'Paris Declaration' came 99 years and 364 days after the decision was taken in 1895 by the Northern Union to break away from the Rugby Football Union (RFU) in the row over 'broken time' payments.

The decision by the IRB in the wake of the 1995 Rugby World Cup, and under threat of a breakaway by the world's leading 500 players, removed all restrictions on payments or benefits to those connected with the game. 'Shamateurism' was dead, and the way was cleared for clubs and unions to negotiate proper contracts with their players. Some 17 years on from that momentous decision, the Lions marked the 125th anniversary of the pioneering tour by Arthur Shrewsbury, Alfred Shaw and James Lillywhite's 'English Footballers' with a tour worth tens of millions of dollars to the Australian economy and one that netted more millions for the Australian Rugby Union, earned each home union millions of pounds and allowed the players the chance to supplement their earnings with up to £50,000 each as a bonus for winning the tour.

But how different are the figures when compared to 1888? Using the average earning comparison, £1 in 1888 was equal to £422 in 2010. That would make the £200 paid to players like Andrew Stoddart the equivalent of £84,300 122 years later. Using the retail price index, it equates to £17,400. Whichever figure you choose, the offering from the cricketing trio was not to be sniffed at.

The figures from that tour are amazing:

- 22 players (9 backs, 13 forwards)
- 54 games in 21 weeks
- 35 rugby union matches (19 in New Zealand, 16 in Australia)
- 19 Victorian Rules matches
- 249 days away from home – left 8 March and arrived home 11 November

But how did it fall to three cricketing entrepreneurs to launch the first major overseas rugby tour undertaken by a representative side? New South Wales had crossed the Tasman in 1882 and 1886 to visit New Zealand, with the All Blacks reciprocating in 1884, but the 1888 tour was on a completely different scale. There had been, as highlighted by the Australian rugby historian Sean Fagan, a rugby tour from England to Australia as early as 1879. One year later, Frank Adams, the

Richmond captain and England international, contacted the Southern RFU, which became the New South Wales Rugby Union, about sending a team to tour both Australia and New Zealand. The example of cricket, which had developed strong playing links with Australia, was cited as a reason for trying to spread the rugby union gospel. The plan failed when Adams suggested the cost of the tour would be in the region of £3,000. The football bodies in Australia suddenly got cold feet as they contemplated how they might raise the funds and gate receipts to cover such costs. The dream died.

So how did three of England's greatest cricketers, all of whom captained touring teams in Australia in Test matches, get involved in planning the first major overseas rugby union tour from the UK? All three were open professionals and entrepreneurs. Shrewsbury and Shaw even threatened to strike after not getting the £20 they had demanded from the All England XI for playing against the 1880 touring Australians. At the age of 19, Shrewsbury began to play regularly for Nottinghamshire County Cricket Club. He would develop into one of the greatest run scorers in the club's history. In a career lasting from 1875 to 1902, he led the first-class batting averages seven times, attained the highest seasonal average of any batsman to date and hit ten double centuries. He was an automatic choice for England, twice captaining his country in a series against Australia. In all, he made 498 first-class appearances, 357 for Nottinghamshire, and played in 23 Test matches. He toured North America in 1879 and Australia four times, 1881–82, 1884–85, 1886–87 and 1887–88. Shrewsbury was the first cricketer to pass a 1,000 Test runs and his record career total of 1,277 runs lasted for 15 years before it was beaten in January 1902 by Joe Darling. He amassed 26,505 first-class runs and became immortalised by an answer given by the greatest cricketer of the Victorian age, W.G. Grace, when he was asked which player he would most like in his side: 'Give me Arthur.'

In 1879, Shrewsbury was one of seven Nottinghamshire players signed up by a Nottingham businessman to play matches in Canada and the USA. A certain Alfred Shaw, another Notts and England player, also made the trip and it was probably during their time spent abroad that they hatched a plan to open a sports-equipment business in Nottingham. The Midland Cricket, Lawn Tennis, Football and General Athletic Sports Depot was opened in 1880. Later, its name was to be changed to Shaw and Shrewsbury.

Shaw held the distinction of bowling the first ball in Test cricket, for James Lillywhite's XI (England) against a Combined Australia XI on 15 March 1877 at the Melbourne Cricket Ground. He was the first player to take five wickets in a Test innings and made seven appearances for England. He took more than 2,000 wickets in a first-class career that spanned 1864–97 and saw him lead Nottinghamshire to four successive championships. A natural leader with a powerful persona, he was a fervent champion of professional cricketers' rights and did a lot of work in support of his contemporaries.

Lillywhite was from an illustrious cricketing family, and between 1862 and 1881 he appeared in all of Sussex's matches. He captained the English side that played in the first Test in Melbourne and went on to become a Test umpire.

▲ Nottinghamshire's Arthur Shrewsbury was one of the finest batsmen of his age as well as a budding entrepreneur

▲ Shrewsbury's Nottinghamshire and England teammate Alfred Shaw was the first man to bowl a delivery in Test cricket

English cricket teams had been going out to Australia ever since 1861–62, and in 1876 Lillywhite organised a tour down under which made him a handsome profit. Seeking a further financial killing, Lillywhite asked Shaw to help him plan another trip in the winter of 1881–82. Given that Shaw was in business partnership with Shrewsbury, it seemed sensible to factor him into the equation, and the three partners each netted £700 for their efforts. The profits from that Australian venture obviously whetted the appetite of Shrewsbury for more tours. There is no doubt he had a meticulous business brain when concentrating on his domestic shop, but when it came to turning tours into hard cash he never quite managed to rediscover the magic formula.

He went on to promote three more tours, the first of which delivered a modest profit. The others were financial flops on a grand scale. The tour of 1887–88 had a rival in Australia at the same time in the shape of George Vernon's XI. Ironically, Vernon himself was a double international, having played cricket for England whilst an amateur with Middlesex and rugby for England while playing with Blackheath and Middlesex. He had in his tour party, which travelled to Australia on the same Orient steamer, *Iberia*, as Shrewsbury's side, the great Andrew Stoddart, who would captain England at both cricket and rugby and who took over the captaincy of the 1888 Lions midway through the tour. Having been a rival to Shrewsbury on the cricket fields of Australia, he quickly turned into his biggest box-office draw weeks later on the rugby union tour. Not that it made too much difference to Shrewsbury and Shaw, who had to find the money to pay for the small fortune they lost on their cricket venture, some £2,400, because the rugby tour lost money as well. Shrewsbury was obviously a gambler in business, and certainly no quitter. No sooner had it become clear that the cricket venture was financially doomed than he started planning to recoup his losses by organising a rugby tour to Australia and New Zealand. By the time Shrewsbury returned from his double sporting venture, the cricket and rugby trip, he had been away from his Nottinghamshire home for 15 months and lost himself up to around £1,600. It was the same for Shaw. To make financial matters even worse, Shrewsbury missed the whole of the 1888 domestic cricket season, and Lillywhite declared himself unable to meet his part of the financial liability.

Shrewsbury beavered away trying to arrange matches and terms as the cricket tour developed, while his English agent for the rugby union tour, Henry Turner, went about the task of getting official backing from the Rugby Football Union for the venture. He also had to convince some top-class players to give up 33 weeks of their working life to go on the trip. The RFU proved a tougher nut to crack than the players, flatly refusing to sanction the tour. The princely advance sum, as a 'clothing allowance', of £15 and the promise of between £90 and £200 each for the tour seemed to do the trick with the players.

The thunderbolt from the RFU was delivered in a formal statement from Rowland Hill on 18 January 1888. It was part of a double blow to Shrewsbury's planning, as it coincided with the decision of the Victorian Football Association to veto his request to play six or eight games under their code:

The Rugby Union Committee wish it to be known that in response to the request from the promoters to give their support and approval to the projected football tour to Australia they declined to do so. They do not consider it within their province to forbid players joining the undertaking but they feel it their duty to let gentlemen who may be thinking of going know that they must be careful in any arrangements made

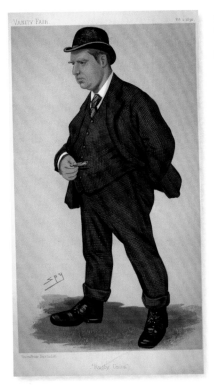

VANITY FAIR.

'Rugby Union'.

▲ A caricature of George Rowland Hill, secretary of the RFU, published in Vanity Fair in 1890. Hill was passionately concerned with preserving rugby football's amateur roots

that they do not transgress the laws for the prevention of professionalism. The committee will look with a jealous eye upon any infringement of such laws, and they desire specially to call attention to the fact that players must not be compensated for loss of time.

As secretary of the RFU, Hill saw himself as one of the foremost guardians of the laws of the game and when the team was announced he sent a confirmation telegram to Australia to underline the fact that his union had not given their blessing to the tour. As if to hammer home the final nail in the coffin, he circulated to all members of the squad on 2 March a copy of the 'Rules of Professionalism'.

It is obvious that Shrewsbury and Shaw were unaware of the much stricter and better policed rules regarding amateur and professional status in rugby union as compared to those that existed in cricket. While W.G. Grace was able to make a very healthy living out of being an 'amateur' cricketer – he was paid ten times the rate of the professionals on the 1873–74 tour to Australia and is estimated to have earned more than £120,000 from cricket – as were many of the players Shrewsbury had recruited for his own cricket tours, there were constant witch-hunts in rugby circles regarding payment for 'broken time' and players being offered jobs at inflated wages to entice them to transfer. Plans for the tour came just before the great rugby revolution, the 1895 schism in the union game that led to the formation of the Northern Union, which ultimately became the Rugby Football League. That final step came after years of bitter disputes over payment to players, especially at clubs in the north.

Peter Wynne-Thomas, in his book on *Shrewsbury, Give Me Arthur: A Biography of Arthur Shrewsbury*, used carbons of 300 letters written by the man himself – or written to him – to produce a fascinating work. Excerpts from the letters provide an incredible insight into the background of the tour. Trevor Delaney's *Rugby Disunion* is another book that delves deep into the letters to bring to life the disputes between the different parties in England and Australia.

Shrewsbury wrote to Shaw on 9 November 1887 to comment on the selection of the rugby team:

The question of amateur and professional players is not recognised so much in football as in cricket, at the same time amateurs give tone to the team and you may well be able to get them to come for their bare expenses. We want the best of players and a few Scotchmen in the team would I think be popular.

Over the New Year period in 1887, he wrote:

Turning to football matters again, you would have to get a nice outfit especially made for the team. Something that would be good material and yet take them by storm out here. You could also have a monogram worked on the front of it. The players will have to take a lot of exercise on board ship, or they will be too stout to play for some time when they arrive. They could use the football on board ship for the little kicks from one to another, which is practised to a great extent in the Victorian game, as the players are not allowed to use their hands to throw it to another player.

In February 1888, he wrote again to Shaw and in three different letters highlighted by Wynne-Thomas and Delaney he exposed the financial fragility of his tours and left no room for imagination when it came to determining whether or not the rugby players were being paid:

The football tour seems to be going all right, and up to now we have obtained first class terms for the use of grounds, but some difficulty may arise if the players require a large share of the takings.

[Please forward]... all particulars of engagements of players. Salary, length of stay and all other details...

I can tell you we have been pretty hard pressed, having had to pay £800 to £1,000 a/c to the New Zealand Shipping Co for the team coming out and home. We expect that as soon as they arrive we shall commence picking up some money and by all accounts the Football team is bound to be a big success. Of course that very much depends whether you have sent out first class players...

We are sure to lose a lot of money by the cricket venture, but hope to get it back at Football.

The level of payments are revealed in a letter to Shaw on 22 June 1888 in which he tells his partner he has renegotiated the contracts for an extra six-week stay in order to extend the tour into Queensland.

You must send Anderton's pay to his mother or whoever it is, a month extra, on account of him staying out longer. I will let you know whether to do the same with Nolan's people later. It all depends on how he behaves himself. Thomas, I see by the book, was to have £3 a week. Now if we were to give him £3 per week for the extra six weeks he stayed he will be having £18 for the extra time, whereas the other men are staying for nothing except Anderton. Originally Thomas was to have £90. If the thirty weeks he agreed to stay was divided into £90 for convenience sake, so as to arrive at what the amount would come to per week, then he won't be entitled to any extra money. If on the other hand you agreed to pay him £3 per week from the time he left home until his return, then we shall have to pay him the extra £18.

William Thomas was the only Welshman in the squad of 21 that eventually got selected. A student at Cambridge University, he had already played seven times for Wales by the age of 22 and broke his studies to take the trip of a lifetime. Jack Anderton was one of the star backs at Salford and had already become a regular with Lancashire.

The power in English rugby was in the north in the 1880s, and Turner went in search of a team mainly in Lancashire and Yorkshire. Shrewsbury did his bit in Australia, twisting Stoddart's arm by offering him a cash advance of £50 and also inviting three members of his own cricket team, C. Aubrey Smith, George Brann and Billy Newham. All three were sound soccer players, but had next to no rugby experience. In the end, injury forced Newham to head home after the cricket tour, while protracted financial negotiations with Smith and Brann eventually saw them both opt out of turning their hand to rugby. It was a double-edged sword for Shrewsbury. On the one hand, he wouldn't have to pay Stoddart-size wages to two players who may or may not have worked out for him, while on the other he was faced with paying 80 guineas for three more round-trip fares.

Among those players who received the canvassing letter sent by Turner and signed terms was the future England captain from Dewsbury, Dicky Lockwood. In the end, he didn't make the trip and neither did another player who gave a positive response to Turner, his Welsh international clubmate William 'Buller' Stadden. They both, however, became embroiled in a major row in the weeks building up to departure. Lockwood signed articles on Tuesday, 17 January, along with Tommy Haslam and Charlie Mathers.

▲ One of the 1888 jerseys – 'a nice outfit especially made for the team' in the words of tour organiser Arthur Shrewsbury – that can be seen at the World Rugby Museum in Twickenham

Shrewsbury got his way with the 'Scotchmen', with the first set of brothers to have played for the Lions, Willie and Robbie Burnet, being joined by their Hawick and Roxburgh County teammate Alex Laing. A fourth – already world-renowned – Scot was added, although initially to act as referee, in Dr John Smith. The biggest man in the squad at 6ft 3in tall and weighing in at a then massive 15st, he was a Scottish soccer international who had also been a reserve for the Scottish rugby team. He ended up playing in nine rugby matches on tour, as well as turning out in a number of Victorian games. He celebrated his 33rd birthday on the tour.

Smith had learned his sport at Ayr Academy and Edinburgh University and was a good all-rounder. He played cricket for Edinburgh University in 1878 and won the Scottish Universities Championship at 100 yards (10.5 seconds), long jump (20ft 3.5in) and triple jump (41ft). He joined Queen's Park FC (Glasgow) after leaving university, where he had introduced the game of football to his fellow students. He helped Queen's Park to win the Scottish Cup in 1881, when he became the first player to score a hat-trick in a Scottish Cup final. Those goals came in the 1881 final replay against Dumbarton. He didn't play in the 1882 final but was part of the team that was awarded the trophy in 1884 when Vale of Leven failed to appear for the final. First capped by Scotland in 1877, he became one of the mainstays of the side, scoring ten goals in ten matches between 1877 and 1884, including a hat-trick against England. In 1879, he was the world's top international goal scorer with three in two appearances, and he was second in 1881 and 1883. He often appeared as a guest player under the pseudonym J.C. Miller, playing with Corinthians FC (London), Swift London and Liverpool Ramblers. One such appearance, for the Corinthians against a professional English club in 1885, saw him banned for life by the Scottish Football Association. They claimed he had infringed his amateur status and he was never allowed to play for or against any Scottish club or for the Scottish national team. Regarded at the time as the best Scottish inside-forward around, he had also been a reserve player for Scotland's rugby team against England in 1876 while still a student.

There was also one Irishman among the tour party, giving the 1888 squad representation from all four constituent nations for the Lions. Arthur Paul was born in Belfast, the son of an army officer who later became the chief constable of the Isle of Man. He was educated in Douglas and became an all-round sportsman.

A trained architect, he was playing rugby for Swinton and Lancashire when selected for the 1888 tour, but he was also a first-class cricketer. He played 96 matches for Lancashire (1889–1900) and also played for XVI of Blackpool against Australia in 1893. He faced the Aussies again in 1896 for Lancashire but had his greatest cricketing moment a year earlier when he partnered Archie MacLaren for Lancashire against Somerset. The two put on 363 runs for the second wicket in 190 minutes as Lancashire scored 801 runs. MacLaren registered an English batting record of 424 runs in a first-class innings, a total that stood until beaten by Brian Lara in 1994. Paul scored 177 that glorious day and ended with 2,976 first-class runs, including four centuries. He also played in goal for Blackburn Rovers and went on to become a first-class umpire at the end of his playing days.

Paul played in 29 of the 35 games, while Harry Eagles, who scored the Lions' first try and points in Australia in the 18–2 win over New South Wales, played in every single one of the 54 games on tour.

At the other end of the spectrum was Halifax forward Jack Clowes, who became embroiled in a bitter dispute between his club and Dewsbury that ended in him being professionalised by the RFU on the very day the team departed. As a result, he never

got to play a game on tour. A factory worker, Clowes admitted at a Yorkshire Rugby Union disciplinary hearing to receiving £15 from Mr Turner as an advance to help him buy clothing for the tour. The hearing came in the wake of Clowes scoring a try for his club in a Yorkshire Cup tie on 3 March. A crowd of 12,000 turned up to see the vital match against Dewsbury. The Dewsbury chairman had heard about the money being given to Clowes from one of his own players who had signed for the tour, Angus Stuart. Stuart was cunningly left out of the Dewsbury team, and once the game was lost the losers cried 'foul' and claimed Halifax should forfeit their win for playing a professional player. Clowes offered to return the money but was declared a professional. He was already at the docks when the decision came through, so he undertook the whole eight months of the tour without playing a single game, spending much of his time in Sydney visiting his brother. Dewsbury and Halifax were ordered to play their cup tie again, but Halifax triumphed once more. At the RFU annual general meeting on Friday, 13 April, Captain Bell of Halifax moved that Clowes should be reinstated, but the resolution was ruled out of order by the chairman. He was eventually reinstated at an RFU meeting at the Craven Hotel, The Strand, London on Thursday, 22 November 1888. At the same meeting, it was decided that all members of the touring party would be required to make a declaration that they didn't receive anything beyond their expenses for hotels and travel. They all complied, leaving Clowes as the only player who suffered in the whole sorry affair.

The *Otago Witness* ran biographies of the players before their arrival:

J.T. HASLAM (Yorkshire and Batley) Full-back. Age 25. Height 5ft 9in, weight 11st 10lb. First played for Batley fifteen October, 1882. Was full-back in Yorkshire county trial match in season 1883–84. In 1884–85 played for his county against Durham and Cheshire. Since then has been a fixture in the county team. Displayed splendid form in cup contests in 1885, when his club won the Yorkshire Cup. Played in all county matches this season, and also in North v South matches. About the best full-back in the North. Can also play well at three-quarter. A clever drop-kick, using both feet equally well, he picks up splendidly, and tackles unerringly. Has good pace, though he usually prefers to kick, and plays hard throughout. Also a fair cricketer.

A. PAUL (Swinton) Full-back. Age 23. Height 6ft, weight 14st 7lb. Born in Belfast. Played several years with the Isle of Man F.C., but joined Swinton last season. Was a reserve in Lancashire match with Edinburgh this year. Very strong and muscular, and a powerful kick. Plays finely at three-quarters, and is a brilliant forward. A sure place-kick. Also a capital cricketer. It is rumoured that he will not go back to England, and that he will take a hand in the management.

HENRY COLLINGE SPEAKMAN (Cheshire and Runcorn) Three-quarter back. Age 24. Height 5ft 8 ½in, weight 11st 12lb. Began playing with the Weston F.C., a small club near Runcorn, as half-back, nine years ago. His first great match was West Lancashire and Border Towns v Batley in 1884–85, when he won fame as a three-quarter back. First played for Cheshire against the Fettesian-Lorrotorians, the famous Edinburgh scholastic organisation, in the same season. Played twice more for his county that season, and proved himself the best centre three-quarter in the county. This season he represented Cheshire in all her matches. Runs strongly, picks up splendidly, drops well, and has fine dodging powers. Passes with good judgement. In nearly every instance the press proclaimed him the best three-quarterback on the field, his kicking, running, passing, collaring, and judgment being of the finest order.

▲ Andrew Stoddart was a hugely accomplished all–round sportsman, captaining England's cricket team in eight Tests and later becoming a founding member of the Barbarians

A.E. STODDART *(Middlesex, Blackheath, and Harlequins) Three-quarter-back. Age 24. Height 5ft 11in, weight over 12st. A Durham man by birth, though a South of England player – the only one in the team. After a fine club career, made his debut in a first-class match in season 1883–84, playing for London against Oxford and Cambridge. The form then shown has been sustained. He was chosen for the South against the North in 1884–85, and represented England in her two international contests the same season. In 1885–86 played in all the big matches for his county, the South, and England. In 1886–87 an accident in the first spell of the North v South match stopped his career for some time. During the season just closed he has been in Australia with Vernon's cricket team. He is a grand runner and dodger – 'like a bloomin' dancin'-master,' the Cockneys describe him – a fine drop kick, and is only found fault with for his high tackling. Despite this, he seldom misses his man, knows the game thoroughly, and is a keen enthusiast. His cricketing abilities are well known.*

DR. H. BROOKS *(Edinburgh University and Durham Co.) Three-quarter-back. Age 29. Height 5ft 8in, weight 12st 6lb. First played in 1874 as full-back for Darlington, and represented his county in the same position in 1885. In 1876 played against Yorkshire as three-quarter-back. Played for Edinburgh University from 1878–83, being captain in season 1882–83, during which season he played in the leading Scotch matches. Played for North v South in 1884–85, being then on the side opposite to Stoddart. Was not in good form that match. After a visit to Burmah, played Association, on the right wing forward, for Darlington. Resumed the Rugby game this season, captaining the Durham county team, though, through professional work, was prevented from playing against Yorks and Middlesex, but was able to play against Cheshire and Northumberland. When in form is a fine three-quarter.*

J. ANDERTON *(Salford) Three-quarter-back. Age 22. Height 5ft 7in, weight 12st. Particulars with respect to this player are not very full. The SPORTSMAN merely describes him as of Lancashire and Swinton. There is a J.C. Anderton of the Manchester Free Wanderers, a grand forward, Lancashire County and North of England, who has just won his international cap. But he is not the man. J. Anderton is probably the Salford three-quarter-back, a rising player who has scored consistently for his club this season, and is clearly worth something.*

W. BUMBY *(Lancashire and Swinton) Half-back. Age 26. Height 5ft 9in, weight 11st 13lb. First played in 1873 for Pendlebury as three-quarter-back. Joined Swinton in 1860, playing one season in the same position. In seasons 1882–83 he played half-back, scoring 23 tries. In 1884–85 he was four times a county reserve man, and at last got his county jersey, playing against Cheshire. During this season was chosen to play against Somerset and Durham, against whom he played remarkably well. His defensive tactics in the latter match saved Lancashire from being beaten. Fairly fast, and a wonderful dodger. Stops rushes well, but needs to feed his backs better. A fair place kick.*

J. NOLAN *(Rochdale Hornets) Age 24. Height 5ft 7in, weight 11st 8lb. Was very successful as a junior, scoring wonderfully at three-quarters. Joined the Hornets, the crack Rochdale club, six years ago, and has scored splendidly since. In the three seasons 1884–85, 85–86, and 86–87, he scored no less than 59 tries against the best clubs in the north. His strong point is backing up, and by this chiefly he has scored.*

But he is also excellent in tackling, dribbling, running, and passing, his play being very unselfish. Being strong on his legs, and having a very fair turn of speed, he is very dangerous when near the line. As junior and senior he has gained no less than 114 tries.

W.M. BURNET *(Hawick) One of the Scotsmen of the team. Half-back. Age 23. Height 5ft 9in, weight 11st 7lb. Has played for his club six seasons, also for his county (Roxburgh) and the South of Scotland. Brilliant at half back, being a sure tackler, useful passer, good kick, and fine runner and dodger. Can always be relied on for turning out in good condition. Also plays an excellent centre three-quarters game.*

TOM BANKS *has been a rarely useful sort of player to the Swinton Club, and he is a man the 'Lions' will miss very much. He is thoroughly Lancashire, as he was born at Pendlebury, a village a few miles out of Manchester, went to Edinburgh to study medicine, and, while there, played half-back. On leaving college in 1881 he joined the Swinton club, and with the famous 'blues' has played ever since. Like Kent, he can take a turn anywhere, and is equally at home at three-quarters, half, or forward. He is a strong runner, good kick, and one of the best tacklers ever seen. It was as a forward that he got into the Lancashire team in 1884 and he has very seldom been left out of a county fifteen since. Is certain to do well in Australia, for not only can he take any position, but can stand any amount of knocking about. Has picked up a few prizes on the running path; and when at Edinburgh won a College Swimming Championship. Was born August 17, 1859, and weighs about 12st.*

R. BURNET *(Roxburgh Co. and Hawick) Forward. Age 26. Height 5ft 10in, weight 12st 8lb. Captain last season of Hawick F.C., for which he has played six years. He has also played for his county. Sterling forward, always at work. Is one of the best centre three-quarters going, and also brilliant half-back; in fact, he can play anywhere behind the maul. Is a sure tackler and good dodger, a very useful passer, powerful kicker, and is very fast. Especially sound in the scrummages. Keeps in very fit condition, training systematically. Will be of great service in all the hard work.*

J.P. CLOWES *is the first Rugby player who has ever been declared a professional. This young man, who has just attained his majority, and who stands 5ft 8in, and weighs 11st 7lb, learned his football with the Halifax Free Wanderers. He has been of great service to the Halifax Club, but landed it in a hole when he played in the cup tie with Dewsbury lately. Dewsbury was beaten, and, as is invariably the custom in cup ties of every sort, forthwith protested, on the plea that young Clowes had received a sum of money on account from the promoters of the Australian tour. Clowes, on being tackled by that august assemblage the Yorkshire County Committee, did not deny the soft impeachment and, as the rules of the Rugby Union in the district are very stringent, Clowes was declared a professional, and Halifax and Dewsbury ordered to re-play their tie, with the result that Halifax won. The Northern committee of the Rugby Union has also confirmed the decision of the Yorkshire County Club, and poor Clowes has had to suffer. Clowes is a capital forward, good tackler, and a speedy dribbler, and is one of the most promising players in the North of England.*

▲ John Nolan's cap, now part of the Priory Collection of sporting memorabilia assembled by Saracens chairman Nigel Wray. The Rochdale Hornets half-back was reportedly a deadly finisher blessed with excellent pace

H. EAGLES (*Lancashire and Salford*) *Forward. Age 20. Height 5ft 6½in, weight 11st 12lb. Began play in 1876, joined Salford in 1881, and was at once put in the first team. His reputation steadily grew till in season 1886–87 he was chosen for Lancashire, in all of whose matches he has since played, scoring in the two seasons seven tries for his county and 12 for his club. This season Eagles has played very well, and only missed one county match, and that was the Saturday before he left for Australia. The Salford champion played in both matches for the North against the South, and was included in the international fifteen selected by the English Rugby Union. Is the only member of the English international fifteen in the team, and presumably, therefore, is the best forward, though Seddon and Thomas both are probably nothing behind him. Is a grand all-round player, but especially good at dribbling and backing up. Is a wonderfully active forward, especially good from the line out, never tires, and plays correct football. He says that with the Australian tour he will finish his career as a football player.*

ANGUS STUART *is about 27 years old, and weighs 12st. First came into notice as an amateur runner, and was a member of the Rusholme Club, at Manchester. Then joined the now defunct Manchester Athletic Club, at Manchester, and from there transferred his services to the Salford F.C., with whom he did very good service as a three-quarter back. In the meantime Stuart had joined the noble army of professional pedestrians, and eventually left Manchester. Soon deteriorated as a three-quarter, and was tried forward with such good results that he was thought worthy of a place in the Yorkshire county fifteen against Cheshire and Middlesex last month. Stuart's speed is undeniable and, as he has weight likewise, it can easily be understood that he is a dangerous sort of opponent. He may not return to England with the rest of the team.*

A.P. PENKETH (*Douglas F.C., Isle of Man*) *25 years of age, stands a little over 6ft, and weighs about 12st 12lb. Played three-quarter back for the Douglas F.C. for six years, of which he was captain for three years. Can play a good forward game also. The Douglas F.C. played this season fourteen matches (some against first-class English teams), won 13, and drew 1. Also played forward during two seasons for the Penge F.C., in Surrey (now playing as the Kent Rovers).*

R. L. SEDDON (*Lancashire and Swinton*) *Forward. Age 26. Height 5ft 11½in, weight 12st. Has played chiefly with the Broughton Rangers, to which club he has been wonderfully useful. Has recently joined Swinton. For six years Seddon has been one of the best county forwards, and also played for the North against the South in 1885–86, 1886–87, and twice this season. In 1886–87 played for England against Scotland, Ireland, and Wales, is a splendid all-round forward, and has no superior in the north of England.*

DR. J. SMITH (*Edinburgh University*) *Height 6ft 3in, weight 15st. Formerly played for his university and in most of the first-class Scotch matches; was reserve for Scotland v Ireland in 1877 as full-back, losing his place only by the casting vote of the chairman. From then until 1883 played as three-quarter back, and then took up the Association game, in which he made a name and reputation throughout the United Kingdom. Was one of the most prominent members of the celebrated Queen's Park Club, Glasgow, playing in the position of centre forward, where he showed wonderful cleverness and ability. Six times has he been selected to play for Scotland against England, and four times against Wales. Residing now in London he plays with the Corinthians and the London Casuals. He will be the recognised umpire of the team during the tour in the colonies, but will on many occasions don*

the Jersey and take his place in the team as a forward, where his weight and strength will make themselves felt in the scrummages.

W.H. THOMAS *(Wales, Cambridge University). Forward. Age 21. Height 5ft 11½in, weight 13st 7lb. Learned his football at Llandovery school, a great nursery of footballers. Captain of the school team in 1884–85, playing then at centre three-quarter back. Playing as a substitute in the match Swansea v Llanelly in the forward division in the same season, he was pronounced the best on the ground. Was consequently chosen second reserve forward for Wales v England, and actually gained his international cap against Scotland a week later. He was then only 18. Since then has always been chosen for Wales. For the last two seasons has represented Cambridge University, and the London Welsh. Is a dashing forward, always on the ball, and works hard in the scrummages. Also a fine all-round athlete.*

THOMAS KENT *(Salford) Born in Nottingham, June 22, 1864. Height 5ft 10in, weight 12st. Began his football career during the season of 1880–81 in the Radcliffe F.C., and showing exceptional promise as a back, was drafted into the first team the following season. A vacancy occurring at half-back he was given a trial, and came off wonderfully well; his quick picking up, unselfish passing, and clever screw kicks often proving invaluable to his side. Is also proficient at stopping rushes, and as a place kick; many matches having been won by the Radcliffe team owing to this latter accomplishment. For many seasons ably officiated as captain of the first team of the Radcliffe F.C., but being anxious to achieve more distinction, threw in his lot with Salford F.C. at the beginning of the present season. Went in the forward division, and by his dash and untiring energy at once installed himself a great favourite, and all along has been a very consistent scorer. In a match against Rochdale Hornets dropped a goal (which proved the winning point) when his opponents were leading by two tries. Also distinguished himself against the Cheshire Champions by crossing their lines twice in the first encounter at Runcorn, and by scoring the winning point against them in the return fixture. Then came under the notice of the Lancashire County Committee, which selected him to play against Somersetshire; and in the match he amply notified the choice. In the next match against Durham was again selected, and showed up very prominently. The following Saturday saw him doing duty for the North of England team against the South at Blackheath.*

A.J. LAING *(Roxburgh Co. and Hawick) Forward. Age 23. Height 5ft 10in, weight 11st 11lb. A former pupil of the Royal High School of Edinburgh, has played five seasons for Hawick, and also for Roxburgh County and the South of Scotland. Very fast, a good dribbler, splendid tackler, and very dangerous near the goal line, knows the game thoroughly, and plays hard to the finish. Captain this season of his club.*

C. MATHERS *(Yorkshire and Bramley) Forward. Age 27. Height 5ft 8in, weight 12st 8lb. The best forward in his club, and one of the best in his county and in the North. Has played fourteen times for Yorkshire, and twice this season for the North against the South. Is a fine scrummager as well as brilliant in the open.*

S. WILLIAMS *(Swinton) Age 26. Height 5ft 9in, weight 11st 7lb. Began playing football in 1879 with a minor club, the Crescent, which amalgamated with the Salford F.C. in 1881, for which he played three-quarter for the 'A' team, but was soon drafted into the first. After playing for some time as three-quarter, went forward, and in the second season as a forward was selected to play in a county trial match (1886). Was appointed to play for the county, and proved the most*

successful try-setter for the Lancashire county that season. Later on was selected and played for the North against the South, is considered a speedy forward, and very useful at the outside of the scrimmage. Dribbles very well. At the end of last season was appointed captain of Salford Club. Under his captaincy the club has had the most successful chapter in its history, as, although battling against all the leading amalgamations of the North, it has only been beaten twice, and then after a hard struggle, by the powerful combinations of Leeds, St. John's, and Bradford.

Though below representative strength, the team is a good one, probably equal to fairly strong English county form. It is a matter for regret, however, that Stoddart is the only representative of the South of England. The South has been unbeaten since 1881, and is generally acknowledged to play the most scientific game. Teams like Blackheath and Richmond often are more than half composed of Internationals and these afford the really finest exhibitions of Rugby football.

'The Pioneers of 1888' were feted at the Manchester Hotel, 136–145 Aldersgate Street, on Wednesday, 7 March. The following day, 19 of the 21 players went by special train to Tilbury and embarked on their great adventure. The captain, Robert Seddon, joined the SS *Kaikoura* at Portsmouth, and Stoddart met up with the party in New Zealand.

▲ The touring party, pictured aboard the SS Kaikoura and bound for New Zealand

The Lancastrian contingent had been most enthusiastically met at Manchester, and the Scottish players at Hawick, prior to leaving by train for London. At the farewell dinner, the chair was occupied by Lord Newark, MP, and among the chief guests were another MP, Henry Broadhurst, and tour organisers Henry Turner and Alf Shaw.

Contemporary newspaper reports stated:

The proceedings were of a particularly sociable nature, and after Lord Newark had proposed the healths of Messrs Shaw, Shrewsbury, and Lillywhite (tour organisers), 'Success to the Team' was given by Mr H. Turner, and replied to by Dr. John Smith, the celebrated Edinburgh player, who is a member of the combination.

The secretary of the RFU declined an invitation to attend the gathering at the Manchester Hotel because at the same time a meeting in Leeds was declaring that one of the tourists, Clowes, was a professional for accepting £15 to buy clothing to go on the tour.

Having departed Tilbury on 8 March, the contingent headed to Dunedin via London, Plymouth, Tenerife and the Cape. They arrived in Hobart, Tasmania, on 18 April, where the *Mercury* newspaper recorded their arrival and gave details of their journey:

The Kaikoura, like the other boats of the same line, is a regular caller here, and the arrival of any one of them is always looked forward to with a certain amount of interest by nearly every member of the community from various motives, but on this occasion more than usual interest centred on her arrival, when it became generally

known sometime back that the first English football team and Sir Thomas Brady, the well known fisheries expert, were amongst the passengers. The former have come out to try their luck in the football fields of the colonies, and the latter is in charge of the salmon ova shipped to the order of the Government. It is satisfactory to learn that the venture promises to be a great success. The Kaikoura *has also on board 300 stoats and weasels for the destruction of rabbits in New Zealand...*

The voyage out, although a remarkably tempestuous one as to weather, was rendered as agreeable as possible socially speaking by concerts and other forms of diversion. Sir Thomas Brady, as chairman of the amusement committee, entered heartily into every arrangement to benefit the ship's company, and thanks took the form of an address presented to him by the members of the Anglo-Australasian F.C. yesterday...

The Kaikoura *left Plymouth on the 10th March at 1.30 p.m. Encountered strong S.W. gale, with heavy head sea, which necessitated proceeding with reduced speed for 12 hours. The worst of this lasted till the 14th when the winds and sea began to moderate. Moderate to light S.W. winds were experienced thence to Teneriffe, which was reached at 5.37 p.m. of the 13th. After coaling the* Kaikoura *proceeded next day at 5.25 a.m. Light N.W winds were experienced thence to the parallel of 21 deg. N., when moderate trades with fine weather were encountered. These took off, and were replaced in 10 deg. N., by southerly and S.E. winds, light to moderate as to force, with fine, clear weather to the Line. Thence fresh S.E. trades, with lumpy sea, to the lat. of 20 deg. S., where a heavy swell was running. The weather was fine and trades falling light. Arrived at Cape Town on the 31st March, at 7.04 a.m., and left again at 2.50 p.m. same day. On April 1 experienced a heavy gale from the N.W. for two days. Fine weather to the 8th, when a dense fog set in, with strong northerly winds at times, increasing to gales, the worst of which lasted to the 17th, and during the whole of this time neither sun nor stars were seen. On the 17th a strong N.W. wind, with clear weather, set in, and held till arrival.*

The brief stopover in Hobart allowed the players to stretch their legs and get in some much needed practice at the Victorian Rules game they were going to play later in the tour. After the first of many mayoral receptions on their trip, the players were treated to 'champagne and cigars' at the Hobart Town Hall. They then went to the South Tasmanian Football Club, where they were made honorary members, and finally got a ball in their hands. They had tried to do some passing and kicking on board the *Kaikoura* but, as the *Otago Witness* pointed out in their story to mark the arrival of the team in Dunedin on 22 April, some 46 days after leaving England:

Athletic sports were organised during the voyage, and an attempt was also made to play football on deck, but so many balls were lost overboard that the pastime had to be abandoned. The physique of the men has been generally admired, and they appear to be in excellent health, though a little bit out of condition.

Their first training session involved another practice of the Victorian Rules game and the first rugby match followed at the Caledonian Ground, Dunedin, against Otago on 28 April. For the record, the first British & Irish Lions team was:

Lions (v. Otago): Full-Back: J.T. Haslam (Batley); Three-Quarter Backs: A.E. Stoddart (Blackheath), H.L. Speakman (Runcorn), J. Anderton (Salford); Half-Backs: W. Bumby (Swinton), J. Nolan (Rochdale Hornets); Forwards: R.L. Seddon (Swinton, captain), W.H. Thomas (Cambridge University), T. Banks (Swinton), W. Burnet (Hawick), T. Kent (Salford), H. Eagles (Swinton), C. Mathers (Bramley), S. Williams (Salford), A. Laing (Hawick)

The players were driven to the ground in a 'six-in-hand drag' and a crowd of around 8,000 witnessed history being made. The gate receipts were £350 and the battle to claw back the £6,000–£9,000 it eventually cost Shrewsbury and Shaw to fund the tour had begun in earnest. The team wore red, white and blue hoped jerseys and fell behind to a speculative drop goal from Otago half-back D. Simpson before Tom Kent claimed the distinction of scoring the first points and try for the Lions. Jack Anderton bagged a second try and Harry Speakman added two drop goals to claim an 8–3 victory.

There were nine games on the first leg of the New Zealand visit and 51,500 fans turned up to watch the Lions win six, draw against Wellington and lose to Taranaki Clubs and Auckland. The 4–0 defeat to Auckland on 25 May was a blow, and one which Shrewsbury didn't take kindly to. In a letter home to Shaw he wrote: 'We simply lost the match through our players not taking care of themselves, too much whisky and women.'

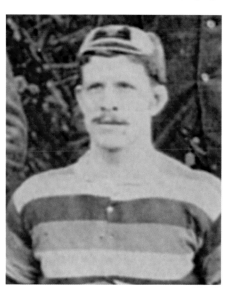

The players had little time to dwell on the defeat, as the following day they stepped aboard the *Zealandia* to head to Australia for the second leg of their journey. Ahead were 15 games of rugby and 19 under Victorian Rules. Shrewsbury had organised a practice match for the players against 17 locals on 7 May in Christchurch to test out their Victorian Rules skills, and he also employed two coaches, Jack Lawlor and Fred McShane, the former Essendon players. There was a further practice in Auckland and then another in Sydney on 13 June prior to departure for Melbourne.

An intrepid reporter from the *Otago Witness* went on the trip with the players and picked up the first major 'scoop' with a Lions captain when he conducted an in-depth interview with Seddon. It offers an interesting insight into what the players felt about New Zealand rugby and the Victorian Rules code they hoped to crack in Australia:

▲ Tour captain Robert Seddon had played three times for England prior to the tour and earned many plaudits for his leadership through the early stages of the trip

OTAGO WITNESS, 13 JULY 1888
THE ENGLISH TEAM IN AUSTRALIA
A Chat with Captain Seddon
The English team of footballers, who are being pioneered through the Australasian colonies by Messrs J. Lillywhite and A. Shrewsbury, of cricket fame, left Sydney by the express, and were met at the Benalla railway station by a Herald representative on the Thursday morning. Through P.G. McShane and Lawlor, who have accompanied the Englishmen on their travels, an introduction was obtained to Mr R.L. Seddon, of Broughton, Lancashire, who is the captain of the visitors. A hasty breakfast was partaken of and the train resumed its journey. Mr Seddon, who is a stalwart specimen of humanity and jolly at that, then unburdened himself. Of course the conversation turned upon what show the Englishmen would have with the Victorians in the Australasian game. Mr Seddon, who is a capital conversationalist, said: 'At first when our fellows heard or read of the Australian game we certainly did not favour it in the least, as it is quite a different game to ours. Under Victorian rules knocking the ball forward and off side play is allowed, but not so under our rules. Naturally the impulse in seeing that style of play for the first time was to say, "That is wrong." But after the practice we had in Sydney yesterday, our fellows seemed to rather like the game and, in fact, some of the men said they liked it better than Rugby. But for myself, I would rather wait and play in a few matches before I give an authoritative opinion. However, I have not the least

doubt that after we have played a few matches we will acquire such a knowledge of the various tactics that we will be able to give a good account of ourselves, against the best teams in Melbourne.'

How many practices have you had? — *Just about four.*

And in England? — *None.*

We heard you had the rules in England? — *The rules were only handed to us when we had been a week on our voyage hither. The only idea we had was a statement in the Manchester paper that the ball had to be bounced every seven yards. Now, in reference to the bouncing of the ball, my opinion is that it is hardly necessary to do so. Very prominent features of your game are the long kicks to each other and the awarding of free kicks for breaches of the rules. I do not see why a man should risk a run with the trouble of bouncing the ball when with a long kick he could send it to any player at another part of the field, and probably do more good. I admit that with your larger playing space if a man carried the ball as in Rugby he would perhaps be able to run the entire length of the field, and doubtless the rule requiring the ball to be bounced at intervals forms a good check against any such form of play. Should a man do a run of 50 yards, and lose his kick, would it not be just as well to have kicked in the first instance? Had we picked a team to play the Australian rules we should have picked different men [at the] back. We thought in England we had quite enough back players who could kick and dodge and run. Our forwards are not expected to kick in the least, their great characteristics being the ability to dribble and tackle, and they must be of good stamina. However, after a few practices our back men ought to play as well as yours. Personally, in the two or three practices I had in New Zealand in your game, I kicked more than I had done in England for the past five years.*

Then a chat ensued as to the Rugby game as played in New Zealand. Mr Seddon said: *Throughout New Zealand the men, individually, are quite equal to our own players, but they seem to play exactly as we did in England two or three years ago. In England the game is cut so very fine that we have found out all the fine points and we utilised our knowledge in New Zealand, and whilst the players there perhaps take a couple out of five chances we score four out of five. The style of passing the ball in New Zealand is certainly not equal to ours. Their idea of passing is to throw the ball behind without looking where their men are placed. My opinion of passing is that a man should never pass unless the man he passes to is in a better position than himself, and if he is charged he should turn his back towards the man who does so, and pass with both hands. I have continually drilled into our fellows the necessity of using both hands. The New Zealanders seemed to think that passing with one hand is good enough, but that is a mistake.*

As to the physique of the New Zealanders? — *They are heavy men and good scrummagers. We do not believe in too much scrummaging and try to make the game fast and open, and therefore we try to screw the scrum in order to get the ball into the open. Why should we push through nine men when we can screw the ball out much quicker, and, besides, the play is much prettier to watch. Then the New Zealanders do not play a proper concerted game. Sometimes a man got the ball and could have passed to someone in a good position to 'run in'; but the man seemed to forget that there were 14 other men on his side, and his sole idea was to score a try and everything else went out of his head except the plan of crossing the line. In our team the men play to each other, and pass at the proper opportunities. Perhaps the New Zealanders are a little better in scrummaging than we are.*

Your men have been accused of rough play? — *The only time we have been accused of roughness was at Wellington and considering that up to half time four of our men had been carried out of the field I think the roughness was on the other side. We heard before we got to Wellington what to expect there. I told their captain, King, that if their men did not play less roughly I would withdraw my team from the field, as we had only a certain number of men to fall back upon during the whole of our tour. King said they ought to give and take in a game of the kind. It was very well for King because Wellington could easily supply half-a-dozen men for vacancies. We were treated splendidly in Otago. I do not think there is much difference between the provinces Canterbury, Otago, and Auckland, so far as play is concerned. The Taranaki backs were certainly the best tacklers we have met. In the second half we pressed the game, but could not score, owing to their splendid tackling. They won this match, but it must be remembered we had travelled all night by steamer, on which we could not get berths. We landed at 11 o'clock in the morning and played in the afternoon.*

As to the Rugby game in New South Wales? — *We were well treated there. The New South Wales players are certainly not up to the New Zealand standard. Generally they are much too small for Rugby. They are thus placed at a disadvantage. They have some smart players, but I think a 'good big one' is better than a 'big little one'. They are three or four years behind the time.*

They made a draw with you up Parramatta Road? — *Yes, King's College, past and present players, nine of the best men being former students. I imagine that most of our fellows were sore and stiff in the first half, as the College scored two goals, which meant 10 points. Our fellows woke up and scored five tries in the second half, equal to 10 points. Three out of the five points were behind the posts. As to New South Wales players, Colquhoun, a three-quarter back for Sydney, is a very smart player indeed. Wade is also a good man. He was not picked in the return match, and I think it was the greatest mistake made. Cameron, a little fellow, half-back, played a very pretty game, but prettiness has not much effect in Rugby.*

As to the disqualification of Clowes, of Halifax, by the English Rugby Union? — *We cannot play Clowes at all. I think the Rugby Union have dealt harshly with him. Had he known he would become a professional for accepting a comparatively small sum of money for his outfit he would not have taken it. He wanted to give the money back through the secretary of the Union. The Yorkshire County have been trying to get the disqualification removed without success.*

It is stated that the whole of the members of the present team will be called upon to show cause why they should not be deemed professionals? — *If I am called upon I will ignore the matter altogether. They must prove me to be a professional. I do not think I ought to be called upon to prove I am not. One of their rules is simply that clubs can pay travelling and hotel expenses for their players, and what more has been done in this instance I do not know. So far as I can judge not one of our players has received any money for his services. I have not, and I know for a certainty others have not.*

Why should the English Rugby Union object to the tour? — *I do not know why they should object. Shaw intimated his willingness that they should pick the team and manage it altogether, and they said they could not get up a team. He said he would get up a team and place it in their hands. They objected to the various propositions, and would take no notice of the team now out here. I think some opposition came from cricketing circles, because Shrewsbury, Brann, Stoddart, and Smith were wanted at home for the cricket season.*

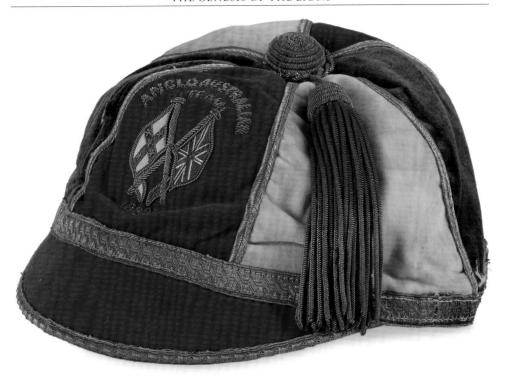

What kind of grounds did you play on in New Zealand? — *I have never played on better grounds. You see they are cricket fields. Now in England they will not allow football on cricket grounds, which are often almost under water in the wet season, consequently we secure a place with rough turf because it is always better for soakage.*

In New South Wales? — *The grounds were hard, as rain had not fallen for some time.*

Is the assertion true that the Association is supplanting the Rugby game at Home? — *No, I believe the professional element will sap the foundations of the Association game. Good juniors are snapped up and thus the sources of the supply are checked. Junior clubs are afraid to let it be known that they have good men.*

Your average weight in your first match in New Zealand was given as 12st 4lb? — *That is about the average. Paul is about 13st 11lb; Thomas, 12st 13lb; Mather, 13st 11lb; and Bumby, 12st 11lb.*

During the course of the conversation Mr Seddon stated that the team would not have suffered the two defeats, one by Taranaki and the other by Auckland, if it had not been for the too good treatment extended to them by the New Zealanders. Summed-up, his opinion is that in Maoriland there is plenty of good material for Rugby footballers. But he is evidently possessed of a poor opinion as to the merits of the players in New South Wales. He believes that Warbrick's team of Maori footballers will not display more than ordinary club form in their matches in England. He casually heard the other day that they had been beaten in New Zealand. He thought that there were some 'professionals' in the Maori team. He was pleased to hear of the establishment of Rugby Union clubs in Melbourne. He was acquainted with the two Scarboroughs who were in that club. Tom Scarborough used to play for Yorkshire County, and was a very good dodger and runner, and was noted at Home for his dodging runs. He was under the impression that Chapman, of the same club, used to play at Home, and if so they were acquainted. Mr Seddon concluded his talk of football, pure and simple, by a statement that O'Connor, of Auckland, was about

the best man they ever met in New Zealand. They had heard a great deal of Whiteside, the Auckland three-quarter back, but he was unfortunately hurt at the commencement of the game and they had no chance of seeing what he could do.

And all that without a press officer or media manager in sight! Just over a month later, Seddon had to be replaced as tour captain after drowning in an accident on the River Hunter on 15 July. Robert Lionel Seddon was born in Salford in 1860 and worked in a large woollen factory in the warehouse. His rugby career started at the Ascensions Club at Broughton before he joined Broughton Rangers. He played with Rangers for many years and was picked to play in all three of England's internationals in the 1886–87 season. He joined Swinton in 1887–88 and was a regular for Lancashire and the North of England. He played in every game on tour in both codes up to his tragic accident – 20 rugby games and 19 Victorian Rules matches.

The Australian leg of the tour involved 35 fixtures across the two codes, often involving playing every two days. For the record, the first Lions team to play in Australia, against New South Wales at the Association Cricket Ground in Sydney on 2 June, was as follows:

Lions (v. NSW): Full-Back: A. Paul (Swinton); Three-Quarter Backs: T. Haslam (Batley), A.E. Stoddart (Blackheath), J. Anderton (Salford); Half-Backs: W. Bumby (Swinton), R. Burnet (Hawick); Forwards: R.L. Seddon (Swinton, captain), W.H. Thomas (Cambridge University), A. Penketh (Douglas), W. Burnet (Hawick), T. Kent (Salford), H. Eagles (Swinton), C. Mathers (Bramley), S. Williams (Salford), A. Stuart (Dewsbury)

Eagles scored the first points and first try in the game and the 18,000 strong crowd, which included the Governor of New South Wales, Lord Carrington, were treated to a great exhibition of rugby.

The two Victorian Rules coaches often turned out for the 20-a-side fixtures, as did the old Halifax player Tom Scarborough. There were other occasions when the Lions had to recruit players to help fill gaps caused by injuries, Clowes' unavailability and then Seddon's death. Shrewsbury didn't rate many of his players after watching them in their first few attempts at Victorian Rules. He wrote to Shaw:

I can play better than some of our players who don't shape at all and never will. The elder Burnet and Anderton are very good, whilst Stoddart and a few others are also likely to make good men at it. We play a big match tomorrow with a certain licking before us.

It didn't help the team's cause that Shrewsbury pitted them against the premier team in Australia, Carlton, in their first game. The match was played at the Melbourne Cricket Ground and a crowd of 25,000 turned out to watch. The Lions had to use two guests, Scarborough and another former English rugby player, C.E. Chapman, to make up their numbers to 20. For the record, the Lions team that played the first game of Victorian Rules football was:

The Lions (v. Carlton): C.E. Chapman (Guest), T.L. Scarborough (Guest), Dr J. Smith (Edinburgh University), W. Bumby (Swinton), W. Burnet (Hawick), T. Banks (Swinton), Dr H. Brooks (Durham), A.J. Stuart (Dewsbury), A.E. Stoddart (Blackheath), R.L. Seddon (Swinton, captain), S. Williams (Salford), A. Paul (Swinton), J.T. Haslam (Batley), J. Nolan (Rochdale Hornets), H.C. Speakman (Runcorn), J. Anderton (Salford); W.H. Thomas (Cambridge University), C. Mathers (Bramley), A. Laing (Hawick), H. Eagles (Swinton)

Seddon's accident occurred the morning after the side had been beaten by nine goals to four by Northern Districts in a Victorian Rules match in Maitland. Seddon,

Stoddart and Anderton stayed behind while the rest of the tour party headed by train for nearby Newcastle to prepare for a rugby union match two days later. They wanted to spend some leisure time on the river, and while Seddon chose an outrigger, the other two shared a skiff. Despite being an experienced sculler, and being in the prime of his life at 28, Seddon got into difficulties quite quickly. He was wearing his red, white and blue team jersey, flannel trousers and shoes. His feet were strapped to the footrest and, when the outrigger capsized some 200 yards from the Clubhouse, he was unable to free himself. He was seen struggling in the water, twice attempting to swim on his back, but after sinking for a second time he drowned. His teammates were unaware of what had happened at first.

The *Argus* of 16 August recorded the incident as follows:

THE LATE MR R.L. SEDDON

Mr R.L. Seddon, the captain of the English Rugby football team, was drowned at West Maitland to-day. The footballers, after the match yesterday, were having a day's spell, and Mr Seddon visited the River Hunter, which flows past the town, for the purpose of indulging in a little sculling exercise. He procured an outrigger at the Floating Baths, and pulled some distance up the river, when the boat was accidentally overturned, and Mr Seddon was drowned. His body was recovered 20 minutes after the accident, and every means of restoring animation was tried, but without avail. Mr Seddon was watched away from the baths by two other members of the team, but he was a considerable distance away from his friends when his boat upset. Mr Seddon belonged to the Lancashire and Swinton teams, and was an international player. He had made himself exceedingly popular during the time he had been in the colonies, and his death has caused a painful sensation in athletic circles in Sydney.

A report on the funeral, which took place the next day, appeared in the *Maitland Mercury & Hunter River General Advertiser*:

The coffin was borne from the Royal Hotel to the hearse by eight of the late Mr Seddon's companions and taken to St. Paul's Church, followed by a very large body of mourners. The footballers, who numbered about 160, wore the colours of their respective clubs and crape on their breasts, walked to the church and afterwards to the cemetery. At each side of the hearse were delegates from various clubs in the Hunter district. In front were the general body of footballers, and the Englishmen walked behind the hearse, next to which came four mourning coaches; then the Mayor of West Maitland (Mr John Gillies) driving. Sixty other vehicles were behind. Nearly all the aldermen were present. At the church a portion of the beautiful burial service of the Church of England was impressively read by the Rev. T.D. Warner, incumbent, who was assisted by the Rev. Canon Tyrrell, President of the Northumberland Football Club. The surpliced choir had been got together and when the solemn hymn 'Brief life is here our portion' was sung, many a stout heart gave way to tears and the grief that was outwardly shown by the numerous Congregation assembled to join in the solemn service was doubtless nothing by comparison with what was inwardly felt.

The same newspaper, some time after the tourists had returned to England, published two letters, sent to them by Anderton, that had been printed in the *Manchester Courier*. Seddon had arranged with the *Courier* to write to them and give them details of the tour to keep rugby lovers back home in England up to date with proceedings. It was, if you like, the first newspaper column written by an international captain. While Anderton's note is self-explanatory, Seddon's letter to

the *Courier* editor, presumably written hours before he drowned, shows that he was in high spirits and obviously enjoying the tour.

CAPTAIN R.L. SEDDON'S LAST LETTER

The following letters will be interesting to our readers on several grounds. The first is from Mr. J. Anderton, to the editor of the Manchester Courier, *and the other a letter written by Mr. Seddon on the morning of his death probably, and sent on as Mr. Anderton explains:*

Sir,

The enclosed letter, addressed to you, was, amongst other things, found in Mr. R.L. Seddon's breast pocket immediately after his death, and had evidently been written this morning, just previous to the unfortunate circumstance, by which he lost his life, occurred, and I thought it advisable to forward same on to you. We went out (Stoddart and I) in company with Seddon, to the Hunter River, to have a row and swim, and he embarked in a racing outrigger and left us lying in an old punt, smoking and taking it easy, and the next thing we found him dead, about half a mile up the river from whence he started. You will have heard of the sad occurrence long before this reaches you, but I must say it has cast a gloom over the whole town, and the people have shown the utmost kindness to Stoddart and myself in making all arrangements with regard to the inquest, which is now going on as I am writing. A gentleman named Hulme, a native of Manchester, has just left a beautiful wreath.

Yours, etc.

Jack Anderton.

Royal Hotel, Maitland, N.S.W., August 15, 1888.

P.S. The remainder of the team had left for Newcastle about 50 minutes before the unfortunate accident took place.

To the Editor of the Manchester Courier...

Dear Sir,

My last letter was sent to you after playing Bathurst. The following morning was looked forward to with great interest, being the day fixed for a day's kangaroo hunting on the mountains. Six o'clock next morning saw about 15 waggonettes at the hotel ready to convey us to the field of slaughter. Half-an-hour later we were on our way, each being supplied with guns and shot. After two hours drive we arrived at the forest, and very soon all was bustle and commotion. In a very short time fires were lit, tea brewing in 'billies', and each man cooking his own steak at the end of a long stick. It would have surprised a careful housewife at home to see the vast quantity of steaks so quickly disappear, besides fowls, tinned beef, cheese, etc. Soon after we started for the forest. The beaters, 20 in number, all mounted, formed a half-circle, the shooters forming another. The beaters drove the kangaroos, hares, etc, which we shot down. The first beat was pretty successful, somewhere about 35 kangaroos and hares falling to our guns. After this we moved on to the mountains, where we were again successful. The scenery here was simply wonderful. I was so lost in my admiration that I had almost forgotten the shooting and rambled down the rocks, but was brought up short by hearing a gun shot and feeling a few pellets on my back. In a very short time I had forgotten the scenery and rushed for safety. The day's outing was one of the most enjoyable we have had. Getting the spoil together we found that our day's sport resulted in bagging about 120 kangaroos and hares. Many of these we skinned, some of us carrying home the skins as trophies. Thanking Mr. and Mrs. Grist, Mr. and Mrs. Schofield and daughters (on whose land we had been shooting), for the kind manner in which they had assisted in making our day's outing

so enjoyable, Mr. Grist replied, saying it was a far greater pleasure to him to see his own countrymen enjoy themselves so much than it was for us to have the day's shooting. Should we ever be that way again, he would feel proud to have the chance of entertaining us at his house. After giving him and his three hearty cheers, which re-echoed throughout the wood, we were soon in the conveyances and on our way back to Bathurst. We started for Sydney the next morning at 10.30, arriving at our destination at 5.30 pm on Friday evening. Saturday turned out a very hot day. Our match v. Sydney University had caused some excitement, especially among the schools. This team, which really are past and present players, have not been defeated for two years, and have scored 200 points against 12, a very good record, and when it was found we were without Bumby (Swinton), Nolan (Rochdale), half-backs, and Stuart (Dewsbury), Penketh (Isle of Man), and Banks (Swinton), forwards, their excitement worked up to such a pitch that it was hard to have victory so cruelly snatched from them when they fancied how secure they had it within their grasp. The spectators also took the defeat with very bad grace. Sunday most of the team were glad to rest. Owing to the very fine weather the grounds are dreadfully hard, making the games much faster and the falls much more dangerous. C. Mathers met with a nasty twist of the knee, and many others are scratched and skinned in some way or other. Monday afternoon (five o'clock) saw us on our way to Maitland, part of the journey by train and part by steamer. The sail was a most beautiful sight, which will long be remembered by most of our players. Sailing up the river, a bright moon was out, and creeks and tall mountains covered with trees on each side of us, while we were smoking and singing as if we had not a care in the whole wide world. Half-past 12 was the time we got to the Royal Hotel, Maitland, getting to bed without delay. Our match against the Northern District under the Victorian rules was played in 78 degrees of heat. This is the winter weather we are enjoying out here. Our men don't seem to enter into this game with any spirit whatever. The consequence was we were defeated by eight goals to four, though Stoddart missed three or four (an unusual occurrence) very easy goals. In the evening our team were invited to the skating rink, where a special night was given in honour of the English football players, which most of us accepted. Inside the place was beautifully decorated with red, white and blue (our colours), and 'Welcomes' hanging all about the place. Today all of the team are going out 'driving and boating'. The rowing party will also enjoy themselves by stripping and having about an hour's fun in the water.

Tonight we leave for Newcastle, a coal-mining district, playing Newcastle and 'Northern districts' under the Rugby Rules. From what I can hear they are very strong, and without the six good men we have on the injured list we shall have all our work cut out to win. From Newcastle we have two days' and nights' journey by train to Brisbane, where we play some three or four matches in the districts. Mr. Lillywhite has had a very pressing letter asking us to visit Rockhampton, some 400 miles further, and play two matches, but our time being so fully occupied I hardly think it probable we shall visit them. The weather since we landed has been beautiful and summerlike. Here, in Maitland, it has only rained twice for the last six months. Out in Newcastle they are coming out on strike next week for more money, their salaries now being £16 per month. What would some of our colliers at home think of wages like this?

Yours, etc.,
R.L. Seddon
Maitland, August 15, 1888.

Seddon's death was a huge blow to the team and an even worse situation for his fiancée back in England, his four brothers and two sisters. The mood of the team was summed up best by Charlie Mathers in his tour diary:

August 15: A telegram came saying your captain is drowned. We were all amazed and decided to cancel the match with Newcastle the following day. At night everyone very quiet and discussing the matter.

August 16: In morning went from Newcastle to Maitland, 20 miles to bury our poor, unfortunate captain, Mr Seddon. When we got there we found him laid in his coffin. They all broke down but me. We went and had a service. Church crowded. All shops closed.

Shrewsbury acted quickly to invite Stoddart to take over the captaincy, which he did, and the players were back on the field on 18 August and beating Queensland 13–6 with seven tries. It was a fitting tribute to their late captain. There were four more games before the team left for New Zealand by the Union Company's steamer *Manapouri* on Friday, 31 August to embark on the third and final leg of their journey.

They left Australia undefeated in 16 rugby union matches, winning 14 and drawing with Sydney Grammar School Past & Present and King's School Past & Present, and they also won nine of their 19 games under Victorian Rules. Ahead of them lay a further ten fixtures in New Zealand. They started by avenging their earlier defeat to Auckland by beating them 3–0 and then drawing 1–1, and they drew two other matches. Their seven wins on the final leg enabled them to end their rugby union fixture list with 27 wins and six draws from 35 matches.

Three members of the tour party, Stuart, Speakman and Robbie Burnet, didn't return with the rest and made new lives for themselves in New Zealand and Australia. Burnet became a farmer in Australia, while Speakman stayed in New Zealand until March 1889, when he made his way to Queensland, where he settled in Brisbane and worked as an engine fitter. He played for the local Wallaroo club and captained the Queensland state side for three seasons. A couple of years later, he moved to Brisbane's Union Harriers team, but once gold was discovered in the Charters Towers region of Queensland he headed north. He was soon involved with the local Charters Towers team, which still exists today, and in the 1950s the club remembered Speakman in its anniversary celebrations, stating: 'During the eight or nine years of his residence here he imparted a lot of his genius to local players and raised the game to a high standard.'

The Scottish-born Stuart, who had played for Cardiff and Dewsbury before the tour, stayed in New Zealand and between 1889 and 1893 represented Wellington, before moving across Cook Strait to play five matches for Marlborough in 1894. In 1893, Stuart, then aged 35 and a member of the Poneke club, was included in the New Zealand team, the first national side chosen under the auspices of the recently formed New Zealand Union, for the tour of Australia. Stuart played in seven of the 11 matches, including the first six in Australia. He returned to England in 1902 and became trainer of the Dewsbury rugby league club.

By the time the team got home, Shrewsbury had been away for 15 months and Stoddart for 14. Shrewsbury arrived back to be presented with 72 sovereigns by Nottinghamshire Cricket Club, as a collection for his 1887 season. He needed that and more to wipe out his mounting debts. Would he be going back? It sounded as though he had had his fill, judging by his acceptance speech for his benefit payment:

Travelling about Australia and New Zealand is not all pleasure. Twenty to thirty hours at a stretch in a railway carriage slowly creeping along with bad sleeping and

◄ Tour manager Andy Irvine, captain Sam Warburton and centre Manu Tuilagi visit the grave of Robert Seddon during the 2013 Lions tour of Australia

refreshment accommodation is an experience not to be desired. The frequent short journey along the coast of New Zealand, sick and ill the whole time, is equally unpleasant, and not at all to my taste.

The Lions returned to Australia in 1899 and to New Zealand in 1904. In 2013, Australia was the venue for the 125th anniversary tour, which saw captain Sam Warburton, England centre Manu Tuilagi and tour manager Andy Irvine place wreaths at Sneddon's grave, which is maintained by Maitland Rugby Club. 'We're very honoured to be here,' Warburton said. 'It makes you realise how long it's been going on for and it makes you realise what you've achieved.'

IN MEMORIUM

His manly form lies stiff in death's calm hush;
Never again upon his men he'll call;
No more across the turf he'll lead the rush
Of forwards, ever playing 'on the ball'.
No more we'll grip his honest English hand,
Nor hear his cheery greeting as of yore;
And they, his comrades in that sea-girt land,
Will watch in vain. They'll meet him nevermore.
Brother and sister, in that far off home,
Grieve not; he is at rest. His spirit free
Calleth so tenderly across the foam.
'Brother, I am but sleeping; sister, comfort ye.
It may seem hard to you who cannot see
Beyond the veil — a bitter cruel lot.
God knoweth best in all things. All that ye
Can know or do is this — Forget me not.'

'Scrimmage'
The Referee, 1888

RUGBY UNION RESULTS OF THE 1888 BRITISH TEAM IN AUSTRALIA AND NEW ZEALAND

P 35 W 27 D 6 L 2 F 292 A 98

Otago	W	8–3	Bathurst	W	20–10	
Otago	W	4–3	University of Sydney	W	8–4	
Canterbury	W	14–6	Queensland	W	13–6	
Canterbury	W	4–0	Queensland Juniors XVIII	W	11–3	
Wellington	D	3–3	Ipswich	W	12–1	
H. Roberts XV	W	4–1	Queensland	W	7–0	
Taranaki Clubs	L	0–1	Northern Districts	W	14–7	
Auckland	W	6–3	Auckland	W	3–0	
Auckland	L	0–4	Auckland	D	1–1	
New South Wales	W	18–2	Hawke's Bay	W	3–2	
Bathurst	W	13–6	Wairarapa	W	5–1	
New South Wales	W	18–6	Canterbury	W	8–0	
Sydney Juniors XVIII	W	11–0	Otago	D	0–0	
King's School, Parramatta Past & Present	D	10–10	South Island	W	5–3	
Adelaide XV	W	28–3	South Island	W	6–0	
Melbourne Rugby Union	W	9–3	Taranaki Clubs	W	7–1	
New South Wales	W	16–2	Wanganui	D	1–1	
Sydney Grammar School Past & Present XVI	D	2–2				

ROBERT SEDDON'S 1888 BRITISH TEAM

FULL-BACKS
J.T. Haslam	Yorkshire and Batley	
A. Paul	Lancashire and Swinton	

THREE-QUARTERS
J. Anderton	Lancashire and Salford	
Dr H. Brooks	Durham and Edinburgh University	
H.C. Speakman	Cheshire and Runcorn	
A.E. Stoddart	Blackheath and Middlesex	England

HALF-BACKS
W. Bumby	Lancashire and Swinton	
W. Burnet	Roxburgh County and Hawick	
J. Nolan	Rochdale Hornets	

FORWARDS
T. Banks	Lancashire and Swinton	
R. Burnet	Roxburgh County and Hawick	
J.P. Clowes	Yorkshire and Halifax	
H. Eagles	Lancashire and Swinton	England
T. Kent	Lancashire and Salford	
A.J. Laing	Roxburgh County and Hawick	
C. Mathers	Yorkshire and Bramley	
A.P. Penketh	Douglas, Isle of Man	
R.L. Seddon (capt.)	Lancashire and Swinton	
Dr D.J. Smith	Corinthians and Edinburgh University	
A.J. Stuart	Yorkshire and Dewsbury	
W.H. Thomas	Cambridge University	Wales
S. Williams	Lancashire and Salford	

1891
BATTLING THE 'BOKS

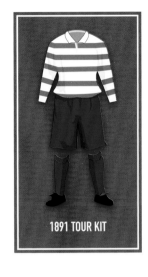

1891 TOUR KIT

Captain: Bill Maclagan (Edinburgh Academicals and Scotland)
Squad Size: 21 players
Manager: Edwin Ash (England)
Tour Record: P 20 W 20 D 0 L 0 F 226 A 1
Test Series: P 3 W 3 D 0 L 0

It was in 1891 that *The Picture of Dorian Gray*, *The Adventures of Sherlock Holmes* and *Tess of the d'Urbervilles* were first published. A Boston architect, Louis Sullivan, made buildings ten storeys high that 'scrape the sky', by using a new type of special steel girders; the periscope was invented in France; and the Wrigley Company, which brought us chewing gum, was founded in Chicago.

The team that toured South Africa in the same year was the first to formalise the concept of international rugby competition by playing three Test matches. As hosting the tour was a step into the unknown for the newly formed South African Rugby Board, the tour was organised by the Western Province Union. Formed in 1883, Western Province was soon followed by Griqualand West in 1886 as the game spread throughout the states and colonies of southern Africa.

Kimberley met Cape Town in the first 'inter-town' match in 1884, and the following year the first tournament, including teams from Cape Town, Kimberley and Port Elizabeth, was held in Grahamstown. In 1888, Pretoria started playing Johannesburg, which led to the formation of the Transvaal Rugby Football Union in 1889. Later that year, the South African Rugby Football Board was formed and a regional tournament involving Western Province, Griqualand West, Eastern Province and Transvaal was staged in Kimberley.

The stage had been set for a rugby tour by the 1888–89 England cricket tour. C. Aubrey Smith's side won both Tests, held in Port Elizabeth and Cape Town, and the tour, sponsored by the founding father of the Union Castle Line shipping group, Sir Donald Currie,

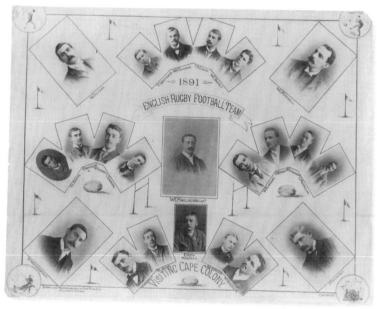

▲ A photographic illustration showing the 21 members of the squad and tour manager Edwin Ash. Bill Maclagan, the tour captain, is pictured in the centre

provided Africa with its first international sporting contests. Sir Donald also started a trend as he presented a trophy to Smith's side to present to the team that performed best against them. That became the Currie Cup for cricket.

Wisden reported that the 19-match cricket tour arranged and directed by Major Wharton 'did not pay its expenses', and it wasn't until the received guarantees from the Cape Colony prime minister Sir Cecil Rhodes to underwrite the tour that secretary Rowland Hill agreed to endorse the project. 'Let them come. I shall stand firm for any shortfall,' were Rhodes' reassuring words. It helped that he also had the financial backing of President Kruger of the Transvaal Republic.

After the financial failure of the 1888 tour, albeit one suffered by non-rugby promoters Shrewsbury, Lillywhite and Shaw, the RFU wanted the next overseas trip to be 'official' and financially viable. In the end, more than 75,000 fans paid £7,500 to watch the Lions in their 18 games – almost £450,000 in modern terms.

If the original idea to invite a team to tour in South Africa is credited to Thomas Barry Herold, who was the honorary secretary and treasurer of the Western Province Rugby Union, then it was the negotiating skill of Joe Richards that saw the dream become a reality. Richards was an old boy of the Leys School, Cambridge, who combined a business meeting in London with a trip to see the RFU to try to negotiate terms for the tour. In a meeting with the union on 10 September 1890, he suggested the tour, and some seven months later it was formally announced that 21 players under the captaincy of London Scottish stalwart Bill Maclagan would become the first British rugby team to visit South Africa. Richards' brother, Alf, had the honour of playing in the first South African Test team against the Lions and was captain in the third Test.

The length of the tour was fixed at 30 days, and the squad was selected by the

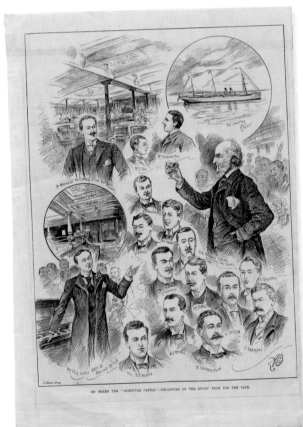

▲ The Illustrated Sporting and Dramatic News celebrated the tour with this depiction of the squad. It also shows shipping tycoon Donald Currie (centre, right) toasting the team

executive of the RFU. All the players were recruited from England and Scotland, although Rob Thompson had been born in County Antrim. Only nine of the 21-strong squad were international players, and of those nine only five had played in the 1891 Four Nations Championship: Paul Clauss, William Wotherspoon and Rob MacMillan for Triple Crown-winners Scotland, and William Mitchell and William Bromet for England. Of the 12 uncapped players, nine played in Test matches on tour, but only two of them, Howard Marshall and Walter Jackson, went on to play for their country thereafter.

The Old Leysians forward William Lindsay was named in the original squad announced in *The Times* on Friday, 5 June, but he wasn't able to tour in the end and Cambridge University student Edwin Mayfield replaced him. The party was effectively reduced in number after only six games when another Light Blue undergraduate, William Thorman, slipped and broke a bone in his foot the day after helping the Lions beat Port Elizabeth 22–0. He was unable to play again on tour.

The tour party were entertained at lunch on board the *Dunottar Castle* in the East India Docks by Sir Donald Currie on Wednesday, 17 June, before sailing from London the next day to Southampton. They set sail for the Cape on Saturday, 20 June, stopping in Madeira en route. In much the same way as he had done with Major Wharton's cricket team, Union Castle Shipping Line magnate Currie gave a silver cup to Maclagan to present to the team that put up the best display against his side. As no team beat the Lions, and only one managed to score a point against them, it was presented to the gritty Griqualand West side that lost 3–0. The cup was to be held by that club until the next season and then would be competed for by the clubs of South Africa. The Currie Cup went on to become the holy grail for the provincial teams in South Africa, doing so much to keep up their playing standards during the years of the sporting boycott caused by apartheid.

This was the first of three Lions tours for the Cambridge University and Blackheath forward Johnny Hammond. Despite becoming a Cambridge Blue as far back as 1881, he never played for England. However, he made the first British tour to South Africa at the age of 31, the next as captain as a 36-year-old, and then a third trip as manager of the 1903 squad, by which time he was on the committee. He made five Test appearances against South Africa, winning four and losing one.

There was a huge Oxbridge influence in the party, with no fewer than 16 players (14 Cambridge and two Oxford) having attended those two great seats of learning. Bert Roscoe and Rob MacMillan both eventually graduated from Edinburgh University. The composition of this selected tour party differed greatly from the working-class, northern-based team that had gone to New Zealand and Australia three years earlier. The organisers also made sure that the tour was managed by an establishment man. This was Edwin Ash, the first Honorary Secretary-Treasurer of the RFU and a leading light at Richmond FC, whom the players called 'Daddy' and whose credentials were impeccable. He had Mr Ashley as his assistant.

The captain, Bill Maclagan, had officially retired from international rugby at the end of the 1890 championship series after winning a world record 25 caps over 13 seasons. He had the distinction, with Ninian Finlay and Robert Mackenzie, of forming the first three-man three-quarter line to appear in an international match when they lined up against Ireland in Belfast in 1881. A stockbroker, Maclagan had captained London Scottish for a decade and had also played cricket for Scotland. His international rugby debut had come against England in 1878 at the Oval on 4 March in a scoreless draw and his next international date was also against England – at cricket on 23 May. He bagged a pair against an England XI on that occasion in a three-day match played in Edinburgh. The visitors won by seven wickets, and opening the batting for England was none other than Arthur Shrewsbury, who ten years later promoted the first Lions tour.

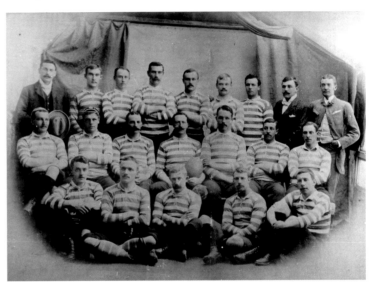

▲ The squad was dominated by players from both Oxford and Cambridge University, with no less than 14 players hailing from the latter

Even though Maclagan was 33 at the time of the tour, he still managed to play in 19 of the 20 matches and scored eight tries. But the dominant character on the tour was the Blackheath and Cambridge University centre Randolph Aston, who, at 6ft 3in and 15st, used his remarkable size for a back (in those days) to terrorise his opponents and score 30 tries – 31 if you include the unofficial game against Stellenbosch – a record by any British player on one tour to the southern hemisphere. Aston was one of five players who had featured in the Varsity match in March and had already played twice for England in 1890 at the age of 20. Although he had been on two winning sides, he didn't figure in English colours the following season, and, remarkably, didn't win another cap, despite his extraordinary exploits with the Lions.

Another Aston, however, did figure prominently on the next Lions tour, when Randolph's younger brother Ferdy played seven times against the tourists in South Africa in 1896. He saved his best for last, helping the South African side to win their first Test in Cape Town in the fourth and final game of the series.

Alongside Randolph Aston, the 1891 Lions had his Oxford University rival Paul Clauss, a German-born, lightning-fast wing who had made his debut for Scotland in the 1891 Four Nations Championship and scored three tries and a drop goal in their Triple Crown triumph. Clauss' recollections of the tour in Ivor Difford's first edition of *The History of South African Rugby Football* give a real flavour of a

▲ The squad pose alongside a 'coach and ten'. Arranging suitable transport to the various venues proved a constant challenge for the tourists

journey that involved a total round trip of 16,500 miles. Included in that total was a record crossing of 16 days on board the *Dunottar Castle* from Southampton to the Cape. The Lions left England on 20 June and returned into Plymouth on the *Garth Castle* on 28 September. Their trek around South Africa involved 3,263 miles by train, 650 by coach and 260 by sea. By the time they returned to Plymouth they had covered in the region of 16,500 miles.

It wasn't all plain sailing. There were no saloon cars on the trains, which meant jumping off at remote stations and hunting down a cup of tea or coffee, and the players often had to toss a coin to see who would get a blanket to keep them warm on the overnight trips. The train journey from Cape Town to Kimberley took two days and nights. The road travel was by 'coach and ten', which meant a team of ten horses pulling a bone-rattling Wells Fargo-style coach. Even the sea travel proved precarious: halfway through the tour, the Lions had to leave East London for Durban on a coaster, and to reach the *Melrose* they had to cross the bar in a small tug in a howling gale. It was a near miss, as Clauss later wrote: 'Our tug was taken right across the bows of the *Melrose* which seemed to tower miles above our heads. Had she caught the tug amidships we should have sunk with little chance of saving ourselves.'

Maclagan's men were in action three days after completing their record-breaking voyage, and they completed three games in five days at Newlands. The Cape High Commissioner, Sir Henry Loch, was among a 6,000-strong crowd for the game against a Cape Town XV, which the Lions won 15–1. The visitors fielded nine forwards, two half-backs, three three-quarters and a full-back in almost all their games. The rivalry between Aston and Clauss began immediately with both players scoring twice. A try was only worth one point and 11 points came from the boot of Scottish outside-half William Wotherspoon. Conversions and penalties were worth two points, and drop goals and goals from a mark, three.

The opening match was notable not only for being the first played on South African soil by an overseas rugby team, but also for the fact the Lions conceded their only point on the tour. The honour fell to Hasie Versfeld and his try led to 'hats being thrown in the air, hooters being blown and fans running onto the pitch to shake his hand and slap him on the back'. The *Cape Times* reported: 'Versfeld found an opening, put in a grand sprint and scored a try for Cape Town amidst tremendous cheering. Duff took the kick, but failed to announce the major points.'

Between them, the two Versfeld brothers, Hasie and Marthinus, faced the Lions 12 times during the tour. Another face that was to become familiar to the tourists was that of Herbert Castens. He was involved in six of the first eight games on the

tour in various guises. He refereed the opening match, coached and played for Western Province in the second and then played for Cape Colony in the third. He missed games four and five before returning to referee the matches against Port Elizabeth and Eastern Province. Two days after the Eastern Province match, he captained South Africa in their first international appearance.

He went on to referee the final three games, including the third and final Test, and also had a hand in the selection process for the last Test. Castens was at Rugby School with one of the Lions, Aubone Surtees, and won Blues at Oxford University in 1886 and 1887. He also played for the South v. North and could conceivably have played for England and the Lions, but he returned to South Africa and became one of the early sporting giants in his homeland. Not only did he captain his country in their first rugby Test, but he also led the South African cricket team on its first overseas tour to England in 1894 a few months after skippering Western Province to their victory in the cricketing version of the Currie Cup.

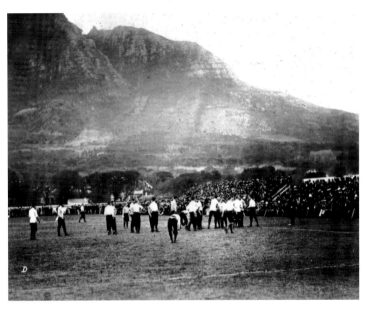

After the Lions' three opening wins in Cape Town, the side moved on to Kimberley, where they played two games, including one against Griqualand West. They were horrified to find themselves playing on a sun-baked ground that was as hard as concrete and without a blade of grass. (It had not changed when I toured with the Lions in 1955, and we could hear our studs drumming on the rock-hard ground.) One of the players described it as 'like playing on a pavement', and the field was covered with a red dust, which saw 30 pairs of boots creating miniature sandstorms.

▲ The scorched playing surfaces of South Africa proved quite a shock for the 1891 tourists, although serious injuries were thankfully scarce

Clauss painted a vivid picture of the tough playing conditions in his analysis of the tour in *The History of South African Rugby Football*: 'We stepped into the arena with no little anxiety, as for the first time in our lives, we were going to play on a ground absolutely destitute of grass, hard and covered with reddish dust; so that, with a bright sun overhead, there was a considerable glare. Frequently, too, one lost sight of the ball in the pillars of dust that rose up in the wake of the players as they run.'

The home side, being hardened to the conditions, gave the visitors, who had never seen a pitch like it in their own green and pleasant land, such a hard time that they won by only 3–0 from a try by Maclagan and a penalty by Arthur Rotherham. Consequently, at the end of the tour, Griqualand were handed Sir Donald Currie's cup.

The Lions returned to Kimberley for the second Test. Kimberley was a town of some note and prosperity at the time, due to the diamonds mined from the biggest man-made hole in the world. For the first major international sporting contest staged in the town, the entrance fee was four shillings for the main stand, three for the temporary stand and two for standing. The Lions stayed at the Central Hotel for ten shillings per head.

The first Test match took place in Port Elizabeth on Thursday, 30 July, and was the first ever played by a representative South African team. The home side wore white and the Lions donned their red and white hoops. It was very much a social

occasion and, according to the *Cape Times*, 'the pavilion was crowded with ladies, all intent on the game'. Apparently, the crowd of 6,000 were not disappointed with the football. Maclagan, the captain, had to claim several penalties, which was the custom in those days, all of which were granted. Many marks were made and many drop goals attempted, all of which were missed. There were no stands, so the crowd were kept on their toes by countless dribbling rushes, which sometimes covered the length of the field. The tourists won by two tries and a conversion scored before half-time. Aston got the honour of scoring the first Test try by a Lions player, in a game refereed by the former Welsh international Dr John Griffin.

Quaintly, it was reported that 'during the interval, the two teams received instructions from well-known backers of either side and enjoyed lemons and sundry'. Although the South African forwards were on top for long periods of the second half, there was no more scoring. It is difficult to ascertain why South Africa were such slow starters, but some clue may be found in the fact that, when the touring team was still at sea before arriving at Cape Town, the locals, Western Province, organised a trial match to test their own strength ahead of the tour. It was a disaster, as many invited players failed to turn up because, as reported in the *Cape Times*, 'the doubtful aspect of the weather and the arrival of the mail mitigated against a strong muster'.

The series was clinched with a 3–0 win in the second Test in Kimberley. Hero of the day was the England full-back William Mitchell, who opted to drop for goal from a mark made near touch just inside the South African half. When Maclagan asked him what he intended to do, he rather surprised him by telling him he was going to shoot for goal. It was a great strike, but the ball didn't go over until it had struck an upright and bounced twice on the crossbar. The Lions used four three-quarters in this game and were helped by the fact that South Africa played almost the whole of the second half without the services of Wilf Trenery, who was carried off on a stretcher.

Alf Richards was the outstanding player on the South African side and faced the tourists six times. He was the only player the Lions met who was ever credited with being on a par with the touring players. He captained South Africa in the third Test and went on to play for his country at cricket as well, facing the England side in 1896. Jack Hartley wrote his name into the record books as the youngest South African international player in the third Test, although there is some controversy over his exact age. At the time he was either 18 years and 18 days old or a mere 15 years and 18 days old,

▲ The tour drew large crowds to each game and has long been credited as one of the key factors behind South Africa's emergence as a leading rugby nation

if you take the inscription on his tombstone in the cemetery at Muizenberg as correct, which says he was born on 18 August 1876.

The South African selection system was based on local committees picking the team. That meant there was strong 'local' bias in all three games, as each group leaned towards their own. There were seven Griquas players in the second Test and 11 from Western Province in the third. There was another game against Cape Colony squeezed in between the second and third Tests, and an extra, unofficial match tagged on the end against Stellenbosch. They were all tight games, but the Lions weren't about to give up their unbeaten record. They beat Cape Colony 7–0 and then made it 3–0 in the series with a 4–0 triumph at Newlands. It is incredible to think that this series scoreline still stands as the only Test whitewash on a Lions tour if you take all games into account.

Aston scored again, and the captain also grabbed a try. Rotherham, who ended the tour as the leading points scorer with 81, added a conversion. It was 0–0 at half-time, but the Lions turned on the style in the second half. This was how one local reporter described what he saw: 'Then followed such a display of passing by the British backs as had never been seen in South Africa; the bladder travelled from one to the other and back like lightning.' The Lions style was born!

The extra game was no picnic. Stellenbosch fancied their chances of catching the tourists off guard as they thought of heading home. The Lions were taken around the local farms and given wine tastings and there was a huge banquet before the game. But it was all to no avail. Edward Bromet and his brother William became the first set of brothers to play for the Lions in a Test match, in Kimberley. Aston scored tries, and the skipper made a timely contribution when he caught Tinie Daneel over the goal line and mauled the ball out of his hands before he could touch down. That made it 20 wins from 20 games.

> English second row forward Froude 'Baby' Hancock of Blackheath and Somerset is commonly acknowledged as the largest of the early Lions. At 6ft 5in and 17st 2lbs he towered over his colleagues during the 1891 tour, and by the time he returned to South Africa with Johnny Hammond's 1896 Lions he reportedly tipped the scales at 18st 8lbs — a colossal weight for the period. One newspaper of the time described him as, 'the king of the lineout, but a real problem to fit into a scrum'.

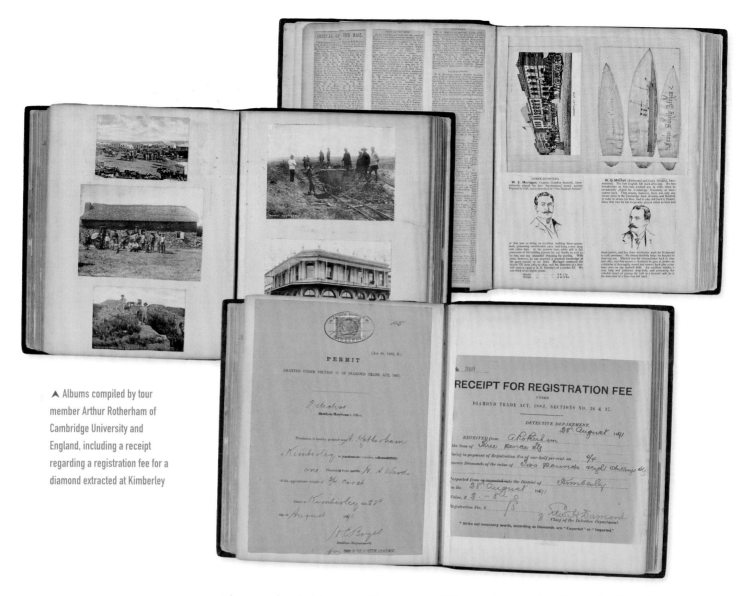

▲ Albums compiled by tour member Arthur Rotherham of Cambridge University and England, including a receipt regarding a registration fee for a diamond extracted at Kimberley

The team headed home to Plymouth on 9 September on the *Garth Castle* and arrived back in England on 28 September, and it was said by the Rev. Marshall that 'the team of footballers to the Cape have initiated the colonists of South Africa into the fine points and science of the Rugby game'.

In summing up the whole tour in *The History of South African Rugby Football*, Clauss said:

Had the tour been a success? Judging by the scoreboard, yes. But the measure of our success was not the number of matches won, of points scored; it went further than that. Had we showed them in South Africa how to play the game in true sporting spirit? Have we taught them that self must be subordinated to side, that science and combination are better than brute strength? Time will show. But we felt that the material and enthusiasm were there and were confident that the lessons we tried to impart in science and teamwork would bear fruit in the future.

The tour, which, in a sense, had a strong missionary element, gave South African rugby a huge fillip. At the grand ball at the Commercial Exchange to mark the end of the tour, attended by Mr Cecil Rhodes (prime minister of Cape Colony), Mr Jan

Hofmeyr (member of Cape Assembly), Mr John Merriman (who later became the last prime minister of Cape Colony) and Sir Thomas Upington (premier of Cape Colony), Maclagan and Hammond predicted a great future for the game in the colony. How right they were!

On their return, the players told of the good times, of the dry and sunny winter climate, the shooting parties and the hectic party round, numerous receptions and the principal amusement of the day, the smoking concert.

Clauss raved about the hospitality in his review of the tour for Difford:

During the first week after arrival we were overwhelmed with social engagements. A smoking concert, a dinner given by the Western Province, a Government House Ball, a dance at Sea Point, a visit to the theatre, a lunch on HMS Penelope lying off Simonstown, a picnic at Hout Bay: all these were a fore-glimpse of the doors of hospitality which were flung wide open throughout the tour. Wherever we stayed, whether for a night or two or longer, we were right royally entertained.

It remained like that for the Lions wherever they toured until the professional era was ushered in during the 1990s.

RESULTS OF THE 1891 BRITISH TEAM IN SOUTH AFRICA

P 20 W 20 D 0 L 0 F 226 A 1

Most reference books state that there were only 19 games, but Dr Danie Craven's Springbok Annals reveals that there were 20 matches, and although many sources believe that the last match against Stellenbosch was unofficial, it is included here.

Cape Town Clubs	W	15–1	Grahamstown District	W	9–0	
Western Provinces	W	6–0	King Williams Town	W	18–0	
Cape Colony	W	14–0	King Williams Town & District	W	16–0	
Kimberley	W	7–0	Pietermaritzburg	W	25–0	
Griqualand West	W	3–0	Transvaal	W	22–0	
Port Elizabeth	W	22–0	Johannesburg	W	15–0	
Eastern Province	W	21–0	Johannesburg-Pretoria	W	9–0	
South Africa (Port Elizabeth)	W	4–0	Cape Colony	W	4–0	
			South Africa (Kimberley)	W	3–0	
			Cape Colony	W	7–0	
			South Africa (Cape Town)	W	4–0	
			Stellenbosch	W	2–0	

BILL MACLAGAN'S 1891 BRITISH TEAM

FULL-BACKS			FORWARDS		
E. Bromet	Cambridge University and St Thomas Hospital		W.E. Bromet	Richmond	England
W.G. Mitchell	Richmond	England	J.H. Gould	Old Leysians	
			W. Jackson	Cambridge University and St Thomas Hospital	
THREE-QUARTERS			J. Hammond	Blackheath	
R.L. Aston	Blackheath	England	P.F. Hancock	Blackheath	England
P.R. Clauss	Oxford University and Birkenhead Park	Scotland	R.G. MacMillan	London Scottish	Scotland
			W.E. Mayfield	Cambridge University	
W.E. Maclagan (capt.)	Edinburgh Academicals	Scotland	C.P. Simpson	Cambridge University	
			A.A. Surtees	Harlequins	
HALF-BACKS			R. Thompson	Cambridge University	
H. Marshall	Cambridge University		W.H. Thorman	Cambridge University and St Thomas Hospital	
B.G. Roscoe	Manchester				
A. Rotherham	Cambridge University	England	T. Whittaker	Manchester	
W. Wotherspoon	Cambridge University	Scotland			

1896 TOUR KIT

1896
RETURN TO AFRICA

Captain: Johnny Hammond (Richmond)
Squad Size: 21
Manager: Roger Walker (England)
Tour Record: P 21 W 19 D 1 L 1 F 310 A 45
Test Series: P 4 W 3 D 0 L 1

The year 1896, which saw Cecil Rhodes make peace with the Matabele after their uprising in Rhodesia, was probably the zenith of the British Empire. Marconi made his first communication by wireless telegraph. Ethiopia routed the Italian army, and a new newspaper, the *Daily Mail*, was established. It was also the year when rinderpest ravaged the bovine herds of southern Africa. This did not prevent British rugby celebrating with a second consecutive visit to South Africa, which was more accessible to them than the Antipodes.

Johnny Hammond's squad were to find that the lessons he and his fellow tourists had handed out in South Africa five years earlier had been fully absorbed, and the opposition was far stiffer. Although they won the series 3–1, becoming South Africa's first Test victims in the fourth and final Test, it was to be the last time the Lions would win there until 1974.

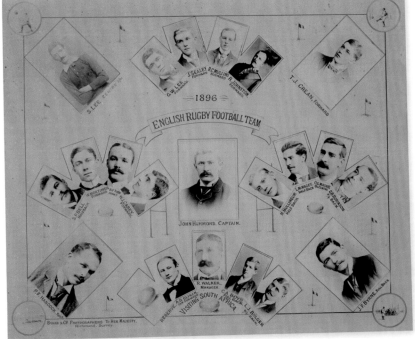

▲ Captained by Richmond's Johnny Hammond, the 1896 tour saw Ireland's success in the Four Nations reflected in nine Irishmen making the squad

An itinerary was worked out by the South African Rugby Board, for which the costs were estimated at £3,300. The figure was made up as follows: passage £1,000, expenses on board £100, railway fares £200, board for 70 days £1,750 and miscellaneous expenses £250. Each Province or Union was allotted matches and levied accordingly: Western Province's five games and £900; Transvaal five and £1,000; Griqualand West four and £550; Eastern Province four and £550, Border three and £250; Natal £100 and Orange Free State £75. The tour itinerary was laid out a year in advance, and the wealth of each centre had a bearing on the disposition of matches.

As it turned out, the Board was very happy with the tour, which ended with a profit of £600 12s 2d, but regretted that no matches were played in Natal or the Orange Free State. They then began to consider a tour of their own to the UK, but the fixture list was full so they had to wait another decade.

In 1891, only English and Scottish players had been selected, but the Irish success in winning the Four Nations title earlier in 1896 meant that not only were

there nine players among the 21 from Ireland, but also that their forward tactics, notably with the wheeling scrum, were adopted on tour. Whereas Cambridge University had provided the 1891 tour party with 14 current or former players for the first tour to South Africa, five years later this number had more than halved to six. The Varsity link to the Lions was still as strong as ever, with two Oxford University players among their number, but this time there were also five members of the Dublin University side in the party. The large Irish contingent added colour and character to the tour party, and British teams soon discovered the value of having Irishmen in their ranks. They are born tourists and have the knack of introducing a delicious sense of humour into any party which might be in danger of taking itself too seriously.

The first wave of the team was selected at a meeting of the RFU at the Craven Hotel, The Strand, on 23 April. There were 13 names announced in *The Times* the next day, but no half-backs. One of the 13, Irish international Samuel Lee, dropped out because of a family illness and his place was taken by fellow Irishman Arthur Meares. *The Times* carried the full squad on 11 June and on 20 June the team left England. They arrived in Cape Town on board the *Tartar* too late at night to disembark, so the South African officials and enthusiasts, impatient to greet the players, chartered the tug *Enterprise* and sailed out to board the liner. They spent the night talking to the team and had breakfast with them, before they landed and streamed off to the Royal Hotel, where the team was again quartered.

▲ Scrapbooks containing newspaper coverage of the tour from the African Review lauding the tourists' play but noting that the standard of South African rugby had much improved since 1891

Included among the Irish contingent were three remarkable characters: Tommy Crean, Robert Johnston and Louis Magee. Louis had his younger brother James with him on tour, while the third member of the famous sporting family, his elder brother Joe, who many people believed had made the tour party, was left behind. Louis became a celebrated veterinary surgeon who pioneered a number of equine surgical techniques that revolutionised the horse-racing industry and he widely lectured in his field of endeavour. He also won 27 caps as a multi-skilled half-back and captained the Irish side to their second Triple Crown in 1899. His brother James was better known as a cricketer, but still impressed enough on tour to play in two Tests. He never played rugby for Ireland, but did so at cricket. He toured North America with the Gentlemen of Ireland cricket side in 1909 and played against Yorkshire for Ireland. Like his other brother, Joe, James also became a referee. In fact, he refereed four of the fixtures on the 1896 Lions tour, including the opening game against Cape Town Clubs and then went on to take charge of four internationals between 1897 and 1899 on his return. He also controlled the game between Munster and the All Blacks in 1905.

Hammond and P.F. 'Froude' Hancock were the only survivors from the 1891 tour. By this stage, the skipper was 37. He had been vice-captain in every game five years earlier, yet despite having taken part in two tours with the Lions he never played for England, a fact that was mainly attributed to his lack of stature for a forward. This time Hammond managed only seven appearances, and in real terms the onfield skipper was the incredible Crean. Standing 6ft 2in tall, and weighing in at more than 15 stone, he was a giant of a man with great energy. He was a typical

fighting Irishman, witty and with a devil-may-care attitude – probably the Tom Reid and Moss Keane of his day, all rolled into one. It was claimed he was the fastest man in the team, and he is best summed-up by teammate Walter Carey as 'the most Irish, the most inconsequent, the most gallant, the most lovable personality one could imagine and he made the centre of the whole tour'.

By his own admission, Crean's life at this time was made up of wine, women, song and rugby. Having qualified as a doctor by the age of 22, when the tour finished he stayed on in South Africa and worked at the Johannesburg Hospital and played for the Wanderers club in Johannesburg. At the start of the Second Boer War he enlisted in the Imperial Light Horse as a trooper and in 1901 became the Brigade's Medical Officer. On 18 December 1901, at the Battle of Tygerkloof, Tommy won his Victoria Cross (VC), when he successfully attended the wounds of two soldiers and a fellow officer under heavy enemy fire. He was wounded in the stomach and arm during these encounters and was invalided back to England, where he made a full recovery despite uttering the immortal phrase at the time: 'By Christ, I'm kilt entirely now.'

▲ Tommy Crean was, by the standards of the day, a colossus with a huge presence on the pitch. His courage would later earn him a Victoria Cross

On 13 March 1902, he was presented with the VC by Edward VII in a ceremony at St James's Palace. The citation for his VC, one of only four won by rugby internationals, read: 'Thomas Joseph Crean, Surgeon Captain, 1st Imperial Light Horse. During the action with De Wet at Tygerkloof on 18 December 1901, this officer continued to attend to the wounded in the firing line under a heavy fire at only 150 yards range, after he himself had been wounded, and only desisted when he was hit a second time, and as it was first thought, mortally wounded.'

Crean's next honour was to be made an Honorary Fellow of the Royal College of Surgeons of Ireland and when the First World War broke out he went back into action, despite being 41. He rejoined the Royal Army Medical Corps and served with the 1st Cavalry Brigade. Wounded several times and 'mentioned in dispatches', he won a Distinguished Service Order (DSO) in June 1915. He was promoted to major in 1916 and commanded the 44th Field Ambulance, British Expeditionary Force, in France. The war took a heavy toll on him and he died in London a month short of his 50th birthday.

Robert Johnston was the second VC winner in the tour party, and was another Irish forward and Dublin Wanderers player. An experienced soldier, he eventually reached the rank of major in the Imperial Light Horse. In October 1899, while still a captain, he distinguished himself in the Battle of Elandslaagte and won a VC in conjunction with Captain Charles Mullins, brother of his 1896 Lions teammate Cuth Mullins. The joint citation for Johnston and Captain Charles Herbert Mullins read: 'On 21 October 1899, at Elandslaagte, at a most critical moment, the advance being momentarily checked by a very severe fire at point blank range, these two Officers very gallantly rushed forward under this heavy fire and rallied the men, thus enabling the flanking movement, which decided the day, to be carried out.'

Johnston was seriously wounded during the Siege of Ladysmith and was nursed back to health by Crean. Johnston had also stayed on in South Africa after the tour and actually played and captained Transvaal in the Currie Cup. The 1896 Lions boasted two VC winners and a DSO, but, not to be outdone by Crean and Johnston, the Dublin University wing Cecil Boyd and the Blackheath half-back Rev. Matthew Mullineux added Military Crosses (MC) during the First World War. Mullineux would go on to captain the Lions on their next expedition, to Australia in 1899, but, like Hammond, he never won an England cap.

▲ George Lee was another heroic member of the touring party, earning a DSO during the First World War

Four more of the 1896 tour party later returned to South Africa. George Lee was a vet who stayed in South Africa after the tour to help control rinderpest. He worked in Kimberley and then Salisbury, Rhodesia, before joining the Southern Rhodesian Volunteers shortly before the outbreak of the Second Boer War. During the war he served in Kitchener's Fighting Scouts, took up an appointment with the Transvaal Repatriation Department and then the Civil Veterinary Division of the Transvaal government. In the First World War, Lee saw active service with the South African Volunteer Corps in the South West Africa Campaign and was awarded the DSO. Between 1915 and 1920 he was the Civil Director of Agriculture in South Africa.

Alexander Findlater Todd, or 'Fin' to his friends, served in the Second Boer War from 1899 to 1900 as Squadron Commander of Roberts' Horse and Carrington's Horse, and was wounded at Diamond Hill. He twice played for England on his return from war, and in 1914, at the age of 41, was commissioned as lieutenant into the Norfolk Regiment (Special Reserve Battalion). Mentioned in dispatches and gazetted captain, he was shot through the neck while in the trenches near Hill 60 in the Ypres Salient and died three days later. He had only been back on the front line for one day after a trip home and became the first rugby international to lose his life in the First World War. He is remembered at his old school, Millhill, through the annual Todd Sports Scholarships.

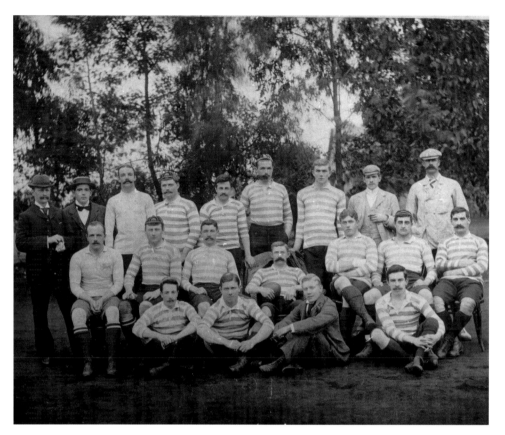

Reginald Cuthbert 'Cuth' Mullins was South African-born and spent the first 18 years of his life there before heading from St Andrew's College, Grahamstown, to Oxford University and then Guy's Hospital. He went home in 1899 when he enlisted as a Civil Surgeon at the Imperial Yeomanry Hospital, Pretoria, during the Second Boer War. He went back to England to complete his studies before returning to South Africa full time in 1913. He served as a captain in the RAMC in the First World War and was mentioned in dispatches.

Oxford University nominated both Mullins and Walter Carey for the tour, and the latter, who was to coin the Barbarians' motto, 'Rugby football is a game for a gentleman of all classes, but never for a bad sportsman of any class,' was appointed as Bishop of Bloemfontein in 1921. He remained in that post until ill-health forced him to return to England in 1934.

As well as becoming an extraordinarily courageous Lions tour party, it also turned out to be one of the most religious, for, in addition to Mullineux and Carey, Osbert Mackie later became a priest. He was ordained in 1899 and went on to become Rector of Guisborough.

On the 1896 tour itself, there was a degree of familiarity about the Lions' itinerary, as the first ten games virtually mirrored the matches that Maclagan's men had played. The improvement in the home teams can be gauged by the fact the Lions conceded only one try on the whole tour in 1891, but had four scored against them before the first Test five years later. They also conceded 21 points and were held to a draw in the game against Western Province in their third outing. There is a nice little story concerning the 0–0 draw in Cape Town. Apparently, the Lions took lunch with the prime minister, Sir Gordon Sprigg, and despite Crean telling his players that they could only have four tumblers of champagne, apparently that was

only starters. Needless to say, they were lucky to get away with a pointless draw, but when they returned to play Western Province in the penultimate match of the tour, without the pre-match temptations, they won 32–0, the highest score and biggest winning margin in 75 Lions games up to that point.

Discovering that South Africa were beginning to harness their great power in forward play, the tourists developed the art of wheeling the scrum and created the snap shove on their opponents' put-in to counter their strength. Consequently, they remained unbeaten until the final Test match in Cape Town when, to scenes of huge delight, South Africa began a march that would take them to world supremacy by claiming a historic victory. The final Test had an element of controversy surrounding it, as the Lions complained that the referee had repeatedly penalised them at the scrummages for wheeling, claiming that they fell offside as the scrum turned. The referee was Alf Richards, who had played at outside-half for the South African side in 1891, captaining them in the second Test. He also skippered the South African cricket side. This was also the tour when it was decided that neutral referees would be used and not drawn from players in the games.

Thus began an ongoing battle between the two hemispheres, concerning different interpretations of the always too complex laws of Rugby Football. Being so far apart, and with little contact apart from infrequent tours, it was inevitable that differences in the interpretation and styles of play would develop. This persisted until the modern day when, belatedly, the International Rugby Board introduced exchange referees, and the holding of a World Cup every four years began to provide far more uniformity of thought.

The try had been increased in value from one to three points, with drop goals being worth four, and the South Africans had some battle-hardened veterans from 1891 ready for revenge. When the teams for the first Test were announced, the South Africans had three survivors from the 1891 series: Barry Heatlie, Frank Guthrie and Charlie van Renen. Two more veterans of the 1891 tour, Toski Smith and Jackie Powell, played later in the series and, like Heatlie, faced the Lions on three tours over a 12-year period.

Heatlie became a legendary figure in South African rugby. He also faced a fourth Lions side in 1910, when he appeared for Argentina in their first international against John Raphael's tourists. Amusingly known as 'Fairy', Heatlie led South Africa in the final Test of 1903, when they won the series for the first time. On that occasion he decided to issue green jerseys to the team from his Old Diocesan club in Cape Town and therefore, coincidentally, South Africa won their first game wearing the colour they were to adopt as their national colour. He was inducted into the IRB Hall of Fame in 2009.

South Africa went through 38 players in the four-match series, and only two of them played in all four. One of these players was the skipper in the opening three Tests, the English-born Fitzmaurice Thomas Drake Aston, younger brother of the Lions' star centre from 1891, Randolph Aston. 'Ferdie' Aston made seven appearances against the Lions and was able to taste victory in his final outing when South Africa won their first international.

The Lions, on the other hand, used 18 players and had 11 permanent fixtures in the four games. The only change up front came in the second and fourth Tests when Hammond came into the side in place of Mullins. The Lions had won all three Tests in 1891 to nil and extended that sequence to four games with an 8–0 triumph in the opening game in Port Elizabeth thanks to tries from Carey and Larry Bulger.

The second Test was won 17–8, with three tries from the forwards, and it looked at one stage as though it might be a rout when the tourists led 13–0 in the second half. But the Griqualand West wing Theo Samuels wrote his name into South African history by not only scoring the first points in a Test for his country, but also becoming the first player to score not just one but two tries. Those tries ended more than six hours of rugby against the Lions in which the South Africans had failed to register a point and launched a revival that saw the gap cut to five points. A drop goal from Osbert Mackie gave the Lions a last-gasp boost, but the home side had demonstrated they were getting stronger.

▲ The kicking of J.F. Byrne was instrumental to the tourists' success. Like Stoddart before him, Byrne was a fine cricketer who went on to make 140 first-class appearances for Warwickshire

The third Test was played on the same bone-hard Kimberley pitch that Hammond's men had so detested earlier in the tour when they had two narrow squeaks against Griqualand West, winning 11–9 and 16–0. They developed a specific art of tackling in those two games, to try to avoid injury in the conditions, which saw them falling on their opponents to cushion the blow of hitting the deck. The South Africans picked up where they had left off in the second half in Johannesburg a week earlier and were 3–0 ahead at half-time thanks to a try by Percy Jones. Byrne's boot came to the Lions' rescue in the second half as he landed a drop goal on the run and converted a try by Mackie to clinch the series with a 9–3 victory.

That left both teams heading to Cape Town for the fourth and final Test with different points to prove. For the Lions, there was the chance of making it a clean sweep, while the South Africans were playing for pride and a historic first international triumph. Before they went at it for one final time, however, there was the return game against Western Province. The Lions fielded 14 of their Test team, while Western Province had nine of the South African side. Eight tries made amends for the scoreless draw in their first meeting but may have lulled Hammond's men into a false sense of security about their final game two days later.

It was obvious from the start that the South African forwards would be a force to be reckoned with, led from the front, as they were, by Heatlie. Their strong forward rushes kept the tourists on the back foot and the vital score came midway through the first half, when the Lions won the ball from a lineout and moved it to the strong-running Byrne in the centre. He was tackled by Aston, and the South African centre 'Biddy' Anderson darted in, snatched the ball from Byrne's hands and bolted upfield. He drew the full-back, Meares, and put his outside-half Alf Larard over for what was to be the winning score. Tommy Hepburn converted and South Africa were leading 5–0. That was how events stood at half-time, and despite the posts being peppered by drop and penalty goal attempts in the second half, South Africa held out amidst huge excitement, and the players and spectators were beside themselves with joy on the final whistle, knowing history had been made.

The Larard try didn't please the Lions, who claimed the ball had been taken out of the grip of Byrne illegally. The next day, the *Cape Times* agreed that it was illegal, severely criticising Anderson. Their reporter said, 'It was a pity that the match should have been decided on a piece of sharp practice. A player less inclined than Anderson to take every advantage he can get, whether lawfully or unlawfully, would have left Byrne in charge of the ball and allowed a scrum to be formed over the

place he was held.' The try scorer, Larard, had been born in Kingston-upon-Hull and emigrated to South Africa in his early twenties. In Johannesburg he began playing rugby union with the 'Diggers' club and then played for Transvaal in the Currie Cup. Despite his call-up for South Africa, he joined the Imperial Light Horse Regiment to serve in the Second Boer War before heading back to England, where he signed on for the Huddersfield NU club. Perhaps under modern rugby conditions, with touch judges able to aid the referee's decision-making, as well as video officials to refer to, the try might not have been awarded. However, there was no post-match inquest and the Lions left not worrying about what might have been.

Carey described the tour as being 'a very happy one, as the play of our opponents was scrupulously fair. I hope and pray that South African teams will always play like gentlemen. Rugby football is a game for gentlemen: it is so easy to cheat at it and so destructive for this wonderful game. If a man wants to do dirty tricks, let him do it at ninepins in his own back yard, but let him keep clear of rugby football.' In the professional era, rugby needs to preserve this kind of ethic.

RESULTS OF THE 1896 BRITISH TEAM IN SOUTH AFRICA

P 21 W 19 D 1 L 1 F 310 A 45

Cape Town Clubs	W	14–9	Queenstown	W	25–0
Suburban Clubs	W	8–0	Johannesburg–Country	W	7–0
Western Province	D	0–0	Transvaal	W	16–3
Griqualand West	W	11–9	Johannesburg–Town	W	18–0
Griqualand West	W	16–0	Transvaal	W	16–5
Port Elizabeth	W	26–3	South Africa (Johannesburg)	W	17–8
Eastern Province	W	18–0	Cape Colony	W	7–0
South Africa (Port Elizabeth)	W	8–0	South Africa (Kimberley)	W	9–3
Grahamstown	W	20–0	Western Province	W	32–0
King Williams Town	W	25–0	South Africa (Cape Town)	L	0–5
East London	W	17–0			

JOHNNY HAMMOND'S 1896 BRITISH TEAM

FULL-BACK			FORWARDS		
J.F. Byrne	Moseley	England	W.J. Carey	Oxford University	
			A.D. Clinch	Dublin University	Ireland
THREE-QUARTERS			T.J. Crean	Wanderers	Ireland
C.A. Boyd	Dublin University		J. Hammond (capt.)	Richmond	
L.Q. Bulger	Dublin University	Ireland	P.F. Hancock	Blackheath and Somerset	England
O.G. Mackie	Cambridge University		R. Johnston	Wanderers	Ireland
	and Wakefield Trinity		G.W. Lee	Rockcliff and	
J.M. Magee	Bective Rangers	Ireland		Northumberland	
C.O. Robinson	Northumberland		A.W.D. Meares	Dublin University	
			W. Mortimer	Cambridge University	
HALF-BACKS				and Marlborough Nomads	
S.P. Bell	Cambridge University		R.C. Mullins	Oxford University	
A.M. Magee	Bective Rangers	Ireland	J. Sealy	Dublin University	Ireland
M.M. Mullineux	Blackheath		A.F. Todd	Blackheath	

1899
AUSSIE ODYSSEY

1899 TOUR KIT

Captain: Rev. Matthew Mullineux (Blackheath)
Squad Size: 21
Manager: Roger Walker (England)
Tour Record: P 21 W 18 D 0 L 3 F 333 A 90
Test Series: P 4 W 3 D 0 L 1

The 1899 Lions were unique for 90 years because until 1989 they were the only Lions team that had embarked on a tour of only Australia. This was the second time the Lions had played in Australia, but the first since the trailblazers of 1888 had played 14 games there. As the years went by, Lions' tours down under became combined affairs with New Zealand generally gathering more and more of the matches and Tests. There was talk during this tour of an Australasian governing body being created and of either a combined Australia–New Zealand team being assembled to face the Lions or the tourists heading to New Zealand to face the 'ultimate test'. In the end, nothing came of it and there was a feeling of a missed opportunity all round.

As Australian Rules and rugby league codes took hold in Australia, rugby union was marginalised, so tours by both the Lions and Springboks tended to be more cursory than prolonged. These days, however, Australia is one of the three teams in the 12-year Lions cycle and played host to the 125th anniversary tour in 2013. The 1899 tour broke new ground and provided the Aussies with their first taste of Test rugby, but these days the Wallabies are very much part of the challenge to the Lions.

This was the year the Boer War broke out. When the *Uitlanders* (foreigners) were refused voting rights, war ensued between the British, based in Natal and Cape Province, and the Boers from Transvaal and the Orange Free State. It started at the end of the Australian tour, when the Boers, after delivering an ultimatum regarding the withdrawal of British troops from the colony, finally invaded. It was the year of Kimberley, Mafeking and Ladysmith. In the rest of the world, Elgar's Enigma Variations were performed for the first time, the Samoan Islands were split up between the USA and Germany, and a 16-year-old anarchist attempted to assassinate the Prince of Wales in Brussels.

One of the most successful players picked for the Lions' first full tour of Australia, Charlie Adamson, stayed on after the tour and enrolled in the Queensland Imperial Bushmen (Mounted Infantry) and saw a considerable amount of active service in the Boer War. He wasn't the only member of the tour party who served in South Africa. Fred Belson joined the Imperial Yeomanry on his return from Australia, Dr Alan Ayre-Smith worked in a dressing station, and the captain, the Rev. Matthew Mullineux, also joined the fight.

Adamson was a good all-round sportsman who played three times for the North v. South and won 27 caps for Durham County over 13 seasons, although he never played for England. He also played against the 1905 All Blacks. He was comfortably the top scorer for the Lions on tour and was an excellent place kicker. In the final game at the Melbourne Cricket Ground he kicked six out of seven shots at goal, and once scored 21 points for Durham against Cumberland, landing nine of

his dozen shots at goal and crossing for a try. He was also a sound cricketer who played Minor Counties for Durham for 19 years. After the Lions tour, he played one cricket match for Queensland v. New South Wales in November 1899, scoring zero and ten. Back home, he captained Durham against the 1912 Australians, scoring 65 in the first innings, and he also faced the 1907 South Africans. He was commissioned into the Tynedale Scottish Battalion early in the First World War and became Capt. (Quartermaster) in the 6th Battalion of the Royal Scots Fusiliers. He was killed in action in Salonica, Greece.

The 1899 Lions squad was picked, captained and in part managed by Rev. Matthew Mullineux. A busy man, he even managed to find the time to preach to the locals after matches and actually refereed the final game of the tour in Victoria. A diminutive scrum-half – he was only 5ft 2in and weighed in at nine stone – he played for Cambridge University and Blackheath, yet never won a Blue nor played for England. He still managed to travel on two Lions tours, though, and was the only survivor from the 1896 team that went to South Africa.

Injured during the first Test, Mullineux stepped down as captain for the remaining three internationals, although he certainly left his mark after the series had ended in a 3–1 success for his side in Sydney by asking the Australians at the post-match dinner to rid their game of some of their dark arts. The *Sydney Morning Herald* of 14 August 1899 reported the captain's post-match speech in the following manner:

The Rev. M. Mullineux, in rising to respond, was requested to get on a chair, which he did. He regretted that a section of the press had misinterpreted his remarks. What he had said at Rockhampton was that in that match there had been less pointing than in any other they had played which was quite true. He was out here as a representative of English Rugby football, and he felt it his duty to speak against anything that was not conducive to the game being played in a sportsmanlike way. He was also a clergyman of the Church of England, and therefore he should denounce anything in the game that was unmanly. Whatever he had pointed out he wished those present to understand that it was simply for the purpose of affording them information that would improve the game, and that it was not done in any carping spirit. The points to which he would refer were the trick of holding players back when coming away from a scrum; on the lineout pushing a man who has not got the ball – as, for instance, A and B are Australians, they push an opponent away while another Australian comes along and secures the ball; placing the elbow in an opponent's

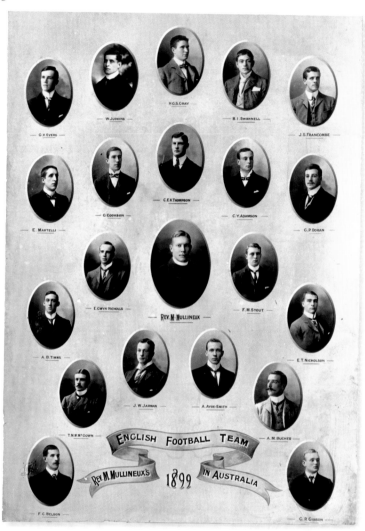

▲ The 1899 tourists, with captain Rev. Matthew Mullineux pictured in the centre

face in the scrum – he was told the Australian remedy was to bite the hand, but they had not mastered the art of cannibalism yet; and shouting to an opponent for a pass – this was the lowest thing that he had heard of and was taking a mean advantage. 'Please blot these things from your football,' said Mr Mullineux, 'for instead of developing all that is manly they bring forth all that is unmanly.' (Cheers). Mr Mullineux was subjected to some interruption during his speech.

Misquoted by the media? Some things never change! Barracking during a speech? Par for the course! Message understood by the Aussies? Just ask those Lions who followed in the footsteps of Mullineux's men of 1899. As much as they might have despised the perceived pomposity of the 'Englishmen' lecturing them on 'fair play', they secretly admired Mullineux's strength of character. This was a player who never shirked or hid when the going got tough. He ended up being immortalised in a poem by Australia's popular poet A.B. 'Banjo' Paterson that was published in *The Bulletin*:

> *I'd reckon his weight at eight-stun-eight,*
> *And his height at five-foot-two,*
> *With a face as plain as an eight-day clock*
> *And a walk as brisk as a bantam-cock –*
> *Game as a bantam, too,*
> *Hard and wiry and full of steam,*
> *That's the boss of the English Team,*
> *Reverend Mullineux.*
>
> *Makes no row when the game gets rough –*
> *None of your 'Strike me blue!'*
> *'You's wants smacking across the snout!'*
> *Plays like a gentleman out-and-out –*
> *Same as he ought to do.*
> *'Kindly remove from off my face!'*
> *That's the way that he states his case –*
> *Reverend Mullineux.*
>
> *Kick! He can kick like an army mule –*
> *Run like a kangaroo!*
> *Hard to get by as a lawyer's plant,*
> *Tackles his man like a bull-dog ant –*
> *Fetches him over too!*
> *Didn't the public cheer and shout*
> *Watchin' him chuckin' big blokes about –*
> *Reverend Mullineux.*
>
> *Scrimmage was packed on his prostrate form,*
> *Somehow the ball got through –*
> *Who was it tackled our big half-back,*
> *Flinging him down like an empty sack,*
> *Right on our goal-line too?*
> *Who but the man that we thought was dead,*
> *Down with a score of 'em on his head –*
> *Reverend Mullineux.*

After the tour, Mullineux was one of a number of Lions who stayed on in Australia. He briefly joined the 'Bush Brotherhood', a group of young and enthusiastic ministers who spread the 'good word' among remote areas, serving small communities and families that were beyond the reach of a local parish. The Lions had played their final game on tour in Melbourne on 18 August and Mullineux was back in New South Wales when the Boer War broke out on 11 October. When the first 'Colonial Contingents' were announced, New South Wales were asked to provide two sub-units of 125 men each. Mullineux, who was already planning to head home via South Africa, offered to provide support to the units as a chaplain. It got the New South Wales government out of a political hole, as they had assumed all support services for their men would be provided by the British. To make matters even better, the Lions skipper offered to do the job for nothing and even paid his own passage. He travelled as chaplain with the New South Wales Rifles on the voyage over, but was quickly commissioned into the British Army as a chaplain after arriving in South Africa. He became a prisoner of war for almost three years, but was able to return to England relatively unscathed to become a chaplain in the Royal Navy. His wanderlust never abated and he served on ships that took him to China and the Pacific and, a decade later, he could be found working at a Mission in San Francisco.

▲ Industrious, charismatic and devout, Mullineux lived a truly extraordinary life

When the First World War broke out, he worked his own passage to New Zealand, working as a stoker and deckhand on a mail ship, and awaited confirmation of his orders from the Royal Navy. However, the wait became too great for this man of action, and when his patience ran out he joined the New Zealand Expeditionary Force and was soon to be found working in Ypres and on the Somme in France as a chaplain with the rank of captain. It should come as no surprise that he was awarded the MC in 1918. The *London Gazette* of 13 September that year outlined his heroics:

During two days' hard fighting, when the medical officer had become a casualty, early on the morning of the first day, he took charge of the Regimental Aid post, dressed the wounded and superintended their evacuation. The Regimental Aid post was subjected to very heavy high explosive and gas shell fire for twelve hours, and but for his skill and excellent dispositions, serious congestion would have occurred. His untiring energy and cheerful service in providing comfort for the troops under most adverse circumstances were of the greatest value to all ranks of the battalion.

After the war, Mullineux devoted his time to improving military cemeteries across Europe before settling down as the vicar of Marham, Norfolk. This remarkable man eventually died at the age of 77 in London in 1945.

▲ An 1899 tour cap. The initials A.A.R.F.T. stand for 'Anglo-Australian Rugby Football Tour'

The 1899 trip was the first time the Lions had toured with an international player from each of the Four Home Unions. The sole Welshman selected in Mullineux's party was Cardiff's gifted centre Gwyn Nicholls, while there were three Irish and three Scottish players. Mullineux selected seven players who had played international rugby – Frank Stout and George Gibson up front for England, Alf Bucher and Alex Timms behind for Scotland, and Ireland's 1899 Triple Crown heroes Gerry Doran, Tom McGown and Nicholls. Of the 14 uncapped players, only centre Elliot Nicholson (England) and forwards Wallace Jarman (England) and Blair Swannell (Australia) gained caps for their countries after the tour.

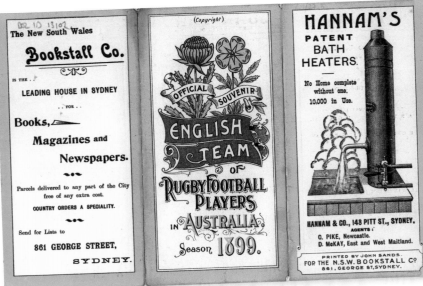

Before departure, Mullineux wrote to the *Brisbane Courier* and provided a sketch of the team he had selected to give them some advance publicity. It was printed on 1 June 1899, only 13 days before the tour opened against a Central Southern team in Goulburn. Here is the transcript of the letter. Note that some of the spellings of the players' names are incorrect and that the letter states there was still one place to be filled, by either Scot James Couper or Welsh wing Viv Huzzey. After failed approaches were made to them, the place eventually went to Scottish international wing Alf Bucher:

▲ A souvenir programme from the tour, which includes an advert for Hannam's Patent Bath Heaters, proudly proclaiming that 'No home is complete without one'

THE ENGLISH FOOTBALL TEAM
LETTER FROM THE REV. M.MULLINEAUX – DETAILS OF THE PLAYERS
(By Telegraph from Our Correspondent.)
SYDNEY, May 31

With reference to the English football team which is about to visit Australia, the Rev. M. Mullineaux, writing to Mr. Rand, hon. secretary of the New South Wales Rugby Union, by the mail which reached Sydney today, says: I have had some disappointments since I last wrote, but have got a good side together, and all are decent fellows. Several are Varsity men, and many are Public School men. The following is the team so far:

Backs: E. Martelli (Dublin Wanderers) an excellent drop, punt, and place kick, and plays three quarters as well as back; C.E. Thompson (Lancashire) a good kick, can play three quarters, and also take a place in the forwards.

Three-Quarter Backs: G.P. Doran (Lansdowne) a most deadly tackler, who played for the Irish team this season; A.B. Timms (Edinburgh University) played in Scotch trials, and is an excellent centre or wing; E.G. Nicholls (Cardiff) plays for Wales, and is the greatest centre three quarter since the days of A.J. Gould, and is supposed by many to be better than Gould; E.T. Nicholson (Liverpool) a very fast wing, played for Lancashire.

Half-Backs: C. Adamson, can play centre, three quarter, or half, and got his North of England cap last season; G. Cookson, a very 'nippy' half-back, plays for Lancashire, and got his North of England cap last season.

Forwards: F.M. Stout (Gloucester) one of England's best forwards, and always to the front; T.M. McGown (late Cambridge University), a good Irish forward, brilliant at times; W.J. Jarman (Bristol captain) a splendid, hardworking forward, played for England; G.R. Gibson played for England, a capital worker; F.C. Belson, an old Clifton College boy, played for Somerset; A. Ayre-Smith (Guy's Hospital) a cap-holder for the last two years, and a grand forward, he has played for Surrey; B.I. Swannell, got his East Midlands cap, and many think him up to international form, he is an old Repton School boy; G.V. Evers (Moseley) an old Haileybury boy and is a capital little worker forward; W. Judkins (Coventry), an old Repton boy, a good scrummager; J.S. Francombe, played for Lancashire, an old Oxford man, very tall, and wants a lot of stopping when he gets going; H.G. Gray, Scotch trials, a good forward of the Scotch type. The last place in the team will be filled by either Huzzey (Wales) or J.H. Cowper (Scotch international).

The tour party left Charing Cross railway station at 11am on 9 May, coincidentally on the same day the Australian cricketers launched their tour in England, and crossed the channel before travelling the length of France to the port of Marseilles. Here they boarded the P&O liner *Oriana*. It was to be their home for the next five weeks as they headed to Adelaide. The players were kitted out with formal tour blazers, complete with a badge that read 'The Anglo-Australian Football Team', and they also had maroon caps with a kangaroo motif. The jerseys were red, white and blue hoops, the shorts were dark blue and the socks were blue with red and white tops.

From Adelaide, the tourists travelled the next 2,000 plus miles to Sydney by train. They stopped in Goulburn for their first fixture against a scratch XV, Central Southern. The Lions had been made to feel very much at home by constant rainfall since their arrival in Adelaide and the muddy conditions probably suited them. They won the opener 11–3 and then headed to Sydney to face New South Wales in the first of six matches at the Sydney Cricket Ground.

The game was tight, ending in a 4–3 win for the visitors, who enjoyed an unusual breather ten minutes into the game when the band struck up 'God Save the Queen' on the late arrival of the governor, Earl Beauchamp. Nicholls was marked out early as 'the great player of the side'. The *Daily Telegraph*'s rugby writer claimed: 'He's a wonder on defence, worth two or three ordinary men.'

There was little to commend in an 8–5 triumph in the third outing against a Sydney club side. The Lions were said to be out of condition, but what was expected of them after a five-week sea voyage and a further 2,000-mile train trek across Australia? Two weeks into the tour, Mullineux's men were confronted with the first of four Tests against Australia. It was a historic moment for the game in Australia, as it was their first international. There were nine players from New South Wales and six from Queensland. The home side scored the first try through Alexander Kelly before Nicholls replied in the second half. Seven Lions handled in the move, with Nicholls involved twice, as the tourists turned on the style. But it was the Australians who finished strongest. Tries from Lonnie Spragg and Poley Evans, both converted by Spragg, made it 13–3 and first blood to the home team.

The Lions were clearly not yet at their peak, a point illustrated by the fact that after comfortably beating Toowoomba in their first foray into Queensland, they went down again to the State XV 11–3. The second Test was at the Exhibition

▲ Gwyn Nicholls was widely considered to be the best player on the 1899 tour. The Welsh three-quarter would go on to earn 24 caps for his country

Grounds and the Lions had to go into the game without the services of their injured skipper, Mullineux. Frank Stout took over as skipper and the Australian-born Alex Timms was fit to resume at centre with Nicholls.

Nicholls had a hand in all three tries as the Lions won 11–0, making breaks that led to scores from Charlie Adamson and Alan Ayre-Smith before crossing for the third himself. The series had been squared and there was all to play for with two more Tests to come.

The third Test was back in Sydney and was scoreless until just before half-time, when Scottish wing Alf Bucher hacked a loose ball towards the home line. The danger seemed to be covered by Syd Miller, but his attempt to kick the ball dead failed miserably, allowing Bucher to dive on the ball for the try. Charlie Adamson converted and for the first time in the series the Lions were ahead. Bucher scored again after the break, making him the first Lion to score two tries in a Test, but the Aussies hit back with a try and conversion from Spragg. The game was back in the melting pot at 8–5. Nicholls then ghosted through the home defence to set up Timms for the Lions' third try, and the game seemed secure at 11–5. But there was a late home rally that led to Spragg grabbing his second try and conversion, despite protests to the referee from the incensed Lions that the scoring pass was forward, and there was only a point between the two teams. It went down to the wire and Aussie scrum-half Ignatius O'Donnell had the chance to be the hero with a last-gasp drop goal, but his kick drifted wide. The Lions were 2–1 up with a game to play and couldn't lose the series.

The Lions saved their best for last, perhaps proving their early defeats were as much to do with a lack of condition and practice as anything else, and won the fourth and final Test 13–0. It was 0–0 at the end of the first half, but it became one-way traffic once scrum-half Adamson had crossed for a try at the posts, which he also converted. Bucher was next to score and Adamson ended with a match tally of ten points with another conversion and penalty. Job done!

The honour of leading the Lions to their first Test series triumph in Australia fell to the England and Gloucestershire forward Frank Stout, as Mullineux had stepped down after the opening defeat. The most experienced international on the trip, with seven caps, Stout's Test career for England and the Lions stretched from 1897 to 1905. He played 14 times for England and in seven successive Lions Tests in 1899 and 1903, capturing the Lions appearance record on his second tour as he overtook Harry Eagles' 35 games in 1888 by reaching 41 in the final Test against the Springboks in Cape Town on 12 September 1903.

Stout's brother, Percy, also played five times for England, and both earned honours during the First World War. Percy was awarded the DSO, while Frank, who served first with the 20th Hussars and then with the Machine Gun Corps, won the MC. This is the citation for his award:

On hearing that the enemy had been seen working close to the British positions, he took Corporal G. Tester and a light machine gun to the saphead, at the end of the trench. They mounted the machine gun on top of the trench, and then Corporal Tester, standing on Stout's shoulders, opened fire on the enemy who were only 30 to 40 yards away. Under heavy enemy fire, Tester fired 150 rounds, before he and Stout switched positions to allow Stout to continue the attack. The next day fourteen enemy dead were counted.

Unfortunately, Stout was badly wounded and remained an invalid for the rest of his life. He went to live with his brother in Egypt for a while, but returned to England and died in Sussex on 30 May 1926, aged 49.

The Lions broke up into small groups after the final game. Stout, Timms, Bucher and Simpson left Australia on 21 August on HMS *Victoria*. Swannell went home via the Cape, and on 22 August, Francomb, Cookson, Jarman, Evers, Ayres-Smith, Nicholson, Martelli, Doran, Thompson and McGown departed on the *Mariposa* via New Zealand and San Francisco.

Mullineux, as we now know, stayed in Australia, as did Nicholls. The Welshman stayed and worked in a bank in Brisbane for a short while, causing consternation back in Cardiff. Nobody knew of his whereabouts and, even though he was the club captain, he missed the first 19 fixtures of the Cardiff RFC season.

He eventually returned on 11 January 1900, catching the same train from London as the Blackheath team who were heading to the Arms Park to face the 'Blue and Black', and found himself selected by the Welsh selectors to play against Scotland in Swansea on 27 January. He made one club appearance against Bristol the week before the international and then turned out at St Helen's, Swansea, to help Wales beat a Scottish side that contained his Lions midfield partner, Timms.

RESULTS OF THE 1899 BRITISH TEAM IN AUSTRALIA

P 21 W 18 D 0 L 3 F 333 A 90

Central Southern	W	11–3	Australia (Brisbane)	W	11–0	
New South Wales	W	4–3	New England	W	6–4	
Sydney Union	W	8–5	Northern Districts	W	28–0	
Australia (Sydney)	L	3–13	New South Wales	W	11–5	
Toowoomba	W	19–5	Metropolitan	L	5–8	
Queensland	L	3–11	Western	W	19–0	
Bundaberg	W	36–3	Australia (Sydney)	W	11–10	
Rockhampton	W	16–3	Combined Public Schools	W	21–3	
Mount Morgan	W	29–3	Victoria	W	30–0	
Central Queensland	W	22–3	Australia (Sydney)	W	13–0	
Maryborough	W	27–8				

REV. MATTHEW MULLINEUX'S 1899 BRITISH TEAM

FULL-BACKS

E. Martelli	Dublin University	
C.E.K. Thompson	Lancashire	

THREE-QUARTERS

A.M. Bucher	Edinburgh Academicals	Scotland
G.P. Doran	Lansdowne	Ireland
E.G. Nicholls	Cardiff	Wales
E.T. Nicholson	Birkenhead Park	
A.B. Timms	Edinburgh University	Scotland

HALF-BACKS

C.Y. Adamson	Durham	
G. Cookson	Manchester	
M.M. Mullineux (capt.)	Blackheath	

FORWARDS

A. Ayre-Smith	Guy's Hospital	
F.C. Belson	Bath	
G.V. Evers	Moseley	
J.S. Francombe	Manchester	
G.R. Gibson	Northern	England
H.G.S. Gray	Coventry and Scottish Trialist	
J.W. Jarman	Bristol	
W. Judkins	Coventry	
T.M.W. McGown	North of Ireland	Ireland
F.M. Stout	Gloucester	England
B.I. Swannell	Northampton	

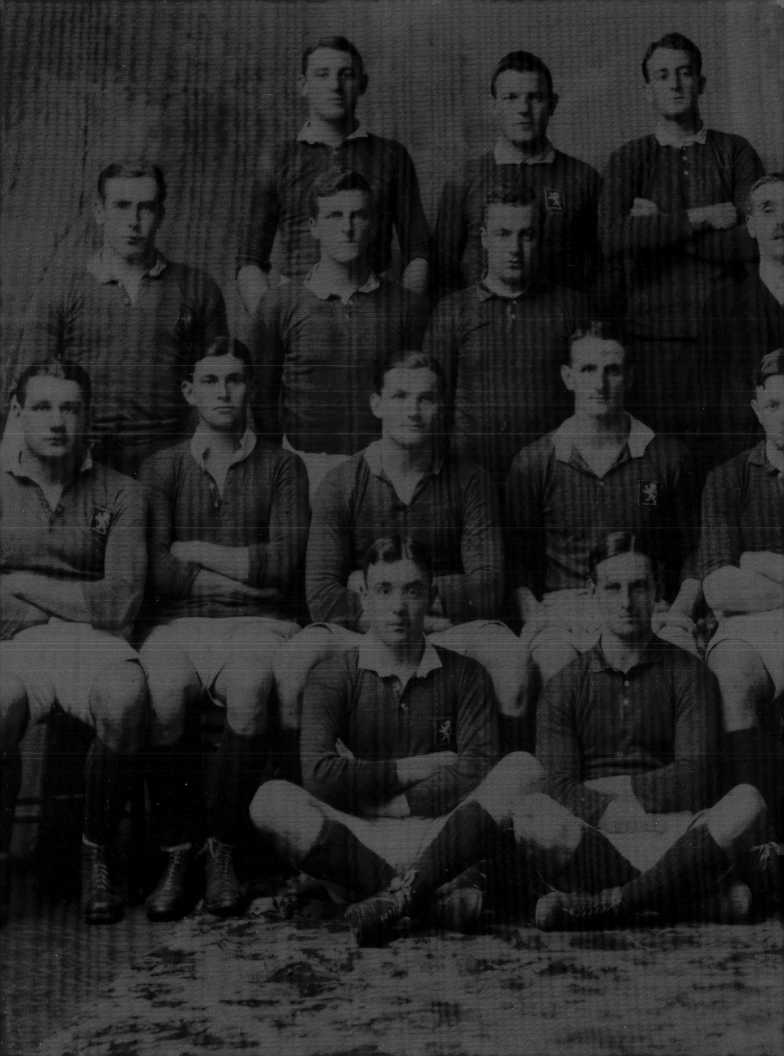

2
TABLES TURNED

The start of the twentieth century brought a rude awakening for British rugby, as their missionary days ended and they were forced to face the stark reality of the emerging sportsmen from Africa and Australasia.

Trouble was now brewing elsewhere in the world, as the Bolsheviks split the Russian Socialists and Serbian army officers murdered their King and Queen. Delegates at the Zionist conference clashed over plans to set up a Jewish state in Uganda. Women were coming into their own, as Madame Curie won the Nobel Prize for the discovery of radium, and Emmeline Pankhurst formed the militant Women's Social and Political Union.

The guns in South Africa fell silent as the Second Boer War ended on 31 May 1902. The battles had raged between the Commandos and the British Empire forces for almost three years, and the Afrikaans-speaking Dutch settlers of two independent Boer republics, the South African Republic (the Transvaal Republic) and the Orange Free State, went back to their farms to prepare for annexation following a British victory. Both republics would eventually be incorporated into the Union of South Africa, a dominion of the British Empire, in 1910.

The British lost no time in sending a rugby team back to what they already knew to be an extremely pleasant country to tour. It was a tour later described by prominent South African rugby historian Paul Dobson as 'a tour of reconciliation – rugby's contribution to healing the sad and painful wounds of the Anglo-Boer War'.

In 1903, the British sent a team to the colony for a third time, and a year later they went to Australasia. Only one player travelled on both tours: the Scottish international forward David Bedell-Sivright, who led the team down under. They had a rude awakening as Mark Morrison's 1903 team became the first to lose a Test series to South Africa and then, following an unbeaten run through Australia, Bedell-Sivright's side lost their Test in New Zealand.

1903
SOUTH AFRICAN SUPREMACY

1903 TOUR KIT

Captain: Mark Morrison (Royal High School FP and Scotland)
Squad Size: 21
Manager: Johnny Hammond (England)

Tour Record:	P 22	W 11	D 3	L 8	F 231	A 138
Test Series:	P 3	W 0	D 2	L 1		

Mark Morrison's men left Southampton on RMS *Briton* on 20 June and arrived in the Cape on 8 July. They arrived in South Africa 13 months on from the end of the Second Boer War, an event that saw Boer women and children placed in 'concentration camps' in which an estimated 28,000 died. More than 7,000 Republicans died, while the losses incurred by the British Imperial forces amounted to almost 22,000. Fixtures were played at a time when many parts of the country were still reeling from the effects of the conflict.

A number of players involved in the matches had been involved in the three-year conflict. Jackie Powell, who captained South Africa against the Lions in the second

Test at Kimberley and had played against the two previous Lions touring teams, had served in the Diamond Field Horse as a native of Griqualand. He took his total number of appearances against the Lions to 12, signing off in style with a third Test, series-clinching victory. Charles Brown, from Boksburg, fought with Roberts' Horse during the conflict and featured in six matches against Morrison's men, never ending on a losing side. Others who fought and then played included Griqualand back Bertie Gibbs, present at the Siege of Kimberley, and the Irish-born forward George Crampton. Crampton had gone to South Africa for the Mashonaland Rebellion in 1896, settled there and subsequently fought in the Second Boer War. He was once captured by the Boers before making his escape.

On the Lions' two previous trips to South Africa, they had won 39 of their 41 matches, drawn another and lost one by five points. The fact that the one defeat had come in the final Test of the 1896 tour gave South Africa hope of a brighter future and should have served as a warning to the British rugby authorities. The year 1903 proved to be a watershed, with the emergence of South Africa as the most powerful force in world rugby. They shocked the rugby world by winning the three-Test series by one match to nil – with two matches drawn – against the Lions. No one expected it, least of all the British team managed by the same Johnny Hammond who had

▲ The 1903 tour took place scarcely 13 months after the conclusion of the Second Boer War, which ended with the signing of the Treaty of Vereeniging on 31 May 1902

▲ The Lions were captained by Scotland's Mark Morrison (middle row, centre), a powerful forward renowned for his ball-carrying, while vice-captain Reg Skrimshire (back row, far left) was the only Welsh representative on the tour

captained the 1896 party on a highly successful tour. What they weren't to know then was that South Africa would not lose another Test series for over half a century, until their 1956 series in New Zealand.

Morrison had won 20 of his eventual 23 caps for Scotland before he was invited to lead the 1903 Lions. First capped as an 18-year-old in 1896, he added durability to his vast experience, playing in 19 of the 22 games, including all three Tests. He became president of the Scottish Rugby Union in 1934–35 and was later inducted into the Scottish Sports Hall of Fame. His side found life much tougher going in South Africa than their predecessors had in 1891 and 1896, and they came close to the ignominy of being the first British team to have lost more matches than they had won. (The first side to actually do so was the 1924 Lions in South Africa.) Morrison's men won 11 of their 22 games and drew three others, including the opening two Tests.

It didn't help the Lions' cause that having arrived on a Wednesday, they played their first game the following day. Cue the first of three successive defeats in the space of five days at Newlands. The first was against Western Province Country (7–13), then Western Province Town Clubs (3–12) and finally Western Province (4–8). The future South African wing Japie Krige scored three tries in two of the wins and ended the tour with three wins and three draws in his six games against the tourists. The Lions side recovered its poise after its rude awakening and the next five matches were all won as the team got to know each other.

Then came another ambush as Griqualand West, twice, and Transvaal both took the Lions' scalp. Now Morrison, and the whole of British rugby, was getting to see just how much the game had developed in South Africa. The Lions skipper told *The Sportsman* on his return just how South African rugby had 'improved out of all knowledge, particularly in the Western Province, where the players were Colonial-born and principally Dutch'. He concluded that 'a thoroughly representative team

of South African footballers would now fully extend any international fifteen in the Old Country'. He was to be proven right in 1906 when Paul Roos and his team embarked on the Springboks' first overseas tour.

Wales and Scotland were the strongest teams of the first decade of the twentieth century, yet Wales only provided one player to the 1903 side. Reg Skrimshire, who divided his playing time between Blackheath and Newport, had won three caps as a centre in 1899, but at 25 found himself on the international scrapheap. The Lions may have been weak behind the scrum, with only four of the ten players selected having won caps and none of them having played in the Four Nations tournament that season, but Skrimshire provided the sparkle and star quality that was needed to give his side a real cutting edge. He played in all 22 games, top-scored with 59 points, scored ten tries, including four against King Williams Town, dropped seven goals and scored a try in the first Test in Johannesburg that lived long in the memory. Feinting to drop for goal from halfway, he instead went on a run that ended with a try at the posts to help the Lions take a 10–0 lead in the first half. The game ended in a draw, but every player in South Africa feared Skrimshire.

Morrison had made Skrimshire his vice-captain and the two men sat on a Match Committee that also included Hammond, Bedell-Sivright and James Wallace. Wallace was a civil engineer who worked mainly in Ceylon, Southern Africa and India and was employed by the Foreign and Commonwealth Office to help build railways and bridges around the British Empire. His most notable work was on the railway from Johannesburg to the Victoria Falls, including the famous bridge over the falls.

Skrimshire was the Lions' foil for some very special South African backs who were to become household names for generations to come, such as Krige, outside-half Paddy Carolin and Bob Loubser. The Lions only made two changes in their back division throughout the series, blooding five uncapped players, while there were two more players up front who made their international debuts for the Lions before their home nation.

Skrimshire's centre partner was the young Glaswegian Louis Greig. He was just embarking on one of the most colourful lives of any Lion, making his international debut in South Africa. On his return home, he won five caps for Scotland, captaining the side on four occasions, but rugby was only a small part of Greig's extraordinary life. He joined the navy in 1906 and served with Prince Albert, later King George VI, on HMS *Cumberland*. He was taken prisoner of war in Antwerp during the First World War and served eight months in captivity. He joined the Air Force in 1919, rising to rank of Wing Commander, and taught the then Duke of York to fly. He played doubles at Wimbledon with the Duke of York in 1926, and was knighted in 1932 after helping Prime Minister Ramsay MacDonald form his cabinet. He became chairman of Wimbledon, and during the Second World War he was personal air secretary to Sir Archibald Sinclair when he was Secretary of State for Air. He was a man of quite astonishing influence behind the scenes of the British establishment, conveying the political wishes of prime ministers and presidents to editors and equerries.

▲ Scottish forward David 'Darkie' Bedell-Sivright was a member of the Match Committee and would go on to captain the 1904 Lions

An even greater measure of the man is illustrated by the fact that at his funeral in 1953 there were representatives for not only the five most senior members of the Royal family, but also Winston Churchill, J. Arthur Rank, Catford dog track, the All-England Wimbledon Tennis Club and the Scottish rugby team.

If the 1903 Lions were a bit wet behind the ears in their backline, they were a different prospect up front. Alongside the outstanding Morrison were players of the calibre of Ireland's Alf Tedford, who was regarded as one of the best Irish forwards of his or any other time. He was the sort of Irishman who, over the generations, became a template for players like Fergus Slattery and many others who have created such mayhem around the rugby-playing world. Tedford became an Irish selector and was president of the Irish Rugby Union in 1919–20. Other top-class forwards on tour included 'Darkie' Bedell-Sivright, who went on to captain the 1904 Lions, Scotland's William 'Bummer' Scott, who was ever-present on tour, and England's Frank Stout.

> When the Lions headed to South Africa in 1891, the weakest opposition they faced came from Eastern Province and on the high veldt, where they put 46 points past Transvaal without conceding. However, by the time Mark Morrison's squad returned in 1903 they found Transvaal a significantly tougher nut to crack as the provincial side became the first domestic team to beat the Lions twice on the same tour.

The South Africans became convinced the Lions were focusing all their attentions on the Test series when they saw them come into the opening game of the three-match series with a record of nine wins and seven defeats. The first Test at the Old Wanderers Ground in Johannesburg was refereed by the former Scottish international Bill Donaldson, who had to call forward two other Scots for the toss of the coin before the game. Morrison was in charge of the Lions, and South Africa were led by Alex Frew, who had played in the same Scottish Triple Crown side in 1901 as Morrison and Bedell-Sivright. Another Scot, Willie McEwan, joined Frew in becoming the first players to play for two countries, while in the back row the South Africans capped Joe 'Birdie' Partridge. Born in Abergavenny, Partridge was a former Blackheath captain, and a Newport and Barbarians stalwart who went on to found the Army Rugby Union on his return from South Africa, and he played for the Barbarians against Wales in Cardiff in 1915.

Skrimshire's try lit up the first half and gave the Lions a handy lead, but the tourists blew up in the second half due to setting too high a pace early on at the high altitude. William Cave, the Cambridge University student who had replaced his fellow Light Blue, A.F. Roberts, in the original party, scored the other try, and Jimmy Gillespie converted both scores. After surviving the early attacks in the second half, South Africa took charge and scored tries through Fred Dobbin, who went on to play against the 1910 Lions, and Jimmy Sinclair, the famous cricketer with a penchant for hitting sixes. Fairy Heatlie added the conversions for a 10–10 draw.

The second Test was, as they say, a match of two halves, this time with hosts South Africa being on top in the first and the British coming back to dominate the second period. There was no score at the end, the only time a Lions Test match has ended in a scoreless draw, but the Lions had the satisfaction of providing the man of the match in a 20-year-old Richmond half-back not long out of Dulwich College: Pat Hancock.

The third and final historic Test was to give South Africa their first Test rubber. In the odd manner of South African team selection in those days, there was no national selection committee, and it was the union staging the match which was also responsible for selection. Nepotism was, therefore, fairly rife and, with 11

Western Province players and only four Transvaalers in the side, there are no prizes for guessing which province staged the match. Heatlie, who was once again captain of South Africa, once more brought out the Old Diocesan green jerseys, which had proved so lucky in the 1896 match against the British (South Africa had worn blue jerseys in the second Test).

There was a rumour the game might have to be postponed after torrential overnight rain left pools of water standing on the Newlands pitch, but the sun broke through the clouds as the two captains arrived. The conditions for what became known as 'the umbrella Test' should have favoured the Lions' forward power and limited the brilliant South African backs' opportunities to attack. But even in the mud bath, Loubser, van Renen and Krige were magnificent. Skrimshire got over for the Lions just before the whistle, but it was ruled out for a forward pass and there was still no score at half-time. The second half saw South Africa overcoming their opponents' forward skill at dribbling the ball, and they scored when they moved the ball to their left wing, Joe Barry, who plunged through the water for an unconverted try in the corner. Amid huge excitement, South Africa kept up the pressure and pressed home their superiority when Tommy Hobson made the crucial break before handing on to Alec Reid, a forward who remarkably eluded three defenders. According to the Lions, the defenders stood still because they believed that Hobson's pass was well forward. Few close games are without controversy, but the consensus was that South Africa deserved their win and their first Test series.

The home side included Hugh Ferris at scrum-half. He had been capped by Ireland against Wales in 1901 and had played alongside Lions tourist Ian Davidson. Another South African debutant was Paul Roos, who three years later would captain the first Springbok touring team in the UK. It was a momentous moment in South African rugby, their first Test series victory, and from that moment on they would always wear green.

The next British tour to South Africa was not until 1910, by which time the name 'Springboks' had become firmly established and was to gain respect wherever the game was played. Although there are other stories about how the Springbok name came into existence, the authenticity of a letter by J.C. Carden, the tour manager of the 1906 tour, is undeniable. He states in the letter to Ivor Difford:

The fact is that the Springbok, as a badge, existed when my team left South Africa, and here is proof positive. We landed at Southampton on the evening of 20 September 1906 and, from the Daily Mail *of 20 September, I culled this paragraph: 'The team's colours will be myrtle green jerseys with gold collar. They will wear dark blue shorts and dark stockings and the jerseys will have embroidered, in mouse silk on the left breast, a Springbok, a small African antelope, which is as typical of Africa as the kangaroo is of Australia.'*

Carden continues:

As to the adoption of the name. No uniforms or blazers had been provided and we were a motley turn-out at practice in Richmond. That evening I talked with Paul Roos, the captain, and Carolin, and pointed out that the witty London Press would

▲ Paul Roos – who would come to be known as Oom Polla. Afrikaans for 'Uncle Polla' – made his debut for South Africa during the 1903 tour. He would go on to captain the Springboks' iconic 1906 tour of Britain

invent some funny name for us if we did not invent one ourselves. We thereupon agreed to call ourselves the Springboks and to tell pressmen that we desired to be so named. I remember this distinctly, for Paul [Roos] reminded us that Springbokken was the correct plural.

However, the Daily Mail, *after our first practice, called us the Springboks and the name stuck. I at once ordered the dark green, gold edged blazers and still have the first Springbok badge that was made.*

RESULTS OF THE 1903 BRITISH TEAM IN SOUTH AFRICA

P 22 W 11 D 3 L 8 F 231 A 138

Western Province (Country)	L	7–13	Pretoria	W	15–3	
Western Province (Town)	L	3–12	Pietermaritzburg	W	15–0	
Western Province	L	4–8	Durban	W	22–0	
Port Elizabeth	W	15–0	Witwatersrand	W	12–0	
Eastern Province	W	12–0	Transvaal	L	4–14	
Grahamstown	W	28–7	South Africa (Johannesburg)	D	10–10	
King Williams Town	W	37–3	Orange River Colony	W	17–16	
East London	W	7–5	Griqualand West	W	11–5	
Griqualand West	L	0–11	South Africa (Kimberley)	D	0–0	
Griqualand West	L	6–8	Western Province	D	3–3	
Transvaal	L	3–12	South Africa (Cape Town)	L	0–8	

MARK MORRISON'S 1903 BRITISH TEAM

FULL-BACK

E.M. Harrison	Guy's Hospital	

THREE-QUARTERS

G.F. Collett	Gloucester	
I.G. Davidson	North of Ireland	Ireland
A.E. Hind	Leicester	
R.T. Skrimshire	Newport	Wales
E.F. Walker	Lennox	

HALF-BACKS

J.I. Gillespie	Edinburgh Academicals	Scotland
L.L. Greig	United Services	Scotland
P.S. Hancock	Richmond	
R.M. Neill	Edinburgh Academicals	Scotland

FORWARDS

D.R. Bedell-Sivright	Cambridge University	Scotland
W.T. Cave	Cambridge University	
T.A. Gibson	Cambridge University	
J.C. Hosack	Edinburgh Wanderers	
M.C. Morrison (capt.)	Royal High School FP	Scotland
W.P. Scott	West of Scotland	Scotland
R.S. Smyth	Dublin University	Ireland
F.M. Stout	Richmond	England
A. Tedford	Malone	Ireland
James Wallace	Wanderers	Ireland
Joseph Wallace	Wanderers	Ireland

1904
BACK DOWN UNDER

1904 TOUR KIT

Captain: David Bedell-Sivright (West of Scotland and Scotland)
Squad Size: 24
Manager: Arthur O'Brien (New Zealand)

Tour Record:	P 19	W 16	D 1	L 2	F 287	A 84
In Australia:	P 14	W 14	D 0	L 0	F 265	A 51
Test Series (Aus):	P 3	W 3	D 0	L 0		
In New Zealand:	P 5	W 2	D 1	L 2	F 22	A 33
Test (NZ):	P 1	W 0	D 0	L 1		

Just imagine it: a Lions team returns from a 22-match, three-Test tour of South Africa in September of one year and then heads off again eight months later to Australia and New Zealand to play a further 19 games and four Tests. And only one man straddled the two tours: David 'Darkie' Bedell-Sivright.

Apparently Bedell-Sivright was a man after my own heart, being a rough handful as a player. He was one of the first in a long line of Scottish forwards to master the art of wing-forward play and had the reputation of breaking up opposing teams with his marauding spoiling. He was the Douglas Elliot or John Jeffrey of his day. He played in four Varsity matches for Cambridge and 22 internationals for Scotland between 1900 and 1908, and was one of the best forwards produced by the British Isles in the first decade of the twentieth century.

Bedell-Sivright holds the distinction of being the only Scot ever to play in three Triple Crown-winning sides (1901, 1903 and 1907) and was still only 23 when he led the Lions down under. It is alleged that one night, following some riotous celebrations after an international, he rugby tackled a carthorse in Edinburgh's Princes Street. He is also alleged to have lain down on the cable tram rails in the Scottish capital and held up traffic for an hour, with no policeman being foolhardy enough to disturb him for as well as being captain of the Scottish rugby team, he was also a good enough boxer to have become the Scottish Amateur Heavyweight Champion in 1909.

He played his one and only Test for the Lions in Australia in 1904, leading his side to a convincing 17–0 victory in Sydney, and was at the centre of one of the most contentious incidents in Lions history at the Newcastle Cricket Ground on 6 July 1904.

Captaining the tourists against a Northern Districts team, Bedell-Sivright took the unprecedented step of leading his team off the pitch after the referee, Hugh Dolan, had dismissed Lions forward Denys Dobson (Oxford University and England) for allegedly addressing an obscene remark to him after awarding two free kicks to the

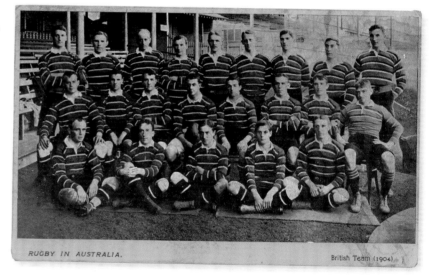

RUGBY IN AUSTRALIA. British Team (1904)

▲ The 1904 Lions, captained by the imposing Bedell–Sivright (middle row, fourth from left), dominated proceedings in Australia but narrowly lost to New Zealand in the final Test of the tour

home side. In fact, Dobson had merely said to the referee, 'What the devil was that for?' The Lions players were off the field for a full 20 minutes, during which time a discussion was held involving Bedell-Sivright, his vice-captain Teddy Morgan and the referee. This is how the *Sydney Morning Herald* reported the incident: 'After a lapse of about ten minutes Sivright, the English captain, and Morgan, the vice-captain, walked across from the British quarters and conferred with the referee. The Britishers were willing to continue the game but insisted on Dobson being allowed to play. The referee, however, held to his decision stating he would not officiate if Dobson were allowed on the ground. The British captain and his lieutenant returned to the dressing-room and it seemed as if the game had ended, but after a delay of fully 20 minutes the Britishers returned without Dobson and resumed the game with 13 men. They were greeted with a ringing cheer.'

The Lions, who were down to 13 men at this stage, having earlier lost Fred Jowett through injury, went on to win the game 17–3. After the match, Bedell-Sivright claimed that he regarded the referee's decision as a reflection on the personal character of the whole team. Dobson later denied the offence and claimed it was a case of mistaken identity and that Mr Nolan had had his back to him at the time. At a New South Wales Rugby Union disciplinary hearing Dobson was cleared of the charge of using indecent language, but found guilty of using an improper expression and suffered no further penalty.

Dobson never played international rugby again after the tour, but he did rather unfortunately hit the headlines once more in his life. Working for the Colonial Service in Ngama, Nyasaland, in 1916, he was killed by a charging rhinoceros. He was 35. It is alleged that when news of his death reached an old lecturer from either Cheltenham College or Oxford University, he reportedly said, 'He always had a weak hand off.'

The captain stayed on in Australia after the tour and didn't return to England until May 1905. He visited Japan between December 1904 and May 1905 and returned to Sydney from Hong Kong on the *Empire*, whose on-board doctor was none other than his Lions teammate Sid Crowther. Bedell-Sivright also figured in a friendly game in May 1905, turning out alongside Blair Swannell for the Fleet against North Sydney, scoring a try in a 14–11 defeat at the Sydney Sports Ground. In June 1905 he was proposed as a referee for Metropolitan matches in Sydney with an aim to end the controversy over officials in those hotly contested games. He left Sydney on Saturday, 3 June on the *Ormuz*.

Having studied medicine at Cambridge and Edinburgh universities, Bedell-Sivright became a surgeon, and he served with the Medical Unit of the Royal Naval Division stationed at Gallipoli during the Dardanelles Campaign of the First World War. After a period onshore in the trenches while serving at an advanced dressing station, he was bitten by an unidentified insect. He complained of being fatigued

▼ Tour captain David Bedell-Sivright's tour cap, now part of the Priory Collection

and was taken offshore and transferred to the hospital ship HMHS *Dunluce Castle*. Two days later, on 5 September, he died of septicaemia and was buried at sea. He was only 34.

Three other members of the 1904 tour party, Sidney Crowther, Ron Rogers and Blair Swannell, also died in the First World War. John Leaper Fisher was injured during the landings in Gallipoli while fighting in the AIF 9th Infantry Battalion.

The unfortunate Dobson, of Devon and England, was one of only four other capped forwards in the squad. The others were Reg Edwards, of Malone and Ireland, and Sid Bevan, of Swansea and Wales, who had won their only caps playing against each other in Dublin three months before the tour, and the redoubtable Arthur 'Boxer' Harding, of London Welsh and Wales fame. (More on 'Boxer' in the 1908 tour section, when he captained the 'Anglo-Welsh' team to Australia and New Zealand.) Of the other eight forwards in the squad, none of them were generally regarded as being above club standard and none of them went on to play for their countries on their return. Two of them, Malone's Charlie Patterson and Hull & East Riding's Burnett Massey, only played three games each on tour. The RFU, as organisers of the tour, had plenty of top-class candidates for their back line, but were obviously struggling for forwards. In fact, they even advertised for players in *The Times*. This is the extract from a 'Sports in Brief' story from the paper on Saturday, 9 April 1904:

As it has been decided that the Rugby Football team visiting Australia this summer shall also play matches in New Zealand, the committee think it desirable to add to the number of forwards. Before making the final selection from the names before them, the committee wish to give other players, in the new circumstances, an opportunity of sending in their names if they wish to undertake the trip. The team will leave London on May 11, arriving home again about October 24. Any forwards wishing to join the team should communicate with Mr G.W McArthur, 13, Silk Street, Cripplegate, E.C before Wednesday, April 13.

Mr McArthur was joined on the selection panel by 1896 Lions tour captain Johnny Hammond; George Harnett, an international referee who went on to manage the 1908 Lions tour; and Mr N. Spicer. By this stage, 17 players had been named as having agreed to tour. On Tuesday, 19 April, following a final selection meeting at the City Liberal Club the previous evening, a squad of 23 was named. Included were the uncapped Clifton and Gloucestershire three-quarter Edward Watkins-Baker, the uncapped Devon forward Tom Kelly and the uncapped London Welsh and Newport forward Jack Jenkins. None of them went on the tour, but three more forwards, Arthur 'Boxer' Harding, the 1899 Lions tourist and Northampton player Blair Swannell and Streatham's uncapped John Sharland, did make the trip. Swansea wing Fred Jowett took the place of Watkins-Baker.

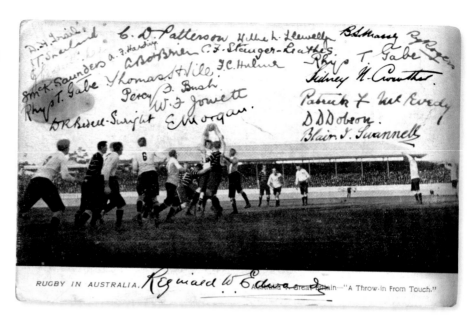

▲ A postcard showing the 1904 Lions in action in Australia and signed by the squad

Jowett became the fourth Welsh international three-quarter in the party, joining household names such as Willie Llewellyn, Rhys Gabe and Teddy Morgan. Half-backs Tommy Vile and Percy Bush took the Welsh contingent behind the scrum up to six out of 11 players. Many of these were the players who carried Wales through their first 'Golden Era', when they won the international championship five times in seven seasons.

I knew four of these old players – Rhys Gabe, Tommy Vile, Teddy Morgan and little Willie Llewellyn – and often enjoyed long discussions with them concerning this tour. I was always surprised at how little we differed in our views of our particular eras for, apart from the differences resulting from technological progress in areas such as travel, accommodation and facilities, our personal experiences of the marvellous hospitality we received, and the adventure of it all, tallied exactly.

This was the first tour on which Wales had a strong representation and all bar Jowett, who was kept out of the reckoning by fellow countrymen Llewellyn and Morgan, played in the Tests. In fact, seven of the remaining eight featured in all four internationals, and Vile, just short of his 22nd birthday, launched his remarkable Test career by playing in the last two games against Australia and the one-off match with New Zealand. He finally brought down the curtain on his international career at the age of 37 when he captained Wales against Scotland in 1921. He then went on to become an international referee of high repute, controlling 13 Tests between 1923 and 1931.

Bush became the darling of the crowds in Australia and was the forerunner of a stream of Welsh outside-halves who have graced the Lions No. 10 jersey. Where he led in 1904, Tuan Jones (1908), Cliff Morgan (1955), David Watkins (1966), Barry John (1971), Phil Bennett (1974, 1977), Gareth Davies (1980) and Stephen Jones (2005, 2009) have all followed.

The rugby correspondent of the *Capricornian* weekly newspaper in Rockhampton obviously loved watching Bush, as you can tell from his report of the second Test in Brisbane, which the Lions won 17–3 with the Cardiff wizard contributing a try, a goal from a mark and a drop goal:

The champion of the visitors is Percy Bush, who although he has never before represented England, is considered by many good judges to be far ahead of any other English back player in this team or the last one that visited Australia under the Rev. M Mullineux. When Bush gets the leather from the half-back (Vile) he does not immediately pass the ball, but he begins propping and dodging from side to side and the local men are unable to hold him. When he gets clear he can run like a deer, and sometimes he runs clean away from comrades and opponents alike, and generally ends up by scoring himself. Of course, he is a very selfish player, but when he can finish up by scoring a try or kicking a field goal well, his selfishness is readily excused. He is always taking flying drops at goal, and twice on Saturday he sent the ball straight between the posts, and on another occasion the ball just struck the bar and bounced back into the field of play from a kick about midfield. Without Bush I don't think the Britishers would be nearly the strong team they are, for he opens up all the work for the backs and always beats a couple of men before he gets rid of the ball.

Bush played in 18 of the 19 games, missing one outing in Australia, and scored in all bar four games. In Australia, he top scored in the Test series, picking up 20 of the Lions' 50 points, and ended the tour with 101 points, including 11 tries. Both totals were the best of all the Lions. Seventeen months after making his Lions debut, Bush

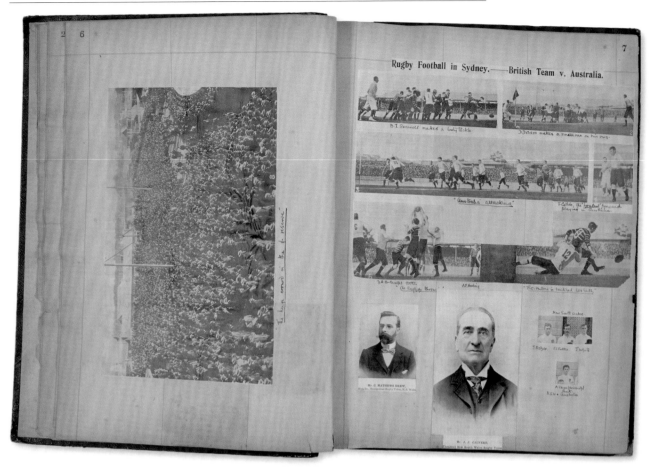

▲ Scrapbook from the tour showcasing the Lions' 17–0 triumph over Australia in Sydney courtesy of tries from tour 'darling' Percy Bush and Willie Llewellyn

made the first of his eight appearances for Wales, gaining revenge for the 9–3 defeat against the All Blacks in Wellington as Wales became the only team to beat Dave Gallaher's men at Cardiff Arms Park. Morgan scored the only points of that game in 1905 with his try, and Harding and Gabe joined him in the most famous of Welsh victories.

If Bush was the 'darling' in the Lions squad, then Swannell was definitely the 'demon'. His rough, tough approach even shocked a few of the Aussies and his fists were in evidence in a number of games. As a veteran of the last trip to Australia, maybe he knew what to expect. In all, he made 28 appearances for the Lions in Australia on the two tours and won 26 of them. He didn't make the first Test in 1899, but played and won the next three. He then helped the Lions win the series 3–0 in 1904 and still holds the record with P.F. 'Froude' Hancock with the most Test victories by a Lion with those six against the Wallabies. Even more amazing, Swannell settled in Sydney, where he became a player and coach, and he actually played for Australia on their first fully representative tour of New Zealand in 1905. He played in six of the seven games on tour and became a 'dual-international' on 2 September 1905 in a 14–3 defeat in Dunedin against an All Blacks side missing the players who were ready to undertake their tour of the UK and Ireland that same month.

Renowned the world over for his unsavoury play and unusual hygiene, Swannell always turned up to club matches in a filthy, once-white sweater, with badges and dates of all countries he had represented on it. His prized possession was an also once-white pair of football breeches, which he refused to wash, and which he wore in every match. A veteran of the Second Boer War, he enlisted with the Australian Infantry when the First World War broke out, was commissioned as an officer,

became a major in the 1st Battalion, Australian Imperial Force, and was posted to Egypt. When the Gallipoli Campaign was launched in April 1915, Swannell's men were among the first to land, on 25 April. They became involved in heavy fighting for a small hill, known as 'Baby 700'. Early successes with the landings were followed by heavy losses and, as the Australian historian Charles Bean recounted, Swannell had a premonition of his own death: 'He realised that he would play this game as he had played Rugby Football – with his whole heart.' He died while kneeling up to show his men how to take better aim and was shot. He was awarded the MC and is remembered in the Australian War Museum in Canberra. He was 39.

Two other key members of the squad were the Guy's Hospital Kiwis, Arthur O'Brien and Pat McEvedy. Full-back Edward Montague Harrison had launched the Guy's touring tradition with the 1903 Lions squad, and O'Brien and McEvedy were among five medical students from Guy's in the 1904 party (Teddy Morgan, Stuart Saunders and David Trail were the others). O'Brien doubled as the tour manager and played in all four Tests, while McEvedy played in three Tests in 1904 and then another two in 1908, when he was one of four Guy's men on the tour.

Although he had trials for both England and Ireland and was an England reserve on many occasions, McEvedy never played international rugby in the UK or Ireland. He did, though, help Kent win the County Championship and steered Guy's to the United Hospitals Cup on a number of occasions. He qualified as a doctor in 1906 and practised in England until 1928, when he returned to New Zealand. His remarkable rugby career then took on a different guise as he became president of both the Wellington and New Zealand rugby unions.

On the field, there were 12 games in Australia to launch the tour, six in New Zealand and a final outing against New South Wales before heading home via New York on the *Campania*. It had been at the invitation of the New South Wales Union that the RFU had sent the team to Australia and six games were played at the Sydney Cricket Ground: three against New South Wales, two Tests and a game against a Metropolitan XV. Financially, it was a wise move because there were 135,000 fans at the six games at an average of more than 20,000 per game.

Despite having only arrived in Sydney on the Wednesday, the Lions opened their tour with a thumping 27–0 win over New South Wales, which included five tries. There were seven more tries, including a Bush hat-trick in game three against the same opposition, but the Metropolitan XV at least twice took the lead in the final outing before the first Test. Swannell would no doubt have warned his teammates of the perils of playing at the Sydney Cricket Ground, having witnessed the first Test played by Australia against the 1899 Lions. That was the Wallabies' debut international and their 13–3 win was a great way to start. Charlie White was the only playing survivor from that first meeting in the Aussie ranks, and it was to be his last Test and his seventh and final game against the Lions.

The home side had the better of the early exchanges and defended well with the wind at their backs. There were seven Queenslanders in the team who had not faced the Lions up to that point, but the rest had either played against the tourists or seen them in action. There was no score in the first half, and Bedell-Sivright, leading the Lions in his one and only Test on two tours with the team, must have said some stern words in the interval. Three second-half tries put the Lions in control and Bush added a trademark drop goal for good measure. The Lions were certainly helped by the fact Australia lost White with a broken rib just before half-time and had to play with 14 men throughout the second half.

DINNER IN HONOUR OF
THE BRITISH FOOTBALL TEAM.
COFFEE PALACE
WEDNESDAY, AUGUST 10, 1904.

"Much would have Moa"

With the first five games in New South Wales won, the Lions headed to Queensland and continued to rack up the points and victories ahead of the second Test at the Exhibition Ground in Brisbane. It was a similarly tight affair in the first half of the second Test, with the home side leading 3–0 thanks to a try from Bluey Burdon, but once again the Lions' back-line firepower carried them through as they ran in three tries to emerge victorious with another second-half burst of 17 points. Bush scored 11 of them to overtake Charlie Adamson's Lions Test record of ten in the fourth Test in Sydney in 1899. It was a record that stood until another Welshman, Lewis Jones, went through the card and scored 16 points in the first Test against the Wallabies back in Brisbane in 1950.

Teddy Morgan had taken over the captaincy from Bedell-Sivright in the Test matches, and he scored one of the four tries that wrapped up the series in Sydney with a 16–0 victory. It remains the only 3–0 clean sweep by the Lions in Australia to date. The Lions used 19 players and scored ten tries against one. All seemed well as they took their unbeaten record with them to New Zealand. There, however, it became a different story, particularly after Bedell-Sivright badly injured his leg in the opening game at Canterbury and did not play again until the final game of the tour back in Sydney.

New Zealand rugby was reaching its first peak and events took a rapid turn for the worse after the Lions' heady success in Australia. The British won the first game at Canterbury by a mere conversion and won the next against Otago in another tight game, before losing to New Zealand in Wellington, drawing at Taranaki and finally losing heavily to Auckland.

It was the beginning of that now familiar tale of annihilating New Zealand forward play wiping out the brilliance of British back play. The British were completely thrown by the New Zealand forward formation, which was to pack 2-3-2, and by a forward known as a 'rover', who never packed down and made a huge nuisance of himself in defence. This was to be abandoned after the acrimony of the 1930 Lions tour to New Zealand, when the law was changed to force them to put three men in the front row. The All Blacks also differed, as they do to this day, with having two five-eighths, a first and a second, as opposed to an outside-half and two centres. The theory was to get the ball to the wings by going through the same

▲ A menu from a celebratory dinner held in the tourists' honour at The Coffee Palace hotel in New Zealand, which depicts a Lions player facing off against a Kiwi while hauling a defeated Wallaby behind him

sequence of hands, and to work out moves to combat the loose forwards, whereas the old British system of a left and a right centre meant a change of position alongside the outside-half or once removed from him, dependent on whether you are going left or right. There is no difference, however, between a second five-eighth and a player picked as an inside-centre.

▲ The official programme from the Lions' 1904 Test against New Zealand at Wellington

It was the time when the vernacular of rugby was about invincibles and immortals, and certainly many famous names were beginning to emerge as rugby stars. Billy 'Carbine' Wallace was one of the first. He scored a career record of 379 points for New Zealand, which stood for 50 years, until bettered by Don Clarke.

Another was the mighty Dave Gallaher, a tremendous thinker concerning the game, who was to captain the 1905 team to Britain and so displease the crowds with his role as a destructive 'rover'. There was also Charlie Seeling, who was famous for his flying tackles and was regarded as one of the finest of all New Zealand forwards to visit the UK and Ireland.

The coach of the New Zealand team which beat Bedell-Sivright's side was another fine strategist, Jimmy Duncan, who was also to coach the 1905 All Blacks team which came to Britain and lost only one game. Like A.F. 'Oubaas' Markotter of South Africa and Adrian Stoop of England, he was among the great rugby innovators of the time, and it was he who devised the New Zealand five-eighth system.

There was terrific interest in the Test match, which drew 20,000 to Wellington's Athletic Park. The game was attended by the governor, the prime minister and most of the Ministers of the Crown, and New Zealand kicked off in perfect conditions. Wallace drew first blood with a penalty after half an hour, but Harding replied with one for the tourists to make it 3–3 at half-time. In the second period, the New Zealand forwards got well on top and Duncan McGregor scored two fine tries to make the final score 9–3. He was carried off shoulder high by the crowd who, amid scenes of intense excitement, had invaded the pitch.

Bedell-Sivright admitted that his team had been beaten by a better side, but thought that they were tired and out of sorts after all their travelling. On arrival in Auckland, both O'Brien and Trail had to be carried off the boat because of seasickness. He also suggested that the lavish New Zealand hospitality could have damaged their cause.

There was one final game back in Sydney, the third against New South Wales, before the squad headed home. The true toll of the tour showed in the final performance, as the Lions only won 5–0. But at least it kept alive their unbeaten record on Australian soil. They also left a favourable impression on their hosts, as the *Sydney Morning Herald* revealed on Friday, 2 September 1904:

The British footballers, who have been teaching our players how to put a bold face on defeat, have finished their programme and will shortly move on homewards. It is not too much to say that the visiting team has done a great deal to place football as it is known here in the category of scientific games. We have all seen and read much of the violence of footballers, and the comic papers have familiarised us with the spectacle of the umpire or referee safely ensconced in an armoured vehicle,

and, later, of such members of the rival teams as have escaped being carried to hospitals in ambulance wagons, limping slowly home in battered condition. Our British visitors have shown us that skill and success are far from being necessarily related to violence. They have shown the rugby game in its perfection, shown it as calling forth the highest power of the athlete in the avoidance of danger as well as in the overcoming of obstacles.

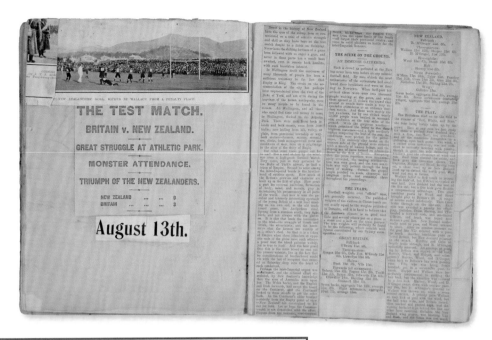

▲ Newspaper coverage of the final Test of the tour, which saw the All Blacks claim the spoils with a 9–3 victory. The report lauds the Lions' wholehearted performance and marvels at the game's 'monster attendance'

RESULTS OF THE 1904 BRITISH TEAM IN AUSTRALIA AND NEW ZEALAND

P 19 W 16 D 1 L 2 F 287 A 84

New South Wales	W	27–0	Australia (Brisbane)	W	17–3
Combined Western Districts	W	21–6	New England	W	26–9
New South Wales	W	29–6	Australia (Sydney)	W	16–0
Metropolitan Union	W	19–6	South Canterbury, Canterbury &	W	5–3
Australia (Sydney)	W	17–0	West Coast		
Northern Districts	W	17–3	Otago-Southland	W	14–8
Queensland	W	24–5	New Zealand (Wellington)	L	3–9
Metropolitan Union	W	17–3	Taranaki, Ranganui & Manawatu	D	0–0
Queensland	W	18–7	Auckland	L	0–13
Toowoomba	W	12–3	New South Wales	W	5–0

DAVID BEDELL-SIVRIGHT'S 1904 BRITISH TEAM

FULL-BACKS

C.F. Stanger-Leathes	Northern	

THREE-QUARTERS

J.L. Fisher	Hull & East Riding	
R.T. Gabe	Cardiff	Wales
W.F. Jowett	Swansea	Wales
W.M. Llewellyn	Newport	Wales
P.F. McEvedy	Guy's Hospital	
E.T. Morgan	Guy's Hospital	Wales
A.B. O'Brien	Guy's Hospital	

HALF-BACKS

P.F. Bush	Cardiff	
F.C. Hulme	Birkenhead Park	England
T.H. Vile	Newport	

FORWARDS

D.R. B'll-Sivright (capt.)	West of Scotland	Scotland
T.S. Bevan	Swansea	Wales
S.N. Crowther	Lennox	
D.D. Dobson	Newton Abbott and Devon	England
R.W. Edwards	Malone	Ireland
A.F. Harding	London Welsh	Wales
B.S. Massey	Hull & East Riding	
C.D. Patterson	Malone	
R.J. Rogers	Bath	
S.M. Saunders	Guy's Hospital	
J.T. Sharland	Streatham	
B.I. Swannell	Northampton	
D.H. Trail	Guy's Hospital	

1908
ANGLO AGONY

1908 TOUR KIT

Captain: Arthur Harding (London Welsh and Wales)
Squad Size: 28
Manager: George Harnett (England)

Tour Record:	P 26	W 16	D 1	L 9	F 313	A 201
In New Zealand:	P 17	W 9	D 1	L 7	F 184	A 153
Test Series (NZ):	P 3	W 0	D 1	L 2		
In Australia:	P 9	W 7	D 0	L 2	F 129	A 48

In 1908, Asquith became prime minister, and men and women over 70 in Britain began to draw the first old age pensions. In America, Jack Johnson KO'd Tommy Burns to become the first black heavyweight champion of the world. In rugby, Wales became the first team to complete a Grand Slam. An international conference in Switzerland banned night work for children under 14 years old. Picasso held a banquet for Henri Rousseau in Paris, and anti-British articles in the *Daily Telegraph* by the Kaiser caused consternation. The Model-T Ford was built in Detroit, bringing transport to the masses.

Similarly, sporting teams were becoming more mobile. The 1908 team was in no sense a fully representative British side and, at first, I was reluctant to include it in a book about the Lions. However, some of those early 'pioneer' teams were also hardly representative and, after all, Arthur 'Boxer' Harding's players did play three Tests against the All Blacks, which was sufficient for them to qualify. It was the first and last Anglo-Welsh team to go on tour, and the reasoning behind the refusal of the Scottish and Irish unions to grant permission for their players to join the trip was wrapped up in the fight against professionalism and the Northern Union. This tour had a hint of evangelism about it, in that the RFU believed it could help to stem the tide of rugby league that they felt was threatening to both engulf the colonies and destabilise the amateur rugby code at home. Speaking at the Special General Meeting of the London Society of Referees on Thursday, 19 March 1908, George Harnett drew attention to the difficulties which had been met in organising the tour. He pointedly told the referees, 'The Rugby Union in sending out the team was merely carrying out its mission for the preservation of amateurism. In the present conditions of the game in the colonies the visit of a British Rugby team was quite imperative.'

The 1905 tour to the UK and Ireland by Dave Gallaher's All Blacks had been an outstanding success, both on and off the field, netting huge profits. Likewise, the 1906 tour by South Africa proved equally popular: it yielded a £7,000 profit, and £6,000 was sent to South Africa for the development of the game there. In 1907, another New Zealand team had headed north – but this time to play rugby league.

There were a number of Gallaher's men in the professional outfit, and the Aussies were to follow suit in 1908. The RFU had already suffered at the end of the nineteenth century when the Northern Union broke away to form the professional rugby league code. In Australia, rugby league began as a rebel football competition set up in open defiance of the New South Wales Rugby Union. Rugby union was the dominant code of football in New South Wales and Queensland in the 1890s,

AUSTRALIAN R.F.U. 1908-1909. "(WALLABIES.)"

GRIFFEN. PRENTICE. CARROLL. McCABE. STEVINSON. CARMICHAEL.
WICKHAM. FLANAGAN. McMURTRIE. BURGE. McCUE. MIDDLETON SMITH RICHARDS ROW. CRAIG.
PARKINSON McGUVATT. MANDIBLE. McINTYRE. D'MORAN(Capt) McMAHON(Mgr) WOOD(Vice Capt) BARNETT. HAMMOND. RUSSELL.
HICKEY McARTHUR DIX. DALY.

◄ The famous Wallabies side that toured the UK in 1908–09. Alarm bells began ringing within the RFU when several of the squad's players switched codes to rugby league

capable of attracting tens of thousands of fans to interstate and touring matches. But then the same discontent that had led to the 'great schism' in the north of England began to spread through the ranks of players in Australia, with the by now familiar call for 'broken time' payments and insurance against injury.

Those first Australian touring teams in both codes, rugby union and rugby league, arrived in the UK at the same time in 1908. Herbert Moran's inaugural Wallabies played 39 matches on their trip, while the Kangaroos played 45 games. The Wallabies played their first game against Devon on 29 September, before the Lions had returned home following their final fixture in Brisbane on 2 September. The Wallabies became Olympic gold medallists on their tour and accepted a challenge to play against the Kangaroos on their return home. It was the ultimate clash between the two rugby codes and a huge boost for the professionals, even though the four-match series ended in a 2–2 draw. The majority of the Wallabies' leading players, however, defected to rugby league, giving the new code a massive shot in the arm.

Maybe the English had been right all along, and their plan to give their colonial cousins some quality opposition was the right thing to do. Rugby league quickly took a stranglehold on the Aussie public and remains the dominant code in that part of the world. Nothing has ever threatened the exalted status of rugby union in New Zealand.

In *The Times* on 21 December 1907, under the heading 'The Rugby Unions and Professionalism', the paper tackled the issues that threatened to end English hopes of sending a team overseas:

The object of the meeting of the International Board, held in London about a fortnight ago, was to discuss the question of tours by colonial sides in Britain, and of British sides in the Colonies. This question must be described as merely one of the many issues raised by the wider problem of professionalism in rugby union football. A team of New Zealand players are at present engaged in a series of matches with 'professional' clubs under the control of the Northern Football Union. There is every reason to believe that the said players were tempted to undertake the tour by the large profit made by the New Zealand amateur team that visited this country in 1905. The profits of the tour in 1905 went, of course, to the New Zealand Rugby Union and were devoted, or are in the process of being devoted, by that body to purposes connected with the advancement of the game in New Zealand. In the case of the present tour, however, the profits are to be divided among the players, who, for the sake of a large, immediate and still larger prospective pecuniary reward, were prepared to suffer disqualification as amateurs – a sentence of excommunication which has now been pronounced against them by the New Zealand Union. In addition to this open secession from amateurism by a section of the New Zealand players, there have been other happenings of an extremely significant character both in this country and in Australia. Certain statements that were made by an official of a Welsh club as to the prevalence of 'veiled professionalism' in the Principality led the Welsh Union to appoint a commission of enquiry. The commissioners found that many of the charges had been proved. The first result was that certain clubs and certain players were permanently suspended. Further consequences were open revolt on the part of these clubs, the formation of Northern Union clubs, and a recrudescence of Northern Union activity in Wales directed partly towards the securing of the services of prominent Welsh players by large payments for North of England 'professional' teams, and partly towards the winning over of Wales to the Northern Union, or professional banner...

▲ A 1908 tour cap, currently in the possession of the World Rugby Museum

In face of these facts, it is only natural to find the unions are very far from being agreed as to the steps which should be taken to arrest the professional movement and defeat the schemes of the Northern Union. At present, it is true, their differences are confined to questions of colonial policy...

The English Union are desirous of sending out to New Zealand a representative British side to play a series of matches in that colony, while they are also of the opinion that an Australian side should be invited to visit England next season. The English Union hold that such tours 'popularize' the game in this country and the colonies, and are better calculated to arrest the Northern Union advance than any measures which could be adopted. The Scottish and Irish Unions, on the other hand, maintain that the financial success of the New Zealand tour of 1905, and of the South African tour of 1906, is the indirect cause of the recrudescence of the

professional peril. The attitude of the two unions is at present one of passive resistance. They have declined to grant permission to players under their jurisdiction to take part in the proposed tour in New Zealand, while they have absolutely refused to join in the invitation to an Australian team to visit this country, or to give any promise that they will support or countenance the tour, if the invitation be given by the English Union and accepted by the Australian Unions...

The English Union admit that the 'big gates' secured by the colonial sides in 1905 and 1906 are the indirect cause of the present trouble, but they hold that the ground lost can be regained, or at least that further encroachment can be checked and new adherents won over by the colonial tours.

The British Rugby Football Team 1907 + 8
New Zealand + Australian Tour
Taken at Plymouth on Board S.S. Athenic

▲ The squad pictured at Plymouth prior to their departure on the Athenic

Despite the reluctance of the Scots and Irish unions to provide players, the tour did go ahead and the team was described as an 'Anglo-Welsh' side. Wales had completed the first Grand Slam by adding a victory over the French, in their first fixture against them, to a Triple Crown. There were 12 Welshmen, 15 Englishmen and one New Zealander, the Guy's Hospital doctor Pat McEvedy, in the 28-strong squad, which was led by London Welsh forward Arthur 'Boxer' Harding.

Harding and McEvedy were the only survivors from the 1904 tour, and both later moved to New Zealand and died there. Although born in England, Harding played 20 times for Wales in a Test career that started in 1908 and lasted four years. Included in his list of successes with Wales were Triple Crowns in 1902, 1905 and 1908, a Grand Slam in 1908 and a win over New Zealand in 1905. He captained London Welsh and Middlesex and decided to emigrate to New Zealand in 1910, where he lived until he passed away in 1947.

The lack of Scottish and Irish players robbed the tourists of a number of possible candidates, such as half-back Louis Greig, who had captained Scotland during the 1908 championship campaign and who was a Lion in 1903. Arthur Tedford had joined Greig in the 1903 squad in South Africa and was still in the Irish pack, while the 1910 Lions skipper Tom Smyth was playing for Ireland. Only 11 of the 28 tourists had played for their country, although several were to be capped later. *The Times* announced a squad of 27 on Friday, 6 March, with 13 backs and 14 forwards. Not included at that stage were James Phillips 'Tuan' Jones or the Coventry and England forward, and workhouse master, Bill Oldham. T. Wilson, the Carlisle and Cumberland player, was named in *The Times*, but didn't tour. The Sydney Morning Herald on Friday, 1 May 1908, explained Wilson's situation:

▲ A scrapbook containing newspaper clippings detailing the squad's departure on board the Athenic and postcards picked up by the tourists following their arrival in New Zealand

THE WILSON SUSPENSION

The committee of the Rugby Union met shortly before latest files left England to decide the course of action to be taken in regard to the suspension of T. Wilson, the Cumberland and Carlisle forward. It was decided that in view of Mr. Wilson's statement that he would certainly not go to New Zealand without permission of the union, thereby submitting himself to the jurisdiction of the Scottish union, the committee would decline to include him in the team going out to New Zealand. Further, that as Wilson was not suspended by the Scottish union owing to rough play, misbehaviour, or breach of any professional laws, the provisional suspension passed by the emergency committee of the Rugby Union be rescinded. G.R. Hind (Kent) took the place of Wilson in the team for New Zealand.

Guy Hind took the Guy's Hospital contingent up to four, and he went on to play in two of the three Tests in New Zealand. He was eventually capped by England in 1910. Two other hitherto uncapped forwards, Fred Jackson and Tom Smith, both of whom played for Leicester, never got to play for England. Jackson remains one of rugby's great enigmas and found himself forced out of the tour. In the Lions tour brochure it was stated he had been born in Camborne and educated at the Camborne College of Mines. The college is unable to substantiate this, and even Jackson's now distant relatives have little or no clue about his real identity. The *Manchester Evening News* insisted that he was a former professional with the Swinton rugby league club and that he had been born in Wales under the name of Gape or Gabe and educated at Monmouth. This has never been proved either. The *Sporting Life*, in their report of the annual meeting of the RFU in June 1908, was at

least able to provide some insight into why Jackson had been suspended by the RFU and subsequently withdrawn from the tour after playing in six matches: 'Mr. Godfrey, on behalf of Mr. Byrne, produced an affidavit showing that Jackson (Leicester), now with the English team in New Zealand, signed a professional form for Swinton in 1901–2; that he played for that club for £40 down and a weekly wage, and had since been identified by the parties to the affidavit as Jackson, the Leicester and Cornish forward.'

Harnett received the missive from the RFU telling him to banish Jackson on the eve of the second Test in Wellington. A reporter from the *Wellington Evening Post* broke the news to both Harnett and Harding on Thursday, 25 June. The formal telegram arrived later in the day, and Jackson left New Zealand on Friday, despite having been named in an 18-man squad for the game on Saturday. He was a huge loss to the squad, being among the best forwards, along with Edgar Morgan. Jackson missed out on a 3–3 draw in the second Test. His suspension also cost him an Olympic silver medal: having spearheaded Cornwall's march to the County Championship title in the 1907–08 season, Jackson was a shoo-in for the team that was chosen to face Australia in the Olympic Games rugby final in London in October.

Jackson only got as far as Sydney on his return journey before asking to cash in his ticket and return to New Zealand. He arrived back in Wellington and launched a new life after the Lions had returned home. Banned from rugby union, he turned to rugby league and went on to captain Auckland against the 1910 British touring team. He then played for the Kiwis in their first Test match on home soil, kicking four goals in a 52–20 defeat to the British side. Finally reinstated in rugby union, Jackson became a selector for the East Coast Union. Having married a 'native' girl, he had two sons, Everard and Selwyn. Everard won six caps for the All Blacks from 1936 to 1938 and Selwyn represented Hawkes Bay and New Zealand Maoris. An adopted brother, Tututaonga Wirepa, played for the Maoris in the 1938–39 season, while Everard's son, Syd, a prominent Maori activist, played for Wellington in 1959–60 and in a Maori trial.

While Jackson had protested his innocence, his cause wasn't helped when the RFU professionalised his Leicester teammate Smith in October 1908 and opened an investigation into the club over alleged payments to players.

Even though Jackson departed the tour, there was still a strong Cornish flavour left in the squad, with England internationals John Jackett and James 'Maffer' Davey. The 30-year-old Jackett became one of the stars of the side and on his debut in the opening game against Wairarapa-Bush he made a massive impact. This is how the United Press Association reporter summed up his contribution in the 17–3 victory in Masterton that kept a 6,000 crowd, who produced a record £350 gate, thoroughly entertained:

But the player who was most in evidence all through the game was the full back, Jackett, whose conception of the duties of that position was so novel as to entirely take the fancy of the crowd and establish him as a favourite. He is a cool, active, and lithe player, who takes the ball with accuracy, kicks well, and has the faculty of extricating himself happily from difficulties. He was as often up among the forwards as in his position, and now and then he took charge of the game all to himself, dodging, running, and passing in a style that many avowed three-quarter backs might envy, and also copy with advantage. No doubt he will find it necessary to be less exuberant in most of his matches, but he was undeniably a bright and amusing feature of to-day's game.

Jackett went on to play in 16 of the 26 games, including all three Tests, but eventually turned professional with Dewsbury in 1911 and helped them to win the Challenge Cup a year later, at the age of 33.

The Jones boys, John Phillips 'Jack' and James Phillips 'Tuan', became the first Welsh brothers to tour together with the Lions and the third set to play in a Test together, following in the footsteps of the Bromets and Magees. William Llewellyn Morgan followed in the footsteps of his brother, 'Teddy', who had been vice-captain of the 1904 Lions, by playing in a Test. It was to be the first of two tours for 'Jack' Jones, who confusingly was branded 'Ponty' Jones by the New Zealand fans, presumably because he played for Pontypool; however, back home another Jones brother, David Phillips, who also played for Wales, was also known as 'Ponty'. The two touring Joneses learned their rugby at that great nursery, Christ College, Brecon, and were among six ex-pupils in the 1908 tour party. The others were Harding, John Charles Meredith Dyke, John Frederick 'Jack' Williams and William Llewellyn Morgan, all of whom, bar Dyke, played in the third Test. Coming on top of Edward Morgan, William's brother, and Willie Llewellyn, who had toured with the 1904 Lions, the school made a huge contribution not only to Welsh rugby, but also to the Lions. (There was to be another Old Breconian in the 1983 Lions tour to New Zealand: Robert Ackerman.)

The tourists departed from London on the *Athenic* on 3 April and docked in Wellington on 17 May. They played 17 games in New Zealand, including the first three-Test series in that country, and then a further nine games in Australia. For the first time, the New Zealand stage of the tour became larger and more significant than the Australian section. This was strange, because rugby was popular in Sydney in 1907, with crowds of over 45,000 going to see the touring All Blacks. Somehow, this tour heralded the beginning of the decline of Australia as a rugby world force over the next 70 years. Not until the 1980s did the Aussies finally stop the decline and reorganise themselves into a side capable of consistently beating the All Blacks, taking the Grand Slam against the four home nations in 1984 and winning the World Cup in 1991.

The Lions players were given a daily allowance of two shillings (10p) per day out-of-pocket expenses, which were paid every fortnight, although with a shilling deducted for training expenses. They played in red jerseys with broad white hoops, a combination of English and Welsh colours, and made up their own 'war cry' for the tour. This was first heard on arrival in Wellington at the official welcoming ceremony in the Town Hall. It certainly impressed the *Evening Post* reporter, who wrote:

The British team of Rugby footballers which landed here yesterday has brought its 'stunt' with it, as part of the usual accessories to the game. The cry was given in the Town Hall last evening, a conclusion of the official reception of the Britishers, and it was listened to with more delight than comprehension by the football followers there assembled. The chief reason of this was the repetition of three Welsh words, 'Cymru am byth,' which may be translated as 'Wales on top' or 'Wales forever.' The complete 'stunt' runs: 'Rule Britannia, Cymru am byth, hip, hip, hurrah,' but the words are reiterated to an extent that makes them suggest the singing of an anthem.

It was never a serious contender to the haka, and neither were the tourists good enough to match the All Blacks. It may have been a few years on from the All Blacks' great tour of 1905, but there were still a dozen of that tour party who figured in the Test series against the Lions, six of who played in the decisive victories in the first

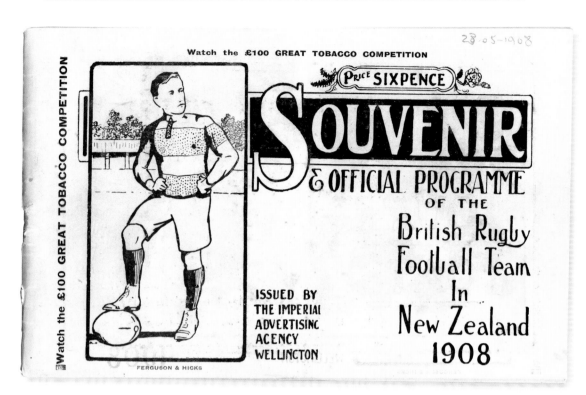

Watch the £100 GREAT TOBACCO COMPETITION

PRICE SIXPENCE

SOUVENIR
& OFFICIAL PROGRAMME
OF THE
British Rugby
Football Team
In
New Zealand
1908

ISSUED BY
THE IMPERIAL
ADVERTISING
AGENCY
WELLINGTON

FERGUSON & HICKS

28·05·1908

◄ The programme
from the second Test
against New Zealand
at Wellington, which
saw the Lions secure
a hard-earned draw

and third internationals. In all three Tests, Harding's men had to contend with outside-half Jimmy Hunter, who was famous for his sniping runs and his speciality of walking in tries once he had broken the defence. In 1905, he scored an all-time record of 44 tries on a single tour. The All Blacks also had the great Bob Deans at centre in Auckland, and they had Fred Roberts, one of the greatest scrum-halves New Zealand has ever had, orchestrating their two victories. Charlie Seeling, the great exponent of the feared dive tackle, was also in the side, as were Billy Stead and George Gillett. Harding had no such ammunition in his locker.

There were only four games in the build-up to the first Test and the Lions lost two of them. A bright opening against a combined side that had never played together before was followed by defeats to Wellington and Otago. The Lions recovered to beat Southland before taking on the All Blacks in Dunedin. An interesting feature of the match against Wellington came when Jackett left the field for an extended period of time with an injury. The Wellington captain, Freddy Roberts, offered a substitute, a practice often used following a typically pragmatic decision made in the southern hemisphere, but one which made the British-dominated IRB furious. The gesture was declined on the grounds that it transgressed the laws of the game, which typifies some of the conservative attitudes of the game's administrators: attitudes that lasted for far too long. Because of the physical nature of rugby in the southern hemisphere, the Lions often suffered grievously with injuries; therefore, those who refused to change the laws on substitution can be seen to have contributed to a number of their defeats.

The home side had tasted defeat only once in their international history up to this point, that world-renowned 3–0 defeat by Wales in Cardiff, and they were in no mood to lose to a team led by one of the men who had helped to inflict that defeat. The All Blacks might have been a formidable team in their heyday, but all was not well with the game in New Zealand. The fans were incensed at the excessive price of the ground tickets, which had doubled to two shillings, so they tore down corrugated fences and hundreds poured through the gap on to the terraces, with the police

powerless to stop them. A record crowd of 23,000 saw the first Test, which was played in brilliant sunshine. The All Blacks were vastly superior in every phase of play and ran out easy winners by 32–5, scoring seven tries along the way. It was an enormous defeat and it left the Lions with a lot of improving to do before the second Test, in Wellington. The four matches between the Tests saw the Lions improve slightly, winning three and losing only to Canterbury, and there were six changes in personnel. For their part, the All Blacks selectors virtually fielded a 'B' team as they made eight changes to their starting line-up.

The second Test, in Wellington, was played in such wretched conditions that only 10,000 spectators braved the cold and wet to see what they believed was going to be a one-sided affair. In the event, the tourists played some excellent wet-weather rugby and surprised their opponents with the strength of their scrummaging to draw the match. There was no score at half-time, but in the second half Arthur 'Bolla' Francis put New Zealand ahead with a penalty goal for offside, before 'Jack' Jones scored a try under the posts from a forward rush, which, calamitously, Harding failed to convert. The All Blacks were lucky to escape with a draw and the series was again very much alive.

However, in the third Test, played at Potter's Park, Auckland, New Zealand showed that the drawn game in Wellington had been an aberration, and punished the British side for their final week of much festivity at places like Rotorua after they had lost to Auckland. Apparently that last week at Rotorua was a lot of fun, with sightseeing every day and dancing every night. They even played an unofficial game against a Maori team on the Tuesday in Rotorua, fielding no fewer than seven members of the Test team in what was an unofficial 'picnic match'. The Lions ran out 24–3 victors:

The Lions (v. Maoris): E. Jackett; R.B. Griffiths, 'Tuan' Jones, F. Chapman, P. McEvedy, H. Laxon, G.L. Williams, A. Harding (captain), E. Morgan, W. Oldham, R. Green, G. Kyrke, J. Ritson, R. Dibble, J. Dyke
Scorers: Tries: J. Dyke (2), H. Laxon, 'Tuan' Jones, R.B. Griffiths, P. McEvedy;
Con: R.B. Griffiths, J. Dyke, P. McEvedy

The Lions left for Auckland in poor shape on Thursday, and it was no surprise when it became a one-sided game, particularly after they lost their captain, Harding, in the opening minutes. New Zealand led 12–0 at half-time, with two tries by Frank Mitchinson and one each from Hunter and Frank Glasgow. In the second half, Gillett, Harold 'Circus' Hayward, Mitchinson, Deans and Francis all scored further tries, but the goal kicking was appalling and only one try out of the nine was converted by John Colman. The Lions were lucky, then, to get away with losing only 29–0: their heaviest-ever international defeat and a record that stood until 1983. The Lions shipped 16 tries in three games and the nine tries scored against them in the third Test in Auckland remains a record number against them in a Test.

There was more drama when the Lions headed to Sydney in the wake of their Test drubbing for the final leg of their tour. The Lions were boarding the steamer *Victoria* from Queens Wharf, in Auckland Harbour, en route to their opening game in Australia against New South Wales at Sydney Cricket Ground. Despite being well beaten in the Test series, Harding's side proved hugely popular with the home fans and hundreds of them came to see the Lions off. It has been suggested by a variety of sources that members of the British team were extremely well looked after throughout the afternoon prior to departure, and the fact that England centre Henry Vassall failed to arrive at all – reputedly 'visiting lady friends' – points to some pretty extensive celebrations.

Even when the players were on the steamer and the deck hands were loosening ropes from the piers to get under way, the long goodbyes were far from done. The Bristol forward Percy Down had leaned over for his last farewell when the steamer suddenly swung out from the dock and he over-balanced, becoming entangled in a portion of the gear, and, turning a complete somersault over the rail, fell with a splash into the water.

Immediately there were cries of 'man overboard' and ropes were quickly dropped over the side of the steamer for Down to clutch hold of. Unfortunately, even though he was a fair swimmer, Down was wearing a heavy overcoat because of the chilly evening air, and in the dim light he could be seen struggling frantically. Jackett threw off his own overcoat and dived overboard and All Blacks 'Bolla' Francis and George Gillett also plunged into the harbour from the shore. It took several minutes before the rescuers succeeded in getting Down and themselves back on dry land, and Jackett, with true understatement, wrote in a letter home during the voyage to Sydney that the dramatic farewell from New Zealand had 'made matters rather lively'.

This is how the *Auckland Star* reported the incident on Tuesday, 28 July:

THE BRITISH FOOTBALLERS
A 'COLD' LEAVE-TAKING
DOWN HAS AN INVOLUNTARY BATH
TWO ALL BLACKS TO THE RESCUE

The departure of the Anglo-Welsh footballers for Australia last evening was marked by an incident which caused considerable excitement among the thousand or more spectators assembled on Quay-street jetty to bid the team bon voyage. For some time prior to the sailing of the steamer, the Britishers were lined up along the rail of the steamer Victoria, which was to take them to Sydney, and frequently leaned over to shake hands with friends on the wharf, which was considerably below the deck of the steamer. There was nothing unusual, therefore, in Percy Down bending to shake hands with a lady acquaintance on the wharf, and before his comrades who were round about him could interpose, he had slipped over the rail. To the majority of the people assembled the first intimation of the accident came when a dull splash caused them to exclaim 'Man overboard.' The Britishers on the steamer became greatly excited and at first cried out that it was 'Ponty' Jones, who is not a swimmer, but this player answered to his name, and it was then discovered that the man in the water was Percy Down. Immediately after Down fell

▲ A note from Henry Vassall to George Harnett apologising for 'anything he might have done during the tour to make [Harnett's] task as manager difficult'. Given Vassall's reputation as a hellraiser, the possibilities are endless…

▲ A scrapbook containing the menu for the welcome dinner held for the Lions squad upon their arrival in Australia

into the water, Francis, the 'All Black' forward, divested himself of his coat and jumped into the water to give assistance to the Britisher, who was appealing loudly for help. George Gillett, another 'All Black,' followed Francis, and by this time ropes had been lowered from the deck of the steamer. The people on the wharf and steamer were now greatly excited, and shouted out numerous suggestions. Another footballer named Cassidy went into the water, and Mr. Neil Galbraith, treasurer of the New Zealand Rugby Union, descended by means of a pile to the stringers underneath the wharf, where he watched operations, prepared to render further assistance if required. However, Francis (who is a powerful swimmer) and Gillett had Down well secured to one of the ropes, and he remained where he was at the water's edge. The people overhead, however, could see nothing of the rescue, and excitement continued to increase. Jackett, the British full-back, who is also an enthusiastic yachtsman, jumped over the rail of the steamer and let himself down to the wharf, where he was preparing to jump into the water; when a policeman forcibly detained him, giving him an assurance that his comrade was safe, and in good hands. Meanwhile, the steamer had been moved out a little from the wharf to facilitate the work of rescue. The launch Adventure, *in charge of Messrs. Foster and Nixon, slipped into the open space thus made, and Messrs. Down, Francis, and Galbraith were taken on board. Messrs. Gillett and Cassidy were hauled on to the wharf by means of the ropes. The launch landed its party at the man-o'-war steps, and Percy Down, who appeared very pale, walked round to the steamer, being cheered as he passed through the crowd and regained the deck. The rescuers were driven to their homes. Everything would appear now to have ended happily — the Britishers were given a hearty cheer, which they returned, and as the vessel moved off, the departing footballers gave cheers for Messrs. Gillett and Francis. But some of the spectators were positive that one had not been accounted for, and was still in the water. A policeman was also of this opinion, and to make sure Sergt. Ramsay, assisted by Constable Armstrong, dragged the harbour bottom in the vicinity for several hours, and at nine o'clock, being confident that no one had been drowned, they gave up the search.*

Mr. Galbraith was surprised on returning to the Central Hotel to find Vassal, the Oxford three-quarter, there. Vassal explained that he had been visiting friends at Mt. Eden, and then hurried down to the wharf, only to find that the steamer had gone. Vassal was a passenger by this afternoon's West Coast steamer for Wellington,

where he connects with the steamer leaving for Sydney on Thursday next. He will arrive in Sydney on Tuesday next, a day before the team's first match in Australia, which will be played at Sydney. Naturally, Vassal's absence would be the occasion for much anxiety on the part of the Britishers on board the Victoria, *and to allay any uneasiness on this score, Mr. Galbraith made arrangements with the light-keeper at Cape Maria Van Diemen to signal to the* Victoria *when she passed there this morning that Vassal was in Auckland. At the time of writing, it was not known whether the message had been delivered.*

The Lions arrived in Sydney and found themselves immediately plunged into a three-match series against New South Wales. There were no Tests in Australia, but the three games against the New South Wales Waratahs and the two matches with Queensland were supposed to expose the Lions to the best players in the country. The Lions had won their previous 19 matches played in Australia in 1904 and 1899, and in three visits to the country had lost only three times in 51 games, with two more matches being drawn in 1888. The recent record rainfall, coupled with heavy showers during the curtain raiser between Sydney Grammar School and Newington College at the Sydney Cricket Ground, turned the game into a slog in the mud. The Lions were thankful to leave with a 3–0 win, courtesy of a first-half try from scrum-half William Morgan.

Three days later, and in front of a crowd of 20,000, double that of the opening game, the two teams met again at the same venue. This time the scoreline was a little more favourable for the Lions as they triumphed 8–0. It is interesting to note that at the end of the game there was a send-off for the first Australian touring team as they headed to the UK. They played two warm-up games against Victoria and Western Australia before sailing to the UK, where they played their opening game against Devon on 26 September. It meant that after facing ten of the tourists in the opening two games in Sydney, the Lions never met the top 31 players in Australia again on tour, hence their disappointment at losing the third game against New South Wales, 6–3, and falling 16–13 to the Western Districts in an up-country game in Bathurst.

The tour ended on a high with a 26–3 win over Brisbane, although it was a bit of a hollow victory, as evidenced by a quote in the match report in the *Brisbane Courier*: 'Their opponents were a Metropolitan fifteen, not, however, by any means representative of the best Club football in the City, owing to the fact that many of the players selected for the match were unable to obtain leave.' There were six tries, three of them to the Newport centre Rowland Griffiths, who ended the game with 17 points. Gibbs ended the tour as the leading points scorer, with 67, and he also edged out his Cardiff clubmate Johnnie Williams to beat him by one to end

▼ A scorebook recording the second match between the Lions and New South Wales

▲ A collection of postcards, programmes, letterheads and tickets from the Australian leg of the 1908 tour

the tour as the top try scorer, with 13. Both were prolific try scorers throughout their careers, Gibbs matching Williams' Welsh record of 17 tries in one less appearance, 16. Williams was cut down in the First World War while serving as captain in the Welsh Regiment's Cardiff City Battalion at Mametz Wood, on the Somme. He died at the age of 34 from leg wounds received during the battle.

His fellow Welsh three-quarter, 'Tuan' Jones, lived to tell the tale of the horrors of France and earned himself the MC with bar as a captain, Royal Army Medical Corps. He was gazetted for the MC on 1 February 1918, with the citation appearing on 5 July: 'For conspicuous gallantry and devotion to duty. He worked in the line for a fortnight organising advanced dressing stations and bearer systems. During an enemy attack he was cut off from battalion headquarters, but established an aid post and worked under heavy fire in the open for thirty-six hours attending to a large number of wounded. He showed the greatest courage and endurance throughout.'

The bar to the MC was gazetted on 26 July 1918: 'For conspicuous gallantry and devotion to duty. He was in charge of an advanced dressing-station, and when the village had been temporarily evacuated he was entirely responsible for the getting away safely of many of the wounded. Throughout the ten days of the battle he displayed the most conspicuous ability, cool courage and devotion to duty.' He later emigrated to Australia and practised in Melbourne, where he was introduced to the touring 1959 Lions.

John Ritson, the Northern RFC and future England forward, was also decorated in the First World War, being twice mentioned in dispatches, gaining the MC and being gazetted for DSO in October 1917 and March 1918 and for a bar to his DSO in July 1918. All awards were for 'conspicuous gallantry'. He rose to the rank of Lt Col. with the Durham Light Infantry.

The 1908 Lions tour party was full of interesting characters and many talented individuals, but their overall record was poor. Speaking to the *Brisbane Courier* on the eve of his team's departure for home via Vancouver on the RMS *Marama*, the tour manager revealed his frustration at some of the results:

When we were in Sydney it rained for thirteen days without a stop, and the ground we played on was in an awful condition. We all liked the glorious weather we have had in Queensland. It is really perfect. We were very fortunate also while in the South Island of New Zealand. There was a nice dry spell while we were there and none of us felt the cold.

It was sheer hard luck (that we lost so many games in New Zealand) – we should never have lost them. We had a bad time as regards accidents. The number of casualties was abnormal. Harding, our captain, was damaged in the first match we played and hasn't been the same Harding since.

There was one final, 'unofficial' game on the way home against a Vancouver XV on 26 September, which the Lions won 63–5, before many of the players locked horns on their return home with the touring Wallabies. There was a gap of 22 years before the Lions were next seen in Australia.

The Lions (v. Vancouver): E. Jackett; R. Gibbs, J.P. 'Jack' Jones, J.P. 'Tuan' Jones, J.L. Williams; J. Davey, W.L. Morgan; R. Dibble, P. Down, E. Morgan, G. Hind, W. Oldham, G. Kyrke, J.F. Williams, L. Thomas. **Scorers: Tries:** R. Gibbs (4), J.F. Williams (4), J.L. Williams (2), 'Jack' Jones, E. Jackett, W. Morgan, J. Davey, W. Oldham; **Cons:** W. Morgan (4), R. Gibbs, 'Tuan' Jones, E. Morgan, 'Jack' Jones, R. Dibble

RESULTS OF THE 1908 ANGLO-WELSH TEAM IN NEW ZEALAND AND AUSTRALIA

P 26 W 16 D 1 L 9 F 313 A 201

Wairarapa-Bush	W	17–3	Wanganui	W	9–6
Wellington	L	13–19	Taranaki	L	0–5
Otago	L	6–9	Auckland	L	0–11
Southland	W	14–8	New Zealand (Auckland)	L	0–29
New Zealand (Dunedin)	L	5–32	New South Wales	W	3–0
South Canterbury	W	12–6	New South Wales	W	8–0
Canterbury	L	8–13	Western Districts	L	10–15
West Coast-Buller	W	22–3	Metropolitan	W	16–13
Marlborough-Nelson	W	12–0	Newcastle	W	32–0
New Zealand (Wellington)	D	3–3	New South Wales	L	3–6
Hawke's Bay	W	25–3	Queensland	W	20–3
Poverty Bay	W	26–0	Queensland	W	11–8
Manawatu-Horowhenua	W	12–3	Brisbane	W	26–3

ARTHUR HARDING'S 1908 ANGLO-WELSH TEAM

FULL-BACKS			FORWARDS		
J.C.M. Dyke	Penarth	Wales	H.A. Archer	Guy's Hospital	
E.J. Jackett	Falmouth	England	R. Dibble	Bridgewater Albion	England
			P.J. Down	Bristol	
THREE-QUARTERS			R.K. Green	Neath	
F.E. Chapman	Hartlepool Rovers		A.F. Harding (capt.)	London Welsh	Wales
R.A. Gibbs	Cardiff	Wales	G.R. Hind	Guy's Hospital	
R.B. Griffiths	Newport		F.S. Jackson	Leicester	
J.P. 'Jack' Jones	Pontypool	Wales	G.V. Kyrke	Marlborough Nomads	
J.P. 'Tuan' Jones	Guy's Hospital		E. Morgan	Swansea	
P.F. McEvedy	Guy's Hospital		W.L. Oldham	Coventry	England
H.H. Vassall	Oxford University	England	J.A.S. Ritson	Northern	
J.L. Williams	Cardiff	Wales	T.W. Smith	Leicester	
			L.S. Thomas	Penarth	
HALF-BACKS			J.F. Williams	London Welsh	Wales
J. Davey	Redruth	England			
H. Laxon	Coventry				
W.L. Morgan	London Welsh				
G.L. Williams	Liverpool				

1910 TOUR KIT

1910
SMYTH'S SAFARI

Captain: Dr Tom Smyth (Newport and Ireland)
Squad Size: 26 + 2 replacements
Manager: William Cail (England)
Assistant Manager: Walter Rees (Wales)

Tour Record:	P 24	W 13	D 3	L 8	F 290	A 236
Test Series:	P 3	W 1	D 0	L 2		

There was only to be one more tour before Europe went up in flames in 1914, and the flower of Britain's youth were to undertake a far more dangerous and deadly contest. Their visit to South Africa coincided with George V succeeding to the throne and the Union of South Africa becoming a Dominion of the British Empire. Also in 1910, Tolstoy died as a hermit. Dr Crippen was hanged, Florence Nightingale died aged 90 and Captain Scott set out for the South Pole. It was also the year that Twickenham staged its first international.

No longer was it a question of missionary work and the spreading of the message that rugby was the best character-building game of all, with its huge demand on physical and mental bravery. These, together with its more intellectually stimulating requirements, were all qualities which saw the colonials, tempered in hard and tough environments, taking to the game like ducks to water. It has often occurred to me that rugby always seems to find its spiritual home where life is at its toughest and most unsophisticated, as in those southern hemisphere places, which even in relatively modern times are new frontiers, and in the south-west of France and the mining valleys of Wales.

Instead, the 1910 tour was all about survival and the Lions selected 26 players, only four short of what was to become, for a time, the normal full complement of 30 players for a tour. This was further evidence of the increasing strength of rugby in places like South Africa and New Zealand, and the growing realisation that the former pupils were becoming the masters.

For the first time on a tour to South Africa there was full representation from Wales in the Lions squad. Only one of the previous three tours had included a Welshman, Reg Skrimshire in 1903, but this time there were no fewer than seven players from the Newport club. Five

▲ Tom Smyth, a former teammate of 1904 Lions skipper David Bedell-Sivright at Edinburgh University, earned 14 caps for Ireland over the course of a distinguished playing career

of them played for Wales; a sixth, the Welsh-born Stan Williams, went on to play for England; and the tour captain, Dr Tom Smyth, was an Irish international. This 'magnificent seven' remained a record number of players from one club on a Lions tour until Leicester Tigers provided eight members to the 2005 squad that went to New Zealand. Sir Clive Woodward's squad, however, had 50 players in the end, compared to 28, including two replacements, in 1910.

The Lions skipper graduated as a doctor from Edinburgh University, where he played alongside the 1904 Lions captain David Bedell-Sivright and his 1910 teammate Bill Robertson. He joined Newport after taking up an appointment at the Royal Gwent Hospital and played two seasons with the Welsh club before

transferring back to his native Belfast, where he joined Malone RFC. He got the 1910 Lions tour off to a flying start as he scored two tries in the opening victory over South Western Districts and played in the final two Tests at prop after missing five games, including the first Test, through injury. He was the first of ten Irish captains of the Lions up to 2013.

Another of the Newport contingent, John 'Jack' Phillips Jones, led the team in the opening international in Johannesburg. Jones was the only survivor from the 1908 tour to Australasia and took his tally for the Lions to 41 appearances, six Tests, 13 tries and a drop goal. That made him level with Frank Stout, of Gloucester and England fame, at the top of the Lions appearances table. It was a record they would keep until 1962, when the English scrum-half Dickie Jeeps played his 42nd game on his third tour. Having launched his international career against the mighty All Blacks in 1908, Jack was two months short of his 35th birthday when he won the last of his 14 Welsh caps against France in 1921.

▲ John 'Jack' Phillips Jones was a survivor of the 1908 tour and led the Lions in the first Test against the Springboks two years later

According to the passenger records of the *Edinburgh Castle*, which took the team from Southampton to the Cape, only 24 players accompanied tour manager William Cail and his assistant, Walter Rees, on their departure on 21 May 1910. Selection hadn't been easy, once again, and no fewer than eight of the players who went on the tour never played for their country: Jack Spoors, Charles Timms, Ken Wood, Noel Humphreys, George Isherwood, Bill Ashby, Edward Crean and Bill Robertson. *The Times* ran a list of names for the tour on 13 April, yet the finalised Lions squad showed nine variations the day before departure some five weeks later.

Included among the list were Irish full-back Billy Hinton, Scottish three-quarters James Pearson and Walter Sutherland, forward Louis Spiers, England centre Harry Shewring, wing Percy Lawrie and the Welsh trio of 1908 tour half-back Willie Morgan, wing Phil Hopkins and forward F. Morgan. It shows that seven of the original 11 backs named didn't travel, and two of the forwards also pulled out.

In the end, the Lions travelled with only 13 forwards (Handford's arrival made it 14), but an injury to the Scottish international James Reid-Kerr before the first game reduced the playing numbers up front by one. Despite his inability to play, Reid-Kerr stayed in Cape Town, greatly angering the South African Rugby Board, who eventually refused to continue paying for his keep. Eventually, some seven weeks into the tour, the South African Rugby Board informed the Lions manager William Cail they would 'cease to be responsible for any expenditure whatsoever incurred by Mr Reid-Kerr' (South African Rugby Board Minutes of 27 July 1910). The already strained relations at boardroom level were stretched to breaking point. The tour had come close to being abandoned even before the Lions had left England when the Transvaal Rugby Union reported to the South African Rugby Board that two players, 'Messrs Williamson and Flemmer, ex-Rhodes Scholars residing in Transvaal, had been approached by the International Rugby Board to play for the English team' (South African Rugby Board Minutes).

The players in question had been Rhodes Scholars at Oxford University, and the Dark Blues' match-winning half-backs had faced their home country together when the Springboks played against Oxford in 1906. They learned their rugby at St Andrew's College, Grahamstown, and then moved on to Oxford and Blackheath. Rupert Williamson had already played five times for England, and Wal Flemmer had had a trial, but both were back in South Africa in 1910. The South African Rugby Board said that it was 'strongly opposed' to their inclusion and their argument won the day.

The next fight came when Cail asked for an extra forward. In the South African Rugby Board's meeting of 27 June it was recorded that the 'British Touring team having found it imperative to have the assistance of another forward' had received permission to ask England's Rugby Football Union for another forward. The RFU said that the only player available was Reg Hands, another former Rhodes Scholar, who had played twice in the England pack in wins over France and Scotland in the 1910 Five Nations Championship and who was back in Cape Town and playing for Villagers. Again, Cail received a slap in the face as the South African Rugby Board refused permission. He did eventually get two forwards as reinforcements. Hands went on to become a double international by playing Test cricket for South Africa before falling in the First World War.

The Scottish scrum-half Eric Milroy and the England forward Frank Handford were both named among the 26 for the tour on 20 May but didn't travel with the main party. In Handford's case, he arrived in time to make his debut in the second game, but Milroy didn't leave Southampton until mid June and missed the first half of the tour. This might have been due to the fact he was studying mathematics at Edinburgh University and could have been taking his final exams, although there is no concrete proof of this.

What is known, thanks to Alex Foster's tour reminiscences in Ivor Difford's *The History of South African Rugby Football*, is that Milroy, known as 'Puss', was obliged to take thirteen as his official number following his late arrival. It proved unlucky, as he was restricted to a mere four appearances on tour after contracting dangerous blood-poisoning from gravel rash. He was carefully nursed by William Tyrrell, then a medical student, and only recovered fully on the way home. Milroy went on to captain Scotland and was one of six Scots who played in the 1914 Calcutta Cup match at Inverleith to die during battle. He joined the 9th Royal Scots from the Watsonian Military Training Corps in September 1914 and won speedy promotion. In January 1915, he was gazetted second lieutenant in the 11th Royal Highlanders, and in July 1916 he gained his Lieutenancy and was attached to the 8th Royal Highlanders as Lewis Gun Officer. Crossing to France in 1915, he was engaged in the severe fighting in the Ypres Salient. During the Battle of the Somme he was posted missing at Delville Wood in July 1916 and was later presumed killed in action.

Milroy wasn't the only 1910 Lion to lose his life in France. The Welsh international Phil Waller died at the same age, 28, in Arras in 1917, and the Welsh-born Tynedale outside-half Noel Humphreys lost his life near Etaples, France, a year later, aged 27. Humphreys was killed a year after his youngest brother, John, died during the First World War. Noel Humphreys had become a captain in the Tank Corps (10th Battalion) and was mentioned in dispatches as well as being awarded the MC. The citation for the MC read: 'For conspicuous gallantry and devotion to duty. His tank becoming stranded, he commenced to dig it out, and though wounded, he completed his task and continued in action the whole day, finally bringing his tank out of action to the rallying point.'

There were many remarkable young men within Smyth's squad, and nearly every man rallied to the call of their country when the First World War began. Humphreys wasn't the only winner of the MC in the squad: Charles Henry 'Cherry' Pillman received the award while serving in the 4th Dragoon Guards; and Arthur McClinton was a second lieutenant in the 10th (South Belfast) Battalion of the Royal Irish Rifles and was mentioned in dispatches before being awarded the MC on 13 November 1916, his citation 'for conspicuous gallantry' stating 'he kept his

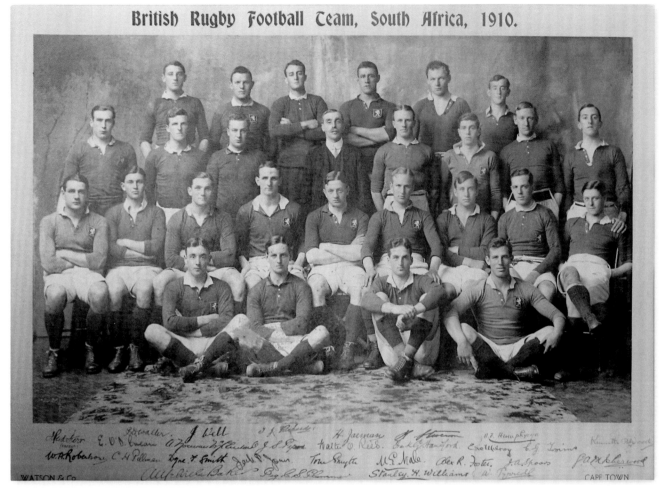

British Rugby Football Team, South Africa, 1910.

▲ The 1910 squad featured seven players from Newport, a record number of tourists from a single club that remained unsurpassed until 2005

company in hand with great determination under heavy fire, and finally led it over "No Man's Land" into the enemy's lines'. Stanley Horatio Williams, a captain in the South Wales Borderers who later reached the rank of acting major, Royal Field Artillery, was twice gassed and three times mentioned in dispatches before being gazetted on 4 June 1917, for a DSO for 'distinguished service in the field'.

Pride of place in the honours stakes, however, goes to the Edinburgh University undergraduate Charles Timms, who was actually awarded the MC four times for bravery while serving as a Unit Medical Officer attached to 7 Battalion Royal Fusiliers. After his first award, he received three bars to denote the extra honours. Born in Australia, Timms followed in the footsteps of his elder brother Alec in both studying medicine at Edinburgh University and gaining selection for the Lions. Alec Timms had become a Test Lion in his native Australia 11 years earlier and also played for Scotland. Charles never achieved international honours, but he covered himself in glory during the First World War after being awarded his captaincy on enlistment. The citation for his first MC, gazetted on 18 July 1917, read: 'For two days he attended the wounded in the open under heavy and incessant shell fire, quite regardless of personal danger, and his coolness and energy alleviated much suffering.'

His first bar was gazetted on 26 July 1918, the citation reading: 'He continued to collect and evacuate wounded from his post, though several times nearly surrounded by the enemy and under heavy shell fire. By his fine courage and self-sacrifice he was able to get away a large number of wounded under most difficult conditions.'

A second bar was gazetted on 11 January 1919: 'During a counter-attack this officer went forward from battalion headquarters and effected several rescues of seriously wounded men, conducting them personally to the lines. Throughout the week's fighting he worked night and day, and the manner in which he disposed of stretcher cases under heavy fire was admirable.'

Finally, a third bar was gazetted on 1 February 1919: 'Near Cambrai on 1 October 1918, during a severe enemy barrage, when his CO was wounded, he at once took up a squad of stretcher-bearers into the barrage to the rescue, tending his wounds and seeing that he was conveyed to a place of safety.'

Another medical hero within the tour party was the Belfast-born William Tyrrell. Although turned down for a commission by the regular Royal Army Medical Corps because of a slight error of refraction, he was accepted for the Special Reserve in 1912. During the war he was mentioned in dispatches no fewer than six times, won the MC in 1914 and was awarded the DSO and bar in 1918. He was also awarded the Belgian *Croix de Guerre* in 1918.

▲ Australian captain John Eales lifts the Tom Richards Trophy aloft following his side's 2–1 series victory over the 2001 Lions

In 1922, Tyrrell's own experiences in the war played a part in the findings of the War Office Committee of Enquiry into shell shock. Tyrrell found himself buried by a shell explosion during his service as medical officer to the 2nd Battalion Lancashire Fusiliers on the Western Front. He stated that it was his belief that the major cause of shell shock could be ascribed to the repression of fear. His military career continued after the war, but in the RAF rather than the Army. He rose to become Air Commodore in 1935 and was eventually made Air Vice Marshal in 1939, when he also became honorary surgeon to King George VI, a position he held until 1943. When he retired in 1944, he was knighted for his service during the war.

The final name in the 1910 Lions' wartime 'roll of honour' is that of one of the two replacements added during the tour, Tom Richards. The charismatic Aussie bolstered the pack, along with the Abertillery and Wales forward Jim Webb, and played in two Tests in a dozen outings for his adopted team. Tom had already won an Olympic gold medal with the Wallabies on their 1908 UK and Ireland tour, and qualified for the Lions because he had been playing for Bristol during the 1909–10 season. Richards, who was already in South Africa, made his first appearance on 2 July in the defeat against Transvaal. Webb, who had helped Wales win the Grand Slam in 1908 and 1909, made his debut three weeks later and he went on to play in all three Tests. These days, Richards is immortalised in glass and has his name associated with the prize for the side that wins the Test series between the Lions and Wallabies every 12 years. The Tom Richards Trophy was first played for in 2001, when John Eales carried it off for the Australians after a 2–1 series triumph. So who exactly was Tom Richards?

Born on 29 April 1882, near Tenterfield in New South Wales, Richards was the son of a wandering Cornishman who went to Australia during the Gold Rush. Known as 'Rusty', Tom began playing football in Charters Towers, following in the footsteps of his elder brother Bill, who made the first of his five Test appearances for Australia against the 1904 Lions and faced the tourists four times on that tour.

Tom's appetite 'for the glory and the glamour of a footballer's life', as the Australian Rugby Union's Hall of Fame puts it, was whetted when he saw a New South Wales Rugby Union team playing. He joined the local Waratahs team in 1898

and next year began a successful career with the Natives club. In 1902, Richards represented Charters Towers against other towns. He played in Brisbane for the Northern District and Country 'B' (1903) and for Queensland's 'Next Fifteen' against New South Wales (1905).

With other family members, Richards followed his father to Johannesburg, where he played for the Mines club and represented Transvaal in the Currie Cup. Ruled ineligible for South Africa's tour of Britain, he nevertheless sailed for England, where he played for Bristol in 1906–07 and represented Gloucestershire, playing against the South Africans on their tour. Hearing of plans for an Australian team to visit Britain, he returned home in July 1907. His strong performances for Queensland ensured his selection for the tour to Britain, France and North America. A big, fast, versatile and opportunistic breakaway forward, with a natural rugby brain, he played against Wales and England, scoring a try at Cardiff Arms Park in a narrow 9–6 defeat.

He was also a member of the gold medal-winning Australian team at the London Olympic Games in 1908, when rather ironically they beat his father's home county, Cornwall, who were representing Great Britain as the champion English county.

Richards returned to Australia in March 1909 and that year captained and coached Charters Towers and North Queensland. He sailed to South Africa during the Lions' visit in 1910 and was in Johannesburg when he was invited to join the tourists after a spate of injuries. He made his Lions Test debut against the Springboks on 6 August in a 14–10 defeat and then helped them square the series with an 8–3 victory in the second Test.

Richards was back in Sydney by June 1911, and in 1912 he was vice-captain of the Waratahs team that toured North America, playing in the Test against 'All-America'. He returned to England before heading to the south of France with an East Midlands team in February 1913. He helped to train France for its match against Wales in Paris, and he played for Toulouse and briefly lived at Biarritz. He retired from football after returning to Australia in August 1913, when he began to write for the *Sydney Morning Herald*, the *Referee* and other newspapers.

During the First World War, Richards enlisted in the Australian Imperial Force on 26 August 1914, giving his occupation as 'traveller', and in October sailed for Egypt with the 1st Field Ambulance. Landing at Gallipoli on the morning of 25 April 1915, he served as a stretcher-bearer and was mentioned in divisional orders in July for 'acts of gallantry'. He returned to Egypt in January 1916 and in March left for the Western Front. On 25 November, Corporal Richards was commissioned second lieutenant and on 2 December transferred to the 1st Infantry Battalion. In May 1917, near Bullecourt, he led a 19-man bombing party on a raid, which earned him the MC. Gazetted on 16 August 1917, his citation read: 'For conspicuous gallantry and devotion to duty. He was in charge of a bombing party, and despite strenuous opposition succeeded in extending the line 250 yards and holding a strong post. He set a splendid example throughout.'

Richards was promoted to lieutenant and was twice evacuated to England after his back and shoulders were damaged by a bomb blast. His Australian Imperial Force appointment was terminated on 3 November 1919, and for two years he was in charge of the employment section of Sydney's Department of Repatriation. Thereafter, he became a travelling salesman. He died in Brisbane on 25 September 1935, suffering from tuberculosis, admitting 'the gas I swallowed during the war is beating me down steadily'.

▲ The programme from the tour match against Griqualand West

Richards, Waller, Melville Baker and Ken Wood all remained in South Africa after the 1910 tour. Waller died wearing a South African uniform in France seven years later, while Baker went on to help Griqualand West win the coveted Currie Cup in 1911.

The Lions had a run of 16 matches before the first Test, and they got off to a much better start than their 1903 counterparts. They won four and drew one of the opening five games and were able to successfully negotiate the tricky four games in a row against various Western Province sides, ending their initial stay in Cape Town with a 5–3 triumph over the full provincial team. A narrow reverse at Griqualand West was followed by a record defeat on South African soil, a 27–8, six-try thumping by Transvaal in Johannesburg. The response was emphatic, as the Lions scored 15 tries in their next two games, beating Pretoria 17–0 and running in 11 tries in a 45–4 defeat of Transvaal Country. Both the score and the winning margin, as well as the try count, were records for the Lions in South Africa. The revival was halted when the tourists faced Transvaal for the second time, although a 13–6 defeat showed how much had been learned and improved after their earlier mauling. At this stage of the tour they were being forced to play three games per week, and injuries began to take their toll. So, too, did the train travel that saw the Lions spend six days and six nights on rolling stock in the build-up to the first Test as they worked their way back to Johannesburg.

Up to this point in their international career, the Springboks had only been exposed to European opposition. They had embarked on their first overseas tour in 1906 and turned it into a major success as they beat Ireland, Wales and France, drew with England and lost to Scotland. They won all 23 non-Test matches before going down 17–0 to Cardiff in their final game – on New Year's Day! They hadn't lost to the Lions since the 1896 tour and were looking to build on their 1903 series triumph. The old Springboks system of selection by the Province in which the Test was played had been amended slightly, although there were still three different panels for the three internationals, with the centre where the Test took place providing two selectors and the other Test centres one each. Griqualand, having lost their Test match, were still allowed to have a selector on the panel. The Griquas may not have staged a test, but they matched the achievement of Transvaal in beating the Lions twice, 8–0 and 9–3, before the first Test.

▲ Charles Henry 'Cherry' Pillman of Blackheath and England was the leading light of the 1910 tour, causing mayhem whenever he took to the field

Hopes of success for the Lions in the opening game of the three Test series were dented when both the captain, Smyth, and the outstanding player in his squad, Pillman, were ruled out through injury. Pillman had made his England debut a week before his 20th birthday in 1910 and so impressed the South Africans that he was portrayed as a rugby revolutionary, one of the first predatory flankers who targeted the opposition outside-half. Seldom has a tour been so completely dominated by one man, as this one was by this Blackheath and England loose forward. The Springboks captain, Billy Millar, considered him to be the greatest wing-forward of all time, and said that Pillman revolutionised the South African concept of forward play. By now, the new strategies of forward play with an emphasis on the loose-head were coming

into use and this, together with Pillman's skill, was to establish a pattern of forward technique which remained for 70 years, until they began to curb the wing-forward, who had become far too destructive.

In South Africa, it was Pillman who made the template for future generations of superb Springboks loose forwards, such as Hennie Muller, Doug Hopwood, Jan Ellis and many others who became cult figures in the game. Millar also stated categorically that it was Pillman who single-handedly inspired the British to their unexpected victory in the second Test when, astonishingly, he operated at outside-half.

Pillman also operated as a place kicker of remarkable accuracy and easily headed the points-scorers for the tour with 65 points, even though he was an unrecognised kicker when he went on tour. It is easy to see, therefore, why the South Africans were in awe of this remarkable young man, who was only 20 years old, stood 6ft 3in tall and weighed 173lbs. A leading critic of the day wrote that 'he played as though he had invented the game himself'.

Apart from the new concept of a winging forward, Smyth's team was also credited with having been the first side in South Africa to introduce half-backs in the fixed positions of scrum-half and outside-half; previously they had played on a left and right, or even a first-up, basis. The South African Provinces quickly adopted this system, with the exception of Western Province, who waited another four years.

The first Test was played at the same Wanderers ground on which the Lions had been so badly mauled by Transvaal, but the tourists had by far the better of the first half. At half-time the scores were level, with a try apiece from the Irish wing Alex Foster for the Lions and one from the Springbok centre Dirkie de Villiers. South Africa then seemed to have the game comfortably won, when a try by Dougie Morkel, and another by Dick Luyt, converted by Morkel, made it 11–3. Then a drop goal by acting skipper 'Jack' Jones and a try by Bristol outside-half Jack Spoors made it a thriller and anybody's game at 11–10.

It was the splendid Morkel who won the game for South Africa, after they had been put on the rack by repeated Lions attacks, when he put in an intelligent kick to the left flank for 'Cocky' Hahn to gather in his stride and score. South Africa won a most thrilling game by 14–10, despite losing centre Jack Hirsch with a career-ending broken leg in the second half, which reduced the side to 14 men. The Morkel family from Somerset West became a legend in South Africa, as ten members won Springboks colours in the period from 1903 to 1928 – a feat unlikely ever to be repeated.

Before the second Test, the Lions played two matches against Border. They romped home 30–10 in the first outing, but then played the next game four days later in their club jerseys, as they considered it a game too far and, in their eyes at least, 'unofficial'. It ended in a 13–13 draw.

The second Test at the Crusader Ground in Port Elizabeth saw South Africa as hot favourites to win, but they had not counted on the return of the dreaded Pillman, who was an inspired choice to play at outside-half. Even more astonishingly, South Africa dropped Dougie Morkel. The game was largely won by the performance of the forwards, who played out of their skins (in particular, Jarman and Waller), and by the scrum-half, George Isherwood, who had the game of his life. Playing with the wind, the Springboks were 3–0 up at half-time following a try by Wally Mills.

In the second half, Pillman took over so completely that the new Springbok skipper Billy Millar wrote years later: 'I confidently assert that if ever a man can have been said to have won an international match through his unorthodox and

lonehanded efforts, it can be said of the inspired, black-haired Pillman I played against on the Crusader ground on 27 August 1910, when the "rover" played as fly-half, mark you, not as forward.'

Pillman started both his team's second-half match-winning tries, first with a kick over Percy Allport's head for Spoors to score. Two minutes later he was at it again, when he initiated a try for the winger, Maurice Neale, which he also converted, and the game was won 8–3.

The third Test to decide the rubber, poised at one win each, was played at Newlands in Cape Town. Unfortunately, and again in keeping with the tour's unlucky chapter of injuries, the tourists lost their full-back, Williams, in the opening ten minutes and played with 14 men for the rest of the game. They stood little chance after that and were well beaten 21–5. The only first-half score was a try by Gideon Roos, converted by the recalled Dougie Morkel. In the second half, Dick Luyt scored a try which was again converted by Morkel, who also kicked a penalty. Although Spoors maintained his record of scoring a try in each Test, and Pillman added the conversion, a further try by Koot Reynecke, converted by Morkel, saw the Lions well beaten.

This match also marked the introduction of 'Boy' Morkel, who, at the time and for a long time after, was regarded as the best all-round forward in the world. Alongside him in the Springbok pack in that third Test was Clive van Ryneveld, father of the double Oxford Blue of the same name, who played rugby for England at centre in 1949, and captained South Africa at cricket against Peter May's side in 1960–61.

The Lions lost the series, but Pillman got some small revenge two years later when he joined his fellow England international, and brother, Robert, in the London Counties side that beat the Springbok tourists.

Ivor Difford's *History of South African Rugby* includes Alex Foster's candid assessment of the two teams:

In 1910 the standard of South African rugby was high. The players were almost all fast and the game was fast. The forwards attempted little or no dribbling, but they were formidable in the scrum and at the lineout. Their main offensive was the wing-three-quarter, who was well supplied with the ball and trusted to speed and resolute running. We, on the other hand, played a mixed game, combining forward rushes with back play. The quick heel after a checked rush, we thought, gave us our best advantage. I think we also practised the cut-through, the reverse-pass and the cross-kick more than our friends the enemy.

This was the end of another era and, as the lights went out finally all over Europe during the First World War there was to be no further rugby contact between teams from the British Isles and those from the southern hemisphere for 14 years. Many South Africans fought gallantly for Britain in those hostilities.

One of the stalwarts of the Lions' pack throughout the tour, and particularly the Tests, was Harry Jarman. He was hugely admired for his performances in a Lions shirt, particularly his commanding display in the second Test win over the Springboks in Port Elizabeth. The destructive yet mobile forward received plenty of praise from the South African critics, yet it was his actions off the field of play for which he will be forever remembered. Like many of his Welsh teammates, Jarman

> Uncapped Englishman Jack Spoors remains the only player to score a try in each match of a Lions Test series. Despite that feat, he was never capped for England, whose backline at the time was dominated by players hailing from Adrian Stoop's all-conquering Harlequins. Only centre Jeff Butterfield in 1955 has equalled the feat of scoring in three Tests on one tour.

was part of the mining industry, working as a blacksmith at a colliery in Talywain, near Pontypool. Some 18 years after returning from South Africa, he came to the rescue of several children who were playing on a colliery tramway, heroically throwing himself in front of a runaway wagon. He used his body to derail the truck, thus saving the children from suffering any serious injuries. Although he survived the impact of the initial incident, complications set in and Jarman lost his life just before Christmas 1928. He was just 45 years old. This truly was an heroic team of Lions both on and off the field of play.

◄ Newport and Wales forward Harry Jarman's tour cap, now part of the Priory Collection

RESULTS OF THE 1910 BRITISH TEAM IN SOUTH AFRICA

P 24 W 13 D 3 L 8 F 290 A 236

South Western Districts	W	14–4	Orange River Colony	W	12–9
Western Province (Country)	W	9–3	Griqualand West	L	3–9
Western Province (Colleges)	W	11–3	Cape Colony	L	0–19
Western Province (Town)	D	11–11	Rhodesia	W	24–11
Western Province	W	5–3	South Africa (Johannesburg)	L	10–14
Griqualand West	L	0–8	North Eastern Districts	D	8–8
Transvaal	L	8–27	Border	W	30–10
Pretoria	W	17–0	Border	D	13–13
Transvaal (Country)	W	45–4	Eastern Province	W	14–6
Transvaal	L	6–13	South Africa (Port Elizabeth)	W	8–3
Natal	W	18–16	South Africa (Cape Town)	L	5–21
Natal	W	19–13	Western Province	L	0–8

DR TOM SMYTH'S 1910 BRITISH TEAM

FULL-BACK			FORWARDS		
S.H. Williams	Newport		W.J. Ashby	Queen's College, Cork	
			E. O'D. Crean	Liverpool	
THREE-QUARTERS			F.G. Handford	Manchester	England
A.M. Baker	Newport	Wales	H. Jarman	Newport	Wales
A.R. Foster	Derry	Ireland	C.H. Pillman	Blackheath	England
J.P. 'Jack' Jones	Newport	Wales	O.J.S. Piper	Cork Constitution	Ireland
M.E. Neale	Bristol		J. Reid-Kerr	Greenock Wanderers	Scotland
R.C.S. Plummer	Newport		T.J. Richards*	Bristol	Australia
J.A. Spoors	Bristol		W.A. Robertson	Edinburgh University	
C.G. Timms	Edinburgh University		D.F. Smith	Richmond	England
K.B. Wood	Leicester		T. Smyth (capt.)	Newport	Ireland
			R. Stevenson	St Andrews University	Scotland
HALF-BACKS			W. Tyrrell	Queen's University, Belfast	Ireland
N.F. Humphreys	Tynedale		P.D. Waller	Newport	Wales
G.A.M. Isherwood	Sale		J. Webb*	Abertillery	Wales
A.N. McClinton	North of Ireland	Ireland	*Replacements		
E. Milroy	Watsonians	Scotland			

3

BETWEEN THE WARS

SINCE 1888

In the 21 years between the two great wars, the rate of touring slowed down and only three teams, the 1924 and 1938 sides to South Africa and the 1930 team to New Zealand, left British and Irish shores. This was largely due to the exhaustion and worry which many felt at that time and to the world-wide economic depressions of the 1920s and 1930s.

These teams were also officially the first fully representative teams to be sent by the Four Home Unions. However, they were often weakened by the unavailability of players, who were loath to risk giving up good jobs, as were the employers to give them the time off, as money was short. Nowadays, people have no idea how poor the population was at that time; even after the Second World War, a meal for a rugby player in Wales, and in parts of England and Scotland, was a valuable commodity.

It is not surprising that in January of 1924 Ramsay MacDonald, a weaver's son from Scotland, became the first Labour prime minister. In October, however, the Tories won a huge election victory after the scare of the Zinoviev Letter and the Campbell case. It was also the year when Lenin died. Stalin denounced Trotsky and Mussolini assumed full dictatorial power in Italy. Harold Abrahams and Eric Liddell triumphed in the Paris Olympic Games and Jan Smuts lost his parliamentary seat in the South African elections. When the armistice was signed on 11 November 1918, and the guns fell silent, many rugby players of all nationalities failed to return home from the battlefield. The list of fatalities among capped players was as follows: Australia 9, England 27, France 22, Ireland 8, New Zealand 14, Scotland 31, South Africa 5 and Wales 13. The full list of players who had played for The British & Irish Lions who lost their lives in the First World War is (in date order):

Sidney Crowther (1904 tour to Australia and New Zealand)
Died 18 October 1914 at Flanders, aged 39
Lions Career: 18 matches, 4 Tests

Alex Todd (1896 tour to South Africa)
Died on 21 April 1915 at Ypres, aged 41
Lions Career: 19 matches, 4 Tests

Blair Swannell (1899 tour to Australia/1904 to Australia and New Zealand)
Died 25 April 1915 at Gallipoli, aged 39
Lions Career: 32 matches, 7 Tests

Ron Rogers (1904 to Australia and New Zealand)
Died 28 June 1915 at Krithia, aged 32
Lions Career: 7 matches, 1 Test

David Bedell-Sivright (1903 tour to South Africa/1904 to Australia and New Zealand)
Died on 5 September 1915 at Gallipoli, aged 35
Lions Career: 21 matches, 1 Test

Johnnie Williams (1908 tour to New Zealand and Australia)
Died 12 July 1916 at Mametz Wood, aged 34
Lions Career: 20 matches, 2 Tests

Eric Milroy (1910 tour to South Africa)
Died on 18 July 1916 at Delville Wood, aged 28
Lions Career: 4 matches

Jimmy Hosack (1903 tour to South Africa)
Died 20 July 1916 at Kangata, aged 37
Lions Career: 4 matches

Phil Waller (1910 tour to South Africa)
Died 14 December 1917 at Arras, aged 28
Lions Career: 23 matches, 3 Tests

John Raphael (1910 tour to Argentina)
Died on 11 June, 1917 at Remy, aged 35
Lions Career: 6 matches, 1 Test

Noel Humphreys MC (1910 tour to South Africa)
Died 27 March 1918 at Etaples, aged 27
Lions Career: 5 matches

Charlie Adamson (1899 tour to Australia)
Died on 17 September 1918 at Salonica, aged 43
Lions Career: 20 matches, 4 Tests

Typically, it was South Africa and New Zealand who were to set the first rugby tours rolling again, for the New Zealanders would go anywhere for a game. Their New Zealand Imperial Services team, which won the Inter-Services tournament in England at the end of the war, jumped at the chance of visiting South Africa on their way home in 1919 and played 14 matches, winning ten, drawing one and losing three.

This further whetted the insatiable appetite for the game in both these mighty rugby countries, which led to one of the greatest rugby rivalries of all, and to the 1921 Springboks tour of New Zealand and Australia, where they lost only two of 24 matches with two draws, and shared the unofficial Test series with the All Blacks.

The Lions hadn't toured in 14 years and the return to South Africa came at a time when rugby was still very much getting back on its feet after the First World War. The post-war period was dominated by England in the home countries. They played 20 internationals between 1920, when rugby returned at Test level, and the end of the Five Nations Championship before the tour, winning 17 of them and drawing another.

Yet in the original 29-man tour party there were only four members of the England 1924 Grand Slam side and a mere six full England caps. The Scots provided nine, the Irish four and the Welsh three. There were then six uncapped players behind the scrum and another up front. These figures give an indication as to why the Lions were regarded as having a poor three-quarter line, although injuries compounded the situation behind the scrum.

Many key players, including England's Grand Slam skipper, the legendary Wavell Wakefield, and those fine Scottish centres, Archibald Gracie and G.P.S. 'Phil' Macpherson, were unavailable. There was no place for Ulster and Ireland centre George Stephenson, who was in the fourth of his ten seasons in the Test

arena on his way to a world record 42 caps and 89 points. It didn't help, either, that the 22-year-old Eric Liddell decided to chase Olympic gold that summer instead of playing rugby. The Scottish international wing claimed the world 400 metres title in Paris the day before the Lions kicked off their tour with a 7–6 defeat to Western Province Town & Country in Cape Town on 12 July. How different things might have been had the best players been available.

1924 TOUR KIT

1924
KICKING DISASTERS

Captain: Dr Ronald Cove-Smith (Old Merchant Taylors' and England)
Squad Size: 29 + 2 replacements
Manager: Harry Packer (Wales)

Tour Record:	P 21	W 9	D 3	L 9	F 175	A 155
Test Series:	P 4	W 0	D 1	L 3		

Ron Cove-Smith was handed the captaincy and had never before tasted defeat on the international stage in 13 outings with England. He was at the heart of the pack that had delivered back-to-back Grand Slams in 1923 and 1924 and strung together nine successive victories. The former Cambridge University skipper had not led an international team before, but, with Wakefield out of the equation, there weren't many other viable options. Wales had used four different skippers during an indifferent championship, and neither the Scottish captain, John Buchanan, nor the Irish, William Crawford, was in the tour party.

▲ Captain Strong of the Edinburgh Castle (left) and tour skipper Ronald Cove–Smith pose during the voyage

A fine and delightful man, at the time of the tour Cove-Smith was working as a doctor at King's College Hospital, having gained a first-class honours degree in the Natural Sciences Tripos at Cambridge. As well as playing for King's, he was a regular second row with Old Merchant Taylors' and Middlesex.

While the playing record of his Lions side left a lot to be desired – they failed to win in eight outings at one stage on tour, a record that still stands as the worst run of results on any Lions tour – they were competitive throughout the Test series and were let down by injuries and goal kicking.

This was the first touring team to be called the Lions. The name had a better journalistic ring to it than the official name of British Isles Rugby Union Team, or BIRUT, on the official notepaper and kit-bags.

They left Southampton on 21 June on the *Edinburgh Castle*, stopping for a few hours in Madeira on their way to the Cape. As ever, the Lions made their own fun on board, with the larger-than-life Arthur Blakiston very much at the centre of things. Rowe Harding's book, *Rugby Reminiscences and Opinions*, published in 1929, gave an invaluable insight into and assessment of all aspects of the tour, including the trip out:

The voyage was enlivened by flying fish, whales, deck sports, concerts and Blakiston. During this voyage someone espied what he thought was a school of

sharks. One of the ship's officers said they were porpoises, but Blakiston said they were going down in his diary as sharks.

During the deck sports, Blakiston made a book and cut a picturesque figure in rugby shorts, a top hat, and Whitley's tail coat. He lent added excitement to the proceedings by 'Welshing' at the conclusion of the sports, but of course he did not get too far.

Jamie Clinch wrote, produced and took the leading part in a revue, and produced some very beautiful young ladies who had not been seen on the boat before; but the play ended in a high-pitched note of tragedy when he slipped in attempting a high kick, and jarred his spine rather badly.

From the start this tour was to be ill-fated, as rugby in the British Isles was at a low ebb. This was evidenced by the progress of the 1924 All Blacks, who ran through the four home nations undefeated. On the other hand, South Africa was embarking on a golden period of its noble rugby history.

Once again, Cove-Smith's side was not representative of all the talent of the British Isles, for Lions sides have never been at full strength. In contrast, you always knew that the All Blacks and the Springboks would never dream of missing a rugby tour, gladly giving up jobs and studies for an experience of a lifetime, and you could virtually guarantee that you were watching the full cream of their talent.

Not only were many important players left at home, but also injuries played havoc with the team. Disaster struck early in the tour when two goalkicking full-backs were ruled out in the opening weeks. The 22-year-old uncapped Wilf Gaisford,

▲ The Lions squad wave farewell to their families as the Edinburgh Castle sets off on her lengthy voyage

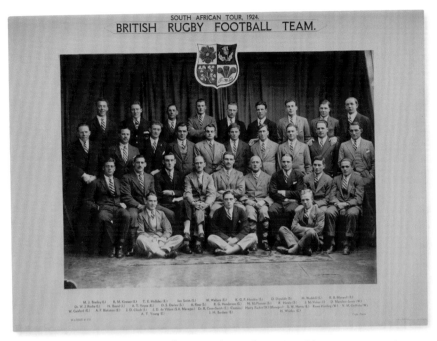

SOUTH AFRICAN TOUR, 1924.
BRITISH RUGBY FOOTBALL TEAM.

▲ The 1924 Lions squad was hit particularly hard by injuries, which left them without a recognised goal kicker, a development that would come back to haunt the side during the tour

who had been playing for Bart's Hospital, was injured in the very first training session and didn't play a game on tour, while England's Tom Holliday was ruled out of the rest of the tour after breaking his collarbone in the opening game. The Scottish lock Rob Henderson, like Gaisford, dislocated his knee during training before the opening game and didn't play until 27 August. He eventually recovered to play in seven matches, including the final two Tests. The Scottish hooker Andrew Ross damaged his knee so badly in the fourth game, against Rhodesia, that he never played again, and countryman Ian Smith broke a bone in his wrist that put him out for three weeks and restricted him to a mere four more matches. Another key injury victim was England's Grand Slam scrum-half Arthur Young, who managed only nine matches and, significantly, only one Test.

Holliday, like the uncapped Scottish centre Roy Kinnear, turned to rugby league and played for Oldham and England. Kinnear played 182 games for Wigan and was capped by Great Britain against Australia in 1929, the same year he scored a try in Wigan's Challenge Cup Final victory at Wembley Stadium.

So desperate was the Lions' plight that they had to call on the services of Bill Cunningham, an Irish international who had won the last of his eight caps a year earlier and was now working as a dentist in Johannesburg. He played only four matches, but they included the third Test as an outside-half. The selectors also sent for Newport's Welsh international wing Harold Davies, who arrived in time to play in nine games and one Test.

Roy Kinnear played in all four Tests on the 1924 tour and went on to win three caps for Scotland, but elected to change codes and joined Wigan RLFC in 1927. When the Second World War broke out, union and league players were allowed to join ranks to play in fund-raising services matches and Kinnear tragically died on the pitch in just such a game at the age of 38.

His son, the comedian and actor of the same name, also sadly died in unusual circumstances in 1988, suffering a heart attack after falling off his horse during the filming of *The Return of the Musketeers* in Spain.

The injuries left Cove-Smith's side with one fit full-back, Scotland's dependable Dan Drysdale, but no regular goal kicker. Drysdale was a duffer when it came to kicking for goal, preferring instead to grab the headlines with his running rugby, and he didn't kick a goal on tour. He tried a couple of times, but in the third Test he missed from point-blank range with a penalty that could have won the game.

It meant the Lions managed to convert only ten of their 43 tries on tour. On top of that astonishing statistic, they only managed to kick four penalties in 21 games. It meant the tourists lost nine games – six of them by six points or less – and threw the kicking duties around a number of players. England and Gloucester forward Tom Voyce proved to be the most

successful of them, landing five conversions and three penalties. He ended the tour as the highest points-scorer with 37 points – he also scored six tries – but the 1924 Lions ended with a mere 175 points scored at an average of less than nine points per match, a tally that was never going to be good enough to earn them victory in the Test series.

Voyce not only proved invaluable as a goal kicker, but also popped up as a wing and full-back when needed. A former centre who had only become a forward when sent to an England trial by mistake and given a back-row berth, he played his way into the Test team after being overlooked at the start. The Scottish forwards Robert Howie and Neil Macpherson led the appearances with 16 each on the tour, and the Blackheath and the England stalwart Blakiston joined them in all four Tests and 13 games altogether. Blakiston was an interesting character. He won the MC in the First World War and inherited his father's baronetcy in 1941, becoming the 7th Baronet Blakiston of London and Master of Hounds in Hampshire. The citation for his MC, when he was a lieutenant in the Royal Field Artillery in France, read: 'For conspicuous gallantry and devotion to duty. When a convoy of ammunition wagons of which he was in charge was heavily shelled and suffered several casualties, he succeeded in removing all the wounded men, under continuous shell fire, and by his coolness and initiative prevented further casualties among the convoy.'

The Lions team also included one of the most remarkable sporting all-rounders there has surely ever been. Born in South Africa, but schooled in England at Bedford, Stan Harris became an international in five different sports and a finalist at the World Amateur Ballroom Dancing Championships. He also survived injuries sustained in the First World War and was a prisoner of war during the Second World War, working on the Japanese railway in Siam.

Badly injured in the Battle of the Somme in 1916, Harris recovered to play for Blackheath after returning to England in 1919. He set try-scoring records on the wing for his club and was picked to play for England against Scotland and Ireland in 1920. That same year he was asked to join the Great Britain Olympic team to compete in the Modern Pentathlon at the Antwerp games, but he declined due to rugby commitments. He played on the wing for Transvaal after returning to South Africa in 1921 and competed in trials for the Springboks, turning down an offer to play against the All Blacks in order to fulfil commitments as an athlete. He won the Transvaal 440-yard hurdles title and then went on to become the South African light heavyweight boxing champion. For good measure, he was runner-up in the heavyweight division.

Back in England, Harris broke his leg playing for the England XV in the final trial at Twickenham on 8 January 1923. This seemed to be the end of his rugby career, and it was then that he took up ballroom dancing to exercise his leg. He went on to win the waltz section of the World Amateur Championships in London.

In 1924 he made another bold choice, turning down the chance to box as a heavyweight for South Africa at the Paris Olympics and instead joining the Lions on their South African tour. He was playing for Pirates, in Johannesburg, at the time, and scored four tries in 15 outings, also playing in the last two Tests.

▲ Versatile England and Gloucester forward Tom Voyce took on kicking duties for part of the tour

He was captain of the Kenyan Colony XV in 1926, and when his rugby days were over, he turned his hand to tennis. He had trials for the British Davis Cup team in 1929 before playing doubles for South Africa against Germany in 1931.

Having displayed his desire to survive through two world wars, this remarkable man then decided to try out at polo. He quickly became an accomplished player and, after competing with the best in England, he represented Great Britain at an international tournament in Deauville, France. He was a member of the British Olympic Games Council from 1935 to 1939 and was made OBE and CBE. Colonel Stanley Wakefield Harris, a *Boy's Own* hero and what a Lion! I am proud to have met him when I was on the 1955 tour.

There were two 'father and son' connections in this Lions side. The famous Irish forward 'Jammie' Clinch became the first son to follow in his father's footsteps by playing for the Lions, and made it a family double: Andrew Clinch had played with Johnny Hammond's team in 1896, and later become president of the Irish Rugby Football Union. His 22-year-old son, from Dublin University, made 12 non-Test appearances on tour. The other family link was provided by Scottish outside-half Herbert Waddell, who later became a member of the International Board and president of that world-famous and unique rugby club the Barbarians. Herbert Waddell made 14 appearances on tour, including three Tests, and

▲ 'Jammie' Clinch became the first son to follow his father in playing for the Lions. Renowned as one of the game's most vivid characters, the younger Clinch made 30 appearances for Ireland and was considered one of the hardest tacklers of the period

later saw his son, Gordon, play 22 matches, including two Tests, for the Lions in New Zealand and South Africa. Gordon later emigrated to South Africa, where he married Mary Oppenheimer of the family dynasty built on the diamond and gold industry. He later became a member of the South African Parliament.

There have been two further 'father and son' double acts on Lions tours down the years. Gordon Wood was a front-row forward on the 1959 Lions tour to Australia and New Zealand and his son, Keith, played in 1997 in South Africa and 2001 in Australia. Derek and Scott Quinnell packed in five tours between them, Derek travelling in 1971, 1977 and 1980, and Scott in 1997 and 2001.

In the light of all the Lions' injury problems in 1924 – on the eve of the first Test, Vince Griffiths had to play as a roving forward against Natal because the Lions only had seven fit forwards – it was, perhaps, not surprising that Cove-Smith's team wound up with the worst record of any Lions side. Unthinkably, they won only nine matches out of 21 and scored the lowest number of points ever recorded by a Lions side, 175. Only the fourth Wallabies side to the British Isles in 1947–48 suffered such indignity.

They lost their opening game 7–6, scoring two tries to one against a Cape 'Town & Country' XV, but then beat Western Province Universities, Griqualand West – Percy Park's Billy Wallace scored five tries in this game – Rhodesia and Transvaal. They seemed to be on a roll. But then they went a full month, and eight games, without a win. There were draws against Transvaal and Natal in that sequence, but also Test defeats in Durban and Johannesburg.

Writing about the sequence of defeats that followed the 12–12 draw against Transvaal, Harding wrote:

Up to this point we had done fairly well, but then a rot set in. Many unkind things were said about our wining and dining, but that was not the explanation of our failures. The long train journeys, the hard grounds, and a heavy casualty list had taken a heavy toll of players unaccustomed to such conditions, and when we played

the Country Districts in the Orange Free State, we had to play eight backs because, of sixteen forwards, only seven were fit to play.

The game was played in a dust storm which obscured the sun, and we were beaten by six points to nil. The next match, against the Orange Free State at Bloemfontein, we lost. At Pietermaritzburg we drew with Natal, and we went to Durban for the first Test a tired and demoralised team.

Nevertheless, we gave the Springboks a hard game. From Durban we travelled back to Johannesburg, and were beaten again in the second Test. In that match at least three good players were quite unfit to stand eighty minutes' hard rugby. Drysdale could hardly run at all, Smith's wrist was still giving him pain, and Arthur Young was suffering from a twisted ankle.

Things perked up at the end of the tour, however, with the Lions posting four wins and a draw in the third Test in their final eight outings.

It was in this series that South Africa introduced the 3–4–1 scrum formation, devised by their coach August Friedrich 'Oubaas' Markotter to protect the scrum-half from the quick-breaking loose forwards. Markotter had had the distinction of captaining the first South African provincial side to beat the Lions in 1903, when he led the Western Province Country XV to victory in the opening game of the tour. An old outside-half, whose career was cut short by injury, he devised the scrum system to provide quicker, channel-one ball. His captain, Pierre Albertyn, reverted to the more fashionable 3–2–3 scrum formation for the fourth Test, but by then the series had been secured. Markotter's system was soon universally adopted and gave South Africa a huge advantage in scrummaging and defensive qualities for over 30 years, before the British finally adopted it in the 1950s.

The Lions forwards got the upper hand in the first Test, despite having to compensate for the loss through a dislocated shoulder of centre Reg Maxwell. The 'Boks went 7–0 up in the first half, playing with both the wind and the sun at their backs, thanks to a brilliant try by Hans Aucamp on the wing and a drop goal from the new star in the making, Bennie Osler. The Lions forwards hammered away in the second half, but the tourists' only reward was a try for scrum-half Herbert Whitley. It had been a valiant effort, but was not enough to end their losing streak.

Osler made his debut for the Springboks in Durban and his drop goal was the first of many great kicks that turned him into a household name. He was to become a true legend, as were Hansie Brewis and Naas Botha in later years, but his influence on this series was less marked than that of the captain, Pierre Albertyn.

Albertyn began his career as a wing, but he became a devastating centre three-quarter with a lethal, blindingly fast sidestep. Nobody was more surprised than he was to have been called into the Springbok squad after spending three years in England studying dentistry at Guy's Hospital. Before he left to study, he so badly damaged his knee in a game against the All Blacks Military side that it was feared he would never play again. The softer grounds in England gave him the chance to resurrect his career and he went on to have a major impact on the series.

As the first Test was so tight, there was huge interest for the second game in Johannesburg, and the gates were locked after the ground's full capacity of 15,000 spectators had paid to go in. Those locked out, however, broke the locks and swarmed in, and it was estimated that more than 25,000 saw the game in the end. Again it was an exciting affair in the first half, when the only score was an Osler penalty. Had the referee awarded a try to Blakiston shortly after the restart, rather than make a late call for a forward pass, the final result might have been different.

▲ A cartoon of Scotland full-back Dan Drysdale. Extremely secure under the high ball and a sound kicker from hand, Drysdale was a reluctant place kicker – a fact that was to cost the Lions during the tour

Instead, the Springboks struck form and they scored what was at the time their most convincing Test rugby victory as they went on to win 17–0. They piled on tries by Kenny Starke, Phil Mostert, Jack van Druyten and Albertyn. Osler converted the second try and the Springboks couldn't lose the series.

In the third Test, the Lions recovered some of their self-esteem by forcing a draw, but they should have done much better, for once again Drysdale missed an easy conversion of their only try, scored by Cunningham at half-back, who had blazed his way over from a five-yard scrum. Drysdale also missed a sitter of a penalty later on in the second half. South Africa scored when van Druyten steamrollered his way over from a lineout on the half-time whistle. Although the Springboks were on the defensive for most of the second half, there was no more scoring and the Lions were in the now familiar territory of losing another series to the Springboks.

A misinterpretation of what was meant to have been a jocular remark in a speech by Cove-Smith in East London, coupled with the side's poor results, led to them becoming increasingly unpopular with the home fans.

'I can honestly say that taken all in all, our worst fault was thoughtlessness, and if fellows occasionally drank more than was good for them, that state of things was contributed to by the kind-heartedness of our hosts,' admitted Harding in his book. He continued:

I am certain that the occasional junketings were not responsible for our somewhat inglorious displays on the South African football fields. We never lost a game through lack of stamina, and invariably outlasted our opponents, whether we beat them or not.

The third Test match took place at Port Elizabeth and we were definitely the better side and should have won the match, but Drysdale missed a penalty goal in front of the posts just before the final whistle, when the sides were level with a try each.

Place kicking was one of the weaknesses contributing to our non-success. It was impossible to make a heel mark in the stone-hard ground, with the result that Drysdale and the other place-kickers seldom converted a try.

On the dirt grounds, the native players placed the ball on a tee of gravel, but our players never accustomed themselves to this method, and a good many of our matches were lost through inaccurate place-kicking.

The final Test at Newlands, in Cape Town, was an absolute cracker of a game, and many South African critics of the time thought it the perfect game of rugby football. Again South Africa won, but the Lions matched them all the way with some marvellously inventive and flowing football. Jack Bester scored the first Springbok try and Starke kicked a huge 50-yard drop goal, but, a minute later, Tom Voyce actually kicked a penalty to put the Lions back in the game. South Africa led 7–3 at the interval, and in a sensational second half, Starke scored a second try before Harris crossed for the Lions. That made it 10–6 to the home side. Starke made it a hat-trick with a third try for the Springboks, but the Lions weren't finished. Voyce charged through for a try that cut the gap to four points again at 13–9, but with the game in the balance right up to the death, the Springboks clinched victory with a marvellous unconverted try by Slater on the final whistle. They said at the time no better Test had ever been played in South Africa.

◄ Bennie Osler (left), pictured here with fellow Springbok Phil Mostert, was in imperious kicking form throughout the series and would go on to become a South African great

Cove-Smith's tour may have been a statistical disaster, but it was nevertheless a terrific Test series, which increased the appetite and enthusiasm of South Africans for the game. The goal-kicking lesson should have been learnt by the British selectors, but it never was, and time and again they failed to ensure that there were enough good goal kickers in the party.

Writing in Difford's *History of South African Rugby*, Cove-Smith summed-up the tour as follows:

Looking back, one cannot help but laugh at the subterfuges to which we were forced to resort in order to place 15 fit men on the field... A tour such as this, where everything is new and fresh, lives long in the memory... some of the incidents stand out strongly to dwarf the others. Perhaps the most noticeable of these was the quietly efficient captaincy of P.K. Albertyn in the Test matches. He always seemed to have his players well in hand and be able to produce the requisite thrust at the right moment.

Writing in 1932, he said about Benny Osler:

In those days (1924) Benny Osler was just making a name for himself, but even then kicked more than was warranted... Then, as now, the main glory of the team lay in the pack, led by Kruger and ably backed-up by Mellish and van Druyten – this last an ubiquitous fellow, who frequently functioned as an auxiliary back, so quick was he in falling back and covering up. His anticipatory play marked him head and shoulders above the others as far as brain power went, while his pace and powerful kicking were rarely at fault.

Against these formidable forwards, we had such stalwarts as Marsden-Jones, J. Clinch, T. Voyce, A.F. Blakiston, Neil Macpherson, J. McVicker and D.S. Davies, but outside the scrum and in the centre we had no one who could deal with the wily Albertyn.

Harding was one of the few successes behind the British scrum, playing in three Tests and making 14 appearances. In hindsight, it is clear that his views on the preparation and attitude taken to the tour are astute and accurate, but they were not welcomed by the rugby authorities at the time.

The British team record was, bluntly, one that did British sporting prestige in South Africa a good deal of harm. Not only did we suffer from a lack of good reserves, but we never got properly together as a team. Most of us had never met till we embarked at Southampton and it took us a good many days before we got to know each other.

We had practically no team practice before we took the field for our first match, and half the tour was over before the selection committee could decide on the relative merits of individual players.

Furthermore, our programme was compressed into an absurdly short space of time. We played twenty-two matches in ten weeks, an average of two matches a week, and in between we sometimes travelled forty-eight hours in the train, so that anything more than a perfunctory practice the day before the match was impossible.

Even before a Test match, most of the players were called upon to play a midweek match, while the Springboks were collected together and given a week's rest before playing against us.

Little wonder then that we were a tired, dispirited, demoralised collection of units and failed to live up to the high-sounding name we bore.

These tours will have to be taken more seriously by the players, by the governing bodies concerned, and by the British nation at large. We must get rid of the old conservative theories that rugby, and tennis, and all the other sports are merely games.

He went on to add: 'The real reason for our failure was that we were not good enough to go abroad as representatives of the playing strength of these islands. It is not sufficient to send abroad some players of international standard and others who are only second-class. Every member of the team must be absolutely first-class or disaster is bound to overtake it.'

Even as long ago as 1929 players like Harding were questioning the unyielding amateur ethics of the Four Home Unions. While rugby in South Africa and New Zealand was now embarking on a euphoric period that would last up to the Second World War, rugby in the British Isles was poorly directed and got nowhere in global terms.

RESULTS OF THE 1924 LIONS IN SOUTH AFRICA

P 21 W 9 D 3 L 9 F 175 A 155

Western Province (Town & Country)	L	6–7	South Africa (Johannesburg)	L	0–17
Western Province (Universities)	W	9–8	Pretoria	L	0–6
Griqualand West	W	26–0	Cape Colony	W	13–3
Rhodesia	W	16–3	North Eastern Districts	W	20–12
Western Transvaal	W	8–7	Border	W	12–3
Transvaal	D	12–12	Eastern Province	L	6–14
Orange Free State (Country)	L	0–6	South Africa (Port Elizabeth)	D	3–3
Orange Free State	L	3–6	South Western Districts	W	12–6
Natal	D	3–3	South Africa (Cape Town)	L	9–16
South Africa (Durban)	L	3–7	Western Province	W	8–6
Witwatersrand	L	6–10			

DR RONALD COVE-SMITH'S 1924 LIONS TEAM

FULL-BACKS			FORWARDS		
D. Drysdale	Heriot's FP	Scotland	A.F. Blakiston	Blackheath	England
W.S. Gaisford	St Bart's Hospital		M.J. Bradley	Dolphin	Ireland
			T.N. Brand	North of Ireland	
THREE-QUARTERS			J.D. Clinch	Dublin University	Ireland
J.H. Bordass	Cambridge University		R. Cove-Smith (capt.)	Old Merchant Taylors'	England
W.R. Harding	Cambridge University	Wales	D.S. Davies	Hawick	Scotland
	and Swansea		R.G. Henderson	Durham University and	Scotland
S.W. Harris	Blackheath	England		Northern	
T.E. Holliday	Aspatria	England	K.G.P. Hendrie	Edinburgh University and	Scotland
R.M. Kinnear	Heriot's FP			Heriot's FP	
R.B. Maxwell	Birkenhead Park		R.A. Howie	Edinburgh University and	Scotland
I.S. Smith	Oxford University	Scotland		Kirkcaldy	
W. Wallace	Percy Park		N. Macpherson	Newport	Scotland
			J. McVicker	Belfast Collegians	Ireland
HALF-BACKS			D. Marsden-Jones	London Welsh	Wales
W. Cunningham*	Lansdowne	Ireland	W.J. Roche	Newport	Ireland
H.J. Davies*	Newport	Wales	A. Ross	Kilmarnock	Scotland
V.M. Griffiths	Newport	Wales	A.T. Voyce	Gloucester	England
H. Waddell	Glasgow Academicals	Scotland	*Replacements		
H. Whitley	Northern				
A.T. Young	Cambridge University	England			

1930
THE NEARLY MEN

Captain: Doug Prentice (Leicester and England)
Squad Size: 29
Manager: James Baxter (England)

Tour Record:	P 28	W 20	D 0	L 8	F 624	A 318
In New Zealand:	P 21	W 15	D 0	L 6	F 420	A 205
Test Series (NZ):	P 4	W 1	D 0	L 3		
In Australia:	P 7	W 5	D 0	L 2	F 204	A 113
Test Series (Aus):	P 1	W 0	D 0	L 1		

1930 TOUR KIT

The 1930 tour of New Zealand came almost exactly midway between the two great European wars. Times were fitfully peaceful, with Germany not yet aware of resurgent nationalism and the imminent appearance of Adolf Hitler. King George V was on the English throne. It was a time of growing economic depression and uncertainty for the working man but, as ever, the British upper- and middle-classes were reasonably cushioned from its effects.

In that year, Donald Bradman scored a record 452 not out, and the planet Pluto was discovered. D.H. Lawrence died, white women were given the vote in South Africa, and Haile Selassie was crowned Emperor of Ethiopia. There was uproar in the Reichstag, Berlin, when Nazi deputies arrived in uniforms which were banned. Winston Churchill resigned over a policy of conciliation with Indian nationalism and Mahatma Gandhi was released from prison. Two million people died from famine in China. The BBC formed its own orchestra, and George Gershwin

composed 'I Got Rhythm'. Marlene Dietrich starred in the film *The Blue Angel*. The Rev. Dr William Spooner (of spoonerism fame) died, and Wallace Carothers discovered a new synthetic material called nylon.

It must be remembered that, at the time, rugby union was almost entirely in the hands of the middle-class in England, Scotland and Ireland. It was not the same in Wales and therefore, at this time, more working-class Welshmen like Dai Parker of Swansea were included in the team. Dai was a character who possessed a marvellous native wit and a physique which overcame and eliminated any pretensions by the varsity and posher elements to be superior; elements which were present in all Lions teams before the war. These men from different social backgrounds had begun to emerge; they had used life as their university and they were no less skilled in the arts of rugby or in debates on important issues than their well-educated counterparts. They may have had something to learn about social graces, as many of them, before touring, had lived extremely confined lives. Some of them had barely moved out of the valleys or the towns in which they lived. As ever, they were quick to learn. These were the men that the 1896 Lions tourist, Rev. Walter Carey, was talking about when he made his statement about rugby being a game for 'gentlemen of all classes'.

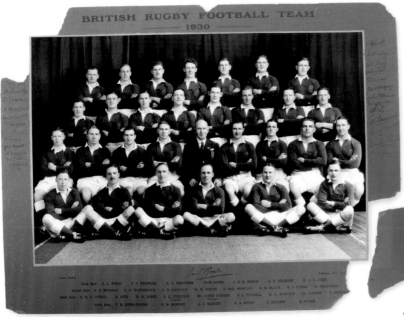

▲ Unsurprisingly given that many months had elapsed since the provisional squad had been selected, the 1930 tour party bore only a partial resemblance to the initial group of players contacted by the RFU

It had been six years since the last Lions had toured and there had been a gap of 22 years since the Lions had last visited Australasia. The planning for the tour began early, and on 18 April 1929, the secretary of the RFU, Sydney Coopper, sent the following letter to 28 players:

Tour of a Rugby Union British team to New Zealand and Australia in 1930
Dear Sir,

You have been provisionally selected to take part in the above Tour. The final selection will not, however, be made until two or three months before the Team sails.

The Team will leave England about the second week in April 1930, and arrive back about the second week in October. Each player should be in possession of about £50 to £75 for incidental expenses.

We hope that the team eventually chosen will represent the full playing strength of the Home Unions, in order that we may give New Zealand and Australia a true idea of our standard of play, and we hope you will make every effort to take part in the Tour.

Will you please inform the Secretary of the Rugby Football Union, Twickenham, whether you would be able to take part in the Tour.

Yours faithfully
SF Coopper

The early selection may have seemed a sound idea at the time, trying to give everyone a chance to plan their lives to allow them to embark on a near six-month-long tour, but only nine of the original squad eventually made it to New Zealand.

The 1930 originals were made up of nine English, seven Scottish, six Irish and six Welsh players, all of whom were capped. By the time the party set sail for New Zealand in April 1930, the split was 16 English, seven Welsh, five Irish and only one Scottish player. The first draft of players was as follows (players in bold made the tour):

Full-backs: Ken Sellar (United Services/England), Tom Brown (Bristol/ England)

Three-quarters: Jim Ganly (Monkstown/Ireland), **Carl Aarvold** (Headingley/England), Bill Simmers (Glasgow Academicals/Scotland), Phil MacPherson (Edinburgh Academicals/Scotland), Ian Smith (London Scottish/Scotland), **Tony Novis** (Army/Blackheath/England), **Harry Bowcott** (Cambridge University/Wales)

Half-backs: James Nelson (Glasgow Academicals/Scotland), Wick Powell (London Welsh/Wales), Harry Greenlees (Leicester/Scotland), Frank Williams (Cardiff/Wales), Mark Sugden (Dublin University/Ireland)

Forwards: Ivor Jones (Llanelli/Wales), **Dai Parker** (Swansea/Wales), Tom Arthur (Neath/Wales), Standish Cagney (London Irish/Ireland), **George Beamish** (RAF/Leicester/Ireland), **Mike Dunne** (Lansdowne/Ireland), Charles Payne (North of Ireland/Ireland), Hugh MacKintosh (Glasgow University/Scotland), John Paterson (Birkenhead Park/Scotland), **Henry Rew** (Exeter/England), Charles Gummer (Plymouth Albion/England), Eric Coley (Northampton/England), Wavell Wakefield (Harlequins/ England), **Sam Martindale** (Kendal/England)

The idea was for the great English forward Wakefield to lead the team. He had won four Grand Slams and captained England to back-to-back clean sweeps of the Five Nations Championship. He was unavailable for the 1924 Lions tour and was eventually forced to consign to the dustbin any hopes of touring in 1930 because of a groin injury picked up in January that year. The Cambridge University and Wales outside-half Harry Bowcott initially made himself unavailable, but then had a change of heart when the Irish three-quarter Morgan Crowe broke his collarbone playing for Lansdowne the week before departing. Crowe had been called up to replace one of the original squad.

▲ The New Zealand Association hosted a glittering dinner at the Savoy Hotel in London in anticipation of the upcoming tour

The Oxford University and England back-row man Peter Howard was another replacement who pulled out, this time for business reasons, and his place was taken by Manchester's uncapped Howard Jones, who had played in two trial matches that season. Doug Kendrew, a 19-year-old forward from Woodford, replaced Wakefield.

He had won two caps for England before going on tour and just missed out on a Lions Test place through injury. He went on to captain his country, play in the 1935 win by England over the touring All Blacks and become governor of Western Australia. While serving as General Officer Commanding and Director of Operations in Cyprus, he also survived an assassination attempt in Nicosia in which one of his escorts was killed. He became a lieutenant with the Royal Leicestershire Regiment in 1931 and was promoted to major in 1941. During the Second World War, he served in North Africa and Italy in 1943 and served as a Brigade Commander in Italy, Greece and the Middle East between 1944 and 1946. His leadership and bravery saw him achieve the rare distinction of being awarded the DSO four times. The citation for his first award gives a flavour of the man:

Colonel Kendrew took over command of his battalion only a few days before the battle for Sedjenane. But, in these few days he succeeded in bringing out the latent fighting spirit of the officers and men to such a degree that, when fighting the Barantine Regiment in the enclosed country south of the mine, they proved irresistible. Colonel Kendrew controlled the fire support from closely behind the advancing troops. The unit made eight charges with the bayonet in the course of the action, Colonel Kendrew taking part in one of these himself. The success of this action was largely due to his energy, drive and personal example.

The citation for his first bar, for an action at Salerno, in 1943 said:

Finally, when ordered to prevent the destruction of the La Molina bridge, which was heavily defended by the enemy, who had the use of numerous pill-boxes, he planned the attack so well that, not only was the bridge saved but all the enemy in its vicinity killed, captured or put to flight.

Throughout the somewhat critical period in the Salerno area, Colonel Kendrew has shown complete disregard for personal safety and has by his example and drive instilled such a fighting spirit into his troops that they are now prepared to follow him in any operation, however hazardous, with complete confidence.

The citation for his second bar was given for his actions in January 1944 at the River Peccia, Italy:

The task given to Colonel Kendrew's battalion on 5 January 1944 was to cross the River Peccia, clear an area, consolidate and actively patrol, thereby protecting the flank of the United States 6 Armoured Infantry Brigade... Colonel Kendrew's unquenchable spirit on his visits to companies and during periods of ordeal in his headquarters area so encouraged the officers and men that they kept their morale and, when ordered to withdraw at the end of the day, came back through the icy river and further shell fire in splendid spirit.

The battalion captured some 70 prisoners and killed about 50 Germans during the day. The withdrawal was well organised, all enemy weapons were destroyed or brought away and every one of our own weapons, including those of some seventy casualties, were brought safely back. A difficult operation, magnificently carried out. Its success was mainly due to Colonel Kendrew's planning, courage and example.

The third bar came in Korea in 1953, when Kendrew, affectionately known as 'Col Joe', was vigorously praised for how he 'inspired his men to superhuman efforts, and working day and night under constant shelling, somehow they managed

to rebuild the entire position until it became a veritable fortress against which the enemy was powerless'.

While the remarkable Kendrew, who was knighted in 1963, having risen to the rank of major general, rampaged through the Second World War, two of the tour party weren't so lucky and were among three Lions who lost their lives in the 1939–45 global conflict:

Brian Black (Oxford University/England)
Died 29 July 1940 in Wiltshire, aged 37
Lions Career: 20 matches, 5 Tests

Henry Rew (Exeter/England)
Died 11 December 1940 at El Alamein, aged 34
Lions Career: 14 matches, 4 Tests

'Dark Blue' lock Black was a talented all-round sportsman and was one of the British two-man bobsleigh team that won a gold medal at the 1937 World Championship in Cortina. He then clinched a second gold in St Moritz as part of the British four-man bob. He may have been a second row, but he was also one of the best goal kickers of his era, notching 77 points in his 20 games on tour, including six conversions in the big win over Otago. He served in the RAF as a Pilot Officer and died in action over Worcestershire in July 1940.

The second casualty was the Exeter and Blackheath forward Henry Rew. He was a captain in the Royal Armoured Corps (Royal Tank Regiment) who led A Squadron of 7th RTR in Operation Compass in December 1940. The Italians were routed as the British secured Sidi Barrani, taking more than 2,000 prisoners. Unfortunately, Rew, aged 34, was among 56 British soldiers who died or were injured. He had won the first of his ten caps for England in 1929 and was picked to play in the front row against Wales in the 1930 Five Nations Championship opener. But a foot injury forced him to drop out on the morning of the match, leading to an emergency call for Bristol hooker Sam Tucker. So tight was the time for him to get to Cardiff that he flew across the Bristol Channel to ensure he arrived just in time to play in a famous English victory. There were no fewer than 12 of the players on view that day who joined forces in the Lions squad later in the year.

Rew was already in the Army at this stage, as was the England wing Tony Novis, while the Leicester and Irish No. 8 George Beamish was in the RAF. One of four rugby-playing brothers who all served in the RAF – Charles Beamish travelled to Argentina with the 1936 Lions party and also played for Ireland; Group Captain Francis Victor Beamish flew in the Battle of Britain and became a 'fighter ace' who was awarded the DSO plus bar, the DFC and the Air Force Cross before being killed in action on 28 March 1942; Air Vice Marshal Cecil Beamish played rugby for London Irish and was seven times the RAF golf champion – George Beamish was one of the star forwards of the 1930 tour and enjoyed a great career in the RAF. He made 17 appearances for the Lions and was a first-choice pick for all five Tests. A career fighter pilot, he made Squadron Leader by 1936 and three years later became Senior Operations Officer for Palestine and Transjordan. In 1941 he was appointed senior RAF officer on Crete, overseeing the reception of units after their withdrawal from Greece, and was among the last few Brits off the island after staying behind to help evacuate General Freyberg. He eventually became an Air Marshal and was

▲ The Lions squad prepare to depart from Waterloo station (top) and get some scrum practice in on the deck of the SS Rangitata en route to New Zealand

knighted in 1955. He is also credited with leading a delegation to management on the 1930 tour that expressed its displeasure at the lack of Irish representation in the Lions kit. The jerseys were blue with white collars, the shorts were white, and the socks were red with a white turnover top. By the next tour in 1938, a green top had been added to the Lions socks, and has remained ever since.

The tour manager was James 'Bim' Baxter, who had an impressive sporting pedigree and was one of the English selectors. He played three times for England and then went on to become an international referee. He also won a silver medal in the 12-metre yachting section of the 1908 Olympic Games in London. This was one of the more dubious events at the first Games to be held in the UK, as it wasn't held in London, nor even England. With only two vessels entered – the Scottish boat *Hera*, crewed entirely by members of the Royal Clyde Yacht Club, and *Mouchette*, crewed largely by members of the Royal Mersey Yacht Club – it was agreed that the owners should not be put to the trouble and expense of transporting their boats and crews from Glasgow and Liverpool to the Isle of Wight, where the other Olympic races were held. The race for the medals was the best of three, but only two were needed to decide the destiny of the gold medals as, on home waters, the sailors of the *Hera* convincingly won the first two races and took the title.

As the 1930 Lions got onto the train at Waterloo Station on Friday, 11 April, Baxter announced to the touring party that Doug Prentice would take over from Wakefield as captain and that Wilf Sobey would be his vice-captain. The night before, the Lions had dined at the Savoy as guests of the New Zealand Association and received a 'bon voyage' message from the King, which was read out by the Duke of York. The train took them to Southampton, where they boarded the steamship *Rangitata*, and they went via the Panama Canal to the other side of the world, arriving in Wellington Harbour on 14 May.

Prentice, aged 31, was probably past his best at this stage, and took the unusual step of standing down for three of the four Tests in New Zealand. He captained the side in Christchurch and returned to the helm for the single Test in Australia, but he only played in 12 of the 28 games. He went on to become an England selector from 1932 to 1947, was RFU secretary from 1947 to 1962, and managed the 1936 Lions

in Argentina. His England teammate Sobey was one of the geniuses of the game of his era and formed a brilliant half-back pairing with Roger Spong for club, Old Millhillians, and country. They had also played together for the Lions in Argentina in 1927 when they had joined forces in three of the four Test victories. Much was expected of these two, but a knee cartilage injury suffered by Sobey in the opening game meant he never got to play on tour with his pal, and he never played again for the Lions. Spong went on to play in 17 of the 28 games and started in all five Tests. He made a big impression and earned the highest of praise from the legendary New Zealand full-back, George Nepia. In his autobiography, *I, George Nepia*, with Terry McLean, he wrote:

Spong was a great player, very nearly a genius. He was quick, lively, courageous, a fine handler, a nippy runner and a brilliant improviser. I would unhesitatingly rank him among the three or four greatest players I have seen in this vital position. He was so good that he was always a nuisance to us and if he had had the luck always to be served by good scrum halves – it was the major tragedy of the tour, of course, that he lost his club mate, Wilfred Sobey, in the very first match – he might have dictated our defeat... I say this now, advisedly, that had Spong received as swift a service as the New Zealand five-eighth did, we would have lost the series.

The date of the departure meant the seven Welsh players had to miss their country's final game in the Five Nations Championship against the French on 21 April, but there was plenty of rugby ahead of them. The New Zealand Rugby Union had proposed an even more strenuous itinerary than was finally played out, cutting out the midweek fixtures before the Tests following a plea from the RFU committee in October 1929. It was certainly a good idea, but this was only the first of a number of diktats from the RFU to their New Zealand counterparts. No sooner had Baxter and his players landed in Wellington than the battles began.

The first issue was one that engaged the whole of the country, as it quickly became clear there was going to be a clash of colours for the Test matches, with the Lions wearing blue jerseys. Protocol dictated it was the 'home' team's duty to change colour, but given that the 'All Blacks' had worn their famous black shirts with the silver fern in each of their 38 international matches before the tour, the Kiwis weren't happy at the prospect of becoming the 'All Whites'. Under the headline 'Vigorous Protests', the *Evening Post* listed the names of some powerful antagonists: 'Among those who have voiced their disapproval are Mr. J. Richardson, vice-captain of the 1924 All Blacks; Mr. J.R. Bell, vice-captain of the 1925 Native team to England and France; Mr. J.W. Stead, vice-captain of the 1905 All Blacks, and Mr. A.J. Geddes, Southland and New Zealand selector.'

Something had to be done, and Baxter moved swiftly and cleverly. Having spent a day at the New Zealand Rugby Union offices shortly after arriving, he offered an olive branch, as reported by the *Evening Post*:

Mr. Baxter, manager of the British Rugby team, has forwarded the following letter to Dr. Adams, president of the New Zealand Union: 'As the All Black colours appear to count so much to a very considerable section of Rugby players and

supporters in New Zealand, and it is our most earnest desire that not one single jarring note should mar our visit, my team will be only too happy to play in All White in the four Test matches; in all the other games, of course, the usual custom to be observed when the colours clash — i.e. the home team to make the necessary change. I should like to place on record that this offer is spontaneous. No suggestion or even hint has been made by any member of the executive.'

While the Lions hadn't taken a spare kit with them, Baxter's move suggested he was prepared to find one for the four Tests. In the end, it took the host union a week to decide they would do their duty and play in white. Next on the agenda were a number of issues much closer to Baxter's heart, the IRB laws. Ever since their first tour in 1905, where they used their skipper as a 'rover' and bamboozled so many sides with their feed to the scrum, the New Zealanders had generally stayed ahead of the lawmakers. They'd even introduced some of their own 'by-laws', such as permitting teams to go into the dressing-rooms at half-time and even going as far as allowing replacements for injured players. Part of Baxter's mission was to bring the game back together and to try to encourage the proper use and interpretation of the IRB laws.

The *Evening Post*, once again, picked up Baxter's first salvo in their edition of Wednesday, 21 May, the day of the opening match against Wanganui, as they outlined the impact and influence the Lions manager was having before even a ball was kicked:

> *The referee, Mr. H. J. M'Kenzie, of Wairarapa, had a consultation with the manager and captain of the British team before the match, and the differences between the International Board and the New Zealand rules and rulings were discussed. The International Board rules will, of course, apply, and with regard to the mark, the British representatives point out that a mark must be allowed so long as the player taking the ball is on one or both feet and makes a heel mark. This should clear up any misunderstanding.*
>
> *The visitors insist upon the referee taking the time for play, and will not recognise any bell or signal other than that by the referee. They also insist upon the use of only one ball, and did not agree with the practice of having spare balls on the side-line. They would consent, however, to the use of another ball in the event of the one in play being kicked right out of the ground.*
>
> *A British practice with regard to putting the ball into the scrummage is to allow the half-back to indicate the side on which the ball is being put in. They believe in a strict interpretation of the rule relating to a tackle, stating that a player tackled must immediately part with the ball.*
>
> *Concerning the knock-on, they agree that a fumble should be allowed to go without any penalty, but when the ball is actually propelled forward a knock-on should be ruled.*

The next big issues were the role of the wing-forward and half-time intervals. It was the custom in New Zealand for teams to head to the dressing-rooms at half-time and take a ten-minute break. Baxter tolerated this for the opening two matches but then put his foot down, demanding the IRB rule of a mere five-minute break and

▲ A caricature of tour manager Jimmy Baxter, who repeatedly clashed with the New Zealand Rugby Union over the role of the wing–forward

"JIMMY" BAXTER
CHAIRMAN OF THE ENGLISH R.U. SELECTION COMMITTEE
H.H.OWEN

teams not leaving the field be adhered to. That promoted the *Evening Post* to run a cartoon under the headline 'Red Tape Rugby', which depicted the Lions' manager sheltering under a big umbrella, bearing the words 'International Board Rules' while two muddied players continue to get wet in the teeming rain. The caption beneath the cartoon read:

New Zealand and England (during half-time): Er! May we leave the field during the interval, Sir?

Mr Baxter (manager – British team): Certainly not! Don't you realise we are playing under International Board Rules and your dishevelment is part of the entertainment.

Then came what now appears to have been something of a premeditated bombshell dropped by Baxter in the post-match dinner after the opening victory over Wanganui. He had seen his side start well, with a 19–3 victory, but he laid the foundations for a running battle with the New Zealand Rugby Union, and rugby fans throughout the country, by branding the wing-forward 'a cheat'. Baxter followed up those remarks with equally strong sentiments and statements after the win against Taranaki. Cue diplomatic mayhem!

The *Evening Post* reported Baxter as saying in his speech at New Plymouth:

The New Zealand Rugby Union has pronounced against wing-forward play, but has thrown the onus of correcting his malpractices on the referee. With all due deference to the controlling body, it has thrown a tremendous responsibility on the referee. No referee can control a wing-forward who is on to beat him. The referee has too much to do at the pace the game is played to-day.

The onus of correcting the malpractices of wing-forward play is on the clubs. Every club has a committee which picks its players, and if this committee sees any player guilty of malpractice it should be perfectly frank. The ordinary man who tries to play wing-forward is nothing more nor less than a cheat. He is deliberately trying to beat the referee by unfair tactics. The club can say it will not play a man who is deliberately outwitting the referee.

The *Auckland Star* didn't beat about the bush and ripped into the Lions manager:

Mr. Baxter speaks vaguely of the malpractices of the wing-forward. What are they? He is silent on this point. A wing-forward is a player who puts the ball in the scrum for a New Zealand team; the scrum-half does the same for Britain. In theory they act precisely alike until the ball is out of the scrum. It is up to Mr. Baxter to state precisely wherein they differ in practice, or in malpractice.

▲ A cartoon inspired by allegations of biting by members of the Combined Ashburton, South Canterbury and North Otago side — yet another controversy from one of the most dramatic tours in Lions history

Clad in the mantle of the English Rugby Union, and issuing the commandments of that body in a voice of thunder, Mr. Baxter, in his own department, appeals to New Zealanders as the least impressive figure among the British visitors. Hopes are now centred in the team itself. So far it has commanded universal admiration by its admirable sportsmanship and high standard of play. It promises to prove itself a power which may win the honours on the field, and become a persuasive force to bring Britain and New Zealand together in style of play much more surely than will Mr. Baxter's fulminations.

Baxter pointed out that the New Zealand administrators were in violation of the laws of the game, which stated that no player may leave the field of play unless granted in special circumstances. Furthermore, they were allowing the mark when both feet were off the ground. They were also allowing players to appear in advertisements, which gave the British authorities apoplexy – as it continued to do until very recently.

Baxter, being a member of the RFU committee and a prominent member of the International Board, pointed out to his New Zealand counterparts that they were in defiance of the Tour Agreement, which stated that they were to play to the IRB laws.

His one-man crusade centred on New Zealand's seven-man scrum formation, of 2–3–2, and the 'rover' who put the ball into the scrum. He was incensed by the seven-man scrum and it didn't help the situation that the All Blacks skipper, Cliff Porter, played in the 'rover' role. Having put the ball into the scrum, the 'rover' then stayed on his feet to harass the opponents if they won the ball, or to support his own backs, while the scrum-half was at the base of the scrum to collect the incredibly quick heel, which was produced by the formation of a front row of two hookers, a second row of a lock binding them together with a flanker on either side and two back-row forwards. Baxter may have branded Porter a cheat, but in the end he was powerless to do anything about Porter's harassment of the brilliant Lions outside-half, Spong. Porter faced the Lions five times in total and won on four occasions.

The ball would squirt out of the 2–3–2 scrum like a pip out of a lemon as the two hookers swung the outside foot and hurtled the ball back through the lock's legs. That made it essential that the 'rover' put it in and the scrum-half received it. Such a heel had the huge merit of giving the New Zealand backs so much room that it was to develop those world-class inside-backs of the time, Mark Taylor and Bert Cooke.

New Zealand pointed out that the laws never stipulated how many players constituted a set scrum and they did not see why they should discard a method of scrummaging which was not only legal, but which was the one they had adopted ever since the game began organising itself into formations in the 1880s.

The problem was exacerbated as New Zealand had their own rule of not allowing any player to advance beyond the middle of the scrum until the ball was out. As there was no such International Board law, this meant that Porter was able to get at the British halves ridiculously early, to the fury of Baxter who, on his return to England, quickly had the scrummaging laws changed, so that New Zealand had no option but to put three men into the front row.

This meant that, in future, the ball would come back much more slowly to the half-backs, who were also to become easy prey to fast breakaway flankers and so, pragmatically, the All Blacks changed their style to attritional forward play, supported by kicking half-backs and a strong full-back who, preferably, was their goal kicker. We all know how successful they have been in developing their all-embracing forward game which has become synonymous with winning rugby but which, in the aesthetic sense, set rugby back 50 years.

Those opening two games ended in comfortable enough wins for the Lions, 19–3 over Wanganui and 23–7 against Taranaki, and their three tries in the first outing came from their speedy three-quarter line as Novis, Carl Aarvold and Jack Morley raced over. Novis ended the New Zealand leg of the tour as the top try scorer with 12. The Newport and Wales wing Morley scored eight and Aarvold six. If you add in the tries scored by the Harlequins and England wing Jim Reeve (seven), the London Welsh and Wales wing Terry Jones-Davies (eight) and the Cambridge University and Wales centre Harry Bowcott (six), then you see where the real strength of this team lay, as they accounted for 47 of the 82 tries scored in New Zealand.

An interested observer in Wanganui was the captain of the 1908 'Anglo-Welsh' side, 'Boxer' Harding, who gave the *Evening Post* reporter his first impressions of the Lions:

On their form to-day, the Englishmen have the makings of a great side, but we must take into consideration that they are not quite fit yet. The forwards are very good in the scrum, and they work very hard in the tight. One of the features of their play was the way the forwards combined with their three-quarter line. Ivor Jones was the best forward. He has a beautiful pair of hands. It must be remembered when commenting that the back line was disorganised by the accident to Sobey. The backs, when they get together, will, I think, take a tremendous amount of stopping. Football has changed so much since the old days that I would not like to make any comment on the respective merits of Bedell-Sivright's team, the side I captained and the present tourists.

Two wins quickly became four as the Lions began to find their feet, although the Penarth and Wales full-back Jack Bassett wasn't able to play in any of them after spraining an ankle on the boat trip over. He eventually took his place in the game in Wellington and became one of the mainstays of the side, featuring in all five Tests on tour. Those early wins gave the Halifax and England forward Harry Wilkinson the chance to shine, and he distinguished himself by scoring a hat-trick on his Lions debut, against Taranaki. Although he never made the Test team, Wilkinson scored tries in nine of the 12 games in which he played and ended the tour with 14. As the first Test approached, so the games got harder, and there were successive defeats against Wellington (12–8) and Canterbury (14–8). Neither reverse dented the spirit or confidence of the squad, who blended into a very happy, and much admired, group of young men.

Some indication of the middle-class nature of the Lions was the fact that at that time it was necessary, indeed, de rigueur to have a dinner jacket, together with a required sum of £80 spending money, before they could embark on such a tour. The dinner jacket was largely for the five-to six-week return boat journey when, every night, they were required to dress for dinner on board. Consequently, the poorer members of the party, especially the Welshmen, were sponsored by their clubs, which gladly passed the hat round to ensure that their players would not be disadvantaged for what became recognised as a trip of a lifetime, and one which brought great honour to the club which they represented.

I was fortunate and privileged to know Harry Bowcott, whose remarkable memory for all the events of that time remained vivid until he died aged 97 in 2004. Talking to him added enormously to the authenticity of events concerning this tour, because he was able to give me the earliest eye-witness account of the events on a Lions tour.

Harry was a Cambridge Blue who won eight Welsh caps, captained his country and played in all five Tests on tour. He went on to become a Welsh selector and, in the 1974–75 season he became president of the Welsh Rugby Union. He admitted that the earlier Lions tours were elitist because of the very nature of overseas travel and the meeting of different people and cultures. He told me what an extraordinary adventure it was for young men who otherwise could never afford such luxurious travel, and explained the astonishing experience of seeing far-flung corners of the world, all achieved through rugby union football because of the accident of being talented in the sport.

According to Harry, the dominating side of the late 1920s was Scotland, yet they had only one player in the side. He added that the young men of the time had forgotten the war and were optimistic about the future, despite growing unemployment and the fact that jobs were hard to find. The idea of such a tour was as hugely exciting for the young men of the period, as, indeed, it still is today.

The players had great fun on the boat out to New Zealand. It was just the 29 players and their manager and nobody else: no coach, no doctor, no physiotherapist and, as Harry told me with a smile: Thank goodness, no pressmen, which was a wonderful thing, for we could do as we liked without looking over our shoulders. When we got to New Zealand, we picked up a masseur, whose only qualification was experience.

We were no better and no worse than the young men of today in our behaviour. We drank a bit and enjoyed female company, but we tended to carouse only after matches. Standards of behaviour were left to the individual. I will not say that the manager, Jim Baxter, could not care less, for he was a typical RFU man. It so happened they were all nice people.

The teams were selected by the senior people in the side, including one from each country, and I was the Welsh representative. Scotland, for a number of reasons, had only one man on the tour, Bill Welsh from Hawick, and even after seven months we could not understand what he was saying! So Scotland were not represented in selection.

Any coaching of the Lions, as it was for the next four decades, was left to the captain, Doug Prentice. The Lions' standards and style of play were largely based on the football of the two universities, Oxford and Cambridge, which in those days were immensely powerful. Their adage was 'Let the ball do the work'. Previously, rugby had been more elitist, and Harry explained that more ordinary working-class people went on the 1930 tour.

▼ A ball signed by all 29 members of the touring squad and subsequently donated to the World Rugby Museum

The manager acted as the tour banker, carefully guarding and recording the £80 deposited by each player and, when a pound or two was required, the players went to him. The players also received a tour allowance of three shillings a day subsistence but, in the nonsensical ambivalence concerning amateurism at the time, it was received not in money, but in chits from the manager for, let us say, one shilling or sixpence to be spent in the hotel. Money as hard cash could not be allowed to tarnish the amateur game! This, however, was virtually only pocket-money, for everything was paid for and, in the manner of nearly all Lions tours that one has been on, it was hard to spend a penny in the face of the overwhelming hospitality of New Zealand or South African rugby people.

New Zealand in the 1930s was not a sophisticated place, particularly outside the main centres such as Auckland, Wellington, Christchurch and Dunedin, and many of the players and the spectators arrived on horseback for the matches. The Lions travelled largely by train and they would stop and, in the leisurely manner of the time, take lunch on the platform as the train waited. The shorter distances were undertaken by coach.

There were many keen golfers in the squad, Beamish among the best of them, and provision was made within the Lions' schedule by their hosts to take in the odd round, as the *Evening Post* pointed out in a story regarding the social roster surrounding the Lions' game in Wellington:

KEEN GOLFERS ENTERTAINMENT OF PLAYERS

A number of the members of the British team are keen golfers, and one, G.R. Beamish, is stated to be well above the average. The team is also fond of dancing, and no doubt the various cabaret parties that have been arranged for them during the tour will be well patronised.

The programme of entertainment of the British team proposed by the Wellington Rugby Union prior to the match on 3 June and the following day is as follows:

Sunday, 1 June – Private evenings to be arranged.

Monday, 2 June – Morning practice; afternoon, drive round the waterfront; evening, free (cabaret or pictures if desired).

Tuesday, 3 June – Morning, free; afternoon, match; evening, informal dinner and cabaret for those desiring it.

Wednesday, 4 June – For those desiring it, a day at the Heretaunga golf links; others will be taken for a drive round the other portions of the waterfront; and entertainment at Dr. McEvedy's home at Lowry Bay in the afternoon; evening, leave for Christchurch.

The run-in to the first Test saw the Lions having to tackle three of the major provincial sides, starting with Wellington. Porter was the local captain and among five current All Blacks. A great game and thrilling contest, in which Spong once again stood out, ended with the home side inflicting the first defeat on the tourists 12–8, a Porter drop goal proving the difference between the two teams. The 30,000-strong crowd loved every minute of the victory and carried their local heroes shoulder high off the field at the end. Not to be outdone, Canterbury, boasting nine internationals, made it two defeats in a row with their 14–8 triumph. The power of the better packs was causing the Lions difficulties and they needed to get back to winning ways before meeting the full might of New Zealand rugby in Dunedin. A seven-try romp, including a hat-trick for full-back Jones-Davies, paved the way for a 34–11 win over West Coast-Buller before the Test team was given a dress rehearsal at the same Carisbrook venue at which they would face the All Blacks the following week.

Things couldn't have gone better for stand-in skipper Aarvold and his team. They scored seven tries, Black converted six of them, and the Lions ran out 33–9 winners over Otago.

The same team was given a vote of confidence for the first Test, and the All Blacks, or 'All Whites', were soon three points down. Spong kicked diagonally into the arms of Reeve, who beat George Hart and scored his fourth try at Carisbrook following his hat-trick a week earlier. The score stood at half-time, when the home side were denied their cup of tea in the dressing-room by the wrath of Baxter and merely withdrew to the touchline. The snow and hail that fell merely exacerbated the situation. New Zealand, however, quickly scored after the restart, when Hart went over in the corner from a sweeping three-quarter movement, but George Nepia hit the upright with the conversion. With the game drifting towards a draw, the Lions were defending desperately when Ivor Jones intercepted a pass from Jimmy Mill intended for his half-back partner Herb Lilburne. Jones sped up to halfway, where he found Nepia waiting for him. The great Nepia, who had a reputation for mesmerising attackers, couldn't stop the Welshman passing out of the tackle to the supporting Morley, who raced to the corner to score the winning try right on the final whistle. The Lions had won a Test match in New Zealand for the first time, but, as many a side has found to its cost, the All Blacks regrouped and made sure it would not happen again in that series.

New Zealand made four changes for the second Test, dropping their half-backs and introducing the diminutive Auckland half-back Merv Corner for his international debut on his 22nd birthday for what was to become the first of four wins for him over the tourists. The Lions brought in the captain, Prentice, for Hodgson in the pack, and Novis replaced the injured Reeve on the wing. There had been record receipts of £4,200 in Dunedin from the capacity crowd of 27,000, and 3,000 more turned up for the second Test at Lancaster Park, Christchurch. The Lions had won their two games between the Tests to gather even greater momentum, but they fell behind to a goal from a mark by Corner's half-back partner Mark Nicholls. The Lions hit back with a try by Aarvold after Prentice had had a score ruled out. Some slick passing, and a neat break by Morley, allowed the classic English centre to cross for a try, which Prentice converted. George Lucas and Porter then made a try for Hart, which Nicholls converted for New Zealand to regain the lead, which they kept until half-time. But the critical moment in the game came after half an hour, when the Lions

▼ A scrapbook showing images from the first Test, which saw the Lions – despite a superb try from New Zealand winger George Hart – claim a 6–3 victory

scrum-half Paul Murray dislocated his shoulder and had to leave the field. For the rest of the game, Ivor Jones showed his remarkable versatility by filling in at scrum-half.

In the second half, a Nicholls break paved the way for his wing, Don Oliver, to score in the corner, and Nicholls converted most handsomely from the touchline. The Lions had the last word with a try made by a tremendous break by Ivor Jones; Aarvold was up, changed direction and scored a magnificent try with a 40-yard run. This try, rated as one of the finest seen on this historic ground, was converted by Prentice, but New Zealand grimly held on to their 13–10 lead to win the match. The tourists believed that, had they not lost a man, they would have won. If only they had adopted some of the local law variances, things might have been different!

New Zealand again changed their back division for the third Test, and the Lions were forced to bring the uncapped Cardiff scrum-half Howard Poole into their side for the injured Murray. Baxter appealed for a scrum-half replacement and was finally granted permission to try to track down the 1924 Lions tourist and former England No. 9, Arthur Young. He was in India, but because it had taken so long to agree on who would pay for the extra man, he never did make it to New Zealand. The fit-again Hodgson replaced Prentice and the recovered Reeve was restored to the wing in the only other changes to the Lions line-up.

As the series was so close, a record New Zealand crowd packed into Eden Park, Auckland, as the Lions won the toss and opted for the sun at their backs in the first half. They opened the scoring with a try after 13 minutes, when Bowcott made a brilliant break to score under the posts for the ubiquitous Ivor Jones to convert. New Zealand responded with a well-executed try by Lucas, who gathered a clever kick by Nicholls and went in under the posts for Archie Strang to convert and level the scores to 5–5 at half-time.

Although the Lions forwards were on top in the tight, they were being outplayed in the loose, where Walter Batty and the newcomer, Hugh McLean, were outstanding. A Nicholls interception made the next try for McLean and the All Blacks went further ahead with a drop goal by Nicholls. McLean scored a second try from a forward drive and New Zealand, at 15–5, seemed to have matters in hand as the rain began falling. The Lions, however, continued to move the ball and Aarvold, showing a fine turn of speed, scored under the posts and Black converted. In spite of this, the All Blacks kept a firm grip on the remaining few minutes, but at least the

▲ Newspaper articles proclaimed a 'Clean Cut and Decisive Victory' after New Zealand's 22–8 triumph in the final Test handed the hosts the series

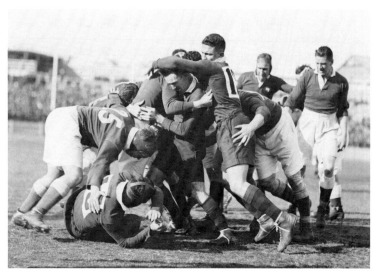

Newspapers applaud the Lions' victory over New South Wales

Australia snatched a 6–5 win in the final Test of the tour

Lions had the satisfaction of seeing their splendid outside-half, Spong, adjudged the best back on the field, with his speed and elusive swerving which seemed to take him through impossible openings. He would later be described as the 'British Bradman of Rugby Football' on the Australian leg of the tour. Other Aussie newspaper critics nicknamed him 'Slippery Spong' and one was moved to describe him as 'the greatest Roman of them all'. High praise indeed!

Two weeks later, the final Test pulled another record crowd to Athletic Park, Wellington, where New Zealand made only one change, Lilburne returning for the unavailable Nicholls. The Lions simply ran out of steam in the face of a vigorous set of home forwards and the All Blacks clinched the series 3–1 by running in six tries in a comfortable 22–8 victory. It was a rather one-sided ending to an otherwise closely fought series. The New Zealanders had finished their great era of the 1920s in some style, but they were still disgruntled by the actions of Jim Baxter, who, they said, had great influence in the halls of power, and who, whilst in New Zealand, plotted to outlaw their roving wing-forward and their scrum formation. This soon came about, with changes to the scrummage offside and hooking laws in 1932, which, at the time, was seen as being a disadvantage for New Zealand.

There were six official games to follow in Australia and a couple of 'fun' fixtures at the tail end, against Western Australia and Ceylon. New South Wales were put to the sword in a masterly six-try performance in the opening game in Sydney, but a week later at the same Sydney Cricket Ground venue, and against nine of the side they had thumped 29–10, the Lions went down 6–5 to a Wallabies side inspired by their former Oxford University Rhodes Scholar Tommy Lawton.

'This is a red letter day for Australian Rugby,' Lawton said at the post-match dinner, which was reported in the *Brisbane Courier*. 'I was only a small boy when the last British team was here. Everyone has been saying what a lot of good these visits do. But don't you think they are too far apart? Twenty-three years is a long time.' It had been even longer since the Wallabies had beaten the Lions, in the first Test in 1899, and it would be another 59 years before they would taste victory again.

Queensland were beaten comfortably enough and then there was revenge of a sort against an Australian XV. Unfathomably, despite the presence of nine of the team who had played in the Test in Sydney, the game wasn't given international status and so the Lions' 29–14 victory was somewhat hollow. That was the last high of the tour and the final few weeks seem to have been a few games too far. The return fixture with New South Wales turned into a disaster, with the home side running in six tries this time to secure a 28–3 win, and then the Lions were forced to come from behind at the Melbourne Cricket Ground to rescue their pride against Victoria. Down 21–17 at half-time, they eventually ran in ten tries to clinch a 41–36 win. They conceded eight, three of them to Wallaby centre Dave Cowper.

RESULTS OF THE 1930 LIONS IN NEW ZEALAND AND AUSTRALIA

P 28 W 20 D 8 L 0 F 624 A 318

Wanganui	W	19–3	East Coast, Poverty Bay &	W	25–11
Taranaki	W	23–7	Bay of Plenty		
Manawhenua	W	34–8	Auckland	L	6–19
Wairarapa-Bush	W	19–6	New Zealand (Auckland)	L	10–15
Wellington	L	8–12	North Auckland	W	38–5
Canterbury	L	8–14	Waikato, Thames Valley & King County	W	40–16
West Coast-Buller	W	34–11	New Zealand (Wellington)	L	8–22
Otago	W	33–9	Marlborough, Nelson & Golden Bay	W	41–3
New Zealand (Dunedin)	W	6–3	New South Wales	W	29–10
Southland	W	9–3	Australia (Sydney)	L	5–6
Ashburton, South Canterbury &	W	16–9	Queensland	W	26–16
North Otago			Australian XV	W	29–14
New Zealand (Christchurch)	L	10–13	New South Wales	L	3–28
Maoris	W	19–13	Victoria	W	41–36
Hawke's Bay	W	14–3	Western Australia	W	71–3

DOUG PRENTICE'S 1930 LIONS TEAM

FULL-BACKS			FORWARDS		
J.A. Bassett	Penarth	Wales	G.R. Beamish	Leicester and RAF	Ireland
G. Bonner	Bradford		B.H. Black	Oxford University	England
			M.J. Dunne	Lansdowne	Ireland
THREE-QUARTERS			J.L. Farrell	Bective Rangers	Ireland
C.D. Aarvold	Headingley	England	J.McD. Hodgson	Northern	
H.M. Bowcott	Cambridge University	Wales	H.C.S. Jones	Manchester	
	and Cardiff		I.E. Jones	Llanelli	Wales
R. Jennings	Redruth		D.A. Kendrew	Woodford	England
T. Jones-Davies	London Welsh	Wales	S.A. Martindale	Kendal	England
J.C. Morley	Newport	Wales	H.O'H. O'Neill	Queen's University, Belfast	Ireland
P.F. Murray	Wanderers	Ireland	D. Parker	Swansea	Wales
A.L. Novis	Blackheath and Army	England	F.D. Prentice (capt.)	Leicester	England
J.S.R. Reeve	Harlequins	England	H. Rew	Exeter and Army	England
			W.B. Welsh	Hawick	Scotland
HALF-BACKS			H.J. Wilkinson	Halifax	England
T.C. Knowles	Birkenhead Park				
H. Poole	Cardiff				
W. Sobey	Old Millhillians	England			
R.S. Spong	Old Millhillians	England			

1938 TOUR KIT

1938
PRIDE RESTORED

Captain: Sam Walker (Instonians and Ireland)
Squad Size: 29
Manager: Col. Bernard Hartley (England)
Assistant Manager: Hamilton 'Jack' Haigh-Smith (England)

Tour Record:	P 24	W 17	D 0	L 7	F 414	A 284
Test Series:	P 3	W 1	D 0	L 2		

As the war clouds began to billow again over a divided Europe, the Four Home Unions squeezed in one more tour to South Africa in 1938. It was the year when Neville Chamberlain promised 'peace for our time' as Hitler was welcomed into Austria, and Sigmund Freud fled the Gestapo and came to London. General Franco's troops pushed the Spanish government forces back to Catalonia, the Moscow show trials ended in the execution of 18 commissars and the Japanese bombed Canton.

In America, Disney released the first full-length feature cartoon, *Snow White and the Seven Dwarfs*. The Anglo-Italian agreement was signed, and the Marquis of Bute sold half the city of Cardiff for £20 million in the biggest property deal in British history. Football pools were condemned as a menace and Joe Louis KO'd Max Schmeling in a one-round revenge bout to regain the world heavyweight boxing title.

Like Joe Louis, South Africa were now the champions of the world, having beaten New Zealand and Australia the previous year on their remarkable five-month tour of Australasia that saw them lose twice in 26 matches. The 1938 Lions had the usual problem with non-availability of players and, once again, many leading players and personalities were all left at home. Writing for the South African rugby magazine *The Outspan*, Major Teddy Wakelam said:

One cannot help opening this trailer to the forthcoming tour of a British rugger side on a note of regret – regret that through business and other reasons we are unable to send out the real, full force of our rugger representation. I do not, in point of fact, consider that the game in our islands is at the moment at a particularly high peak, but our recently concluded international programme has clearly indicated at any rate we have plenty of latent scoring power and, alas! our most brilliant gap makers and

▼ An invitation to join the 1938 tour from the RFU, with the date in the letterhead amended by hand

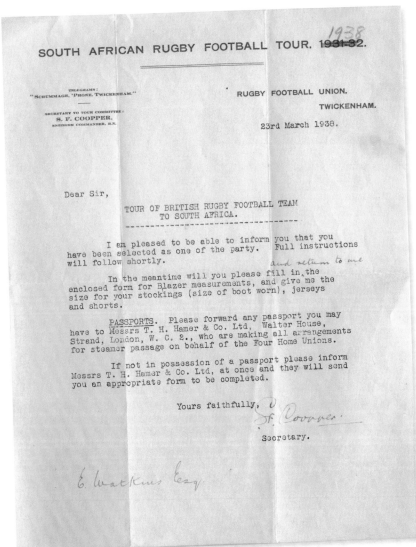

runners-in, men like R.W. Shaw and R.C.S. Dick, of Scotland, W. Wooller and Cliff Jones, of Wales, and F.G. Morgan, the sprinter from Ireland, have all had to be omitted. Many sterling forward names are missing too – H.B. Toft, the English hooker, who has secured almost a monopoly of the ball in the three big games this year, his fellow front row stalwarts, R.E. Prescott and the veteran R.J. Longland, T.F. Hoskisson, W.H. Crawford, D.L.K. Milman and W. Vickery – in fact, one could write down a representative team of those staying behind! It is a great pity, but with business and so on as it is an unavoidable one.

He could, and should, also have mentioned the English three-quarters Peter Cranmer and Hal Sever, leaving the Lions' selectors with a whole team of candidates they couldn't consider. The 1930 Lions manager, Jim Baxter, chaired a selection panel that included assistant manager Jack Haigh-Smith and Baxter's successor as manager, Bernard Hartley, who had turned down an invitation to be considered for the 1903 Lions tour to South Africa as a player on the advice of his father, who was more concerned about his son's business interests than his rugby. The squad was announced on 18 March by the secretary of the RFU, but by the time they gathered in London on 20 May five of the original squad of 29 had withdrawn. It meant a recalculation of the numbers, and England ended up with nine representatives, Ireland and Wales eight each and Scotland four. The average age of the squad was 25, there were 15 backs and 14 forwards, and they had a mere 18 caps between them – and the party contained only two married men in Dancer and Jones!

▲ Each invitation was accompanied by a form in which the players were to note their measurements ahead of being supplied with their playing kit and blazer

◄ The 1938 squad was a particularly youthful one but was expertly led by Instonians prop Sam Walker

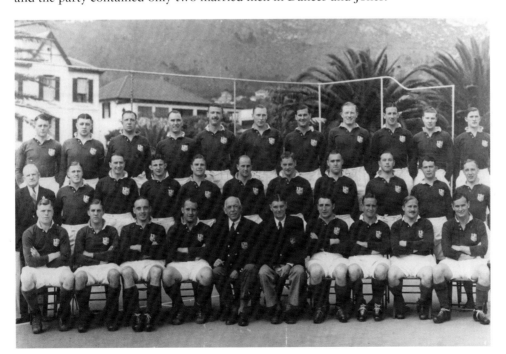

Sam Walker, the Ulster and Ireland front-five forward, was given the task of leading the sixth British & Irish Lions tour to South Africa, but he was unable to end a gap of 42 years since the Lions had last won a series against the Springboks. Despite the notable absentees, no fewer than 23 of the 29-strong squad were capped players, the odd ones out being Cardiff flanker Ivor Williams, Old Birkonians No. 8 Bill Howard, Old Cranleighans lock Stan Couchman, Coventry back-five player Arthur 'Griff' Purchas, Bedford prop George 'Beef' Dancer up front and the Llanelli flyer Elvet Jones behind the scrum. Three of them, Howard, Dancer and Jones, played in Test matches. Purchas, Dancer and Howard were late additions at forward for William Inglis, Tommy Kemp and Eddie Watkins, while Charles Grieve replaced George Roberts and Elvet Jones took over from John Ford among the backs.

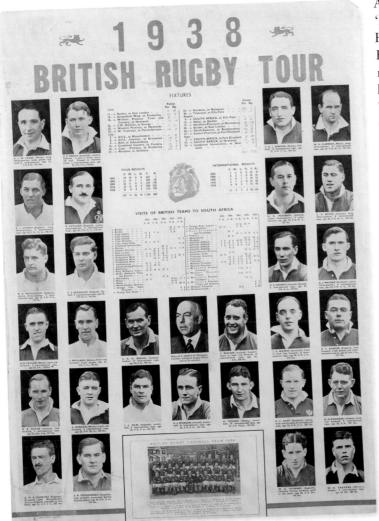

A promotional poster profiling all members of the 1938 squad. With an average age of only 25, it was one of the youngest of the early Lions tours

There were some considerable personalities in the side who became famous characters in the game, such as Haydn Tanner, who was my first captain when I played for Wales in 1949. I would have no hesitation in putting him forward as one of the very finest scrum-halves of all time. There was Viv Jenkins, who became a notable writer on the game, and Jeff Reynolds, a delightful man and an elegant outside-half who became a hotelier in Cape Town, and whose home I often visited on my many visits to the Cape.

There were Harry McKibbin and Bill Clement, both of whom were destined to become respected administrators in their respective countries, Harry becoming a member of the IRB and president of the Irish Rugby Football Union in its Centenary Season, while Bill became secretary of the Welsh Rugby Union. Stan Couchman, too, became president of the RFU.

McKibbin's co-centre, Duncan Macrae, was another classy centre. Because of the usual casualty list sustained on tours of South Africa, the reserve scrum-halves were important, and here Jimmy Giles of England and George Cromey of Ireland, were to do well, and both played a Test match because Tanner was out of action for much of the time. The question of taking three scrum-halves was found to be flawed on the next trip to South Africa in 1955. The durability of the English duo Dickie Jeeps and Johnny Williams meant Trevor Lloyd spent most of the tour kicking his heels. Therefore, once quick replacement by air was possible, the selectors began to pick only two.

The England centre Basil Nicholson joined the tour late because he was taking his final engineering exams and he only arrived in South Africa in time to make his Lions debut in the eighth game of the tour against Orange Free State. He managed to

play in the second Test and went on to put his engineering skills to good use after being commissioned to the Royal Engineers in the Second World War. The Royal Engineers took care of constructing ports and installations during the conflict, and Nicholson, who progressed to the rank of lieutenant colonel and group commander, was actively involved in the planning of the Normandy Landings.

There were a number of members of the tour party who had distinguished wars. The Irish wing Vesey Boyle earned the Distinguished Flying Cross (DFC), and Welsh wing Clement and Scottish centre Macrae were both awarded the MC. Then there was the remarkable Ulsterman Blair Mayne.

Lieutenant Colonel Robert Blair Mayne was a combination of hellraiser, rebel, combatant and hero, all, it seems, in equal measure. There was no question he was the hard man in the Lions pack – he had been the Irish Universities heavyweight boxing champion while studying law at Queen's, in Belfast – who was revered by his fellow tourists. His performance in the second row alongside his skipper in the third Test was pivotal in one of the greatest of all Lions Test triumphs. He lived and played hard and many suffered at his hands during the Second World War as he took the fight to the enemy, often behind their own lines, as one of the most influential and courageous members of the newly formed SAS. Many people credit Mayne as being one of the founding fathers of the regiment with the motto 'Who Dares Wins'. It was a phrase that perfectly suited Mayne's attitude to life on and off the rugby pitch.

The list of honours he accrued from his distinguished service with the Royal Ulster Rifles and the SAS is outlined on a special website compiled by the Blair Mayne Association, which continues to campaign for the great man to be awarded the VC for which he was recommended. Quite why he merely received a third bar to his growing collection of DSOs remains a mystery. Many have connected the downgrading of the VC recommendation to Mayne's attitude to senior officers. More than 100 MPs from both sides of the House of Commons, as well as thousands of backers from all over the world, have joined a campaign to have his heroics recognised by an upgrading to the VC. The fight continues for Blair Mayne more than 50 years after his untimely death in 1955, in a car accident in the early hours of the morning a few hundred yards away from his home in Newtownards. He was 40 and was working as a solicitor. There is a statue erected in his honour in the centre of his home town.

VC or no VC, it is a fact that Lt Col. Mayne remains one of the most decorated Allied soldiers from the Second World War. The citation for his first DSO gives a flavour of the man:

At Sirte on 12/13 December this officer was instrumental in leading and succeeded in destroying with a small party of men, many aeroplanes, a bomb dump and a petrol dump. He led this raid in person and himself destroyed and killed many of the enemy. The task set was of the most hazardous nature, and it was due to this officer's courage and leadership that success was achieved. I cannot speak too highly of this officer's skill and devotion to duty.

The citations that achieved three bars for his original award are progressively more dangerous and remarkable. How he lived to tell the tales beggars belief, as do the number of German fatalities he inflicted. He was also honoured by the French, who awarded him the *Croix de Guerre* with palm and the *Légion d 'honneur*. There were a few early signs of his love of adventure on tour in South Africa, where he would head down to the quayside bars with his great friend Bunner Travers in tow

➤ The squad pose for a photo on board the Stirling Castle, a luxurious vessel which offered the Lions ample opportunities to hone their fitness ahead of the tour

and engage the locals in bar-room brawls. He also surprised Walker the night after the win over Natal by returning to the team hotel with a 'buck' wrapped around his ample shoulders: the spoils of a shoot with some local farmers. Of all the players who have played for the Lions down the years, Mayne stands out as arguably the most charismatic and courageous, a man of action who always made things happen.

All bar Nicholson met at the Hotel Victoria, London, on Thursday, 19 May, and eventually, on Saturday, 21 May they left Waterloo Station to head to Southampton. They were given a special 'send-off' lunch by the management of the Union Castle Line before they eventually set sail on the company's flagship vessel, the Belfast-built *Stirling Castle*, at 4pm. In keeping with their modern-day, professional counterparts, they travelled first-class and found the swimming pool and gymnasium on board a huge help in keeping off the pounds as they prepared for their 24-match trip. They received three shillings a day to spend on board and went through a 90-minute training regime each day to stay in shape.

En route to South Africa, a six-man tour committee had been formed, comprising the management, Hartley and Haig-Smith; the captain, Walker; his newly appointed vice-captain, Jenkins; England's Jim Unwin and Scotland's Jock Waters. This effectively became the selection panel for the tour. After almost two weeks at sea, the tour party arrived at Cape Town on Friday, 3 June, after a single stop in Madeira, and stayed off-shore that night in Table Bay. They retained

▼ A programme from the tour match against Western Transvaal, which saw the Lions claim a 26–9 victory

their cabins on board because they still had a further 569 miles to sail around the coast before they reached East London, via Port Elizabeth, for their first game. The match against Border was still a week away, but it must have felt fantastic for the players to actually be running on dry land when they finally got through the inevitable welcome luncheon, with more than 200 guests, at the Cape Town City Hall and then headed to the Green Point Track. They were able to go ashore in Port Elizabeth for two more interim training sessions on 5 and 6 June before disembarking for good at East London on Tuesday, 7 June.

Four days later, Walker led his team into action in front of a 10,000-strong crowd. It was eventually a try from Unwin that brought the Lions their first points of the tour and paved the way for an 11–8 victory. Walker's men had not only got off to a winning start, but had also trialled the 3–4–1 scrum formation that was favoured in the southern hemisphere. It had been used by Wales during the Four Nations Championship, but all the other countries had continued with the more traditional 3–2–3 formation.

The itinerary in the early part of the tour wasn't favourable to the Lions. Having been able to spend six nights at the King's Court Hotel, they faced an agonising 26-hour train journey to Kimberley for their second fixture against Griqualand West. The journey was just over 500 miles, but at an average speed of 20 mph it was torturous. Better planning by their hosts could have saved a lot of travelling in those early few weeks, but, instead, the Lions seemed to take the longest possible way to anywhere. From Kimberley they went back to Cape Town on a mere 24-hour train journey, then on to Oudtshoorn and back to Cape Town before heading north to the Transvaal.

The Griquas were comfortably dealt with, but eight Springboks lay in wait in the Western Province Town & Country XV for the third assignment of the tour. The Lions rose to the challenge and were 5–3 to the good at half-time, but eventually went down to the first of their tour defeats. The tourists scored two tries to their powerful hosts' one, but this was the first time the Lions had come into contact with Gerry Brand. The big-kicking full-back became a real thorn in the side of Walker's team and ended with three victories before injury struck. His wide-angled penalty with the last kick of the game gave the home side an 11–8 victory, and the following weekend, back at Newlands, he scored nine points in a convincing 21–11 win for Western Province. He captained both teams and was unsurprisingly one of the first names down on the team sheet for the Springboks for the first Test.

There was only one more defeat before the first game in the three-match Test series, a 16–9 reverse against Transvaal, but that was avenged the week before the opening date with the Springboks to leave the Lions in pretty good shape going into the series.

▲ A scrapbook containing the match report from the Rand Daily Mail on the Lions' 17–9 victory over Transvaal

There is always an argument about which was the best Springboks team to represent South Africa. The choice was between Benny Osler's 1931 team in Britain and Ireland, which won all four Tests against the home nations; the 1937 team which won four out of five Tests in Australasia; the 1951 team to Europe, which won all five Tests; or Avril Malan's team, which lost only against the Barbarians at Cardiff. To those amateur sides you now have to add Francois Pienaar and John Smit's Rugby World Cup-winning teams of 1995 and 2007. It is, in my view, almost impossible to arrive at a just verdict, because there are too many factors to allow a valid comparison. Suffice to say, these were all teams of the highest quality, whose credentials were impeccable.

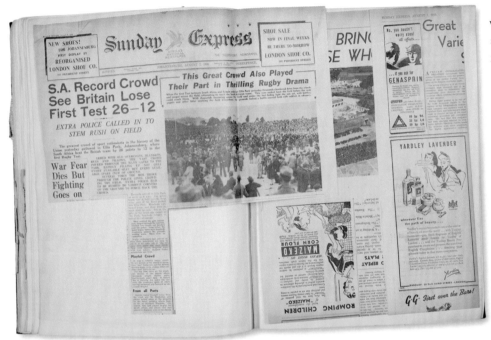

Therefore, the 1938 Lions were taking on a Springboks side of immense quality which, in 1937, had been said by the New Zealanders to be the best team ever to leave New Zealand. Those Springboks, on their triumphant tour of Australasia the previous year, had failed by only two matches to become invincible. They lost one match in each country, losing to New South Wales by 17–6, and to New Zealand in the first Test by 13–7. They returned to South Africa as champions of the world, a title they were to hold until 1955, when the Lions drew the series two-all.

Walker's men were taking on not only some of the best South African players of all time, but also some of the best rugby brains they had ever produced. These included the now legendary Danie Craven, who was to captain the team, and Boy Louw, the most-capped Springbok of his time and one of the greatest of all South African forwards.

Craven went into the first Test with 11 members of the side that had beaten the All Blacks 13–6 in Christchurch 11 months earlier in their last Test outing. That win had clinched the series in New Zealand 2–1 and left the Springboks wearing the unofficial crown of world champions. Brand had been the lynchpin of the side in Australia and New Zealand, scoring a record 209 points on the tour. His 14 points against the Lions in the first Test took him over 300 for his country in what was to be his final appearance for South Africa. It was some send-off – an injury in the build-up to the second Test forced him to miss the remainder of the series – as he converted all four Springbok tries and added two penalties for a match-winning haul of 14 points in a 26–12 win at a packed Ellis Park.

A record gate of 36,000 turned up and some fans had to sit around the pitch perimeter because it was such a crush. The match lived up to expectations, producing fast and thrilling rugby which delighted the crowd, who afterwards agreed that it was one of the best Test matches ever witnessed in South Africa.

The first of the Lions' four penalties, kicked by Russell Taylor, put the visitors ahead, and the lead changed hands four times before the Springboks emerged with a 13–9 interval advantage. The kicking from the two full-backs, Jenkins and Brand, was a highlight of the game and the first of Jenkins' hat-trick was from a few metres inside his own half. There were two tries among the Springboks' four from their speedy wing Dai Williams, another from outside-half Terry Harris, who became a dual-international when he toured England with the Springbok cricket team, and a fourth from Fanie Louw. Williams was the son of Welsh parents, and he won four of his five games against the Lions and scored three tries.

The disappointment of losing the first Test was compounded by the biggest defeat of the tour, a 26–8 loss to a Northern Provinces XV in Durban. This was no ordinary fixture. The national selectors had picked the team, using the best players from Transvaal, Northern and Western Transvaal, Orange Free State and Natal. The game was a sop to the Natal Union for not staging a Test match and there were six Springboks in the side. Defeat was followed by a string of four successive, and impressive, victories in the build-up to the vital second Test.

The Lions were forced to go into the game without the injured Jenkins, but had Travers back in the front row. Tanner was available for selection and was one of four changes behind the scrum from the first Test. Up front, Travers and Laurie Duff made it a half-dozen alterations. Conditions at Crusaders Ground in Port Elizabeth were perfect for running rugby, but the temperatures soared to an estimated 95 degrees in the shade. The heat took its toll on the Lions, who were easily beaten 19–3 in what Craven always described as the 'Tropical Test'. The Springbok captain's tactics were to hit hard early on, both in the first and second halves. The result was never in doubt as Ben du Toit, Flappie Lochner and John Bester scored tries, with Ferdy Turner adding two conversions and two penalty goals. The only Lions score came from a try at the very end by Duff, who had got up in support of a fine run by Jeff Reynolds.

The Lions travelled from Port Elizabeth to Cape Town by boat, arriving at the last Test with the usual long list of injuries, which meant that the side had a make-do-and-mend appearance. The Lions had long odds against them and they were the recipients of polite sympathy, but the bulldog breed lived up to its reputation and produced one of those marvellous surprise moments, when the underdog finally has his day. Perhaps it was the presence of eight devil-may-care Irishmen in the team which wrought the miracle.

Furthermore, South Africa played with a strong wind, because the groundsman had told Craven that the wind would drop in the second half. Therefore, when Craven won the toss with his lucky ten-shilling gold coin, given to him by the Mayor of Johannesburg at the start of the series, he took the advantage to run up what was a considerable lead in those days, of 13–3 at half-time. Tries by Turner, which brought up the 500 points scored by South Africa in their first 50 Test matches, and by Johnny Bester and Jan Lotz, with Turner converting the first two, against a first try for the Lions by Elvet Jones, seemed to put South Africa in an unassailable position.

The wind failed to die as predicted and the Lions took full advantage and played with enormous spirit. With Mayne playing the game of his life, the Lions forwards took control, and a converted try by Dancer, followed by a penalty kicked by McKibbin brought them to within two points of the lead. Then Bob Alexander, the Irish forward later killed in the war, added another try and the Lions led by a point. The Springboks regained their lead with a penalty by Turner, but Charlie Grieve then

kicked the last four-point drop goal to be scored in South Africa, which might not have been given had not the Springboks sportingly indicated that it was over, and so the Lions were back in a precarious lead. Duff then hammered his way over for a try and, with the score at 21–16, South Africa were in trouble, especially when the players were told by the referee, Nick Pretorius, that the next scrum would be the last of the match.

The Springboks won the ball and Craven spurted round the blind side and passed to Bester, who put Williams over at the posts for what seemed to be a score to draw the match. The referee, however, ruled that Bester's pass was forward, so the Lions redeemed their pride and scored a famous victory. Walker was carried shoulder-high off the field. An immensely proud Lions skipper told the *Cape Argus*: 'I am overjoyed our lads were able to pull it off and that we were able to win a game which I think delighted the crowd and which I have already been told will be remembered as one of the most exciting international games that have been played in this country. It was just the hard sort of game we like to play in Britain and we enjoyed every moment of it. Speaking for all my boys I can say we were very proud of being able to beat South Africa on this historic ground, which, I understand, is the home of South African rugby. I hope the Springboks enjoyed the game as much as we did.'

It was a result that few at home believed, including, apparently, a reporter at a London news agency who knew a thing or two about rugby. On seeing the result after the half-time score, he took it on himself to change the final score to Springboks 21, Lions 16!

It was a valid query by the sub-editor, for:
• It was the first Lions Test win in South Africa since 1910, nine games previously.
• The victory ended a run of six successive Test defeats for the Lions (three v. New Zealand 1930, one v. Australia 1930 and two v. South Africa 1938).
• It was the highest score in their 36-Test history by the Lions, beating 17 in South Africa in the second Test in 1896 and Australia in the first and second Tests in 1904.
• The Lions scored more points in the second half than they had previously done in a full Test match: 18.

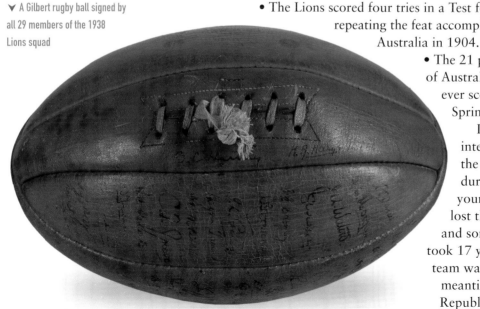

▼ A Gilbert rugby ball signed by all 29 members of the 1938 Lions squad

• The Lions scored four tries in a Test for only the second time, repeating the feat accomplished in the third Test in Australia in 1904.
• The 21 points equalled the record of Australia in 1933 as the most ever scored against the Springboks in a Test.

It was the end of all international rugby between the two hemispheres for the duration of the war. Many young players on both sides lost the best years of their lives and some never came back. It took 17 years before another Lions team was to visit what, in the meantime, had become the Republic of South Africa.

The Second World War saw South African rugby thrown into terrible turmoil, as the pro-and anti-war factions fought bitterly concerning support for the war effort. Clubs like Stellenbosch, Paarl, Gardens, Maitland and Bellville broke away from Western Province, but Griqualand West, who avoided any breakaways, Eastern Province, Natal and Western Province remained loyal to the Crown. Fortunately, although political turmoil was to envelop South Africa until the present day, the wounds of wartime healed and, with the South African Rugby Board acting in the role of peacemakers, rugby adopted the concept of reconciliation and reunification, to become a moderating force in politics.

The Lions had an extra game and week tagged on to their schedule when it was agreed to head home on the *Athlone Castle* rather than the older and slower *Edinburgh Castle*. The fixture against Western Province Country XV was lost 12–7 and the Lions eventually sailed for home on Friday, 23 September, arriving in Southampton on 7 October. It was the end of another great adventure!

RESULTS OF THE 1938 LIONS IN SOUTH AFRICA

P 24 W 17 D 0 L 7 F 414 A 284

Border	W	11–8	Rhodesia	W	45–11	
Griqualand West	W	22–9	Transvaal	W	17–9	
Western Province (Town & Country)	L	8–11	South Africa (Johannesburg)	L	12–26	
South Western Districts	W	19–10	Northern Province	L	8–26	
Western Province	L	11–21	Natal	W	15–11	
Western Transvaal	W	26–9	Border	W	19–11	
Orange Free State	W	21–6	North Eastern Districts	W	42–3	
Orange Free State (Country)	W	18–3	Eastern Province	W	6–5	
Transvaal	L	9–16	South Africa (Port Elizabeth)	L	3–19	
Northern Transvaal	W	20–12	South Africa (Cape Town)	W	21–16	
Cape Province	W	10–3	Combined Universities	W	19–16	
Rhodesia	W	25–11	Western Province Country	L	7–12	

SAMMY WALKER'S 1938 LIONS TEAM

FULL-BACKS			F.J. Reynolds	Old Cranleighans and Army	England	
C.F. Grieve	Army	Scotland	H. Tanner	Swansea	Wales	
V.G.J. Jenkins	London Welsh	Wales				
			FORWARDS			
THREE-QUARTERS			R. Alexander	North of Ireland	Ireland	
C.V. Boyle	Dublin University	Ireland	S.R. Couchman	Old Cranleighans		
W.H. Clement	Llanelli	Wales	G.T. Dancer	Bedford		
E.L. Jones	Llanelli		P.L. Duff	Glasgow Academicals	Scotland	
R. Leyland	Waterloo	England	C.R.A. Graves	Wanderers	Ireland	
H.R. McKibbin	Queen's University, Belfast	Ireland	W.G. Howard	Old Birkonians		
D.J. Macrae	St Andrews University	Scotland	R.B. Mayne	Queen's University, Belfast	Ireland	
B.E. Nicholson	Harlequins	England	M.E. Morgan	Swansea	Wales	
E.J. Unwin	Rosslyn Park and Army	England	A.G. Purchas	Coventry		
			A.R. Taylor	Cross Keys	Wales	
HALF-BACKS			W.H. Travers	Newport	Wales	
G.E. Cromey	Queen's University, Belfast	Ireland	S. Walker (capt.)	Instonians	Ireland	
J.L. Giles	Coventry	England	J.A. Waters	Selkirk	Scotland	
G.J. Morgan	Clontarf	Ireland	I. Williams	Cardiff		

THE EVOLUTION OF THE LIONS JERSEY

From the red, white and blue hoops of 1888 to the classic red shirt that has become one of the most iconic in the whole of sport, the story of the Lions jersey — and the badge that adorns it — makes for a rich and colourful chapter in the history of the game's greatest tourists.

The modern era has witnessed the advent of professional kit managers but the organisers of the groundbreaking if unsanctioned 1888 visit to New Zealand and Australia had no such dedicated support, and only when tour promoter Arthur Shrewsbury had finalised the itinerary of his epic five-month Australasian adventure did he turn his thoughts to what the players would wear.

Shrewsbury wanted 'something that would be good material and yet take them by storm' and the result was a tour jersey featuring horizontal red, white and blue hoops beneath a white collar worn above white shorts and dark socks.

It would be another 62 years before the game's most famous tourists adopted the iconic red shirts with which they are synonymous today but Shrewsbury and the 1888 squad had set the sartorial wheels in motion. In 1891 the Lions embarked on their second foray below the equator, this time venturing to South Africa, now wearing red and white hooped shirts and dark blue shorts. The subsequent 1896 Test series against the Springboks brought no changes to the players' kit but by the time the Lions faced

▲ An 'Anglo-Australian Rugby Football Tour' badge taken from an 1899 blazer

the Wallabies in 1899 – Australia's first international engagement – the squad were sporting shirts with thick blue hoops framed by thinner red and white bands designed to represent the Union Jack. The shorts remained blue as did the socks, which now featured a white flash. When England played Australia in 1999 in the Centenary Test in Sydney to celebrate 100 years of Wallabies rugby, the Red Rose wore an updated version of the 1899 jersey in acknowledgement of the pioneering Lions of the 19th century.

The tourists returned to South Africa in 1903 bedecked in a similar strip to the one they had chosen when they crossed swords with the Springboks seven years earlier. The shirts were once again red and white hoops but, in contrast to 1896, the red bands were slightly thicker than the white.

Continuity was also in evidence in 1904 when the Lions headed to Australia, the squad wearing exactly the same kit as they had five years earlier, but politics precipitated a significant change to the strip when they set off in 1908 for another tour of Australasia.

It was the year both Scotland and Ireland refused to release players for the trip as a result of a bitter row about professionalism. The 28-man squad selected was therefore an exclusively Anglo-Welsh one and to reflect this the Lions opted for a red jersey with a thick white band across the chest. Despite the lack of Scottish players, blue shorts were retained but for the first time the socks were red with a white flash.

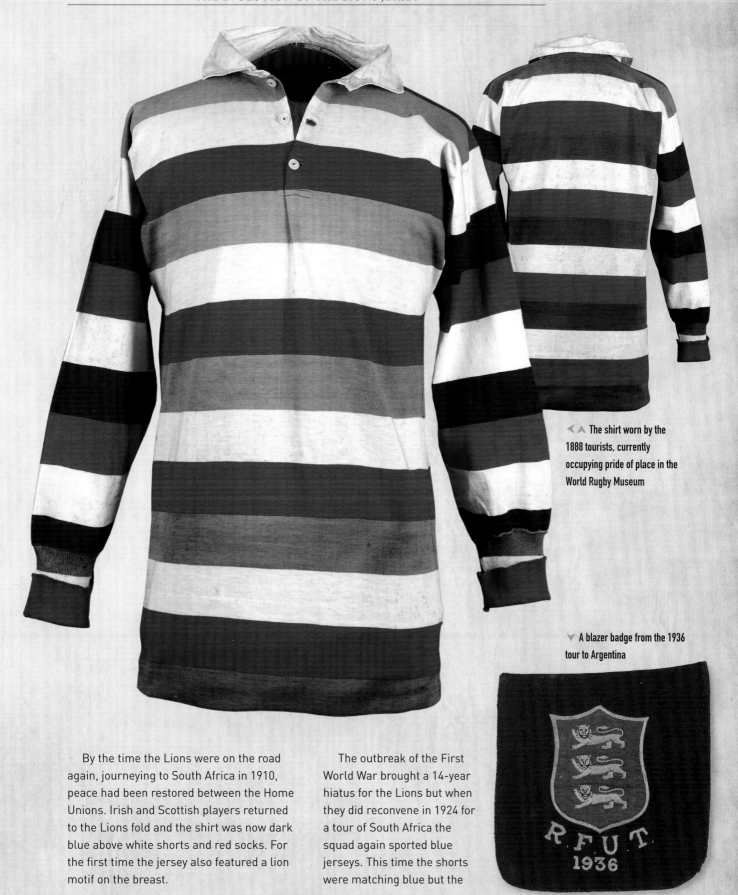

◄▲ The shirt worn by the 1888 tourists, currently occupying pride of place in the World Rugby Museum

▼ A blazer badge from the 1936 tour to Argentina

By the time the Lions were on the road again, journeying to South Africa in 1910, peace had been restored between the Home Unions. Irish and Scottish players returned to the Lions fold and the shirt was now dark blue above white shorts and red socks. For the first time the jersey also featured a lion motif on the breast.

The outbreak of the First World War brought a 14-year hiatus for the Lions but when they did reconvene in 1924 for a tour of South Africa the squad again sported blue jerseys. This time the shorts were matching blue but the

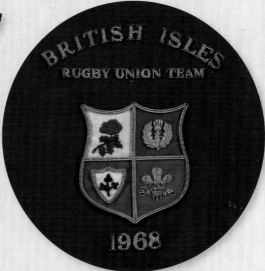

▲ A jersey badge from the 1930 tour to New Zealand and Australia, captained by England and Leicester's Doug Prentice

▲ The jersey badge from the 1936 trip to Argentina, the last before the four-quartered badge was formally re-adopted

▲ By the time of the 1968 tour to South Africa — the infamous 'Wreckers' tour — the iconic Lions badge was firmly established

Lion crest was abandoned and replaced by the four-quartered badge depicting the respective emblems of the Home Nations.

The Lion motif however survived on the players' official tour ties, prompting South African reporters and Springbok supporters to refer to the squad as Lions for the first time in their history.

The blue shirt became standard issue between 1924 and 1950, although the incarnation of the strip for the 1930 tour of New Zealand featured three heraldic lions in preference to the four-quartered badge of six years earlier. However, after an appeal from a delegation led by Ireland second row George Beamish, a green flash was added to the socks to reflect the party's Irish contingent.

The decision to persevere with dark blue caused something of a diplomatic incident in the Test series against the All Blacks. The jerseys clashed with the Kiwis' by now iconic black strip and after much debate the hosts agreed, albeit reluctantly, to play in white to accommodate their visitors.

The only significant change in the Lions' appearance for the next two decades came in 1938 when they re-adopted the four-quartered badge for the visit to South Africa, a decision which has endured to this day, but it was all change in 1950 when they returned to New Zealand. Neither the Lions nor the Kiwis had forgotten the controversy caused by the clash of kits 20 years before. Eager to avoid a repeat, the tourists choose a radical new appearance. The players would run out in red shirts, white shorts and green and blue socks and the modern Lions strip was born. The tourists became intrinsically associated with their famous red shirts but the inexorable move towards professionalism in the 1990s eventually sparked a series of regular redesigns.

It was the 1989 tour of Australia which signalled the imminent arrival of a new chapter in the team's history. Sportswear giant Umbro supplied the squad with 103 jerseys and other kit valued at £30,000 and asked for 'maximum brand exposure whenever possible'. The Lions balked at the suggestion of shirt sponsorship but the pressure to commercially develop the tour was clearly building.

In 1993 that pressure became irresistible and the players who flew out to New Zealand did so with red shirts with the

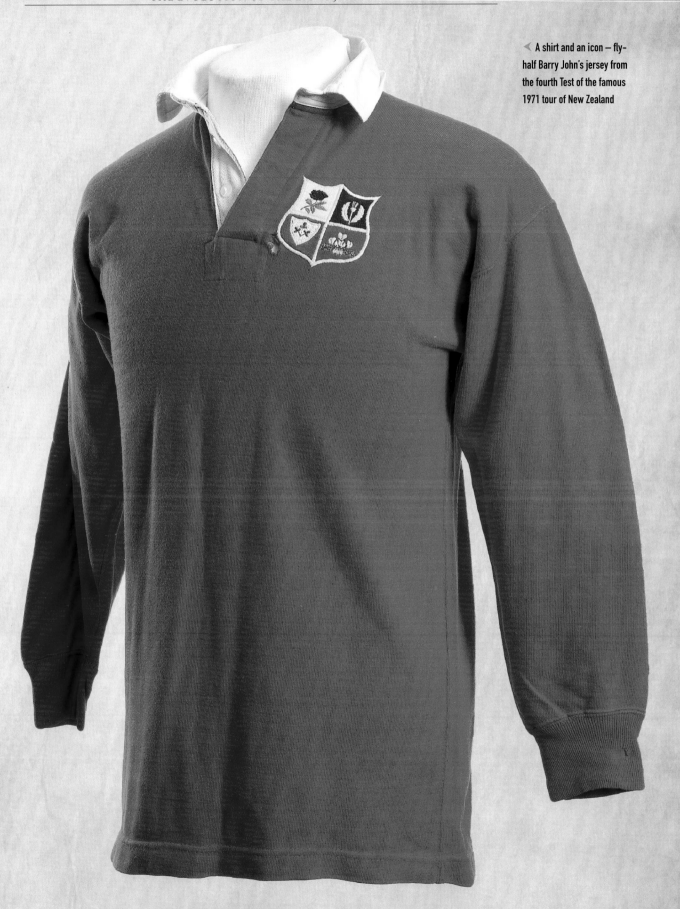

◁ A shirt and an icon — fly–half Barry John's jersey from the fourth Test of the famous 1971 tour of New Zealand

▲ The tradition of adding the year and tour destination to the Lions shirt has proven popular with fans and players alike

▲ A 2001 tour shirt worn by Mike Catt and signed by the entire squad

name of Nike emblazoned in white on the right breast. The company's famous white swoosh was also on show while the tourists' white shorts now sported a black Nike logo on the left thigh. The Lions has entered a new, more commercial era.

It was also the tour on which the shirts first featured the year and country of destination stitched beneath the four-quartered badge.

The death of amateurism in 1995 inevitably brought further changes and the 1997 Lions who journeyed to South Africa were the first of the professional age. The tour saw adidas replace Nike as the official kit supplier but more significantly there was shirt sponsorship for the first time, the name of insurance company Scottish Provident unmissable in large white letters on the players' chests. The shirts also sported adidas' trademark three-stripe motif across the shoulders and down the sleeves while a stitched, golden heraldic lion was added to the right of the collar. It was also the last tour for 16 years to feature a foldable collar.

Four years later communications firm NTL replaced Scottish Provident as official shirt sponsor. Once again adidas manufactured the strip – adding its triangular three-bar logo to its name on the front – while the three-stripe pattern that had adorned the shoulders and sleeves was reconfigured across the biceps.

It was more evolution rather than revolution in 2005 as the Lions prepared to play in New Zealand – adidas were retained as kit supplier but Zurich were the sponsor and for the first time the strip had the company logo as well as name on the chest.

The squad of 2009 that flew the flag in South Africa had HSBC on the front of their adidas shirts. The jerseys were significantly tighter than on previous tours and the white collar had disappeared, replaced by red. The colour was evidently in vogue as three red stripes also appeared on either hip of the team's white shorts.

Both adidas and HSBC were to the fore in 2013 when the tourists registered a series win over the Wallabies, the kit featuring two notable modifications. The iconic red shirt was for the first time actually two different but similar shades of red, subtly combined in a horizontal hoop pattern, while the collar was foldable once again.

British rugby's finest will journey to New Zealand in 2017 wearing shirts sponsored by Standard Life Investments and made by Canterbury, an arrangement which ends the team's agreement with adidas after five consecutive tours. Appropriately, the deal with Canterbury represents something of a historical reunion between the Lions and the sportswear company originally from New Zealand but now based in the UK.

The 1959 squad which toured New Zealand unexpectedly found itself in urgent need of a new strip after their original jerseys were ruined in one of their provincial fixtures and in their hour of need it was Canterbury who stepped forward to supply replacement shirts.

THE KIT ROOM

A selection of the shirts worn by the Lions over the years

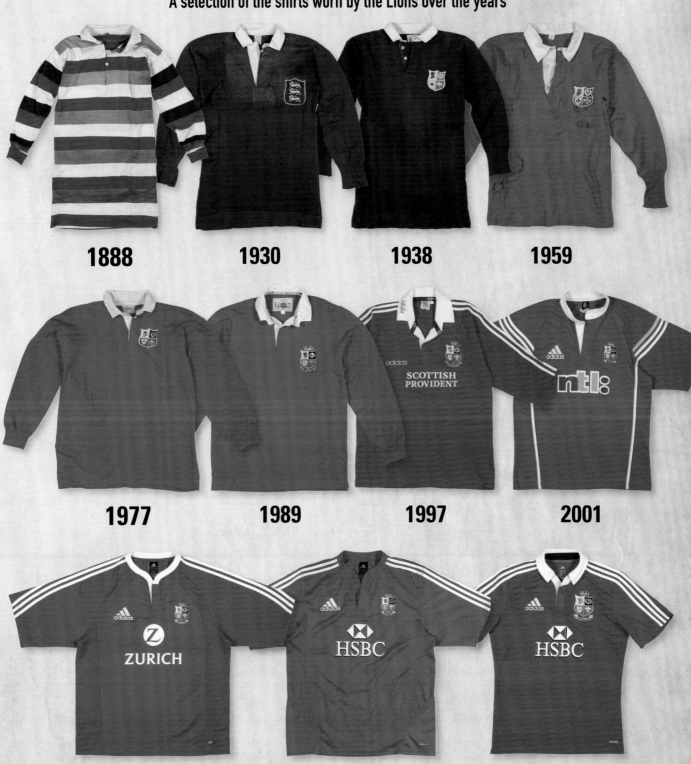

1888 **1930** **1938** **1959**

1977 **1989** **1997** **2001**

2005 **2009** **2013**

4

THE FORGOTTEN TOURS
ARGENTINA 1910, 1927 & 1936

They became collectively known as the 'Forgotten Tours', but the historic, trailblazing Lions trip to Argentina in 1910 lit the blue touchpaper for something that has become totally unforgettable – because it provided the launch pad for the now world-famous Los Pumas and, just over 100 years on, Argentina is now part of the annual southern hemisphere Rugby Championship, with home and away fixtures against Australia, New Zealand and South Africa.

However, the 1910 Lions tour to Argentina is a retrospective term applied to the six-match visit by a side made up of 17 English players and three Scots, later followed by more recognised Lions parties in 1927 and 1936 that together form those 'Forgotten Tours'. The organisers of the 1910 venture named the team the 'English Rugby Union Team' but the host country advertised the touring team as the Combined British – or the Combinado Británico – and the Test on 12 June 1910 was the first international in the history of the Argentine national team with caps awarded.

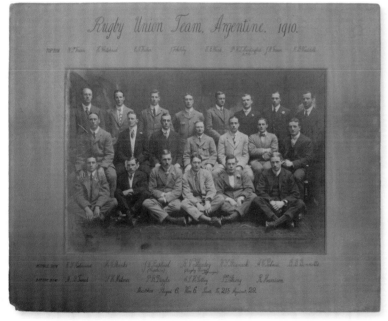

▲ The 1910 squad consisted of 17 English players and three Scots, with the star turn being full-back John Raphael – a prodigiously talented sportsman who earned Blues in three sports at Oxford University

The 11 June edition of *The Standard*, the leading English language newspaper, proudly announced 'this Match is to be played tomorrow, Sunday, at the Sociedad Sportiva, kick-off at 2.45pm. The following are the teams...'

The match ended in a 28–3 victory for John Raphael's 'Combinado Británico', with the 32nd-minute try by Frank de Courcy Heriot, of the Buenos Aires Football Club, the first international points scored by Argentina.

In his book *History of Rugby Union in Argentina from the First Game in the Year 1873*, James McGough wrote:

The most important event in the history of our rugby is, well, the arrival of an English team in the year of the celebration of the centenary of the Republic Argentina.

They did what was expected of them, making an open game and making us highlight clearly the duties of the halves and three-quarters.

The Standard's match report stated: 'Brilliant game [by] Argentina in the first half. The visitors showed a scientific game, clean, strong and [the] backs were efficient in defense and attack. The fullback Raphael made exceptional moves.'

Belgian-born Raphael was capped nine times for England and played first-class cricket with Surrey. Educated at Merchant Taylors', Raphael won his first cap in 1902 when England took on Wales in the Home Nations Championship. A centre, winger or full-back, he also played in the 1905 and 1906 tournaments, as well as in Test matches against France and New Zealand.

Raphael, who was Jewish, played his cricket as a specialist batsman and most of his appearances at first-class level were for either Surrey or Oxford University. He also played first-class matches for the Marylebone Cricket Club, Gentlemen of England, London County and an England XI amongst others.

1910 LIONS IN ARGENTINA

Manager: **Major R.V. Stanley (RFU)**

Captain: **John Raphael (Old Merchant Taylors')**

Alexander Palmer (London Hospital)
Barrie Bennetts (Penzance)
Anthony Henniker-Gotley (Oxford University)
Harold Monks (Liverpool Old Boys)
Horace Ward (Harlequins)
Ernest Holmwood (Blackheath)
William Fraser (Merchistonians)
Edward Fuller (Old Merchant Taylors')
John Ashby (Birkenhead Park)
Robert Waddell (Glasgow Academicals)
Henry Fraser (Merchistonians)
Walter Huntingford (United Services)
Robin Harrison (Northampton)
Whalley Stranach (Guy's Hospital)
Stanley Smith (Cumberland)
Martin Tweed (Guy's Hospital)
Percy Diggle (Oxford University)
Peter Strang (Old Merchant Taylors')
Henry Whitehead (Manchester)

In the First World War, Raphael served with the King's Royal Rifle Corps as a lieutenant and died of wounds in 1917 at the Battle of Messines, while fighting in the country of his birth. In the same year as Raphael and his fellow tourists were making history in Argentina, on a tour organised by R.V. Stanley, more famously known as Major Stanley of Oxford and later an England selector, a Lions side toured South Africa for the fourth time, so Raphael was one of only four Argentina tourists with international experience. An Oxford Blue in rugby, cricket and water polo, Raphael was joined by Alexander Palmer, a New Zealander who played on the wing for England; fellow England wing Barrie Barzillai Beckerleg Bennetts; and England half-back Anthony Henniker-Gotley.

The remaining 17 players were uncapped, but in addition to their Test victory the Lions beat Argentina A 17–13, Belgrano 58–0, Argentina B 39–5, Buenos Aires 28–0 and Argentinos – a team of Argentine-born players – 41–10.

While that final match was against what were known as 'nativos', the Test team was a different matter.

Try-scoring centre Heriot was born in Musselburgh, and lock Frederick Sawyer – a First World War casualty at Aisne – was from Reigate in Surrey. But without a shadow of doubt Barry Heatlie was the star 'home' turn.

Before pulling on an Argentine jersey the No. 8, affectionately known as 'Fairy', was South Africa's fifth rugby captain, winning six caps between 1891 and 1903. He was credited with being the inspiration behind the Springboks wearing green jerseys, which they did for the first time in the final Test of the 1903 series against the Lions. He made 16 appearances against the Lions on their tours to South Africa in 1891, 1896 and 1903.

He also suggested the leaping Springbok as an emblem for their team badge and, in 2009, along with Frik du Preez and Bennie Osler, was inducted into the International Rugby Board's Hall of Fame.

In sharp contrast, the 1927 tour was a much more representative and authentic mix, with players from England, Scotland and Ireland, 15 of whom were either already capped or then went on to represent their countries.

▼ The 1927 tour party was captained by David MacMyn, who later served as president of the Scottish Rugby Union

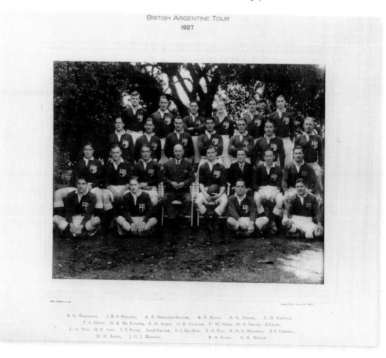

BRITISH ARGENTINE TOUR
1927

1927 LIONS IN ARGENTINA

Manager: Jim Baxter (RFU)

Captain: David MacMyn (London Scottish)

Roger Wakefield (Cambridge University)

Jack Wallens (Waterloo)

Arthur Hamilton-Smythe (Cambridge University)

Rob Kelly (Watsonians)

Edward Taylor (Oxford University)

Carl Aarvold (Cambridge University)

Peter Douty (London Scottish)

George McIlwaine (Cambridge University)

Arthur Allen (Cambridge University)

Granville Coghlan (Cambridge University)

Tom Gubb (Oxford University)

Donald Troup (Oxford University)

Eric Coley (Northampton)

Theodore Pike (Lansdowne)

Douglas Law (Birkenhead Park)

Charles Payne (North of Ireland)

Ernie Hammett (Blackheath)

Jimmy Farrell (Bective Rangers)

Wilf Sobey (Old Millhillians)

Jules Malfroy (Cambridge University)

Roger Spong (Old Millhillians)

Guy Wilson (Birkenhead Park)

▼ Framed badges worn by the Lions and Argentina during the 1927 tour

While the Lions were the winners on the field, the visit was a financial success for Argentine rugby off the field, with four Tests being played at Estadio GEBA in Buenos Aires.

The tourists were captained by London Scottish's David MacMyn, who had a record of 10 wins in 11 matches at No. 8 for Scotland and went on to become president of the Scottish Rugby Union in 1958. Carl Aarvold, or, to be more accurate, Sir Carl Douglas Aarvold OBE, TD, was a key member of the squad. He scored four tries in the second Test and three more in the fourth international as the Lions made a clean sweep of the series with 37–0, 46–0, 34–3 and 43–0 wins, conceding just nine points in the nine matches. An Anglo-Argentinos team was beaten 27–0, with other victories coming 14–0 against Club Atlético San Isidro, 24–0 against the combined team of Gimnasia y Esgrima and Universitario, 44–3 against another combined side of Belgrano Athletic and Buenos Aires Cricket Club, and finally a 29–3 win over a combined club team.

Aarvold was capped 16 times, leading England six times, and in 1930 he toured Australia and New Zealand with a Lions party that saw the likes of Roger Spong, Harry Bowcott, Jack Bassett and Ivor Jones become world stars. Aarvold captained the Lions in three of the four Tests against the All Blacks, scoring three tries for a party managed by his Argentine team manager James 'Bim' Baxter. Three more players from the 1927 tour joined Aarvold and Baxter in New Zealand: Spong, Jimmy Farrell and Wilf Sobey.

Aarvold went on to make his mark worldwide in the legal profession, including presiding at the 1965 trial of the Kray twins. He served in the Royal Artillery, reaching the rank of lieutenant colonel during the Second World War, and was awarded an OBE in 1945 for his war service. He was promoted to be senior judge at the Old Bailey in 1964 and knighted in 1968.

Spong and Sobey had the distinction of being not only products of the famous Mill Hill rugby conveyor belt but also half-back partners from those school days on, with scrum-half Sobey winning five England caps and appointed vice-captain of the Lions. Outside-half Spong was capped seven times by England.

If the 1927 tour to South America was somewhat low key, the 1936 trip was never going to go under the radar, thanks, in particular, to the presence of legendary England wing Prince Alexander Obolensky, the White Russian prince.

A member of the Rurik dynasty, he was born in Petrograd (now Saint Petersburg). The family fled Russia after the 1917 Revolution,

settling in Muswell Hill, London. He scored two tries on his 1936 England debut in a 13–0 victory over the All Blacks, the first time England had beaten New Zealand, and then continued his try-scoring feats in South America. Obolensky was called up to active service with the RAF in 1939. Despite this, he still found time to play rugby, turning out for the joint English and Welsh side that beat their Irish and Scottish counterparts 17–3 at Richmond in December 1939. All proceeds from this match were donated to the Red Cross, as was the case when he later played for an England XV that beat the Welsh 18–9 at Cardiff in March 1940, scoring one of his by now signature solo tries crossing the pitch to touch down.

Away from the pitch, Obolensky found himself posted to 504 Squadron, newly equipped with Hawker Hurricane fighters, and a few days prior to the outbreak of war the squadron was transferred to Digby, using Martlesham Heath as its forward base. It was here that Obolensky was killed in his Hurricane L1946 on 29 March 1940, just three days after his promotion to full pilot officer was gazetted.

Aside from Obolensky, the 1936 squad also included mercurial Scottish outside-half Wilson Shaw and Irish stars Charles Beamish – whose brother George had toured with the 1930 Lions – and Vesey Boyle, Tom Knowles having toured down under with the 1930 Lions. But, prince or no prince, the only way for a touring team to travel was by ship, and the outward journey was made on the Blue Star Line's *Andalucia Star*, a 15,000-ton liner and deluxe mail steamer that six years later was torpedoed and sunk off the coast of Africa by the German submarine U107.

The team travelled first-class and several activities were available on board, including 'race meetings', while normal practice for rugby touring teams was light training, forward drills and team practice on the deck, to keep the players in trim and prime them ready for an arduous tour.

Sailing from London, during the 20-day journey the liner stopped off at Boulogne, Lisbon, Madeira, Tenerife, Rio de Janeiro, Santos and Montevideo before docking at Buenos Aires.

The Madeira stopover saw the party buy a bulk order of Madeira hats, which quickly became adopted as part of the official uniform – something which seemed like a good idea at the time – while the Santos stop in Brazil saw the first bit of action.

In between marathon swimming and sunbathing sessions, a Test was played against Brazil, with Obolensky scoring a reported extraordinary 17 tries during the 82–0 destruction of the Brazilian side. Not surprisingly, that still stands as a world record. However, even this was not enough to convince the selectors to continue their faith in him, and he never played for England again.

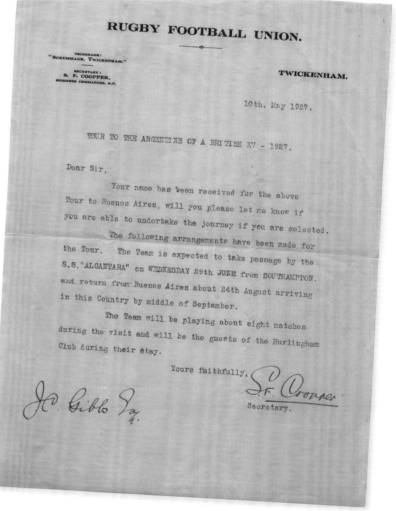

▼ Ahead of the 1927 tour, the RFU contacted players by letter to ascertain their availability and willingness to tour. The letter explains that during the visit the team will be the guests of the prestigious Hurlingham Club

1936 LIONS IN ARGENTINA

Manager: Doug Prentice (RFU)
Captain: Bernard Gadney (Leicester)
Charles Beamish (Leicester)
John Brett (Oxford University)
Vesey Boyle (Dublin University)
John A'Bear (Gloucester)
Owen Chadwick (Cambridge University)
Paul Cooke (Oxford University)
Philip Dunkley (Harlequins)
George Hancock (Birkenhead Park)
Peter Hobbs (Richmond)
Peter Hordern (Gloucester)
Thomas Huskisson (Old Merchant Taylors')
Tom Knowles (Birkenhead Park)
John Moll (Lloyds Bank)
Alexander Obolensky (Oxford University)
William Pratten (Blackheath)
Robin Prescott (Harlequins)
Wilson Shaw (Glasgow High School)
John Tallent (Blackheath)
Harold Uren (Waterloo)
Jim Unwin (Rosslyn Park)
Jock Waters (Selkirk)
William Weston (Northampton)

▼ Scrapbooks of the 1936 tour, currently in the possession of the World Rugby Museum. Amongst the photos are shots of bustling Buenos Aires and a slumbering Doug Prentice, the tour manager and previously the captain of the 1930 Lions

The Leicester partnership of manager Doug Prentice, who had led the Lions to Australia and New Zealand in 1930, and captain Bernard Gadney headed the trip, and when they arrived they were greeted with four headlines on the front page of the *Buenos Aires Herald*: 'An Army of Giants, Six-Foot Team Arrives'... 'Strongest Side Yet Seen'... 'Policy of Open Play'... 'The Men and Their Methods'.

Gadney played scrum-half for Leicester Tigers and won 14 England caps between 1932 and 1938 and was captain on eight occasions. He made his Leicester debut in 1929 and went on to make 170 appearances for the club. He made his England debut against Ireland in 1932 and was appointed captain in 1934, becoming Leicester's first England captain and leading his team to the Triple Crown.

In 1936, he captained England to that Obolensky-inspired victory over the All Blacks, and shortly after his death Gadney was, along with Nick Farr-Jones, added to the Museum of Rugby's 'Wall of Fame' at Twickenham Stadium in 2000. Gadney's brother, Cyril, was an international rugby referee who became president of the RFU.

Meanwhile, Jim Unwin, who also played cricket for Essex, was an uncapped wing when the Lions launched their tour, but he promptly made an impact. He opened the tour in spectacular style by scoring four tries in the team's 55–0 victory over Buenos Aires Football Club.

As the tour progressed, he was to score five tries in the match against Pacific Railway AC and another hat-trick against Belgrano. In all, he scored 17 tries, including one in the 23–0 Test win over Argentina on 16 August 1936, with Boyle (two) and John Tallent the other try scorers at the BA Cricket Club.

The match was marred by the chants of the 'soccer element' in the crowd, which 'cast a slur on the game in Argentina'. Despite that, and the occasional punch, the Lions ran out worthy winners.

There were two notable things about that Test. First, it attracted an excellent crowd of around 15,000 and, second, the Argentine team included just four ex-pats, as local players were rapidly emerging in the club scene. It meant that, as the numbers increased even more, the Argentine game took on more and more of a distinctive, Latin approach after the early outside influences.

As for the Lions, it was no surprise when Unwin was selected for the next British tour, this time to South Africa in 1938, where he was joined by 1936 teammates Boyle and Jock Waters.

▲ The 1936 squad gather at Fenchurch Street Station before departing for Argentina

The full list of 1936 tour results were wins against Buenos Aires Football Club 55–0, Argentina A 27–0, Olivos RC 27–3, Argentina B 28–0, Pacific Railway AC 62–0, Union de Rugby Litoral 41–0, Old Georgian 55–6, Belgrano Athletic 37–3, Argentina 23–0 and CASI-Hindú-CUBA 44–0.

While only a handful of those involved on Lions tours to Argentina also featured in ventures where caps were awarded, the prelude to the 2005 tour to New Zealand was a full-blown Test against the Pumas at Cardiff's Millennium Stadium.

A crowd of 61,569 were at the venue in the Welsh capital on 23 May and they had to wait until deep into injury time for the score that earned the Lions perhaps a fortunate share of the spoils in a 25–25 draw.

Because of club commitments, the Pumas were without 25 players who might have made their first-choice team, and the Lions rested many of their top players to field a second-string combination. Tour captain Brian O'Driscoll was rested, so Wales' Michael Owen took his place.

The Lions looked disjointed, turning over the ball 15 times in open play. Their pack was outplayed; the Pumas shoved them off their own scrum three times. Meanwhile, the Pumas played a match that was almost universally called 'inspired' in the rugby media worldwide. The Pumas led 19–16 at half-time and could easily have been ahead by more. The main plus for the Lions was the performance of Jonny Wilkinson, making his first appearance against international opposition since the 2003 World Cup final. He set up their only try – scored by centre Ollie Smith – converted it and kicked six penalties. His last penalty saved the Lions from defeat, salvaging the draw in the eighth minute of stoppage time. The match was granted full Test status by the IRB in 2006.

The result – allied to that action from the IRB – confirmed just how far Argentinian rugby had come since that first tentative 'forgotten' 1910 Lions tour to South America and the first international for the Pumas.

▼ Jonny Wilkinson breaks through the tackle of Felipe Contemponi during the 2005 Test at the Millennium Stadium

BRITISH & IRISH LIONS V. ARGENTINA

MATCH 1

12 June 1910, Polo Club, Flores
Argentina 3 The Lions 28

Argentina: J. Saffery; C. MacCarthy, O. Gebbie [capt.], F. Heriot, H. Talbot;
C. Mold, A. Watson-Hutton; A. Reid, A. Donelly, A. Bovet, F. Sawyer, F. Henrys,
W. Hyman, L. Gribbell, B. Heatlie. **Scorer: Try:** C. MacCarthy

The Lions: **J. Raphael [capt.]; A. Palmer, B. Bennetts, E. Fuller, H. Monks;
A. Henniker-Gotley, R. Harrison; W. Stranack, B. Waddell, H. Ward, H. Whitehead,
W. Fraser, W. Huntingford, M. Tweed, P. Strang. Scorers: Tries:** H. Monks 2,
W. Fraser, J. Raphael, H. Ward; **Cons:** R. Harrison 2, J. Raphael; **DG:** H. Monks

Referee: T. Duncan

MATCH 2

31 July 1927, Estadio Gimnasia y Esgrima de Buenos Aires
Argentina 0 The Lions 37
HT: 0–17

Argentina: C. Pollano; C. Vazquez, A. Rodriguez Jurado [capt.], F. Lucioni,
W. Braddon; A. Zappa, R. Cooper; E. Bustamante, J. Conrard, R. Cameron,
J. Cuesta Silva, R. Serra, M. McCormick, A. Hobson, A. Pasalagua.

The Lions: **J. Wallens, G. Wilson, E. Hammett, R. Kelly, C. Aarvold; R. Spong,
W. Sobey; C. Payne, D. Law, A. Allen, J. Farrell, D. Troup, G. McIlwaine, T. Pike,
D. MacMyn [capt.]. Scorers: Tries:** G. Wilson 2, C. Aarvold, E. Hammett, R. Kelly,
D. MacMyn, C. Payne, R. Spong; **Cons:** E. Hammett 3; **Pen:** E. Hammett;
DG: R. Spong

Referee: Tommy Vile (Wales)

MATCH 3

7 August 1927, Estadio Gimnasia y Esgrima de Buenos Aires
Argentina 0 The Lions 46
HT: 0–14

Argentina: A. Jacobs; M. Ayerra, C. Reyez, C. Vazquez, G. Cooke; M. Hernandez, R. Cooper; E. Bustamante, J. Conrard, A. Riganti, J. Cuesta Silva, R. Cameron, R. Botting, A. Rodriguez Jurado [capt.], Julian Somme.

The Lions: P. Douty; C. Aarvold, E. Hammett, R. Kelly, E. Taylor; R. Spong, W. Sobey; C. Payne, D. Law, A. Allen, J. Farrell, G. Coughlan, G. McIlwaine, E. Coley, D. MacMyn [capt.]. Scorers: **Tries:** C. Aarvold 4, R. Kelly 2, G. MacIlwaine, D. MacMyn, C. Payne, R. Spong; **Cons:** E. Hammett 6; **DG:** E. Hammett

Referee: Tommy Vile (Wales)

MATCH 4

14 August 1927, Estadio Gimnasia y Esgrima de Buenos Aires
Argentina 3 The Lions 34
HT: 0–13

Argentina: C. Derkheim; N. Escary, C. Reyez, M. Hernandez, L. Makin; F. Torino, R. Cooper; E. Bustamante, V. Grimoldi, A. Riganti, J. Cuesta Silva, R. Serra, A. Pasalagua, A. Rodriguez Jurado [capt.], R. Botting. Scorer: **GM:** F. Torino

The Lions: J. Wallens; C. Aarvold, E. Hammett, A. Hamilton-Smythe, E. Taylor; R. Spong, P. Douty; C. Payne, D. Law, A. Allen, J. Farrell, T. Gubb, G. McIlwaine, D. Troup, D. MacMyn [capt.]. Scorers: **Tries:** E. Taylor 3, A. Hamilton-Smythe 2, P. Douty, G. McIlwaine; **Cons:** E. Hammett 5; **Pen:** E. Hammett

Referee: Tommy Vile (Wales)

MATCH 5

21 August 1927, Belgrano Stadium, Buenos Aires
Argentina 0 The Lions 43
HT: 0–13

Argentina: A. Jacobs; C. Vazquez, C. Reyez, M. Hernandez, N. Escary; F. Torino, R. Cooper; E. Bustamante, V. Grimoldi, A. Riganti, J. Cuesta Silva, R. Serra, S. Muller, A. Rodriguez Jurado [capt.], R. Botting.

The Lions: J. Wallens; C. Aarvold, R. Kelly, G. Wilson, E. Taylor; R. Spong, P. Douty; C. Payne, D. Law, A. Allen, J. Farrell, G. Coghlan, G. McIlwaine, E. Coley, D. MacMyn [capt.]. Scorers: **Tries:** C. Aarvold 3, R. Kelly 2, G. Coghlan, G. McIlwaine, D. MacMyn, W. Sobey, R. Spong, G. Wilson; **Cons:** G. Wilson 5

Referee: Tommy Vile (Wales)

MATCH 6

16 August 1936, Estadio Gimnasia y Esgrima de Buenos Aires
Argentina 0 The Lions 23
HT: 0–4 **Att:** 15,000

Argentina: H. Alfonso; R. Elliot, H. Talbot, H. Pascuali, E. Schiavio; P. Talbot, N. Cooper; B. Mitchelstein, V. Inchausti, R. Cameron, J. Francombe [capt.], T. Salzman, J. Cilley, J. Frigoli, G. Logan.

The Lions: H. Uren; J. Unwin, J. Tallent, W. Shaw, V. Boyle; T. Knowles, B. Gadney [capt.]; R. Prescott, O. Chadwick, J. Brett, C. Beamish, T. Huskisson, W. Weston, P. Hordern, P. Hobbs. Scorers: **Tries:** V. Boyle 2, J. Tallent, H. Uren; **Cons:** J. Brett 2; **Pen:** J. Brett; **DG:** W. Shaw

Referee: G. Hughes (England)

MATCH 7

23 May 2005, Millennium Stadium, Cardiff
The Lions 25 **Argentina 25**
HT: 16–19 **Att:** 61,569

The Lions: G. Murphy; D. Hickie, O. Smith (Shane Horgan 60), G. D'Arcy, S. Williams; J. Wilkinson, G. Cooper (C. Cusiter 60); G. Rowntree, S. Byrne (S. Thompson 71), J. Hayes (J. White 55), D. O'Callaghan, D. Grewcock (B. Kay 71), M. Corry, L. Moody, M. Owen [capt.]. Scorers: **Try:** O. Smith; **Con:** J. Wilkinson; **Pens:** J Wilkinson 6

Argentina: B. Stortoni; J. Nunez Piossek, L. Arbizu, F. Contepomi [capt.], F. Leonelli; F. Todeschini (L. Fleming 72), N. Fernandez Miranda; F. Mendez, M. Ledesma, M. Reggiardo, P. Bouza (M. Carizza 68), M. Sambucetti, F. Genoud, M. Schusterman (S. Sanz 61), J. Manuel Leguizamon. Scorers: **Try:** J Nunez Piossek; **Con:** F Tordeschini; **Pens:** F Tordeschini 6

Referee: Stuart Dickinson (Australia)

V. ARGENTINA
LIONS TEAM RECORDS

MOST IN TEST MATCH

Points	46	46–0 (2nd Test) Buenos Aires 07.08.1927
Win Margin	46	46–0 (2nd Test) Buenos Aires 07.08.1927
Tries	11	(4th Test) Buenos Aires 21.08.1927
Cons	6	(2nd Test) Buenos Aires 07.08.1927
Pens	6	Cardiff 23.05.2005
DG	1	Several

MOST IN TEST SERIES

Points	160	1927 (Four Tests)
Tries	36	1927 (Four Tests))
Cons	17	1927 (Four Tests)
Pens	2	1927 (Four Tests)
DG	2	1927 (Four Tests)

LIONS INDIVIDUAL RECORDS
MOST IN TEST MATCH

Points	20	Jonny Wilkinson Cardiff 23.05.2005
Tries	4	Carl Aarvold (2nd Test) Buenos Aires 07.08.1927
Cons	6	Ernie Hammett (2nd Test) Buenos Aires 07.08.1927
Pens	6	Jonny Wilkinson Cardiff 23.05.2005
DG	1	Harold Monks 1910, Roger Spong, Ernie Hammett 1927, Wilson Shaw 1936

MOST IN TEST SERIES

Points	41	Ernie Hammett 1927
Tries	8	Carl Aarvold 1927
Cons	14	Ernie Hammett 1927
Pens	2	Ernie Hammett 1927
DG	1	Roger Spong, Ernie Hammett 1927

ARGENTINA TEAM RECORDS
MOST IN TEST MATCH

Points	25	25–25 Cardiff 23.05.2005
Win Margin	N/A	
Tries	1	Flores 12.06.1910 Cardiff 23.05.2005
Cons	1	Cardiff 23.05.2005
Pens	6	Cardiff 23.05.2005
GM	1	(3rd Test) Buenos Aires 14.08.1927

MOST IN TEST SERIES

Points	3	1927 (Four Tests)
Tries	0	1927 (Four Tests)
Cons	0	1927 (Four Tests)
Pens	0	1927 (Four Tests)
DG	0	1927 (Four Tests)
GM	1	1927 (Four Tests)

ARGENTINA INDIVIDUAL RECORDS
MOST IN TEST MATCH

Points	20	Federico Todeschini Cardiff 23.05.2005
Tries	1	Cornelius MacCarthy Flores 14.08.1910 Jose Nunez Piossek Cardiff 23.05.2005
Cons	1	Federico Todeschini Cardiff 23.05.2005
Pens	6	Federico Todeschini Cardiff 23.05.2005
GM	1	Francisco Torino (3rd Test) Buenos Aires 14.08.1927

MOST IN TEST SERIES

Points	3	Francisco Torino 1927
Tries	0	
Cons	0	
Pens	0	
MG	1	Francisco Torino 1927

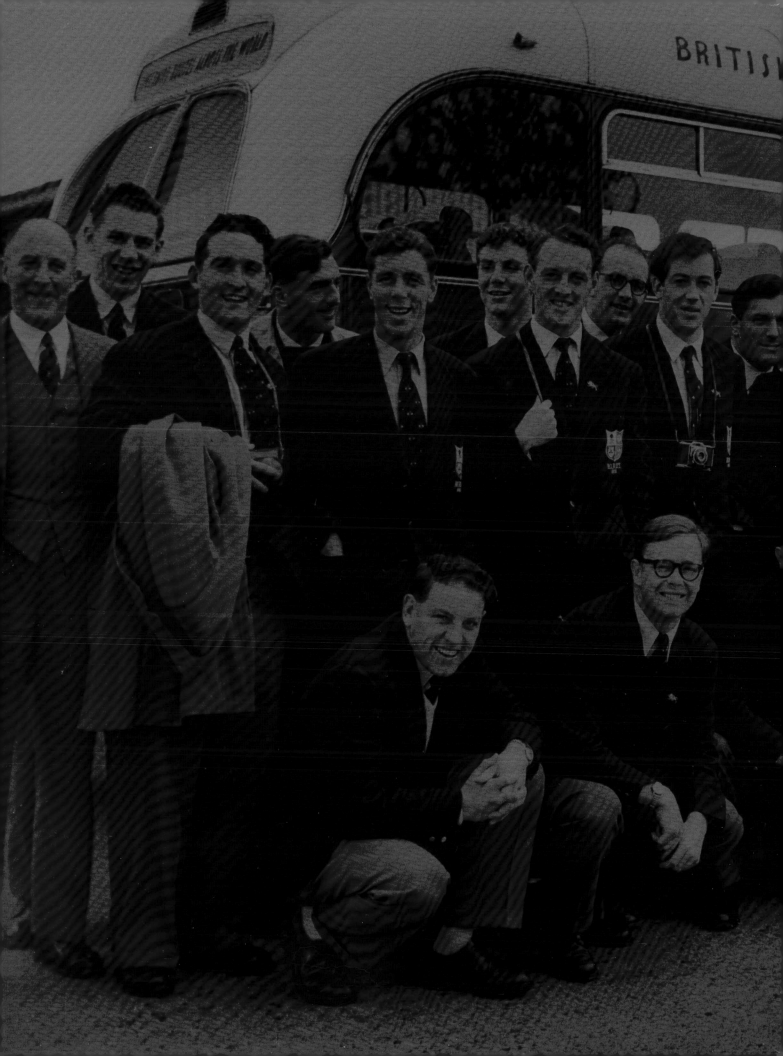

5

THE
BUCCANEERS

SINCE 1888

This was the decade which was to reignite the popularity of Lions tours in the southern hemisphere after the Second World War, and the players made a good job of it. Although the Lions didn't win a Test series in the 1950s, the 1955 team came close and were the first to break the stranglehold of the Springboks on British Isles touring teams which had existed since South Africa lost their last series to the Lions of 1896. As even the mighty All Blacks had never won a series in South Africa until 1996, this was some achievement, bettered only by the magnificent 1974 Lions.

In the 1950s, British back play became the talk of the southern hemisphere as the Lions, on two tours of New Zealand and one of South Africa, played glorious, open and adventurous rugby to earn the admiration and, indeed, the respect and affection of the rugby supporters in both those rugby-mad countries. You cannot do much better than that.

The Lions played 16 Tests across the three southern hemisphere countries in the 1950s, winning seven, drawing one and losing eight. Of the eight defeats, six came against the All Blacks and two against the Springboks. Four of the defeats in New Zealand were by three or less points, and over the 16 Tests in the decade the Lions outscored their rivals by 36–31 in tries.

Remarkably, none of the 31 players who went on the 1950 tour went on to play in South Africa five years later, although the Newport and Wales utility back Malcolm Thomas bridged the gap from 1950 to 1959 to make a second tour of Australia and New Zealand. The charismatic Irish wing Tony O'Reilly and the Wales lock Rhys Williams made a record ten consecutive Lions Test appearances by featuring in all four internationals in South Africa in 1955 and the six Tests four years later. The England scrum-half Dickie Jeeps made it nine in a row before missing the final Test in 1959 through injury. It was the decade when Lions legends were made.

1950 TOUR KIT

1950
BACK IN THE GROOVE

Captain: Karl Mullen (Old Belvedere and Ireland)
Squad Size: 30 players + 1 replacement
Manager: Surgeon-Captain Leslie Bartlet 'Ginger' Osborne (England)
Assistant Manager: Edward Savage (England)

Tour Record:	P 29	W 22	D 1	L 6	F 570 A 214
In New Zealand:	P 23	W 17	D 1	L 5	F 420 A 162
Test Series (NZ):	P 4	W 0	D 1	L 3	
In Australia:	P 6	W 5	D 0	L 1	F 150 A 52
Test Series (Aus):	P 2	W 2	D 0	L 0	

The first post-war tour by the Lions was to New Zealand in 1950, and they were the last team to travel in the more gracious and leisurely manner of passenger boat. They went out via the Panama Canal and home through the Suez Canal, thus circumnavigating the world. My eye-witnesses of that tour are no less than the

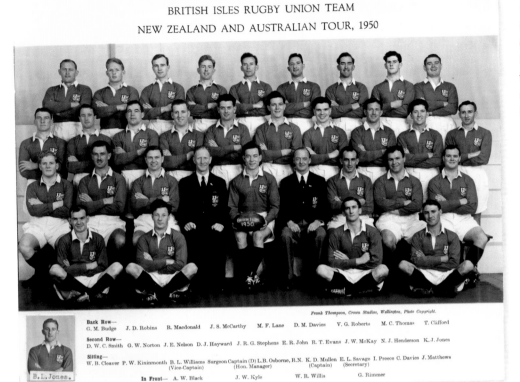

BRITISH ISLES RUGBY UNION TEAM
NEW ZEALAND AND AUSTRALIAN TOUR, 1950

Frank Thompson, Crown Studios, Wellington, Photo Copyright.

Back Row—
G. M. Budge J. D. Robins R. Macdonald J. S. McCarthy M. F. Lane D. M. Davies V. G. Roberts M. C. Thomas T. Clifford

Second Row—
D. W. C. Smith G. W. Norton J. E. Nelson D. J. Hayward J. R. G. Stephens E. R. John R. T. Evans J. W. McKay N. J. Henderson K. J. Jones

Sitting—
W. B. Cleaver P. W. Kininmonth B. L. Williams Surgeon Captain (D) L.B. Osborne, R.N. K. D. Mullen E. L. Savage I. Preece C. Davies J. Matthews
(Vice-Captain) (Hon. Manager) (Captain) (Secretary)

In Front— A. W. Black J. W. Kyle W. R. Willis G. Rimmer

B. L. Jones.

captain, the quietly spoken Karl Mullen, who had led two Irish Triple Crown teams in 1948 and 1949 and later became a distinguished gynaecologist in Dublin; and the vice-captain, that prince of Welsh centres, Bleddyn Williams.

It was the year when England lost 1–0 to America in the World Cup. Senator McCarthy launched his anti-communist crusade, and India was declared a republic. North Korea invaded the South and Britain decided to send troops, Labour remained in office and the Liberals lost a record 314 deposits. The French declared their plans for the federated states of Europe. George Orwell died, and Karen Carpenter and Bill Murray were born. Richard Dimbleby made the first live television broadcast from overseas, when he spoke from Calais. The FBI began its 'Ten Most Wanted Fugitives' programme. It was also five years after the first Sydney to Hobart Yacht race and a year after Australian citizenship had been officially introduced (previously Australians had been subjects of Britain).

The Lions knew that they were going to the friendliest of all the Commonwealth countries and, after the dreadful austerity of the war and post-war years (remember that food rationing remained in force until 1954), they were determined to have a good time. That started when they first met on Thursday, 30 March at the Mayfair Hotel in London. This was a mere five days after Wales had won the Grand Slam and there was still a full month of the domestic season to run. Dr Jack Matthews had been forced to hire a locum to replace him at his general practice while he went on tour, at a personal cost of around £5,000, but at least he and his teammates were granted a 'refreshments allowance' of 50 shillings per week (£2.50 in modern-day money and worth about £69.50 in real terms today). The players learned from their management team that the New Zealand Rugby Union would be paying for all meals, but that 'Expenses for the lighting of fires in bedrooms shall not be a

◄ The 1950 Lions squad was captained by experienced and dynamic Ireland hooker Karl Mullen and dominated by the three Celtic nations, the 30-man squad featuring just a trio of English players

▼ A commemorative badge from the World Rugby Museum commissioned for the 1950 tour of New Zealand and Australia, the Lions' first of the post-war era

charge to the Union unless authorised by the Representative.' Their hosts weren't going to cover the cost of 'cablegrams' either, and the maximum allowance for medical fees and treatment was £500 per person. The team were guests at the annual dinner of the New Zealand Society on that first night at the Savoy Hotel and they were kitted out, and photographed, at Twickenham the next day. The Lions provided

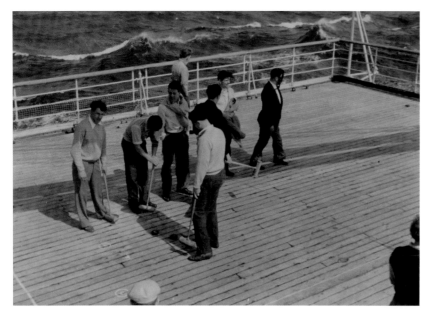

blazers and ties, but the players had to provide their own trousers. Their tour contract also expressly prohibited the swapping of playing jerseys. On Saturday, 1 April, the squad left Euston Station for Liverpool, where they boarded the *Ceramic* and set sail at around 4.15pm. A six-course banquet may have filled their stomachs, but once the boat got into clear water the seasickness began to bite.

A 'working and consultative committee' was formed, containing one player from each nation – Karl Mullen (Ireland), Bleddyn Williams (Wales), Peter Kininmonth (Scotland) and Ivor Preece (England) – and there was also a 'medical advisory committee' comprising three qualified doctors – Jack Matthews, Karl Mullen and Doug Smith – and the ship's physician. On Tuesday, 4 April, the tour manager, Surgeon-Captain Leslie Bartlet 'Ginger' Osborne, announced that Bleddyn Williams would be Mullen's vice-captain. In David Walmsley's book *Lions of Ireland*, Mullen outlined what the players did to keep fit during the voyage:

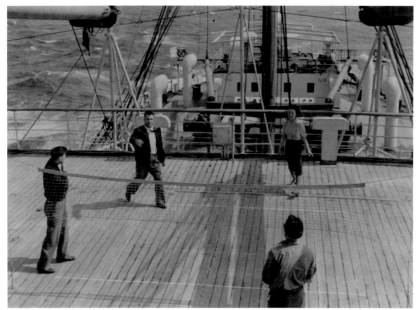

▲ The 1950 tourists were the last to travel by sea rather than air and their long journey from Liverpool to Australasia via the Panama Canal gave the players ample time to relax

We had a manager who was a diplomat so I was really in charge and had to decide on how to get the boys fit on the five-week journey out to New Zealand. Luckily we had three PE teachers and we had a regime each day where we did workouts on the deck including sprinting, running laps of the deck and all kinds of gymnastics. And then we had a team-talk every day and discussed every aspect of the game from hooker to full-back, in every position, whether in defence or attack... Having five weeks together was a great settling in time. There was no boredom and we had no disagreements. We were an unusual side from that point of view, there were no guys who were nasty and it was same on and off the pitch. We had a very well organised and disciplined team.

The ship docked in Curacao, in the Dutch West Indies, on 12 April, allowing the Lions to stretch their legs on dry land for a few hours, and two days later the ship entered the Panama Canal. There was an overnight stop in Panama City. They crossed the equator on 17 April and then spent two more weeks on board before arriving in Wellington Harbour on Tuesday, 2 May. The Lions had taken 31 days to reach their destination and they had three months to look forward to in New Zealand before heading to Australia. At the formal 'welcome' party at Wellington's Hotel St George, 'Ginger' Osborne launched his charm offensive on the Lions' hosts in his speech, which was reported in the *Wellington Evening Post*: 'I think there is one question for us to ask ourselves. It is a very simple one – what can we as a party of rugby footballers from the British Isles give to New Zealand, which has given so much of her blood, of her wealth, and of her greatness in coming to our aid? I think we will give the best we can of the football of the four home countries. We will give great friendship and high spirits; we will give our kind interest in your country; in fact, there is nothing we will not give.'

As Alan Evans, author of *Lions Down Under 1950: Tour to New Zealand, Australia and Ceylon* stated, it set exactly the right tone for the tour. Osborne made the High Commissioner, Bill Jordan, an honorary Lion by presenting him with a Lions pin badge, and then set his sights on the local media, telling them: 'We hope to enjoy our games and we hope the people of New Zealand will enjoy them too. We hope that the people of New Zealand will be sad when we leave.' They undoubtedly were, even though the All Blacks won the series!

*Pøst! Speak in Welsh, boys – There's that New Zealand Fifth Column Again!* — N.Z. Herald 4·4·50

▲ A cartoon from the New Zealand Herald, poking fun at the fact that High Commissioner Bill Jordan – later to become an honorary Lion – travelled with the squad from the UK

Many of the players, happy to be able to discard post-war sobriety, put on a stone in weight during the course of the outward voyage, despite all the physical training and jogging around the decks. They were the first British team to visit the 'Land of the Long White Cloud', as the Maoris called it, since Doug Prentice's side in 1930, and they became the first Lions team to wear the now traditional red shirts, white shorts and green and blue stockings. The welcome which awaited them in New Zealand was so overwhelming that it is a wonder they were able to perform at all. It was to become known as the 'Friendly Tour', and the bonds between the two teams who represented their countries endured to their dying days.

The manager, 'Ginger' Osborne, who went on to become the Queen's honorary dental surgeon and a Rear Admiral, was well liked by the tourists – perhaps a primary requirement for success. The secretary, or assistant manager, was Edward 'Ted' Savage. They were assisted by Taff Davies, the baggage man, and Snowy McQueen, a masseur. Mullen's cheery spirit and the presence of eight other Irishmen set much of the tone for enjoyment, the Irishmen including one of the finest of all outside-halves, the legendary Jackie Kyle. He, along with Ken Jones, was recognised

by the *Rugby Almanack of New Zealand* as being one of the five players of the year, together with New Zealanders Tiny White, Pat Crowley and Lester Harvey. George Norton was at full-back and the delightfully relaxed Irish centre, Noel Henderson, was a powerful back-up for the centre pairing of Bleddyn Williams and Jack Matthews, and he won a Test cap on the wing, as did young Michael Lane. The powerful flanker Bill McKay was one of the bravest of forwards on the tour and was to return to New Zealand for the rest of his life as a doctor. In the front row were the genial Tommy Clifford and Jimmy Nelson. Jim McCarthy, who had made such a contribution to winning those Irish Triple Crowns in 1948 and 1949, found it hard going because he was relatively small; he later became a respected executive in Tony O'Reilly's business empire, which meant he must have been good!

Scotland had five players, including Doug Smith, who was injured and did not play until the 18th game of the tour, but who was to make a considerable impact in another role on another occasion in New Zealand. He was, however, to play only two games in New Zealand and three in Australia, including one Test. Ranald Macdonald, a 22-year-old medical student at Edinburgh University, was a relaxed player and personality who played as a wing or centre and won two caps as a winger. There was another Edinburgh University player in the party, Angus Black, who was the most experienced of the three scrum-halves in the party, with six caps; he had a lovely service and played in the first two Tests against the All Blacks. In the forwards, Scotland was represented by Graham Budge, a Canadian-born Scot, who became the soul-mate of the Welsh prop, Cliff Davies. The other was Peter Kininmonth who, in 1951, was to drop a goal from the touchline, about 45 yards out, to beat Wales; an Oxford Blue, he was another of so many of these Lions to make a name for himself in business.

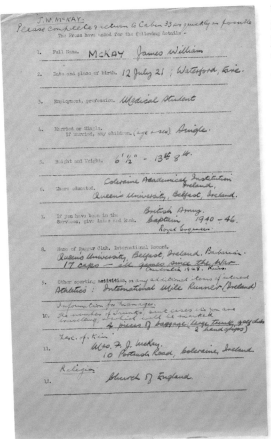

▲ A press release on Queen's University and Ireland flanker Bill McKay. The forward already had 17 caps when he was selected for the tour and played in all six Tests against New Zealand and Australia

There were only three Englishmen, which reflected the fact that they finished bottom of the Five Nations Championship in 1950 and 1951. Two were half-backs; one was Ivor Preece, a strong outside-half, who was a powerful kicker of the ball and a good link. I played with him for Coventry the year after the tour, and I always respected his composure on and off the field, and his strength of character. He was, however, up against the greatness of Jackie Kyle and, therefore, was destined, like so many other talented players on Lions tours, to be a bridesmaid rather than the bride. Gordon Rimmer was in a similar position but did well to make the tour, considering he was playing at the heels of an England pack which invariably was beaten, but he played in only one Test. The sole English forward was the immensely likeable and popular Cornishman Vic Roberts, who, although he too never made the Test team, played in ten games in New Zealand. Vic was later to be a dedicated Baa-Baa 'alickadoo'.

Wales, as Grand Slam winners in 1950, provided the bulk of the touring party: there were 13 Welsh players in the original selection, which rose to 14 when the 19-year-old Lewis Jones went out as a replacement. Wales used 18 players in their Grand Slam season and all bar five of them – the unavailable skipper John Gwilliam, Gerwyn Williams, Ray Cale, Trevor Brewer and Windsor Major – went on the tour, and no fewer than nine Welshmen played in every Test. On paper it was a great Lions team, and with Kyle at outside-half, why did they not sweep all before them?

The answer probably lies in the different standard of northern and southern hemisphere rugby, and the far higher and tougher level of forward play in the latter. It must also be remembered that the All Blacks had been whitewashed the year before by South Africa, yet they won this series 3–0.

Only Bob Scott of that New Zealand back division had any claim to rugby immortality, although Ron Elvidge was another magnificent player. While the Lions back division bristled with great names – some of the best in the world at the time – they failed to win a Test match, though they drew the first international 9–9. This suggests that forwards win matches, especially in New Zealand, and that the Lions pack of 1950 simply failed to match them.

Billy Cleaver, or 'Billy the Kick' as he was known in Wales, was chosen as a utility man, and at centre there was Bleddyn Williams, who missed the first Test, and had also missed Wales' Grand Slam campaign, through injury. Bleddyn was one of the finest centres with whom I ever played. Another was Jeff Butterfield, and these two, together with Mike Gibson and Danie Gerber, were the best centres I ever saw play and I would not want to choose between them. Bleddyn was the trusty henchman for Cardiff and Wales, and Dr Jack Matthews, known as the iron man of Welsh rugby, was a tower of strength alongside him in the centre. A measure of Jack's quality and durability was that he played in all six Test matches on tour. 'Dr Jack' went on to become the first Medical Officer taken on tour by the Lions in 1980. He died in 2012, at the age of 91.

At scrum-half there was the resilient and brave Rex Willis, a man who was prepared to die for his outside-half, who finally played in the last three Tests, while on the wing was the Olympic sprinter, the superlative Ken Jones. Ken was my accomplice as we contrived a try with a cross kick when Wales managed to beat the All Blacks for the last time, in 1953. Ken was immensely fast, but was also a marvellous footballer in both defence and attack. His try in the final Test in Auckland, more of which later, still ranks as one of the greatest ever scored in New Zealand. Ken had turned down the chance to compete for Wales at the British Empire Games in Auckland earlier in the year to concentrate on his rugby. It was a wise decision, because he scored 16 tries in 16 games on that leg of the tour. His sporting career is unquestionably one of the greatest of all time among the rugby fraternity. He was crowned the 100-yard sprint champion of All-India in 1945 during his war service and went on to set four Welsh sprint records – his fastest time was 9.8 seconds over 100 yards – and win 17 nationals titles over 100 metres, 200 metres and the long jump. He was captain of the British track and field team at the 1954 European Championships, where he won a silver medal in the sprint relay, and was a bronze medallist at the 1954 British Empire and Commonwealth Games over 200 metres for Wales. In rugby, he equalled the Welsh try-scoring record, with 17, in a world-record 44 internationals, including the match-winner against the 1953 All Blacks, and he scored 145 tries in 293 games for his beloved Newport. Yet none of those great deeds could compare with the ultimate thrill in any sporting career: competing at an Olympic Games. With England wing Jack Gregory, Emmanuel McDonald Bailey and Alistair McCorquodale, Jones was actually presented with an Olympic gold medal at Wembley Stadium after the Americans had been disqualified in the 4 x 100 metres relay final. The British quartet had held off the Italians to finish second, but then found themselves elevated to the top of the podium – for a day! The inevitable American appeal got them reinstated and Ken ended up with a silver medal. In an interview he said: 'When I think back on my career as both a rugby

player and an athlete I would have to pick the 1948 Olympic Games as the highlight. Reaching the semi-finals of the 100 metres, and being among the 12 fastest men in the world, as well as winning a silver medal in the relay, has to top the lot. It made me feel especially proud, as a boy from Blaenavon who had never competed on a cinder track before winning the Southern Counties title in 1948, to reach that level.'

Another fine Welsh back of the 1950s, who was chosen as centre or wing, was the young Malcolm Thomas, who became the top scorer, with 96 points in 15 appearances. He was to return nine years later with the Lions of 1959. When George Norton broke his arm in the fifth match of the tour, the call went out for Lewis Jones to join the party. He was a rating in the Royal Navy doing his national service in Devonport and was wondering why he hadn't been picked in the first place when he got the call. It was a request that led to an amazing four-and-a-half-day journey from London to Gisborne, as he explained in an interview for lionsrugby.com in 2008:

I was playing cricket in Plymouth for one of the Services teams when I got the call to go to New Zealand. I was fielding in the covers when someone ran onto the field and said there was an urgent phonecall for me. It was a Mr Haig Smith, who informed me that George Norton had broken his arm in New Zealand and that the Lions intended to send out a replacement.

He asked me if I would like to go. I had just turned 19 and was only just getting over the disappointment of being one of only two players who had played throughout the Welsh Grand Slam season who had not been picked to tour. My first thought was about what I would tell the Navy, but he assured me he would fix that. After all, he was talking about going on a trip that would see me away from the UK for the best part of three months.

Within a week everything had been fixed for me to fly out to New Zealand to join the tour. No Lion had ever flown before, but they worked out a schedule for me to go by air. I'd never been on a plane before, but I had a journey to the other side of the world to look forward to. I went from my home in Swansea to London Airport and boarded a Boeing Stratocruiser. Up it went and, within half an hour, down it came again – in Shannon. Next stop was Newfoundland and then New York. There was a change of planes in New York – a Super Constellation aircraft – and on to Chicago and then San Francisco, where I had to stay the night.

That's where I ran into a bit of a problem. I was only allowed to take £25 transit money with me and I'd used some of it in New York. When I arrived in San Francisco I took a taxi into town to find a hotel. By the time I got there I'd used all my money on the cab fare. I spent the night and left rather quickly in the morning without paying. I went to the nearest travel agency, explained my dilemma and they arranged to put me on an airport bus. I was glad to be back in the air, on another Super Constellation, and the first stop in the Pacific was Canton Island. It was so small I think the only thing on the island was the landing strip and refuelling truck.

Honolulu was next on the agenda before I flew to Sydney – I can't remember if there were any other stops in between. There was another change of plane in Sydney as I headed to Auckland, and then another change of aircraft to take me to finally team up with the Lions in Gisborne. When I arrived, after four and a half days of travelling, Bleddyn Williams was there to meet me. Two days later I was making my Lions debut against Poverty Bay/East Coast and Bay of Plenty.

Jones played in 11 games, made three Test teams and was the second-highest scorer on the tour, with 92. He also notched a Lions record 16 points in the first Test victory in Australia, becoming the first tourist to go through the modern-day scoring

◄ The Lions players take time off from training to get acquainted with two kiwis, New Zealand's national bird. The tourists were in the country for three gruelling months before crossing the Tasman Sea for six games in Australia

card with a try, two conversions, two penalties and a drop goal. He picked up another Grand Slam with Wales in 1952 before succumbing to the temptations of rugby league, a game in which he became a global star after transferring to Leeds for a world-record fee of £6,000 in November 1952. He played once for the Wales rugby league team, 15 times for Great Britain and once for the Rest of the World. He returned to Australia with the 1954 British rugby league side, scoring a record 278 points, and spent six years as player-coach at the Sydney-based Wentworthville side.

They celebrated their centenary in 2012 and Jones was the first name on the team sheet. Jones is used to being honoured. A member of the Welsh Sports Hall of Fame, his home town club of Gorseinon renamed their clubhouse after him, the Lewis Jones, Arriva Buses in Leeds named one of their new fleet after him, and there is a Lewis Jones stand at Headingley.

Among the Welsh forwards was one of the greatest characters in the game, whose naivety and sense of humour were of enormous value on such a campaign. Cliff Davies was a miner from Kenfig Hill who, on the outward journey on the *Ceramic*, typically struck up a friendship with the High Commissioner for New Zealand, Mr William Jordan; they played cribbage together throughout the voyage, and it was always 'Bill and Cliff'. His inseparable buddy, however, was Graham Budge, who was Cliff's best man when they returned to the UK. Another Welsh prop was John Robins, who played in the first three New Zealand Tests. He was a quiet but purposeful man, who was to become a Lions coach in 1966.

Neath contributed those two fine locks, the incomparable Roy John, the best all-round forward of his day with superb technique in the lineout, and that strong, durable forward, Rees Stephens, who was regarded by French forwards of his time with some awe. Another Welsh lock was Don Hayward, later to be converted by Wales into a prop when confronted by the 1951 Springboks. There was no more powerful a forward or scrummager at that time than this huge man from the

Monmouthshire valleys, who had hands as big as hams and was as hard as nails. He was to return to New Zealand in 1952 and then went to play rugby league in England, before returning to Wellington for good. His big pal on tour was the Somerset policeman and Welsh hooker Dai Davies, who was never lost for a word, on or off the pitch. The only man who could handle him and Hayward together was the Welsh Triple Crown captain, John Gwilliam, who used to treat them like naughty boys – which at times they were! But they were the type of players you wanted on your side. Finally, there was the Newport flanker, Bob Evans, who worked as a CID officer. He was a powerful, intelligent player with fine anticipation, and he played in all the Tests.

The tour started well enough and the Lions piled on 80 points to 15 in their easy first three games in South Island, where they began the tour after an acclimatisation period at Nelson. In the first match against Nelson and Marlborough district, Malcolm Thomas set a Lions record of six penalty goals in New Zealand, a feat since emulated both by the All Black Don Clarke in 1959 and by Gavin Hastings in 1993 in Test matches. Malcolm also scored a try, to give him 21 out of the 24 points. Nine years later, against the same opposition, he kicked eight conversions and three penalties for an even bigger match haul of 25 points. No wonder he was much revered in Nelson!

The Lions then went to pot against Otago, even though they had put out what they considered their strongest team, with an all-Welsh three-quarter line, Norton at full-back, and Kyle and Willis at half-back. Otago scored a decisive win, scoring three tries to one by wiping out the Lions forwards, so the first lesson of the tour was learned. Even more disappointingly, they now lost to a lesser team, Southland, at Invercargill, and again the standard of play was low, despite the fact that over half the Test team was playing. Nothing went right for them in this game, as Norton broke his arm.

The 1966 Lions were also to lose to Otago and Southland, but the 1950 Lions never lost another provincial match on the tour. Nevertheless, you could have got

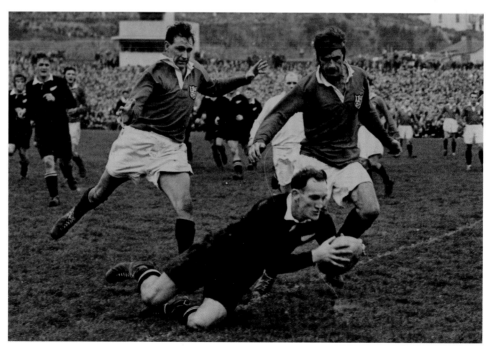

➤ The first Test of the 1950 tour saw the Lions tackle the All Blacks at Carisbrook. Two tries from each team, including a Ron Elvidge score (pictured), resulted in a 9–9 draw in an entertaining opener in Dunedin

long odds against the Lions winning the first Test in Dunedin, as all the critics had written them off as not having a ghost of a chance. However, on the day, the Lions forwards rose to the challenge of the fierce rucking of the All Blacks, which most of them, with the exception of those who had watched or played against the 1945–46 Kiwis' army side in Britain just after the war, had never seen, let alone experienced.

The Lions could have won that first Test but for a late try by Ron Elvidge, the New Zealand second five-eighth, who created havoc against them for Otago, and who captained the All Blacks in the first three Tests. Late in the second half, the Lions led by 9–3. John Robins had kicked a first-half penalty, and Kyle scored a try after a super break which left Bob Scott for dead. Roy Roper beat four men to score a try for the All Blacks, and Ken Jones scored in the corner by using his exceptional pace to chase a kick by Kyle. Scott then closed the gap with a penalty midway through the second half and it was anybody's game. In the last minutes, Scott came into the line and punted high for the posts, and although Roy John and Tom Clifford held the rush by the All Blacks forwards, Elvidge scored a try from the resultant scrum and New Zealand had scraped a 9–9 draw.

As Bleddyn Williams said: 'We were pleased to have held the All Blacks in the first Test, when our forwards showed their claws. What a pity the forwards did not play again with the same tigerish tenacity! It was as if they had burnt themselves out in that one game.'

The Lions went on to win their next three games, including the usual tough game against Canterbury, which gave morale a big lift. They made two changes for the second Test, bringing in Malcolm Thomas on the left wing in place of Macdonald, and Bleddyn Williams, recovered from injury, in place of Preece, who had played at centre in the first Test. New Zealand also made two changes, bringing in Laurie Haig at first five-eighth, or outside-half, and Peter Henderson, who had recovered from injury, on the left wing. Like Jones on the wing for the Lions, Henderson was a flyer. Earlier that year he had won a bronze medal at the Auckland British Empire Games in the 4 x 100 metres relay and finished fifth in the individual 100 yards final, achieving a personal best of 9.7 seconds over the distance. Henderson joined Huddersfield rugby league club after the Lions left and was banned by the New Zealand Rugby Union until 1989.

In the second Test, the All Blacks were 8–0 up at half-time from a try by Pat Crowley, who was the outstanding loose forward of the series. The Lions then lost Bill McKay with a broken nose and concussion, and the gaps developed for Roper to get the second try, which Haig converted. The second half became a dour struggle and there were no further scores. Kyle had another fine game and so did Ken Jones, whose defensive qualities proved to be invaluable.

Again, as Williams tells us:

The Otago-style rucking in the second Test upset our forwards. In all the Tests, the All Blacks rucked viciously in a manner we had never before experienced. Pat Crowley proved to be a merciless and destructive scrum-half killer. He concentrated on the scrum-half, thus disrupting the supply of the ball at source. He hammered Gus Black with relentless persecution in this second Test, and the Scotsman's usually immaculate service became completely disjointed. Crowley was killer number one

OFFICIAL

Souvenir Programme

British Isles Touring Team

versus

Wairarapa—Bush

★

Price 1/-

JUNE, 1950

▲ The programme from the Lions' match against Wairarapa–Bush, which saw the tourists bounce back from their defeat in the second Test to claim a 27–13 victory

and the All Blacks owed more to him than to any other player for victory in the rubber. In one strategic blow, the All Blacks threw a spanner into our attacking machinery. I also resented their midfield obstruction, as the New Zealand centres ran across us with deliberate intentions, but Crowley's spoiling was legitimate. That practice of obstruction in midfield has spread and is now, unhappily, widely used.

After another important win over Wellington, the Lions approached the third Test totally unabashed and not at all in awe of the All Blacks. They made two changes in the backs, with Noel Henderson coming in for the injured Ken Jones and Gordon Rimmer being given the unenviable task of absorbing the batterings of Pat Crowley. Scrum-half was undoubtedly the weak link in the Lions side, and Crowley had good claim to be the player of the series for the home side for the way in which he applied pressure on the Lions number nines. Mullen was unfit, so Dai Davies played, and Bleddyn Williams took over the captaincy. Roy John replaced Kininmonth at No. 8, and Jimmy Nelson joined Hayward in the second row. The New Zealand team was unchanged.

Like its predecessors, this Test was another close-run thing, and again it was Elvidge who scored the vital try, after being seriously injured in the face and chest following a tackle by 'Dr Jack'. He came back on the field with a stitched eyebrow and a bruised collarbone, merely as an extra full-back and just to make a nuisance of himself, but, in the event, he came into the line to score a winning try in the second half. Once again it was the All Blacks forwards who won the game, even when they were reduced to six men, as Johnny Simpson also went off the field with a knee injury that ultimately finished his career. They were still too much for the Lions forwards, though, and went on winning the ball. The Lions had managed to lead at half-time with a Robins penalty, but in the second half Elvidge got his try, and a few minutes later Scott kicked a penalty to win the match.

The Lions had now lost the Test rubber but refused to be depressed, for they knew that so little separated them from the All Blacks. They had lost two Tests by the narrowest of margins and the fourth was also to be lost by only three points. In the meantime, they continued to thrill the New Zealand provinces with their delightful back play and won the next six games before the final Test, including a crushing of Auckland, who had Scott at full-back, by 32–9.

> The 1950 match between the Lions and the New Zealand Maoris at Wellington was such an entertaining affair that at the final whistle, with the tourists having won 14–9 courtesy of the accuracy of Lewis Jones' boot, the crowd invaded the pitch and wouldn't let the players leave until they had given them a full round of 'Auld Lang Syne' followed by 'Now Is The Hour'.

They were still without the injured Mullen for the final Test, so Bleddyn Williams again captained the side. The Lions made sweeping changes and brought in two new props, Graham Budge and Cliff Davies. Roy John reverted to second row with Nelson, and Kininmonth returned as No. 8. Cleaver gave way to Lewis Jones at full-back, Willis took over at scrum-half and Ken Jones, recovered from injury, was back on the right wing.

New Zealand brought in John Tanner for the injured Elvidge, and in the pack Graham Mexted, father of Murray, who would enjoy his own Lions conquest in 1983, came in at No. 8, moving Peter Johnstone to the flank and captaining the side.

The Lions lost again, but the game was always remembered in New Zealand for a magnificent try scored by Ken Jones, which came from a scrum on the Lions' line. This was how the doyen of New Zealand rugby writers, Sir Terry McLean, described it in the *Weekly News* in 1959:

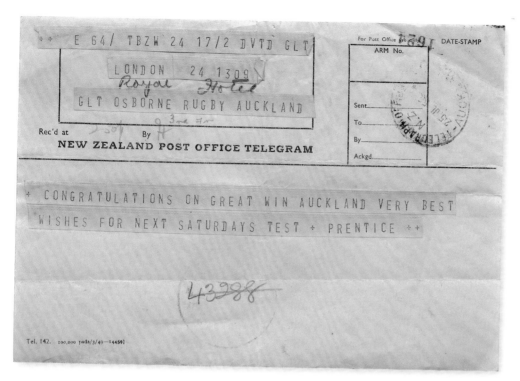

E 64/ TBZW 24 17/2 DVTD GLT

LONDON 24 1309

GLT OSBORNE RUGBY AUCKLAND

NEW ZEALAND POST OFFICE TELEGRAM

+ CONGRATULATIONS ON GREAT WIN AUCKLAND VERY BEST
WISHES FOR NEXT SATURDAYS TEST + PRENTICE ++

◄ A telegram sent by Doug Prentice, the 1930 Lions captain, congratulating 1950 tour manager 'Ginger' Osborne after his side's 32–9 victory over Auckland

The All Blacks led 11 to 3, only a dozen minutes of play remained and the Lions, it was plain to see, were done for. And then the ball came to Willis and from him to Kyle and thence to Lewis Jones. Rugby lore commanded that Jones should kick for touch. A whimsical rugby genius commanded that he should feint and dummy and start to run. With the dummy and the burst of speed he was past Tanner. Every other All Black was minding his man and for once the cover defenders were far away. Perhaps they were still resting on the side of the scrum. What lay in front of Lewis Jones was not a tangled mass of All Black jerseys but a green field and, far away, Scott, the lone sentinel.

Lewis Jones ran, lord how he ran! At halfway, or thereabouts, Scott loomed in his path. He was perhaps conscious too, that Henderson, in an extremity of excitement, had been lured from his post on the wing and was coming in toward him. Almost certainly, with the divine instinct of genius, Lewis Jones knew that Kenneth Jones, the red panther of Wales, was striding smoothly to his right, perfectly positioned and only awaiting the signal and the ball to begin his effort.

And here, now, was Scott. Neither sooner not later, but only at the perfect moment, Lewis flung the ball toward Kenneth. Henderson was almost in the path and with a blinding brilliance Lewis, recognising the danger, threw the pass a little high so that the All Black could not reach it. The ball reached Kenneth at chest height. He ran at all times with the sinuous grace of a greyhound and now his long legs stretched forth, flashing over the green and driving onward toward the goal...

As Jones swooped onward, so did the All Blacks run as never before. It is quite certain that none of them knew that 58,000 people were now shouting, if not actually screaming, with the excitement of the chase. All that Jones could see was the goalpost and all that his pursuers could see were those flying heels. With one tremendous effort, Roper half dived, half tumbled and as he fell his right hand forked out like the fangs of a snake, seeking to clip Jones' heels. An instant later Jones himself dived. With a great spring he leaped forward. The goal line was

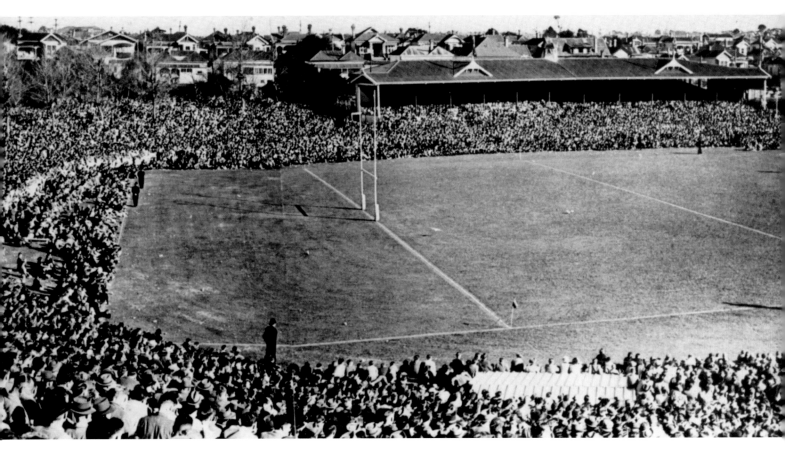

▲ The Lions faced New Zealand at the iconic Eden Park in the fourth Test

beneath him as he flew through the air. And then, partly in ecstasy and partly in uncontrollable flight, he tumbled over and over three or four times before at last his flight was stilled and he could gaze about him.

What a sight! Modest maidens, stout matrons, gawking schoolboys, the long and the short and the tall, were jumping, throwing paper and hats and bags, waving scarves and programmes and yelling, bellowing, making any kind of noise that seemed proper as an expression of total joy.

No wonder they called it the greatest try of all time! Lewis Jones popped over the conversion and the gap was a mere three points. New Zealand had scored first, when Crowley kicked the ball away from a Lions heel and Hec Wilson fell on it for a try, which Scott converted. Lewis Jones replied with a penalty, and then Scott produced one of his specials, a glorious drop goal from a long way out and on the touchline, to give the All Blacks a half-time lead of 8–3. Henderson then gathered a diagonal kick by Roper to score and make it 11–3, but next came the Jones gallop and score. The Lions had about five minutes to snatch the match and they almost did. Only a tremendous tackle by Henderson on Bleddyn Williams, after Roy John had dummied his way through the All Blacks forwards, prevented the captain from scoring at the death. It had been one of the best internationals seen in New Zealand.

There was no denying the superiority of the All Blacks forwards throughout the series, and every Lion who has toured what the Australians like to call 'the Shaky Isles', because of all the volcanic tremors, will know about that.

They were, as ever, worthy winners, but they had taken great pleasure in the brilliance of the Lions backs and the 1950 Lions remain one of the most popular teams ever to visit New Zealand.

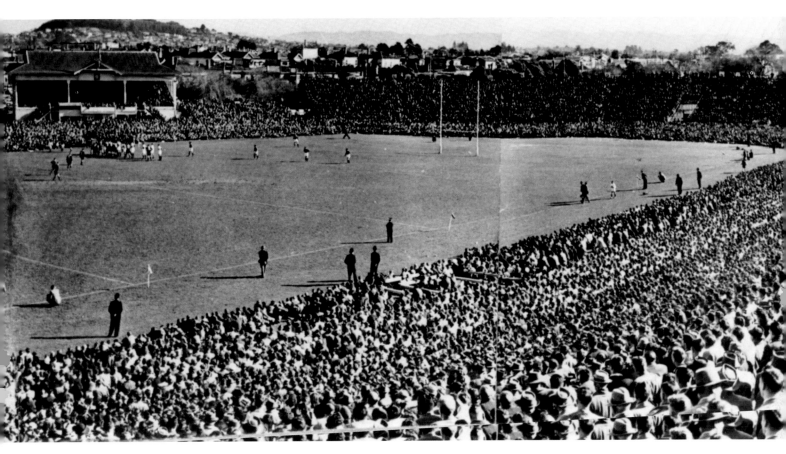

The editorial in *The Rugby Almanack of New Zealand – 1951* was glowing in its praise for the tourists:

The British Isles side of thirty players, supplemented by a reinforcement flown out to New Zealand after the side's sole full-back had been injured, gave untold enjoyment to thousands of New Zealanders. Producing open Rugby and with an excellent approach to the manner in which our grand game should be played, the side drew record attendances wherever they appeared. Such was the team's popularity, that the oft-expressed hope that a Test win would eventuate was borne out by the reception accorded the side at Auckland on the occasion of the final Test, when a desperate effort to gain the major points almost met with success. However, the All Blacks were too strong on the day, and our visitors had to leave our shores without an International victory. The visit did a wonderful lot of good for our Rugby, reminded us that spoiling tactics are detrimental to the game, and that pace, especially in the backs, is most essential. We were pleased to have the British Isles team with us.

Later in the *Almanack*, in their review of the Test series, the editors added:

It is doubtful if any side has done as much for a country's Rugby as the British Isles team did for New Zealand's. The visit, coming on top of the All Black tour to South Africa of the previous season, definitely stayed the trend towards defensive Rugby, which we were noticeably adopting as a result of a style copied in South Africa. Not for the British Isles players dull and uninteresting matches. Instead, open play and enjoyment for all was their forte, and well and truly did they dispense.

The Lions went on to play six games in Australia, where they found the rugby nothing like as hard as it had been in New Zealand, evidenced by their scoring 150 points in six games. They rattled off five convincing victories, including the two Test

BRITISH ISLES
v.
AUSTRALIA
at
SYDNEY CRICKET GROUND

Souvenir 1/-
Saturday, August 26, 1950

▲ The match programme from
the second Test against Australia
in Sydney, which saw the tourists
run out 24–3 winners

matches and the New South Wales state side, before surprisingly
losing to a New South Wales XV in their last match. Basil Holmes
'Jika' Travers, who was a colonel in the Australian army during the
war, and then played for Oxford University, Harlequins and
England, was the captain of that side, and his astute rugby brain had
much to do with the defeat.

After Malcolm Thomas had given a repeat performance, this
time against a New South Wales Country XV, of his 21 points in the
opening match in New Zealand, with six conversions and a penalty
goal, the Lions played New South Wales on the Sydney Cricket
Ground. Like many other sides, they were astonished when they
played across the Test pitch and churned it into a morass where, six
weeks later, Freddie Brown's English team was to play.

Although New South Wales was virtually the Australian Test
team, they were dispatched by 22–6 and the Lions left for Brisbane,
where the first Test was to be played, in a fairly relaxed mood.
They won their first Test of the tour fairly comfortably, 19–6,
despite losing Thomas with a broken collarbone after only 26
minutes. There were 20,000 fans at the Gabba and they
experienced typically humid Queensland conditions. The new prodigy, Lewis Jones,
scored 16 of the points with a 50-yard drop goal, a try, two penalties and two
conversions. Bleddyn Williams, still captain in the absence of the injured Mullen,
grabbed another try. Burke kicked two penalties for Australia. The Lions pack had
three changes from the last Test in New Zealand and, in the backs, Doug Smith won
his first Test cap of the tour.

Playing against them was that great character Nick ('Sudden Death!') Shehadie,
who had toured Britain with the 1948 Wallabies and who would later tour with the
1958 team. He was to become Sir Nicholas Shehadie OBE, Lord Mayor of Sydney
and president of the Australian Rugby Football Union. He was the epitome of the
interesting personalities one encountered in rugby, especially on Lions tours.

The Lions also won the second Test comfortably by 24–3, and had the unusual
experience of being watched by a 25,000 Test crowd while on the adjoining ground

➤ The Lions stopped off on their
way home for an unofficial game
against Ceylon. It was the 30th
fixture on their gruelling itinerary,
signing off with a 46–6 victory in
the capital Colombo

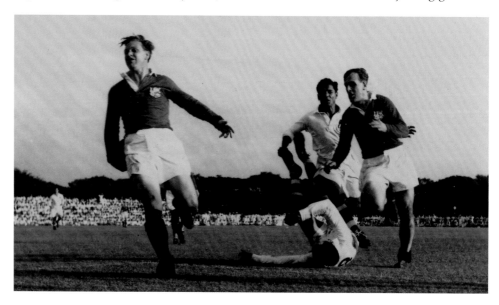

there was double the number making more noise watching a rugby league cup-tie. Nelson scored two tries and John, Kyle and Macdonald also scored, with Lewis Jones kicking a penalty and a conversion and Robins converting two. Cyril Burke scored Australia's try.

Coming home through the Suez Canal, the Lions played an 'unofficial' match en route against Ceylon, now Sri Lanka. This match mirrored the team of 1930 and the game was won 44–6. Lewis Jones helped himself to another 20 points and Vic Roberts ended his tour on a high with four tries. The Lions finally arrived home at Tilbury Docks on 7 October after a further 31 days at sea.

RESULTS OF THE 1950 LIONS IN NEW ZEALAND AND AUSTRALIA

P 29 W 22 D 1 L 6 F 570 A 214

Nelson, Marlborough, Golden Bay & Motueka	W	24–3	Wanganui	W	31–3
			Taranaki	W	25–3
Buller	W	24–9	Manawatu-Horowhenua	W	13–8
West Coast	W	32–3	Waikato, Thames Valley & King Country	W	30–0
Otago	L	9–23	North Auckland	W	8–6
Southland	L	0–11	Auckland	W	32–9
New Zealand (Dunedin)	D	9–9	New Zealand (Auckland)	L	8–11
South Canterbury	W	27–8	New Zealand Maoris	W	14–9
Canterbury	W	16–5	Combined Country	W	47–3
Ashburton County-North Otago	W	29–6	New South Wales	W	22–6
New Zealand (Christchurch)	L	0–8	Australia (Brisbane)	W	19–6
Wairarapa-Bush	W	27–13	Australia (Sydney)	W	24–3
Hawke's Bay	W	20–0	Metropolitan Union	W	26–17
East Coast, Poverty Bay & Bay of Plenty	W	27–3	New South Wales XV	L	12–17
Wellington	W	12–6	Ceylon (unofficial)	W	44–6
New Zealand (Wellington)	L	3–6			

KARL MULLEN'S 1950 LIONS TEAM

FULL-BACKS

W.B. Cleaver	Cardiff	Wales
B.L. Jones*	Llanelli	Wales
G.W. Norton	Bective Rangers	Ireland

THREE-QUARTERS

N.J. Henderson	Queen's University, Belfast	Ireland
K.J. Jones	Newport	Wales
M.F. Lane	University College, Cork	Ireland
R. Macdonald	Edinburgh University	Scotland
J. Matthews	Cardiff	Wales
D.W.C. Smith	London Scottish	Scotland
M.C. Thomas	Newport	Wales
B.L. Williams	Cardiff	Wales

HALF-BACKS

A.W. Black	Edinburgh University	Scotland
J.W. Kyle	Queen's University, Belfast	Ireland
I. Preece	Coventry	England
G. Rimmer	Waterloo	England
W.R. Willis	Cardiff	Wales

FORWARDS

G.M. Budge	Edinburgh Wanderers	Scotland
J.T. Clifford	Young Munster	Ireland
C. Davies	Cardiff	Wales
D.M. Davies	Somerset Police	Wales
R.T. Evans	Newport	Wales
D.J. Hayward	Newbridge	Wales
E.R. John	Neath	Wales
P.W. Kininmonth	Richmond	Scotland
J.S. McCarthy	Dolphin	Ireland
J.W. McKay	Queen's University, Belfast	Ireland
K.D. Mullen (capt.)	Old Belvedere	Ireland
J.E. Nelson	Malone	Ireland
V.G. Roberts	Penryn	England
J.D. Robins	Birkenhead Park	Wales
J.R.G. Stephens	Neath	Wales

*Replacement

1955 TOUR KIT

1955
HONOURS EVEN

Captain: Robin Thompson (Instonians and Ireland)
Squad Size: 30 + 1 replacement
Manager: Jack Siggins (Ireland)
Assistant Manager: Danny Davies (Wales)

Tour Record:	P 25	W 19	D 1	L 5	F 457	A 283
Test Series:	P 4	W 2	D 0	L 2		

It had been 17 years since a British team had last toured South Africa, but the 1955 Lions emerged with the best Test record since 1896, drawing the series 2–2. They were a side that captured the imagination of fans across the rugby-playing world with their free-flowing style. Included in their ranks were some of the biggest names of the decade: Cliff Morgan, Jeff Butterfield, Tony O'Reilly, Rhys Williams and Dickie Jeeps. The 30 players were selected in April, and of the original squad, only the Irish prop Fred Anderson pulled out. His place went to Scotland's Tom Elliott, a Borders sheep farmer.

I now come to my own Lions tour, which I intend to cover in some depth, in an attempt to give you a more intimate insight into the mechanics and character of such a tour, and my own thoughts on some of the pleasures and problems encountered.

▲ For a third successive tour, the Lions were captained by an Irishman, Instonians forward Robin Thompson, who led a squad featuring ten Welsh players, nine Englishmen, six Scots and four compatriots

First came the extreme delight I felt at being selected for such an adventure, and then crept in the personal doubts about taking on a country who were the undisputed world champions, and whether I was good enough to measure up to the challenge and make the Test team. I was given huge support by my club and my parents. The Swansea Rugby Club, in their generous Welsh fashion, gave Billy Williams and me a suitcase and £50, a handsome sum of money in those days, which, in fact, contravened the IRB's laws on amateurism. The Welsh, like the dominions, were always pragmatic in such matters.

I left with the rest of the Welsh Lions by coach for Eastbourne, where we were to meet our fellow adventurers, to be kitted out for our four months' trip of a lifetime and to be instructed on what would be expected of us. I had not a care in the world apart from the prospect of the huge challenge which faced us, for the Springboks had not been beaten in a Test series by any country, either home or away, for 59 years.

When we congregated at Eastbourne, we were unaware of any problems, and our first rude awakening came when we were addressed by a man from the Foreign Office. He told us that we were to be careful how we behaved with non-white people

in the recently formed Republic of South Africa, which had embarked on the disgraceful path of apartheid which was to bring them so much grief for over 40 years. We were instructed that on no account should we invite these people into our hotels and warned that any sexual contact with people of a different colour would put us in grave danger of imprisonment. We were surprised, even astonished, but at the time, made light of it. On the whole we were a bunch of politically agnostic young men, who had not thought too deeply about politics either at home or abroad and, being more or less apolitical, we were determined to go ahead and enjoy ourselves.

At that time, immigration from the West Indies into the UK was increasing, the Mau Mau were being offered an amnesty in Kenya and 60,000 blacks were evicted from their homeland west of Johannesburg. We were probably more interested in other things, such as Joe Davies making the first 147 break on television, and Marlon Brando winning an Oscar for *On the Waterfront*. Churchill resigned that year and Albert Einstein, James Dean and Thomas Mann all died. The Warsaw Pact was created and Tito and Krushchev made up. Ruth Ellis was sentenced to be the last woman hanged in Britain, and independent commercial television was launched, with toothpaste as the first advertisement.

Later in our week at Eastbourne, we were told by our big bluff manager, Belfast man Jack Siggins, what was expected of us in terms of behaviour, and we thought that the ground rules he set out were pretty generous. Basically, he said that we were to be well dressed at all times, particularly at official functions, that we were adult and that we should keep our own hours, but that the two nights before a game he expected us to be in the hotel and in bed before midnight. He also told us, more enigmatically, that we should always make sure the water was clean before we dived in. All good advice which, on the whole, we heeded.

It was amusing to recall how we were on our best behaviour with Jack and each other for the first week. Nobody misbehaved, we went to bed reasonably early, no one had much to drink and our fitness level improved considerably. We were kitted out with two pairs of boots each from a well-known manufacturer, but a couple of us had handmade boots by one of the finest makers of football boots, Law of Wimbledon. They were as light as a feather and, seeing their quality, a number of players immediately made phone calls and arranged details for measuring and having the boots sent out to them. We had all given the outfitters our measurements but, when we tried on our blazers, it was apparent that somebody had paid insufficient attention to detail, so, amid ribald comments about shapes and sizes, the next couple of days saw fitting sessions with the tailors, who were kept working flat out.

The training sessions began, and it was quickly evident that there were as many as half a dozen players who simply were not up to the standards required for such a hard tour, an assessment which was borne out by subsequent events. I have also asked members of many other pre-and post-war tours whether they experienced the same problem. Invariably the answer was an

▲ Capped 13 times by Wales by the time of the 1955 tour, author Clem Thomas played in the third Test in Pretoria and the fourth in Port Elizabeth

▲ The 1955 Lions' player's agreement document – each tourist had to sign a copy before heading to South Africa

unequivocal 'Yes'. Therefore, there has always been a problem with selection on Lions tours, which is not surprising considering the horse trading that goes on between selectors drawn from four different countries. Wild horses would not drag the names of these inadequates from me, but I remember hearing that mighty Lions forward, Rhys Williams, saying, 'Some of these guys could not get into Llanelli seconds.' It meant, of course, that these players had to be used sparingly, thus causing huge problems for team selection during the tour. From the start, that delightful man and great centre Jeff Butterfield assumed the responsibility of fitness coach and he took over the training sessions.

In terms of tactics and strategy, there was soon established a natural pecking order of those who really knew their rugby and those who did not, and a sort of senior unofficial committee evolved, to which, wisely, the management and the captain listened. People like the hard-bitten Scot Angus Cameron, the elegant and brilliant Jeff Butterfield, those 100 per cent forwards Rhys Williams, Jim Greenwood, Bryn Meredith and the irrepressible Welsh wizard Cliff Morgan were among the better rugby minds of the tour and set the agendas to follow.

Another feature of a Lions tour was that you were able to assess a player's ability and, by the end of the tour, you knew every player's strengths, weaknesses and capabilities, both on and off the field, to the nth degree.

It was soon apparent, in that first week spent training at Eastbourne College, that there were some remarkably talented players and people of considerable substance on the tour. There was also an immediate sense of fun, emanating mostly from the Irish and that remarkable man Cliff Morgan, who became a household name. We

▼ The 1955 Lions squad broke new ground by flying out for their South African assignment, taking a plane from London Heathrow to Johannesburg via Zurich, Rome, Cairo, Khartoum, Nairobi and Entebbe

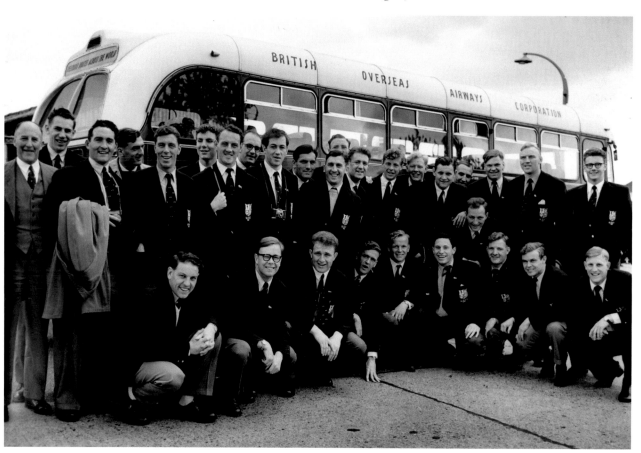

were highly amused when, at a team meeting, the ubiquitous Trevor Lloyd, the third scrum-half, suddenly said in his high-pitched Welsh accent, 'Hey, Jack!' (which was very brave, for we were still thinking in terms of Mr Siggins). 'What if a player has a girl and somebody tries to muscle in? Now, that could cause a great deal of trouble on a tour. I think that we should have a rule that nobody interferes with another player's girl.' Jack Siggins, for once, seemed lost for words, but the laughter relieved him from making a response. Thus 'Lloyd's Law' was born, which was invoked, more in jest than seriously, throughout our tour and has entered into the vocabulary of most Lions tours ever since.

I remember, too, that great character Reg Higgins creating another catchphrase of the tour. As we were walking along the tarmac to our plane at Heathrow, a gorgeous air hostess wiggled her way past us and, as we all stopped to admire her as young men will, he suddenly said in his broad Lancashire accent, 'Eh, Dad! Buy me that!' Again, it was to be used many times in a country so rich in wildlife and lovely girls!

We left our shores virtually unheralded and unnoticed, and the next morning the papers only had the briefest accounts of our departure for what turned out to be an experience of a lifetime. We were the first Lions team to travel by air, thus shortening a tour to South Africa by about a month. We flew in a Lockheed Constellation and the flight took 36 hours, stopping at Zurich, Rome, Cairo, Khartoum, Nairobi, Entebbe and, finally, Johannesburg.

It was the first time that most of us had been to Africa and one will never forget the thrill of that flight, the humidity of Cairo and looking forward to getting out at Khartoum for a breath of air, only to feel the blast of oven-hot air as the 140-degree heat rolled into the aircraft off the tarmac and one was immediately drenched in sweat. On the flight onwards to Nairobi, we finally cast off our deference to the management and, in the ladies' powder room at the tail of the aircraft, half a dozen of us started a small party, and proceeded to drink the plane dry. In no time we were joined by others, and eventually there were about 20 of us crammed into an area designed for a quarter of that number. Finally the captain of the aircraft appeared and breathed a huge sigh of relief, because for the last hour he had been trimming the aircraft as it gradually became increasingly tail-heavy.

There were 30 players, none of whom were aged over 30, because Jack Siggins made that the criterion of his selection policy. Consequently, some famous players such as Jack Kyle, Bleddyn Williams, Ken Jones, Noel Henderson, Rees Stephens and Don White were left at home. Our captain, Robin Thompson, was, frankly, not sufficiently experienced. The vice-captain was Angus Cameron, a strong character with a fine football brain who, fully fit, would have been a tremendous asset, but he came on tour with a wrecked knee and he really should not have played. Angus was finally rumbled by the Springboks in the second Test, when they played on him with disastrous results. The captain of the tour should have been the immaculate Jeff Butterfield.

The stars of the tour were Cliff Morgan, Jeff Butterfield and the precocious baby of the team, Tony O'Reilly, who had his 19th birthday in the Kruger National Park and who was the most mature teenager I have ever seen, both in intellect and in playing ability. The friendship of the Dubliner with the equally amusing Northerner Cecil Pedlow was one of the features of the tour, particularly as they conducted a friendly running battle with the Ulster hard-liner, Jack Siggins. O'Reilly said of Pedlow, when he was late for his 50th birthday lunch at the O'Reilly mansion in Kildare many years later, 'Did you know that Pedlow is a rear-gunner on a bread van

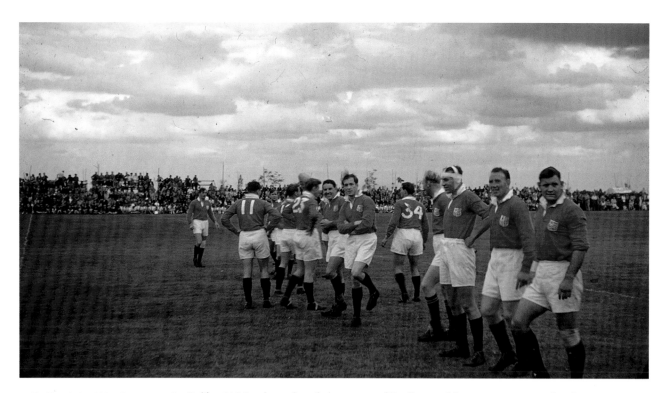

▲ The Lions before kick-off. The 1955 tour was one in which the British and Irish tourists were severely tested in many of their bruising provincial fixtures

in Belfast?' He also related the story of Pedlow asking a guy at a cocktail party, 'What do you do?' the reply to which was that he was a writer, currently writing a book about Belfast. 'Then you'd better hurry up,' said Pedlow.

Another find on the tour was the uncapped Dickie Jeeps, who was really Morgan's choice, for he knew that you could not have two conductors in the band. He got four Tests for the Lions before he played for England. Danie Craven, however, always maintained that had the Lions played Johnny Williams, a reserve scrum-half, in the Tests, then the Lions would have won the series.

It was the forwards, for my money, who were the unsung heroes of this tour: that remarkable front row who sounded like a firm of solicitors, Meredith, Meredith and Williams (the last only 6ft 3in tall but a giant), backed up by Tom Reid and splendid back-row men like Jim Greenwood, Russell Robins and Reg Higgins, the last until he got injured. I also loved the play of Johnny Williams and the admirable Douglas Baker, and, in the background, the young Arthur Smith was learning the trade which was to make him into a fine player and goal kicker.

The South Africans were kindness personified to us. No people are prouder of their country, which is not surprising considering its great beauty and enormous variety of climates and contrasting regions, from the tropical North East Transvaal and east coast to the Indian Ocean, to the Savannah of the Karoo and the temperate Cape. They were always, in my view, aware of the flaws in their politics and were, as a nation, uneasy with their politicians and their appalling policy of apartheid. They wanted us to ignore the bad element and love them for themselves, their country and their great hospitality, which has been the hallmark of the Afrikaner since his trekking days. It was not surprising, therefore, that so many rugby people were beguiled by them and became so ambivalent over their racial policies.

It was to have a profound effect on many of us, and the first time that I really began to think about apartheid and worry about our role in it was when a number of United Party women, who had organised themselves into an anti-apartheid

organisation called 'The Black Sash Women', picketed our hotel in Port Elizabeth. I also observed at the games how the black people were segregated behind the goalposts, and I saw how they were treated in so many other aspects of normal life.

I learned from O'Reilly, who became a good friend of the South African leader Nelson Mandela, that Mandela was one of those who stood in support of the Lions under the huge advertisement for Quinn's bread at Ellis Park, as a gesture of defiance towards the nationalist regime. When we won that unforgettable first Test, and at other times, our black supporters lit newspaper bonfires whenever we scored. We would always run over and applaud them at the end of a game, in recognition of their support.

After our exhausting flight from the UK, we arrived at Jan Smuts airport in Johannesburg and were astonished at the number of people who had come to the airport simply to see us. In turn, we surprised and delighted them when we sang 'Sarie Marais' in Afrikaans, which we had bothered to learn under our choirmaster, Cliff Morgan. We were then taken by coach to Vereeniging on the Saturday night, for ten days' acclimatisation before the first game. I was so tired after the flight that I fell on my bed fully clothed and was woken the following morning by Angus Cameron, to be told that I was expected on the first tee at nine o'clock against some of the locals. Once again, we had an insight into how rugby-mad the country was, as thousands came out from Johannesburg to see us, and they lined the fairways of the golf course as if it were the British Open.

That week, the details of touring were worked out, the duty boy rosters were organised and the policy of changing room-mates every week or fortnight was put in place. On the following Wednesday, we were taken to Pretoria to see Northern Transvaal beat Western Province. It was our first glimpse of provincial rugby in South Africa and we were shocked and appalled at the power and the pace of it all, together with the liveliness of the ball, which bounced like a mad thing on those hard grounds. We could not believe how far the ball travelled in the thinner air of the high veldt. I can still remember O'Reilly, who was to score a post-war record of 16 tries on the tour, sitting behind me in the stand and whispering in my ear, 'When does the next plane leave for home and shouldn't we be on it?' We were pretty quiet that evening, and the next day in training it was apparent that everybody was working twice as hard.

We were fortunate that we were a fast side, with quick-thinking backs in Morgan at outside-half, the peerless Jeff Butterfield at centre with the powerful Phil Davies, and fast and intelligent wingers in Pedlow, O'Reilly and Gareth Griffiths, with quick back-row forwards and a mobile front row.

The hospitality was overwhelming. One farmer, whose wife was the daughter of my tutor at St John's College, Cambridge, actually kept a leopard, which had been decimating his cattle, alive for a couple of weeks so that I could shoot it! Jack

▲ The interim tour report from manager Jack Siggins to the chairman of the Four Home Unions Tours Committee, dated 16 July 1955, which lauds the hospitality the Lions received in South Africa

Siggins, the manager, heard about it and decided to ban my involvement, but the farmer shot it anyway and gave me the cured skin. It was not so politically incorrect in those days but, alas, the skin was stolen from my hotel room in Nairobi on the way home. On another occasion, a farmer pitched up at our hotel, the old Carlton in the centre of Johannesburg, and again, to the chagrin of the management, presented me with a lion cub. Siggins insisted on my donating it to a local zoo, which I did with some relief. South Africa was unsophisticated in those days and there were still some dirt roads between Johannesburg and Pretoria.

For the first time, the Lions were accompanied throughout the tour by two journalists, the 1938 Lions full-back Vivian Jenkins of the *Sunday Times* and J.B.G. 'Bryn' Thomas of the *Western Mail*, in Cardiff. They were both popular with the team and were virtually accepted as members of the party, as was the equally likeable Roy McKelvie of the *Daily Mail*, who arrived in time for the first Test. As the press contingent grew to astonishing levels on later tours, they were never able to enjoy the same intimacy that these early journalists achieved, particularly when the tabloids began examining aspects of the tour other than those connected with rugby.

We were to play 25 matches in 15 weeks with 19 wins, one draw and five defeats and, in the process, we drew the series at two-all. Strangely, we gave the lie to the theory that it is difficult to perform at altitude, for we won both our Tests at altitude (Johannesburg and Pretoria are over 5,000 feet) and lost the two at sea level. We got off to the worst possible start as we lost the first game against Western Transvaal, a team of no consequence at the time and one that we should have been able to put away quite comfortably. They won 9–6 after the Lions had led by two tries to nil, but a drop goal by P. Pieters, and the Lions' first encounter with the prodigious kicking by Jack van der Schyff, who dropped a huge goal and then kicked a penalty, both from the halfway line, severely dented the Lions' confidence.

The Lions decided to put two days' allowance each into the kitty for the scorer of the first try on tour. The cash was incidental to the honour of actually registering the first score, but it was a move that promoted considerable debate as Cliff Morgan revealed in his autobiography, *Cliff Morgan: The Autobiography – Beyond the Fields of Play*:

> *Our opening game was against Western Transvaal at Potchefstroom. To avoid the worst of the heat we kicked off at four in the afternoon on a ground that was set like concrete. Although we were living on only five shillings pocket money a day, we decided to put ten shillings each into a kitty which would go to the player who scored our first try. The chance came to me in the second minute of the game.*
>
> *I took the ball behind a 10-yard scrum, went on the blind side, sold a dummy and dived over to score. So I took the kitty – or almost all of it. Cecil Pedlow, the Irish wing who was outside me, reckoned that I should have passed the ball and given him the honour, so he refused to pay up. Cecil did get a try of his own soon afterwards, and we were looking pretty good at that moment.*

I had been selected for that first game, but I was feeling poorly, and spent the day in bed with what seemed an upset stomach. Picked again for the Saturday game against Griqualand West, I was determined to play but, again, felt desperately ill on the morning of the game. The manager saw me and, realising that I was in a bad way, asked Norman Weinberg, the president of Griqualand and a prominent surgeon, to have a look at me. He promptly diagnosed appendicitis and shipped me off to Kimberley hospital where, after attending the match dinner, he arrived to perform the operation – but not before I had questioned his sobriety. He laughed and

said that I had ruined his evening, because he was unable to drown the sorrow of his side's defeat by 24–14. He did a great job on me, for I missed only the first ten matches of the tour and returned to play against Rhodesia five weeks later.

It was a pretty bleak moment when the manager and a few players came to see me the next day, before they left for Johannesburg to play the Northern Universities and then on to Orange Free State and Windhoek in South West Africa, before I was to join up with them again in Cape Town. That night, however, two men arrived in my private ward with a crate of beer and announced that they would leave only when it was finished. They were Sailor Malan, the Second World War ace fighter pilot who shot down the record number of 32 enemy aircraft, and a local businessman called Sam Armstrong, who was a dead ringer for Victor McLagen, the film star. They came in every night for five nights and, on the fifth, Sailor told me that the next day I was going to convalesce on his farm. In the meantime, the town of Kimberley avalanched my ward with crates of booze, cartons of cigarettes and dozens of boxes of chocolates, enough to open a large shop. Such was the hospitality of those South Africans, both English- and Afrikaans-speaking.

I had a week's convalescence with Malan, who had led the Torch Commandos for Oppenheimer in opposition to the nationalist policies and, as a reward, had been given the lease on this showpiece property, a de Beers farm of some 600,000 acres which was as much a game farm as anything else. Almost every day we went out shooting the high-flying partridges coming into the dams, or shooting other game such as springbok, and I was as fit as a fiddle when I rejoined the team in Cape Town some 12 days later.

Meanwhile, the Lions had begun to show their quality with strong wins over Northern Universities, Orange Free State, whom they shattered by 31 points to three, when they became angry after a Free Stater had knocked out two of Rhys Williams' front teeth, and South West Africa, now known as Namibia. Wins over Western Province and South Western Districts followed, before the Lions were brought down to earth with their biggest provincial defeat of the tour. They lost by 20 points to nil against Eastern Province, but the result was pre-ordained, because by now the Lions had accumulated a dreadful list of injured and sick players. We played O'Reilly at full-back and Bryn Meredith was unfit, so we had to play Robin Roe with two cracked ribs at hooker. We lost 35 out of the 41 scrums, as Amos du Ploy bored in on Roe, thus winning a Test cap which he had not really earned in light of the circumstances. He was not to survive after playing in the first Test at Ellis Park.

Roe's courage shone forth in more than a few matches when he deputised for Meredith and it was a trait he carried forward in his working life, winning the MC whilst serving as an Army Chaplain in Aden in 1967. He heard gunfire outside the Radfan Camp and, after investigating, he found a British Army lorry on fire with British soldiers lying scattered around it. Under heavy fire, he bravely helped the

Tour Itinerary and Lions' results on 1955 tour

(LIONS' SCORES SHOWN FIRST)

				1955	1962
May:					
26	Rhodesia	Salisbury		W 27-14	W 38-9
30	Griqualand West	Kimberley		W 24-14	D 8-8
June:					
2	Western Transvaal	Potchefstroom		L 6-9	W 11-6
6	Southern Universities	Newlands		W 20-17	W 14-11
9	Boland	Wellington		W 11-0	W 25-8
12	South-West Africa	Windhoek		W 9-0	W 14-6
16	Northern Transvaal	Pretoria		W14-11	L 6-14
23	**FIRST INTERNATIONAL**	Johannesburg		W 23-22	D 3-3
27	**NATAL**	Durban		W 11-8	W 13-3
30	Eastern Province	Port Elizabeth		L 0-20	W 21-6
July:					
4	Orange Free State	Bloemfontein		W 31-3	D 14-14
7	Junior Springboks	Pretoria		W15-12	W 16-11
11	Combined Services	Potchefstroom		—	W 20-6
14	Western Province	Newlands		W 11-3	W 21-13
17	South-Western Districts	Oudtshoorn		W 22-3	W 11-3
21	**SECOND INTERNATIONAL**	Durban		L 9-25	L 0-3
25	Northern Universities	Springs		W 32-6	D 6-6
28	Transvaal	Johannesburg		W36-13	W 24-3
August:					
4	**THIRD INTERNATIONAL**	Newlands		W 9-6	L 3-8
8	North-Eastern Districts	Burghersdorp		W 34-6	W 34-8
11	Border	East London		L 12-14	W 5-0
15	Central Universities	Port Elizabeth		W21-14	W 14-6
18	Eastern Transvaal	Springs		D 17-17	L 16-14
25	**FOURTH INTERNATIONAL**	Bloemfontein		L 8-22	L 14-34

(Summary of 1955 Results: Played 24, Won 18, Lost 5, Drew 1. Points for 418; Points against 271. This includes an additional match against Rhodesia, which the tourists won 16-12.)

▲ A tour itinerary recording the results of both the 1955 and 1962 Lions, although some of the scores fail to tally with official records

wounded soldiers back into the camp. Army Chaplains do not carry weapons and are non-combatants; their work is to sustain, not destroy. For his outstanding bravery, Roe was awarded the MC. The citation for Reverend Robin Roe's MC read:

He played a particularly gallant part during the 'Aden Mutiny' on 20 June when, oblivious to the heavy fire being directed at the camp, he attempted to drive about 400 yards across open desert to the scene of an accident where several men had been killed and some badly wounded. He was turned back forcibly by another officer only after he had personally been shot at and his Land Rover hit by machine gun fire.

He then devoted his attention to assisting the Medical Orderlies inside camp with the local casualties until it was possible to recover the victims of the main attack.

His courage and example in the face of danger has been outstanding and his infectious enthusiasm and confidence under all conditions has been an inspiration to the whole Battalion.

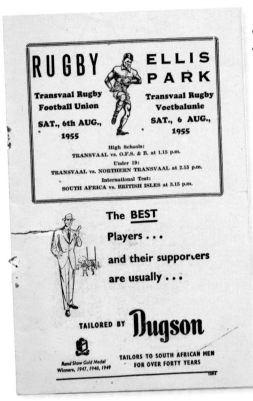

▲ The match programme from the first Test at Ellis Park, widely considered to be one of the finest games in Lions history

The Lions bounced back and won the next eight games in a row, including the first Test. That Test was never to be forgotten by all who saw it, and it attracted the biggest gate in the history of the game. An official record 95,000 spectators paid to see the match, many from the most rickety scaffolding stands thrown up for the occasion which, nowadays, would give any building inspector or ground safety officer a nervous breakdown. They also estimated that another 10,000 got in with forged tickets, or one way or another. The black market got up to £100 a ticket, a fortune in those days, but the sheep farmers coming in from the Karoo would pay anything to see that match. The Lions sold their surplus tickets to the hotel barber at £50 a time and everybody made a killing.

The selling of tickets was, for some, their only income during a four-month tour, apart from the one pound and ten shillings a week pocket money, so they had no compunction in breaking the amateur laws. In future Lions tours there would be a team fund organised by the players, which was shared out at the end of the tour, and it usually amounted to enough to buy presents for their families and wives or girlfriends.

Those hard Afrikaner cases, from Transvaal and throughout the high veldt, had come to see the Lions thrown to the Christians, but were astounded when 45 points, the most ever in a Test in South Africa at the time, were scored and the Lions got one more than their beloved Springboks. To add insult to injury, the Lions had lost Reg Higgins with a knee injury soon after half-time, and played most of the second half with only 14 men.

The Lions won 23–22, and it was, without question, one of the greatest Test matches ever played anywhere in the world, in any era. There is a famous photo of van der Schyff letting his head drop in dejection, when he failed with the last kick of the game to convert a last-ditch try. Like most of the team and their supporters, O'Reilly could not look at the kick, and when somebody asked him in the dressing-room what he was thinking of at the time of van der Schyff's kick, he said, 'I was merely in direct communication with the Vatican.'

Ernie Michie, immaculately turned out in his kilt, had led the Lions on to the field with his bagpipes wailing what some thought was a lament for the Lions, and Robin Thompson, clutching our tour mascot, a large toy Lion named Elmer, had run the team out to the huge roar of a crowd waiting to see the first British side play their invincible Springboks for 17 years.

It was a nail-biting thriller of a game, and it was no wonder that a total of 678,000 flocked to see all 24 matches during the tour. The hallmark of these Lions was their direct, simple play, their speed of pass, their speed of running, and their philosophy of ignoring whether it was good or bad ball; they merely used whatever was available. Above all, they were adventurous and ran everything they could. To underline the fact, coming into the first Test the try count in 12 matches was 55–8 in the Lions' favour, at an average of more than four tries per game.

The Lions scored a dazzling opening try in that vital opener game of the series in Johannesburg, when Butterfield, or 'Buttercup' as Morgan called him, collected a poor pass and classically broke on the outside and drew the full-back, to put Pedlow over in the corner. Van der Schyff then kicked two penalties with two superb kicks, which people forgot in the recriminations which were to follow. The diminutive scrum-half Tommy Gentles, the smallest-ever Springbok and the smallest player I ever saw in Test rugby at 5ft 3in, broke and Stephen Fry, the Springboks captain, put Theunis Briers, a Paarl farmer, away on one of his powerful runs for a try. It was converted by van der Schyff, and South Africa led 11–3. An eight-point lead was never safe from these Lions and Butterfield now contrived another try, scoring at the post with a clever change of direction, and Cameron converted to make it 11–8 at half-time.

Immediately after the restart, the Lions lost Higgins for the rest of the tour with torn knee ligaments, but this misfortune only seemed to inspire them, and the pack played like men possessed. In a ten-minute period, the Lions scored 15 points, to roar into a commanding 23–11 lead. First, from a strike against the head by Meredith, Morgan weaved some of his magic and I can still see him sticking his neck out and rocketing past the great Basie van Wyk with a devastating outside break, to score an inspirational try. Two more tries swiftly followed when, from two kicks ahead, the bounce deceived van der Schyff, and the indefatigable Greenwood and the alert O'Reilly went over. Cameron converted all three and the Johannesburg crowd were stunned. Five tries was a record for the Lions in a Test match and it is a mark that still stands in 2013, matched only by the 1950, 1959 and 1966 teams against Australia and the 1974 side in the second Test in South Africa.

▲ Fly-half Cliff Morgan in action against the Springboks in Johannesburg. The Welshman played all four Tests and was voted player of the series

In the last quarter, the seven Lions forwards inevitably began to tire and the Springboks began to get back into the game. The Lions continued to hold until the last few climactic minutes when, with only a couple of minutes to go, that mighty forward Chris Koch picked up and stormed his way over from 20 yards out and van der Schyff banged over the conversion. Then, late into injury time, with the massive crowd screaming deliriously, Fry picked up a loose ball and flipped it to Briers, who beat both Pedlow and Cameron with an inside swerve to score from about halfway out. Agonisingly, the Lions stood there waiting for a conversion, which was difficult only because of the pressure. The scoreboard read 23–22 and the last number then

THE BRITISH & IRISH LIONS: THE OFFICIAL HISTORY

disappeared, as the scorer prepared to put up 24. That photograph will remain a monument to van der Schyff's despair, as the ball swung to the left of the posts. It was van der Schyff's last game for South Africa and he turned to making a living by crocodile hunting in Rhodesia.

Danie Craven put the defeat of his beloved Springboks down to the fact that they were not motivated: 'You must be keyed up for the big occasion, and the belief among old Springboks that a team which sings before a Test is destined to weep afterwards is not a silly superstition.' He was to ban singing by the team on the way to future Tests.

It was the match of that generation and all who saw it will never forget it. The Lions were jubilant, for they knew they had achieved the minor miracle of putting South Africa on the back foot in a Test series in their own country. One man in the crowd dropped dead from excitement. The South Africans took defeat very well and it was to revive back play in the Republic, as the Lions quickly found to their cost.

Three more games were won against Central, Boland and Western Province Universities, the last providing one of the best games of the whole tour, which was not surprising as 11 of the students subsequently won Springboks colours. I happened to be captain that day, and I remember that they matched us try for try at four each, and that I was sweating. Only a try by Tom Reid in the dying moments saw us through by 20–17. I recall they had a lovely pair of half-backs in Richard Lockyer and Brian Pfaff and they had Butch Lochner, later to become a Springboks selector, in the back row. At the time Butch was a farmer, but on subsequent visits to that country I found that, in turn, he became a lecturer at Stellenbosch and then a colonel in the army.

> The 1955 tour was the first in which the Tests were filmed and subsequently shown back in Britain.

The great Johannes Claassen, who played against us that year, had a similarly chequered career, first in the university, then the army, and at one time he even became a bishop. I often wondered about this, and I concluded that it was a system by which the Afrikaner brotherhood rewarded their famous sons.

For the next Test, South Africa dropped five of the team. Wilf Rosenberg, a really sharp centre, came in to partner Des Sinclair in the centre and Tom van Vollenhoven was switched to the wing. Sias Swart and van der Schyff were the backs dropped, with Roy Dryburgh drafted in at full-back. The three forwards dropped were du Ploy, Colin Kroon and the legendary van Wyk, who had played his last game for the Springboks. In their place came the immensely strong Northern Transvaal prop Jaap Bekker, Bertus van der Merwe, and the fast flanker Dawie Ackermann, who had played so well for Southern Universities against us. The Lions made only two changes: Gareth Griffiths, flown in as replacement after Arthur Smith had broken his thumb in the first game, was preferred to Pedlow, and Russell Robins was moved to flanker, to accommodate Tom Reid at No. 8.

Apparently Fry, the Springboks captain, was too nervous to address his team before the kick-off and asked Danie Craven to do it for him. The Lions on the other hand were cheerful, but the back row and the unfit Cameron were to be our Achilles heel, and we lost by the resounding margin of 25–9, a big score in those days. Van Vollenhoven had found his spiritual home on the wing, as Gerald Davies did a couple of decades later, and the Springboks back, later to score 392 tries in 408 appearances in rugby league for St Helens, scored three magnificent tries.

The seven tries scored by the Springboks at Newlands constituted a record for a Test in South Africa, and was one less than the most scored in a Test against the Lions, by New Zealand in the third and final game of the series in 1908. There was no hint in

the first 20 minutes of the avalanche to come and, at that stage, the Lions led with a penalty goal by Cameron. Jeeps and Morgan were unhappy at half-back and the Lions pack was far from its best. Nevertheless, it was not until three minutes before half-time that the Springboks scored, when Sinclair kicked across field for van Vollenhoven to steal the ball from O'Reilly's nose and score. At half-time it was 3–3.

The Springboks had now spotted how slow Cameron was at getting into the corners with his crook knee and they played on him, in what was to be his last game of the tour. Inexorably the tries came as the Lions, for the only time on tour, really cracked. Van Vollenhoven got two more quick tries for his hat-trick, and Rosenberg, Dryburgh, Briers and Ackermann all added tries, although Dryburgh converted only two of them. The only response by the Lions was a couple of tries by Butterfield and Meredith, two of the most outstanding players of the tour.

It was the Lions' turn to lick their wounds, as the South Africans had picked up the gauntlet of running rugby and had beaten us at it. We journeyed north, sadder and wiser men, for what should have been an easy game against Eastern Transvaal at Springs but, with a side mostly composed of the midweek 'dirt-trackers', as they are called in Lions parlance, we nearly came to grief again and only scraped a draw at 17–17. We only had 14 men in the second half, for Baker pulled a muscle and, as he was needed for the Test as a makeshift full-back, he could not be risked. To make matters worse, Doug lost his contact lenses the next day and we had to enlist the aid of the British High Commission to get a new pair flown out from Germany.

There was now the prospect of the hardest week of the tour, as we had to play Northern Transvaal one Saturday and the Springboks the next, which was almost the same as playing back-to-back Tests. I was fully fit again and I was delighted to be included in the team against the Blue Bulls, as Northern Transvaal are known. I was renewing my 1951 Swansea confrontation with Hansie Brewis, that great Springbok outside-half. He was now at the end of his fine career, as was Fonnie du Toit, his scrum-half in the fantastic South African side which toured Britain in 1951. In addition, Northern Transvaal had van Vollenhoven in the centre and Bekker, Retief and 'Salty' du Rand, their captain, in the pack.

The Lions were expected to lose, but we won another famous victory by only the narrow margin of 14–11. I shall never forget Butterfield's try that day when, with a couple of minutes to go, he juggled the ball from somewhere behind his back inside his own 25, and shimmied his way through a gap to race 80 yards to score, with the local hero, van Vollenhoven, chasing him every step of the way, but unable to make up an inch of his three- or four-yard lead.

So we had set the scene for another battle of the giants in the third Test. The Lions made four changes, with Baker coming in for Cameron, and I came into the pack at flanker, for Reid to revert to the second row in place of the injured Thompson, and allow Robins to return to No. 8. Morgan was given the captaincy and Billy 'Stoker' Williams, the indestructible prop, was given the leadership of the forwards and the vice-captaincy.

South Africa made only one change, bringing in the Free Stater Coenraad Strydom, known as 'Popeye', for the tiny Gentles. Later, Dan Retief withdrew with an injury, and he was replaced by Butch Lochner at No. 8.

This Test became known in South Africa for a remarkable training session as Danie Craven, obsessed by the idea that the British press were spying on him, took his players off the field and, when they had gone, took them back again for a session under bright moonlight. The press dubbed it 'the moonlight sonata'.

It did them no good, as the Lions now changed their tactics and decided to attack the 'Boks where they least expected: through the forwards, with heavy support kicking from the backs. We made a few mistakes, but we were well worth our 9–6 margin at Loftus Versfeld, another of those magnificent grounds which abound in South Africa.

There were 63 lineouts, which illustrated how we decided to make it a kicking and not a running game and took the Springboks forwards on up front. It was a hot, enervating day and some of the forward exchanges were particularly fierce. The scrummaging of our front row of Williams, Meredith and Meredith was quite magnificent, and I well remember Jappie Bekker talking to Chris Koch and swapping places for a few scrums. I asked Koch at the after-match function what happened, and he told me that Bekker was having trouble with Courtenay Meredith and asked him to change. After a couple of scrums, Koch said he told Bekker to do his own dirty work.

During this match, Courtenay Meredith picked up one of the worst mouth injuries I have ever seen. He came up to me at half-time and, with blood streaming from his mouth, showed me his tongue, which was almost severed halfway back to the root, and asked me, 'How bad is it?' I said, 'It's bloody terrible, but keep your mouth shut and stay on the field for the second half or we are done for.' He was in great pain but, to his undying credit, he did just that and, after the game, was rushed to hospital to have it stitched. He was in trouble with this injury for a couple of weeks and did not play again until the final Test.

As often happened on these Lions tours, players like Courtenay Meredith and Rhys Williams were, in the Orange Free State match, victims of what is known as 'the cheap shot'. It became necessary to have a fixer to stop such unprovoked attacks. O'Reilly

became the principal spotter from the safety of the backs and I was made the avenging angel. Tony would come up to me and say, 'Number four' or whatever, and I was supposed to go in and mete out the punishment at the next opportunity, preferably at a nice loose maul. I don't know how I got such a difficult job! It was merely, as Tony often explained, that I could hit harder than the others, even though I was one of the smallest forwards at about 14 stone. It was all about having been taught to fight on the coal tips in Brynamman during the school holidays and having boxed a bit at school.

The first Test to be held in Pretoria was an unpretty, dour game and out of character with the normal style of the 1955 Lions, because our strategy was to win at all costs, to go one-up in the series with one to play. In a grimly fought first half, the only score was a left-footed drop goal by Butterfield. Twelve minutes into the second half, Baker increased our lead with a penalty, before Dryburgh replied with a huge 50-yard drop goal from a penalty. Sustained Lions pressure finally brought reward, when I managed to pick up a loose ball and gave to Butterfield, who crashed over for a try. Although Dryburgh then kicked an orthodox penalty, the Lions finished strongly and were attacking fiercely at the end. Everybody, including Danie Craven, said that we deserved a win, a fact which shook South Africa and, indeed, the world of rugby, to the core.

After the enormously successful fortnight in Pretoria, we then took off in high spirits to the Kruger National Park for a well-deserved break. On the way, we lunched at Crocodile River at the home of Ivan Solomon, a millionaire citrus grower, who typified the massive hospitality we received wherever we went in the new Republic by laying on a braai or barbecue of such quality that it was something to

remember. We spent the next four days in this extraordinary game reserve which is the size of Wales, and most of us saw lions, leopards, elephants, buffalo, crocodiles, hippopotamuses and almost every type of game. It was magic, and I will never forget the first night, for we were celebrating O'Reilly's birthday and that of our assistant manager Danny Davies. Remarkably, it was only the former's 19th, for his maturity of mind and body was equal to anyone on tour. What a grand party it was! The next day we had to send our truck, which accompanied us full of cases of beer, back to Nelspruit for new supplies.

We had three matches to play before the final Test, and the first was against Natal in Durban which, in many ways, was the most English of all the provinces we played. Unthinkingly, we offended them by resting most of the Test team and trotting out the dirt-trackers, including none of our stars like Morgan, O'Reilly and Butterfield. The local press, the *Natal Mercury*, called us the 'Insult XV', but then we had to rest our top players who had just finished a tough campaign in Northern Transvaal.

I was made captain of what was considered to be a rag-bag side and, frankly, we played as though we were, although there was no criticism of the forwards, for it was the backs who squandered one opportunity after another. I remember we snatched our 11–8 win against a very lively and young Natal team only in the closing seconds of the game, when Tom Reid, bless his big heart, picked up and fed me, so that I put Tug Wilson over for the try.

We now played the Junior Springboks at Bloemfontein, which was virtually as hard as any Test match and, again, the temperature reached 80 degrees. It was also evident that the Lions were beginning to get travel and tour weary, and we struggled to win a dour game by 15–12. Worse was to come, for next we lost 14–12 to Border

▲ Author Clem Thomas and the Lions in the Kruger National Park. The tourists hadn't visited the country for 17 years and enjoyed a warm welcome throughout their lengthy South African adventure

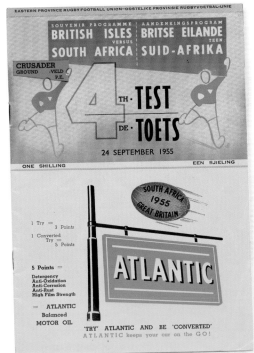

▲ The programme from the decisive fourth Test at Port Elizabeth, which saw the Springboks battle back to level the series

▼ A match ball signed by the the 1955 and 1962 Lions squads as well as the 1955 Springboks

East London, who were a really tough outfit. They were a bit like the Llanelli or Swansea of South Africa: always guaranteed to give any touring team a hard time.

It is easy to make excuses, and some of them were true, for we were by now a tired side and beleaguered with injuries, and some of the selections for the final Test were disastrous. Reid should have been retained after his great game in the third Test, but tour politics saw the captain, Thompson, brought back, and O'Reilly, who played on the wing for most of the tour, was brought into the centre in place of Phil Davies. Morgan was not really fit to play after an ankle injury sustained against the Junior Springboks but, as it was unthinkable both in his own mind and those of the other members of the team that we should take the field without him, he decided to play.

The only changes made by the Springboks selectors, chairman Frank Mellish, Bill Zeller, Danie Craven, Maurice Zimmerman and Basil Kenyon, who refused to panic after Pretoria, were to bring back Gentles at scrum-half and the formidable Retief into the pack.

The major factor in the final disappointing defeat was, of course, the Springboks spirit, which dictated that they were not going to lose a Test series at home and, on the day, they were magnificent. The Lions had the chance of being the first team since the turn of the century to win a Test series, but were simply not good enough, on that day, to do it.

The Lions threw everything they had at the Springboks in the first 20 minutes and scored first when, from a sweeping three-quarter attack, Gareth Griffiths kicked ahead; the always energetic Greenwood won the race with Gentles, and Pedlow converted. In the first half, the Lions looked good to win and created many scoring chances which were not taken. Clive Ulyate then began to ply Pedlow with high balls where his eyesight was suspect and Briers, chasing up, stole a ball from under his nose to score a try. At half-time it was 5–3 to the Lions.

In the second half, Ulyate applied the same tactic and, again, Briers stole in for a try. A break by Gentles brought a try from Ulyate, converted by Dryburgh, and the Lions had no petrol left in their tank, as van Vollenhoven scored a try in the corner and Ulyate dropped a goal to make it 17–5. The Lions showed that they could still bite back when O'Reilly scored, breaking his shoulder in the process; but, with a minute to go, Retief scored under the posts and Dryburgh converted, to make the final score 22–8.

And so ended a dream, and a tour which was measured as much by its friendliness, great humour and comradeship as by the standard of play, among one of the finest bunches of players to represent the British Isles. They were popular wherever they went and Danie Craven, who, in his famous office in Stellenbosch University, granted me the

last interview he gave to a pressman shortly before he died in 1992, said they were the team he always admired most for their attitudes both on and off the field.

The South African media were no less flattering. One newspaper said that they were grateful to these Lions for reminding them that the skull was still a receptacle for brains, rather than being just a battering ram.

No wonder thousands of South Africans turned up to say 'Tot Siens' (goodbye) to us, and as we walked out on to the tarmac we turned and sang 'Sarie Marais', 'Sospan Fach' and 'Now is the Hour' for them, before heading home, via one game in Nairobi.

After leaving the UK unheralded all those weeks ago, we were to arrive home to a fanfare of plaudits, as far finer players and better men for such an amazing and fulfilling experience. We had enjoyed a crash course in the University of Life.

RESULTS OF THE 1955 LIONS IN SOUTH AFRICA

P 25 W 19 D 1 L 5 F 457 A 283

Western Transvaal	L	6–9	Central Universities	W	21–14
Griqualand West	W	24–14	Boland	W	11–0
Northern Universities	W	32–6	Western Province Universities	W	20–17
Orange Free State	W	31–3	South Africa (Cape Town)	L	9–25
South West Africa	W	9–0	Eastern Transvaal	D	17–17
Western Province	W	11–3	Northern Transvaal	W	14–11
South Western Districts	W	22–3	South Africa (Pretoria)	W	9–6
Eastern Province	L	0–20	Natal	W	11–8
North Eastern Districts	W	34–6	Junior Springboks	W	15–12
Transvaal	W	36–13	Border	L	12–14
Rhodesia (Kitwe)	W	27–14	South Africa (Port Elizabeth)	L	8–22
Rhodesia (Salisbury)	W	16–12	East African XV (Nairobi)	W	39–12
South Africa (Johannesburg)	W	23–22			

ROBIN THOMPSON'S 1955 LIONS TEAM

FULL-BACKS
A. Cameron	Glasgow HSFP	Scotland
A.G. Thomas	Llanelli	Wales

THREE-QUARTERS
J. Butterfield	Northampton	England
W.P.C. Davies	Harlequins	England
G.M. Griffiths*	Cardiff	Wales
H.T. Morris	Cardiff	Wales
A.J.F. O'Reilly	Old Belvedere	Ireland
A.C. Pedlow	Queen's University, Belfast	Ireland
J.P. Quinn	New Brighton	England
A.R. Smith	Cambridge University	Scotland
F.D. Sykes	Northampton	England

HALF-BACKS
D.G.S. Baker	Old Merchant Taylors'	England
R.E.G. Jeeps	Northampton	
T. Lloyd	Maesteg	Wales
C.I. Morgan	Cardiff	Wales
J.E. Williams	Old Millhillians	England

FORWARDS
T. Elliot	Gala	Scotland
J.T. Greenwood	Dunfermline	Scotland
R. Higgins	Liverpool	England
H.F. McLeod	Hawick	Scotland
B.V. Meredith	Newport	Wales
C.C. Meredith	Neath	Wales
E.T.S. Michie	Aberdeen University	Scotland
T.E. Reid	Garryowen	Ireland
R.J. Robins	Pontypridd	Wales
R. Roe	Lansdowne	Ireland
R.C.C. Thomas	Swansea	Wales
R.H. Thompson (capt.)	Instonians	Ireland
R.H. Williams	Llanelli	Wales
W.O.G. Williams	Swansea	Wales
D.S. Wilson	Metropolitan Police	England

*Replacement

1959
THE GREAT ENTERTAINERS

1959 TOUR KIT

Captain: Ronnie Dawson (Wanderers and Ireland)
Squad Size: 30 + 3 replacements
Manager: Alf Wilson (Scotland)
Assistant Manager: Ossie Glasgow (Ireland)

Tour Record:	P 33	W 27	D 0	L 6	F 842 A 353
In Australia:	P 6	W 5	D 0	L 1	F 174 A 70
Test Series (Aus):	P 2	W 2	D 0	L 0	
In New Zealand:	P 25	W 20	D 0	L 5	F 582 A 266
Test Series (NZ):	P 4	W 1	D 0	L 3	
In Canada:	P 2	W 2	D 0	L 0	F 86 A 17

In that last year of the 1950s, we saw the phenomenon of Teddy boys and girls, and the juke-box; Cliff Richard sang his hit song 'Living Doll'; cinemas were closing due to television, with 57 closing that year; Hugh Greene became governor of the BBC; duty-free booze was approved at airports; the first Mini was produced; and they began building the first hovercraft. Overseas, Buddy Holly was killed in a plane crash; mobs rioted in Little Rock, USA, against the schooling of blacks in mixed schools; and Castro took power in Cuba.

Although unsuccessful in New Zealand, some tremendous players went on the 1959 Lions tour, six of whom had been on the 1955 tour. These were Tony O'Reilly, Jeff Butterfield, Dickie Jeeps, Bryn Meredith, Hugh McLeod and Rhys Williams. All of them made a big contribution to the Test team, apart from that star of 1955, Butterfield, who was plagued by a thigh injury. There was also one player from the 1950 Lions side which toured New Zealand, Malcolm Thomas, who was an invaluable source of information as well as being a very experienced player.

This was another tour which committed itself to all-out attack, but which never got its just deserts. The 1959 Lions scored more points than any other Lions team, 842 in 33 games, 25 of which were in New Zealand, six in Australia and two in Canada. They won only one of the four Tests in New Zealand, and were robbed of the title of the most successful team so far in this century only by the boot of Don Clarke. He kicked six penalty goals in the first Test, which was enormously depressing, as the Lions scored four tries, only to lose 18–17. Clarke also deprived them of victory in the second Test, with a late try and conversion. Without Clarke, the Lions' record would surely have been played four, won three, lost one, instead of lost three, won one.

Nevertheless, they played brilliant rugby and scored a remarkable 165 tries. Tony O'Reilly got 22 of them, 17 in New Zealand in as many games to overtake Ken Jones' 16 in 1950 and establishing a record which may never be broken. The mercurial Coventry and England wing Peter Jackson scored 19 on the tour. Thus, it was one of the most attractive and effective sides ever to tour New Zealand, and they drew huge gates everywhere, because of their propensity for attacking from anywhere. Their 113 tries on New Zealand soil came at a rate of 4.52 per match, while they only conceded 38 at less than two per game. If they had a weakness, it was that they gave away too many penalties. It is interesting to note that, in the first

◄ Ireland's domination of the captaincy continued in 1959 with the appointment of Wanderers hooker Ronnie Dawson as skipper

Test at Dunedin, they drew a record crowd of 41,500, and the match takings were £20,500. It seems a far cry from today's big gates, which in some cases fetch well over a million pounds. Overall, 801,750 fans watched the 25 games in New Zealand and paid £320,000 for the pleasure. Both were record figures for any Lions team in that country and the tour generated a £200,000 profit for New Zealand rugby.

For once, the Irish were the most predominant of the home nation teams on the tour, with ten players; England and Wales had nine apiece, and Scotland five. The squad was picked by a group of nine men, two selectors from each of the four home unions and the tour manager, Alf Wilson, at the time the chairman of the Scottish selectors, as chairman. England were represented by Carston Catcheside and Robin Prescott, Wales by Ivor and David Jones, the Scots by Charlie Drummond and George Crerar and Ireland by Cyril Boyle and David Barry. The party was announced on 24 March and the party left on Saturday, 16 May. The selectors weren't able to consider 1955 wings Arthur Smith and Cecil Pedlow, or Scotland forward Hamish Kemp, or Oxford University and England centre Malcolm Phillips, who had made themselves unavailable, and the manager asked his players not to play any rugby after 5 April unless it was necessary. Excluded from this edict were the Irish contingent, who had to round off their country's Five Nations campaign against France on 18 April. There were no casualties from that game, but the Moseley and England flanker Peter Robbins lost his place after breaking a leg playing for the Barbarians against Newport on 31 March. As O'Reilly told the *Sunday Times* rugby correspondent Viv Jenkins at the time: 'After that we were afraid to cross the road, let alone take any serious exercise.'

The squad assembled on 10 May in Eastbourne and were put through hell by Butterfield with twice daily, two-hour-long physical-conditioning sessions. Alan Ashcroft was made the team's choirmaster. The team departed from London Airport after six days in camp and flew to Melbourne for their opening fixture with Victoria.

As ever, there were some terrific, fun guys and characters like Andy Mulligan and O'Reilly, Ray Prosser and David Marques, who became unlikely buddies, hard cases like Gordon Wood of Limerick, and city slickers like John Young, the AAA

▲ The power of tour skipper Ronnie Dawson (top), Llanelli second row Rhys Williams (bottom left) and Newport hooker Bryn Meredith meant the 1959 Lions were blessed with formidable options in the pack, although Dawson's presence meant Meredith's Test opportunities were limited

100-yards champion of 1956, who had recorded a best time of 9.6 seconds, and who later became secretary of the London Stock Exchange. It was the sort of perfect blend of gentlemen of all classes which always epitomised a Lions tour, and which made a nonsense of that British disease of class distinction and privilege. Such a tour can only sustain a meritocracy and a bond of fellowship arising from the soldiering which is a fact of life when touring the southern hemisphere.

Once again, the team had men like Rhys Williams, an automatic choice at lock on both his tours, as durable as they ever came, and Roddy Evans, who played so well in the first two Tests but missed the latter stages of the tour due to injury. Hughie McLeod, the Hawick and Scotland prop, had now grown into a magnificent player. Ronnie Dawson claimed the hooker position and this was a contentious argument before and after the tour, for it was always claimed by the cognoscenti that Bryn Meredith was one of the greatest hookers of his or any other era and it was therefore considered a mistake to make Ronnie captain, which meant Bryn would be left out of the Test team. It was another example of poor selection by those secretive men in the East India Club in St James's Square. That is not to say that Dawson was a poor player: far from it, and he was also a hard-working captain. His conscientious work for rugby later saw him become the coach to the 1968 Lions, a leading administrator, the president of the Irish Rugby Union, and chairman of the IRB. He was a man and a player of some consequence.

This tour also heralded the arrival on the scene of another of the illustrious men in Lions' history who was to make a tremendous contribution to the concept as a player, coach and manager, and who, together with his Northern Irish colleague, remarkably also from Ballymena, Willie John McBride, became one of the most highly regarded and respected Lions of all time. He played in ten Tests on three Lions tours in 1959, 1962 and 1968; he coached the unbeaten pride of them all, the 1974 team to South Africa, and managed Billy Beaumont's 1980 team to South Africa. This truly marvellous and much-loved man was Sydney Millar.

Another person who reached the dizzy heights of influence in the game and became chairman of the IRB was Ken Smith, who came in as a late replacement for Robbins, who, sadly for the tour, because he would have been the life and soul of the party (and there was never a funnier man in rugby), broke his leg. Ken seized his chance with both hands, and played in two Test matches in both Australia and New Zealand.

In the back row, there were big men in every sense of the word in John Faull and Noel Murphy, whose fathers had played for Wales and Ireland respectively. The more I list these players, the more I realise what a fine body of men they were.

At half-back, they had the durable and ever-reliable Jeeps, who, despite losing out to Stephen Smith for three of England's four matches in the 1959 Five Nations Championship, played in five of the six Tests. Cliff Morgan always swore by Jeeps' tough-as-teak approach to the game. Cliff wanted a man who would deliver the ball come hell or high water, and that was the sort of player Jeeps was. His outside-half was Bev Risman for three Tests and Horrocks-Taylor and Malcolm Price for the other two. Bev was the son of the famous Wales and Great Britain rugby league captain, Gus Risman, and was himself to turn pro in 1961. He won five caps for the Great Britain side and one for England, and captained the Great Britain squad at the 1968 rugby league World Cup. He became president of the Rugby Football League in 2010.

Dave Hewitt, the fourth member of his family to play international rugby for Ireland, following in the footsteps of his father, Tom, and uncles Frank and Victor, was the outstanding centre of the tour, closely followed by Malcolm Price of Wales. The efficiency of their three-quarter play was evidenced by the remarkable fact that O'Reilly and Jackson scored an astonishing 41 tries between them. Bill Patterson, Malcolm Thomas and Ken Scotland also played a Test match each in the three-quarter line.

There were two superb full-backs on tour in Scotland and Terry Davies. They had contrasting styles, with Ken being the first in what is now a long line of running Scottish full-backs, and Terry a strong defensive full-back. In the event, they shared the Tests in New Zealand two each, with Ken being preferred for the earlier two Tests against Australia.

The undoubted stars of the tour were the two magnificent wings, O'Reilly and Jackson. It was O'Reilly's second tour and on his two trips he managed to score 38 tries in 38 games and only failed to touch down in 13 of his matches. He played in ten straight Tests, as did Rhys Williams, and scored six tries and ended with a total of 114 points for the Lions. As an 18-year-old fresh out of Belvedere College, it had taken O'Reilly only five senior club appearances to play his way into the Irish team. Between 1955 and 1970 he won 29 caps and, after only four of them, he became a teenage Lion. His 16 tries in South Africa in 1955 still stands as a post-war record in that country and his 17 in New Zealand four years later was equalled by John Bevan in 1971. His 38 tries is the highest tally by a Lions player, and his six tries in ten Tests is another long-standing record.

The Australian leg of the tour got off to a flying start in Melbourne, where the Lions ran in 12 tries in their opening game, a 53–18 romp against Victoria. Risman scored 19 points, including two tries, and was heralded as a chip off the old block by the Aussie press, who remembered his father leading the British rugby league team. A couple of rugby league officials invited Risman junior to lunch to talk about his much-loved Dad and his own performance. The Lions management wouldn't permit such a gathering and used the IRB laws on 'professionalism' to stop their player from attending. It was a move that didn't go down well with the locals and led to charges against the manager, Wilson, of being a 'professional-hater'.

▲ A slightly worse for wear scrum-half jersey from the 1959 tour, donated to the World Rugby Museum at Twickenham

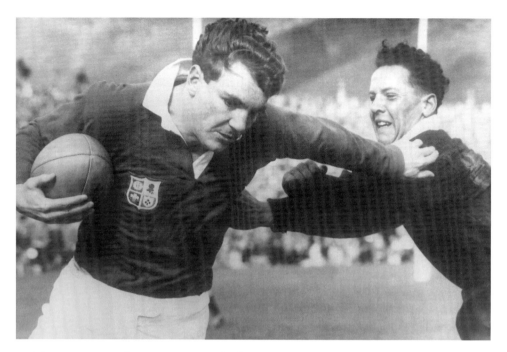

➤ Ireland wing Tony O'Reilly on the charge against the Junior All Blacks in Wellington. After scoring 16 tries in South Africa four years earlier, O'Reilly touched down 22 more times to take his career tally to a remarkable 38. No player has scored more tries for the Lions

The game in Melbourne was watched by the 1908 Lion 'Tuan' Jones, who had a great time reminiscing about Pontypool with the Welsh duo Prosser and Price. Next stop was Sydney and a game against a New South Wales team boasting 11 of the Wallaby Test line-up. It didn't help, therefore, that Brophy limped out of the game after only three minutes with an ankle injury, which left the Lions playing the majority of the game one man down. They still managed to outscore the home side by four tries to three, but eventually lost by four points. Brophy had been forced to take his intermediate accountancy exams in Melbourne on the same day the team arrived, at 5.30 in the morning after a 12-hour delay, and then found his tour ending no sooner than it had started. His ankle was put in plaster and he didn't play again for the Lions until the 1962 tour in South Africa.

Queensland were comfortably beaten 39–11 in Brisbane four days before the first Test in the same city. Hewitt distinguished himself with a record-equalling Lions match tally of 21 points and was one of nine players who figured in the Lions line-up against the Wallabies four days later. The Lions won their Tests in Australia fairly comfortably, by 17–6 in Brisbane and then 24–3 in Sydney. In the first Test, O'Reilly and Smith scored tries, with Risman kicking a conversion; Hewitt kicked two penalties; and Scotland dropped a goal to Australia's two penalties. In the second Test, Price scored two tries and O'Reilly, Risman and the skipper, Dawson, got one each, with Hewitt getting two conversions, and Scotland a penalty goal and a conversion, to Australia's penalty goal.

Australia had been a good grounding for the three-month slog in New Zealand, where the Lions were to play 25 games, including four Tests. First up were Hawke's Bay, and after an overnight stay in Auckland the Lions were given a huge welcome in Napier. There was a large crowd to meet them at the airport before the players were taken off in a car cavalcade to Marine Parade, where thousands of men, women and children cheered as each player went up to the microphone to announce his name, club and country. Two of the all-time greats of New Zealand rugby, George Nepia, who had played against the 1930 tourists, and Bob Scott, who played in the 1950 series, were also there to greet the players. The next day, the Lions turned party-

poopers as they ran in 13 tries, four of them by Hewitt, who once again scored a record-equalling 21 points, in the biggest score ever posted by a touring team in New Zealand, 52–12.

There was another friendly face to greet the Lions ahead of their second game in Gisborne: the former Ireland and 1950 Lions flanker Dr Bill McKay, who had enjoyed his tour so much he emigrated. Another Irishman, the scrum-half Andy Mulligan, grabbed the headlines before the game against Poverty Bay-East Coast as he flew in to replace the injured Scottish scrum-half Coughtrie. With Jeeps also on the injury list, the Lions were without a fully-fit scrum-half. Mulligan had been given 24 hours' notice to pack his bags and was forced to play the day after arriving, which, as anybody who has travelled from north to south by plane will know, is not the easiest thing to do. The Lions scored five tries and won 23–14.

There were 60,000 crammed into Eden Park for the next game against an Auckland team that had claimed a 50 per cent success rate against the Lions in their seven games since 1888, with three wins and a draw. Dawson, the Lions captain, was forced to make his seventh consecutive appearance and his eighth in nine games on tour, because of an injury to fellow hooker Meredith, but he showed no signs of wilting as he scored a vital try in an impressive 15–10 win. That was the good news, but after the match the Lions management found their injury list at crisis point, with 14 players in trouble.

▲ The programme from the second Test against Australia in Sydney, which saw the Lions run rampant to record a decisive 24–3 victory

The next game, against New Zealand Universities, attracted a midweek record attendance of 45,000 to Lancaster Park, and the £15,350 they paid was another midweek record. Back-row man Noel Murphy was forced to play on the wing because of the injuries, and McLeod had to do emergency duty at hooker. Even so, the Lions won 25–10 before moving on to Otago. Once again, Murphy and McLeod had to play out of position, and another back-row player, Haydn Morgan, was included at centre. The subsequent 26–8 defeat was disappointing, if not entirely unexpected. It was to be the first of only two provincial defeats in New Zealand.

Faull was the next back-row forward to be trialled on the wing in the game against South Canterbury-Mid Canterbury-North Otago, and he helped himself to one of the three tries in a 21–11 victory. An 11–6 triumph over Southland, a game in which the latest replacement, the uncapped English centre Bill Patterson, made his debut as a replacement for Brophy, meant the Lions went into the first Test on the back of five wins and one defeat in New Zealand.

The decision by the Four Home Unions Tours Committee to recall the injured Brophy and English in the build-up to the first Test in Dunedin could not have been worse timed. Even though the New Zealand Rugby Union had invited them to stay on as their guests, the order from back home countermanded the generosity of the hosts. The Lions retained all four of their 1955 survivors, O'Reilly on the wing, Jeeps at scrum-half, McLeod at prop and Williams at lock, for the biggest challenge of their tour to date, and they remained, bar Jeeps in the final Test, throughout the six internationals on tour.

There was a record crowd of 41,500 at Carisbrook and the first points in the series were registered by the big boot of All Blacks full-back Don Clarke, who kicked a penalty after 20 minutes and, two minutes later, repeated the performance. Hewitt replied with a penalty for the Lions, and then O'Reilly levelled the scores with an

unconverted try in the corner after Risman made the break. Price scored another try at the end of the half from a cross-kick by Risman, and the Lions changed ends leading 9–6. Jackson then scored in the corner, after Roddy Evans had intercepted a pass, to stretch the lead to 12–6. After Clarke had kicked another penalty, the Lions went into what, in those days, was a comfortable lead, 27 minutes into the second half, when Risman picked up a loose ball and kicked ahead for Scotland to gather and pass to Price, who got his second try of the match, converted by Risman.

At 17–9 the game seemed won for the Lions, but then, to their disgust, they conceded three more penalties. Clarke kicked them all, the matchwinner coming two minutes from full-time. That made it 18–17 to the All Blacks, who snatched what even many New Zealand fans considered to be the hollowest of victories and which continues to be regarded as the cruellest defeat ever sustained by the Lions. What made it all the more difficult to take was that the Lions touch-judge, Mick England, actually signalled that one of Clarke's kicks had gone wide. The home touch-judge and referee saw it differently and the points stood. The *Star Sports* newspaper in Dunedin captured the moment perfectly with their headline after the game: 'Clarke 18, Lions 17'.

Clarke's 18 points earned him a New Zealand and world record for the most points scored by a player in a Test match, his six penalties, from 50, 45, 40, twice from 35 yards and once from close range, precipitating a huge world-wide debate as to the value of a penalty goal against a try. The post-match furore had much to do with the future change in scoring values. The Lions also disputed the role of the referee, Allan Fleury of Otago, who awarded 35 penalties in the game, 21 to the home side and 14 to the Lions. Clarke had ten kicks at goal during the game. Mr Fleury had been in charge when the Lions had beaten Poverty Bay-East Coast in their second game in New Zealand. The tourists didn't meet him again!

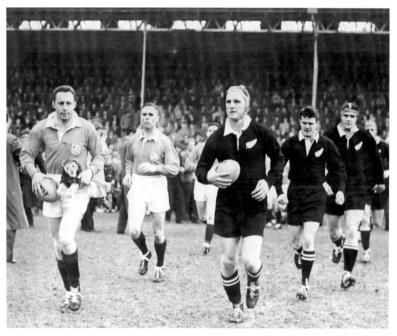

▲ Skippers Ronnie Dawson (left) and Wilson Whineray lead out their teams for the first Test in Dunedin. It was a thrilling clash at Carisbrook in front of a crowd of 41,500 which the All Blacks narrowly edged 18–17

The punishment for losing was a flight to Christchurch followed by a seven-and-a-half-hour bus ride to Greymouth, where the Lions got rid of some of their frustrations by beating West Coast and Buller by 58–3. Jackson and Young, the latter playing his first game in New Zealand, each scored four tries as the Lions increased their earlier record score on New Zealand soil. Terry Davies landed seven conversions. The Lions went even higher after falling from grace against Canterbury, where they went down to a 20–14 defeat, when they beat Marlborough-Nelson-Golden Bay-Motueka by 68–5. One player who enjoyed this game more than most was the full-back Thomas, who hoisted the Lions individual points record in a match to 25, with eight conversions and three penalties. The home fans must have become sick of the sight of the Newport player because ten years earlier he had scored 21 points at the same venue and in the same fixture for the 1950 Lions. This score was the highest by a touring team in New Zealand until 1981, when the 'Boks beat Nelson Bay 83–0.

There were four more wins in the build-up to the second Test, including a 21–6 defeat of Wellington and a 15–3 triumph over Ranfurly Shield holders Taranaki, and the Lions seemed ready to make amends for their bitter disappointment in Dunedin. The All Blacks made eight changes for the second Test at Athletic Park, while the Lions did the same. Davies, Young, Patterson and Thomas came into an injury-ravaged back line and Price moved to outside-half. Up front, Miller took over from Wood at loose-head prop, Ashcroft replaced Smith, and Marques was picked at No. 8 in place of Faull.

It was the first appearance of another New Zealand legend against a British side, for the All Blacks brought back Colin Meads, who had played against Australia the previous season, and Kel Tremain played his first Test. Again, the Lions had the desperate misfortune to lose in the closing minutes of the game and, once more, it was that man Clarke who was to be their executioner by scoring and converting a try in the dying minutes. Ralph Caulton, on his debut, scored two tries to provide a half-time lead of 6–0 to the home side. Ten minutes into the second half, Clarke blatantly obstructed O'Reilly after he had kicked ahead, and instead of awarding a penalty try, as he ought to have done, the referee merely awarded a penalty, which Davies kicked. The Lions then took the lead with a try by Young, after a marvellous run by Price and a lovely scissors with Thomas, which Davies converted. However, John McCullough, with a minute to go, broke down the blind side and passed to the supporting Clarke, who scored the winning try with a massive dive over the line and converted it, to make the final score 11–8 and to give the All Blacks a two–nil lead in the series.

Watching from the stands were the whole of the IRB, who had convened their first meeting outside of the UK and Ireland. In the chair was Ireland's Sarsfield Hogan, while the other delegates were Jack Siggins (Ireland), Sir Wavell Wakefield and Bill Ramsay (England), Herbert Waddell and Wilson Shaw (Scotland), David Jones and E.H. Jones (Wales), T. McCormick and C.W. Blunt (Australia), G.A. Brown and Cuth Hogg (New Zealand) and Dr Danie Craven and Dr G.J. Potgeiter (South Africa). As well as walking into the raging debate about the value of the penalty goal, they also saw at first hand the reasons behind the complaints from the Lions management about the number of players in New Zealand who were wearing leather padding under their kit. No fewer than 13 of the team the Lions faced in Timaru wore the outlawed padding, and come the third Test, assistant manager Glasgow demanded to go into the All Blacks dressing-room with the referee to ensure any players wearing padding had a doctor's note to permit them to do so.

The third Test in Christchurch saw the All Blacks forwards in one of their most devastating moods. After three easy provincial wins, the Lions had Scotland, Hewitt and Jackson fit again. They played Phil Horrocks-Taylor, who had flown out as a substitute for the injured Mick English and who had had only one game on the Tuesday as preparation, at outside-half. A new back row was tried, with Smith and Faull regaining their places, and Morgan getting his first Test. Wood also came in for Millar at prop.

Urbahn scored the first try for New Zealand and Faull kicked a penalty for the Lions. There followed a penalty and a remarkable left-footed drop goal by Clarke, who had become the scourge of these Lions and, with four minutes to half-time, Hewitt scored a magnificent try for the Lions after a half break by Horrocks-Taylor. Faull converted and the Lions were within a point of the All Blacks but, with a minute to go to the interval, Colin Meads swept through for a try and Clarke

THIRD TEST

BRITISH ISLES

NEW ZEALAND

LANCASTER PARK, SATURDAY AUGUST 29,1959
OFFICIAL PROGRAMME ONE SHILLING

▲ The match programme from the third Test in Christchurch, which saw the All Blacks put in their finest performance of the series

converted, to make it 14–8 at the break. There was no further score for the 30 minutes of the second half, and then Urbahn and Caulton scored tries, with Clarke adding the last conversion, to give New Zealand their only convincing win, 22–8, in the series, which they could not now lose.

The Lions registered four more wins before the final Test and were still in good heart, as their popularity was as big as ever with the New Zealand public, who loved their style both on and off the field. This was reflected in the fact that the biggest crowd to watch a rugby match, 63,000, gathered at Eden Park, Auckland, for the final Test.

Jeeps was unfit, so the selectors brought in Mulligan. After the embarrassment of having had a scrum-half too many in 1955, the selectors had cut the number down to two, but it is a vulnerable position and Sod's Law operated. Scotland was brought into the centre and Davies came in at full-back. In the forwards, Prosser was preferred to Wood, and Roddy Evans, who had gone home with a knee injury and homesickness, was replaced by Mulcahy, another great Irish character in the side.

Happily, for they earned it, these Lions finished their tour on a high. It was fitting that they should win by three tries, scored by the three most outstanding backs of the tour. The first came after a Clarke penalty, through that 'Jack in the box' Jackson, who enchanted the New Zealand crowds with his elusive running. O'Reilly came in from the other wing and broke the midfield before passing on to Scotland who, in turn, put Jackson over for the try, which made it 3–3 at half-time. The second try came from O'Reilly, four minutes after the restart, when he was put away on the narrow side by his great pal and fellow entertainer on the tour, Mulligan. Clarke levelled the score with another penalty, but Risman scored a fine blind-side try. Don Clarke, who had scored 39 points in the series, had one final chance to level the score

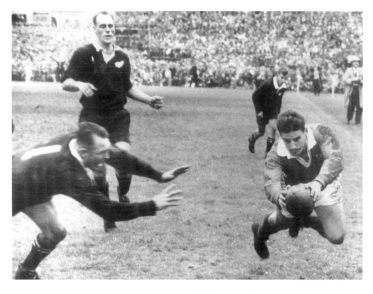

▲ Fly-half Bev Risman scores one of the Lions' three tries in Auckland in the fourth Test to secure a narrow 9–6 victory

in the closing minutes, but he missed what, for him, was a comparatively easy penalty, and justice was done.

It was the first Test won by a British team in New Zealand since the initial Test of the 1930 tour, and only the second Lions victory over New Zealand in 60 years. It was a popular win by an immensely popular side. There was, however, some retrospective criticism about the team selections before the tour, and their erratic nature during the tour itself, but then many of these were dictated by injury.

The team played two games in Canada on the way home, beating a British Columbia All-Stars XV 16–11 at the Empire Stadium, Vancouver, and an Eastern Canada XV 70–6 at Varsity Stadium, Toronto. Risman and Meredith were the try scorers in Vancouver, with Davies adding two conversions and two penalties, while there were 16 tries in the final fixture. Murphy grabbed a hat-trick; Patterson, Scotland, Hewitt and Morgan all scored two. The Eastern Canada XV had some good players in their ranks. Former Scotland centre James Allan was in the back division, and up front the home side had the 1955 Lions

forward Tom Reid and the former Swansea lock David Bruce-Thomas, who had played in the drawn game with the All Blacks in 1953. The Irish forward Reid had played one Test as a No. 8 and another as a lock in the drawn series against the Springboks. He later toured Canada with the Barbarians and decided to settle there. He became the first known Lion to play against his former team. Since then, only Riki Flutey has joined this exclusive club, having played for the Maoris against the Lions in 2005 and then for the Lions on their 2009 tour to South Africa.

RESULTS OF THE 1959 LIONS IN AUSTRALIA, NEW ZEALAND AND CANADA

P 33 W 27 D 0 L 6 F 842 A 353

Victoria	W	53–18	Marlborough, Nelson, Golden Bay &	W	64–5
New South Wales	L	14–18	Motueka		
Queensland	W	39–11	Wellington	W	21–6
Australia (Brisbane)	W	17–6	Wanganui	W	9–6
New South Wales Country Districts	W	27–14	Taranaki	W	15–3
Australia (Sydney)	W	24–3	Manawatu-Horowhenua	W	26–6
Hawke's Bay	W	52–12	New Zealand (Wellington)	L	8–11
East Coast-Poverty Bay	W	23–14	King Country-Counties	W	25–5
Auckland	W	15–10	Waikato	W	14–0
New Zealand Universities	W	25–13	Wairarapa-Bush	W	37–11
Otago	L	8–26	New Zealand (Christchurch)	L	8–22
South Canterbury, North Otago &	W	21–11	New Zealand Juniors	W	29–9
Mid Canterbury			New Zealand Maoris	W	12–6
Southland	W	11–6	Thames Valley-Bay of Plenty	W	26–24
New Zealand (Dunedin)	L	17–18	North Auckland	W	35–13
West Coast-Buller	W	58–3	New Zealand (Auckland)	W	9–6
Canterbury	L	14–20	British Columbia	W	16–11
			Eastern Canada	W	70–6

RONNIE DAWSON'S 1959 LIONS TEAM

FULL-BACKS

T.J. Davies	Llanelli	Wales
K.J.F. Scotland	Cambridge University	Scotland

THREE-QUARTERS

N.H. Brophy	University College, Dublin	Ireland
J. Butterfield	Northampton	England
D. Hewitt	Queen's University, Belfast	Ireland
P.B. Jackson	Coventry	England
A.J.F. O'Reilly	Old Belvedere	Ireland
W.M. Patterson*	Sale	
M.J. Price	Pontypool	Wales
M.C. Thomas	Newport	Wales
J.R.C. Young	Oxford University and Harlequins	England

UTILITY

G.H. Waddell	Cambridge University	Scotland

HALF-BACKS

S. Coughtrie	Edinburgh Academicals	Scotland
M.A.F. English	Bohemians	Ireland

J.P. Horrocks-Taylor*	Leicester	England
R.E.G. Jeeps	Northampton	England
A.A. Mulligan*	London Irish and Wanderers	Ireland
A.B.W. Risman	Manchester University	England

FORWARDS

A. Ashcroft	Waterloo	England
A.R. Dawson (capt.)	Wanderers	Ireland
W.R. Evans	Cardiff	Wales
J. Faull	Swansea	Wales
H.F. McLeod	Hawick	Scotland
R.W.D. Marques	Harlequins	England
B.V. Meredith	Newport	Wales
S. Millar	Ballymena	Ireland
H.J. Morgan	Abertillery	Wales
W.A. Mulcahy	University College, Dublin	Ireland
N.A.A. Murphy	Cork Constitution	Ireland
T.R. Prosser	Pontypool	Wales
G.K. Smith	Kelso	Scotland
R.H. Williams	Llanelli	Wales
B.G.M. Wood	Garryowen	Ireland
*Replacements		

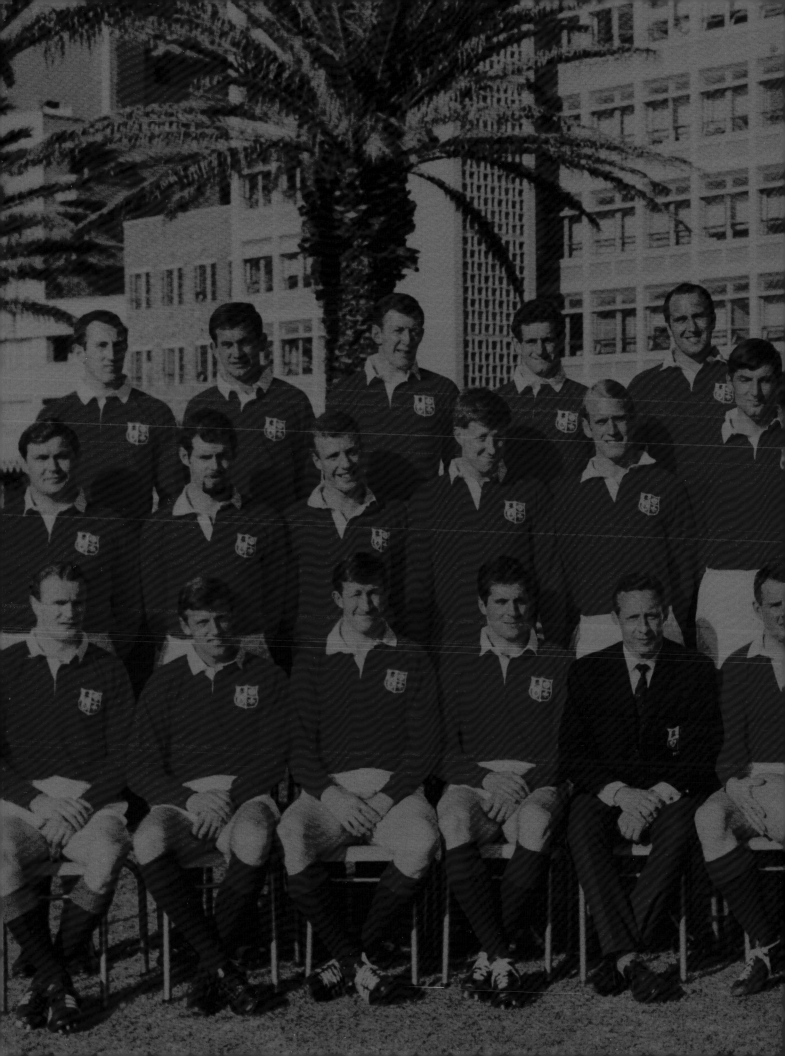

6

BLOOD, SWEAT AND TEARS

The Lions never won a Test match against New Zealand or South Africa in the 12 internationals played against them in the 1960s; their only wins were the two Tests in 1966 against Australia. This reflected the generally poor standards of British and Irish rugby at that time, when there was a shortage of inspiring players such as Jack Kyle, Cliff Morgan, Tony O'Reilly, Jeff Butterfield and Bev Risman. Many players of this era were too defensively orientated, in my view, because they were becoming increasingly exposed to media influences. The advent of television coverage of sport was to have a massive influence on the individual, who began to be afraid of making mistakes.

They were also having to contend with the continuing mistakes made by the Four Home Unions' selectors, who not only seemed inexpert, but were too often wanting the face to fit their ideas of what was required, without any knowledge of, or regard for, the need for specialisation in positions such as the forwards. They obviously had little idea of the difference between a tight-head and loose-head prop, or an open-side or blind-side flanker.

The failure to provide strong blind-side flankers for the tour of South Africa in 1962 was a case in point. They seemed totally unaware of the propensity of the southern hemisphere countries to drive the blind side for long periods. The first instinct of any New Zealand team, when it is in any sort of trouble, is to close it up and go down the narrow side.

The year 1962 was a fateful one in South Africa, for the nationalist government imprisoned Nelson Mandela. In other parts of the world, Decca Records rejected a group called the Beatles; more US soldiers were sent to Vietnam; the Cuban missile crisis ended when Krushchev agreed to dismantle missile sites; astronaut John Glenn orbited the earth; Polaris missiles were agreed for British submarines; Selwyn Lloyd fuelled the consumer boom by cutting purchase tax on cars and domestic appliances, and a Mini cost from £459 19s 3d; Pop Art was created by Andy Warhol, who unveiled his painting of a Campbell's soup can; William Vassall was convicted of spying; James Hanratty was sentenced to death; and Marilyn Monroe was found dead.

1962 TOUR KIT

1962
'BOKS BACK ON TOP

Captain: Arthur Smith (Edinburgh Wanderers and Scotland)
Squad Size: 30 players + 3 replacements
Manager: Instructor-Commander David Vaughan (England)
Assistant Manager: Harry McKibbin (Ireland)
Tour Record: P 25 W 16 D 4 L 5 F 401 A 208
Test Series: P 4 W 0 D 1 L 3

Arthur Smith was a truly delightful man and a player with great erudition, having achieved a first-class degree in mathematics at Glasgow and then a Ph.D. at Cambridge. He was a fine, quiet man and therein lies a tale, for on the 1955 Lions

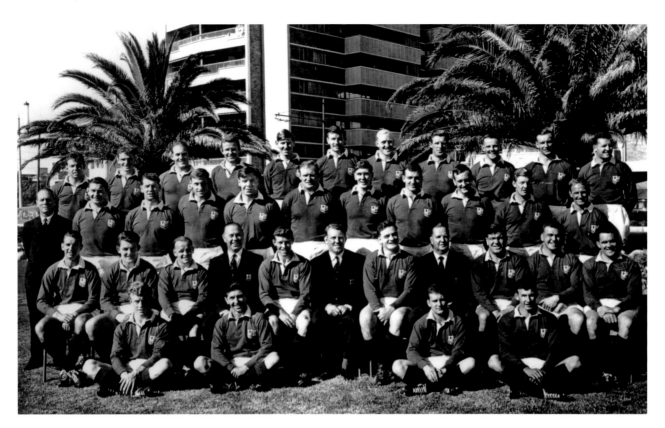

tour, Arthur was put to share a room with a player who shall remain nameless. Suffice to say that he was a fairly nervous individual, and found that Arthur was prone to long silences and to ignoring him whenever he entered or left the room. He became so upset that he asked the manager to move him, which caused a minor crisis, for it would seem odd to change roommates in the middle of a week. The player insisted, so the management decided to put a harder-headed person in with him, to discover what the problem was. I was elected and so I moved in and said, 'Hello, Arthur. I'm your new roommate,' only to be greeted with an absent-minded shrug of the shoulders. That evening, I went up to the room to see Arthur sitting on the bed and he was in a world of his own, so I snapped my fingers under his nose and said, 'A penny for them'. He seemed to wake with a start and said, 'I'm sorry. I was working out a maths problem, as I am studying for my Ph.D.' He could not understand my amusement and was a little startled when I explained what it was about, while Jack Siggins sighed with relief to discover there was no problem after all.

Arthur was a wing of extraordinary ability, and few have ever had his remarkable control of pace. He was a brainy rugby man, who never really shone on his first Lions tour in 1955 because he broke a bone in his wrist at the start and played only four matches. He did not, however, waste the time when he was unable to play but used it to practise, becoming a first-class goal kicker.

Smith was announced as captain on Thursday, 29 March and was one of the players in the 30-man squad who had toured South Africa in 1955. Scrum-half Dickie Jeeps and hooker Bryn Meredith were the others. Jeeps and Meredith were also among eight survivors from the 1959 tour to Australasia, along with Welsh back-row man Haydn Morgan, Scottish outside-half Gordon Waddell and the Irish quartet of Dave Hewitt, Syd Millar, Bill Mulcahy and Niall Brophy. Two more 1959 tourists, the English outside-half Phil Horrocks-Taylor and Scottish full-back Ken

▲ For the first time in 35 years, the Lions had a Scottish skipper after Edinburgh Wanderers wing Arthur Smith was handed the armband. The squad featured eight survivors from the 1959 Australasian tour

➤ The 1962 Lions turn their hand to photography in South Africa. The squad was packed with powerful forwards as tour manager Brian Vaughan was keen to take the ever-physical Springboks on up front

Scotland, made themselves unavailable for business and family reasons, while a third, the Pontypool and Wales centre Malcolm Price, turned professional with the Oldham rugby league club. The Welsh back-row forwards Alun Pask and David Nash both hit the headlines prior to selection when their employer, the Monmouthshire County Council, decided at their education committee that both players, who were schoolteachers in the county, could only have unpaid leave for the three-month-long tour. A South African newspaper offered to launch a fund for them to ease their financial hardship, but this was ruled out because it would have infringed their amateur status. All of this blew up as the South African Sports Association appealed to British and Irish players not to go to South Africa and the Anti-Apartheid Movement in London also called for a boycott.

Following Avril Malan's 1961 Springboks team to Britain and Ireland, when they lost only their last match against the Barbarians, the Home Unions' selectors chose the biggest Lions pack ever to leave the British Isles.

The 1955 Lions had only three forwards over 15 stone, while Smith's team had nine, including Keith Rowlands (who became secretary of the International Board in 1987), Willie John McBride (on the first of his record five tours), Mike Campbell-Lamerton, Mulcahy, Nash, Millar (on the second of his three tours), Peter Wright, Kingsley Jones and John Douglas. They also had

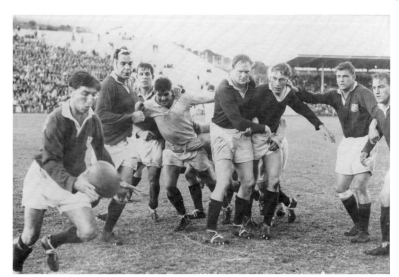

▼ The Lions in action during their 14–6 victory over Central Universities in Port Elizabeth in August. The side played 21 non-Test fixtures, winning 16 and drawing three but lost to Northern and Eastern Transvaal

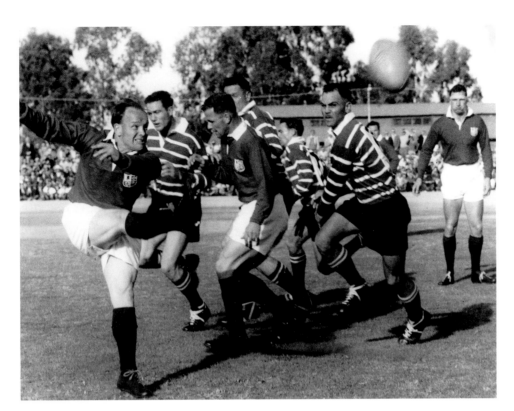

◀ England scrum–half Dickie
Jeeps kicks during the Lions'
clash with Griqualand West in
Kimberley. It was the tourists'
second game in 1962 and
finished deadlocked at 8–8

the magnificent Bryn Meredith, restored as first-choice hooker on his third tour, and
some fine back-row forwards, including Pask, who, although he was in his prime as a
No. 8, was made to play on the blind side. This was because of the tactical decision
of the manager, Brian Vaughan, to go for power and he therefore wanted Campbell-
Lamerton, his biggest forward, locking the scrum in the middle of the back row.

As a result, the Lions were never able to dominate the loose play around the
scrum, at the back of the lineout, or in the tackle situation and broken play. The
ignoring of non-specialist players in key positions can often make the difference
between success and failure. Furthermore these Lions, although they had some
splendid backs in their captain Smith, Richard Sharp, a tremendous and elegant
player on his day, Ken Jones, Dave Hewitt, Dewi Bebb, and the durable Jeeps, a
combative rather than a perceptive scrum-half, they had no one, especially at half-
back, to light the spark. The solid Gordon Waddell and Mike Weston, who played in
all four Tests at centre, but were often pressed into service at outside-half, were more
strong tactical kickers than sharp runners, which is what is required on the hard
grounds of South Africa.

The tour manager, Brian Vaughan, a naval commander who was involved in the
commissioning of the first nuclear submarines, did not have the benefit of a coach, so
he took the job on himself. A man of excellent rugby pedigree, being a former
England forward, he was convinced that they could beat South Africa by winning
possession. However, they gained a reputation for being a static team, unable to
dominate in loose play, and therefore failed to produce any flair in attack, which was
a traditional feature of previous Lions teams in the Republic. These Lions lacked
nothing in commitment, especially in tight forward play, where they stretched the
Springboks to the limit. The hugely experienced rugby correspondent Terry
O'Connor thought that Vaughan was one of the very best managers he had toured
with and that he never got the recognition he deserved.

They lost five matches, including three Tests, and drew four. Their only provincial defeats were against Northern Transvaal and Eastern Transvaal, but they also drew with two provinces, Griqualand West and Orange Free State, and with Northern Universities. England hooker Sam Hodgson broke his leg near the end of the opening win, 38–9, against Rhodesia and had his tour brought to an abrupt end. Bert Godwin came out to replace him, and Welsh flanker Glyn Davidge and the uncapped H.J.C. 'John' Brown also flew out as replacements.

Nevertheless, the Test matches, except for the fourth, were very closely contested. Richard Sharp was not available for the first two Tests, because of that cause *célèbre* which is still talked about, when Mannetjies Roux, playing for Northern Transvaal, hit him with a high tackle which saw his head inflict a broken cheekbone on the luckless Sharp, who, in the manner of the perfect gentleman (which was one of his hallmarks), never made a complaint. The tourists were incensed, for they had seen other examples of Roux's recklessness in this respect, including a similar tackle on Alun Priday in Cardiff the year before. Many South Africans also protested, but Roux was still included in the first Test.

The first Test was drawn, and the second lost 3–0. The third was at 3–3 when a blunder cost the Lions the series, and it was only in the final one that the Springboks came out firmly on top and won by a large margin.

The first Test at Ellis Park was a poor affair, memorable only for two tremendous tries, one scored by each side, and also for the fact that Johannes Claassen was preferred to Malan as captain. The great South African wing, Jannie Engelbrecht, withdrew with injury and Mof Myburgh, the huge Northern Transvaal prop, made his debut.

The problem was that the two packs were so evenly matched that neither side could achieve ascendancy. A few minutes before half-time, Ken Jones kicked for touch, Roux fielded and, switching direction, put Johnny Gainsford, the superlative Springbok centre and one of their all-time greats, away on a decisive run for a try in the corner. Ken Jones made amends for his earlier error when he scored the equaliser ten minutes from the end. John Wilcox gathered a kick ahead in his own 25 and counter-attacked; when he was tackled, the ball went loose and Waddell picked up and gave to Jones, who jinked his way through the defence and raced 60 yards to score. Alas, Smith's conversion attempt failed. The Lions' jumbo pack had held up well at scrum and lineout and Vaughan believed he was on the right track. In a private press briefing, he claimed to have the Springboks just where he wanted them, as South African rugby-writing legend A.C. Parker outlined in his book, *The Springboks 1891–1972*: 'We've got

▲ A ticket for the game against Northern Transvaal in Pretoria

▼ A fixture card, featuring the 1962 Welsh Lions, produced by the Western Mail newspaper to promote J.B.G. Thomas' coverage of the tour

◄ Wales wing Dewi Bebb (left) tackles Springbok Francois Roux during the second Test in Durban. the Lions controversially had a try disallowed at Kings Park and were narrowly beaten 3–0

the measure of the Springboks. That, you must admit, was clear at Ellis Park. We'll play the next two Tests tight as well and then, when we're up in the series, we'll turn on the running stuff in the final Test.'

The second Test, in Kings Park, Durban, brought another of those hugely controversial refereeing decisions, which so often coloured tours abroad and which ultimately led to the production of neutral referees in 1980. It was another tight, undistinguished and close-run affair, with the Springboks leading 3–0 from a 35-yard penalty by Keith Oxlee, kicked five minutes from time. In the last minute, the Springboks were penalised for a crooked throw at a lineout on their own line and, as the scrum went down, Mulcahy called for a hold and a wheel which went like a dream and, as had been the plan, Rowlands fell on the ball. The referee, Ken Carlson of East London, declared that he was unsighted and disallowed the try, to the intense annoyance of the Lions forwards, who were certain that the try should have stood. Rowlands always claimed that he had scored the try and, as he was a man of huge integrity, I believed, along with many South African reporters, that the referee made a grave error of judgement. Had he peeled the players away from the scrum that lay over the Springbok line, he would surely have found the ball underneath Rowlands at the bottom of the pile.

The score stood at 3–0 at the final whistle of a Test which had seen the dropping of Malan and the moving of Frik du Preez, one of South Africa's mightiest forwards, from flank to lock. It also saw the introduction at scrum-half of another Springbok legend, Dawie de Villiers, who was to become South Africa's ambassador to London and a minister in the South African government. The Lions made two changes: Dewi Bebb at left wing for Brophy, and Morgan for Budge Rogers in the back row.

Sharp recovered to play in the third Test and Tom Kiernan came in for Wilcox. The interest was so intense that the largest crowd in the history of Newlands in Cape Town up to that time (54,843) were shoehorned into the ground and another 4,000 were locked out. This set the scene for another grim struggle between the two packs.

▲ Hooker Bryn Meredith (left) in action against Eastern Province in Port Elizabeth. The Welshman toured with the Lions three times, playing four Tests against the Springboks in 1955 and another four against the same opposition seven years later

Meredith, who took his tally of games for the Lions to 41, a Welsh record along with Jack Jones, and his Test count to eight by the end of his third tour, showed that he was the best hooker of his era and the Lions dominated the set pieces, but in the loose play the Springboks had the edge, with Doug Hopwood, that immense No. 8, always in the vanguard of the home forward onslaughts.

Sharp drew first blood with a 30-yard drop goal, but this was nullified with a penalty from Keith Oxlee when the Lions were penalised for hands in a ruck, to make it 3–3 at half-time. The score stood until eight minutes from the end of a dour game, enlivened only by a fine run by Engelbrecht from his own 25, but he was called back as the pass from Gainsford was deemed forward. Next came an ill-advised attempt by Sharp to open up from his own line, from a heel against the head by Meredith. The Springboks defence closed in and Ken Jones, receiving a hospital pass, was flattened in a tackle and the ball went loose. It was Oxlee who scooped it up to weave his way over for a try, which he also converted for the Springboks to win the match 8–3. The conversion was a milestone, for it brought up 1,001 points in South African Test history.

The mobility of the Lions pack suffered further as Pask broke a rib when flung into touch and he collided with the schoolboys crammed in around the pitch in that third Test, and the selectors made a few strange decisions. They brought Mulcahy onto the flank in his place and Rogers, who was to win 34 caps for England, took over from Morgan. Wilcox regained his place at full-back and the fit-again Hewitt played in the centre in place of Jones. Brophy replaced Bebb, and Jeeps took over the captaincy from the injured Smith. It was a fitting honour for Jeeps, who was bringing the curtain down on a record-breaking Lions career. He had already surpassed the record of ten Tests posted by Tony O'Reilly and Rhys Williams with his 11th appearance in the second Test, and he went on to raise the all-time appearance record to 13 Tests and 42 games at the end of his third tour. Both figures still stand as records for an English player.

Although the series was lost, there was a capacity crowd at Bloemfontein for the final Test, which the Springboks won by 34–14, the most points scored by them in a Test in South Africa. Keith Oxlee, the Natal outside-half, after scoring all the points in the third Test, finished as the star of the series with a record 16 points in this final Test, one more than Okey Geffin's 15 points against the All Blacks in 1949.

The score was only 10–6 to the Springboks at half-time from tries by Roux and Wyness, both converted by Oxlee, to a penalty by John Wilcox and a try by Ronnie Cowan. In the second half, Gainsford proceeded to slash open the Lions' defence and scored a try, before Rowlands replied with one for the Lions, converted by Wilcox. It

was still anybody's game at 13–11, before the Springboks went on a scoring spree of 13 points in six minutes. Oxlee kicked a penalty and a typically thrilling run by Frik du Preez, for Hugo van Zyl to score and Oxlee to convert, began the rot. This was quickly followed by a try by Claassen, again converted by Oxlee, and the Lions were undone. A further penalty by Oxlee and a great try by Roux, with an Oxlee conversion, completed South Africa's scoring. Oxlee's 16 points overtook the record of 15 in a match for the Springboks scored by Okey Geffin in 1949 and gave him 22 for the series. Campbell-Lamerton got a consolation last try for the Lions. History should not judge the 1962 Lions harshly, for they could quite easily have won the series with better selection, a bit more luck and different tactics. They headed home via Nairobi, where they rounded off their trip with an 11-try, 50–0 victory over East Africa.

RESULTS OF THE 1962 LIONS IN SOUTH AFRICA

P 25 W 16 D 4 L 5 F 401 A 208

Rhodesia	W	38–9	Western Province	W	21–13
Griqualand West	D	8–8	South Western Districts	W	11–3
Western Transvaal	W	11–6	South Africa (Durban)	L	0–3
Southern Universities	W	14–11	Northern Universities	D	6–6
Boland	W	25–8	Transvaal	W	24–3
South West Africa	W	14–6	South Africa (Cape Town)	L	3–8
Northern Transvaal	L	6–14	North Eastern Districts	W	34–8
South Africa (Johannesburg)	D	3–3	Border	W	5–0
Natal	W	13–3	Central Universities	W	14–6
Eastern Province	W	21–6	Eastern Transvaal	L	16–19
Orange Free State	D	14–14	South Africa (Bloemfontein)	L	14–34
Junior Springboks	W	16–11	East Africa	W	50–0
Combined Services	W	20–6			

ARTHUR SMITH'S 1962 LIONS TEAM

FULL-BACKS

T.J. Kiernan	University College, Cork	Ireland
J.G. Willcox	Oxford University	England

THREE-QUARTERS

D.I.E. Bebb	Swansea	Wales
N.H. Brophy	Blackrock College	Ireland
R.C. Cowan	Selkirk	Scotland
J.M. Dee	Hartlepool Rovers	England
D. Hewitt	Instonians	Ireland
W.R. Hunter	CIYMS	Ireland
D.K. Jones	Llanelli	Wales
A.R. Smith (capt.)	Edinburgh Wanderers	Scotland
M.P. Weston	Richmond	England

HALF-BACKS

H.J.C. Brown*	Blackheath and RAF	
R.E.G. Jeeps	Northampton	England
A. O'Connor	Aberavon	Wales
R.A.W. Sharp	Oxford University	England
G.H. Waddell	London Scottish	Scotland

FORWARDS

M.J. C'll-Lamerton	Army and Halifax	Scotland
G.D. Davidge*	Newport	Wales
J. Douglas	Stewart's College FP	Scotland
H.O. Godwin*	Coventry	England
S.A.M. Hodgson	Durham City	England
K.D. Jones	Cardiff	Wales
W.J. McBride	Ballymena	Ireland
B.V. Meredith	Newport	Wales
S. Millar	Ballymena	Ireland
H.J. Morgan	Abertillery	Wales
W.A. Mulcahy	Bohemians	Ireland
D. Nash	Ebbw Vale	Wales
A.E.I. Pask	Abertillery	Wales
D.P. Rogers	Bedford	England
D.M.D. Rollo	Howe of Fife	Scotland
K.A. Rowlands	Cardiff	Wales
T.P. Wright	Blackheath	England

*Replacements

1966 TOUR KIT

1966
BLACKOUT

Captain: Michael Campbell-Lamerton (London Scottish and Scotland)
Squad Size: 30 + 2 replacements
Manager: Des O'Brien (Ireland)
Assistant Manager/Coach: John Robins (Wales)

Tour Record:	P 35	W 23	D 3	L 9	F 524	A 345
In Australia:	P 8	W 7	D 1	L 0	F 202	A 48
Test Series (Aus):	P 2	W 2	D 0	L 0		
In New Zealand:	P 25	W 15	D 2	L 8	F 300	A 281
Test Series (NZ):	P 4	W 0	D 0	L 4		
In Canada:	P 2	W 1	D 0	L 1	F 22	A 16

They may have been the 'Swinging Sixties', but the 1966 British & Irish Lions never really got in on the mood. London was declared the swinging capital of the world, with Carnaby Street the centre of the new young fashion. England beat West Germany to take the soccer World Cup; Mao Tse-tung proclaimed the Cultural Revolution with his little red book and Brezhnev became the Soviet leader; the Moors murderers were sentenced to life imprisonment; and Verwoerd, father of apartheid, was knifed; Arkle won the Cheltenham Gold Cup; the Pope and the Archbishop of Canterbury met officially for the first time in 400 years; Freddie Laker formed a new cut-price airline; Gwynfor Evans became the first Welsh nationalist MP; Australian troops were sent to Vietnam; Lord Thomson bought *The Times* newspaper; and an unmanned spaceship landed on the moon.

Although they went unbeaten in the eight matches of the Australian leg of their tour and beat Australia by a score and a margin that still remain records for the Lions, 31–0, in the last Test in Brisbane, the 1966 Lions, once they crossed the Tasman Sea, gained a reputation for being an indifferent side. Having come to New Zealand with a name for playing fast open rugby during the Australian leg of the tour, they then seemed to go into a shell. In New Zealand, they lost all four Test matches in a series for the first time, three of them by a large margin, and stumbled raggedly through their provincial games, where they lost four and drew two. On the way home, they were also to lose to British Columbia.

The affable former Irish rugby and hockey international Des O'Brien was named as tour manager, and it was the first Lions tour on which the selectors chose to send a coach, although the 1950 Wales Grand Slam prop and Lions tourist John Robins was still given the title of 'assistant manager'. Robins was a much revered teacher

BRITISH ISLES RUGBY UNION TEAM, 1966
Tour of Australia and New Zealand

D. RUTHERFORD A. R. LEWIS D. K. JONES D. L. POWELL K. W. KENNEDY S. J. WATKINS D. GRANT C. M. H. GIBSON C. W. McFADYEAN
S. WILSON F. A. L. LAIDLAW
K. F. SAVAGE H. NORRIS D. WILLIAMS R. A. LAMONT W. J. McBRIDE B. PRICE W. D. THOMAS P. P. K. BRESNIHAN G. PROTHERO A. J. W. HINSHELWOOD
D. WATKINS D. I. BEBB R. J. McLOUGHLIN J. W. TELFER D. J. O'BRIEN M. J. CAMPBELL-LAMMERTON J. D. ROBINS A. E. I. PASK M. P. WESTON
(Hon. Manager) (Captain) (Hon. Asst to Manager)
N. A. MURPHY R. H. YOUNG
Inset: J. C. WALSH

▲ Scotland and London Scottish second row Mike Campbell-Lamerton was captain of the 1966 tour but the squad was dominated by Wales, with 11 of the 30 players originally selected hailing from the Principality

and coach at Loughborough College, where he had influenced two of the 1966 tourists, the England centre Colin McFadyean and Alun Pask, but tactics and team preparation bafflingly remained largely the responsibility of the manager and captain. To add to his woes, he tore his Achilles tendon refereeing a charity match on 26 June, was forced to undergo surgery and was a passenger for almost six weeks of the tour. Robins did a good job on the fitness front, but his lack of control on the coaching reins was a major issue raised by David Watkins in *David Watkins: An Autobiography* in 1980:

The management structure was absurd. The former Irish number eight forward Des O'Brien was put in charge, and given PE expert John Robins as his 'assistant'. John trained the team and got us fit, but had no brief to coach us or determine our tactical approach. Match preparation lay in the hands of O'Brien and Campbell-Lamerton who seemed unable to make up their own minds, let alone agree between them, what approach we should adopt. As a result of these things the Lions party on tour often resembled a ship with three rudders all steering in different directions.

▲ Former Wales prop and Lions tourist John Robins was named coach in 1966 but his remit in Australasia was largely limited to fitness work

▼ Wales fly-half David Watkins (second from right) later revealed his frustrations with the tour's management structure in his autobiography

There had been considerable surprise and controversy, especially in Wales, when the team was announced and the Scottish second row Mike Campbell-Lamerton was made captain instead of one of his 1962 Lions teammates, Pask, who had led Wales to the Five Nations title that season. This was exacerbated when Campbell-Lamerton came under considerable pressure from the New Zealand press for his lack of form, and he actually dropped himself for two of the Tests. He had hinted at such a move shortly after the former president, Wing Commander J. Lawson, chairman of a selection panel that comprised Tom Berry (England), Charlie Drummond (Scotland), Cliff Jones (Wales) and Johnny Nelson (Ireland), announced their 30-man squad on Sunday, 20 March. In *The Times* two days later, Campbell-Lamerton was quoted as saying 'if I don't think I am worthy of my place I shall simply drop myself, and there will be no question of a diplomatic injury'. He presumably knew his appointment had been a bit of a compromise between the selectors, who picked 11 Welshmen, eight Irish, six Scots and only five English players.

Campbell-Lamerton had played in 20 of the 24 games in 1962 and featured at No. 8 in all four Tests, and it must be said that he was a man of considerable courage and honour for the way in which he effectively dropped himself for two of the four Tests in New Zealand.

It was a measure of his quality as an individual and as a captain, and it mirrored the example set by Doug Prentice in New Zealand 36 years earlier. Campbell-Lamerton's powerful frame – he was 6ft 4.5in tall and weighed more than 17 stone – had made him a hard man to stop on the dry grounds in South Africa, but he found himself up against Colin Meads as a second row in New Zealand. Nevertheless, he went on to become the first Scottish player to play in seven successive Lions Test matches, and in 2013 he remained as the joint Scottish record holder with Andy Irvine of the most appearances for the Lions in all matches with 42. He added a further 22 games in 1966 to his tally of 20 from 1962. His final appearance in a Lions jersey, against Canada in Toronto on 17 September 1966, took him past Frank Stout, Jack Jones and Bryn Meredith on 41 and level with Dickie Jeeps on a record 42 matches in a Lions jersey.

Born into an Army family in Malta, Campbell-Lamerton joined the Duke of Wellington Regiment and served in Korea, Suez, Kenya, Cyprus and Northern Ireland. On one tour he broke his leg jumping from a helicopter and was in hospital for seven months, while at the Battle of the Hook in the Korean War in 1953 he was pipped to a MC by another Scottish rugby international, David Gilbert-Smith. Both men, then lieutenants, had helped to regain high ground overrun by the enemy while under heavy fire. Only one MC could be awarded and, in the end, the older of the two received it, although Campbell-Lamerton did rise to the rank of colonel. When he left the Army, he took up the post of Bursar at Balliol College, Oxford, and he became president and treasurer of Oxford University RFC.

Campbell-Lamerton was one of seven previous tourists – Noel Murphy in 1959 and Pask, Dewi Bebb, D. Ken Jones, Micky Weston, Willie John McBride and the captain himself from 1962 – and there was only one uncapped player in the Llanelli second row: Delme Thomas. McBride would go on to captain the all-conquering 1974 Lions in South Africa and manage the 1983 team in New Zealand; Jim Telfer would coach the 1983 squad and help Ian McGeechan notch a famous series win in South Africa in 1997; and Murphy would coach the 1980 Lions in South Africa. Don Rutherford, the England full-back, became the first Technical Director of the RFU, while Watkins and Rutherford's replacement at full-back, Terry Price, would return to Australia with the British rugby league team after turning professional, Watkins for £15,000 with Salford and Price for £8,000 with Bradford Northern.

The Lions left on Saturday, 30 April and arrived in Perth on 2 May, having had to endure a rather longer than expected time on the ground at one of their scheduled stops after a fault was discovered in an inner port engine on the aeroplane. Their first game was on 7 May, although they had spent time together in the UK preparing for the tour. As Watkins recalled in his autobiography, the fortnight wasn't the best of times:

We spent two weeks at Bournemouth before departure trying to develop team spirit. By today this anachronism has been dispensed with, and teams spend their pre-tour preparation period within the host country. These days, I also gather, the talk is about winning; in 1966 we spent hours in negative, sterile discussion about how we could prevent the All Blacks from doing so.

If Campbell-Lamerton's side were not good enough players, they were, like most Lions teams, good tourists, and remained popular with the New Zealand public. Even though the All Blacks won the series handsomely, there were 58,000 crammed into Eden Park, Auckland, for the fourth and final Test, with another 3,000 locked outside. It must be remembered, too, that it was an immensely long and arduous

tour, sharing with the first tourists of 1888 the record for the longest trip, comprising 35 matches. They got off on the wrong foot before they left the UK because of press controversy, and they became an unhappy party, failing to adjust to New Zealand conditions and attitudes.

According to Vivian Jenkins, the vastly experienced *Sunday Times* rugby correspondent of that time:

There is also the question of whether a team has enjoyed itself on tour. I regret to report that, while nearly every one of the touring party said he would love to come back to New Zealand again as an ordinary visitor, not one of them (and this was confirmed to me by the manager, Des O'Brien) wanted to return there to play rugby.

Competition taken to extreme, as it is in New Zealand, produces things that, to our own players, are not worth the ends involved. Dirty play is one of them and there was more than enough of this on tour. Kicks on the head, which necessitate stitches, or broken noses from stiff arm tackles, do not come under the heading of hard play, to which no rugby man objects. Instead, they are just plain dirty. No doubt we will be accused of squealing, the usual New Zealand comeback, but the only alternative is to stay silent and respond in kind, and what kind of a game does that make rugby?

One wonders whether these words, and the outburst by Telfer after he captained the Lions to a win over Canterbury, were the catalyst for the two later tours of 1971 and 1974, when the Lions coined those emotive phrases of 'Get your retaliation in first' and 'Take no prisoners'.

There was constant criticism by the New Zealand press concerning the lack of leadership at all levels. Terry McLean, the great New Zealand rugby journalist, said:

The British, at times, played shamefully badly, but nobody really cracked the whip. I must be blunt – the trouble was leadership. The discipline within the party was not sufficiently strong for the demands and rigours of the tour. The manager and assistant manager were both charming men, but neither had much taste for cracking the whip. They both preferred quietness and the appeal to the intellect. The series represented a clash between style and method, the classic style of the Lions and the powerful work-a-day method of the All Blacks. Method, as it so often does, triumphed, but style at its best, as portrayed by Mike Gibson with the breadth and quality of his attack, is superior to method.

Wilson Whineray, the illustrious All Blacks captain, said, 'It is clear in retrospect that the Lions' decision, made early in the tour, to play the All Blacks up front was wrong. They suffered from battling to narrow wins, or not winning at all, and the spectators suffered from watching dreary rugby.' He went on to say: 'I believe a team should play to its strength, and the Lions' greatest strength was their backs.'

▲ A less than flattering souvenir tray produced to commemorate the 1966 tour

▲ Ireland and Cambridge centre Mike Gibson was a revelation on his first tour

The outstanding back was Mike Gibson, the Irish outside-half who was on the first of his record-equalling five Lions tours. He played in 19 of the 25 games in New Zealand after joining the party late because of exams at Cambridge University. He left on 2 June and arrived with fellow Irish cap Barry Bresnihan, who flew out as a replacement for another Irish three-quarter, Jerry Walsh, who left the tour when his father suffered a stroke. Gibson, therefore, missed the eight games, and two Test triumphs, in Australia, by which time Watkins had nailed down the No. 10 jersey. Gibson's talent shone through very quickly, however, and he was moved to centre for all four Tests in New Zealand, thus ensuring the Lions had their best talent on the pitch at all times. Along with Ronnie Lamont he was named in the *Rugby Almanack of New Zealand's* five 'Players of the Year'. In time, Gibson would make 12 Test appearances for the Lions and 68 in all matches – one more than the other five-time tourist, McBride.

Scottish full-back Stewart Wilson, who ended as the top points scorer on tour, with 90, Welsh wing Dewi Bebb, leading try scorer, with 14, and Watkins, who played in all six Tests and was captain in two, all had good tours, and Alexander James Watt 'Sandy' Hinshelwood, who scored a dozen tries, and McFadyean were strong elusive runners. Of the forwards, McBride was a giant in every sense of the word; Lamont, who played in the latter games of the tour and final Test with a detached muscle in his arm, and Murphy were outstanding loose forwards, but there was a need for a quick flanker. The front row were strong and durable, while both hookers, Ken Kennedy and Frank Laidlaw, were splendid players who went on to play for the Lions again on more famous tours.

O'Brien was castigated for taking a holiday in Fiji just before the third Test, but this was at the suggestion of the New Zealand Rugby Union, who were concerned at the pressure he had been put under. Make no mistake, the demands of a Lions tour are intense, and unquestionably some tour managements have cracked. Campbell-Lamerton reported on his return that he had made 257 speeches on tour, given 80 radio interviews and appeared on television 36 times, a workload that even in the modern media world would have taken its toll.

There was no problem on the Australian part of the tour, which the Lions sailed through, winding up unbeaten, an achievement no team had matched since Bedell-Sivright's team in 1904. They kicked off with a runaway victory in Perth over Western Australia by 60–3. They gorged themselves on 12 tries and must have impressed the chief guest at the game, the governor of Western Australia, Sir Douglas Kendrew, the former England international and 1930 Lions tourist. The Lions agreed to play under the new local rule, which outlawed kicking to touch from outside the 25, and there were first-game hat-tricks for Walsh and Hinshelwood, as well as 18 points for Rutherford. There were plenty of injuries in the early stages, and the Bridgend and Wales flanker Gary Prothero didn't play for a month, until the seventh game of the tour.

It was a pretty good all-round effort in Australia, considering that the Wallabies had Ken Catchpole, one of the greatest of all scrum-halves, with Phil Hawthorne at outside-half and Peter Ryan at full-back, not to mention Tony Miller, John Thornett,

Peter Crittle, Ron Heming, Jules Guerassimoff and Greg Davies in the forwards. The only real resistance to them came from New South Wales, where a Combined Country XV held them to 6–3, and the New South Wales team itself, then the heart of Australian rugby, held them to a 6–6 draw in the ten days before the first Test in Sydney.

There was an Australian record crowd of 42,303 for a rugby union game at the Sydney Cricket Ground, which was probably due to the League cancelling a big match on an adjoining ground in deference to the tourists. Although it was an open and exciting game, it was marked by too many mistakes by the Lions backs and, in the end, it was the pack which won the game for them. It was this which perhaps clouded judgement for the New Zealand part of the tour. Australia held the lead at half-time by a bullocking try from the 37-year-old veteran Tony Miller, converted by George Ruebner, who also kicked a penalty, to give Australia a useful lead at the interval.

In the second half, Rutherford then kicked a penalty for the Lions, which was followed by a try for the Irish prop Ray McLoughlin on a peel around the front of a lineout. Rutherford's conversion made it 8–8. The Lions' winning try was spectacular, started again by McLoughlin going around the front of the lineout with the forwards inter-passing, before the ball was flung out to the elegant Mike Weston, who wrong-footed the defence with a weaving run before throwing out a long pass for the hooker Kennedy to get over in the corner. It was a good day for the 'Front Row Union' and it led to *The Times* posting a headline in their Monday edition that

▲ The first of their six Test assignments saw the 1966 Lions tackle the Wallabies in Sydney. At one stage they trailed 8–0 but rallied with tries from Ken Kennedy and Ray McLoughlin to register an 11–8 victory

▲ The programme from the second Test against Australia at Lang Park, traditionally a rugby league venue

claimed: 'Lions Shame Doubting Thomases – Forwards Magnificent in First International'. It didn't help the tourists' cause that scrum-half Roger Young (concussion) and wing Stuart Watkins (leg muscle) were virtual passengers by the end of the game, but the Lions had bared their teeth and laid down a marker.

Easily disposing of Queensland, who in those days were a minor force, the Lions then, horror of horrors, were forced to play their final Test at Lang Park, the rugby league ground, for there was no suitable union venue. For without the special dispensation of rugby union's Vatican, the IRB, which was in keeping with other irregularities allowed in Australia in order to combat rugby league, the players could have professionalised themselves. It is hard to believe that such nonsense existed for so long.

The venue proved to be a lucky one for the Lions, who ran away with the game in spectacular and astonishing style, considering that the Wallabies had recently beaten the Springboks and the All Blacks. They also went on to beat Wales for the first time in Cardiff a few months later. The 31–0 scoreline was, and still is, the highest recorded in a Lions Test and the biggest winning margin. It was also the biggest Test drubbing the Wallabies had experienced since they had first begun playing international rugby 67 years earlier. The first half gave no indication of the deluge to come, as they reached the interval leading by a mere three points from a penalty in the first minute by the full-back Wilson. Soon after the restart, Watkins dropped a goal and then, after 18 minutes of the half, the Lions scored 25 points in 22 minutes. Ken Jones, twice, Murphy, Bebb and Watkins all crossed the Wallabies' line and Wilson, who had the game of his life, converted all five to set a Lions record in a Test. Pask had lived up to his reputation as the world's finest No. 8, and Wilson, Watkins, Ken Jones and Bebb all appeared class players.

But it proved to be a false dawn. The Lions were quickly brought down to earth shortly after landing in New Zealand, where they lost their first provincial game against Southland. They went on to lose their next two Saturday games against Otago and Wellington, and the writing was very much on the wall. Watkins wrote in his autobiography:

We beat the Wallabies comfortably in two Tests en route to New Zealand, by margins of 11–8 and then a sizzling 31–0. However, the second, giant victory was just about the worst thing that could have happened to us. It jetted us off to Auckland in a cocksure, as opposed to a confident, mood. It hid our deficiencies in team-work. And it left us all the more unprepared for the days of reckoning which lay ahead.

The Lions arrived at Dunedin for the first Test with three losses and a draw from nine games, and a tally of 113 points for to 106 against, a clear indication that they were not playing fluent rugby. It is true that never at any time in New Zealand were they going well. They managed only three scores of 20 or more points, twice against up-country, combined sides and once against the Universities, and so the omens were bad as the tour got down to the main business. The All Blacks were a reasonably settled side with a great pack that contained forwards of the quality of the incomparable Colin Meads and other all-time greats like Ken Gray, Waka Nathan, Brian Lochore and Kel Tremain.

◄ Fly-half David Watkins revealed in his autobiography the internal tensions which erupted in the Lions camp following their chastening 20–3 loss to the All Blacks at Dunedin

The first half of the first Test was at least even, but ended with New Zealand leading 8–3, following a try by Ken McLeod converted by Mick Williment. Wilson replied with a penalty for the Lions and 'Mac' Herewini put over a drop goal. In the second half, Williment and Lochore scored tries, but Williment missed both conversions. He did, however, kick two more penalties to make it 20–3.

As Watkins described it:

After some half-hearted tinkering with our tactical approach during June and early July we reverted for the first Test to the team and the style which had overwhelmed Australia. Predictably we were not good enough by a mile, going down to defeat by 20 points to 3, which was a huge margin in days before the sweeping changes in the laws and in scoring values.

That did it, now we had a crisis on our hands. There was bitter and outspoken argument within our camp about who was to blame for our poor showing and why we had lost. Individuals took stick. There was a whispering campaign against the biggest national group: 'The Welsh are stand-offish and arrogant!' This was rubbish!

It was in this match that the Lions encountered the new catchphrase, 'second-phase possession of the ball', which has become ensconced in rugby vocabulary. This consisted of a midfield player, usually the second five-eighth or inside-centre, allowing himself to be tackled, and turning in order to set up the feed from the subsequent ruck and, having drawn some of the defence, being able to attack again against a disorganised defence. Ian MacRae was the arch exponent of this ploy.

The Lions pulled themselves together and won the next five games, including those against Canterbury and Auckland, who were two of the big four provincial teams. It was after the 8–6 triumph over Canterbury that O'Brien and Telfer, the latter the captain on the day, decided to verbally lash out at the New Zealand style of play at the post-match function. It was O'Brien who was first into bat: 'Back home we play rugby as a game to enjoy. Here we find obstruction, stiff-arm tackling and other illegal tactics. We are sick of it!' Next up was the skipper for the day, Telfer: 'I'm not going to say today's game was dirty, because every game played in New Zealand has been dirty.'

The outburst brought a swift and cutting response from the president of the New Zealand Rugby Union, Henry Blazey: 'I have seen the Lions play nine games, including one in Australia, and I have yet to see a stiff-arm tackle in any of the games I have watched. It seems to me that before accusing his opponents of illegal play he should look at some of the illegalities the Lions are practising, such as consistently coming into the rucks on the wrong side, failing to roll clear of the ball, and obstructing in the lineouts.'

After a series of bitter brawls in the 12–6 win over Auckland, the chairman of the New Zealand Rugby Union, Tom Morrison, used the post-match event to condemn both sides for their lack of restraint. On the eve of the second

The Scottish Rugby Union took a particularly hard line when it came to the 1966 tour, insisting that each of their Lions players returned the two blazers, playing kit and trousers that had been issued to them in order to ensure that there wasn't even the hint of players profiting from the tour.

Test at Athletic Park, Wellington, he joined no less than the Governor General to have a talk with the captains of the two teams.

The Lions made six changes for the second Test and Campbell-Lamerton sensationally dropped himself. Out went Ken Jones and Roger Young in the backs, and Pask, Brian Price and Kennedy exited the pack. Hinshelwood and Welsh scrum-half Alan Lewis went into the back line, while Thomas, Murphy, McBride and Laidlaw joined the forwards. But it was the issue over the captaincy that naturally grabbed all the headlines.

Watkins explained in his autobiography how he was asked to take over the captaincy reins:

So it was in sad circumstances that I reached what many would deem the summit of achievement in the amateur game. The place was Wellington, the time was early August, and the second Test was a few days away.

Mike Campbell-Lamerton took me quietly on one side after dinner. 'I've decided to drop myself, David,' he said. 'Will you captain the Lions against New Zealand on Saturday?'

For a tour captain not to lead his Test XV was tantamount to dropping a bombshell of unprecedented proportion... I accepted the invitation, but my own

delight was pretty well cancelled out by the wholehearted sympathy I felt for Mike. By this time he had been exposed as a lock who lacked the vigour and craft necessary to match All Black opponents.

However, a captain can still be worth his place if he leads intelligently and inspiringly. In this, Mike's confidence had been undermined by constant sniping criticism from the New Zealand press; and also by the huge social strain he was under as captain...

We lost by 16 points to 12. But my team played some great rugby, leading at the interval by 9–8 – and I will believe to my dying day that we owed our eventual defeat to some crass refereeing by an official called Pat Murphy. First Mike Gibson and later Colin McFadyean were brought back from absolutely clear-cut scoring positions for the Lions to be given the put-in at set scrums – meaning that we were not the infringing side!

▲ A ticket for the second Test in Wellington, a match for which tour skipper Mike Campbell-Lamerton sensationally dropped himself and was replaced as captain by David Watkins

That game in the New Zealand capital was played in typical winter's day conditions of wind, rain and mud. Wilson kicked a penalty and Tremain scored a try for the All Blacks, converted by Williment, before a drop goal by Watkins and another penalty by Wilson took the Lions ahead. In the second half, Colin Meads crashed over for a try and Williment converted, then an unconverted try by the Canterbury winger Tony Steel, before a third Wilson penalty, saw the All Blacks home by 16–12. The game was almost saved in the dying moments, when Delme Thomas made a 50-yard run, but his pass within yards of the line went astray.

The third Test in Christchurch, in cold and slippery conditions, saw the Lions, after being 6–6 at half-time with two penalties by Williment to two tries by Lamont and Watkins, committing too many errors, just as they seemed to have the legs of New Zealand. Consequently, the All Blacks won 19–6, with Steel scoring a try and Waka Nathan getting two tries from his formidable support and backing up, with Williment adding a final conversion to give the All Blacks another comfortable win.

Even though the All Blacks had already won the series, there was a crowd of 58,000 at Eden Park for the final Test, which at the time provided record gate receipts of £43,000 for any match in New Zealand's rugby history. It was a perfect day, with a firm ground and plenty of sunshine – and with Watkins back in charge after Campbell-Lamerton had stepped down for the second time.

Again, the Lions, after losing Pask with a broken collarbone after 27 minutes, were outplayed by the superlative All Blacks pack and had no answer to the aggression of their forwards in the loose. Nathan opened the scoring with a try from a quick throw-in at a lineout and Williment converted. Malcolm Dick then scored a try, converted by Williment, but then a fine try by Hinshelwood and another by McFadyean, after a brilliant run by Gibson and converted by Wilson, made it 10–8 at half-time. Twenty-four minutes into the second period, MacRae scored a try, converted by Williment, and it was followed by a drop goal by Herewini and a try by Steel. Although Wilson got another penalty for the Lions, the final points came from Williment's boot with a penalty, to make it another decisive win for the All Blacks. It was the first four-match whitewash New Zealand had ever recorded against a touring team.

Watkins wrote:

We had been 'done' conclusively. We felt sick. We had touched rock-bottom, with no excuse for our whitewash, and no salve for our pride. That is how it feels in big rugby when you are really taken to the cleaners... What a pity we turned out to be such an inept side on the field. Completely failing to give the All Blacks a run for their money, we went down to an ignominious whitewash, the first ever suffered by a British Lions touring party.

To add to their woes, the Lions lost to British Columbia 8–3 on the way home in a game for which they only had 16 fit players. As well as a host of injuries from New Zealand, they also had a number of sunburn victims courtesy of a stopover in Hawaii.

**BRITISH ISLES
V NEW
ZEALAND**

at Lancaster Park 27 August 1966
Official Programme 2/–

The prop Howard Norris played in the back row and the interpretation of the local referee didn't go down well. That they were even asked to play two games in Canada on the way home after 33 matches, six Tests and five months in Australia and New Zealand just seems madness. They at least won the final game against Canada, 19–8, and eventually arrived home on 20 September.

The Times' rugby correspondent provided a pretty damning summation of the whole tour for his readers after the final game in Toronto:

The truth is that this tour never really got off the ground, for which a number of reasons suggest themselves. Although the general standard of the players turned out to be unexpectedly low – surely those who have reached international level should know how to tackle, how to give and take passes, and not have to learn all over again as a result of mauling by their opponents – the main responsibility must lie with the tour's top brass, the manager, Mr D.J. O'Brien, his assistant, Mr J.D. Robins, and the captain, M.J. Campbell-Lamerton.

To be sure, the manager had thrust upon him some folk of unusual immaturity, at least in a social sense, too many who looked upon the tour as a bucolic jaunt without being able to understand the responsibility of every player to repay selection.

▲ The programme from the third Test at Christchurch, which saw the All Blacks claim a 19–6 victory to decide the series – and perhaps sow the seeds that would lead to the Lions' triumphant return five years later

Robins was too modest, hiding his light under a bushel, and he suffered cruel luck in an Achilles tendon operation that kept him out for six weeks.

Yet it would be totally unfair to lay all the blame at the door of the top brass. At times the players showed carelessness and ineptitude on the field that were almost unbelievable in experienced internationals, the sort of thing that would break any coach's patience if not his heart.

No matter how disappointing all-round the tour was, it instilled a steely resolve in some to improve matters in the future. McBride, Gibson and Thomas hung on for the 1971 return to New Zealand, and Telfer became a Lions head coach in 1983 and a vital assistant to Ian McGeechan in 1997.

In his foreword to the first edition of this book, McBride wrote of 1966:

All the games were tough and uncompromising, but I enjoyed the challenge, and the hospitality was great. We were thrashed in the first Test and I got my big break and partnered Delme Thomas for the second, and played for the rest of the series. We lost all four Tests.

There were signals coming through loud and clear to me. I can remember Colin Meads telling me, 'You guys from the British Isles believe in fairy tales. There is no

way, with your haphazard approach and attitude, that you will ever beat us.' Those words rang clearly in my ears for the years to come and I knew he was right.

We seemed to have good players, but we were not organised and, as far as winning was concerned, it was all dreams. There was no doubt that we were second string, both in South Africa and New Zealand. Many players came home from New Zealand disillusioned in 1966, but there were also many who came back better players and determined that our game would improve.

RESULTS OF THE 1966 LIONS IN AUSTRALIA, NEW ZEALAND AND CANADA

P 35 W 23 D 3 L 9 F 524 A 345

Western Australia	W	60–3	New Zealand (Dunedin)	L	3–20
South Australia	W	38–11	West Coast-Buller	W	25–6
Victoria	W	24–14	Canterbury	W	8–6
Combined Country XV	W	6–3	Manawatu-Horowhenua	W	17–8
New South Wales	D	6–6	Auckland	W	12–6
Australia (Sydney)	W	11–8	Wairarapa-Bush	W	9–6
Queensland	W	26–3	New Zealand (Wellington)	L	12–16
Australia (Brisbane)	W	31–0	Wanganui-King Country	L	6–12
Southland	L	8–14	New Zealand Maoris	W	16–14
South Canterbury, North Otago & Mid Canterbury	W	20–12	East Coast-Poverty Bay	W	9–6
			Hawke's Bay	D	11–11
Otago	L	9–17	New Zealand (Christchurch)	L	6–19
New Zealand Universities	W	24–11	New Zealand Juniors	W	9–3
Wellington	L	6–20	Waikato	W	20–9
Marlborough, Nelson, Golden Bay & Motueka	W	22–14	Thames Valley-Counties	W	13–9
			New Zealand (Auckland)	L	11–24
Taranaki	W	12–9	British Columbia	L	3–8
Bay of Plenty	D	6–6	Canada (Toronto)	W	19–8
North Auckland	W	6–3			

MIKE CAMPBELL-LAMERTON'S 1966 LIONS TEAM

FULL-BACKS
T.G. Price*	Llanelli	Wales
D. Rutherford	Gloucester	England
S. Wilson	London Scottish	Scotland

THREE-QUARTERS
D.I.E. Bebb	Swansea	Wales
F.P.K. Bresnihan*	Wanderers	Ireland
A.J.W. Hinshelwood	London Scottish	Scotland
D.K. Jones	Cardiff	Wales
C.W. McFadyean	Moseley	England
K.F. Savage	Northampton	England
J.C. Walsh	Sunday's Well	Ireland
S.J. Watkins	Newport	Wales
M.P. Weston	Durham City	England

HALF-BACKS
C.M.H. Gibson	Cambridge University	Ireland
A.R. Lewis	Abertillery	Wales
D. Watkins	Newport	Wales
R.M. Young	Queen's University, Belfast	Ireland

FORWARDS
M.J. C'll-Lamerton (capt.)	London Scottish	Scotland
D. Grant	Hawick	Scotland
K.W. Kennedy	CIYMS	Ireland
F.A.L. Laidlaw	Melrose	Scotland
R.A. Lamont	Instonians	Ireland
W.J. McBride	Ballymena	Ireland
R.J. McLoughlin	Gosforth	Ireland
N.A.A. Murphy	Cork Constitution	Ireland
C.H. Norris	Cardiff	Wales
A.E.I. Pask	Abertillery	Wales
D.L. Powell	Northampton	England
B. Price	Newport	Wales
G.J. Prothero	Bridgend	Wales
J.W. Telfer	Melrose	Scotland
W.D. Thomas	Llanelli	
D. Williams	Ebbw Vale	Wales

*Replacements

1968 TOUR KIT

1968
WRECKERS AND KIPPERS

Captain: Tom Kiernan (Cork Constitution and Ireland)
Squad Size: 30 players + 3 replacements
Manager: David Brooks (England)
Coach: Ronnie Dawson (Ireland)

Tour Record:	P 20	W 15	D 1	L 4	F 377	A 181
Test Series:	P 4	W 0	D 1	L 3		

Rugby in the British Isles was at a low ebb at the end of the 1967–68 season, and although the 1968 British & Irish Lions did far better than people expected, they were nowhere near strong enough to beat the Springboks. The South Africans outscored the Lions by eight tries to one over the four-match series and had it not been for the boot of Tom Kiernan it would have been a 4–0 drubbing.

1968 was a troubled year nationally and internationally. The economy was in trouble and five typists from Surbiton began an 'I'm backing Britain' campaign, promising to work an extra half-hour a day for nothing. George Brown resigned as Foreign Secretary; Yuri Gagarin died in a plane crash; and Russian tanks crushed Prague. D'Oliviera was dropped from the South African cricket tour because of his colour; student strikes and demonstrations disrupted Paris and other French cities; and there was a state of anarchy in colleges in Britain. The 22-storey building Ronan Point collapsed; and the first sextuplets were born in Britain. Martin Luther King and Bobby Kennedy were both assassinated. Tony Hancock committed suicide and *The Forsyte Saga* gripped television audiences.

The 1968 Lions were the 20th British team to tour abroad and followed on from the side that had been so badly mauled in New Zealand in 1966. The 1966 tourists were the first side to have a coach, John Robins, but the review of the trip showed that he had had very little chance to operate in the way that had been envisaged when he was named as the 'assistant manager', as the captain still took charge of tactics. The Four Home Unions committee were adamant the same mistakes wouldn't be made again. Planning for the 1968 trip to South Africa started early: in fact, a mere eight months after the 1966 side arrived home. On 26 June 1967, nine candidates filed into the East India Club in St James's Square in Mayfair to be interviewed for the posts of tour manager and assistant manager. England led the way with six hopefuls, three for each post, while Wales ended up with one of their original two candidates, Handel Rogers, being proposed as tour manager. The Scots were pinning their hopes on 'Copie' Murdoch for either post, while the Irish, who had had Des O'Brien as manager of the ill-fated 1966 trip, only proposed the 1959 Lions skipper Ronnie Dawson for the assistant's position.

Of the five men who were interviewed for the role of tour manager, David Brooks triumphed over Rogers, Murdoch and his English rivals Stan Couchman and Brian Vaughan. The director of a major fruit importing company, Brooks had been chairman of Surrey County and was a member of Harlequins. An irrepressible man, he was only 40 and had 18 years of first-class playing experience behind him. He had left school at 16 to join the Fleet Air Arm at the outbreak of the Second World War, falsifying his age to enlist, and he flew Swordfish aircraft hunting for U-Boats.

The role of assistant manager ended up in the capable hands of Dawson, who beat off the 1955 Lions centre Jeff Butterfield, the 1957 England Grand Slam skipper Eric Evans and England's 1966 Lions full-back Don Rutherford for the job. Dawson had toured South Africa with the Barbarians in 1958 and Ireland in 1961 and was at the forefront of coaching in Ireland.

Brooks and Dawson had help in selecting their 30-man squad from England's Micky Steele-Bodger, Scotland's Charlie Drummond, Ireland's Des McKibbin and Wales' Harry Bowcott. They were able to review the players not merely over a club season and Five Nations campaign, but also over the course of an incoming New Zealand tour. They had a number of existing Lions to consider, and the Irish prop Syd Millar was picked for his third tour along with his Ulster teammate Willie John McBride. There were second successive tours for Scottish wing Sandy Hinshelwood, Wales lock Delme Thomas, Irish half-backs Mike Gibson and Roger Young, England wing Keith Savage, Irish centre Barry Bresnihan and Scottish back-rower Jim Telfer.

The original party, named on Monday, 18 March, included the Harlequins and England centre Bob Lloyd and the 19-year-old Northampton and England back-row man Bryan West. Both were forced to miss the tour through injuries, although West was called out later as a replacement and played in two matches. Lloyd's replacement was another teenage sensation, the Newport and Wales player Keith Jarrett. There was plenty of raw talent, much of which would return in three years' time to provide the Lions with the impetus required to record their one and only Test series triumph in New Zealand. The seeds of victory in 1971 were sown in South Africa with the selection of Barry John, Gareth Edwards, Gerald Davies, John Pullin and John Taylor.

▲ Ireland full-back Tom Kiernan was given the honour of leading the 1968 Lions and captained a squad initially boasting six fellow Irishmen, 11 Wales players, seven Englishmen and a five-strong Scottish contingent

➤ Skipper Tom Kiernan holds one of the Super Springbok rugby balls which had been specially flown in to the UK so that the Lions players could train with them before the start of the tour

The captain, Munster and Ireland full-back Tom Kiernan, had been a Lion in South Africa in 1962 and became a key player on the tour. He would go on to coach both Munster and Ireland, and become both president of the Irish Rugby Football Union and a key figure in the creation of European Rugby Cup Ltd, the governing body that introduced the Heineken Cup into European rugby. As well as figuring in 13 matches, in the series Kiernan notched a record points tally of 35 with 11 penalties and a conversion. He also stripped Lewis Jones of the Lions Test record of 16 points, achieved in Australia 18 years earlier, with his 17-point haul in the first Test in Pretoria, won 25–20 by the Springboks.

The shadow cast by the results in 1966 had threatened to drag down the performances of Kiernan's men and this group actually did much better than their Test record suggests. They managed to draw the second Test, but lost the other three, two of them by the narrow margin of five points. Had the third Test been won, then they would have been hailed as a fine side, because their provincial record was superb; they lost only to Transvaal. The main blot on their copybook was that of the 38 points they scored during the Test rubber, 35 came from penalties and they scored only one try. The great South African rugby oracle, Dr Danie Craven, said of them in A.C. Parker's book, *The Springboks 1891–1970*:

The Lions were a good team, well prepared and well coached. How near they came to beating us in the series is something we are inclined to overlook. It is true that we beat them convincingly in the first and last internationals, but in both those matches the important turning points came our way. The Lions gave us grey hairs and it was a great achievement to have beaten them in the internationals.

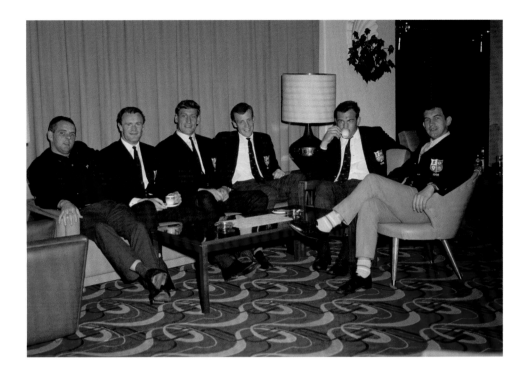

◀ Off the pitch the 1968 tourists split into two distinct camps, the party-loving 'Wreckers' and the slightly more sedate group known as the 'Kippers', although many players, such as Willie John McBride (third from left) and Syd Millar (second from right), adopted elements of both philosophies during the tour...

A major criticism of the tour was that, in common with most Lions teams of the past, they did not take matters too seriously, and that enjoyment of the experience of touring was the primary consideration, with rugby of secondary importance. This is perhaps an oversimplification, but in essence it had an element of truth, for there can be no question that most British teams overseas did not have the same inner driving force and commitment which seems to impel and activate the psyche of the Antipodeans or the South Africans. In the dressing-room of the Australian cricket team in the Sydney Cricket Ground, known as the SCG, there is written in letters about nine inches high 'We shall not fail on the score of determination', which just about sums it up.

On the 1968 tour, there was a growing media presence as the tabloids, who used to treat rugby like the plague until its popularity forced them to sit up and take notice, began reporting those matters which the players regarded as sacrosanct, namely their social activities. Very quickly the 1968 team was split into two camps – 'the Wreckers' and 'the Kippers'. The 'Wreckers' thirst for a good party, with the manager often leading the hunt, became legendary, and the fallout, quite literally at times, was well known. Tales of pianos emerging from windows, various objects ending up in swimming pools and all the usual rugby jaunts became par for the course. And as the injuries mounted, there was often a second bus for the 'crocks'. As for 'the Kippers', they spent more time in bed to stay away from the mayhem.

The parties were, on occasions, fairly riotous, and I gather that Willie John and a few others were not averse to joining in the 'craic'. At the party after the first Test, Willie John slipped and needed eight stitches in his leg and two in a finger. Having lost the first and drawn the second Test, the third in Cape Town was critical for the series. Consequently, when they lost, the scene was set for a really big party. They were staying in Cape Town Hotel, run by the delightful Jeff Reynolds, himself a 1938 Lion. To cut a long story short, it turned out to be quite a night and, as they left the debris surrounding them the next morning, Jeff presented a bill for the damages, which he had halved and halved again, for he was that kind of man. It still came to

about £900, but apparently 'Brooky', as the team called their manager, did not turn a hair. Instead, he signed the account with a flourish, accompanied by the remark, 'Huh. It couldn't have been a very good party!' which, one has to admit, had a bit of style about it.

For all that, David Brooks was a first-class manager and he engendered an excellent spirit in the team and, despite coming from four different nations, they were as united as any Lions team has ever been, or will ever be. His players were fond of him and, had they won that second or third Test, Brooks would have been remembered as one of the great managers.

▲ Bob Hiller was extremely unlucky to find himself competing with tour skipper Tom Kiernan for the full-back spot in the Test team but provided vital leadership for the midweek side

One South African newspaper headline said of the 1968 Lions, 'No angels, but no oafs'. There was no criminal damage done; it was all horseplay and whooping it up. The only things that got broken were glasses and a few items of bedroom furniture, with beds being particularly prone to damage, seeing as one of the purposes of the 'Wreckers' was to tip 'Kippers' out of their beds. The hellraisers had their own code and, according to Edwards, created the 'Loyal Order of Wreckers' on a long train ride to the Kruger Park.

After being presented with some fancy cigarette lighters as presents, they also formed a splinter group called 'the Burners'. They held a symbolic burning of shirts belonging to players and members of the press, and of girls' knickers, outside the hotel in Cape Town after the Boland match, probably in disappointment at having lost Edwards that afternoon with a badly pulled hamstring, which was to keep him out of the third and fourth Tests. As an antidote to both groups, that marvellous man Bob Hiller, who was destined to be a 'dirt-tracker' for two tours because of the presence of Kiernan as captain in 1968 and of the peerless J.P.R. Williams in 1974, formed an alternative pacifist group that became known as 'the Kippers'. Hiller was one of those essential men on tour who led the midweek team and helped to keep them motivated; tours without a leader of the 'dirt-trackers' usually struck problems in the provincial games.

Once again the back play of these Lions, as it was throughout the 1960s, became too stereotyped. They continually used the ploy of the kick ahead, which was so prevalent in British and Irish rugby at that time. Consequently, there was no way they could be creative and this showed up in the Test matches. Another weakness was bad finishing. They never found themselves in the backs and again a long injury list, endemic on the hard and fast grounds of South Africa, must take some of the blame. But for the excellent goal kicking of Kiernan and Hiller, their problems would have been far worse.

Apparently, Gibson had a disappointing tour at outside-half, which suggests that his true position was at centre, where he was to excel in 1971. The injury to John in the first Test was, perhaps, one of the tragedies of the tour.

Having won their first six games leading up to the first Test at Loftus Versfeld in Pretoria, the Lions were in good heart and optimistic. It was a disappointing match,

however, considering the perfect conditions and the hard ground. Although the Lions lost by a mere five points, they were well beaten, and only 17 points from Kiernan's boot kept them in the game. The loss of Barry John midway through the first half, when he was upended by Jan Ellis and broke his collarbone, was critical, for he was the only player who looked likely to open up the middle.

History was made as John left the field, as the International Rugby Board has allowed each side to nominate four replacements to be used if a player was badly injured. Why, again, they took so long to make this decision is one of life's great mysteries. The game at Loftus Versfeld was the first to implement the new law at Test level and meant Ireland's Mike Gibson became the first player to be used as a replacement in international rugby when he finally took over from John. When the Welshman was being led off the field, Gibson was still in his blazer and flannels, watching the game from the radio and TV commentary position on top of the stand. In those days, the four nominated replacements for both sides were unable to change before a doctor had ratified an injury and the need for a substitution. This invariably took ten to twenty minutes, and by the time Gibson had got to the dressing-room, changed and taken the field, the Springboks had scored six vital points against 14 men. Gibson's name may have entered the Test history books, but he was beaten to the punch by fellow Irishman Bresnihan in becoming the first Lion to be used as a replacement. It was an injury to Gibson himself, some 15 minutes before the end of the opening-game victory over Western Transvaal, that paved the way for Bresnihan to replace him.

▲ An itinerary for the tour, featuring a lion-taming Springbok

There were 75,000 spectators jammed into those towering stands at Loftus and they watched 45 points being scored, the same as that first Test in 1955, but the game had none of the drama or the running skills of the earlier occasion. Instead, it was a game ridden with error and the Springboks were simply too good for the Lions. The score was hardly a reflection of how the game went and, as Tom Kiernan remarked afterwards, 'Fancy me scoring 17 points and being on the losing team!' At the time, it was the fourth-highest individual score in Test match history.

Tiny Naude, Dawie de Villiers and Frik du Preez scored tries for the Springboks, and Visagie added two penalty goals and two conversions. McBride scored the only Lions try and Kiernan slammed over five penalties and a conversion, to establish a record of the most points scored by an individual in a Test against South Africa. It was a typical try by du Preez which was the highlight of the game when, like a rhinoceros at full gallop, he steamed through the front of a lineout and through about six defenders for an unstoppable score. The Lions had made much use of the short three-man lineout, but mistakes and the looseness of their play worked against them, and the Springboks won easily.

Two more wins, and their only defeat in the provincial games, preceded the second Test in Port Elizabeth, which produced a huge controversy over the referee, Hansie Schoeman, who was appointed by the South African Board from outside the panel. The refereeing was bizarre, as he allowed the Springboks to double-bank at

the lineouts, and he penalised the Lions so mercilessly in the scrums that, in the end, Gareth Edwards was afraid to put the ball in. The order was then given by the senior prop, Millar, not to strike for the ball. There followed a week of recriminations and negotiations, because the Lions knew that the admirable Pullin, of England, was a totally fair striker of the ball, and they felt that they could not compete with such eccentric refereeing. Terry O'Connor, in the *Daily Mail*, suggested that the Lions should go home in protest. It finally blew over, as such matters usually do, but when touring in those days you always had to be on your toes over such matters. It was amazing how often they seemed to occur.

KINGS PARK DURBAN · SAT 1 JUNE/JUNIE 1968

NATAL

BRITISH ISLES

OFFICIAL N·R·U BROCHURE　PRICE/PRYS 20c　AMPTELIKE N·R·U BROSJURE

▲ The programme from the Lions' tour match against hard-hitting Natal at Kings Park

The game was drawn 6–6, as the Lions gave an impressive impersonation of the thin red line holding out against huge odds. The back row of Telfer, Arneil and Bob Taylor tackled like demons and so did all the backs, while Kiernan had another good day. The Springboks did most of the attacking, but were thwarted by a remarkable Lions defence which, in itself, earned them a draw. Visagie and Naude each kicked a penalty for the Springboks and Kiernan put over two for the Lions to keep the series alive.

After the cheer of earning a draw, the Lions found themselves immediately plunged into despair after moving on to Springs to face Eastern Transvaal. The events that unfolded in what became known as 'the Battles of Springs' did nobody any good and put the Cardiff and Wales prop John O'Shea at the eye of a storm.

Viv Jenkins, covering the tour for *The Times*, claimed that punches had been thrown at the very first scrum and that it was an assault on scrum-half Young, as Hector was scoring his try for the home side that led to O'Shea meting out his rough justice. He chased an opponent 15 yards before finding himself surrounded and taking on all comers. The referee literally slung him off the pitch to make him the first British & Irish Lion to be dismissed for foul play and the first since Denys Dobson in 1904 to receive his marching orders.

O'Shea was pelted with oranges before being struck in the face by a spectator as he left the field. This precipitated the biggest punch-up of the tour, at the mouth of the tunnel, while the game went gaily on. It made Eric Cantona's altercation with a Crystal Palace fan in 1995 look like a minor disagreement at a Sunday School outing, as everybody pitched in, including the Lions reserves, officials, police and Lions supporters. Apparently, the best blow struck was by McBride on the offending spectator, who was later arrested.

'Okey' Geffin, the famous Springbok forward, was quoted in *The Times* on the Monday after the game as saying: 'What happens on the field is a matter for the referee and not for the spectators. They have no right to take the law into their own hands and to assault a player. This is a disgrace and must be condemned by the entire country. I trust that in future police dogs will be there to keep the public in their place. We cannot allow spectators to intervene in rugby.'

In 2009, O'Shea gave a full account of the incident in an interview with BBC Wales:

I'd been picked to play at tight-head prop against Eastern Transvaal. The portents were not good; a year earlier on the same ground France had played them in a brutal match that required the referee to blow early to avoid further bloodshed.

In the wake of that match, one of the Eastern Transvaal players had been suspended 'sine die'. However, with the Lions in town, he was granted a permit to play and a party of hunters was sent into the bush to capture the flanker and bring him back to Springs.

As expected the match was a bad-tempered affair, punctuated by skirmishes that forced the referee, Bert Woolley, to issue a general warning to the forwards regarding foul play, promising that the next man to offend would get his marching orders.

Early in the second period our half-back Roger Young followed his opposite number around a scrum; as he did Britz attacked him, and as I was on the tight-head [side] it happened right in front of me. I took exception, and immediately intervened on Roger's behalf.

This was a big mistake because whilst I was avenging this despicable act, Eastern Transvaal scored their only try. I found myself engaged with a number of the opposition in what might be described as some sort of 'fisticuffs', although I may add that I would be guaranteed to come second in any two-man boxing match.

Mr Woolley, who had been temporarily distracted by the act of awarding a try, was presented with this scenario and made a summary decision. 'No. 3 OFF!!! No. 3 OFF!!!'

I was now in panic mode, and so was Delme Thomas. He suspected if I went off he'd be moved up to tight-head. He suggested that I go behind the posts with him for the conversion, hoping that because the opposition had just scored a try the referee might forget my misdemeanour.

This seemed a good plan at the time, but sadly Mr Woolley proved to have a remarkable memory for a referee and once again delivered his sentence: 'No. 3 OFF!!!'

As I approached the touch line the crowd erupted and started throwing a variety of objects at me including seat covers and large oranges with knobs on which I believe are called 'naartjies'.

There was worse to come! As I was about to leave the field a well-dressed gentleman came through the gate and approached me with his hand out. I thought he wanted to shake my hand in consolation, but instead he closed his fist and struck me on the jaw.

Fortunately for me I was escorted to safety by Ronnie Dawson, our assistant manager, Tony Horton, Hayden Morgan, a '62 Lion then living in South Africa and a number of South African police.

▲ A reunion of the 1968 Lions, the ninth squad to tour South Africa and the third to return home with a record of three defeats and one draw in their Test series against the Springboks

Unfortunately for my assailant, Willie John McBride jumped over the fence, took him in a head-lock and pointed out the error of his ways, an act for which I'll always be in his debt.

My assailant was charged with assault by the South African police. He received a 200 rand fine.

They say that out of adversity great things can be achieved; that was certainly the case on this occasion. After my departure from the field the management sent a message to the dressing-rooms via Keith Jarrett: 'Get dressed as quickly as you can and take your place in the grandstand next to the Lions' management. And hold your head up.'

On arrival at the after-match reception my teammates told me to lead them into the room, to show I had their support. Although the judicial hearing had not been held at this stage, the management selected me for the next game against Northern Transvaal, a selection that should have gone to Tony Horton.

This decision also indicated the management's support. Because of the stand taken by management, the crowd behaviour, the assailant and a favourable report from the referee, I received a severe reprimand and took my place in the team as selected.

1968

We of the British Isles Rugby Union Team bid you farewell We take home with us the happiest memories of our visit, and especially shall we remember the warmth of your hospitality so generously given

Honorary Manager. Honorary Assistant Manager. Captain.

▲ The traditional thank you note sent by the Lions management to their hosts at the end of the tour

J.B.G. Thomas, the leading sports writer of the Western Mail, *took me aside at the team reception and introduced me to Bert Woolley whom he had met when Woolley had brought a South African schoolboy cricket team to Wales. I offered my apologies and said I understood his decision to send me off.*

We kept in touch, and even exchanged Christmas cards for a while, and 11 years later in an interview with a South African newspaper Woolley stated that under the current laws involving touch judges, 'he would not have sent O'Shea off' – just a bit late!

To their satisfaction, the Lions went on to win the match 37–9, despite being down to 14 men, and went on to defeat Northern Transvaal, always an important side to win against, and then Griqualand West and Boland before the third Test in Cape Town.

The Lions were considerably weakened by the absence of the brilliant Cardiff back-line trio of Edwards, Richards and Davies, the last of who had scored the try of the tour at Boland. The Springboks were without their great wing, Jannie Engelbrecht, who was injured. South Africa won the series with a try by Thys Lourens. It was converted by Visagie, who also kicked a penalty, as did Tiny Naude with one of his outfield specials. Kiernan, as usual, scored the Lions' points with two well-struck penalties.

The Lions won their last three provincial games before the last Test in Johannesburg. Although there was no significance, as the series was already lost by the Lions, 60,000 packed Ellis Park for the last game and were rewarded with the best rugby of the tour by Dawie de Villiers' Springboks. With both scrum-halves, Edwards and Young, out with injury, the Lions played their third scrum-half

replacement, Gordon Connell. Bresnihan came back in for Davies, and Pullin, who had flu, should never have played. Mannetjies Roux gave South Africa an early lead with a superbly taken try, and Kiernan levelled with a penalty midway through the first half, but Gould gave the Springboks a half-time lead of 6–3, with a left-footed drop goal.

There was no holding the Springboks in the second half, as Jan Ellis and Tommy Bedford in particular cleaned up the loose ball and linked with their backs. Tries were added by Ellis, Olivier and Nomis, with Visagie converting two. Kiernan had the last word with a final penalty, to beat Okey Giffen's record, and end an undistinguished series.

The Lions lost through no failure by the forwards, who played splendidly and gave their best performance of the series. The backs, however, failed dismally and missed taking their chances, making far too many errors and the game was lost 19–6.

RESULTS OF THE 1968 LIONS IN SOUTH AFRICA

P 20 W 15 D 1 L 4 F 377 A 181

Western Transvaal	W	20–12	South Africa (Port Elizabeth)	D	6–6
Western Province	W	10–6	Eastern Transvaal	W	37–9
South Western Districts	W	24–6	Northern Transvaal	W	22–19
Eastern Province	W	23–14	Griqualand West	W	11–3
Natal	W	17–5	Boland	W	14–0
Rhodesia	W	32–6	South Africa (Cape Town)	L	6–11
South Africa (Pretoria)	L	20–25	Border	W	26–6
North West Cape	W	25–5	Orange Free State	W	9–3
South West Africa	W	23–0	North East Cape	W	40–12
Transvaal	L	6–14	South Africa (Johannesburg)	L	6–19

TOM KIERNAN'S 1968 LIONS TEAM

FULL-BACKS			FORWARDS		
R.B. Hiller	Harlequins	England	R.J. Arneil	Edinburgh Academicals	Scotland
T.J. Kiernan (capt.)	Cork Constitution	Ireland	M.J. Coulman	Moseley	England
			M.G. Doyle	Blackrock College	Ireland
THREE-QUARTERS			K.G. Goodall*	City of Derry	Ireland
F.P.K Bresnihan	University College, Dublin	Ireland	A.L. Horton	Blackheath	England
T.G.R. Davies	Cardiff	Wales	P.J. Larter	Northampton	England
A.J.W. Hinshelwood	London Scottish	Scotland	W.J. McBride	Ballymena	Ireland
K.S. Jarrett	Newport	Wales	S. Millar	Ballymena	Ireland
W.K. Jones	Cardiff	Wales	J.P. O'Shea	Cardiff	Wales
W.H. Raybould	London Welsh	Wales	J.V. Pullin	Bristol	England
M.C.R. Richards	Cardiff	Wales	P.K. Stagg	Sale	Scotland
K.F. Savage	Northampton	England	J. Taylor	London Welsh	Wales
J.W.C. Turner	Gala	Scotland	R.B. Taylor	Northampton	England
			J.W. Telfer	Melrose	Scotland
HALF-BACKS			W.D. Thomas	Llanelli	Wales
G.C. Connell*	London Scottish	Scotland	B.R. West*	Northampton	England
G.O. Edwards	Cardiff	Wales	J. Young	Harrogate	Wales
C.M.H. Gibson	North of Ireland	Ireland	*Replacements		
B. John	Cardiff	Wales			
R.M. Young	Queen's University, Belfast	Ireland			

THE LAND OF THE LONG WHITE CLOUD

New Zealand, home of the all-conquering All Blacks and a nation with a passion for rugby seemingly unrivalled anywhere else in the world, has consistently provided the Lions with their greatest challenge.

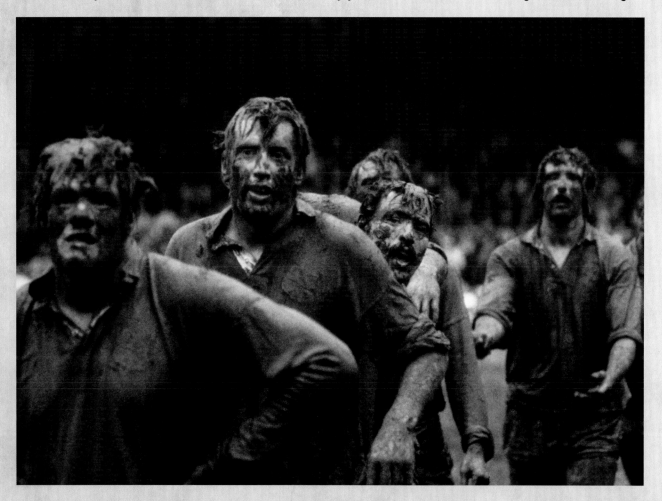

▲ The mud-splattered Lions forwards prepare for a lineout during the 1977 tour match against New Zealand Juniors in Wellington, with the tourists claiming a hard-earned 19–9 victory

Could there be a tougher task facing the 2017 British & Irish Lions than heading to New Zealand, the 2011 and 2015 Rugby World Cup champions, to play three Tests, five Super Rugby sides, the Maoris and one combined side? It is arguably the hardest tour ever undertaken in the Lions' history.

Only twice before have the Lions squared off against the reigning World Cup holders. Graham Henry's side went down 2–1 to Australia – winners of the 1999 tournament – in 2001, while Ian McGeechan's tourists similarly fell 2–1 to 2007 champions South Africa in 2009. Now comes the biggest test of them all, challenging the first team to win back-to-back World Cups.

One of the players who featured in the All Blacks sides that emerged victorious in 2011 and 2015 is the former hooker, Keven Mealamu. He became one of the most capped and decorated rugby players in history before hanging up his boots after the

Keven Mealamu takes on
Shane Williams (centre) and
Jonny Wilkinson (right) during
the second Test of the 2005 tour
at Wellington, which saw the All
Blacks storm to a 48–18 victory

Keven Mealamu takes on Shane Williams (centre) and Jonny Wilkinson (right) during the second Test of the 2005 tour at Wellington, which saw the All Blacks storm to a 48–18 victory

2015 triumph at Twickenham. He won the World Cup twice from four tournaments, played more games than any New Zealand player in Super Rugby, winning the title with the Blues, yet still recalls with crystal clarity the thrill of squaring off against the Lions in 2005. That was the first series played by the Lions in New Zealand since 1993 – Mealamu was only 14 when Gavin Hastings' side went down 2–1 in that series and was still living in the small town of Tokoroa in the South Waikato district.

'I never got to see the Lions play a game in New Zealand before I faced up to them myself and the only clip I can recall seeing of any match between the two teams is of Graham Mourie scoring a try in the 1977 series. Other than that they were a bit of a mystery to me,' recalled the 132-times capped hooker.

Mealamu had already played 24 matches for the All Blacks by the time Brian O'Driscoll's side had landed in New Zealand and couldn't wait to lock horns with the best players from the Home Unions. He had played against England three times and

Wales four. He'd tasted defeat against England and, of course, seen Clive Woodward's side win the World Cup in Australia in 2003. But he will never forget the feeling of testing himself, and the might of All Black rugby, against the full strength of the four nations that comprise the Lions.

'That 2005 tour is definitely up there among my career highlights and they were certainly some of the toughest Test matches I ever played. I have great memories,' he said.

'I'd played a couple of years previously, but I'd never experienced Test matches with that much energy and passion before. To see all their supporters come down to New Zealand for the tour, and then to look at the team sheet of the Lions – such an amazing side – was incredible. I count myself as one of the ones who was lucky enough to play against them.

'You realise that not everyone gets that chance and I cherish the fact I got the opportunity to play a series against them. Twelve years is a big gap between tours and you see so many good players who never

▲ All Blacks captain Kieran Read (back row, centre) poses on stage with Maori warriors — each representing one of the regions hosting Warren Gatland's Lions side — as part of the 2016 'One Year to Go' event held in Auckland to promote the 2017 tour

played against them. When you put it into that context you begin to realise what an awesome opportunity it is.

'When we had the launch of 'One Year to Go' [in 2016] you could see just how much excitement was around. The 2017 tour is going to be pretty cool because it is going to be "old school", with some games against the Super Rugby teams. It will be awesome for the players at that level to experience what it is like to face a top international side.

'And it will be pretty amazing for the new All Blacks side post-World Cup 2015 to find out what it is like to play against a team that brings so many supporters with them. It will be quite eye-opening for the rugby communities as well. It is almost like a mini-World Cup with the fever that is generated. We are expecting another invasion by Lions fans and everyone in New Zealand is going to get behind the tour.'

Despite Mealamu's retirement, the All Blacks put the challenge facing the Lions'

'Class of 2017' into perspective with a resounding 3–0 series 'blackwash' over Wales in 2016. If having to beat the Wallabies in Sydney in the third Test in 2013 was a tough ask, trying to beat a team who made it 41 consecutive home wins when they completed their series victory over Wales in Dunedin is going to be even harder.

'It's the one tour that has historically been the most difficult,' explained Wales and 2013 Lions captain Sam Warburton. 'Any Lions series in New Zealand is immensely tough. They [have lost] a little bit of experience [through retirements], but they have some super players to come in – that's why they are the best rugby nation in the world.'

But has it ever been any different? The record of the Lions in New Zealand speaks for itself when compared to their other traditional destinations. Just take a look at the Test match statistics:

Lions v. New Zealand

P 38 **NZ** 29 **BIL** 6 **D** 3 **Lions Win %** 16
Series Wins (two or more Tests played)
NZ 9 (1908, 1930, 1950, 1959, 1966, 1977, 1983, 1993, 2005)
BIL 1 (1971)

Lions v. Australia

P 23 **AUS** 6 **BIL** 17 **D** 0 **Lions Win %** 74
Series Wins (two or more Tests played)
AUS 1 (2001)
BIL 7 (1899, 1904, 1950, 1959, 1966, 1989, 2013)

Lions v. South Africa

P 46 **SA** 23 **BIL** 17 **D** 6 **Lions Win %** 37
Series Wins (1 draw, 1955)
SA 8 (1903, 1910, 1924, 1938, 1962, 1968, 1980, 2009)
BIL 4 (1891, 1896, 1974, 1997)

Lions Series (two or more Tests played)

P 31 **W** 12 **L** 18 **D** 1 **Lions Win %** 39

This should not be a surprise given the comments made by managers, players and coaches after so many unsuccessful trips to the 'Land of the Long White Cloud'. Here are a few reflections on rugby in New Zealand from down the years:

Arthur Shrewsbury, promoter of the inaugural 'Lions' tour in 1888, which kicked off against Otago on 2 May 1888, wrote:

'We played our first match last Saturday amidst great excitement, in fact all over NZ great interest is being exhibited. Cricketers never had half the reception as the footballers are having, being driven in drags, taken boating, dancing, dinner parties, free entrance to rinks, in fact everything is being done for their enjoyment. Some who had an opportunity of coming will bite their fingernails off when they hear this – I know nothing of this kind has ever been done with cricket teams.'

Percy Bush, who played in the first Test against the All Blacks in 1904, claimed:

'The disadvantage in New Zealand is that they have earthquakes and landslips there. They are horrible things. We had to get out of the train one night about ten o'clock. It was a dark night, and it was raining. There had been a landslip, and we had to walk about half a mile to another train on the other side of the landslip. When we reached New Plymouth that night the native Maoris were outside the hotel waiting for us and they danced for us. They made a hideous noise. They are horribly keen on football in New Zealand. In little stations... they had brass bands, which played patriotic airs in our honour, no matter what the weather was like or the time of night.'

George Harnett, the manager of the first Lions side to play a full series of Test matches in New Zealand in 1908:

'In every place we have visited the play has been very good. The keenness manifested in football in Australia and New Zealand is something extraordinary. Why, the enthusiasm they evince in the game over there is absolutely unknown in this country. This is so not only amongst the players themselves, but in the large ranks of the onlookers, from the child in the street, who is scarcely able to kick a ball right up to the people who are beyond practical play. It is just the same everywhere you go. Football is one of the main topics of conversation. They talk football at all times and in all places.'

J.C.M. 'John' Dyke, one of the full-backs on the 1908 tour, offered a similar opinion:

'The enthusiasm shown over football in New Zealand is remarkable. Football is the New Zealanders' religion purely and simply. They go absolutely mad on it.'

The love of rugby in New Zealand, it seems, knows no bounds. And the All Blacks love nothing better than beating the Lions! And they are pretty good at it. Apart from 1971, when the tourists won the series 2–1 with the fourth game drawn, there is no getting past New Zealand's astonishing

RUGBY HIGHLIGHTS
1971 LIONS
IN NEW ZEALAND

with Bob Irvine's original N.Z.B.C. Commentary
Narration & Continuity by Ron Findlay DECCA

△ So spectacular was the 1971 series between the Lions and the All Blacks that the commentary — featuring the voice of sports broadcasting legend Bob Irvine — was turned into a best-selling record

record. In fact, the 2017 Lions will be looking to end a run of five successive Test defeats by the All Blacks, who have won 11 of the past 13 internationals between the two teams.

While the Lions went 41 games before losing a game in South Africa, and 21 matches in Australia, they tasted defeat in their seventh game in New Zealand – Taranaki Clubs earning a 1–0 victory in New Plymouth on 16 May 1888, with Harry Good grabbing the only score of the game.

Harry was one of two sets of brothers in the home ranks, joined by his sibling Alan Good as well as Alf and Charles Bayly. However, according to tour sponsor Shrewsbury, it was two other Bayly brothers who were most responsible for handing the Lions their maiden defeat. The Bayly family were at the time one of the most notable sporting clans in New Zealand. Alf, who captained Taranaki in the famous 1888 fixture, was the fourth of nine sons and one of two who played for the All Blacks, while Charles joined him in the Taranaki side against the touring Lions. However, it was two more of the Bayly brothers, Fred as referee and George as an umpire, whose influence an infuriated Shrewsbury alluded to.

As the local newspaper reported it: 'The time went on until only a minute was left in which to turn the tables. The visitors rushed the ball up to the Taranaki line continually, but the local men held their own at every point. Finally the ball was kicked out of play within a yard of Taranaki's corner flag, and some of the Englishmen scrambled over the goal line.

△ Full-back Don Clarke's kicking prowess destroyed the tourists' hopes during the 1959 tour

The visitors were jubilant, as testified by their cries of "A try! A try!" but the Taranaki umpire and referee held that there was no score as the Englishman had not dropped the ball into play before he went over the goal line. They therefore disallowed the try, much to the disappointment of the Englishmen, who maintained that the ball was dropped into play. However, the referee's decision was final and the Englishmen abided by it, although some suggested taking the kick for goal under protest. The game thus ended in a win for Taranaki. The visitors say the game was the hardest they have yet played.'

In a letter to his business partner, Alf Shaw, Shrewsbury said he felt robbed by the 'family' decision:

'...though we actually won, getting two tries which the referee disallowed. He not only disallowed the tries, but refused to take off the time spent in discussing the matter, which was about 12 minutes. There were four brothers playing in the match, two being players, one umpire and one referee. We were not likely to win with this combination against us.'

There was similar condemnation of the referee in 1959, when the Lions were beaten 18–17 in the first Test in Dunedin. If Alan Fleury, the game's referee and a bank manager by trade, had picked up the local evening paper on his way to the post-match dinner after the game he would have read the *Dunedin Evening Star*'s bitter condemnation of a game that included 35 penalty kicks: 'The saddest rugby Test that had ever been played in New Zealand took place this afternoon.'

Don Clarke kicked his way into immortality with 18 points as he hit the mark with six out of 10 shots at the Lions' posts, although the Lions' touch judge, Mike England, signalled one of them as wide only to be overruled by Fleury and the home touch judge. For their part, the Lions ran in four tries, but simply didn't have a Clarke in their ranks. Indeed, of their four tries the Lions only managed to convert one and they also missed four penalty attempts.

Just imagine if all the kicks from both teams had gone over – the Lions would have won 37–30.

Writing in *The Dominion*, Alex Veysey was definitely in the Lions' corner: 'Statistics are coldly factual things; they cannot show that the moral victory was the Lions', that it was a travesty of justice that they should be a Test down.' Meanwhile, the doyen of Welsh rugby writers, J.B.G. Thomas, summed it up in his own inimitable style for the readers of the *Western Mail*: 'To the All Blacks the victory – to the Lions the glory.'

Those six penalties by Clarke were a world record for an international match and inspired one newspaper to give the scoreline as 'Clarke 18, Lions 17'. For his part, Clarke felt some sympathy for the referee. In his autobiography, *The Boot*, written by Pat Booth, Clarke said that 'Most of the Lions lost like gentlemen. They congratulated the All Blacks and me on that kicking record while making no secret of their own disappointment.'

By the end of that amazing series the Lions managed to outscore the All Blacks by nine tries to seven, yet lost the series 3–1. Clarke ended the series with a massive 39 points. Of that total, 36 came from the boot, while the Lions managed a mere 15 from kicks. Oh for a Barry John, Neil Jenkins, Jonny Wilkinson or Leigh Halfpenny in an earlier era.

Of the teams opposing the Lions in 2017, only the All Blacks and the Maori sides have been faced before. The Maoris notched a famous 19–13 victory against the tourists in Hamilton in 2005 – their first over the Lions in an 'official' match in seven attempts.

However, while the first official fixture was played at Wellington's Athletic Park in 1930, the Lions triumphing 19–3, there were 'picnic matches' played between the two teams prior to that date. The first of these took place in Rotorua at the end of the 1904 tour and the Maoris won 8–6. The next game was in 1908, when the Lions, no doubt having learned the dangers inherent in overindulging in the local culture and

hospitality, won 24–3 with a team that contained seven members of their Test team. The fact the 2017 contest will be played at the Rotorua International Stadium will add to the lustre of the fixture, but it certainly won't be any picnic for the Lions this time...

POVERTY BAY HERALD
Monday, 22 August 1904

BRITISH FOOTBALLERS AT ROTORUA

WELLINGTON, this day

The Native Minister has received a telegram from Mr O'Brien, the manager of the British footballers, stating that the English team received a splendid reception from the natives at Rotorua, who gave a haka and poi dances, and presented the team with a number of valuable relics.

ROTORUA, this day

The British team arrived at Rotorua at five yesterday morning by a special train. After breakfast they proceeded across the lake to the Hamurana Spring, thence to Tikitere, and after viewing the wonders there were driven to Whakarewarewa, where the natives welcomed the team with hakas and poi dances. After dinner the party proceeded to Ohinemutu, where a large gathering welcomed them.

Captain Turner, chairman of the Rotorua Borough Council, made a speech of welcome. Several chiefs also spoke, after which they presented the team with numerous presents, including mats, piupiu, greenstones, kits, and a mere, said by the natives to have been brought from Haikaiki by the Arawa tribe, was presented to Sivright. Several hakas and poi dances were given in honour of the visitors, and a half-holiday was granted for the football match this morning. Two 30-minute spells were played. A large crowd assembled, and, contrary to expectations, the Rotorua team won by 8–6. Gabe and Llewellyn scored in the first spell, but the tries were not converted. In the second spell the Maoris rallied, and scored two tries, one of which was converted. The result

pleased the natives, who went nearly mad with excitement. The team were delighted with Rotorua, and would have liked to prolong their stay. They expressed wonderment at the sights, and one of the party is staying for another week. The party left by special train at 1pm for Auckland. They are leaving there tonight by the Mararoa. At the station a large crowd assembled to farewell the visitors, and additional presents were given [to] the team.

There will be three matches in Auckland in 2017, with all three games being played at Eden Park. It is the venue at which the Lions have faltered more than anywhere else in New Zealand. Their full record at the ground is as follows:

TEAM	P	W	D	L
v Auckland	9	6	0	3
v Maoris	4	4	0	0
v New Zealand	9	0	1	8
OVERALL	22	10	1	11

▼ The diary of 1950 tour manager 'Ginger' Osborne detailing his side's 32–9 victory over Auckland, historically one of the Lions' most troublesome opponents

The battle with the Super Rugby side, the Blues, will replace the previous clashes with Auckland. The Lions once went 62 years without a win over Auckland and have drawn

once and lost six times to the provincial side in 15 meetings down the years. Exactly what beating the Lions means to Aucklanders is amply demonstrated by this extract following the 19–6 triumph over the tourists at Eden Park in 1930:

NEW ZEALAND HERALD

HOW THE RESULT WAS RECEIVED

THE NEWS IN THE CITY

A few hundred people, who were prevented from going out to Alexandra Park for various reasons, congregated round the Herald Office, where bulletins were constantly posted up giving details of the course of events as they happened... The interest manifested by the 500 or 600 people who were anxiously awaiting all particulars possible concerning the game was keen indeed. The first score registered was received with great enthusiasm and excitement, which knew no bounds when the second and final seven scores were duly posted up on the extra board. Cheers and cheers rent the air, and hats were wildly thrown up with excessive jubilation.

CONGRATULATORY TELEGRAMS

The officials of the Auckland Rugby Union and the members of the victorious team received numerous telegrams congratulating the Aucklanders on their success. The following wire was received by His Worship the Mayor (Hon. E. Mitchelson) from the Premier during Saturday evening: 'Representatives of Auckland today have well maintained the best football traditions of our colony in the match against the British team. Kia ora.'

The Hon. T. Thompson telegraphed to the chairman

of the Auckland Rugby Union Committee (Mr. M. J. Sheahan) from Wellington: 'All here delighted with the performance of our boys. Kia ora! Kia ora!'

REJOICINGS IN THE COUNTRY
BY TELEGRAPH – OWN CORRESPONDENTS

THAMES – Saturday

Great interest was taken here today in the football contest between the British and Auckland teams. The news of Auckland's success was received with great delight and enthusiasm.

WHANGAREI – Saturday

When the news of the result of the Auckland-British football match arrived this evening, there were great rejoicings. Over 500 Whangarei people went to Auckland to see the match.

WAIHI – Saturday

Had one of the mines struck a rich patch of specimen stone, greater excitement could not have prevailed than was the case this evening, when Auckland's great achievement in the football field was wired through. There was great cheering and shaking of hands, and tonight there is only one topic of conversation in the street, and that is Auckland's victory in the great match.

COROMANDEL – Saturday

There was great rejoicing here when the result of the Auckland and British football match was received this evening.

That passion for rugby, and pride in beating the Lions, will be repeated in Dunedin, Wellington, Hamilton and Christchurch when the leading lights of British and Irish rugby go up against the other Super Rugby franchises. The tour will kick-off in the North Island at Whangarei against a Provincial Union XV. It will make a change for the Lions not to run into a Going that far north. The great New Zealand scrum-half Sid Going made 12 appearances

against the Lions between 1966 and 1977 – only Colin Meads with 14 appearances can top that figure – but the Going clan total 21 appearances against the Lions. The Meads brothers, Colin and Stan, together amassed 19 appearances.

The brothers Sid, Ken and Brian Going provided the core of an exciting Northland backline for the best part of a decade from the mid-1960s and all three played together for New Zealand Maori, while Sid and Ken made the step-up to the All Blacks. 'Super Sid' played 86 matches (including 29 Tests) for the All Blacks between 1967 and 1977. The brothers became famous for their 'blindside triple-scissors movement' – known as 'Going, Going, Gone' – which they had perfected on the back lawn of the family home and which almost bamboozled the Lions defence during the iconic 1971 tour.

Not a 'picnic match' in sight. It is going to be another incredible journey and tour for the Lions in 2017.

▲ Scrum-half Sid Going (centre) proved a constant thorn in the Lions' side throughout the 1960s and '70s

BRITISH & IRISH LIONS IN NEW ZEALAND 2017		
3 June	v. Provincial Union XV	Toll Stadium, Whangarei
7 June	v. Blues	Eden Park Auckland
10 June	v. Crusaders	AMI Stadium, Christchurch
13 June	v. Highlanders	Forstyth Barr Stadium, Dunedin
17 June	v. Maori All Blacks	Rotorua International Stadium
20 June	v. Chiefs	FMG Stadium Waikato, Hamilton
24 June	v. New Zealand	Eden Park, Auckland
27 June	v. Hurricanes	Westpac Stadium, Wellington
1 July	v. New Zealand	Westpac Stadium, Wellington
8 July	v. New Zealand	Eden Park, Auckland

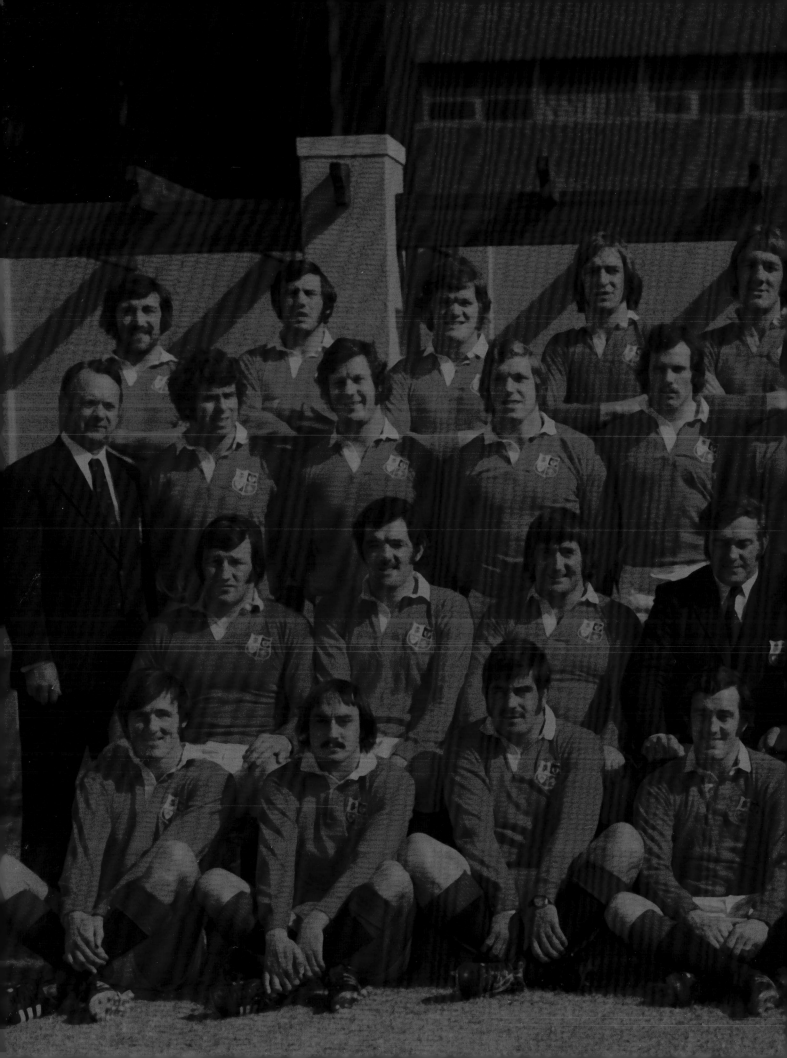

7

SEVENTIES
SENSATIONS

Throughout the twentieth century, and for over 70 years, the Lions had lived more in hope than in glory, as the southern hemisphere became increasingly hard to beat. The Lions of 1971 and 1974 destroyed this aura of invincibility and once more made British and Irish rugby respected throughout the world, not only because they had defeated both New Zealand and South Africa, but for the style of rugby which they employed.

On three tours in the 1950s, the Lions had beaten Australia four times, South Africa twice and New Zealand once. Their record was P16 W7 D1 L8. In the 1960s, there were two wins over the Wallabies to enjoy, but nothing else. The record over three more tours read: P14 W2 D2 L10. Something had to change to enhance the credibility of the Lions. The Test series triumphs in 1971 and 1974 changed the way the southern hemisphere viewed the Lions and, had they had a bit more luck, the 1977 tourists might have made it three series wins in a row. Even so, the record for the 1970s makes it the most successful of the twentieth century: P12 W6 D2 L4.

Over the course of those dozen Tests the Lions scored 168 points, 113 of which were scored by Welshmen, including ten of the 19 tries. A further 40 points were provided by the Lions' Scottish contingent, with the Irish and English elements scoring eight and seven points respectively. It really was the decade of the men in red!

It is my view that the dazzling successes of 1971 and 1974, which were no flukes but emphatic events as crushing as anything that New Zealand or South Africa had achieved, can be traced back to the disastrous Wales tour of South Africa in 1964. Those events began the thinking behind an explosion of coaching and organisation, such as the squad system and the appointments of Ray Williams of Wales and Don Rutherford of England as technical advisers to their Unions. There was also a considerable influence exerted on the 1971 tour by the Welshmen who had failed in their tour of New Zealand in 1969, and were burning to go back and gain their revenge.

1971
CARWYN'S CELEBRATION

1971 TOUR KIT

Captain: John Dawes (London Welsh and Wales)
Squad Size: 30 + 3 replacements
Manager: Dr Doug Smith (Scotland)
Coach: Carwyn James (Wales)

Tour Record:	P 26	W 23	D 1	L 2	F 580	A 231
In Australia:	P 2	W 1	D 0	L 1	F 25	A 27
In New Zealand:	P 24	W 22	D 1	L 1	F 555	A 204
Test Series:	P 4	W 2	D 1	L 1		

The 'Swinging Sixties' were over. In 1971, the 'Angry Brigade' bombed the house of the Employment Secretary, Robert Carr, and postmen went on strike for the first time, for a 19.5 per cent wage rise. Idi Amin took power in Uganda; the Provisional

IRA broke from the Officials and the first British soldier was killed in Ulster. The *Daily Sketch* newspaper closed after 62 years; Arsenal won the League and Cup double, and George Best was sent off in the referees' revolution against persistent arguing. Margaret Thatcher stopped free school milk, Charles Manson was sentenced to death, and Louis Armstrong died. Decimal currency was introduced in February of that year.

It was propitious that, at the time, there emerged a generation of some of the greatest backs in Welsh history, such as Gareth Edwards, Barry John, Gerald Davies, John Dawes, J.P.R. Williams and John Bevan, backed up by superlative players from the other Unions, like David Duckham and Mike Gibson, playing in his best role as a centre. They were the finest set of backs since the 1955 team in South Africa, and they became such renowned names in the rugby world that many are referred to only as Gareth, Barry, Gerald or J.P.R.

I was often asked, and indeed I often asked myself the same question, which was the greater team, 1971 or 1974? The jury is out for all eternity on this issue, and you cannot get any group of rugby people who witnessed both to agree on the subject. It was my opinion, however, that the 1971 Lions had backs who were without equal in my experience. Never did I see more consummate play from backs, with such unparalleled mastery of the basic skills.

The 1974 Lions had the better record, for they never lost a game, and had the best pack of forwards ever put on the field by The British & Irish Lions. They were able to defeat the Springboks forwards, whereas the 1971 Lions were praised merely for matching the All Blacks forwards. I refused to take sides on this issue, for there is no conclusive answer. Suffice to say that they were the two best Lions teams ever to take the field, and we will be fortunate if we ever see their like again. Perhaps if you had the 1971 backs and the 1974 forwards, you would be close to creating the perfect Lions team.

Before the 1971 tour started, the forwards appeared more suspect than the backs but, in the event, they performed superbly and gave the lie to the theory that British packs could not hold a candle to an All Blacks eight. Among them were forwards who were, or who were to become, giants in the game: Willie John McBride, Mervyn Davies, Ian McLauchlan, John Pullin, Sean Lynch, Peter Dixon, John Taylor and Derek Quinnell.

▲ The Lions journeyed to New Zealand in 1971 seeking to avenge their demoralising 4–0 mauling five years earlier

Doug Smith, an old Lion himself on the 1950 tour to New Zealand and Australia, was the right sort of man to manage such a party. He beat off the challenges of Duggie Harrison, of England, and the Welsh duo of Gwilym Treharne and Handel Rogers. Doug was a tough guy with extremely strong points of view, and suffered fools not at all gladly, but he was charismatic and popular. He also made the most amazing and awesome prediction of all time when he said, before and during the tour, that the Lions would win the Test series 2–1 with one match drawn. He was a good listener and, as he says, 'In the early part of the tour, Ray McLoughlin was invited into our daily meetings and contributed enormously to the success of the Lions forwards, and latterly Willie John McBride and Mike Gibson were also part of our "Brains Trust".'

The Tours Committee had four candidates to consider for the role of assistant manager or coach. England's Martin Underwood, Ireland's Roly Meates and Wales' Roy Bish were up against Carwyn James, but there was a potential problem. Carwyn was standing as one of 36 Plaid Cymru candidates in the 1970 General Election, hoping to win a seat as a Member of Parliament for Llanelli. It was a tough ask, given that the seat had been held by Labour since 1922 – and in fact it remains in their hands up to this very day. Carwyn polled 8,387 votes to finish second behind the sitting tenant, Denzil Davies, but it was still the best result achieved in that constituency by a Plaid Cymru candidate since 1922, and remained so until 2001. The man had charisma, style and appeal. The selectors confidently predicted that Carwyn would lose and knew that in him they had the most imaginative and brilliant coach of all time. He understood the secret of quietly motivating the players under his command, with no fuss or bother, using the carrot rather than the goad. Merely by a quiet word here and there, he allowed all their natural talents to develop. He was also a master at handling the media, giving them what they wanted to know, without telling them too much. He had all the hard-bitten New Zealand journalists like Terry McLean, and the Brits such as Terry O'Connor and John Reason, eating out of his hand.

Smith, the manager, said of him in the report to the Tours Committee after the tour, 'I cannot praise my assistant, Carwyn James, too highly. From the day of our appointment, we began to think alike as far as the tour and its preparation was concerned. He was an outstanding coach, who did things in a simple, methodical way, which made each member of the team realise that the player is an integral member of a great side. He was held in the greatest esteem by the team and the New Zealand officials.'

Above all, Carwyn was determined that the Lions should express themselves. He was not averse to the barbed comment about such matters as dirty play and poor refereeing. He was determined that a certain referee should not handle the final Test, even though the New Zealand Council tried desperately to get him to agree. Carwyn showed an iron will and refused point blank, pointing out the man's grave deficiencies as a referee. He remembered that in one Test in 1969, this referee had thrown both hands in the air in triumph when McCormack dropped a goal against Wales.

Carwyn was a close personal friend of mine. He came to see me about a week before leaving to ask my opinions on various matters, and suddenly asked me how I thought his Lions team would do. Having been in New Zealand and Australia with the Welsh team in 1969, and knowing that a third of the team was made up of the same Welshmen, I was unable to offer him much encouragement. Subsequently, when I pitched up in Wellington halfway through the tour, where he was having dinner in

the team hotel with a delightful half-Maori girl, he gleefully gave me a hard time for a minute or two over the results so far. I immediately sensed a quiet confidence in him, as if he held a royal flush and, as the ace coach holding the 'king', Barry John, he certainly did.

Carwyn was a very complex man and a wise man who, after matches, liked a quiet corner. He was certainly the greatest rugby intellectual I ever knew and, after his untimely death in 1983, I sorely missed those fascinating post-mortems we held in the BBC Club after every international at Cardiff.

We were lifelong friends, and I was his captain when he played for the Welsh Schools Under-19 group in 1947, and again when he won his two Wales caps against Australia and France in 1958, first as a centre and then in his real position of outside-half. Yet strangely, in those early years, he showed none of his remarkable qualities as a rugby thinker, but then perhaps he was a little too shy and diffident in those days. He was unfortunate that his playing career coincided with Cliff Morgan's.

Doug Smith, assisted by a selector from each country but, ridiculously, not officially by his coach (who, in truth, should have been the chairman of selectors), spent the 1970–71 season selecting the team. A very busy season it was, being England's centenary year, with various celebration matches and a World Rugby Congress attended by some 49 countries, which did much to accelerate the expansion of the game worldwide. A combined England and Wales side played Scotland and Ireland at Twickenham; then a Wales XV played a European team in Cardiff to officially open the new North Stand at Cardiff Arms Park; and Fiji toured England.

▲ Llanelli coach Carwyn James gets his message across to the squad during a training session. The former Wales fly-half's tactical acumen was crucial to the Lions' historic success in New Zealand

In fact, when the Fijians destroyed a powerful-looking Barbarians team at Gosforth, they also demolished the aspirations of some players to tour with the Lions. At the end of the tour, there was a very strong recommendation by Doug Smith and Carwyn James, in their reports to the Four Home Unions Tours Committee, that the coach should in future be a member of the selection committee.

Carwyn made his feelings crystal clear at a special International Players' Conference held at the Polytechnic of North London in July 1971:

I believe that Rugby football is a dictatorship. I think there is only one man in the club who can have the vision. Coaching means having a vision, seeing a pattern. Only one man can do that. I played in an era where there were thirteen men picking the Llanelli side. The question that one of them always asked was 'Why is their full-back standing so far back?' You see you cannot have people contributing to that extent! I work on the principle that if I want selectors to work with me, I will invite one or two advisers who are kindred spirits. Obviously there are selectors who do not know a great deal about Rugby football, but it is amazing how many people want to be selectors. This is the glamour job of Rugby football. In every club – even at international level – the ambition, the burning ambition, is created by the power people think they have if they are made selectors, and these days, with the advent of the squad system it does not mean a thing. You don't NEED selectors.

At the time, the Wales team, which had been steadily evolving since 1968, won the Triple Crown and the Grand Slam under the captaincy of John Dawes, so it was inevitable that Welsh representation would be strong. Thirteen of them were chosen, together with six each from Ireland and England and five from Scotland. The original selection, announced on Monday, 22 March, included the English centre Chris Wardlow, but he broke his jaw playing for Northern Counties in April. He wasn't going to recover in time, so Chris Rea, the Headingley and Scotland centre, was drafted in. Rea had been one of six official reserves named by the selectors. The 1968 Lion Rodger Arneil and Geoff Evans were both called up during the tour, but Loughborough Colleges prop Fran Cotton, Gordonians scrum-half Ian McCrae and Oxford University hooker Dave Barry were unused.

John Dawes also got the captaincy, and what a marvellous job he made of it! Dawes had already made an enormous impact when he helped develop London Welsh into one of the best clubs in the land. He did it by first of all creating a strong defence, and then developing a tremendous attacking ethic, which certainly had its influence, not only on the Grand Slam Wales side, but on his British & Irish Lions team, which contained no fewer than six London Welsh players, with another flown out as a replacement.

▲ London Welsh and Wales Grand Slam-winning centre and captain John Dawes was appointed captain for the tour, the 31-year-old leading the Lions in all four Tests against the All Blacks

Doug Smith was to say of him in his end-of-term report, 'The appointment of John Dawes was probably one of the main reasons for the success of the tour. A charming and knowledgeable man who held the respect of everyone in the team, not only for his own outstanding ability as a player, but for his friendliness.'

Dawes played more games than anyone else, and his team always looked better when he was in it. He also had some excellent and intelligent senior 'pros' around him: men like Willie John McBride, on his fourth tour; Ray McLoughlin, on his second; Ian McLauchlan; and, of course, those terrific Welsh half-backs Gareth Edwards and Barry John. The last of these became the major individual star and genius of the tour, which saw him called 'the King' by those around him, in

deference to his authority and effrontery on the field. Everybody thought he was too young to retire as he did at the age of 26. Gareth was no less a star, and remains one of the very greatest and most popular of players to have worn a Wales and a Lions jersey. He once said, 'The Lions experience is a step ahead of home internationals. You have more wise men around you; no one is distracted from the game; you learn to play with judgement rather than pure emotion.' This is so true, because the Lions are the distillation of the best in our four countries and, therefore, everything that happens is that much faster and more skilful.

The drink of the tour was an LGT, or a large gin and tonic, a tipple that some of the players were perhaps to embrace all too fervently in the period ahead, but that has nothing to do with the events of the time. They got through more than a bit of their tipple on their overnight stopover in Hong Kong on their way to Australia. It took 58 hours for the squad to get from Heathrow to Brisbane and the rest time spent in Hong Kong involved a memorable night out – so memorable, in fact, for a few of the players that they got into hot water the next day.

J.P.R. Williams takes up the story in his autobiography, *JPR*:

The tour was planned to include a stopover in Hong Kong, during the long flight, with the intention of providing us with a night's rest. This did not quite turn out according to plan – Hong Kong really is the last place to stop off for a quiet night! Most of us found the place irresistible having been let loose after all the pre-tour tensions at Eastbourne. I remember that night particularly my first experience of the tremendous character of Sean Lynch. We were sharing a room and had both been equally late. The next morning I was horrified to find that I had woken five minutes after the bus had left for the training ground. I was really upset and started panicking because I had wanted to start the tour well and give a good impression. Sean, however, was quite unperturbed. He proceeded to order a full breakfast, with egg, bacon, sausages and so forth and took his time enjoying every mouthful...

In due course we ordered a taxi and rolled up at training a good half-hour late. Sean's attitude had been infectious and I was beginning to wonder if I had not been a bit schoolboyish in my wish to do everything right. I soon changed that idea after my first encounter with the wrath of Dr Doug Smith, the manager. He gave me the biggest 'talking to' I have ever received during my rugby life – in front of all the other players. I was trembling at the finish, and the other players, sensing how shaken I was, stayed quiet.

Dawes' opposing captain was none other than the legendary Colin Meads, aptly known as 'Pinetree'. He was one of the very greatest forwards of all time and the ultimate competitor, being totally uncompromising, as All Blacks forwards usually are. He faced the Lions on three tours and ended up with eight wins and a draw from 14 matches. Of those wins, seven came in the 11 Tests he played against the Lions, along with a draw. A New Zealander to the core, he took enormous pride in the All Blacks and he believed more than anybody that forwards won matches. Carwyn understood this, and his tactic was not to allow much opportunity for second-phase possession, in which the All Blacks were better versed than any. His tactics were, therefore, to move the ball wide as quickly as possible, and this was why he used to coach his backs into fast fingertip passing.

Carwyn also coined the now famous phrase 'Get your retaliation in first', which was originally intended to combat the illegal lineout play of the All Blacks but which, in the end, was to cover a much wider field! This, together with Willie John's slogan in 1974 of 'Take no prisoners', was to become another part of Lions folklore.

Two other important elements of Carwyn's strategies for the tour were the use of the counter-attack and the way in which he targeted as a danger that other All Blacks powerhouse, Sid Going, more noted for his strong breaks and linking with his forwards than for his passing to his backs. Derek Quinnell was selected in the third Test specifically to look after him.

I have many lasting memories of that side. The first is of the athleticism, intensity and service of Edwards, mixed with his ability to break, and this, with the sheer genius of John in the midsummer of his all-too-short career, when he became the focal point for praise by the Lions and the New Zealand public, were essential to the Lions' high morale. The emergence of Barry John as a goal kicker, scoring an amazing 170 points from kicking alone, was really what won the series. He scored in every game he played in.

Another memory is the timing and unerring skill of Dawes in drawing men, and in his perfect passes to those better placed to run. One of those tremendous runners was Mike Gibson, also in the salad days of his career, whom many New Zealanders, including Meads, chose ahead of John as the finest of he Lions backs, largely because they could understand the strong positive running of Gibson and they also admired his defensive qualities. Their philosophies of hard play could not accept the almost supernatural ghosting of Barry John, which Norman Mair once so beautifully captured in a match preview in *The Scotsman* when he wrote, '*What a relief it was to see Barry John leaving by the door, rather than simply drifting through the wall!*' They preferred the directness of Gibson, because that was something they could come to grips with, whereas the ethereal quality of John's play was something totally alien to the All Blacks' philosophy of power rugby.

▼ Gifted full-back J.P.R. Williams was selected for his first Lions tour in 1971 after helping Wales claim the Grand Slam, one of 14 Welsh players to make the trip to New Zealand

There was also the full bloom of Gerald Davies' flair for running with the grace and speed of a gazelle. Even when in full stride, he was apparently in full control and able to swerve or sidestep or do whatever was necessary to create a score for himself or others. He was the consummate running machine and a highly intelligent and charming man. He was converted, totally against his will, from a centre to a winger on the 1969 Welsh tour in New Zealand for he had played there for Cambridge University and for the 1968 Lions.

On the other wing, there was the equally likeable David Duckham, whose elegant running belied his size. He was a big man who could also run on top of the ground, and was extraordinarily nimble in being able to change pace or direction. The Welsh public loved him and called him Dai Duckham, in recognition of his high skills as a runner; they would gladly have given him Welsh citizenship. Neither must we forget another powerhouse wing on that tour, John Bevan, who played in the first Test. I can remember Doug Smith pointing him out to me on the first night I arrived in New Zealand and saying, 'That boy is terrific and he would do anything I asked of him for the team.' John was to prove that point in his distinguished career in rugby league.

Behind all these magnificent players was the incomparable J.P.R.Williams, a veritable rock of a player. He was the sort of full-back which every pack of forwards dreams of having behind them, a competitor beyond compare, in a land which was full of them. He was the only full-back that made the All Blacks forwards think twice about following up a high kick, by being underneath it. I can see him now in my mind's eye, taking a high ball and, with that little touch of madness which seemed to be a part of his courage on the field, picking out an unfortunate All Blacks forward to charge at. The look of triumph on his face when he dropped the critical goal to draw the final Test and win the series was worth going a long way to see.

If these were the stars, the supporting cast of men like Chris Rea, Arthur Lewis, Alistair Biggar, John Spencer, Chico Hopkins and Bob Hiller, who always kept the scoreboard going in Barry's absence, made equally valuable contributions to the tour. So did many of the forwards, some of whom, such as Gordon Brown and Fergus Slattery, were on a learning curve which was to hold them in good stead in 1974.

It all began disastrously when they had to play two matches within five days of flying halfway round the world. The first was some 58 hours after arrival on a night flight, against Queensland who, not surprisingly, beat them by 15–11. This caused Des Connor, the Queensland coach who had played for New Zealand and Australia, to say that this was the worst Lions team to be sent to New Zealand. How wrong first impressions can be! They also only scraped home 14–12 against New South Wales, before moving on to New Zealand, where they won all ten games before the first Test, including taking the valuable scalps of Otago, Wellington and Canterbury. They thus alerted New Zealand to the fact that there were real problems ahead of them.

Of these, it was the Canterbury game which became the main talking-point of the tour outside the Tests, for its totally disgraceful violence and downright dirty play. Nobody there at the time, or the many millions who saw the photographs in the

▲ The Lions in action against a supremely physical Wellington side at Athletic Park. A comprehensive 47–9 victory gave the tourists their sixth win

papers of Sandy Carmichael, who had suffered a multiple fracture of the cheekbone, will ever forget what was the unacceptable face of rugby football as played by some. The Lions laid the blame squarely where it belonged, which was on the attitudes of the Canterbury players, and on Alister Hopkinson and Alex Wyllie in particular.

In his marvellous book about the tour, *The Victorious Lions*, John Reason painted the perfect picture of the grotesque scene post-match in the dressing-room:

The sight of Sandy Carmichael's face as he lay collapsed on the masseur's table in the Lions' dressing-room after the match against Canterbury will stay in the memory of all who saw it for as long as they live. His left eye was closed and a huge blue swelling of agonised flesh hung out from the cheekbone like a grotesque plum. His right eye was a slit between the puffed skin above and below it. His right eyelid was gashed and straggling with blood. Another gash snagged away from the corner of his eye. He was quivering with emotion and frustration. His hands shook as they tried to hold the ice packed on the swellings.

I had seen Carwyn James, the Lions' coach, outside the dressing-room after the match. I asked him how Carmichael was. 'Come and see for yourself,' he said. 'Our dressing-room is like a casualty clearing station.' I had never seen Carwyn so upset…

The scene was like the loser's dressing-room after a gory heavyweight fight. It had been a fight all right. It had been a heavyweight fight. The difference was that it was the winner's dressing-room at a Rugby ground, and if a boxing referee had allowed the punishment which Carmichael had absorbed in the previous hour and a half, he would have been prosecuted.

Canterbury did not go out to play Rugby football against the Lions. They were the Ranfurley Shield holders and as such were considered to be New Zealand's leading provincial side. In some twisted way, they seemed to think that their national honour was at stake and that their best hope of ending the Lions' unbeaten run in New Zealand was to punch and kick them off the field.

It was not only Carmichael who was a victim; Fergus Slattery had two teeth loosened by a punch and suffered bad concussion; John Pullin was felled from behind at a lineout by a punch from behind; and Gareth Edwards was floored by a rabbit punch. The referee, at one point during the battle in the second half, bizarrely called the captains together and told them that from that moment on he was going to follow the ball, and if anything else happened, it was up to the captains to sort it out. The Lions continued to try and play some rugby throughout, and their far superior back play saw them home by 14–3, but they had

▼ Rugby supporters back home were well aware of the physical challenge that faced the Lions in New Zealand, and eagerly toasted their heroes at events such as the celebratory dinner at the National Sporting Club when the squad returned

THE BRITISH LIONS
NATIONAL SPORTING CLUB
25TH OCT. 1971

MENU

Truite fumée
Sauce Raifort

• • •

Oxtail clair
au Xérès
Paillettes dorées

lost their two Test props. Ray McLoughlin broke his thumb while hitting back, and both he and Carmichael, under the ruling of the Tour Agreement, were, sadly, sent home. Strangely, the Lions flew out another lock, Geoff Evans, so that Mike Roberts, one of the now five second rows, had to play a number of games at prop. They also sent out the Cornish prop, Brian 'Stack' Stevens.

Canterbury had shown how schizophrenic New Zealand rugby could occasionally be. There was a considerable backlash in New Zealand, as the *Christchurch Press* called it 'The Game of Shame', while *Truth*, a weekly journal, said, 'New Zealand rugby has become as grotesque as a wounded bull', and named three of the Canterbury villains. The All Blacks coach, Ivan Vodanovich, warned the Lions that if they did not get off the ball in the rucks, then the forthcoming first Test match at Dunedin would resemble the battle of Passchendaele. Happily, the chairman of the New Zealand Council issued a statement saying, 'There will be no battle at Carisbrook next Saturday.'

Because of the damage done in Christchurch, the Lions were left with what were considered their second-string props, Ian McLauchlan and Sean Lynch, for the first Test, but, as so often happens, they more than rose to the occasion and played superbly in all the Tests, to make a reputation for themselves as fine players. The Lions were, unusually, to play six Welshmen and an Irishman, Gibson, in their back division in that first Test.

The All Blacks included six new caps and, therefore, in the last five matches had played 33 players, a sure sign of an unsettled side. Nevertheless, they attacked the Lions from the start, only for the Lions to score first, entirely against the run of play, when McLauchlan charged down a clearance kick by Alan Sutherland in his own 25 and stormed on to score what was not only a crucial try but his only one of the tour. McLauchlan recalled in an interview years later:

I saw the ball going back. John Bevan made the break and came inside. I thought he'd dropped the ball forward but New Zealand had picked it up and played it. Alan Sutherland was standing inside his 25 and somehow he took about a fortnight to wind his leg back to kick the ball and, by that time, I'd charged down his kick. The ball just bounced nicely and I popped it down for my first international try.

As I walked back I thought it was a knock-on, so I wasn't that euphoric. But afterwards was a phenomenal feeling. The try has to be a highlight looking back, but I don't remember that much about it to be honest.

During the tour the fact that we beat all the provinces quite easily gave us a real belief for the first Test. That first Test was probably the most intense game I have ever played in, but at the same time we won it, which set the seal on the tour. If we'd lost that game, New Zealand would have grown in stature.

The dressing-room afterwards was measured and tempered. There was a feeling of relief that we'd won the first Test. The boys were happy and content with the result, but we knew that it was only the start – that New Zealand would come again very hard in the second Test. And of course, the second Test was in Canterbury where they had never lost a Test match before.

A minute from half-time in the first Test, McCormack equalised with a penalty. In the space of a few moments, McLauchlan himself acknowledged that he had made the jump from 'Mickey' to 'Mighty Mouse', by which pseudonym he thereafter became known. The Lions had lost Edwards with a leg injury early in the half, and he was replaced by his admirable deputy Chico Hopkins. In the second period, John kicked two penalties in the 12th and 36th minutes to win the match 9–3.

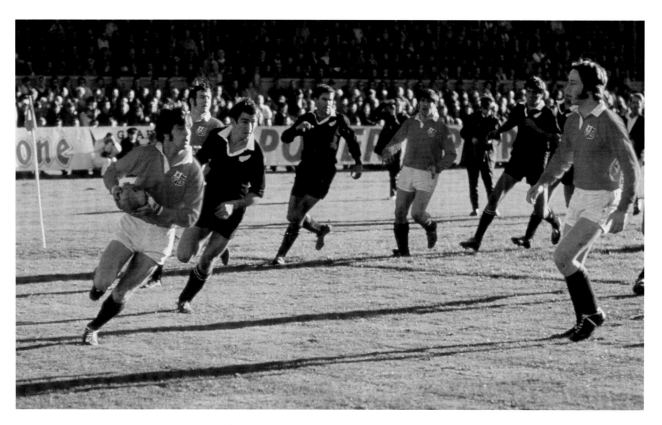

▲ Wales fly-half Barry John was in superlative form in the first Test in Dunedin, landing two penalties as the Lions ran out 9–3 winners in Carisbrook

Beaten in the lineouts, the Lions had done well in the scrummaging, and a big feature of the match was the way that John tortured and tormented McCormack with his kicking for the corners, which saw him floundering and dropped for the subsequent Tests.

Willie John still recounts how he sat in the dressing-room afterwards, wondering how on earth they had won as, for much of the game, the Lions were simply not in it. It did wonders for the Lions' morale, for they had shown that the All Blacks could be beaten and they were no longer afraid of them. It also did Willie John a power of good, for he had previously played nine Tests for the Lions and had never won before.

McCormack was replaced in the second Test by Laurie Mains of Otago, later to become an outstanding coach who took New Zealand to the final of the 1995 World Cup. The All Blacks also dropped Carrington and moved Bryan Williams, their magnificent Samoan, out from centre to wing, and Howard Joseph from Canterbury was brought into the centre. Sutherland had broken his leg in a charity match and was replaced by Wyllie. The Lions made only one change, replacing John Bevan with David Duckham.

Lancaster Park was heavy, as it often is, but the weather was fine as the All Blacks forwards had their most impressive day. The All Blacks drew first blood, when Going worked the narrow side and put Burgess through a gap for a try. The Lions levelled when Williams and Gibson put Gerald Davies away on a 50-yard run, only for John to miss the easy conversion. Going then scored a typical powering try from a ruck, which Mains converted, and John made it 8–6 at half-time with a penalty.

Ten minutes into the second half, referee John Pring awarded a penalty try to New Zealand when Gerald Davies took Bryan Williams early in a tackle, and Mains kicked the goal. Burgess then crossed for his second try, similar to the one he scored in the first half, which Mains failed to convert, but he then succeeded with a penalty.

Now came that famous try from a memorable run by Ian Kirkpatrick, when he burst away from broken play and, handing off Lions galore, raced 50 yards for a great try in the corner, and the All Blacks were cruising home by 22–6. In the remaining minutes, however, the Lions showed some spirit; Gerald Davies got a second try and John dropped a goal. The All Blacks had won impressively by 22–12 and stopped the Lions' run of 15 games in New Zealand without a defeat, and they were well pleased.

Going and Bob Burgess were their stars behind the scrum, and Meads and Kirkpatrick were the outstanding forwards. The Lions paid a heavy price for not stopping the two All Blacks danger men, Going and Kirkpatrick.

Four more wins included a thoroughly nasty game at Hawke's Bay which was a mini-Canterbury, for John Pullin was badly hurt by a punch, but Mike Gibson's pulled hamstring had nothing to do with the unpleasant events on the field. This was the game when Gerald Davies flew on the wind to score four tremendous tries, and when the Welsh halves, Edwards and John, showed their disgust at the Hawke's Bay tactics. John began to toy with the Hawke's Bay players by standing still in his own 25 and passing the ball behind his back, before offering it to them and taunting them before kicking for touch as they closed in on him. It may have been naughty, but John was not prepared to allow such foul play without a demonstration of disapproval.

New Zealand picked the same team for the third Test at Wellington, but two late changes were forced on them. Bryan Williams withdrew with a groin injury, to be replaced by Carrington, and Whiting, who had received a back injury in training, was surprisingly replaced by Brian Lochore, the great All Blacks captain, who was well past his sell-by date for Test matches. The Lions made two changes, with Carwyn bringing in Quinnell in place of Dixon to look after Going on the blind side, and Gordon Brown making his first Test match appearance for the Lions in place of Delme Thomas. Remarkably, Quinnell played in four winning teams against New Zealand, one on each Lions tour in 1971 and 1977, and for Llanelli and the Barbarians in 1972–73. Like Thomas, his Llanelli teammate, before him in 1966, Quinnell played in a Test match for the Lions before being capped by his native Wales.

▲ London Welsh No. 8 Mervyn Davies (far right) was a key member of a Lions pack that was finally able to go toe-to-toe with the All Blacks forwards

Having won the toss, the Lions made good use of the wind in the first half and had the game won by half-time, when John dropped a goal after three minutes, and the All Blacks lost control at the tail of the lineout. Edwards, who had one of his finest matches for the Lions that day, ran around the narrow side and found the gap to put Davies over in the corner, and John's conversion went over via the upright. Another typical burst by Edwards, full of power and purpose, around the tail of a lineout, followed by a hand-off and a quick pass to John, who had come in close to him, brought another critical and smartly taken try. John easily converted, and at half-time the All Blacks were in serious trouble. Although the All Blacks strained every sinew in the second half, they failed to break the well-organised defence and managed only one try by Mains after ten minutes. The Lions had won a handsome victory by 13–3.

Thus, the Lions were in the happy position of being two-one up with one to play, but they still had to win the series. Doug Smith, the manager, was jubilant and referred to Wellington as, 'This wonderful city; we leave it 81 points to the good. We scored 47 here against Wellington, 27 against New Zealand Universities and 13 against New Zealand. What is more, King Jesus John is coming with us!'

Having completed their provincial games without defeat, Willie John captained

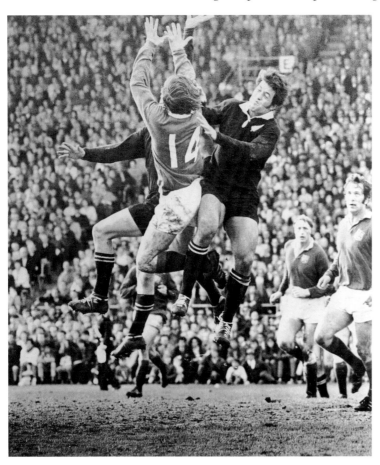

the side for the first time in four tours against Manawatu-Horowhenua. John Bevan scored his 17th try of the tour in this last provincial match, thus equalling Tony O'Reilly's post-war record in 1959. The Lions now prepared for another big one, knowing that a defeat would spoil all their efforts and the end-of-tour party. The only change in their side for the final Test at Eden Park, Auckland, was the return of Dixon in place of Quinnell. For the All Blacks, Burgess was injured in the third Test and his replacement, Cottrell, was retained, and Phil Gard came in at second five-eighth. Williams and Whiting, fit again, were restored in place of Hunter and Lochore, and Tom Lister was brought in at flanker for McNaughton.

The referee, John Pring, was again chosen to officiate, largely at the behest of Carwyn, who detected that he was an honest broker. He became the first and last referee to officiate in all matches of a four-match series.

The game was hard and uncompromising and there was too much at stake for it to be a flowing affair, but, by heaven, it was

▲ Wing Gerald Davies jumps with New Zealand's Bryan Williams during the fourth Test in Auckland, a dramatic 14–14 draw at Eden Park which sealed the series 2–1 for the Lions

dramatic! The All Blacks started at the gallop and were into a four-minute lead with a try from a set scrum, when Wyllie stood off, took Going's pass and sold a dummy before giving to Gard, who slipped to Cottrell, who had looped behind him to score, and Mains converted.

A few minutes later, Mains added a penalty and matters looked ominous but, before half-time, John kicked a penalty and converted a try by the indefatigable Dixon, who went over from a lineout, to make it a nail-biting 8–8 at half-time. John kicked another penalty after the break and Lister again levelled the scores with another try from a lineout. J.P.R. Williams then thumped over a marvellous drop goal but, eight minutes from time, Mains kicked a penalty for the game to end in a draw at 14–14. It was enough for the Lions to win their first series in New Zealand and to go home as heroes, and it was a good party! This Test was to end the magnificent career of Colin Meads, and neither did we see Lochore in the All Blacks jersey again, after the third Test. The mighty Meads faced the Lions on 14 occasions between 1959 and 1971, winning eight times and drawing once. He won seven of his ten Tests against the Lions and drew another. His brother, Stan, also got in on the act, posting five straight wins

over the 1966 Lions to make the family record against the tourists even more impressive.

By becoming the first Lions team to win a major series abroad in the twentieth century, these 1971 Lions had become the greatest, and had struck a huge blow for the cause of British and Irish rugby. Carwyn James had vindicated the new move to coaching and silenced the doubters. His side was named 'Team of the Year' at the BBC Sports Personality of the Year awards in 1971, and Smith and Dawes were awarded the OBE. Carwyn declined an invitation to be treated in the same fashion. Once a Welsh Nationalist...

◀ Skipper John Dawes arrives home to be greeted by his family after becoming the first man to lead the Lions to a series victory over the All Blacks

RESULTS OF THE 1971 LIONS IN AUSTRALIA AND NEW ZEALAND

P 26 W 23 D 1 L 2 F 580 A 231

Queensland	L	11–15	Southland	W	25–3
New South Wales	W	14–12	Taranaki	W	14–9
Counties–Thames Valley	W	25–3	New Zealand Universities	W	27–6
King Country–Wanganui	W	22–9	New Zealand (Christchurch)	L	12–22
Waikato	W	35–14	Wairarapa–Bush	W	27–6
New Zealand Maoris	W	23–12	Hawke's Bay	W	25–6
Wellington	W	47–9	East Coast–Poverty Bay	W	18–12
South Canterbury–North Otago	W	25–6	Auckland	W	19–12
Otago	W	21–9	New Zealand (Wellington)	W	13–3
West Coast–Buller	W	39–6	Manawatu–Horowhenua	W	39–6
Canterbury	W	14–3	North Auckland	W	11–5
Marlborough–Nelson	W	31–12	Bay of Plenty	W	20–14
New Zealand (Dunedin)	W	9–3	New Zealand (Auckland)	D	14–14

JOHN DAWES' 1971 LIONS TEAM

FULL-BACKS			FORWARDS		
R. Hiller	Harlequins	England	R.J. Arneil*	Leicester	Scotland
J.P.R. Williams	London Welsh	Wales	G.L. Brown	West of Scotland	Scotland
			A.B. Carmichael	West of Scotland	Scotland
THREE-QUARTERS			T.M. Davies	London Welsh	Wales
J.C. Bevan	Cardiff College of Education	Wales	P.J. Dixon	Harlequins	England
A.G. Biggar	London Scottish	Scotland	T.G. Evans*	London Welsh	Wales
T.G.R. Davies	Cambridge University and London Welsh	Wales	M.L. Hipwell	Terenure College	Ireland
			F.A.L. Laidlaw	Melrose	Scotland
S.J. Dawes (capt.)	London Welsh	Wales	J.F. Lynch	St Mary's College	Ireland
D.J. Duckham	Coventry	England	W.J. McBride	Ballymena	Ireland
A.J.L. Lewis	Ebbw Vale	Wales	J. McLauchlan	Jordanhill College	Scotland
C.W.W. Rea	Headingley	Scotland	R.J. McLoughlin	Blackrock College	Ireland
J.S. Spencer	Headingley	England	J.V. Pullin	Bristol	England
			D.L. Quinnell	Llanelli	
HALF-BACKS			M.G. Roberts	London Welsh	Wales
G.O. Edwards	Cardiff	Wales	J.F. Slattery	University College, Dublin	Ireland
C.M.H. Gibson	North of Ireland	Ireland	C.B. Stevens*	Harlequins	England
R. Hopkins	Maesteg	Wales	J. Taylor	London Welsh	Wales
B. John	Cardiff	Wales	W.D. Thomas	Llanelli	Wales
			*Replacements		

1974 TOUR KIT

1974
WILLIE JOHN'S WONDERS

Captain: Willie John McBride (Ballymena and Ireland)
Squad Size: 30 players + 2 replacements
Manager: Alun Thomas (Wales)
Coach: Syd Millar (Ireland)
Tour Record: P 22 W 21 D 1 L 0 F 729 A 207
Test Series: P 4 W 3 D 1 L 0

Some critics implied the 1974 British & Irish Lions embraced only a forward-orientated and kicking game. Furthermore, they suggested that organised violence was part of their creed, after Willie John McBride's philosophy of 'Take no prisoners' was leaked. Unquestionably, at times there was a blitzkrieg philosophy, and it was on this tour that the code '99' was evolved, which meant one in, all in. Both Syd Millar, the coach, and Willie John himself had played there in 1962 and 1968, when the Lions did not win a single Test match, although they escaped a whitewash by drawing once on each occasion.

This was Willie John's record-breaking fifth successive tour, while his former Ballymena, Ulster and Ireland teammate, Millar, was on his fourth trip, having toured in 1959, 1962 and 1968 as a player. They were, therefore, conditioned to the concept that you had to be tough to survive in such a physical country, where the white population felt threatened by the sheer weight of numbers of the black population and reacted by denying dignity to anyone who was not white. Sometimes the Springboks would carry such uncompromising attitudes onto the field and into a game which they loved above all others. They knew no way other than wanting to win at any cost.

This was far from the whole story of the 1974 Lions, for Hannes Marais, the South African captain, maintained that these Lions were the best team he had ever played against, including Brian Lochore's 1970 All Blacks. He was also to say that they were unfriendly towards his players.

It is entirely true to say that McBride's Lions were a great side, because of a huge determination to win through a highly organised forward effort; but then, after all, both the captain and the coach were forwards. That is not to say that they did not possess backs who showed tremendous quality, illustrated by the incontrovertible evidence of the huge number of points scored: 729 in their 22 games, more than any other team to visit South Africa. Remarkably, they lost not a single game, which was their passport to recognition of their greatness and of being the most powerful Lions team of all time. Never had the Springboks suffered a greater humiliation for, as they themselves pointed out, they were not a weak team, as their two Test wins in France at the end of 1974 revealed.

The year of 1974 saw the Heath government fall after the three-day week, and Harold Wilson returned as prime minister. There was an attempt to kill Princess Anne, and American heiress Patty Hearst became a bank robber. The boundaries of the English and Welsh counties were reorganised and we saw the demise of Cumberland, Rutland, Huntingdonshire and Westmoreland. There was roaring inflation, with the price of a gallon of four-star petrol rising from 42p to 72p.

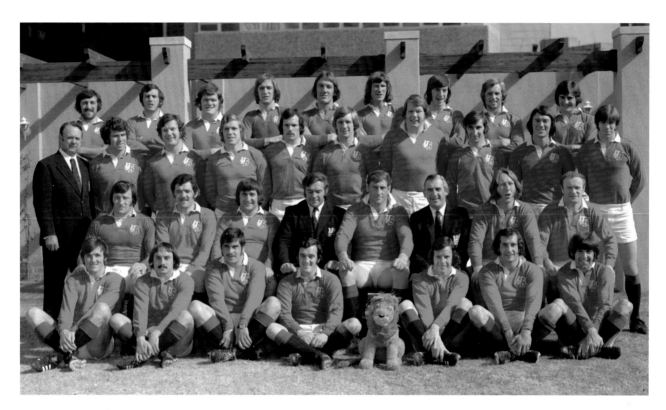

The only inflation they saw in South Africa was in the high scoring of this Lions team. In the weeks before the tour, there were the inevitable objections and denunciations by the various anti-apartheid lobbies but, as I have said before, young rugby men are not primarily interested in politics. Some of them were hurt, however, by some local education bodies in Wales refusing to pay them while on tour, which produced financial hardship.

Alun Thomas, the manager, ensured that the discipline on the tour was strong in matters such as dress and behaviour, but when it came to politics he found himself on the defensive from the word go, receiving a hard time from some members of the press and the tour party. The tour was well managed and the playing side was magic, as Thomas left Syd Millar and McBride to run the events on the field.

In his end-of-tour report, Alun Thomas wrote:

Syd Millar did for the 1974 Lions what Carwyn James had done for the 1971 Lions, in that he motivated and inspired the players to great heights and helped them realise their potential. He was the perfect choice and the perfect companion. His happy nature belied the steel in his character, and whilst very much a players' man, he was broad enough to chide them if they stepped out of line. A 'big' man, yet with a sense of detail about the various problems of South Africa that was uncanny. If there is no substitute for experience, here it was epitomised in one man. He had a clear vision of what was required to win, and to hear him analyse and evaluate tomorrow's problems at the team talks on the eve of a game was an experience. He was so simple, so articulate and yet so masterful. No team has ever gone on the field better prepared.

Willie John's Lions rewrote the record books:

• They won 21 consecutive matches, more than any team before them or since.

• They drew their final game to become only the second Lions team, after Johnny Hammond's side of 1891, to go through a tour unbeaten.

▲ Buoyed by their 1971 success, the Lions set off for South Africa in 1974 hoping to avenge their 3–0 Test series disappointment against the Springboks in 1968

• They were the first Lions to beat the Springboks in a four-match series for 78 years.

• Their aggregate of 729 points was a record for any tour of South Africa, and their 107 tries were a record for British and Irish teams in South Africa.

• Their win by 97–0 against South Western Districts was the biggest win by any touring team in South Africa, and the biggest by any Lions side.

• J.J. Williams set a new try-scoring record with six in that game, and Alan Old set a further point-scoring record in the same match with his 37-point contribution.

• If you add the unbeaten runs at the end of the 1971 tour, nine matches, and the start of the 1977 tour, eight matches, to the 1974 results, you get the second-highest unbeaten run in Lions history, behind the 66 from 1888–1896, of 39 matches.

They were certainly more than merely a forward-orientated team. So upset did Danie Craven become at the eclipse of his beloved Springboks that, in the presentation of Springboks blazers to six new caps in the 'Ostrich Hall' in Port Elizabeth after the third Test, he turned on them and said, 'It hurts me to be giving you these, because you have not earned them.' Danie, for all his geniality, could be a tough old buzzard at times.

▲ Veteran Ireland second row Willie John McBride was named captain of the tourists in 1974 on his fifth and final Lions tour

On the playing side, such undreamt-of success was a tribute to those great Irishmen, coach Millar and captain McBride, for to break so many scoring records and to win the only full-scale Test series in South Africa in the twentieth century was to scale the pinnacle of any rugby man's ambition. These two warriors, for that is what they were and still are, belong at the top of any roll of honour in British and Irish rugby.

The tour manager wrote of McBride:

The captain was another exceptional man, and all the credit for the team's success goes to him and his great ally, Syd Millar. His outstanding qualities as a player and a man are so well known that I can never adequately describe them in print. He was literally worshipped by the players, not only because of his own courage and strength of commitment, but because they saw in him all the things they would like to be. He shielded them, nurtured them and, above all, inspired them. He shirked nothing, and was that 'rare breed', a natural leader of men. He is so obviously a future manager, as too is the assistant manager.

For McBride, it was the perfect fulfilment of a long and distinguished career, and it exorcised those unsuccessful tours of the 1960s in which he had taken part. He launched his record-breaking Test career for the Lions in the 1960s, gaining 17 caps with one draw in nine matches, before registering five wins and two draws in eight Tests in the 1970s. He will tell you that it was a very tough learning curve, but the reward in the end was well worth waiting for.

As the high scoring suggests – the Lions scored 107 tries and conceded a mere 13 – the tour far from belonged entirely to the forwards, for the Lions had some terrific backs in players such as Gareth Edwards, who was the principal strategist following the departure of Barry John. His kicking had South Africa on the rack throughout

the tour, as did his long pass, which did much to protect the delightful free-running Phil Bennett. Phil was a marvellous instinctive player who, on his day, could twinkle as brightly as any star, including John, as he showed when he catalysed that unforgettable try for the Barbarians against the All Blacks in 1973. South Africa tried to target him, but Edwards protected him with his length of pass and by using the option to kick, which was a feature of Wales' golden period of the 1970s. Edwards' running from the base was also a constant threat and produced many crucial tries, and this tour provided some of the finest hours of his illustrious career.

The rock which was J.P.R. Williams was as impregnable as ever. He had physical and mental toughness and courage, which at times seemed to border on dementia, because he was so brave and fearless. J.J. Williams was another to have a fine tour, together with the remarkably talented Andy Irvine, who played on the wing in the last two Tests. The two centres, Ian McGeechan and Dick Milliken, were so consistent that they played together as a centre pairing in all four Tests.

The South Africans made it difficult for themselves by panicking after losing the first Test in the wet at Newlands, and by making wholesale changes. In all they played 33 players in the series, 21 of whom were new caps. Only three of the Springboks, namely captain and prop Hannes Marais, wing Chris Pope and flanker Jan Ellis, played in all four Tests.

Eight changes, one of them positional, were made after that first Test, so it was not surprising that they lost the second Test 28–9. There were also 11 changes for the third Test, one again positional, and once more they lost heavily by 26–9, which speaks volumes for the requirement of continuity and experience if you are to create a settled winning team. In contrast, the Lions played only 17 players in the rubber and one of the changes was due only to an injury to Gordon Brown, who had emerged as one of the best post-war locks in Britain.

Like all Lions teams, they were a fine bunch of men to know, though strangely one of the few criticisms of them by the South African captain, Marais, was that they were unsociable and that his team got the cold shoulder. Perhaps it did not occur to him that there were rather a lot of them to get to know.

These Lions had lots of fun, and apparently their Sunday drinking schools were of university standard. I love the story that Tommy David tells of one of his nights in the Kruger Park, when they were told, while drinking barefoot in the bar, to be careful on their way back because of snakes, poisonous spiders and scorpions. Apparently they left hurriedly, racing back to their rondavels (huts) in huge leaps. He was just drifting off to sleep when there was a thunderous banging on the door, and cries in a Gwent accent of, 'Lemme in! Lemme in!' It was Bobby Windsor and, as Tommy relates:

He was frightened to death, and it takes a lot to frighten anybody who has been shouted at by Ray Prosser. 'Tom,' whimpered Bobby, and until you've heard a member of the Pontypool front row whimpering, you ain't heard nothing. 'Tom, I'm lost. I can't find my 'ut. Can I sleep with you?'

▲ Wales pair Gareth Edwards (left) and Phil Bennett formed a magnificent half-back partnership for the Lions and started all four Tests together

So he climbed into my bed. There was more than 30 stone in that single bed, but it didn't seem to worry Bobby – I suppose that anybody who has spent a lot of his time jammed between Graham Price and Charlie Faulkner is used to living rough.

We lay there listening to the sounds of Africa. Bobby said, 'Tom, I can hear lions.' So could I, and as we lay there sweating and thinking about those massive jaws and terrible teeth, we heard something bumping against the side of the hut and roaring. By this time I was holding hands with Bobby, so you can tell what a terrible state he was in. Then it happened, and something came hurtling through our mesh window. Instantly, me and Bobby were out of our bed and, shrieking with fear, fought each other to get under the bed, each trying to shove the other into the paws of whatever had pounced through our window.

At any second I expected to feel his fangs in my rear. The lion's fangs, that is, not Bobby's – although if biting me could have got me out of the way, I wouldn't have put that past my hooker. We were still fighting and screaming when there were some terrific bangs on the door. Christ! I thought, we got gorillas coming in as well. It wasn't, it was Chris Ralston, Mike Burton and Ian McLauchlan; they'd come for the log which they had thrown through the window and they couldn't stand up for laughing. Just the usual sort of prank to relieve the boredom, but enough for me to consider asking Dr Christian Barnard to put me on his waiting list.

Humour plays a large part on such tours and there are always two or three guys who enliven a tour with native wit, or who can entertain with music and singing. Such people are invaluable on long tours, for they can do so much for morale, whether things are going well or badly. Rarely does one see any real misfits on Lions tours.

Tours are a huge test of character. Apart from training and playing, there are many problems like small beds for big men, noisy rooms and roommates – there is nothing worse than sharing with a snorer – wrong types of food and bad service or problems with the telephone, with journalists trying to phone out and dozens of girls trying to phone in. Willie John had massive experience of all this and understood that all complaints should be brought into the open, each then being examined and solved on its merits. Man management, including encouraging and sympathising with those who fail to get into the team for the Tests, is all-important.

▲ Scotland's Gordon Brown (left) and Willie John McBride had performed wonders as part of the 1971 Lions pack and picked up where they had left off during the 1974 tour

Willie says that one reason for their success was that they never contemplated the possibility of defeat. His Lions concentrated on the scrummage, because they soon discovered that the Springboks had neglected this area of forward play. Consequently, they achieved consistent forward dominance, which they hadn't done in New Zealand in 1971. Another McBride motto was, 'Never ever take a step back' for, as he said, 'We learned over the years in South Africa and New Zealand that you must always stand up to anything that is thrown at you.'

McBride had set the tone for the tour right from the off, giving the following address to his players at their London hotel before flying to South Africa:

I know there are pressures on you, but if you have any doubts, I would ask you to turn around and look behind you. [At the back of the room, there were two large open doors.]

Gentlemen, if you have any doubts about going on this tour, I want you to be big enough to stand up now and leave this room. Because you are no use to me, and you're no use to this team. There will be no stain on your character, no accusations if you do so, but you must be honest and committed. I've been in South Africa before and there's going to be a lot of physical intimidation, a lot of cheating. So if you're not up for a fight, there's the door.

Millar admits that they often played nine- and ten-man rugby, but they also played 15-man rugby and scored more tries than the 1955 Lions, who were previously regarded as the best running team ever to visit South Africa. Those who thought that the 1974 side should play like the 1971 team failed to understand that they were different, with a midfield that did not have the same ability to transfer ball. It was unfair to compare McGeechan and Milliken with Gibson or Dawes, for they had different approaches, but you never saw a higher work rate than that of the 1974 centres.

Another thing which Millar tried to achieve was not to have a midweek and a Test team. He therefore mixed them up as far as he could, but this was possible because he had so many good forwards under his command, these Lions being blessed by having the strongest 16 forwards that ever went on a Lions tour. It was astonishing that some critics failed to understand that they were, sensibly, playing to their strength and not attempting to put back any clocks.

Suffice to say they rattled through the seven provincial matches, including capturing the valuable scalps of Eastern and Western Province before the first Test in Cape Town, which, together with Sydney in Australia and Vancouver in Canada, is one of the best venues in the world for a Test match. Newlands, nestling under Table Mountain, is one of the great rugby shrines, and a Mecca that rugby men the world over should visit some time in their lives.

Eastern Province was the first big test of the Lions' resolve. Twice Edwards, the captain for the day, asked Hannes Marais, the Eastern Province captain, to cut out the rough stuff. Nothing happened, so finally Edwards said, 'All right, if that's the bloody way you want it, you can have it.' There were some vicious fist fights, most of which the Lions won, along with the match. The same weekend, the French club Tarbes were involved in another monumental punch-up with Eastern Transvaal, and the match was abandoned 20 minutes from the end, which tells you something about how hard it can be in South Africa.

I have always maintained that Lions tours to New Zealand and South Africa were a bit like going off to the medieval crusades or soldiering with Wellington in the Peninsular campaign. Furthermore, we all did it for nothing; in fact, most of us lost money. It was all for the love of the game and, I must admit, for the opportunity of having a crack at a bit of glory.

▲ A poster promoting the Western Mail's coverage of the tour. The Welsh newspaper assigned their acclaimed chief rugby writer J.B.G. Thomas to keep fans up to date with events from South Africa

The Lions also played a coloured (mixed blood) team called the SAR Federation XV, or the 'Proteas', before the first Test. Like so many other such events in the apartheid years, it was largely a cosmetic exercise because it was not fully representative, as the bigger coloured union stated that there should be no mixed sport in an abnormal society. Furthermore, there was no structure by which the Bantu or coloureds could play against the provincial teams.

The stage was set for the opening Test of the series. In his autobiography, *Fran: Fran Cotton – an Autobiography*, Cotton said:

So it was to Cape Town for the first Test and we came down to the captain's room. It was half full and nobody was saying a word, not a word. It was probably another five minutes before everyone arrived, and still nobody's saying a word. Willie John arrives, nobody says a word. And then 20 minutes passed – 20 minutes! Well, you can imagine the atmosphere in the room, and he just looked at us all and said: 'Right then, we're ready,' and we got on the coach. It was the most unreal thing I've ever been through. But the tension that had built up was fantastic.

The ground for the first Test was like a quagmire after the overnight rain and after two preliminary curtain-raisers. It was, therefore, tailor-made for nine-man rugby, and played into the hands of the Lions forwards. It was quickly evident that the Springboks had forgotten the art of scrummaging and, after ten minutes, the Lions had them in a vice. Nevertheless the Springboks, with the wind behind them, scored first when Dawie Snyman dropped a goal early on, and it was not until nearly half-time that Phil Bennett kicked a penalty, making the score level at 3–3.

In the second half, with the strong wind behind the Lions, it was evident that they would win comfortably and they were rarely out of the Springboks' half, but in such conditions tries were hard to come by. They finally won 12–3, with two more penalty goals and a drop goal by Edwards.

▼ Gareth Edwards made ten career Test appearances for the Lions, four of them in South Africa in 1974, even dropping a goal in the first Test victory in Cape Town

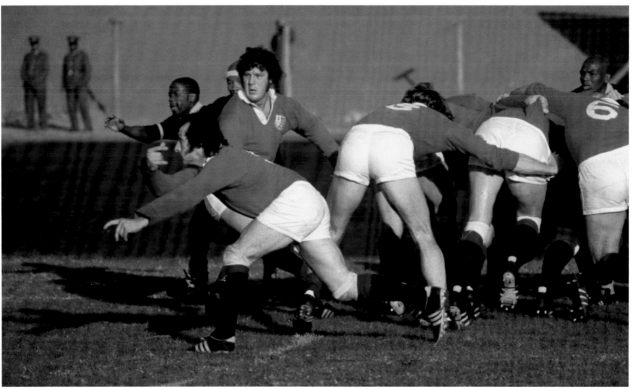

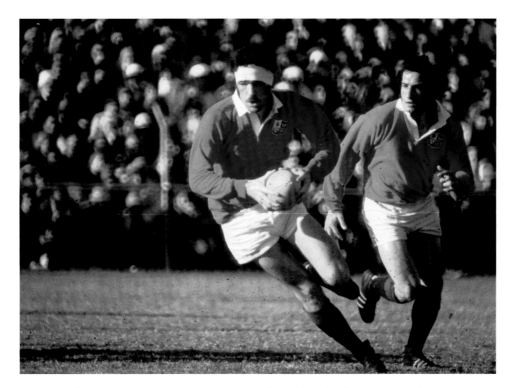

◄ After starring against the All Blacks in 1971, No. 8 Mervyn Davies (left) was again outstanding as a member of a Lions pack which refused to be intimidated by their opponents

Not a few reputations were made or confirmed in this first Test, as the Lions showed that Millar had made the right decisions with regard to his forward selections. Before the start of the tour many thought, for instance, that Mervyn Davies might be the number two to Andy Ripley, but he showed, with one terrific tackle on Jan Ellis in the first Test, which set a pattern for the tour, that he was an absolute hammer, as hard and merciless as they come. With his mobility and basketball skills with the ball in the hand, he was a truly great player. His career ended abruptly when he suffered a sub-arachnoid haemorrhage in the Welsh Cup semi-final in 1976.

Similarly, Slattery was thought to be in the shadow of Tony Neary, but he showed such a tireless workrate and range of skills, most notably his knack of taking a tackle and riding over it before passing the ball to the support, that he easily held his Test place, and he was to retire as the world's most-capped flanker, with 61 caps.

The third member of this unrivalled back row was Roger Uttley, who, on tour, was converted from lock, where he had played for England in 1973 and 1974, into a hard blind-side flanker. He added considerably to tightening the forward effort and gave another dimension to winning the ball at the tail of the lineout, as he took much of the workload and pressure off Mervyn Davies. Later, he was to be assistant coach to Ian McGeechan on the successful Lions tour to Australia in 1989.

The second row spoke for itself with the big man, Willie John, and Gordon Brown, equally as large and as hard in combat, with a huge personality both on and off the field. He was the brother of the Scottish captain Peter Brown, and created an unusual record by replacing him when he was injured against Wales in 1979.

The front row of Ian McLauchlan, Windsor and Cotton was not the sort to be intimidated; on the contrary, any intimidation that was going on was going to be by them. Windsor, a member of the legendary Pontypool front row, was a master at throwing in at the lineout, which is an extremely important art, and it was the reason

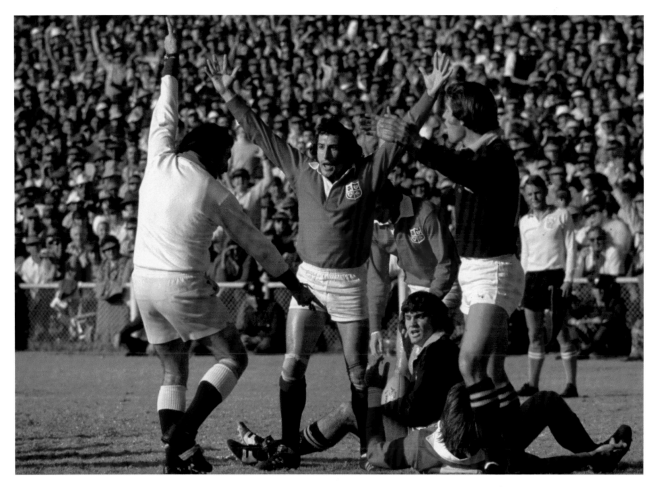

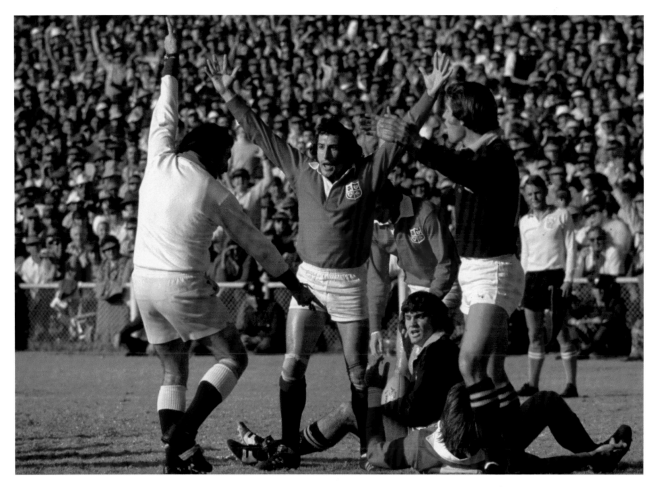 Gareth Edwards appeals to the referee to award the tourists a try. The Lions comprehensively outscored the Springboks across the series, with Llanelli and Wales wing J.J. Williams leading the list of try scorers thanks to a brace of tries in both the second and third Tests

he pipped Ken Kennedy for the Tests. Cotton, an English hard case from Wigan, rugby league country, was brought to South Africa as a back-up loose-head for McLauchlan, only to win his place at tight-head, because of his strength and commitment and his understanding with Windsor. 'Mighty Mouse' was the ideal loose-head prop and the keystone of the Lions pack and, in eight Tests for the Lions, he only once finished on the losing side.

There was only one change in the pack throughout the whole series, when Chris Ralston, a tougher and better lock than his laid-back demeanour implied, came in for the injured Gordon Brown, who had broken a hand in the Port Elizabeth Test brawl, for the last Test. This was a measure of the consistency of their forward play and of their immense durability on such an exacting tour, which was a factor in winning the series. When you look at the reserves of Sandy Carmichael, Mike Burton, Kennedy, Ralston, Ripley, Sean McKinney, Neary and David, then you can appreciate why they never lost a match.

Returning to the high veldt, the Lions continued to give the provincial teams a pounding. They beat one of South Africa's strongest teams, Transvaal, who were Currie Cup finalists that year, by 23–15 before the second Test at Loftus Versfeld in Pretoria, and they also beat Rhodesia handsomely.

The Springboks selectors panicked and made all those inexplicable changes, while the Lions fielded the same team. As expected, the Lions' scrummaging was even more lethal on the hard ground and the Springboks forwards crumbled, as the Lions inflicted on South Africa their biggest-ever defeat. The Springboks managed to hold

the line in the first half, when they trailed from two tries by J.J. Williams scored on each side of the field. Bennett converted the second, while Bosch dropped a goal to make it 10–3 at half-time.

In the second half the Lions crushed the Springboks pack, and Bennett, who played the game of his life, cut loose to score a tremendous try when he split the Springboks' defence and sliced through for a twinkle-toed try which had even the partisan Pretoria crowd on their feet in admiration. Further tries were scored by Brown and Milliken, while Bennett kicked a penalty and Ian McGeechan dropped a goal. South Africa's only response was two penalties by Bosch. The Lions had inflicted the heaviest-ever defeat on the Springboks and had totally given the lie to accusations that they played only nine- or ten-man rugby.

There was now a reaction to this run of unparalleled success and, having peaked, the Lions struggled against the Quaggas, a South African Barbarians-style team named after an extinct species of zebra. They also only scraped home in the dying moments against the Orange Free State with a try by J.J. Williams, which made it 11–9. They got back into their stride with a 69–16 win against Griqualand West, and then beat Northern Transvaal, who won the Currie Cup that year, before easily beating the Leopards, a Bantu team, in East London before the third Test in Port Elizabeth. It was made evident by the performance of the flanker, Morgan Cushe, that one day South Africa would have black Springboks, even though Danie Craven said in 1976 that it would never happen.

This third Test was South Africa's last chance to save the series, and they had gone into 'purdah' and trained behind closed doors, forbidden by their coach, Claassen, to read the newspapers. They also made further changes and included some hard cases in their pack. Inexplicably, they selected Gerrie Sonnekus, a No. 8, at scrum-half, although he had played only briefly in that position. The Lions, for their part, made only one change, with Andy Irvine replacing Steele on the wing.

I must confess that this match is my biggest memory of the 1974 tour. I was never more astonished, as the game became the most violent Test match I ever witnessed. Some of the big Springboks forwards actually ran away from the battle, which was why, that night in the Ostrich Hall, Danie Craven said he was ashamed of them.

I sat there in amazement as two massive fist-fights broke out, one in each half. The first, just before half-time, occurred when the Springboks ran into a ruck with boots flying and Willie John called a '99'. This meant everybody climbed in; even J.P.R. Williams came rushing in from full-back to join in. Moaner van Heerden became the main target and, in the end, he was forced to retreat. Among many other skirmishes, a further outbreak of all-out war came in the second half, with another huge '99'.

McBride, writing in the foreword to the first edition of this book, said:

I will never forget the tension before the third and vital Test. We were doing our last scrummaging session on the Wednesday before, Test pack against the rest, and a few of the rest had a point to prove. At the first scrum, they pushed us

▼ Full-back J.P.R .Williams' tactical kicking was key to the Lions' success in South Africa. as was his enthusiastic reaction to the tourists' legendary '99' call-to-arms

off the ball and it would be an understatement to say I was upset. I recall taking the Test pack aside and giving them a piece of my mind because we had broken concentration. We got down again and they collapsed in a heap under our feet, and Chris Ralston was left lying there, screaming, with a twisted leg. Ken Kennedy, the hooker, who is a doctor, went to his aid and, as he straightened the knee, Chris yelled out, 'The pain is excruciating!' only for Bobby Windsor to remark unsympathetically, 'He cannot be too bad if he can think of a word like that.' Chris was soon down in the next scrum, but that was the calibre of the side: strong of mind and of body.

The battles created one of rugby's immortal tales: Brown hit his opposite number, Johan de Bruyn, so hard that the Orange Free State man's glass eye flew out and landed in the mud. 'So there we are, 30 players, plus the ref, on our hands and knees scrabbling about in the mire looking for this glass eye,' recalled Brown in an interview before his death from non-Hodgkin lymphoma in 2001, aged 53. 'Eventually, someone yells "Eureka" whereupon de Bruyn grabs it and plonks it straight back in the gaping hole in his face.' Shortly after the death of the player so affectionately known around the rugby-playing world as 'Broon of Troon', de Bruyn presented Brown's widow with the glass eye in a specially made trophy.

These incidents brought much criticism of the '99' philosophy, which was blamed for an increase in dirty play in Britain. It was a ploy, however, to show South Africa that the Lions were not going to be pushed around and bullied as some of their predecessors had been in the past. Whether or not they carried it too far is an argument which is still debated.

▼ The 1974 series was a brutal affair with the incredible physicality of the Lions forwards surprising the South African supporters who had grown accustomed to watching dominant Springbok packs

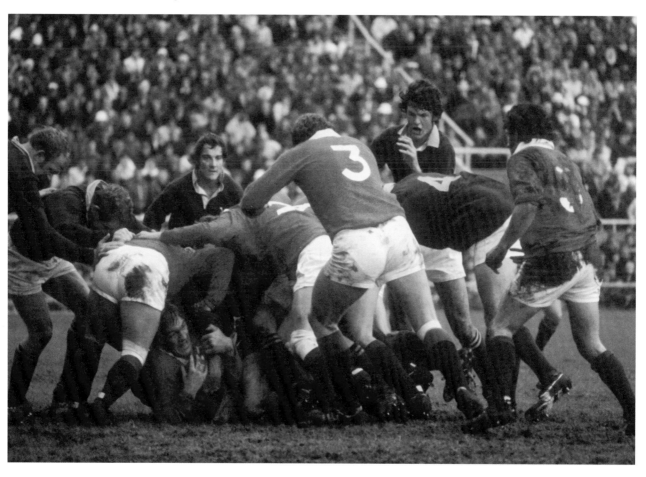

Again the Springboks lost the fight and the game. After an eventful first five minutes, when the over-tense Springboks threw all they had at the Lions, they scored first when Snyman kicked a penalty. The Lions pack quickly re-established control over the opposing forwards and began to turn the screw when Andy Irvine kicked a penalty. Late in the half, after the first '99', Gordon Brown came into the shortened lineout near the Springboks line and stole the ball for a try, which made it 7–3 at half-time, with the wind and the sun still to come in their favour for the second half.

Soon after the restart, Irvine showed the strength of the wind by putting over a penalty from about eight yards inside his own half. After the second '99', Bennett dropped a goal and J.P.R. Williams now combined with J.J. Williams in creating a try for the latter, which Irvine converted. With 20 minutes to go, it was already game, set and match, with the Lions leading 19–3. Winning was now a formality, and although Snyman kicked two penalty goals, the Lions made victory secure when J.J. Williams scored a second try, using his favourite party trick of kicking ahead and scooting around the defender to pick up and score. Finally, Bennett dropped a splendid goal, for the Lions to win the third Test by 26–9.

Thus the Lions won the series, having so far scored eight tries to nil (which was as conclusive as you can get), while the Springboks were in the biggest quandary of their history, with the final Test at Ellis Park still to come.

Border, Natal and Eastern Transvaal were then put to the sword. One of the mysteries and extraordinary memories of the tour was the manner in which the Lions played Natal. This, after all, was the most British of all the provinces, a gorgeous place, the 'Côte d'Azur' of South Africa. They had that marvellous man, Tommy Bedford, as captain, and many of the most knowledgeable rugby people in South Africa and the rest of the world knew he should have been the Springboks captain. However, he was too honestly outspoken on both rugby and political issues to be in favour with the Afrikaner-dominated South African Rugby Board, who always described him as 'controversial'. This was a euphemism for his intelligent resistance to racialism and to the structure of South African rugby. Like the Watson brothers in Port Elizabeth, who also suffered grievously for their beliefs, Bedford always championed the cause of the black man in rugby. His sheer force of character, intelligence and personality ensured, in the end, that he captained the Springboks, but he never became one of the inner circle.

In deference to Bedford's influence, the Lions chose a strong side against Natal and all but three of the Test team played. They played an intimidatory sort of game and were leading by a mere 9–6 ten minutes from the end, but won finally by 34–6. Oddly, 21 of those points came in injury time, or perhaps it should have been called 'fighting time', which in itself was a bizarre record. The Lions' behaviour that day was strange and unsmiling and there was nothing stranger than a rush of blood by J.P.R. Williams. He was tackled into touch – quite fairly, I thought – by Bedford, and a boot struck him, apparently accidentally. However, he seemed to go berserk and rained blows on the luckless Bedford, and the crowd and the police had to go to Bedford's aid and restrain Williams. Later in the game, Bedford was flattened again, this time by a forward, and the crowd went berserk and began pelting the Lions with oranges and beer cans. The game was stopped as McBride led his team to the centre of the pitch, while the police restored order. This took a long time, about ten minutes, which was why the referee added 11 minutes of injury time at the end.

Williams, who was actually staying on to work in a hospital in Durban after the tour, was later contrite about the affair and admitted that he had lost his temper. He

▲ One of the balls used during the 1974 tour, signed by the Lions squad

also said that, during his subsequent stay in Durban, he felt the whole of Natal hated him for a while. His worst punishment was the tremendous dressing-down that his wife gave him in the marquee afterwards; I heard every word of it and she did not spare him.

Another remarkable moment came in Tommy Bedford's post-match speech in the same marquee, when he berated the Springboks selectors and said how delighted he was that they had found their way to Natal at long last, and then put two fingers up to them, which everyone thought was the end of his career. Yes, it was one of the most extraordinary and bizarre afternoons in the Lions' history, and not one of the 1974 Lions' better days. Although the series was over, more than 80,000 spectators packed Ellis Park for the last Test and saw South Africa rescue a little pride, with a drawn game at 13–13. The Lions were now tour-weary and wanting to go home, but there was one last controversy, when the referee disallowed a last-minute try which, according to the photographic evidence, was definitely scored by Slattery.

▼ A programme from the decisive third Test at Port Elizabeth, which saw the Lions run rampant to secure a 26–9 victory thanks to two tries from J.J. Williams and another from Gordon Brown

The referee, Max Baise, was later to say that Slattery had touched down, but he had already blown the whistle and disallowed the try, a statement which was weak, because surely he had plenty of time even after blowing up to award the try. Slattery, in his account, claims that he scored without doubt, but that the Springboks scrum-half, Paul Bayvel, screamed, 'He hasn't touched it, no try, no try,' which influenced the referee. Anyway, that is all water under the bridge and the Lions had almost miraculously gone unbeaten. In the final game of the tour they had scored tries by Uttley and Irvine, with a conversion by Bennett and a penalty goal by Irvine. For South Africa, Cronje scored the Springboks' only try of the series and Snyman kicked three penalty goals.

British Lions
versus South Africa
Saturday, 13th July 1974

Suid-Afrika
teen Britse Leeus
Saterdag, 13 Julie 1974

Boet Erasmus Stadion/Stadium

OFFICIAL PROGRAMME
AMPTELIKE PROGRAM 30c

Bobby Windsor always claims that when he confronted the referee about the try after the game, he said to him, 'Look boys, I have to live here.' Yet despite that last-gasp disappointment, there was no denying how the whole of South Africa, and the South African side, felt about Willie John's team.

'*We took a drubbing,*' said Springbok No. 8 Morne du Plessis in an interview with Kevin Mitchell for *The Observer* years later. '*That 1974 team will forever be held in separate esteem by South Africans; I would certainly rate them as the best team that I played against. Very strong forwards, with some of the best back-line players arguably the world ever saw. If you take J.P.R., Gareth Edwards and Phil Bennett, put that into a pot in any day, believe me, those guys were special.*'

The Lions had created the greatest Lions pack ever and did not lose a single match, and you cannot do much better than that. After all, the object of the game is to win, and the Lions had done that and also scored ten tries to one in the Test rubber. I wonder when we will see their like again.

RESULTS OF THE 1974 LIONS IN SOUTH AFRICA

P 22 W 21 D 1 L 0 F 729 A 207

Western Transvaal	W	59–13	South Africa (Pretoria)	W	28–9
South West Africa	W	23–16	Quaggas	W	20–16
Boland	W	33–6	Orange Free State	W	11–9
Eastern Province	W	28–14	Griqualand West	W	69–16
South Western Districts	W	97–0	Northern Transvaal	W	16–12
Western Province	W	17–8	Leopards	W	56–10
SAR Federation XV	W	37–6	South Africa (Port Elizabeth)	W	26–9
South Africa (Cape Town)	W	12–3	Border	W	26–6
Southern Universities	W	26–4	Natal	W	34–6
Transvaal	W	23–15	Eastern Transvaal	W	33–10
Rhodesia (Salisbury)	W	42–6	South Africa (Johannesburg)	D	13–13

WILLIE JOHN MCBRIDE'S 1974 LIONS TEAM

FULL-BACKS			FORWARDS		
A.R. Irvine	Heriot's FP	Scotland	G.L. Brown	West of Scotland	Scotland
J.P.R. Williams	London Welsh	Wales	M.A. Burton	Gloucester	England
			A.B. Carmichael	West of Scotland	Scotland
THREE-QUARTERS			F.E. Cotton	Coventry	England
R.T.E. Bergiers	Llanelli	Wales	T.P. David	Llanelli	Wales
G.W. Evans	Coventry	England	T.M. Davies	Swansea	Wales
T.O. Grace	St Mary's College	Ireland	K.W. Kennedy	London Irish	Ireland
I.R. McGeechan	Headingley	Scotland	W.J. McBride (capt.)	Ballymena	Ireland
R.A. Milliken	Bangor	Ireland	S.A. McKinney	Dungannon	Ireland
A.J. Morley*	Bristol	England	J. McLauchlan	Jordanhill College	Scotland
C.F.W. Rees	London Welsh	Wales	A. Neary	Broughton Park	England
W.C.C. Steele	Bedford and RAF	Scotland	C.W. Ralston	Richmond	England
J.J. Williams	Llanelli	Wales	A.G. Ripley	Rosslyn Park	England
			J.F. Slattery	Blackrock College	Ireland
HALF-BACKS			R.M. Uttley	Gosforth	England
P. Bennett	Llanelli	Wales	R.W. Windsor	Pontypool	Wales
G.O. Edwards	Cardiff	Wales	*Replacements		
C.M.H. Gibson*	North of Ireland	Ireland			
J.J. Moloney	St Mary's College	Ireland			
A.G.B. Old	Leicester	England			

1977 TOUR KIT

1977
THE ALL BLACKS BITE BACK

Captain: Phil Bennett (Llanelli and Wales)
Squad Size: 30 players + 3 replacements
Manager: George Burrell (Scotland)
Coach: John Dawes (Wales)
Tour Record: P 26 W 21 D 0 L 5 F 607 A 320
Test Series: P 4 W 1 D 0 L 3

After those two glorious tours in the early 1970s, 1977 was akin to 'after the Lord Mayor's show', and turned out to be a huge disappointment. The Lions had a hard act to follow and while, before the tour started, it looked quite good on paper, it all went horribly wrong, as many mistakes were made and the pressures on them became absurd. First of all, they struck one of the worst New Zealand winters on record, for it rained and it rained. Once, on the west coast, it did not stop for four days and nights. The weather set the tone and left bitter memories for many. As Peter Wheeler always says in his after-dinner speeches when talking about the tour: 'It only rained twice this week – once from Monday to Wednesday and again from Thursday to Sunday!'

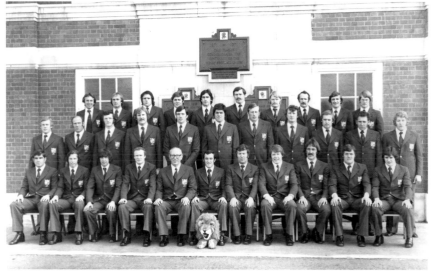

▲ The Lions initially selected a 30-man squad, coached by former captain John Dawes, for the 1977 tour of New Zealand and its 26-match itinerary

The Lions also fell victim to some of the worst and most despicable press coverage I have read on tour. These were some awful, undeserved headlines in a New Zealand weekly called *Truth*, such as 'Lions are Louts and Animals'. They branded the Lions tour party as a disgrace: '*The Lions make a great pack – of animals. The touring British Isles rugby side is a disgrace to its members and their homeland. There has been only one word to describe their behaviour since the team arrived here – disgusting.*' There followed a list of anonymous and unsubstantiated reports of players ripping hotel doors off the hinges, urinating down stairwells, throwing glasses, uncoiling fire hoses and turning over tables. The New Zealand media were out to humiliate the Lions!

Then came the *coup de grâce* in the *Sunday News* some three weeks into the tour. 'They're Lousy Lovers' screamed the front-page headline on 31 May. The exposé, centred around a so-called sworn affidavit by a young lady called 'Wanda from Wanganui', claimed: 'Lions as lovers? Give me the down-to-earth Kiwi male any day.' Wanda, who claimed to have slept with four of the team, added in the story: 'I found them boring, self-centred, ruthless, always on the make and anything but exciting bedmates.'

Thirty young men away from home for three to four months are bound to suffer from homesickness or frustration at some point. They therefore behave badly on occasions and there have been many scenes of over-exuberant wrecking on various tours, induced by a few beers too many, but this is why you need good managers and captains, and I have never known a tour when such behaviour got out of hand.

These lurid press reports were another example of the dirty tricks brigade which is occasionally evident in the isolation of New Zealand. It hurt and bit deep into the Lions' morale, as family and girlfriends rang up from home demanding to know what was going on. Consider what these men went through from the moment they surrendered their passports at the start of the tour: they risked serious injury and drew big crowds to their games, without any personal reward apart from the experience, and yet they were often jeered at and treated badly by the public and the media. It makes you wonder if it was worth it!

I am obliged to John Hopkins, who at the time was the *Sunday Times'* correspondent, for the following statistics. From the time the Lions left London on 10 May until they returned on 19 August, they made 30 different flights, ten major and umpteen minor coach trips and one train journey. They took off and landed 70 times from 20 different airports in three continents, they travelled over 40,000 miles in all, played 26 games of rugby watched by 718,000 spectators and millions more on television, and put $2,025,000 into the coffers of the New Zealand Rugby Union – and all in the name of amateurism. It makes you think!

Against this difficult background, these Lions developed a siege mentality and were led into this by their management. John Dawes later admitted to me that this was his worst mistake and that, if he could have gone back, he would have done things differently. So insular did the management become, that most of the media were at odds with them. A few years later, John Dawes apologised to me for his behaviour towards the press party of which I was a member. I was delighted to accept, for I was always a huge fan of this man who had, and still does have, so much to offer the game. He was, without question, the best tactician and captain of his time, for which he was recognised with the award of an OBE.

George Burrell, the manager, was also a good man, but he, too, succumbed to the pressure of the need for success and to the hateful and unsubstantiated campaign by some elements of the New Zealand press, for he was also imbued with that typical Scottish reserve regarding the press. What a pity that so many tour managements fail in this regard, when all it needs is a little kidology and co-operation, as practised by Carwyn James and Doug Smith.

The management were also a bit paranoid about any references to these predecessors who, on their arrival in New Zealand three weeks before the end of the tour, were hardly embraced. Their sensitivity to criticism was their Achilles heel, for this caused them to create a protective shield around men quite capable of looking after themselves. This manifested itself in a disapproving look across the room and a shake of the head if they saw a player talking to a pressman.

Phil Bennett was made captain, but, as he wrote so self-effacingly in his book, *Everywhere for Wales*, published after his retirement, 'I should never have accepted the captaincy of the Lions tour in 1977. I have spent many a wistful hour thinking what may have been achieved had the leadership gone to someone far better

▲ Each player received a Lions pin badge as part of their official tour kit before boarding the plane to New Zealand

▲ After his influential displays in South Africa in 1974, Phil Bennett was appointed captain three years later but struggled with the pressures of leadership

▲ The 1977 Lions were a relatively experienced squad, although there was space for newcomers like Ireland lock Moss Keane

equipped than I to deal with the all-engulfing pressures of a three-month rugby expedition. By the end of our stay in New Zealand I had no desire to stay in that country since I knew that all my weaknesses as a player and tourist were exposed in that short time. Whilst I admit that I was a bad choice for the captaincy, there were others too who have cause to regret the events of 1977.'

He was not the right choice, particularly as he was having difficulty with his own game at the time, and throughout the tour his backs complained that he was pushing them across the field. Phil is one of the rugby greats in Wales and is one of the nicest, most knowledgeable and most popular of men, but perhaps he did not have that hard edge to his personality which a Lions captain must possess. Had Mervyn Davies not been struck down in his prime by a brain haemorrhage at the end of the 1975–76 season then he would certainly have captained the tour party. Perhaps a forward at the helm might have made a difference.

The team, when it was announced, contained 16 Welshmen, the largest representation from a single country since England's contribution to the 1930 tour. Geoff Wheel of Swansea was to drop out on poor medical advice, as it turned out, his purported heart murmur giving Moss Keane of Ireland his big chance to play for the Lions. Roger Uttley was another casualty, finally admitting defeat with a back injury that paved the way for Jeff Squire, of Newport and Wales, to replace him. Two more Welshmen, Charlie Faulkner and Alan Lewis, went out as replacements so there were, in the end, 18 Welshmen, a record high for the Lions and one which overtook the previous record of 17 Englishmen on the 1888 and 1896 tours. The rest of the party comprised six Englishmen, including Bill Beaumont, another replacement, five Scots and four Irishmen. The number of Welshmen was due both to the success of the Welsh team in the 1970s and because Wales finished second to France in the championship that year, having taken a second successive Triple Crown. On the basis that many of these Welsh players were untried at this level, there were a few too many of them and there were players more worthy of selection from the other countries. There was plenty of experience, though, with Mike Gibson returning for a record-equalling fifth tour, Gordon Brown a third, and Andy Irvine, Ian McGeechan, J.J. Williams, Bennett, Fran Cotton, Tony Neary, Derek Quinnell and Bobby Windsor their second.

The record books may show that Bennett's men became the only Lions team in the 1970s to lose a Test series, but their overall record was not at all bad; it merely suffered because of the expectancy after the success of the early 1970s. Remarkably, they out-played the All Blacks forwards in the Tests, but failed miserably behind the scrum to capitalise on this, thus reversing the usual pattern of matches between the All Blacks and the Lions. Considering that the All Blacks pack contained players of the calibre of Lawrie Knight, Tane Norton, Andy Haden, Frank Oliver, Ian Kirkpatrick and Graham Mourie, this was no mean feat.

In the 25 games played in New Zealand, they won 21 and lost four, which included three Test defeats. They never lost to a province, which was a fine achievement in itself, and the only other game they lost was when the 'dirt-trackers' went down 21–9 to New Zealand Universities on the Tuesday before the first Test.

Against this background, it is difficult to understand why this became known as 'the bad news tour' among the Lions themselves. It was all about the pressure induced on them by the fact that they were expected to win the Test matches and live up to the winning tradition of the 1971 and 1974 tours.

As ever, there were some fine players on this tour, including Scotland's flying full-back Irvine, a great player and a charming man. I found him and his fellow Scots, Brown, Bruce Hay and McGeechan, to be the best-balanced and most delightful of these particular tourists. The front row of Cotton, Peter Wheeler and Graham Price, with Phil Orr in reserve, was a pretty impressive outfit, which had every front row they met in all sorts of trouble. The second row consisted of Brown and Bill Beaumont, who immediately took his place in the Test team on his arrival as replacement. This speaks for itself and begs the question of why he was not chosen in the first place. I remember how, on Beaumont's arrival at the airport, Willie Duggan sidled up to him and said in his rich Irish brogue, 'If I was you, Bill, I'd flick off home again on the next plane.' A bemused Beaumont happily decided to stay. There was also an abundance of cracking back-row forwards in Duggan, Terry Cobner, Quinnell, Neary, Squire and Trevor Evans, and they all played in a Test match at some time. Cobner was to have a huge influence on affairs; when things began to go wrong, he was the man who chose the forwards and led and motivated them. Brown tells the tale that, when they were all feeling depressed before the second Test, and very aware of the hostility of New Zealand towards them, Cobner reassured them. Putting it into the context of Pontypool, he turned to them and said, 'You are not alone, because at three in the morning the lights will be going on in the villages and towns of the valleys, and they will be listening on their radios and willing you on, and they will be with you every inch of the way. So remember, when you are out there on that pitch, you are not alone.' This, said Brown, had a profound effect on him and he could relate to such Welsh exhortation.

The tour badly needed a catalyst like Gareth Edwards at scrum-half who, with those other Lions legends of the 1970s, J.P.R. Williams and Gerald Davies, had decided not to tour again and, for once, to put their careers and families first. The midfield play deteriorated rather than improved as the tour progressed. As McGeechan said, 'I seemed always to be running towards the touchline.' The New Zealand view of the tour was that they were a very good team, but behind the scrum they lacked the real class of the 1971 team, who also enjoyed far better public relations.

▲ Graham Price (left), Peter Wheeler and Fran Cotton (right) formed a formidable front row triumvirate, but unlike the 1971 tourists the Lions lacked a cutting edge amongst the backs

The Lions had lost only one game, to the Universities, before the first Test, but they went into it without their best locks, as Brown was unfit, Nigel Horton had broken his thumb and Beaumont had just arrived. Brynmor Williams, although uncapped by Wales and inexperienced, was picked at scrum-half because of his speed and athleticism, and held the job until his hamstring went in the third Test. He would be the first to admit that he was no Edwards and was on a learning curve at the time, and a very fine player he became.

The All Blacks chose three new caps: Colin Farrell, a young lock called Andy Haden, who had toured Britain in 1972–73 and was to become a legend, and a big loose forward called Lawrie Knight. As usual, the windy city, Wellington, was living up to its name, with the wind blowing directly from Antarctica up the valley that always served as a wind tunnel to Athletic Park, where the *Sunday Telegraph* writer John Reason always reckoned that a jumbo jet could take off without a runway.

The Lions led with a penalty in the second minute, but the lead quickly evaporated when Sid Going bolted through a gap in the forwards for a typical Going try. Bennett, in spite of a shoulder injury inflicted by his own player as he lay on the ground, managed to kick two penalties, one from 50 metres, to give the Lions a lead of 9–4 which lasted until just before half-time. Then Brad Johnstone, following up a Bryan Williams penalty attempt, went over for a try which the Lions disputed, as Bill Osborne seemed to knock the ball over the line. Williams' conversion made it 10–9 to the All Blacks, but another penalty by Bennett restored the lead. Then Grant Batty, that immensely competitive All Blacks wing, intercepted a pass by Evans (with the Lions on the attack with men to spare and a score seeming inevitable), and ran 60 metres for a try under the posts, converted by Williams to give his side a half-time lead of 16–12. This was effectively a 12-point try, as the score should have been 18–10 to the Lions. On such threads hang much of the history of our game, and there the score stood until the final whistle for,

▲ The first Test between New Zealand and the Lions at Athletic Park in Wellington saw tries from Sid Going, Brad Johnstone and Grant Batty secure a 16–12 All Black win

despite the All Blacks having the wind advantage, they failed to harness it and the remainder became a dour, static affair.

For the second Test at Christchurch, the Lions made six changes, all on current form as everyone was available for selection. Brown and Beaumont came in at lock, Quinnell came in to strengthen the back row, and Cotton and Wheeler replaced Orr and Windsor. Surprisingly, Gareth Evans replaced Peter Squires, and J.J. Williams was moved from left to right wing. For New Zealand, Batty withdrew with a leg injury and then shocked New Zealand by announcing his retirement. Small, but very strong and combative, he ended a 56-match career for the All Blacks, in which he had scored 45 tries.

It was a poor game with very little flow and it was mean-spirited, resulting in one dreadful all-out brawl after Kevin Eveleigh late-tackled Bennett. Nevertheless, it gave the Lions immense pleasure because, after the disappointment of losing that psychologically important first Test, it was a win which would keep the series alive until the last Test and put them in with a chance. It will be remembered as Cobner's Test, for he took command of the forwards. It was even said that he picked them.

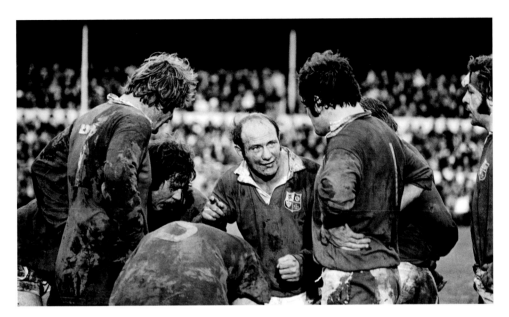

He made sure that the mistakes of the first Test lineouts would not be repeated, and reorganised them and generally tightened up the forward play. The All Blacks had lost their best tight-head prop, Kent Lambert, to appendicitis, which also played into Cobner's hands.

It was another heavy, muddy pitch, but this Test was to show that the Lions forwards were developing into a powerful force, more than capable of beating the All Blacks forwards. It was also evident that the All Blacks were giving Bennett special attention and he was put down fiercely, with one late tackle by Eveleigh producing a huge dust-up. The Lions saw red at this and other incidents and, from time to time, the match generally deteriorated into an unseemly brawl.

Meanwhile, within seven minutes, Phil Bennett had kicked a penalty, and soon the Lions were establishing a considerable advantage in the rucks and mauls. J.J. Williams then scored the only try of the game, with a splendid dummy after a kick ahead by Bennett and terrific approach work by Brown, Quinnell and McGeechan. Bennett banged over another penalty and, after a hectic first 20 minutes, they led 10–0. Bryan Williams now kicked a penalty and got his third, and J.J. Williams another, to make it 13–6 at the break. The second half, marred by that tremendous brawl, was a poor affair and the only addition to the score was another penalty by Williams. Although the All Blacks tried desperately to win in the last ten minutes, the Lions held out for a well-deserved win at 13–9.

New Zealand made six changes for the third Test, including dropping Eveleigh for Graham Mourie, but the biggest surprise was that they dropped Going, who had scored three tries against the Lions on tour, for Lyn Davis. The previous week, the Lions had demolished the powerful Auckland team by 34–15 and were favourites to win at Dunedin. They made only one change, replacing McGeechan with David Burcher.

It was yet another boggy surface, for you could not believe what a wet tour this was, and on the morning of the game they had a helicopter on the pitch trying to dry out the surface. New Zealand began spectacularly when, from the first lineout, they spun the ball to Bruce Robertson, who kicked ahead; the Lions defence made a hash of gathering and Ian Kirkpatrick scored. Bevan Wilson converted and, within a minute, the All Blacks led 6–0. Five minutes later, a break by Brynmor Williams

brought a try by Duggan, and the hectic pace continued as Haden charged over for a try in the 11th minute. The score of 10–4 stood until half-time.

In the second half, the Lions lost Brynmor Williams early on with a hamstring injury and, later in the half, lost J.J. Williams for the same reason. They were replaced by Doug Morgan and McGeechan. Irvine kicked a penalty, but Bevan Wilson, who had an inspired match, kicked two more penalties and Bruce Robertson dropped a goal, to give the All Blacks a well-earned victory by 19–7. The Lions' kicking had been deplorable, the pressure of the captaincy weighing on Bennett's game. Six out of seven attempts at goal had been missed and it was a frustrated and sad Lions team which contemplated the fact that it was now impossible to win the series.

For the fourth Test at Eden Park, Auckland, the Lions had lost four of their best players: Cobner, Quinnell, Brynmor and J.J. Williams, because of injury. Neary and Squire were brought in. Both of them had been playing superbly, and Neary's game against the Maoris was a *tour de force*. Even with these changes, the Lions pack was still too powerful for the All Blacks. Doug Morgan, a terrier of a scrum-half who was a good kicker, came in for Brynmor Williams, and McGeechan was restored at centre.

▲ Despite losing the series, the Lions' scrum proved a potent weapon throughout the tour and led to three-man scrums in the fourth Test

Once more the All Blacks forwards were outclassed, but again the Lions managed to lose a Test that they should have won. This was the game in which the All Blacks pack 'surrendered' at scrum time, packing down with three forwards rather than eight to try to counter the power of the Lions. All Blacks coach Jack Gleeson had actually practised the mini-scrum in training earlier in the week and it became a reality when the prop John McEldowney went off with an injury early in the second half. In those days players had to be checked by a doctor before a replacement was allowed, and so No. 8 Lawrie Knight joined Norton and Kent Lambert in the make-shift front row as flanker Mourie put the ball into the scrum.

Wilson opened the scoring with a penalty and Morgan kicked one for the Lions after 25 minutes, and then scored a tremendous try in which Cotton, Beaumont, Price and Fenwick all played a part. It gave the Lions a half-time lead of 9–3, and with their forward control it was hard to see how they could lose. Wilson kicked another penalty and then, in injury time, Osborne gathered a bad clearance kick and put up a speculative high ball. Fenwick and Wheeler were jolted in tackles from Osborne and Mourie. The ball went loose to Lawrie Knight, who ran 15 metres for the corner and the most vital try of the series.

Two more great All Blacks ended their careers with this game, namely Kirkpatrick, a real giant of a flanker in the game and truly one of the finest in the world, and the long-time respected hooker and captain, Tane Norton.

After the game, the Lions' dressing-room was like a morgue, with some of the hardest-bitten forwards in tears. They knew that they had provided the team with every opportunity to win the series, but it had been blown by the profligacy of the back play. It was a sad end to a sad tour, in which the old Lions tradition of having fun had somehow become lost in the unhappy character of the tour. For that, the management was to blame.

On the way home, they licked their wounds in Fiji, where, for the first time, the Fijian national team played the Lions. However, the jinx followed them and they lost to Fiji 25–21. It was typical that a strike at London Airport of air traffic controllers saw them arriving home 12 hours late, and their planned reception was cancelled. It had been that sort of an experience throughout.

RESULTS OF THE 1977 LIONS IN NEW ZEALAND AND FIJI

P 26 W 21 D 0 L 5 F 607 A 320

Wairarapa-Bush	W	41–13	Wellington	W	13–6
Hawke's Bay	W	13–11	Marlborough-Nelson	W	40–23
Poverty Bay-East Coast	W	25–6	New Zealand (Christchurch)	W	13–9
Taranaki	W	21–13	New Zealand Maoris	W	22–19
King Country-Wanganui	W	60–9	Waikato	W	18–13
Manawatu-Horowhenua	W	18–12	New Zealand Juniors	W	19–9
Otago	W	12–7	Auckland	W	34–15
Southland	W	20–12	New Zealand (Dunedin)	L	7–19
New Zealand Universities	L	9–21	Counties-Thames Valley	W	35–10
New Zealand (Wellington)	L	12–16	North Auckland	W	18–7
Hanan Shield Districts	W	45–6	Bay of Plenty	W	23–16
Canterbury	W	14–13	New Zealand (Auckland)	L	9–10
West Coast-Buller	W	45–0	Fiji	L	21–25

PHIL BENNETT'S 1977 LIONS TEAM

FULL-BACKS			FORWARDS		
B.H. Hay	Boroughmuir	Scotland	W.B. Beaumont*	Fylde	England
A.R. Irvine	Heriot's FP	Scotland	G.L. Brown	West of Scotland	Scotland
			T.J. Cobner	Pontypool	Wales
THREE-QUARTERS			F.E. Cotton	Coventry	England
D.H. Burcher	Newport	Wales	W.P. Duggan	Blackrock College	Ireland
G.L. Evans	Newport	Wales	T.P. Evans	Swansea	Wales
S.P. Fenwick	Bridgend	Wales	A.G. Faulkner*	Pontypool	Wales
C.M.H. Gibson	North of Ireland	Ireland	N.E. Horton	Moseley	England
I.R. McGeechan	Headingley	Scotland	M.I. Keane	Lansdowne	Ireland
H.E. Rees	Neath		A.J. Martin	Aberavon	Wales
P.J. Squires	Harrogate	England	A. Neary	Broughton Park	England
J.J. Williams	Llanelli	Wales	P.A. Orr	Old Wesley	Ireland
			G. Price	Pontypool	Wales
HALF-BACKS			D.L. Quinnell	Llanelli	Wales
R.P. Bennett (capt.)	Llanelli	Wales	J. Squire	Newport	Wales
J.D. Bevan	Aberavon	Wales	P.J. Wheeler	Leicester	England
A.D. Lewis*	Cambridge University and London Welsh		C. Williams	Aberavon	Wales
			R.W. Windsor	Pontypool	Wales
D.W. Morgan	Stewart's Melville FP	Scotland	*Replacements		
D.B. Williams	Cardiff				

8
THE TOPSY-TURVY EIGHTIES

The 1980s were to see dramatic changes in attitudes concerning overseas tours, due to the economic demands of the age. Amateur players found it harder to get away from work and the sacrifice of a job became too big a price to pay, even for the enormous satisfaction and honour of selection for the Lions. The lure of an all-expenses-paid trip to one of the more seductively beautiful countries in the world, described so vividly by the title of Alan Paton's famous book *Cry the Beloved Country*, was insufficient recompense for risking a future career, and therefore the short tour became accepted as a necessity, beginning in 1980.

It was, after all, the year when redundancies in Britain began to reach 40,000 a month and unemployment figures topped two million. There was a steel strike against closures, which lasted ten weeks; 100 men died when a North Sea oil rig collapsed; Hitchcock, Sartre, Tito, Henry Miller and Peter Sellers all died; the SAS stormed the Iranian embassy; and Prince Charles had a new girlfriend, Diana Spencer. Borg won Wimbledon for the fifth time, and Ovett and Coe won Olympic gold medals at a Moscow Games boycotted by the Americans. It was also the year when Rhodesia became Zimbabwe.

Everything was becoming more political in the rugby world. The players were beginning to rethink the old philosophy of amateurism, a process accelerated by the greater exposure to the southern hemisphere, especially in 1987, when, after years of soul-searching debates, the first prototype of the Rugby World Cup was held in Australia and New Zealand. Inevitably, it was the hidebound conservative British establishments which most resisted change and, in the end, England and Scotland in particular were dragged practically kicking and screaming into the World Cup by an ultimatum from the more blithe-spirited New Zealand and Australia.

That inaugural World Cup was won by New Zealand on home soil, although France, who ended as runners-up, and Wales, who finished third, flew the flag for the northern hemisphere. Up to 2011 there had been seven global tournaments, with the Webb Ellis Trophy heading south on all bar one occasion: England's famous triumph in Australia in 2003.

As for The British & Irish Lions, the 1980s was not a successful period, even though Finlay Calder's side managed to clinch a series win in Australia in 1989. As the table below shows, there was only one more Test win than in the 1960s and the percentage success rate in the internationals was well down on the 1950s (43.75 per cent) and 1970s (50 per cent) at 27 per cent. Only the 1960s was worse, with 14 per cent.

Lions Eras	P	W	D	L	Tests	W	D	L
1950s	88	69	2	17	16	7	1	8
1960s	80	54	8	18	14	2	2	10
1970s	74	65	2	5	12	6	2	4
1980s	48	38	0	10	11	3	0	8

1980
BILLY'S BATTLERS

Captain: Bill Beaumont (Fylde and England)
Squad Size: 30 players + 8 replacements
Manager: Syd Millar (Ireland)
Coach: Noel Murphy (Ireland)
Hon. Medical Officer: Jack Matthews (Wales)
Tour Record: P 18 W 15 D 0 L 3 F 401 A 244
Test Series: P 4 W 1 D 0 L 3

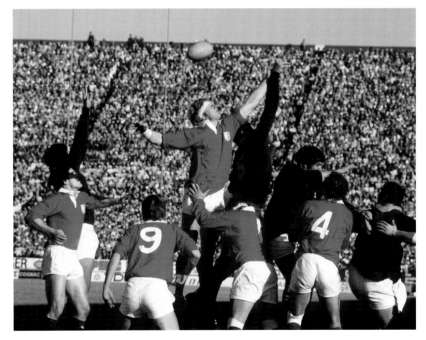

1980 TOUR KIT

The 1980 tour was, therefore, the first of the short tours, condensing 18 matches into ten weeks, which meant greater intensity with fewer easy matches and less time to build Test teams. It was also to be the centre of a bitter controversy in the year preceding the tour, as the anti-apartheid lobby gathered its considerable forces to try to prevent the tour taking place. Remember that resolutions had been passed in the United Nations and in the Gleneagles agreement among Commonwealth leaders, condemning apartheid and discouraging sporting contacts with South Africa. South Africa had not appeared at an Olympic Games since 1960 and were barred from competing internationally at athletics, cricket and soccer. All South African teams were barred from Australia, and a proposed Springboks tour to France was blocked at the last moment when the French government refused to grant them visas.

In the late summer of 1978, the IRB held a board meeting in South Africa and, while they were there, they investigated apartheid in South African rugby. Consequently, in April 1979, the South African Rugby Board absorbed the Coloured South African Rugby Federation and claimed that they represented all races, that coaching courses were to be arranged along non-racial lines, that equal provision, facilities and opportunities were to be given to players and spectators of all races, and that all national teams would be selected on merit from mixed trials. It all sounded pretty good and it was enough for the Four Home Unions to invite a South African Barbarians side to visit Britain.

Fresh from England's Grand Slam triumph, second row Maurice Colclough (centre) was one of eight Red Rose players originally selected for the tour

The opposition could not believe the naivety of the British rugby authorities in the matter, particularly when it was announced that the team would contain an equal number of black, coloured and white players. This was immediately perceived as being mere cosmetic window-dressing, and it was not surprising that there was immense political hostility to the tour, both externally and internally in South Africa.

▲ A ticket from the Lions' 1980 match against Natal. The tour sparked considerable controversy, with many political bodies arguing that it should not go ahead

The forces of HART (Halt All Racist Tours) and SANROC (South African Non-Racial Olympic Committee) mobilised their opposition. The Sports Council, headed by the three-times Lions tourist and former England scrum-half Dickie Jeeps, threatened to remove their annual grant to the RFU, and Hector Munro, the Minister of Sport, a rugby man who managed Scotland on their tour to Australia in 1970 and who had been president of the Scottish Rugby Union in 1976, also pleaded with the Tours Committee of the Four Home Unions.

They got short shrift, and the tour went ahead. It was managed by Chick Henderson, an Oxford Blue and Scottish international in the 1950s, and an old friend of mine who is one of the best of men. I played against Chick in the Welsh game in Edinburgh in 1953, and on one occasion we wheeled the first scrum and took the ball away with the feet, as we used to do in those days. However, we pushed the ball a few yards too far and suddenly Chick threw himself on it, just as I took an almighty kick to send it up to the Scottish line. Suffice it to say that the thud was heard all over Murrayfield and Chick was carried off for a few minutes' treatment. Cliff Morgan, in the meantime, was heard to say to Bleddyn Williams, 'We've won this bloody game!' The sequel was that I had not seen Chick for many years until the 1974 tour and, politely, I enquired about the back. Chick ran his hand over it and said, 'It's getting better!' Needless to say, that exchange has become a ritual between us whenever we meet.

The assistant manager was another charming man, Dougie Dyers, from the Coloured community in Cape Town. So good were Henderson's public relations and his relations with the press that the tour got through unscathed, apart from the Irish withdrawing their invitation because of pressure from their government.

All the same, anti-apartheid lobbies applied pressure to the impending Lions tour, as did a few others besides, such as the Supreme Council for Sport in Africa, which threatened to boycott the Olympics in Moscow and to disrupt the Commonwealth Games in 1982 in Brisbane, Australia. Meanwhile, the Four Home Unions continued to keep their cards close to their chest concerning the 1980 Lions to South Africa, and played for time.

Further pleas by Munro on behalf of the government, and by Jeeps and John Disley on behalf of the Sports Council, were made to the Tours Committee, which was chaired by Micky Steele-Bodger. He was a famous rugby man steeped in the old traditions, who played for Rugby School, Cambridge and Edinburgh Universities, Harlequins, Moseley, the Co-optimists, the Barbarians and England, and who later was to become president of the RFU and the Barbarians. The pleas were turned down and the Tours Committee decided in January that, as all four home nations were in agreement, the tour would go ahead. The final decision was made in the historic East India Club in St James's Square, London, where the news of the winning of the Battle of Waterloo by the Duke of Wellington had been brought to the Prince Regent, as he dined with the prime minister, Lord Liverpool, and the Foreign Secretary, Viscount Castlereagh.

They were considered to be supporting the *Verkramptes* (unenlightened) against the *Verligtes* (enlightened) and alienated many people in South Africa. Good men like Donald Woods, the Watson brothers, Peter Hain and Tommy Bedford, among many

others, opposed their view, because they understood what was meant by apartheid: a racial ideology which, among many abominations, kept wives, husbands and children apart. The events were overtaken by US president Jimmy Carter's boycott of the Olympic Games in Moscow, which drew most of the media's fire and took the heat off the Lions tour.

The British rugby establishment were seen by these people as giving succour to apartheid: as Bishop Tutu said, 'They made the other chaps [the government] feel a little better.' The British 'other chaps' believed that, by their going, the South African government would see the light. I have no doubt that what finally convinced the sports-mad Afrikaners, who had blindly followed the diktats of their government, to see reason was not any economic boycott but the loss of their rugby and cricket, and because world repugnance and the sporting boycott ate so deeply into their psyche.

If 1977 was the unhappy tour, then this was the unlucky tour. The Lions had so many injuries that they required a record number of eight replacements; thus the party included in all 15 Welshmen, ten English, eight Irish and five Scots. The party had been picked against the background of a disgraceful game at Twickenham, when Paul Ringer was sent off following a series of offences. England had finished top of the Five Nations Championship for the first time in 16 years and, led by their enormously popular captain Bill Beaumont, had won the Triple Crown and pulled off the Grand Slam to end one of their most barren periods without success. France, unusually, had finished bottom. The 41 tries scored in the championship were the most scored for 50 years, and Ollie Campbell with 46 and Andy Irvine with 35 had broken the respective Irish and Scottish points-scoring records. The omens for the tour, therefore, looked good.

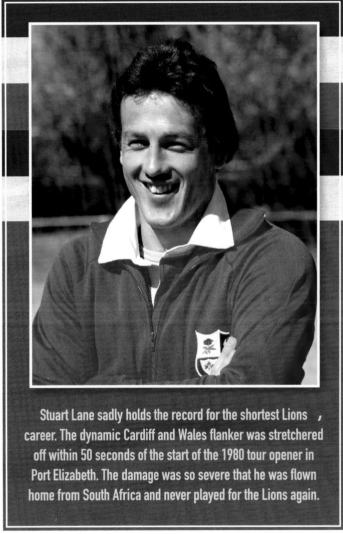

Stuart Lane sadly holds the record for the shortest Lions career. The dynamic Cardiff and Wales flanker was stretchered off within 50 seconds of the start of the 1980 tour opener in Port Elizabeth. The damage was so severe that he was flown home from South Africa and never played for the Lions again.

It didn't help that Tony Neary, Fergus Slattery and Roger Uttley weren't available for business reasons, nor that the injury plague began even before the Lions boarded the plane, when Irvine pulled out with hamstring problems with barely a day to go before departure. It meant Elgan Rees, the Neath and Wales wing who had been uncapped in New Zealand on the 1977 tour, had to be plucked out of the Welsh touring party to North America and sent in his place. David Richards then had to go home for a week following the death of his father, and the playing part of the tour wasn't a minute old when the first serious injury was sustained in the victory over Eastern Province. Stuart Lane had hardly broken a sweat before he tore his knee ligaments, an injury which eventually led to him being one of the first players to head home to Wales.

Lane's injury heralded an epidemic that saw the Lions robbed of the services of Irish full-back Rodney O'Donnell (neck) and Irish scrum-half Colin Patterson (knee); Welsh backs David Richards (shoulder), Gareth Davies (shoulder and knee) and Terry Holmes (shoulder and knee); and English props Phil Blakeway (ribs) and Fran Cotton (suspected heart trouble). On top of that, the English wing Mike Slemen returned home due to a family illness. Yet somehow the 1980 Lions won each and every one of their 14 provincial fixtures and managed a final Test victory over the Springboks, having pushed their opponents mightily close in the previous three internationals.

Injuries came thick and fast, with an unprecedented eight replacements having to be sent out. Consequently, we saw three outside-halves employed in the series, in Tony Ward, Gareth Davies and Ollie Campbell. We also saw five centres used and four wings, whereas the front five of the pack played together throughout the series and there were only four back-row men employed. It is evident where the problems were.

It was the first Lions party to take a doctor with them. In Dr Jack Matthews, a Welsh Lion of 1950, they had the right man, and my word, how he was needed! In fact, these Lions could have done with a team of doctors.

Because of the political content of the tour due to the pre-tour controversies, there was the largest-ever contingent of pressmen and photographers from the UK and Ireland covering the tour. By now the tabloids were gaining strength and were looking for off-the-field stories, and they soon became known as 'the rat pack' by the players. So well did these Lions conduct themselves, and so good-natured and comparatively relaxed were they (in contrast with 1977), that these so-called 'colour writers' found little or no dirt to write about.

It was obvious that strong management was needed for such a tour, and the big, bluff and genial Irishman Syd Millar, with a wealth of experience, was the perfect man. He had played in 43 matches on three Lions tours, including nine Tests, and then extended his Lions career by coaching the previous side in South Africa, the unbeaten 1974 Lions. To partner him, they chose an equally genial, gregarious and tough character in Noel 'Noisy' Murphy from Cork, who was Ireland's most-capped flanker until Slattery overtook him in 1980. Noel was an unusual animal, for he was a teetotaller, but it never seemed to quash his exuberance. He, too, had a rich Lions heritage, having played 36 times on two tours, including eight Tests. So we had a Northern Irish Protestant and a Southern Irish Catholic in charge, which was a fair balance. They did not have to look far for a captain, and Bill Beaumont was duly rewarded for his success in the Five Nations Championship, and became the first Englishman to captain the Lions since Douglas

▲ Lions manager Syd Millar (left) shares a joke with Springbok coach Nelie Smith before the tourists' game against a South African Rugby Federation XV in Stellenbosch. Millar earned rave reviews for his efforts throughout the tour

◄ After leading England to the Grand Slam in March, Fylde second row Bill Beaumont, a natural leader if ever there was one, was named Lions captain for the South Africa tour

Prentice 50 years earlier. Bill had the stature, the strength of character, and a deep sense of loyalty to those in his charge, and was one of the most popular choices ever. This triumvirate had no critics whatsoever.

One of the most poignant moments of the tour, which gave me an insight into Beaumont's character, came when a local man in Windhoek, South West Africa, invited the Lions to a shoot on his private game reserve. I happened to be within a couple of yards of Bill when a warden signalled to us to stay still, and suddenly a massive kudu, with huge spiralling horns, appeared out of the bush and Bill was asked to shoot it. I sensed his reluctance to fire but, egged on by his hosts and some of his team, he brought it down. I was studying his face, which suddenly looked distraught, and I knew he was bitterly regretting his action; if you offered him ten thousand pounds to do it again, I am sure he would have refused. He was such a big man, with all the toughness of a world-class rugby player, but underneath he was a sensitive man with deep feelings, and for a while after this incident he was difficult to console.

Because of Beaumont's outstanding captaincy and the guiding hand of the admirable management of Millar and Murphy, the Lions were a well-controlled and disciplined party, but they were not quite good enough. Although they had a powerful pack which could hold its own with anything that the Springboks could throw at them, they again lacked a couple of midfield backs capable of sparking the team in running attack.

In the original squad, announced on Monday, 17 March, there were 12 Welshmen, eight English, five Scots and five Irish. No fewer than 11 of the squad had Lions experience, with Derek Quinnell and Fran Cotton making their third tours. They were to meet a Springboks side which, although short of Test experience

because of the boycott, were nevertheless able to keep up their standards because of the growing strength of their Currie Cup competition. Although the Lions matched the achievement of their 1974 counterparts in winning all their provincial games, several were close encounters. They did, however, beat two of the strongest provinces, Northern Transvaal and Western Province, with some ease, the latter by 37–6, which was their biggest defeat since Hammond's team in 1896.

They also produced one of the finest tries I have ever seen when, against a South African Invitation XV, they scored what must also be the most astonishing and glorious try ever experienced in South Africa, which snatched a 22–19 victory from what looked like certain defeat. It began when Richards broke from a lineout in his own 22 and darted upfield. What was to happen next beggared belief, for the ball went through a total of four rucks, with Quinnell digging it out three times, and it went through 30 pairs of hands, before Slemen finished it off with a try under the posts. The videotape revealed that the movement lasted one minute and 45 seconds.

The Lions won all six of their provincial games leading to the first Test, but there were signs that the Springboks were stiffening their sinews and it was evident that they had absorbed many of the lessons of 1974. When the Lions were in Bloemfontein to play the Orange Free State, including de Wet Ras (Wouter Johannes de Wet Ras), who was expected to be in the Springboks team, that archetypal Welshman, the lovable Ray Gravell, destroyed him with a tackle that was almost as

▼ Lions wing Mike Slemen (No. 11) races through to score a sensational try against a South African Invitation XV in Potchefstroom and seal a narrow 22–19 triumph

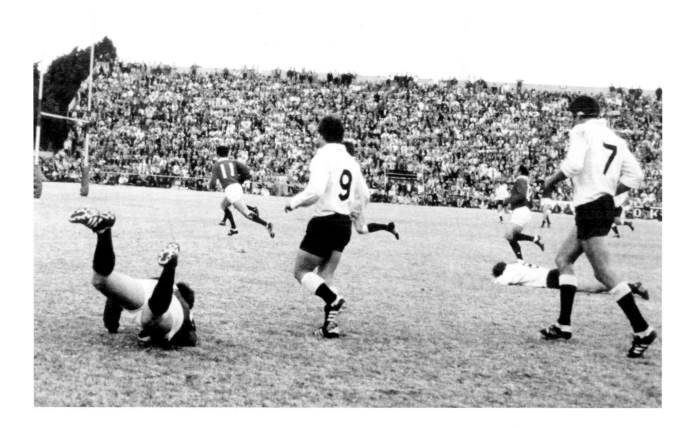

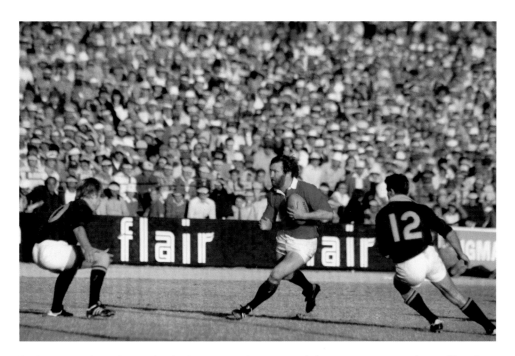

◄ Llanelli and Wales centre Ray Gravell was a hard-hitting presence on the pitch and an ideal tourist off it, always ready to lighten the mood

high as the altitude at which they were playing, and de Wet Ras was taken off with a broken jaw. I was phoning my copy back to the London paper immediately on the whistle and finding it difficult to describe Ray's indiscretion, so I said, 'Ray Gravell had a pretty woolly game and his high tackle broke Ras' jaw', because everyone who knows Ray believes that he would not have done it on purpose. I did not realise that Carwyn James, his Llanelli coach and mentor, was sitting next to me and heard every word which, gleefully, he related to the always over-anxious Ray, who then made my life a misery for the next couple of days by coming up to me and asking, 'What do you mean by woolly?'

The sequel to this came a few days later, when we were waiting for a plane in Jan Smuts airport, Johannesburg. A voice in a guttural Afrikaans accent came over the tannoy: 'Would Mr Clem Thomas please report to the information desk immediately, because he has left his hotel without paying his bill.' It was Ray Gravell, who was later to become a paid-up member of Equity.

Although the Springboks took their revenge for 1974 and won the series 3–1, things might have been different but for the injuries and illness, including that of Fran Cotton, who developed pericarditis. However, South Africa were a fine side led by one of their greatest leaders, Morne du Plessis, and they contained some tremendous players like Ray Mordt and Rob Louw. It was also to be the Lions' first glimpse of the influential Northern Transvaal outside-half Naas Botha, who became regarded as South Africa's greatest-ever kicker and match-winner. The Springboks perhaps surprised the Lions by their enterprising running, with Gysie Pienaar being especially effective as a running full-back. South Africa also had some typically large locks in 'Moaner' van Heerden (whose real names are Johannes Lodeiwkus), Kevin de Klerk and Louis Moolman.

The Lions already had seven players out of contention for the first Test, but their forwards always had the edge. However, their backs let them down, while the Springboks' backs used every opportunity. Rob Louw's pace gave South Africa their first score and it developed into a competition to see whether South Africa could score enough tries to keep up with Tony Ward's exceptional goal kicking. He scored

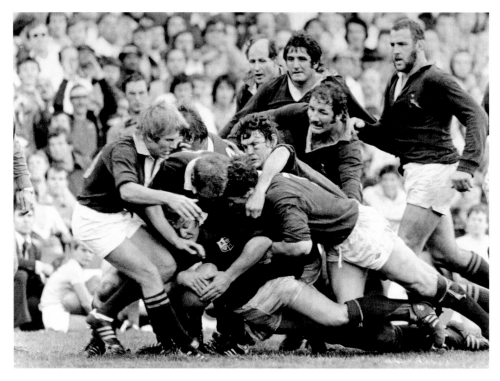

18 points with five penalties and a drop goal, to break the South African record of 17 points established by Tom Kiernan 12 years earlier. The only Lions try was scored by Graham Price. Meanwhile Willie du Plessis, van Heerden and Gerrie Germishuys all went over for tries, and Naas Botha added three conversions to make it 22–22. It was Rob Louw again who created the winning try for Divan Serfontein, for a narrow 26–22 win by South Africa.

The second Test saw the late arrival, Andy Irvine, at full-back in place of O'Donnell; Woodward and Gravell came in for Renwick and Richards; and Bruce Hay replaced Slemen, who had to go home due to illness in his family. Gareth Davies replaced Ward at outside-half, but the pack remained in its entirety, so it is obvious where the selectors thought their problems lay. The Springboks team only had one change, with de Klerk coming in for van Heerden.

It was Lions' errors turned to advantage by the Springboks which won the game, and Gysie Pienaar had a marvellous day, punishing many ill-conceived kicks by the Lions. South Africa scored a try almost identical to the one which started their scoring in the first Test, and it was Louw again who scored it. John O'Driscoll replied with one for the Lions from a chip by Patterson, and Davies converted from the touchline.

Botha then kicked a penalty and Stoffberg scored a try, which the neutral referee Francis Palmade (the first, incidentally, in the history of Lions rugby) should have disallowed, for Mordt had got up with the ball after a tackle. However, it stood and Botha converted to make the Lions 13–6 down after a period of sustained attack which ought to have seen them into the lead. It was a mortal blow and there seemed no way back, particularly after Botha had kicked another penalty, but Gareth Davies also scored and it was 16–9 to South Africa at half-time.

The Lions then pulled up to 16–12 with another penalty by Davies, and Irvine kicked a monster to make it 16–15. Davies then became the next casualty with badly injured knee ligaments and Campbell, his replacement, missed a penalty from 30

yards, but wide out. Germishuys scored a try from a cross-kick by Pienaar and the Lions were finally buried by a try by Pienaar, which Botha converted. Gravell had the last word, with a try in the closing minutes to make it 26–19, but by then the Lions had already frittered away the game.

The Lions needed to win the third Test in Port Elizabeth to stay alive in the series. They brought Paul Dodge into the centre for Woodward, who replaced Carleton on the wing, Campbell for Davies at outside-half, and Colm Tucker came in at flanker, as Squire replaced Quinnell at No. 8. The Springboks changed only van Heerden for de Klerk. For once, the Lions took the early lead with a penalty by Campbell but, midway through the half, Botha kicked the equaliser. Hay, a hundred per cent player if ever there was one, then went over for a try. Soon after half-time, Botha dropped a goal and Campbell landed another penalty; the Lions led by 10–6 and seemed totally in the ascendancy but, as so often happens, South Africa stole another try by Germishuys and Botha converted, to win a game which the Lions should have won comfortably. Morne du Plessis said that the better team lost, but that was no consolation for the Lions forwards, who had won so much ball from rucks, mauls and lineouts, only to see their backs fail to put points on the board.

A midweek frolic against the South African Barbarians, who included the brilliant Argentinian Hugo Porta, followed by a stunning defeat of Western Province, was part of the run-up to the final Test, which showed that the Lions were not giving up and that morale was still high.

In the end, they avoided the ignominy of being the first Lions to be whitewashed by South Africa in the Test matches, and they also became the first Lions to win the fourth Test. After an exchange of penalties by Campbell and Botha, Clive Williams, the prop, burrowed his way over for a try, for the Lions to lead at half-time. Willie du Plessis then scored a try to level and Pienaar, who replaced Naas Botha as kicker after he was booed by his home crowd in Pretoria, seemed to put the Lions in familiar trouble, but they then scored two tries in as many minutes through Irvine and O'Driscoll, and

▲ Skipper Bill Beaumont (centre) and manager Syd Millar (right) talk to the press after the climax of the tour and the Lions' 17–13 victory in Pretoria in the fourth Test

a final conversion by Campbell saw them secure a narrow victory, which was a meagre return for their forward dominance. It left the South Africans wondering what had happened to British back play as practised, best of all, by the 1955 Lions.

Beaumont was carried off shoulder high and he deserved nothing less. He had kept the team going right to the bitter end, when they finally got to taste success. Years later he said in an interview:

I went on two tours and I have to say the honour of being picked for the Lions elevates you onto an even higher level than playing for your country. You have to prove yourself all over again among a new group of players when you tour with the Lions, and they are the very best from each of the four countries.

To play in a winning Lions Test team is a very special and huge honour. I was fortunate enough to taste success on my Lions Test debut against New Zealand in 1977 and then win again in South Africa in 1980.

But we weren't able to win either series, even though the packs of 1977 and 1980 were among the best ever produced by the Lions. We got close in both series, but weren't able to turn our pressure into victories. We were very unlucky with injuries. We had to play four different half-back combinations in the series and lost the services of Terry Holmes and Gareth Davies.

I still think we should have at least tied the Test series. As it was, we were unlucky to lose the first, got well beaten in the second, got pipped in the third and won the fourth.

As I have said, it was a happy tour for the Lions and their supporters, which was epitomised when my wife, who came out for the last couple of weeks, asked Carwyn James, travelling with myself and John Reason, if he had enjoyed it. His reply to her was, 'I wish it could go on for ever.'

RESULTS OF THE 1980 LIONS IN SOUTH AFRICA

P 18 W 15 D 0 L 3 F 401 A 244

Eastern Province	W	28–16	Eastern Transvaal	W	21–15	
SARA Invitation XV	W	28–6	South Africa (Bloemfontein)	L	19–26	
Natal	W	21–15	Junior Springboks	W	17–6	
SA Invitation XV	W	22–19	Northern Transvaal	W	16–9	
Orange Free State	W	21–17	South Africa (Port Elizabeth)	L	10–12	
SAR Federation XV	W	15–6	SA Barbarians	W	25–14	
South Africa (Cape Town)	L	22–26	Western Province	W	37–6	
SA Country Districts	W	27–7	Griqualand West	W	23–19	
Transvaal	W	32–12	South Africa (Pretoria)	W	17–13	

BILL BEAUMONT'S 1980 LIONS TEAM

FULL-BACKS
B.H. Hay	Boroughmuir	Scotland
A.R. Irvine*	Heriot's FP	Scotland
R.C. O'Donnell	St Mary's College	Ireland

THREE-QUARTERS
J. Carleton	Orrell	England
P.W. Dodge*	Leicester	England
R.W.R. Gravell	Llanelli	Wales
P.J. Morgan	Llanelli	Wales
H.E. Rees	Neath	Wales
J.M. Renwick	Hawick	Scotland
D.S. Richards	Swansea	Wales
M.A.C. Slemen	Liverpool	England
C.R. Woodward	Leicester	England

HALF-BACKS
S.O. Campbell	Old Belvedere	Ireland
W.G. Davies	Cardiff	Wales
T.D. Holmes	Cardiff	Wales
C.S. Patterson	Instonians	Ireland
J.C. Robbie*	Greystones	Ireland
S.J. Smith*	Sale	England
A.J.P. Ward*	Garryowen	Ireland

FORWARDS
J.R. Beattie	Glasgow Academicals	Scotland
W.B. Beaumont (capt.)	Fylde	England
P.J. Blakeway	Gloucester	England
M.J. Colclough	Angoulême	England
F.E. Cotton	Sale	England
S.M. Lane	Cardiff	Wales
A.J. Martin	Aberavon	Wales
J.B. O'Driscoll	London Irish	Ireland
P.A. Orr*	Old Wesley	Ireland
A.J. Phillips	Cardiff	Wales
G. Price	Pontypool	Wales
D.L. Quinnell	Llanelli	Wales
J. Squire	Pontypool	Wales
I. Stephens*	Bridgend	Wales
A.J. Tomes	Hawick	Scotland
C.C. Tucker	Shannon	Ireland
P.J. Wheeler	Leicester	England
C. Williams	Swansea	Wales
G.P. Williams*	Bridgend	

*Replacements

1983
TELFER'S TOIL AND TORMENT

1983 TOUR KIT

Captain: Ciaran Fitzgerald (St Mary's College and Ireland)
Squad Size: 30 players + 6 replacements
Manager: Willie John McBride (Ireland)
Coach: Jim Telfer (Scotland)
Hon. Medical Officer: Donald McLeod (Scotland)
Tour Record: P 18 W 12 D 0 L 6 F 478 A 276
Test Series: P 4 W 0 D 0 L 4

The principle of the shorter tour had been widely accepted, but not by all of those who really mattered. Willie John McBride and Jim Telfer, manager and coach respectively of the 1983 tour to New Zealand, were old warriors who understood the necessity of building a team by making these united nations' representatives battle-hardened in the minor skirmishes before the real battles in the Test arenas. To play an international against New Zealand within three weeks of arrival made no sense at all to them. The issue of shorter visits made some question the validity of Lions tours, pointing out that perhaps individual countries, with their strengths and weaknesses more instinctively known through familiarity, may be the better option.

With McBride as manager and Ciaran Fitzgerald as captain, there was always going to be a strong Irish influence on the campaign, especially following Ireland's Triple Crown success of 1982 and back-to-back championship titles in the same season and 1983. But the fact that they had a record only marginally better than the 1966 tour, who held the unenviable record of having the worst results ever by a British Isles team touring New Zealand, was not their fault.

At the time, Iranian forces had crossed into Iraq; Breakfast TV was launched; Shergar was kidnapped; Australia won the Ashes; the Greenham Common protest against the siting of missiles in the UK began; President Ronald Reagan expounded his 'Star Wars' theory; the film *Gandhi* won eight Oscars and Lester Piggott won his ninth Derby.

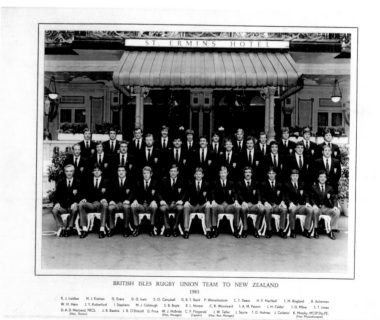

BRITISH ISLES RUGBY UNION TEAM TO NEW ZEALAND
1983

R. J. Laidlaw M. J. Kiernan G. Evans D. G. Irwin S. O. Campbell G. R. T. Baird P. Winterbottom C. T. Deans H. P. MacNeill T. M. Ringland R. Ackerman
W. H. Hare J. Y. Rutherford I. Stephens M. J. Colclough S. B. Boyle R. L. Norster C. R. Woodward I. A. M. Paxton J. H. Calder I. G. Milne S. T. Jones
D. A. D. MacLeod, FRCS J. R. Beattie J. B. O'Driscoll G. Price W. J. McBride C. F. Fitzgerald J. W. Telfer J. Squire T. D. Holmes J. Carleton K. Murphy, MCSP Dip.PE.
(Hon. Doctor) (Hon. Manager) (Captain) (Hon. Asst. Manager) (Hon. Physiotherapist)

▲ Captained by Ireland hooker Ciaran Fitzgerald, the original 30-man Lions squad for New Zealand featured eight Welsh and eight Scottish players while England and Ireland both provided seven tourists

When it came to counting wins, the Lions finished with 12 from 18 starts, with a difficult pre-tour selection presenting Telfer with a daunting task. Imagine leaving out Paul Dodge, among many other questionable errors of judgement.

There was also another dreadful injury list, with Donal Lenihan forced out by a hernia injury even before the flight over to New Zealand, although he later joined the party as one of the replacement players required. The key Welsh trio of scrum-

▲ Wales scrum-half Terry Holmes sustained a serious knee injury in the first Test against the All Blacks in Christchurch. He was replaced on tour by uncapped English number nine Nigel Melville

half Terry Holmes, back-row forward Jeff Squire and prop Ian Stephens all failed to go the distance and were forced to return home early, with the loss of Holmes after just 30 minutes of the first Test a hammer blow. Allied to that was the fact that many players in key positions failed to play to their potential and beyond, while players from all nations were starting to question their role as cannon fodder on the world stage as once again we saw players involved in scenes of attrition in a game which is supposed to be about fun and enjoyment.

Australian David Lord was also getting players to listen to his wild scheme of a professional circus, and there were rumours that around 200 players – including many of the Lions – had signed up. It proved to be pie in the sky, but it was the catalyst which began the rapid advance over the next 12 years towards rugby union becoming a professional game.

A recurring theme in this Lions story was the scale of injuries sustained on the tours, and in 1983 there was no more sorry sight than seeing Holmes propped up in his bed in Ward 10 of Christchurch's Whitchurch Public Hospital.

The Welshman fell awkwardly jumping for a long lineout ball, tearing the anterior cruciate ligament, rupturing the posterior capsule and tearing the medial ligament of his right knee – the same knee that had been damaged on the 1980 Lions tour of South Africa and forced him home early then as well. And then there were the events of the Manawatu game, which turned into a bloody pitched battle ahead of the first Test, when the Lions' dressing-room was a horrible place to be (and one which the Lions doctor Donald McLeod said he viewed with repulsion because of the injuries). Colin Patterson was also injured on that 1980 tour and needed carbon fibre surgery to repair the damage, and Rodney O'Donnell broke his neck while making a tackle on Danie Gerber in the Junior Springboks game, necessitating a graft from his hip on the sixth and seventh vertebrae. These finally convinced me, if I needed any convincing after personal experience, that Lions tours were, on occasions, no longer rugby but war. Indeed they were crusades, so little wonder that the top players began to look for some reward for their endeavours. The only surprising feature was that the game's administrators took so long to realise that it was they, by piling on the pressure of more and more tours, and finally the concept of the World Cup, who guaranteed that professionalism would finally become a reality in 1995.

The results of this tour again mirrored the decline of British and Irish rugby in the 1980s. Without any profound analysis, the brutal truth was that the All Blacks were a far better team and outplayed the whitewashed Lions in the four Tests. The All Blacks outscored the Lions 9–2 in tries overall, with wing Stu Wilson scoring a hat-trick in the 38–6 fourth Test defeat at Eden Park as the Lions suffered their heaviest reverse and worst losing margin to cap a troubled tour.

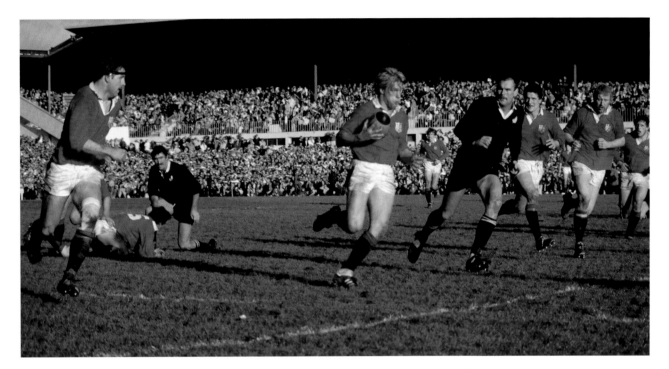

For all that, they were a splendid bunch of men who accepted their vicissitudes and worked hard for elusive success, while Willie John, who was perhaps too protective of his team at times, kept their morale up and ensured they soldiered through to the end.

However, the tour itinerary was a suicidal one. Telfer prepared soundly, but seven matches in the first three weeks, including games against Auckland, Wellington and Manawatu and culminating in the opening Test, put the Lions on the back foot almost from the start.

Some critics took a hard line, and one in the *Irish Tribune* even went so far as to suggest that 'the nearest some of these Irish Lions should have come to this tour was Dublin Zoo'. It took a long time for the Irish to forgive him and meanwhile, when covering internationals, he would fly in and out of Dublin on the same day. Much of the criticism revolved around the fact that most thought Colin Deans was the better hooker in the party, this belief also being held by the All Blacks captain, Andy Dalton. The main criticism levelled at Fitzgerald was that his throwing in at the lineout was weak, but otherwise he soldiered like the stalwart he was, for he was a captain in the Irish army and could always be found in the thick of the fray. He also maintained his dignity as a leader, which was more than you could say for some of his critics. To suggest that the failure was down to him was sheer fantasy.

The zoo story, although amusing, was completely over the top, for the Irish were neither worse nor better than most of the others. Without question, the best forward was Peter Winterbottom, who covered more ground and performed more bravely than anybody. The most indomitable tight forward was Graham Price, who was indestructible. He anchored the scrum from the tight-head and was a cornerstone of the scrummaging and close behind him came Ian Stephens.

Another exceptional forward was Squire, who was a class player, and when he was injured and flown home with Holmes and Stephens it was one of the lowest points of tour morale. You simply could not lose three players of genuine Test class and expect to succeed.

▲ Despite the Lions' travails in New Zealand, tough-tackling England flanker Peter Winterbottom (centre) enjoyed a fine tour and started all four Tests against the All Blacks

Other forwards to do well were Maurice Colclough, now a mature player; Steve Bainbridge; Bob Norster; John O'Driscoll; and the two Scots, Iain Paxton and Jim Calder.

But, once more, the backs, as a unit, were hardly up to Lions standards. Holmes was irreplaceable. His successor, Roy Laidlaw, made a fair fist of it, however, and the failure of the attack was not down to him. Neither was it down to Ollie Campbell, whose support play, defence and especially his goal kicking, were superlative.

Campbell was on target with 22 of his 26 penalty goals attempts and 18 of his 26 conversions for an overall strike rate of 77 per cent, with the others sharing the kicking duties being Dusty Hare (64 per cent), Gwyn Evans (57 per cent), Clive Woodward (33 per cent) and Hugo MacNeill (30 per cent).

John Rutherford had moments of inspiration as a runner and wing John Carleton was the most dangerous three-quarter, while Roger Baird showed that, with more opportunities, he could be dangerous, but the centre combinations never got going.

Meanwhile, the Lions were up against formidable All Blacks forwards – some things never seem to change much, do they? The impressive Dalton, who was picked to captain New Zealand in the first World Cup but never played due to injury, was chosen as captain and he had some seasoned forwards under his command in props Garry Knight and John Ashworth, locks Andy Haden and Gary Whetton and a tremendous back row in 'Cowboy' Shaw, Murray Mexted and Jock Hobbs. Unusually, this pack played throughout the Test series. Behind them they had the dynamic Dave Loveridge at scrum-half, one of the fastest passers in the game, but the rest of the backs were fairly ordinary, apart from the determined Bernie Frazer, who had Bernie's Corner in Wellington named after him. And, of course, they had a certain Stu Wilson.

The only defeat going into the first Test was against Auckland in the second tour match, which, predictably, the Lions lost 13–12. The Lions were badly outplayed in the forwards with Haden and Whetton, two of the greatest locks in the world at that or any other time, dominating the lineouts.

The first indication of the likely Test team came when they twice came from behind to beat Wellington 27–19, all three of the Lions' tries coming in the last 25 minutes.

The first Test at Lancaster Park was seen as probably the best chance the Lions had of winning a Test before the All Blacks started to gel, but although it was a fine day in Christchurch the surface was greasy after rain earlier in the week. Campbell opened the scoring with a sixth-minute penalty but ten minutes later Hewson replied with one from way out on the touchline and about 50 metres from goal, and then kicked another.

A programme from the first Test at Christchurch, which was preceded by a police band and a dog obedience display – an indication of how much professionalism has changed all facets of the game

Campbell levelled with a drop goal and was successful with another penalty, and at half-time the Lions led tentatively by 9–6.

The Lions were now without the injured Holmes, and after Hewson made it 9–9 with another penalty, the All Blacks scored the only try of the match. The ball was moved across the New Zealand back line and Hewson and Frazer created an opportunity for Shaw to grab the loose ball and power over for an unconverted try. Campbell reduced the deficit to a single point with another penalty and, with the

Lions finishing strongly, it became a desperate battle for victory. However, with just seconds remaining, Hewson fielded a clearance kick by Campbell to drop a superb 45-metre goal and settle what was a close and desperate encounter, the All Blacks taking the spoils with a 16–12 win.

The defeat was made all the more bitter by the loss of Holmes, who was replaced by Nigel Melville. But he lasted only one game before becoming the next victim of the jinx when he was felled by a rabbit punch in the clash with North Auckland after having marked his tour debut with two tries against Southland. The irrepressible Steve Smith was summoned as the next No. 9 replacement.

The Lions knew they should have won the first Test, having squandered a golden try-scoring opportunity just before half-time. This, along with three big wins en route to the second Test in Wellington, filled them full of confidence.

The All Blacks restricted themselves to a single change, bringing in Wayne Smith, back from injury, to replace Ian Dunn, while the Lions made five changes, although Norster should not have played due to a back injury. In came Michael Kiernan (nephew of 1968 Lions tour skipper Tom), Carleton, Laidlaw, Staff Jones and O'Driscoll for Robert Ackerman, Trevor Ringland, Holmes, Stephens and Squire respectively.

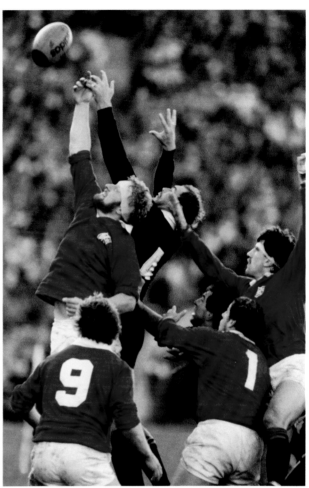

▲ Lineout action from the second Test in Wellington. A crowd of 39,000 packed Athletic Park for the game as the All Blacks edged out the tourists 9–0 courtesy of a try from Dave Loveridge

Dalton won the toss and played with the usual strong southerly wind blowing straight down Athletic Park. Its strength was such that a Hewson clearance kick from his own goal line rolled over the Lions' dead-ball line – a distance of over 100 metres. Loveridge opened the scoring with a 15th-minute try, darting over from a close-range maul, with Hewson adding the conversion and a penalty so that the All Blacks led by nine points at half-time despite the Lions attacking strongly. The lead looked far from insurmountable and everyone expected the Lions to go on and win – everyone except the All Blacks, that is.

They promptly resorted to their old tactic of driving the blind side whenever possible, allied to some tremendous discipline that denied Campbell a single shot at goal, with MacNeill failing with his only chance from long range. The Lions failed in the first half to convert from a defensive mode to attack and, as the renowned sports writer Hugh McIlvanney (of the *Sunday Times*, then with *The Observer*) observed, 'The final score of 9–0 was a euphemism for disaster.'

Once again the Lions had let two Tests slip through their fingers and there was now no way back, for two down with two to play was an impossible situation. After a short break in the Bay of Islands at Waitangi, they beat North Auckland with an indifferent performance and then lost to Canterbury – not the best preparation for the third Test in Dunedin. They made four changes, with Gwyn Evans, Rutherford, Calder and Bainbridge coming in for MacNeill, Dave Irwin, O'Driscoll and the injured Norster. The All Blacks knew they were on a roll and fielded an unchanged team.

Dunedin, I remember, was gripped by wet and Antarctic weather, and the soggy Carisbrook surface did not exactly provide ideal conditions for open play, but the Lions, to their credit, went down with a blazing show of defiance and outscored the All Blacks 2–1 in tries.

Frantic early pressure saw the always-alert Baird beat Loveridge and aquaplane over in the corner for a try from a Campbell kick, but two Hewson penalties gave the All Blacks a 6–4 lead at half-time, with the teams changing ends almost immediately in freezing conditions that saw a number of players, in particular Hewson, verging on suffering from hypothermia.

Early in the second half, Rutherford combined with Baird and Evans to score a fine try for a two-point lead, which they clung onto until the final quarter, when Loveridge made an exquisite break for Wilson to score near the posts. Campbell was again denied a single penalty shot at goal, and Hewson's conversion and later penalty ensured a 15–8 victory and the series, but nobody could ever say the Lions had not tried – they were simply not as good as the All Blacks.

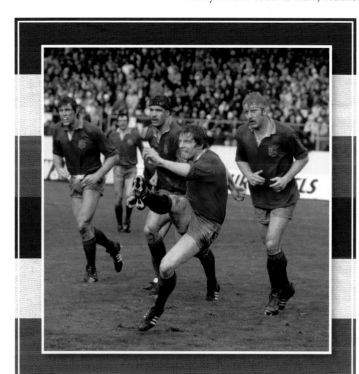

The third Test at Carisbrook in Dunedin was played in conditions so brutal that both sets of players stayed in the dressing-room during the anthems, while several of the All Blacks, including Allan Hewson — who had previously been hospitalised with exposure at the same ground — wore gloves during the match. 'I have never played in conditions like it,' remembers fly-half Ollie Campbell. 'We might as well have played it on the South Pole itself. The New Zealanders were wearing wet suits under their jerseys, and they put plastic bags between their socks and their boots. I remember running out on the red carpet, stepping off onto the pitch and it was like putting your foot in a bucket of ice — five minutes: numb hands, numb feet, numb brain.'

Their brave efforts in the first three Tests were overshadowed in the end by the superb play of the All Blacks in the final Test in Auckland, with Dunn resuming for the injured Smith at outside-half. Having won the series, they indulged in a breathtaking display of attacking rugby, which simply left the Lions for dead. Rutherford was ruled out with an injury and replaced by Irwin, and O'Driscoll was recalled in the back row, but the All Blacks were at their very best and totally outplayed the Lions pack, who were left groping at thin air.

They gave Loveridge an armchair ride and he had an immense game as New Zealand ran in six tries through Wilson — whose hat-trick took him to a national record of 18 Test tries – Hobbs, Hewson and Haden. Hewson added four conversions and two penalties, with the Lions only able to manage penalties from Campbell and Evans.

It was obvious that British rugby had gone backwards since the early 1970s, whereas in New Zealand and Australia it had moved on, due to far better competitive structures. In England, John Burgess had come up with a report and a blueprint for English rugby which made urgent suggestions for more competitive rugby, but, typically, it was turned down.

Instead, they began questioning the role of the Lions after such a whitewash, but any

individual country at the time would have suffered a far greater disaster. Neither was it the fault of the management and leadership, for you would have great difficulty in finding better men than Willie John McBride, Jim Telfer or the much-maligned Ciaran Fitzgerald, and it was evident that something had to be done about British and Irish rugby.

This eventually led to the competitive league structures being universally adopted in the British Isles and Ireland. They failed, however, to close the gap between club and international rugby in the way achieved by the provincial competitions of the southern hemisphere countries.

In April 1986, the Four Home Unions, beset by the world lobby against apartheid, broke the Lions tour schedule by calling off their projected tour to South Africa. However, a Lions team was selected to help celebrate the centenary of the IRB, the principal governing body. It was only the second time a Lions team had appeared on British soil, and a 21-player squad was assembled to play a team drawn from the rest of the International Board countries at Cardiff Arms Park under manager Clive Rowlands and coach Mick Doyle. Scottish back-row man Beattie scored the Lions' only try in a 15–7 defeat.

The Lions XV was: Gavin Hastings (Scotland); Trevor Ringland (Ireland), Brendan Mullin (Ireland), John Devereux (Wales), Rory Underwood (England); John Rutherford (Scotland), Robert Jones (Wales); Jeff Whitefoot (Wales), Colin Deans (Scotland, captain), Des Fitzgerald (Ireland), Wade Dooley (England), Donal Lenihan (Ireland), John Jeffrey (Scotland), John Beattie (Scotland), Nigel Carr (Ireland) Replacements: Malcolm Dacey (Wales) for Rutherford and Iain Paxton (Scotland) for Dooley.

This was the only time the players were issued with blazers and ties and considered official Lions. On another occasion, a Lions team played in Paris after the 1989 tour to celebrate the formation of the French Republic. It was not a full Lions team, as late replacements were made and Finlay Calder refused to be involved because partners were not invited.

For the record, the team in Paris won 29–27, with Gavin Hastings scoring two of his side's three tries and ending with 22 points and skipper on the night Rob Andrew scoring a try and a drop goal. The Lions XV was: Gavin Hastings (Scotland); Scott

▲ Skippers and opposing hookers Andy Dalton (top left) and Ciaran Fitzgerald (top right) embrace after the All Blacks' 38–6 victory over the Lions in Auckland. Fitzgerald and tour manager Willie John McBride (bottom) put their heart and soul into the tour but it was clear that British rugby had fallen behind the game in New Zealand

Hastings (Scotland), Jeremy Guscott (England), Brendan Mullin (Ireland), Rory Underwood (England); Rob Andrew (England, captain), Rob Jones (Wales); Mike Griffiths (Wales), Steve Smith (Ireland), Jeff Probyn (England), Damian Cronin (Scotland), Paul Ackford (England), Andy Robinson (England), Phil Matthews (Ireland), Dave Egerton (Bath).

The World Cup arrived in 1987, the first tournament staged in Australia and New Zealand and, together with the gathering strength of the Hong Kong Sevens as a world rugby event, it provided the forum which would have a profound effect on the attitudes and aspirations of the players and helped accelerate the process of ultimate change to professionalism. The strict interpretation of the amateur laws was already being heavily breached by the southern hemisphere and European countries such as France and Italy and, indeed, by Wales. Many of them had been driving a double-decker bus through the regulations for some years, and people were beginning to be fed up with the dreadful hypocrisy of it all.

RESULTS OF THE 1983 LIONS IN NEW ZEALAND

P 18 W 12 D 0 L 6 F 478 A 276

Wanganui	W	47–15	Wairarapa-Bush	W	57–10
Auckland	L	12–13	New Zealand (Wellington)	L	0–9
Bay of Plenty	W	34–16	North Auckland	W	21–12
Wellington	W	27–19	Canterbury	L	20–22
Manawatu	W	25–18	New Zealand (Dunedin)	L	8–15
Mid Canterbury	W	26–6	Hawke's Bay	W	25–19
New Zealand (Christchurch)	L	12–16	Counties	W	25–16
West Coast-Buller	W	52–16	Waikato	W	40–13
Southland	W	41–3	New Zealand (Auckland)	L	6–38

CIARAN FITZGERALD'S 1983 LIONS TEAM

FULL-BACKS			FORWARDS		
G. Evans	Maesteg	Wales	S.J. Bainbridge	Gosforth	England
W.H. Hare	Leicester	England	J.R. Beattie	Glasgow Academicals	Scotland
H.P. MacNeill	Oxford University	Ireland	S.B. Boyle	Gloucester	Scotland
			E.T. Butler*	Pontypool	England
THREE-QUARTERS			J.H. Calder	Stewart's Melville FP	Scotland
R.A. Ackerman	London Welsh	Wales	M.J. Colclough	Angoulême	England
G.R.T. Baird	Kelso	Scotland	C.T. Deans	Hawick	Scotland
J. Carleton	Orrell	England	C.F. Fitzgerald (capt.)	St Mary's College	Ireland
D.G. Irwin	Instonians	Ireland	N.C. Jeavons*	Moseley	England
M.J. Kiernan	Dolphin	Ireland	S.T. Jones	Pontypool	Wales
T.M. Ringland	Ballymena	Ireland	D.G. Lenihan*	Cork Constitution	Ireland
C.R. Woodward	Leicester	England	G.A.J. McLoughlin*	Shannon	Ireland
			I.G. Milne	Heriot's FP	Scotland
HALF-BACKS			R.L. Norster	Cardiff	Wales
S.O. Campbell	Old Belvedere	Ireland	J.B. O'Driscoll	London Irish	Ireland
T.D. Holmes	Cardiff	Wales	I.A.M. Paxton	Selkirk	Scotland
R.J. Laidlaw	Jedforest	Scotland	G. Price	Pontypool	Wales
N.D. Melville*	Wasps	England	J. Squire	Pontypool	Wales
J.Y. Rutherford	Selkirk	Scotland	I. Stephens	Bridgend	Wales
S.J. Smith*	Sale	England	P.J. Winterbottom	Headingley	England
			*Replacements		

1989
FINLAY'S FIGHTERS

Captain: Finlay Calder (Stewart's Melville FP and Scotland)
Squad Size: 30 players + 2 replacements
Manager: Clive Rowlands (Wales)
Coach: Ian McGeechan (Scotland)
Assistant Coach: Roger Uttley (England)
Hon. Medical Officer: Donald McLeod (Scotland)

Tour Record:	P 12	W 11	D 0	L 1	F 360 A 192
Test Series:	P 3	W 2	D 0	L 1	

1989 TOUR KIT

Because of the South African boycott there was a gap of six years between Lions tours, and when the 1989 party arrived in Australia they were the first to visit Australia on a full-blown Lions tour since the Rev. Mullineux's side in 1899. It was also the only sizeable tour to Australia since 1959, when the Lions played six matches.

Fittingly, it was Australians Kylie Minogue and Jason Donovan who topped the British charts in 1989. It was also the hottest summer in England since 1976; the Bradford Moslems burnt Salman Rushdie's *The Satanic Verses*; Tyson stopped Bruno and the Hillsborough disaster claimed 96 lives. The Queen was the first British monarch to visit Russia since 1917; Margaret Thatcher completed ten years in power; and Bush took over from Reagan in America. Solidarity triumphed in Poland, but Chinese troops massacred demonstrating students and others in Tiananmen Square. Sir Laurence Olivier died and Sky Television was launched, and was to have a huge influence on the development of rugby in the southern hemisphere.

The new-style Lions tour was cut back even further to 12 matches, but whether Australia had the strength and facilities to sustain even a 12-match tour was a major talking point before it began. Australian rugby had been in a parlous state throughout the 1970s, but during recent years they had really put their house in order, and demonstrated this when Andrew Slack's team, coached by the maverick Alan Jones, whitewashed the Home Unions on their 1984 tour of Britain and Ireland.

It was also true that the Australians had become some of the most innovative thinkers on the game worldwide. They introduced such ideas as the 'up your jumper' move which amused the Fijians so much that, when they saw it performed by the New South Wales Country team in Nandi in 1977, those who had climbed trees for a better view simply fell out of them in their mirth. They were also to preach the gospel of the quick-quick pass and the swarm defence.

▲ Captained by Scotland flanker Finlay Calder, the original 30-man Lions squad of 1989 featured ten Englishmen, nine Scots, seven Welsh players and a four-man Irish contingent

➤ The Lions used only ten forwards across the three Test matches. Having struggled in the opening game in Sydney, the pack roused themselves for the following Tests and played a huge role in securing the series

The 'up your jumper' ploy involved forming a huddle from a penalty, in which someone would conceal the ball under his jersey as they exploded to all parts of the field. By the time the opposition worked out where the ball was, the ball carrier had either scored the try or done the damage by piercing the defence. Under the laws as they were, it was entirely legal, but the IRB quickly moved to outlaw it under Law 26 (2) concerning unfair play.

Following the England tour there in 1988, when they were beaten in both Tests and by New South Wales, the Lions knew what to expect. Forwards Brian Moore, Wade Dooley, Gareth Chilcott, Andy Robinson and Dean Richards, along with backs Rory Underwood and replacement Rob Andrew, were looking for revenge, and after losing the first Test they became the first Lions to come from behind to win the series 2–1.

The tour was managed by Clive 'Top Cat' Rowlands, who earned the nickname by virtue of having captained Wales on all his international appearances. He also created a world record 112 lineouts in an international by kicking mercilessly from scrum-half to beat Scotland at Murrayfield. He went on to coach Wales and become president of the Welsh Rugby Union. A notable character in his own right and a jovial man, he did a marvellous job as manager. The Lions now took two coaches on tour, and Rowlands also had excellent lieutenants in Ian McGeechan, by far the most intellectual and dedicated Lions coach since Carwyn James, and his assistant, Roger Uttley, who did such a great job with the England pack which was to dominate Europe for the next seven years.

The team was captained by Scotland flanker Finlay Calder, who led from the front, demanding and giving everything. In his manager's report, Rowlands said, 'His pride and leadership were always in evidence and these qualities, coupled with his strong views on the conduct of the players both on and off the field, add up to a very successful captain of a BIRUT team. One should not omit two more qualities necessary for success: honesty and modesty, both of which belong to Finlay Calder.'

When you look back, you can see how many good and hard players were on that tour. You start with full-back Gavin Hastings and you cannot do better than that, for he was the finest player in his position since J.P.R. Williams, having the same, if not better, physical attributes, and his place kicking was to be a vital winning ingredient.

On the wing, Ieuan Evans was to haunt David Campese, one of Australia's most exciting players of all time. The try he scored in the final Test from a poor pass by Campese was his deserved dividend for being unimpressed and undaunted in marking such a fine and established player, and it launched Evans on a great career of his own.

Scott Hastings, another delightful member of the Watsonians Club and the Hastings family, a powerful runner and intimidating tackler, together with that silky and deceptive runner Jeremy Guscott, were to become the preferred centres for the last two Tests after the battling Mike Hall and the elegant Brendan Mullin had played in the first. As ever, his roaring pace and elusive running saw Rory Underwood having the freehold on the left-wing position.

There was more than ample reserve cover with the powerful Welsh centre or wing John Devereux, who was to make a name for himself in rugby league, and Chris Oti, who was unfortunate to have his try-scoring talent curtailed by injury. McGeechan said after the tour that he regretted that he never had the time to develop the Lions' back play to its full potential.

At half-back, the loss of Paul Dean in the opening game in Perth, although a personal tragedy for the Irishman, was perhaps a blessing in disguise for the Lions, as it allowed Rob Andrew to fly out and claim the outside-half berth from Craig Chalmers for the second and third Tests. Andrew brought steadiness and a new tactical dimension to the side, which, for all the quality of its backs, was struggling to find itself in attack, because of Bob Dwyer's tactic of swarm defence. Andrew also found a soul mate in Jones, the superb Welsh scrum-half who, behind a dominant pack of forwards, was at the top of his considerable game.

The forwards, under the uncompromising command of Calder, who had some of the characteristics of a modern-day Wallace, were at times magnificent – once they had absorbed and taken on the lessons of the first Test, when they crumbled under the force of the Wallabies forward effort that gave their half-backs, Nick Farr-Jones and Michael Lynagh, control of the game. The Lions called on only ten forwards for the Test series: Robert Norster was replaced by Dooley after the first Test, and Mike Teague, absent from the opening Test through injury, claimed his place back from hundred per cent Scottish flanker Derek White for the next two.

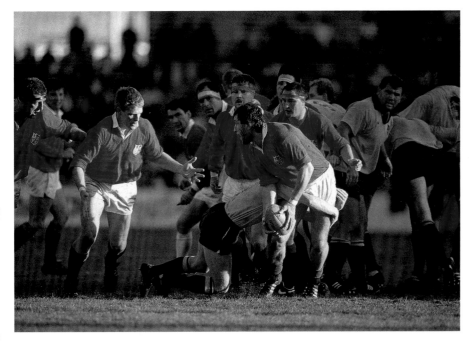

▲ Despite missing the first Test, Mike Teague's (with ball) heroic performances during the rest of the tour saw him named player of the series

▲ A painting of the 'Battle of Ballymore', the Lions' ill-tempered and punishing second Test victory in Brisbane

The whole pack was magnificent. The forwards of the tour were Teague, Dean Richards and Paul Ackford, but another forward who never made the Test team still deserves an honourable mention for his invaluable contribution to the overall success of the tour: Donal Lenihan. He virtually took command of the 'dirt-trackers', and 'Donal's Donuts', as they were affectionately known, became a force to be reckoned with. They provided essential back-up to the Test team, ensuring that morale stayed high and the momentum was maintained. They won all the non-Test matches, as exemplified by the Lions' magnificent comeback against Australian Capital Territoties (ACT) in Canberra when they turned a 21–11 half-time deficit into a 41–25 victory on the eve of the second Test.

It was a well-selected side which brought home the bacon, just as they did in 1971 and 1974. Those who might say that Australia were of lesser strength than New Zealand or South Africa would be wrong, for it was Australia who won the World Cup two years later in 1991, and this was part of the learning curve for that great side. This tour also clearly illustrated the new and growing strength of Australian rugby and they easily sustained a 12-match tour. With the vast improvement of the ACT team, they have developed even further, and whereas a decade ago they only had about 30 players of Test calibre, they now have 50 or 60.

It was as physically demanding a Test series as any I have witnessed or heard about, and the second Test in particular provided scenes of violence of which neither side could feel proud. This created a great deal of acrimony between the teams; some of the Australian press went right over the top with their one-eyed allegations against the Lions and you have never heard such whingeing about the Poms. Farr-Jones, their captain, was quoted as saying, 'I think that the third Test could develop into open warfare. As far as I am concerned the Lions have set the rules and set the standards and, if the officials are going to do nothing about it, then we are going to have to do it ourselves. We won't sit back and cop it again.'

The Australian Rugby Union also issued an intimidatory press release on the eve of the Third Test, which read:

At a Council meeting held today at the Union Headquarters at Kingford, the Australian Rugby Football Union (ARFU) resolved the following:

1) to condemn the violence in the game;

2) that the Executive Director prepare a video depicting certain incidents which occurred during the second Test at Ballymore, which were believed to be prejudicial to the best interest of the game. The video, when prepared, will be sent to the Committee of the Four Home Unions for their information and for any action which they may deem appropriate;

3) the ARFU delegates to the International Rugby Football Board (IRFB) have been requested to raise the matter of video evidence as part of the game's judicial system.

Signed: R.J. Fordham, Executive Director

Ian McGeechan and the delightful Australian assistant coach, Bob Templeman, who is one of the elders of Australian rugby and highly respected wherever rugby is played, had got together and decided that it was impossible to wage war and play good rugby. They both believed that the team playing the better rugby would win the series. They were adamant that there would be no trouble in the final Test and condemned the hysteria of the media in whipping up bad feeling.

In his captain's report on the tour, Finlay Calder was to say:

The large part of Australian life is sport; winning is everything. However, when it comes to playing against the 'Poms' we should never underestimate the undercurrent of their hatred towards their ancestry and, having played against them on several occasions, the explosive situations that occurred only highlighted that feeling. To the credit of the Lions, despite provocation both physical and verbal, the series was settled by tremendous commitment and team spirit. As we approach the 1990s, it is a marvellous tribute to rugby and all it stands for that players from the Home Unions can still come together, enjoy each other's company, play for each other and defeat Australia.

The tour did much to restore the status of the Lions down under after the previous tours of 1977 and 1983. It could be bracketed with the success of the 1974 team in South Africa, for its undoubted strength was in the forwards, who carried all before them apart from in the first Test.

The Lions won their six games before the first Test, including the two mini-Tests against Queensland and New South Wales. Every game counted, for three weeks is no time at all to prepare and select a team which has to start from scratch and which is drawn from the cosmopolitan talent of four different countries. They were consoled by the fact that Australia would also be playing their first Test for seven months. They were in good heart and perhaps in too confident a mood for the first Test in Sydney, their only worry the extent of their injuries. When they named their team, five players, including Teague, Oti and Devereux, were not considered for that reason.

On a sunny day and before a capacity crowd at the Sydney Football Stadium, they were to be deeply disappointing as, having carried all before them in the previous matches, the forwards failed and were well beaten everywhere by a very good Wallaby performance. Australia won the set pieces and were quicker to the breakdown, which saw Nick Farr-Jones and Michael Lynagh having a field day. Australia scored four tries to none, through Lloyd Walker, Scott Gourlay,

OFFICIAL ARFU PROGRAMME

THE **Mitre10** TEST

Second Test

BRITISH LIONS

RUGBY UNION TOUR
OF AUSTRALIA 1989

AUSTRALIA vs BRITISH LIONS
BALLYMORE — BRISBANE
SATURDAY, JULY 8, 1989

▲ A programme from the second
Test at Ballymore Stadium, one of
the most notorious matches in
Lions history

Dominic Maguire and Greg Martin, and Lynagh devastatingly converted all four and kicked a penalty and drop goal. For the Lions, Gavin Hastings kicked two penalties and Chalmers a penalty and drop goal.

After such an emphatic defeat, it was a sadder and wiser Lions team which took stock for the second Test in Brisbane after an interim game against ACT, a provincial side which was beginning to realise its potential. They gave the Lions a hard time in the first half before that comeback by Lenihan's team, who gave them a battering up front in the second half. Although this brought the win, it also brought much criticism concerning their approach, for they scarcely used their backs, even when the game was won.

The Test team showed five changes from the previous Saturday as Dooley and Teague came in for Norster and White in the pack, with Andrew, Scott Hastings and Guscott replacing Chalmers, Hall and Mullin in the back line. Taunted about their toothless performance in the first Test, you could sense they were up for this game and they shocked Australia with the ferocity of their approach. The philosophy should have been to let sleeping Lions lie, not to madden them by poking them with jibes.

To say the least, the game was ill-tempered, and violence was sparked off by the tiniest incident. Jones appeared to tread on Farr-Jones' foot, and when the Australian captain had a go at him, the usually calm and collected Jones astonished everybody by flying at him. While they were rolling around on the ground like two ferrets in a sack, with the hapless French referee René Hourquet trying to pull them apart, the scrum erupted, with the forwards slamming at each other. Although nobody was sent off, the teams remained on a short fuse and there were innumerable punch-ups as well as an incident when David Young seemed to stand on Steve Cutler's head. He was lucky to go unpunished by the French official, but Tom Lawton was to lead the Wallaby forwards into another huge fracas over the incident.

➤ Tempers flared repeatedly during
the pivotal second Test as the Lions
levelled the series. The clash was a
bruising one in which neither team
were prepared to take the slightest
backwards step

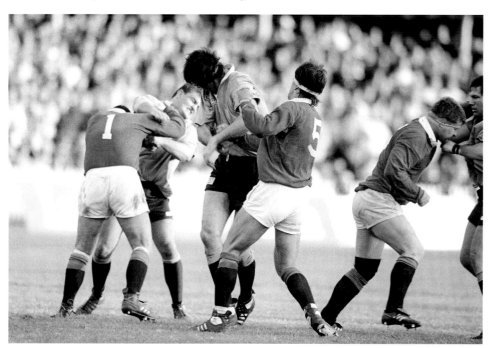

◄ Wales wing Ieuan Evans (middle) scored the crucial try in the third Test in Sydney after a moment of madness from Wallaby counterpart David Campese (right), whose error of judgement was widely criticised in the Australian media

The Aussie media were later to have a ball, highlighting every transgression by the Lions, but conveniently forgetting about a terrible raking of Mike Hall in an earlier game, or the bruising treatment handed out to Teague and Gavin Hastings. In the match, however, the ruthless driving forward play of the Lions saw Australia outplayed as half-backs Jones and Andrew, with some tremendous tactical kicking, dominated as effectively as their opposite numbers had done in the first Test. The Lions had rediscovered their forward authority, and their surging commitment to the rucks and mauls knocked the Wallabies out of the game in the closing stages. However, for all that forward dominance, the Lions were trailing 12–9 after 76 minutes before tries from Gavin Hastings and Guscott settled matters.

Lynagh kicked two penalties and converted an early try by Greg Martin, while Gavin Hastings kicked a penalty and Andrew dropped a goal. Andrew landed a penalty in the second half before the dominance of the Lions pack, supported by the brilliant box-kicking of Jones, brought those two decisive tries, the first by full-back Hastings from a splendid movement and the second by Guscott from his own deft kick ahead. A conversion by Andrew made it 19–12 and the Lions had won a Test which had been bitterly fought out with great passion by both teams.

The Lions went off for a short break at Surfers Paradise on the Gold Coast to lick a few wounds and reflect that they were going to have to do it all again the following Saturday. They were now confident they could handle anything the Wallabies could throw at them, and the harshness of the media criticism only served to increase their motivation to win the series. However, the Australian competitive spirit is one of the best developed in the sporting world, and it would not be easy. Happily, the final Test in Sydney did not become the blood-bath that Farr-Jones and the media implied it might be, as good sense prevailed and the game's ethics were restored.

Both teams were unchanged and once more the Lions forwards took control, but they still struggled against these competitive Australians to win what was an exciting match. It all turned on a moment of mental aberration by David Campese, who is nothing if not a rugby genius and a huge competitor. Part of his charm is

that at times he tries to do the impossible, and when he tried to run the ball out from behind his own line and threw a calamitous pass to Greg Martin that the full-back clearly did not expect, it allowed Ieuan Evans, who had already earned great credit by keeping Campo in check throughout the series, to pounce for the series-winning score.

There were instantaneous press box demands of 'he must never play for Australia again' from some members of the home media, and Campese was pilloried in print without any regard to the years of artistry, skill and match-winning with which he had blessed them. Mark Ella put it best of all when, in typical amusing Australian fashion, he coined the phrase 'One day "Wonderman", next day "Blunderman".' It was absurd to blame Campese for the defeat when their pack was destroyed.

At half-time it was 9–9, with three penalties from Gavin Hastings to an Ian Williams try and a conversion and penalty from Lynagh. Three minutes into the second half, another Lynagh penalty gave the Wallabies the lead, only for Evans to pounce for the Lions' only try of the Test, with Hastings opening up a seven-point lead through two more penalties to make it five in the match. He ended up with a 46 per cent success rate with the boot from 17 penalties and two conversions with fellow Scot Peter Dods, who appeared in five of the lesser matches, weighing in with eight penalties and 19 conversions for a 57 per cent return.

The Wallabies competed until the death, and two more Lynagh penalties had the Lions desperately hanging on as the home side threw everything into all-out attack with time running out. They failed heroically, and the Lions won 19–18, having recovered for the very first time from losing the first Test to bounce back and win the series.

There were still two games to go, a 72–13 romp against New South Wales Country and an unusual fixture against an ANZAC side. It was supposed to be a Test strength team drawn from New Zealand and Australia, but the All Blacks failed to support the concept, and 12 of them dropped out of the squad. Of the three who did turn up – Fran Botica, Keiron Crowley and Steve McDowell – only prop

➤ The Lions celebrate after winning a dramatic and fiercely competitive Test series

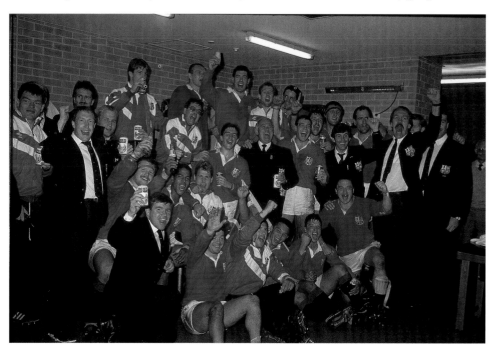

McDowell was a current All Black. The Lions won this tour finale and became one of the three most successful sides in Lions history. They could look back on their tour with great pride.

The Lions had again discovered that the best way to win Test matches was through the forwards, and they were prepared to drop their old tradition of attacking back play. As five of the Lions pack in the last two Tests were English, it was not surprising that this became a successful obsession with England for the next five years. They were to use big, tight forwards, especially the marvellous Ackford and Dooley, at the lineouts to gain possession, and were to employ big back rows as a battering ram to subdue and penetrate. While it was effective, it was not pretty to watch and, because of this static approach, they became bogged down when they attempted to play an open and attacking game. In the 1991 World Cup final, they were unable to do so and lost to Australia.

The Wallabies had given the answer to those who said they were not strong enough for a Lions tour, and the reality was that the Lions were relieved to go home having won the series. They had also had a marvellous time in a lovely country where the pressures of touring are not as intense as they are in New Zealand and South Africa.

RESULTS OF THE 1989 LIONS IN AUSTRALIA

P 12 W 11 D 0 L 1 F 360 A 192

Western Australia	W	44–0	Australia (Sydney)	L	12–30
Australia B	W	23–18	ACT	W	41–25
Queensland	W	19–15	Australia (Brisbane)	W	19–12
Queensland B	W	30–6	Australia (Sydney)	W	19–18
New South Wales	W	23–21	NSW Country	W	72–13
New South Wales B	W	39–19	ANZAC XV	W	19–15

FINLAY CALDER'S 1989 LIONS TEAM

FULL-BACKS			FORWARDS		
P.W. Dods	Gala	Scotland	P.J. Ackford	Harlequins	England
A.G. Hastings	London Scottish	Scotland	F. Calder (capt.)	Stewart's Melville FP	Scotland
			G.J. Chilcott	Bath	England
THREE-QUARTERS			W.A. Dooley	Preston Grasshoppers	England
J.A. Devereux	Bridgend	Wales	M. Griffiths	Bridgend	Wales
I.C. Evans	Llanelli	Wales	J. Jeffrey	Kelso	Scotland
J.C. Guscott	Bath	England	D.G. Lenihan	Cork Constitution	Ireland
M.R. Hall	Bridgend	Wales	B.C. Moore	Nottingham	England
S. Hastings	Watsonians	Scotland	R.L. Norster	Cardiff	Wales
B.J. Mullin	London Irish	Ireland	D. Richards	Leicester	England
C. Oti	Wasps	England	R.A. Robinson	Bath	England
R. Underwood	Leicester and RAF	England	S.J. Smith	Ballymena	Ireland
			D.M.B. Sole	Edinburgh Academicals	Scotland
HALF-BACKS			M.C. Teague	Gloucester	England
C.R. Andrew*	Wasps	England	D.B. White	London Scottish	Scotland
G. Armstrong	Jedforest	Scotland	D. Young	Cardiff	Wales
C.M. Chalmers	Melrose	Scotland	*Replacements		
A. Clement*	Swansea	Wales			
P.M. Dean	St Mary's College	Ireland			
R.N. Jones	Swansea	Wales			

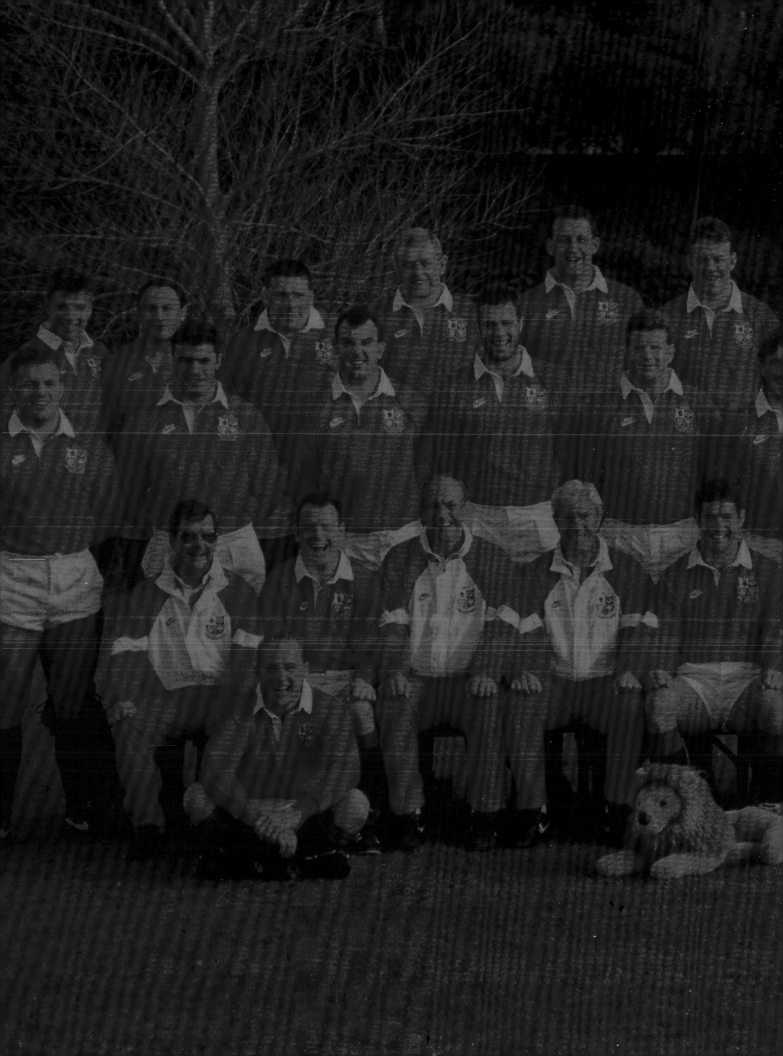

9

A DECADE OF CHANGE

So Close to Glory was the title of the paperback which Ian McGeechan produced after the Lions tour in 1993. For all the tenuous truth of that statement, he might just as easily have called it *Same Old Story*, for this is the tale of another Lions team which came so near to, and yet was so far from, winning a series against the All Blacks, who euphemistically have been called 'The Unsmiling Giants' and 'The Winter Men'. In their previous ten tours of New Zealand since 1888, the Lions had won only one series in 1971, and they had won only five of the 32 Test matches played.

Selection procedures, which had improved immensely in recent years with the adoption of the principle that coaches should have a say, meant that it was a well-selected team and management which set out on what is one of the toughest missions that any team in any sport can conceivably undertake. The recurring theme throughout the history of the Lions is that tours to New Zealand, Australia or South Africa are more of a crusade than a pleasure trip.

The game went 'open' two years after the 1993 tour, so Gavin Hastings' men can claim to be the last 'amateurs', and Martin Johnson's triumphant squad of 1997 can claim to be the first 'professionals'. That is if you accept that the 1888 tourists weren't paid for their troubles!

The 1993 squad were strong enough up front to match the All Blacks, but they could only manage two tries in three Tests. That was the same tally as Ciaran Fitzgerald's side had managed in their four internationals on the previous tour to New Zealand a decade earlier. By contrast, the All Blacks scored five tries in three Tests in 1993 and nine in four in 1983. The triumph by Martin Johnson's side in South Africa in 1997 was the first for 23 years and greatly reinvigorated the Lions brand.

1993 TOUR KIT

1993
THE LAST AMATEURS

Captain: Gavin Hastings (Watsonians and Scotland)
Squad Size: 30 players + 4 replacements
Manager: Geoff Cooke (England)
Coach: Ian McGeechan (Scotland)
Assistant Coach: Dick Best (England)
Tour Doctor: James Robson (Scotland)

Tour Record:	P 13	W 7	D 0	L 6	F 314 A 285
Test Series:	P 3	W 1	D 0	L 2	

The manager was Geoff Cooke, the man who brought efficiency and realism into the England squad, building them into the most successful England team since 1980, and making them the major European power during the first half of the 1990s. He was not a popular man with the Twickenham establishment, for he tended to be a players' man. He understood and identified more easily with their aspirations concerning reward for the shameless exploitation of their talents than did most of his masters at HQ.

Ian McGeechan was Lions coach for the second time. It was the first time that anybody had coached the Lions on two occasions, which was testament to his rugby intellectualism and the high esteem in which he was held by all the Four Home Unions. His assistant coach, Dick Best, was rewarded for his hard work with Harlequins and England. It was a popular triumvirate with the players and they all had the necessary qualifications.

The issue of the captaincy exercised everybody's minds throughout the season prior to the tour and it was probably true that Will Carling must have been in pole position until England's defeat by Ireland at Twickenham. The other outstanding candidate was Gavin Hastings, but he must have felt his chance had gone with the Calcutta Cup defeat at Twickenham. In the end, Hastings was given the nod on 22 March 1993 when the squad was announced, no doubt chosen for his greater experience of New Zealand conditions, for already having toured with the successful Lions to Australia, and for his personal charisma and popularity with the players from all the Four Home Unions. Even so, Geoff Cooke, as Chairman of Selectors, had Hastings telephoned twice to ensure that he wanted it. There had been some needle between the England and Scotland captains since the World Cup, when the Scottish players had turned up at the final wearing Australian colours.

Geoff Cooke assured me that there was no problem whatsoever on tour between the two, that Carling was dropped from the Test side purely on a loss of form, and that Gavin Hastings had no say in Carling's omission from the Test team. He was to emphasise that they were both men of extremely high calibre in both rugby and personal terms. These Lions were lucky that they had three very experienced international captains who were all strong personalities in Gavin Hastings, Will Carling and Ieuan Evans.

There was universal approval of Gavin Hastings as the Lions captain, for there is no man more respected for his abilities both on and off the field than this delightful Scot, who is the epitome of the rugby man: brave, resolute, adventurous and one who enjoys a party. He was to break many Lions records during the tour, including

▲ For a second successive Lions tour Scotland's Ian McGeechan (right) was appointed as head coach, while Englishman Geoff Cooke served as manager for the visit to New Zealand

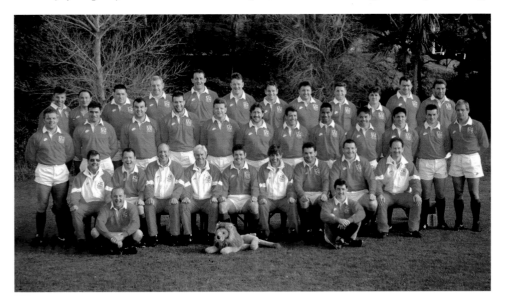

◄ The 1993 Lions were led by Scotland full-back Gavin Hastings but dominated by Englishmen, with 17 Red Rose players selected in the original 30-man squad

▲ Bath forward Ben Clarke, who enjoyed a fine tour, was a key part of the Lions' dynamic Test back row alongside Peter Winterbottom and Dean Richards

the most points by a player in a series (38); most penalty goals in a series (12); most penalty goals in a match (six); most points in a Lions Test career (66); and equalled Tony Ward's record of most points in a match (18). His achievements readily speak for themselves.

England's continuing success in the Five Nations saw them having their biggest representation ever on a Lions tour, with the manager, the assistant coach and 17 players. Perhaps the most intriguing debate was whether Rob Andrew or Stuart Barnes would win the outside-half berth. It was settled emphatically when Rob Andrew proved himself as the ultimate competitor with his superb performance in the second Test, and he played in all the Test matches. Dewi Morris also excelled and his gutsy competitive play was splendid, allowing him to stay ahead of one of the stars of the 1989 series, Welshman Rob Jones, who was brought into the squad before departure when Scotland's Gary Armstrong pulled out with an ankle injury. The pick of the three-quarters was Ieuan Evans, but Scott Gibbs, who displaced Carling in the last two Tests, was also one of the most aggressive and exciting players of the tour, and he would have played in all the Tests but for an early injury.

The outstanding Lions forward was Ben Clarke, who played in three different back-row positions, and close behind were Dean Richards and Peter Winterbottom the latter making his second tour of New Zealand a decade on from his first. Martin Bayfield, who had a marvellous second Test, and Martin Johnson, called out as a replacement for the first of his three tours, became the Test locks and Brian Moore, having lost his place for the first Test, showed his character by getting back for the last two.

During that year of 1993, two young boys were charged with the murder of James Bulger; there was the Braer ship disaster in the Shetlands; the siege in Waco ended in tragedy; Norman Lamont was fired by John Major and Michael Mates resigned, after allegations of links with Asil Nadir; Lord Owen admitted the failure of his peace plan in Bosnia, and US troops attacked a Somali warlord. It was announced that the Queen would be taxed on her income and that part of Buckingham Palace was to be opened to tourists.

The Lions were to discover that the New Zealand team were as tough a nut to crack as ever. They lost six of their 13 matches, but they gave a tremendous account of themselves in the first two Tests and actually won the second, which, as the statistics show, was a considerable achievement.

There was one huge controversy during the tour, which again illustrated the growing gulf between players and administration, and which became known as the 'Wade Dooley affair'. It was born from the sad, sudden death of Wade Dooley's father; the extremely popular Wade was immediately flown home and arrangements were made to fly out Martin Johnson as the replacement.

The Lions had suffered a spate of injuries in the Otago match, which included bad shoulder and neck injuries to Martin Bayfield after he was upended in a lineout. Will Carling strained a muscle at the top of his leg and was replaced by Scott Hastings, who early in the second half suffered a badly depressed fracture of his cheekbone. In addition, the Lions lost substantially by 37–24 in this, the fifth match of the tour, and spirits were fairly low. Consequently, when it was discovered that Wade would not be rejoining them, even though the New Zealand Rugby Union had specifically said that he could come back after his father's funeral, the Lions became angry and immediately took it out on the secretary of the Four Home Unions, Bob Weighill. He was 'sent to Coventry' by the players, who did not fully understand the background of it all, including the implications of the Tour Agreement.

When Wade arrived home, Weighill had arranged for him to be met at Manchester airport, and sent a special floral tribute to his father's funeral. On the following Wednesday, Wade mentioned to him that he had been invited to return to New Zealand by the New Zealand Rugby Football Union, but that he was unlikely to do so. Weighill was surprised when, about a week later, Wade rang him and said he would like to return to the team. At the same time he had received a request from the manager, Geoff Cooke, for Wade to rejoin the party and to fly out with Weighill, who was joining the team on 17 June. Weighill, therefore, with some difficulty booked him a ticket.

As secretary, he now had to inform the chairman of the Tours Committee and there were discussions with the secretary of the RFU, the secretary of the IRB, and the chairman of the New Zealand Rugby Football Union, who was also chairman of the IRB at the time. There was considerable sympathy with the unfortunate circumstances, but there was also a perception that the IRB regulations and the Tour Agreement must be complied with. It was decided that Wade should accept the invitation to return, but could not rejoin the party as a player. The chairman of New Zealand Rugby Union admitted that it had been a mistake to issue the invitation in the first place without consulting the Four Home Unions, when it was possible that another solution could have been arrived at.

Wade was informed of the decision, but declined to rejoin the tour on those terms. Consequently Bob Weighill, who had only followed the book as he was bound to, arrived in New Zealand and ran into a wall of hostility from the Lions, who,

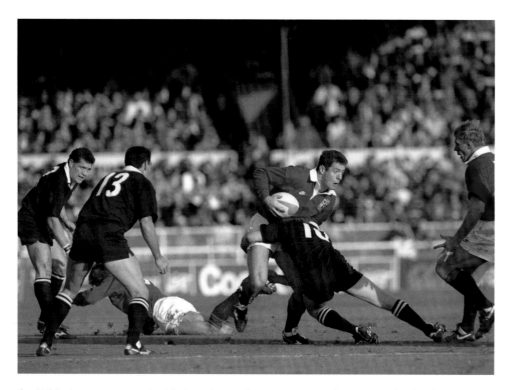

> Skipper Gavin Hastings (centre) scored all of his side's points in the first Test but it was not enough to prevent the Lions from slipping to a 20–18 defeat

▲ A programme from the first Test at Christchurch, which saw the Lions endure a number of debatable calls by the referee

foolishly in retrospect, decided to shoot the messenger. There is no doubt that Bob was hard done by, but this illustrates that there is no flexibility in aspects of the administration, when there ought to be. As Gavin Hastings pointed out in his autobiography, '*It gave us something to bitch about during a low point of the tour.*'

The first Test defeat at Christchurch by 20–18 was a bitter disappointment, and a bitter blow because of the highly controversial awarding of the first try in the opening two minutes. A high kick by Grant Fox was caught by Evans, who fell over the line still holding the ball, with Frank Bunce also clutching at it. As television audiences worldwide were able to see, Evans never let go of the ball, yet the referee, from a long way off, awarded the try to New Zealand. The Lions recovered and took the lead with two penalties by Hastings and, before half-time, Fox kicked two more and Hastings another, to leave the All Blacks leading by 11–9. There was also much controversy concerning the Lions' first penalty, for Michael Jones held Carling without the ball when he would have been in support of Guscott for a try under the posts.

In the second half, the Lions played some of their best rugby of the series and Richards, Winterbottom and Clarke were immense, while Bayfield had a tremendous game in the lineouts. Fox, that remarkable winner of Test matches for New Zealand, kicked another two penalties early in the second half, but so did Hastings and then, with only ten minutes to go, Hastings put the Lions ahead at 18–17 with a terrific penalty into the wind from a difficult angle, and the game was there to win. With only a minute to go, the Australian referee, Brian Kinsey, awarded an outrageous penalty to New Zealand. The disbelief on Morris' face was there for all to see on television, but Fox kicked the goal to win the game.

◄ Second row Martin Bayfield celebrates after the Lions beat the All Blacks 20–7 in the second Test in Wellington, a victory which left the series tantalisingly level at 1–1

Losing to Auckland and Hawke's Bay in the two matches before the second Test in Wellington was hardly confidence-boosting preparation! If there was a criticism of this tour it was the fact that in percentage terms they lost too many provincial matches, losing to Otago, Auckland, Hawke's Bay and Waikato. The 'dirt-trackers' let them down badly against Hawke's Bay and a Waikato side that had a certain Warren Gatland not only hooking for them, but also among their try scorers.

In the second Test, McGeechan and Hastings decided on the dangerous ploy of playing into the wind and sun in the first half, as they believed this would force them to keep the ball in play and concentrate. Hastings wanted to withdraw because he had a hamstring strain, but McGeechan insisted that he played and he lasted the game. The biggest problem came when, after 30 minutes, Fox hoisted a ball and Hastings lost it in the sun, for Eroni Clarke to get the bounce and score and Fox to convert. It was to be the only score by the All Blacks, as the Lions never gave away another penalty for Fox to convert into points. He had not failed to kick a penalty in a Test for five years, so this was some achievement. Hastings then kicked two penalties and Andrew dropped a goal, for a half-time lead of 9–7.

Early in the second half, Gavin kicked another penalty before the Lions scored a glorious try from a counter-attack. The irrepressible Dewi Morris started it by picking up a loose pass inside his own half, and made the break before giving to Jeremy Guscott, who has great ability to inject pace. He did so to beat Bunce and check John Kirwan, before giving to Rory Underwood, who made a 50-metre sprint up the touchline for a try. Hastings kicked another penalty, to give the All Blacks as big a beating as they have ever had at home.

It was the most points the Lions had ever scored against New Zealand in a Test match. The hero of the game was Rob Andrew, who never put a foot wrong, and close behind him was the combative Morris. The forwards, for their part, could say for the rest of their lives that they saw off the All Blacks forwards in a Test match in New Zealand, and not many people can make a claim like that.

The 'dirt-trackers' were to lose heavily in the penultimate game at Hamilton against Waikato, who were the reigning provincial champions, before the final Test, with a dreary performance similar to the one against Hawke's Bay the week before. This is always a difficult time as, at this stage of a tour, those who have not made the final Test team have nothing left to play for and they are thinking about going home. This is why a leader of the second team is of such great value on tour, but this side had no Donal Lenihan or Bob Hiller to jolly them along, and they crashed to their biggest defeat of the tour, Waikato playing splendid rugby to win by 38–10.

The All Blacks had called in Andy Haden as their lineout consultant for the final Test, and they solved the problem by compressing the lineout and crowding Bayfield. They also decided not to kick for touch, thus considerably reducing the number of lineouts with the Lions throw. They continued to play for their lives and produced all that old All Blacks imperative commitment to winning and, completely changing their tactics, outplayed the Lions as decisively as they themselves had been beaten the week before.

The Lions were unchanged, but New Zealand made three changes. Eroni Clarke was replaced by Lee Stensness, and they also dropped Zinzan Brooke for the hard-driving Otago No. 8, Arran Pene, and reinstated Ian Jones in place of Mark Cooksley at lock.

The Lions snatched an early lead of ten points with a Hastings penalty and a try, when Andrew played inside to Rory Underwood on the burst and the ball bounced off Bunce and into the hands of Scott Gibbs who scored, for Hastings to convert. It was, however, no contest, as the All Blacks climbed into the driving seat and stayed there for the rest of the game. A try by Bunce, converted by Fox, and another try by the All Blacks skipper Sean Fitzpatrick, again converted by Fox, made it 14–10 at the interval. There was no let-up by the All Blacks and Fox kicked a penalty. It was followed by one from Hastings, but then Fox kicked another, and although the Lions were attempting to run the ball, it was with increasing desperation. Preston finished them off when he dummied his way over for a try, converted by Fox, who then kicked another penalty to give the All Blacks their second-highest score against the Lions.

It was, in the end, the same old story. The All Blacks wanted to retain their reputation more than the Lions wanted immortality, but then that was always the difference between British and Irish teams and those in the southern hemisphere. Perhaps winning in the new frontier countries is a necessity more ingrained into the psyche than it is in the more relaxed comfort of the old world, where the prospect of losing is never quite as alarming.

There now follows a selection of extracts from Ian McGeechan's coaching report on the tour to the Four Home Unions.

New Zealand remains the ultimate challenge for a tourist and I felt it important that we had as much time as possible to prepare players to cope with the unique environment which New Zealand provides. I was also aware that a number of players, particularly the English players who made up the majority of the party, had not experienced New Zealand at first hand. As with all tours to the southern hemisphere, it is the physical intensity which has to be successfully mastered.

Before the tour my early objectives revolved around producing consistent, dynamic rucking and mauling drives and providing quick ball, from which the backs could move at pace. An awareness of this requirement allowed the forwards to realise what was vital, to enable the backs to have enough space to show what they

were capable of. Our aim was to be successful in New Zealand and to adapt to their referees, their climate, their rugby, their people and their attitude. Not least, we had to adapt to the implication of the new laws.

I made it clear to the players that fitness must not be an issue; they had to be responsible for their own fitness levels, and consequently, after discussions with Rex Hazeldene, we supplied each player with a fitness programme.

In our first week in New Zealand, our team session priorities were:
• To build up a rhythm in our play, both in the forward drives and back movements, but more importantly, in the continuity of reaction between backs and forwards, to allow for consistent recycling of the ball.
• To provide quick driving and players available to the half-back for second drives at pace.
• The transfer of attacks to outside centre and wing, once space was available and the defence had been committed.
• It was also vital that we realised the importance of the gain line in New Zealand both in attack and defence, and once it was crossed, that pace and momentum were maintained. The watchwords were 'stay on your feet' and 'body contact at hip height'.

By the first game on 22 May, codes, short penalties and free kicks had been added and all we had to do now was to make it work where it mattered.

Our aim was to win the first two Test matches, but two crucial decisions, one in the first 60 seconds and the other in the last minute of the first Test, meant that we lost the match I felt we should have won comfortably. We were desperately disappointed at the end of the game, not only because we felt it should have been ours, but because we knew we had to produce an outstanding performance in the second Test and again in the very last match of the tour. It was all going down to the wire.

The big problem in the second Test was whether Gavin Hastings played. He did not feel he could, but I felt it was imperative that he did, even if it was for only one minute, because it was difficult to overestimate his influence as a captain during the build-up and on the attitude of the other players. With the help of Guscott and Andrew, he was convinced that he would not be letting the side down if he had to leave the field in the first minute, and that it was more important that in the next 24 hours he played a significant role in preparing the team. Having agreed, he was a changed man and took everything in his positive style. As a result, we had a side which was very focused for that 80 minutes at Wellington.

It was an outstanding team performance and this will remain one of the most satisfying performances I have seen from a Lions team. We now had everything to play for, but it meant another week of concentration and commitment.

In the final Test, the All Blacks were almost over-psyched and we simply could not match their onslaughts, and we spent the game playing catch-up rugby. It was a very disappointing result, for over the series we probably had the better of them.

The New Zealand environment is intimidating simply because, from waking up in the morning and talking to waiters and waitresses, the key note is rugby. Outside the hotel, people talk in the shops about the rugby, and at the receptions the talk was also obviously about rugby. Some players found this almost too intrusive and did not feel totally comfortable with the atmosphere; others, and in particular Clarke, Bayfield and Gibbs, found it challenging and their progress throughout the tour was dramatic.

GENERAL REVIEW

Like all Lions tours I have been associated with, the players produced many positive reactions to the challenge they were given. I think, with careful development, it should show again in our domestic rugby how much we have on board. The players should return with more confidence in their abilities rather than less, and I would venture to say that all of the 1993 Lions will be looking forward to the next occasion when they can play the All Blacks. There is nothing to fear, only an approach which requires total commitment, error-free rugby under pressure, and a positive attitude to think the game on their feet and react flexibly to the developing situations.

THE MANAGEMENT TEAM

Once again I felt fortunate to be amongst experienced personnel and we did constantly swap ideas, comments and thoughts about rugby, the game in general, New Zealand, food, wine, and aspirations. In fact, our regular Friday evening dinners together were very happy, and an essential element in drawing together our ideas, as well as reviewing the week's activities.

This was a very happy tour, and all the players had a very positive attitude and commitment. I feel there were only a couple who let themselves down on occasions, and that I am sure was due to the positive directions and input given by Geoff Cooke, and the obvious enthusiasm and interest in their wellbeing from Kevin Murphy and James Robson.

GEOFF COOKE

Geoff is a very professional and modern manager, and extremely well organised, which meant that the tour ran very smoothly. The fact that we had no significant problems shows how detailed his organisation, and subsequently our video analysis of the teams and the swapping of ideas, helped us to continually adapt and respond to each challenge.

DICK BEST

Dick had probably got the most difficult job on the tour, because, as assistant coach, more than anyone else he had to remain flexible and adaptable in his role, and this I thought he did very well. We had interesting conversations and were able to share ideas to develop our coaching sessions, and his onfield quips were invaluable in keeping the players on their toes. He was very supportive and we were able through our conversations to share the development and progress, not only with the team and his tactics, but of the individual players as well.

JAMES ROBSON

James, I feel, was an inspired choice as doctor, simply because he is sportsminded, and is a physiotherapist as well. He and Kevin Murphy worked wonders in the medical room and did it so professionally that the players had total confidence in their ability to make them right. James is very aware of the sports needs in the players, and his medical knowledge in that field helped, with the use of the correct drugs and treatment, to dramatically shorten the injury period of a number of players. In fact, only one player, Richard Webster, was injured for longer than one week, and potentially a number of injuries could have taken two to three weeks for recovery. I would also suggest that, if the Four Home Unions consider the

development of a medical group in sports injuries, James Robson should be part of it, as he is the best doctor I have ever worked with in the sports injury field.

KEVIN MURPHY

Kevin is quite outstanding at his job; he never stops and his room is always available for players. He, along with James, had a very approachable attitude and, even when his room was littered with bodies, he never failed to keep a sense of humour. This is very important in the depths of New Zealand in the middle of a tour, when it is easy for players to become negative or depressed because they are injured.

All in all, I feel again a great privilege to be part of a Lions tour and to be a part of a management team that did get on very well together, making a very intense eight weeks so enjoyable. The management of the tour was easy and professional.

THE CAPTAIN: GAVIN HASTINGS

Gavin was quite outstanding as a captain. He has the respect of all the players, but, more importantly, he had already had the respect of New Zealanders from his previous visit, and his performances during this tour only strengthened their views about him, both as a player and as a character.

He was not only professional, but friendly and positive in his dealings with the press, and he defused many potentially difficult questions from what is, at times, a very rugby-illiterate press corps. The fact that his presence in the second Test was viewed with such seriousness by all the Test players shows the influence and input he gave in the preparation. The 1993 Lions were seen in New Zealand as one of the best touring teams ever to visit as a group, and this was the result of the attitude, presence and approach that Gavin gave to the public of New Zealand.

He is a competitor and on the field, when it mattered, he led by example; and, in the end, when you are looking at a very professional approach from your top players, this, more than anything else, significantly makes credible leadership.

▲ Gavin Hastings proved an inspirational captain, leading by example and scoring 38 points in the Test series

COMMENTS AND RECOMMENDATIONS

1. As a tour, the 1993 tour was a successful rugby experience both for those in the Lions party and for New Zealanders in general. I had never come across so many positive comments about our presence and displays. However, in pure results terms, we would have to say that, at the final whistle, we failed.

2. The 13-match tour is a very difficult proposition, particularly in New Zealand or South Africa, and it requires a balanced itinerary and the facility to prepare correctly before departure. As far as the itinerary was concerned, only the Waikato game was completely wrong.

3. The manager, but more particularly, the coach, must have significant, even final, decision on the composition of the tour party, as it is the rugby and the results which are ultimately the most important part of the tour. It would be beneficial for the manager and the coach to have no national involvement during the season prior to the tour.

4. Once again, I felt it was important that we had an additional weekend together, but this was very difficult to organise because of club commitments. If we are to prepare properly and have the players in the correct mental and physical state for such an intense tour, then consideration has to be given to presenting the Lions preparation programme at least 18 months before the tour and asking each of the Home Unions to organise, for that season only, a change to some domestic fixtures. It seems ridiculous to me that we were finally at the mercy of the clubs as to how we could organise our preparation.

5. Realistically, the players should also have at least two or three weeks' break before having to attempt a tour of this intensity.

6. Travel in all respects was excellent, apart from some occasional early morning starts. It is definitely an advantage to be able to train first and travel internally immediately after lunch. One further recommendation I could make is that, on some occasions, it would have been better not to travel at all on the Sunday, particularly after a big game in the major centres. This would allow a complete day off for organisation of free time and, on the Monday, training could then take place, followed by travel.

▲ The Lions squad walk to training through the streets of Bay of Islands. The tourists travelled with all the training equipment they felt they required, a major plus in the eyes of coach Ian McGeechan

7. The equipment available for training, i.e. balls, tackle pads and scrummaging machine, were all excellent and, along with small cones, they all travelled with us, which meant we were completely self-reliant.

8. The major weakness in our squad was the absence of a strong character who could captain the midweek side and give it purpose and focus. I would recommend future selection actually selects a player with this responsibility.

9. There were significant differences in law interpretations, but we did expect this. The only point I would make is that, in New Zealand, the referees are told the type of game that they have to referee towards, and this allows players to develop continuity. They view very harshly the following:

10. The player on the ground should be penalised at all times if he either does not release the ball or move away and that he is rucked dynamically if he is directly in the way of the ball. This undoubtedly helps continuity.

11. The lineout throwing is geared to give the side throwing in possession.

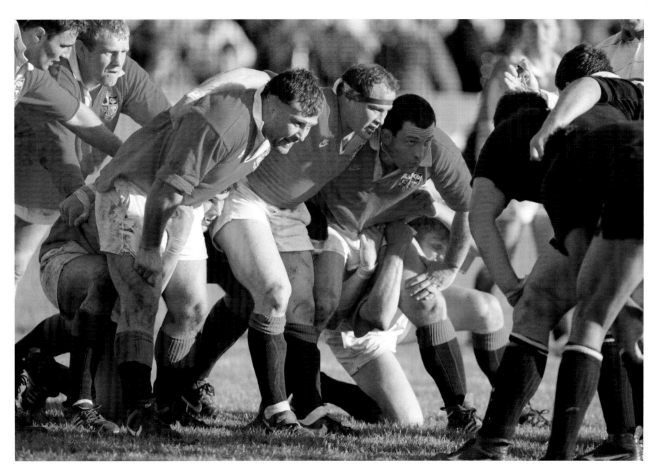

12. *Scrums hit and continue driving so again the ball is put in quickly and favours the side in possession; squint put-in was almost never penalised.*

13. *I know we have a meeting between coaches and referees; the significant difference between the two hemispheres is that referees are dictated to more in the southern hemisphere to produce a certain type of game and, under the new laws, contact, continuity and the availability of the ball are seen as a priority. This is allowing Australia and New Zealand to develop faster, more continuous rugby, and our own players did benefit from this approach. If a Home Unions team is ever to win the World Cup, then we have to look carefully at the way we want our game to develop, and we must interpret the laws positively towards that end. It might not be the purest approach, but it is the practical approach, and it is the only way in which we will be able to compete in the world environment and competitions. Whilst in New Zealand, both Geoff and I heavily criticised their interpretation of the third man 'who can be off his feet and scooping back'. This, more than anything else, took us time to adapt to, particularly as we had emphasised that we wanted our players on their feet.*

14. *The role of assistant coach could be extended, possibly to take official responsibility for the midweek team, and this would help to give a focus to the duties of the assistant coach.*

15. *It would have been very useful to have the squad's photograph with signatures on a card (Christmas card format), to distribute during the tour.*

▲ Jason Leonard (left), Brian Moore (centre) and Nick Popplewell were the first choice front row for the Tests in Wellington and Auckland and gave an excellent account of themselves, but the Lions were frustrated by some of the law interpretations they encountered during the tour

➤ Gavin Hastings (left) and John Timu exchange shirts after the All Blacks' 30–13 victory in Auckland. It was the tourists' sixth defeat in eight visits to Eden Park

16. *A selection of headed notepaper (standard and airmail) would also be very useful for communication purposes.*

17. *The final selection meeting should not take place immediately after the last international weekend. It would be more beneficial for seven to ten days to elapse before this final meeting.*

18. *The Lions must continue – the Test matches provide an arena which is completely different from any other experience the players get and the response in New Zealand is completely different from any national tour. As they kept reminding us, the Lions are the biggest thing which ever happens to New Zealand, and South Africa for that matter. We must not underestimate the Lions' role and their significance in the world rugby stage. Whatever we think nationally, we cannot provide what the Lions provide and, although there will be inherent difficulties of bringing four countries together, the advantages far outweigh any problems, and British rugby will always benefit from the existence of the Lions.*

Finally, I would like to thank Bob Weighill for the time and effort in the preparation and organisation of the party at Oatlands Park, as well as the distribution of the tremendous amount of kit received. Once again, Bob provided a very effective base from which Geoff and I could work, to develop a closely knit touring party. My thanks also go to John Lawrence, Treasurer, whose swift reimbursal of expenses and clear directions are appreciated by both management and players, as travelling can be an expensive business.

Ian R. McGeechan
Honorary Coach and Assistant Manager

RESULTS OF THE 1993 LIONS IN NEW ZEALAND

P 13 W 7 D 0 L 6 F 314 A 285

North Auckland	W	30–17	Taranaki	W	49–25	
North Harbour	W	29–13	Auckland	L	18–23	
New Zealand Maoris	W	24–20	Hawke's Bay	L	17–29	
Canterbury	W	28–10	New Zealand (Wellington)	W	20–7	
Otago	L	24–37	Waikato	L	10–38	
Southland	W	34–16	New Zealand (Auckland)	L	13–30	
New Zealand (Christchurch)	L	18–20				

GAVIN HASTINGS' 1993 LIONS TEAM

FULL-BACKS			FORWARDS		
A. Clement	Swansea	Wales	M.C. Bayfield	Northampton	England
A.G. Hastings (capt.)	Watsonians	Scotland	A.P. Burnell	London Scottish	Scotland
			B.B. Clarke	Bath	England
THREE-QUARTERS			D.F. Cronin	London Scottish	Scotland
W.D.C. Carling	Harlequins	England	W.A. Dooley	Preston Grasshoppers	England
V.J.G. Cunningham*	St Mary's College	Ireland	M.J. Galwey	Shannon	Ireland
I.C. Evans	Llanelli	Wales	M.O. Johnson*	Leicester	England
I.S. Gibbs	Swansea	Wales	J. Leonard	Harlequins	England
J.C. Guscott	Bath	England	K.S. Milne	Heriot's FP	Scotland
S. Hastings	Watsonians	Scotland	B.C. Moore	Harlequins	England
I. Hunter	Northampton	England	N.J. Popplewell	Greystones	Ireland
R. Underwood	Leicester and RAF	England	A.I. Reed	Bath	England
T. Underwood	Leicester	England	D. Richards	Leicester	England
R.M. Wallace*	Garryowen	Ireland	M.C. Teague	Moseley	England
			R.E. Webster	Swansea	Wales
HALF-BACKS			P.J. Winterbottom	Harlequins	England
C.R. Andrew	Wasps	England	P.H. Wright	Boroughmuir	Scotland
S. Barnes	Bath	England	*Replacements		
R.N. Jones	Swansea	Wales			
C.D. Morris	Orrell	England			
A.D. Nicol*	Dundee HS FP	Scotland			

THE FIRST PROFESSIONALS

When rugby became 'open' in 1995, casting off the shackles of amateurism, much was said and written about how the game's administrators had to preserve the ethos and character of the game in the new era of professionalism. Many critics went as far as to herald the end of traditional values that made rugby such a popular international sport. Rugby would never be the same again.

The game undoubtedly struggled in the northern hemisphere in the early days of this new era, while the southern hemisphere surged forward positively towards the new millennium. After all, the southern powers of New Zealand, South Africa and Australia had virtually dragged the rest of the rugby world kicking and screaming into the environment of professional sport.

Rugby was the last major sport to shed its amateurism tag, but at the end of the day everyone involved – administrators, players and the like – must be congratulated for the relatively smooth transition. The early problems in the north were merely regarded as hiccups, and while many more speed bumps may lie ahead, it is fair to say that rugby will never be the same again. It will be bigger, better and more exciting.

The pessimists back in 1995 predicted the demise of one of rugby's best traditions, The British & Irish Lions. It was argued that with professional club competitions, expanded Test schedules and convoluted player contracts there was simply no room for the Lions in the new order. History will record that such thinking was unfounded and wildly wide of the mark. A Lions tour to South Africa in 1997 had been pencilled into the Test schedules many years previously and the South African Rugby Football Union, which had lost several million rand in the transition to professionalism, desperately wanted the tour to proceed. It was to be the first such tour since 1980 and predicted ticket-sale revenue would dramatically boost the organisation's coffers. The tour was such a windfall in terms of crowds, excitement and revenue that South African Rugby Football Union chairman Dr Louis Luyt called for Lions tours to become more frequent. While rugby fans in the south appreciate and enjoy individual countries from the north touring, nothing whets their appetite as much as the four-nation conglomeration. It simply shows that money cannot buy tradition and history. While it is unlikely that the Lions will tour more frequently than every four years, their future – and one of rugby's greatest traditions – seems assured.

1997 TOUR KIT

1997
MCGEECHAN'S MARVELS

Captain: Martin Johnson (Leicester Tigers and England)
Squad Size: 35 players + 5 replacements
Manager: Fran Cotton (England)
Coach: Ian McGeechan (Scotland)
Assistant Coach: Jim Telfer (Scotland)
Kicking Coach: Dave Alred (England)
Skills Coach: Andy Keast (England)
Tour Doctor: James Robson (Scotland)

Tour Record:	P 13	W 11	D 0	L 2	F 480	A 278
Test Series:	P 3	W 2	D 0	L 1		

When the Lions boarded their Virgin Atlantic jumbo jet for South Africa with 2.5 tonnes of baggage, no one gave them a cat in hell's chance of winning the three-Test series. Confident bookmakers were posting odds of 5–1 on them losing every Test. After all, they had won only three of their previous 14 Tests, even though they had won the series in Australia 2–1 eight years earlier.

The southern hemisphere 'super powers' were simply light years ahead. New Zealand had won the inaugural Rugby World Cup in 1987, Australia had followed them in 1991 and South Africa had taken over as world champions in 1995. The Super 12 and Tri-Nations tournaments had given them a huge edge. They played the game at breathtaking pace, tackles and hits were ferocious and their management and administration were far superior. South Africa were confident of a victorious series, one that would be the perfect warm-up for their 1997 Tri-Nations campaign. They even had a cup made, aptly named the Lion Trophy (after its major sponsor).

The Lions management had anticipated such attitudes and, understanding the task ahead of them, had plotted long and hard in the months preceding the tour,

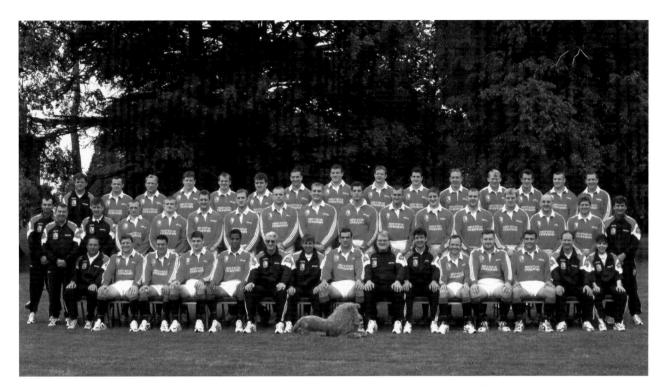

leaving no stone unturned to ensure the first tour to South Africa for 17 years would be a winning one. The player selection process involved comprehensive analysis of ability, attitude and fortitude. Fact-finding trips were made to South Africa, including visits to 1996 Tri-Nations Tests, and advice was sought from such rugby luminaries as All Blacks coach John Hart.

The outcome was a tour party of 35 players (which became 40 after injuries struck) and a huge management contingent that included the usual medical personnel plus a dedicated kicking coach, Dave Alred, and a tactician-cum-technical-guru, Andy Keast, the Harlequins coach. Manager Fran Cotton and coach Ian McGeechan, supported by assistant coach Jim Telfer, were steeped in the history and tradition of the Lions and were meticulous in their preparation. Cotton and McGeechan had been Lions together in South Africa in 1974 and New Zealand three years later and so had first-hand experience of the psyche of their opponents and the climatic conditions they would encounter.

McGeechan, on his unprecedented third consecutive Lions tour as coach, knew the type of player he wanted for the tour: 'I wanted decision-makers, players who would not be afraid to play as they saw it. This meant strong individuals, ones who would be tough and uncompromising and never troubled by thoughts of failure. We had to have people who had no fear of trying things, because if you never try you will never succeed.'

Leicester Tigers and England lock Martin Johnson fitted this mould and was chosen as captain on the basis that he would be an automatic choice in the Test team. McGeechan and Cotton were not prepared to carry a player in the team just because he was captain. Debate on the selection of the captain raged for many months prior to Johnson's appointment. When it was announced, his lack of experience as a captain was regarded as a gamble by several critics, but generally the decision was accepted. A Lion in New Zealand in 1993, he became the first Englishman since Bill Beaumont to lead a tour party and would be instrumental in the success of the tour.

▲ The 1997 Lions squad was an enlarged one, with 35 rather than 30 players initially making the trip to South Africa. England again dominated with an 18-strong contingent

His leadership, along with the management of Cotton and McGeechan, established within the touring party a spirit and camaraderie not seen since the 1974 tour. The players became a tight unit and their loyalty and trust in each other became an important factor in repelling the Springbok onslaught in the Test series.

▲ Neil Jenkins was in prolific form in South Africa, scoring 41 points for the Lions in the three-Test series

The tour party comprised a record 18 Englishmen, eight Welshmen, five Scots and four Irishmen. The English contingent rose to 22 when they had four replacements called up. The oldest player was Welsh wing Ieuan Evans, on his third Lions tour, along with Jeremy Guscott, and the youngest was Irish back-row forward Eric Miller, at just 21. Reflecting rugby's new professionalism, the squad included six players who had returned from rugby league: three-quarters Allan Bateman, Scott Gibbs, Alan Tait and John Bentley, prop David Young, and back-row forward Scott Quinnell. All of the backs went on to win Test honours and distinguish themselves through their tour performances. Young failed to win a Test spot and Quinnell's tour sadly finished abruptly after sustaining a groin injury against Northern Transvaal.

Quinnell joined Keith Wood in following in their fathers' footsteps into the Lions side, matching the achievements of Andrew (1896) and Jammie (1924) Clinch and Herbert (1924) and Gordon (1959, 1962) Waddell. Derek Quinnell had been a Test Lion on three tours, 1971, 1977 and 1980, while Gordon Wood had played for the Lions against the All Blacks in 1959.

Gibbs, the former St Helens rugby league centre, was a revelation and, probably, the player of the tour. Likened to a pocket battleship by the media, his fearless and bone-jarring defence rattled the Springboks, and when he wasn't knocking green shirts over, his physical and committed running caused consternation in the locals' defensive lines. His stature, barrel-chested and 5ft 10in tall, caused co-centre Guscott to describe Gibbs during the tour as 'the fastest prop I have ever seen'!

It would be hard not to mention all of the tour party, as everyone contributed immensely to the success, but Irish lock Jeremy Davidson was extremely impressive, improving as the tour wore on, and his fellow countryman, hooker Wood, free of injury after a string of bad luck in previous years, proved a human dynamo with his work rate around the field. Alongside Wood in the front row, Paul Wallace grabbed his chance with both hands when he replaced fellow countryman Peter Clohessy, who was ruled out with injury, three days before the tourists departed and became a massive success in the series. Wallace was following in the footsteps of his elder brother Richard, who had been a replacement wing in New Zealand in 1993, and a third brother, the Munster back-row man David, later made it a family hat-trick with tours in 2001 and 2009.

Guscott provided the class behind the scrum, full-back Neil Jenkins laid claim to being the best goal kicker in world rugby and props Smith and Wallace showed a maturity and skill level that surprised their critics and enabled them to confront the much larger 'Bok front row. After a slow start, the tour party gelled into a formidable unit, and the tour record of 11 wins from 13 matches, including a 2–1 Test series triumph, was a testament to the resolve of the squad. The pressure to perform in the shadow of the 1974 side was immense, especially as the tour progressed, but the stunning triumph was a shot in the arm for northern hemisphere rugby after several years in the doldrums. What is more, it cast doubt over the Springboks' ambitions of success in the Tri-Nations series against New Zealand and Australia later that year.

For a nation that adores its rugby and treats its Springboks as national heroes, the loss of the Test series, following the loss to New Zealand in 1996, was hard to stomach. Arrogant in their belief that South Africa is the leading rugby nation, the media in particular turned on the Springboks and novice coach Carel du Plessis. The Springboks' final Test victory did little to quell the national disappointment.

It was an abrasive tour, but not unique in that respect. Lions teams of years gone by can testify to the physical and mental stress that goes with touring South Africa. Six players were ruled out of the tour as the physical nature of the campaign took its toll. By the kick-off in the last Test, nearly half of the original Test team had been ruled out through injury.

A notable aim of McGeechan throughout the tour was to avoid the situation where two separate teams within the squad were developed: the Test team and the midweek team. He stated at the outset that there would be no such policy, and this proved true. This had the effect of giving all players ample opportunity to push for Test places and contributed greatly to player morale.

The tour kicked off in positive fashion in Port Elizabeth against Eastern Province. A 39–11 victory over the 'Elephants', while satisfying, was not overly impressive, but it did not merit an attack by opposition coach Johan Kluyts, who declared that the 'Boks would win the Test series 3–0. He also proclaimed that full-back Neil Jenkins was a poor player and that the 'Boks would kill him. Such rants would come back to haunt him.

Next up the Lions headed further east along the Cape to East London, where they disposed of a plucky Border in the mud. The 18–14 victory, however, highlighted several shortcomings in the forward play, and only a late try by Rob Wainwright saved the day. Centre Gibbs caused a scare by damaging his ankle, an injury which necessitated x-rays and kept him out of several matches. It was a similar story in Cape Town against Western Province, where frailties in the pack again surfaced, but the play of the three-quarters indicated that an expansive game plan was part of the tour tactics. Captain Johnson took the field for his first appearance of the tour, but it was obvious that after a gruelling domestic season for the powerful lock McGeechan was going to use him sparingly outside of the Tests. Such tactics reaped dividends later in the tour when Johnson's form peaked for the Test matches.

A plus from the match was the form of scrum-half Howley, but this was tempered by the loss of outside-half Paul Grayson who, after completing the match, was told his tour was over due to a thigh injury. His replacement was Englishman Mike Catt who, much to the displeasure of England coach Jack Rowell, left the English tour of Argentina to go to South Africa.

▲ Ireland hooker Keith Wood (centre) was a hugely influential figure for the Lions in South Africa, leading from the front in the first two Tests before injury ruled him out in Johannesburg

After a week of intense training under the guidance of 'scrum doctor' Jim Telfer, which the Lions forwards will find hard to erase from the memory, the Lions took the field against Mpumalanga in Witbank with Jenkins at outside-half due to the late arrival of Catt. The 64–14, ten-tries-to-two victory was reward for an expansive philosophy, but the match will always be remembered for the vicious and cowardly thuggery of Mpumalanga lock Marius Bosman. An out-and-out thug, he was guilty of several indiscretions before callously stamping on the knee of lock Doddie Weir. The injury ruled Weir out of the tour and threatened his career. To the disgust of the Lions management, Bosman stayed on the field and was only reprimanded by the national union and fined a paltry sum. The postscript to this episode was the call-up of veteran English lock Nigel Redman from Argentina.

With four victories behind them, the Lions were slowly coming to terms with the local conditions, but ahead lay matches against three Super 12 provinces, Northern Transvaal, Gauteng and Natal. The first real examination for the Lions came in Pretoria against the Blue Bulls, and the 30–35 loss was the first against a province in the Republic since 1968. It was a match the Lions could and should have won, but poor ball retention and costly errors were the order of the day, along with another patchy performance up front. The experiment of moving Miller from No. 8 to the

open side was a fizzer, as McGeechan continued his search for answers to his Test pack make-up. What is more, Gibbs, who took the field as a replacement, was later suspended for one match for punching, and the day after the match No. 8 Quinnell was ruled out of the tour because of a groin injury. Centre Bateman, who was pushing for his first Test spot, also aggravated a hamstring injury, putting his tour participation in doubt.

English back-row forward Tony Diprose joined the tour as Quinnell's replacement, just as wing Tony Underwood injured his shoulder against Gauteng. The Lions won the match 20–14, but it took two second-half tries to seal the win. One was a spectacular effort by winger John Bentley, who raced 70 metres to score. Jenkins, who took the field as a replacement, converted both tries after outside-half Catt had missed five penalty attempts.

Leaving the high altitude of Pretoria and Johannesburg, the Lions headed to Durban at sea level to face Currie Cup holders Natal at Kings Park. This was considered to be the 'fourth Test' of the tour, but the Lions showed sublime form to comprehensively thrash the Sharks 42–12. It was an outstanding win, and for the first time the South African media and public sat up and took notice of a team that was now clearly capable of winning the first Test. Tries by Townsend, Catt and Dallaglio were complemented by more superlative kicking by Jenkins, who kicked 24 points including six penalties to secure his spot at full-back for the first Test, ahead of pre-tour favourite Tim Stimpson.

However, the horror injury stretch continued. Scrum-half Howley, a vital cog in the Test team, left the field with a severe shoulder injury in the first half and he became the fourth player to return home. Another Englishman, Kyran Bracken, who was at the time on holiday in Tobago, was brought in as his replacement.

The last match before the first Test saw the Lions dispose of the Emerging Springboks. They cut loose in the second half with the fast, attacking rugby that had become their trademark, and young wing Beal crossed for a hat-trick. The team was captained by veteran English prop Jason Leonard, which indicated he would miss out on a Test berth.

This was the tour that gave birth to the 'fly-on-the-wall' documentaries *Living with Lions*. Telfer, and McGeechan vied for the best speeches on tour, but this one delivered by Telfer to his forwards on the eve of the first Test has gone down in history:

The easy bit has passed. Selection for the Test team is the easy bit. You have an awesome responsibility on these eight individual forwards' shoulders, an awesome responsibility.

*This is your f***ing Everest, boys. Very few ever get the chance in rugby terms to get to Everest, the top of Everest. You have the chance.*

Being picked is the easy bit. To win for the Lions in a Test match is the ultimate. But you'll not do it unless you put your bodies on the line. Everyone jack of you for 80 minutes.

Defeat doesn't worry me: I've had it often and so have you. It's performance that matters. If you put in the performance, you'll get what you deserve, no luck attached to it. If you don't put it in, if you're not honest, they'll second-rate us.

*They don't rate us, they don't respect us, they don't respect you, they don't rate you. The only way to be rated is to stick one on them, to get right up in their faces, to turn them back, knock them back, outdo what they can do, out jump them, out scrum them, out ruck them, out drive them, out tackle them until they're f***ing sick of it.*

Remember the pledges you made. Remember how you depend on each other. You depend on each other at every phase, teams within teams. Scrums, lineouts, ruck balls, tackles. They are better than you've played against before. They are better individually or they wouldn't be there. So it's an awesome task you have and it will only be done if, as I say, everybody commits themselves now.

[Pointing to a whiteboard] That was written yesterday about us. Read it silently, take note of it, and then make a pledge. You are privileged. You are the chosen few. Many are considered but few are chosen.

*They don't think f*** all of us. Nothing. We're here just to make up the f***ing numbers. [Reading from the whiteboard] Their weak point is the scrum. The 'Boks must exploit this weakness. The 'Boks must concentrate on the eight-man shove every scrum. Scrummaging will be the key. Their weakness is the scrum.*

*Nobody's going to do it for you. You have to find your own solace, your own drive, your own ambition, your own inner strength, because the moment's arriving for the greatest game of your f***ing lives.*

For the first Test in Cape Town, McGeechan opted for an all-Celtic front row, consisting of two Irishmen and a Scot. Props Tom Smith and Paul Wallace got the nod ahead of the more experienced Young and Leonard. Hooker Wood was following in the footsteps of his father, who had propped the Lions scrum in 1959. The No. 8 spot went to Tim Rodber, with Eric Miller being ruled out with the flu.

▼ Matt Dawson's audacious try in the first Test in Cape Town helped the Lions storm to a famous 25–16 win at Newlands. The England scrum-half also touched down in the third Test at Ellis Park

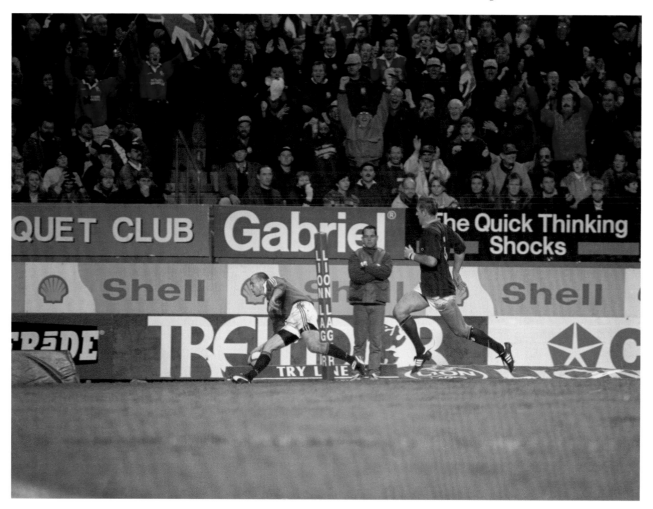

Scrum-half Matt Dawson, out of favour with England months earlier, took Howley's position, Guscott and Gibbs continued their centre partnership from 1993, and Alan Tait, selected as a centre for the tour, won a spot on the wing ahead of Bentley.

Novice Springbok coach du Plessis, with little senior coaching experience and a single Test against Tonga under his belt, stuck with the tried and tested, although he had no room in his side for lock Kobus Wiese and centre Hennie le Roux, much to the angst of the public. Winger James Small became the most-capped Springbok of all time, with 38 caps.

On the shortest day of the year, the Lions stunned the Newlands crowd and delighted their legions of supporters by finishing the stronger team to win 25–16. It was a hard-earned victory, as they had only gone to the break leading 9–8 thanks once again to Jenkins, after the 'Boks had scored the first try of the match through gargantuan prop Os du Randt.

South Africa clearly had the upper hand with regard to territory and possession, and the match looked beyond the reach of the Lions when replacement Springbok wing Bennett crossed for the second try of the match after 43 minutes. The turning point occurred with 12 minutes to go. Bennett appeared to have scored his second try, only to be called back for a forward pass, and the Lions entered the last ten minutes only 16–15 down.

The boot of Jenkins and never-say-die defence had kept them in the match. The front row had met the challenge of the enormous 'Bok scrum, and a moment of individual brilliance broke the hearts of the South Africans. From a scrum on the right of the Springbok 22, scrum-half Dawson broke right down the blind side and outsped flanker Kruger into a gap. With No. 8 Teichmann about to smash him, he feigned an overhead pass back inside. Teichmann took the dummy and Dawson scampered over unopposed to put the Lions ahead with minutes remaining. Then, in the final minute, Tait sealed victory in the left-hand corner with a try after most of the Lions had been involved in the lead-up. The Lions reserves took to the field in celebration and McGeechan's bear hug of Dawson in the tunnel after the match summed up his emotions at his team scoring a record number of Test points at Newlands.

All those months of plotting and scheming by Cotton and McGeechan had paid off. Their mission to put the Springboks on the back foot from the outset had proved successful. The trick now was to maintain the momentum and prevent the wheels falling off the bandwagon.

Bentley further pressed his claims for a Test spot on the wing with a well-taken hat-trick of tries in the tenth match of the tour against Free State. The Lions had chosen to fly to the high altitude of Bloemfontein on the same day as the match, and Fran Cotton declared after the 52–30 victory, 'One of the all-time great Lions performances, when you consider we travelled up on the day and were playing a Super 12 province at altitude.'

With preparations in hand for the second Test and the victory that would secure the series, the Lions lost another two members of the tour party. Uncapped English centre Will Greenwood was knocked unconscious during the Free State match and Test winger Evans damaged his groin in training. Such disruptions became a weekly occurrence for tour doctor James Robson and physio Mark Davies, but, undeterred, the touring party's resolve grew stronger as the tour progressed and the competition for Test spots became intense. Scottish three-quarter Tony Stanger, in South Africa with the Scottish Development team, was called into the squad as cover for Evans and Greenwood.

▲ England centre Jeremy Guscott became a Lions legend when he dropped the winning goal four minutes from time in the second Test in Durban, a dramatic 18–15 win which sealed the series for the tourists

Evans' misfortune opened the door for Bentley and he was the only change in the Lions team for the second Test at Kings Park, Durban. Du Plessis, however, was forced into making several changes behind the scrum. Injured centres Edrich Lubbe and Japie Mulder were replaced by the recalled Danie Schalkwyk and new cap Percy Montgomery, while the injured James Small was replaced by new cap Pieter Rossouw on the wing.

What eventuated at Kings Park was the greatest rearguard action since Rorke's Drift. The vastly underrated Lions heroically withstood wave after wave of Springbok pressure and, despite conceding three tries, triumphed 18–15, thanks to the golden boot of Jenkins and a match-winning drop goal, once again, from Guscott.

Prepared for an onslaught after the first Test, the Lions could not have imagined how ferociously the massive South African pack would attack them second time round. Yet, led from midfield by Gibbs, who tackled his heart out and whose aggression in defence rubbed off on the likes of Smith, Rodber and Wood, they constantly repelled the opposition.

The 'Boks simply dominated territory for 70 minutes but paid the ultimate price for not having in their midst a goal kicker of Test standard. Outside-half Henry Honiball missed two kicks, Montgomery three and full-back Joubert one. Delighted former Lions flanker John Taylor wrote in his newspaper column, 'The Lions committed grand larceny.'

The Lions refused to give in and managed to stay in touch until the last few minutes, thanks to Jenkins' five penalty goals. When it appeared they were out on their feet they found a second, even third, wind and made ground towards the 'Bok 22. Dawson, unable to find his outside-half Townsend, fed Guscott, who went for broke and the drop goal. It sailed high and true to put the Lions in front at 18–15. The final whistle, minutes later, signalled a historic series victory for the Lions and the opportunity to whitewash the Springboks in the final Test.

The local media called for the head of the coach and lambasted the players. One journalist from the *Cape Times* declared, 'The most positive aspect of Saturday's result was that the powers that be now know that their decision to appoint du Plessis was not a moment of inspiration but one of madness.'

The British press lauded the Lions and dismissed claims that they had been lucky. Had the Springboks not beaten New Zealand in the World Cup final in similar circumstances in 1995? Headlines proclaimed 'Bokbusters!', 'Lions Break 'Bok Hearts', 'Truly the Stuff of Legends' and 'Lionhearts Steal Glory at the Last'.

The Lions left Durban buoyed by their success and once again headed for the high veldt and the final Test at Ellis Park, Johannesburg. On the way they stopped at Welkom to play Northern Free State in the penultimate match of the tour. The Lions ran riot, scoring ten tries in the last midweek match to record the highest score of the tour and pass the 50-point mark for the fourth time.

Poised to make history by attempting to win the Test series 3–0, the Lions were a sore and bruised bunch. Spirits were high, but there was no denying that several of the Test team could not muster the energy for a third encounter with the Springboks. Ellis Park is the fortress of South African rugby and the scene of its greatest triumph in 1995. Entering the third Test against the All Blacks in 1996, also 2–0 down, the 'Boks had defended their temple to win the Test and salvage some pride. The Lions took the field with five changes from the second Test. Tony Underwood replaced Tait

▲ The shirt worn by Tony Underwood in the third Test in Johannesburg, signed by the entire Lions squad

on the wing, Mike Catt took over the outside-half role from Townsend, Mark Regan replaced Wood at hooker, Neil Back, rejected by England for being too small, replaced Hill and, on the morning of the Test, Scottish captain Rob Wainwright was drafted into the back row when Rodber was hit by a gastro bug.

Carel du Plessis, fighting for his coaching future, was also forced into changes due to injury and poor form. Bennett took over at full-back for Joubert, outside-half Honiball was relegated to the bench in favour of out-and-out goal kicker Jannie de Beer, James Dalton was recalled at hooker for Naka Drotské, Dawie Theron replaced prop Adrian Garvey, Johan Erasmus replaced flanker Kruger and Krynauw Otto replaced the injured Andrews at lock.

It proved to be a game too far for the Lions. They were battered and bruised, and it was beyond them to compete for the full 80 minutes. To the very end they fought like champions, though, and although two late Springbok tries distorted the final scoreline, the Lions were in the match until the last ten minutes. With Guscott equalling Mike Gibson's record of eight Tests at centre, there was a certain irony to the encounter: the Lions' performance was in many ways a more authoritative one than that of the second Test. Dallaglio had a huge match, as did Smith, in a game that was once again overly physical at times. Indeed, on four occasions various Springbok forwards were warned for foul play.

The South Africans scored two tries to one in the first three-quarters of the match, but with the score at 23–16 to the home side they went on to score two further tries in the last 12 minutes. Full-back Jenkins kicked three penalties to create a new Lions record for points scored in a Test series, his 41 points surpassing Gavin Hastings' 38 points in New Zealand in 1993.

In the end it came down to one thing: who wanted to win more. The Lions were chasing history, but with the series already secured – and

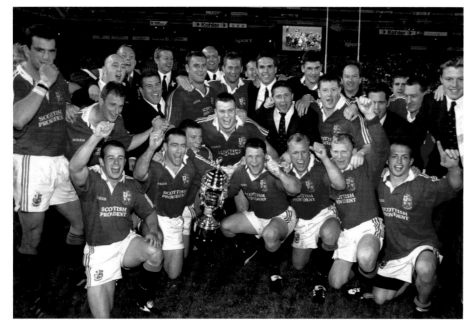

although they would not admit it – the hunger for success so evident in the earlier matches was definitely not so fierce. The 'Boks, on the other hand, were desperate for victory. Castigated by their supporters and the media, it was do-or-die time for most of the players. Their hunger proved greater in the final battle.

The final word has to go to tour manager Fran Cotton, who wrote in his book about the tour, *My Pride of Lions: The British Isles Tour of South Africa 1997*:

History, hopefully, will tell future generations how the 1997 Lions won a Test series 2–1 in South Africa and helped change the face of European rugby...

These first professional Lions had been written off by many as 'no hopers' before they left for South Africa, and the very future of Lions' tours was being questioned by people with their own selfish, commercial axe to grind. Ultimately, however, the players provided their own perfect riposte to the 'no hopers' tag and, through the quality of their rugby and the interest it generated, they left nobody in any doubt concerning the desire for the Lions concept to be retained.

RESULTS OF THE 1997 LIONS IN SOUTH AFRICA

P 13 W 11 D 0 L 2 F 480 A 278

Eastern Province	W	39–11	Emerging Springboks	W	51–22
Border	W	18–14	South Africa (Cape Town)	W	25–16
Western Province	W	38–21	Free State	W	52–30
Mpumalanga	W	64–14	South Africa (Durban)	W	18–15
Northern Transvaal	L	30–35	Northern Free State	W	67–39
Gauteng	W	20–14	South Africa (Johannesburg)	L	16–35
Natal	W	42–12			

MARTIN JOHNSON'S 1997 LIONS TEAM

FULL-BACKS

N.R. Jenkins	Pontypridd	Wales
T.R.G. Stimpson	Newcastle	England

THREE-QUARTERS

A.G. Bateman	Richmond	Wales
N.D. Beal	Northampton	England
J. Bentley	Newcastle	England
I.C. Evans	Llanelli	Wales
I.S. Gibbs	Swansea	Wales
W.J.H. Greenwood	Leicester	
J.C. Guscott	Bath	England
A.G. Stanger*	Hawick	Scotland
A.V. Tait	Newcastle	Scotland
T. Underwood	Newcastle	England

HALF-BACKS

K.P.P. Bracken*	Saracens	England
M.J. Catt*	Bath	England
M.J.S. Dawson	Northampton	England
P.J. Grayson	Northampton	England
A.S. Healey	Leicester	England
R. Howley	Cardiff	Wales
G.P.J. Townsend	Northampton	Scotland

FORWARDS

N.A. Back	Leicester	England
L.B.N. Dallaglio	Wasps	England
J. Davidson	London Irish	Ireland
A.J. Diprose*	Saracens	England
R.A. Hill	Saracens	England
M.O. Johnson (capt.)	Leicester	England
J. Leonard	Harlequins	England
E.R.P. Miller	Leicester	Ireland
L.S. Quinnell	Richmond	Wales
N. Redman*	Bath	England
M. Regan	Bristol	England
T.A.K. Rodber	Northampton	England
G.C. Rowntree	Leicester	England
S.D. Shaw	Bristol	England
T.J. Smith	Watsonians	Scotland
R.I. Wainwright	Watsonians	Scotland
P.S. Wallace	Saracens	Ireland
G.W. Weir	Newcastle	Scotland
B.H. Williams	Neath	Wales
K.G.M. Wood	Harlequins	Ireland
D. Young	Cardiff	Wales
*Replacements		

TRAVELLING COMPANION

Tradition is at the very heart of the Lions, and one of the more famous ones is the fact that the youngest player on the tour looks after the mascot.

The mascot itself has changed many times throughout the years as life on the road has eventually gotten the better of each incumbent.

The latest to join the fray is Bil (short for The British & Irish Lions) who takes over from '90s stalwart Leo and was discovered lurking in an airport shop in Geneva by the Lions staff.

Like all of his predecessors, Bil is proudly carried out by the team captain on matchday and then placed pitchside to watch the game unfold.

Bil made his debut on the 2013 tour to Australia, where he was placed under the day-to-day supervision of Scotland full-back Stuart Hogg. Bil travelled everywhere with Hogg during the tour, even on the flight!

▼ The Lions mascot has changed over the years, but what has never altered is the pride felt by the player carrying him

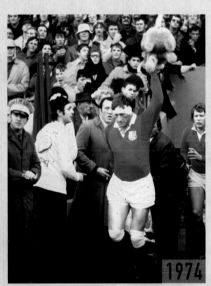

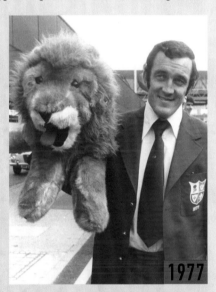

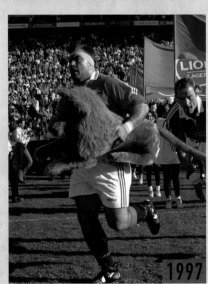

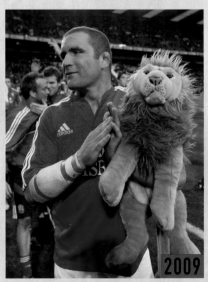

1955

1974

1977

1980

1997

2009

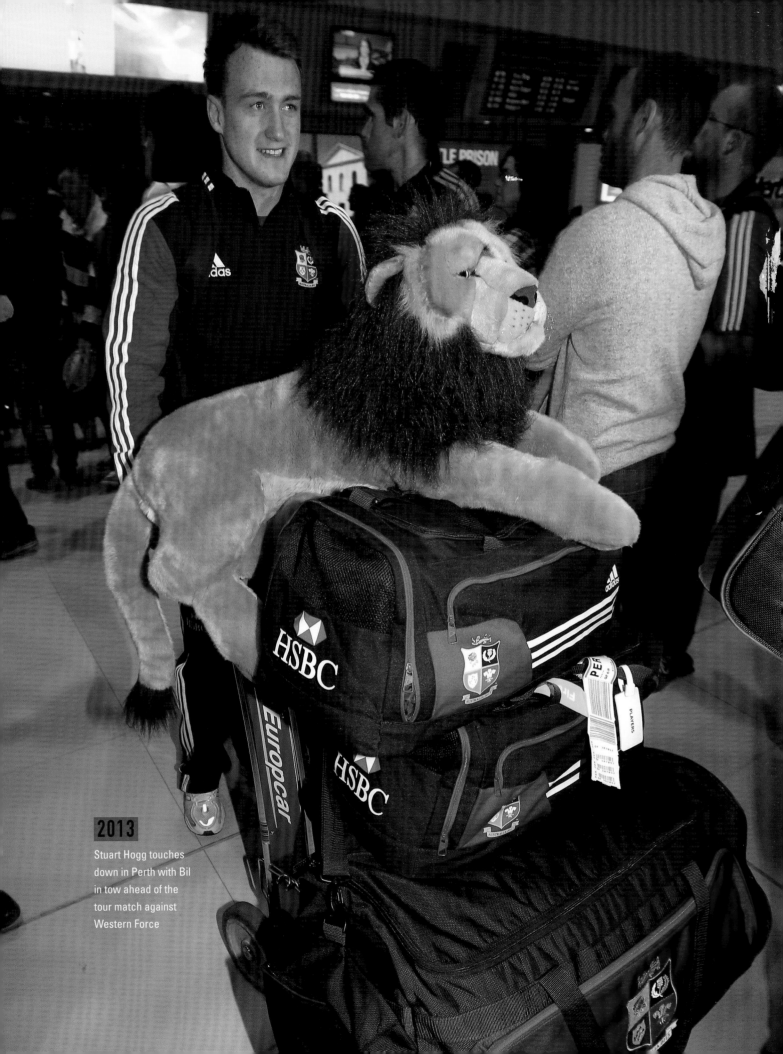

2013

Stuart Hogg touches down in Perth with Bil in tow ahead of the tour match against Western Force

10

NEW MILLENNIUM:
MISSED OPPORTUNITIES

Barely two years after rugby entered a new professional era, the triumphant tour to South Africa in 1997 rekindled the ethos and spirit of Lions tours. Strictly speaking it was the first tour to take place within the new era and the unfancied Lions beat the Springboks, winners of the 1995 World Cup, to bring much needed balance into the international game.

However, it is fair to say that the 2001 British & Irish Lions were the first touring party to experience the full implications of professionalism, an arena in which the rugby tour as we knew it has all but disappeared from the cluttered international rugby calendar. The tour to Australia, then, was an important litmus test for the future direction of Lions tours.

Unfortunately, the management's interpretation of professionalism meant an environment where it focused entirely on a winning outcome at the expense of balancing athletic pursuits with the life-education experiences usually gathered on Lions tours. Many of the traditional touring ideals were disregarded in the quest for outright success.

So intense was the regime that apart from closed training sessions, team meetings and matches, the players were lucky to see anything of the country they were visiting. This is not what Lions tours are about.

This siege mentality, manufactured by the senior management, Wales' Kiwi coach Graham Henry and manager Donal Lenihan, a 1983 and 1989 Lion, was always going to be a double-edged sword with regards to the judgement of their – and indeed the tour's – success. Had they won, such methods would perhaps have been vindicated.

Of course, the series was ultimately lost and the 2001 Lions became the first tourists to lose a series in Australia. Strong ambition and a desire to be successful are admirable qualities but, for players at the pinnacle of their careers, Lions tours should comprise a balance of elite competition and personal adventure.

It had all started out so promisingly. In this fully-fledged professional climate Henry was appointed as the first overseas coach to take the helm of the Lions, and the brooding English bulldog Martin Johnson once again assumed the captaincy to become the first player to lead the Lions on two tours.

What is more, the Lions arrived in Australia as favourites for the first time in a series in the southern hemisphere, due to the core of the squad comprising the resurgent English team that had beaten Australia and South Africa at the end of 2000 – albeit at home.

However, the all-important mind games that are part and parcel of professional sport were clearly won by the Australians. That the Wallabies successfully labelled themselves underdogs for the series highlights the psychological advantage coach Rod Macqueen established over the Lions. For this was a Wallabies team that were the reigning World Champions and holders of the Bledisloe Cup and Tri-Nations Trophy. No British team had won in Australia since the 1989 Lions series and the Wallabies, the best side in the world, were enjoying the most successful era in their history under Macqueen.

The series was the most anticipated clash for many years of two of rugby's superpowers and the Lions were accompanied by probably the biggest-ever contingent of British and Irish supporters. It didn't disappoint. The series went down to the wire, both teams scored seven tries apiece, and it hinged on a couple of key

moments in the second and third Tests. Ultimately the series was lost in the last few minutes of the third Test and represents a major missed opportunity in the eventful history of The British & Irish Lions. They simply dominated their opposition for the majority of the series.

Off the field it was also a missed opportunity, as the Lions remained largely unknown to the Aussie public, as the players became increasingly sceptical of the management regime. In stark contrast, the tens of thousands of marvellous travelling Lions supporters endeared themselves to Australia with their passionate support and good-natured revelry. The 'Red Barmy Army' provided the human face of the tour as the Lions management failed to embrace this important side of touring with their reluctance to allow media access to the players and the players themselves to enjoy the hospitality of their hosts.

This may seem a critical summary of the events surrounding the tour but it is one largely echoed by the players themselves. The Lions sought success, but the management's attempt to achieve it at all costs was hugely disappointing. The financial success of the tour is unquestionable, as is the immense interest it created around the world. In Australia, where rugby continues to surge in popularity, the tour injected around AUS $100 million into the economy.

The Lions are one of rugby's most potent and emotionally charged brands and hopefully lessons learned in Australia will ensure that future tours recreate the right balance on and off the field. The Lions must be restored to their rightful ambassadorial role for northern hemisphere rugby.

2001
SO NEAR, SO FAR

2001 TOUR KIT

Captain: Martin Johnson (Leicester Tigers and England)
Squad Size: 37 + 7 replacements
Manager: Donal Lenihan (Ireland)
Coach: Graham Henry (Wales)
Assistant Coach: Andy Robinson (England)
Tour Doctor: James Robson (Scotland)

Tour Record:	P 10	W 7	D 0	L 3	F 449	A 184
Test Series:	P 3	W 1	D 0	L 2		

The biggest-ever squad to represent The British & Irish Lions was announced in mid-April at the Crown Plaza Hotel, Heathrow Airport, to unprecedented media coverage. The media and the public's interest in the tour to Australia was immense and coach Graham Henry was left in little doubt as to the pressure he was under from day one.

Early tension started with valid criticism of the need for a 37-man squad (which became 44 after injuries struck) for the relatively short ten-match tour. Six lead-up matches to the first Test, including two first-up matches against substandard opposition, left little time for experimentation, development of combinations, or a valid assessment of all 37 players. The pressure intensified when it was revealed that several players, including Englishmen Lawrence Dallaglio, Phil Greening and Mike Catt, would travel with significant injuries.

➤ New Zealander Graham Henry (right) became the first coach hailing from outside the Home Nations to take charge of the Lions. Ten years later the Kiwi would lead the All Blacks to World Cup glory

The spotlight of pressure made Henry look uncomfortable and it was the last thing he needed, considering that the chronic foot-and-mouth epidemic in Britain and Ireland had already hampered the Lions' pre-tour preparations.

The 6 Nations had been severely disrupted, with Tests being cancelled due to travel restrictions put in place by the British and Irish governments. This left the selectors short of matches to assess tour candidates – and the players short of crucial Test-match preparation.

Nevertheless, the omens appeared positive for the Lions. Their record in Australia was excellent, with a record of 14 Test wins from 17. The Lions had never lost a series in Australia and the successful 1997 triumph in South Africa was still fresh in the minds of 16 of the players heading for Australia. On paper the squad looked impressive with the necessary depth to cover all positions and a confidence stemming from England's recent success over southern hemisphere teams. If the squad played to its full potential there was every chance that the Lions' third century of rugby would start on a winning note.

Interestingly, the selection of the 18 English, ten Welsh, six Irish and three Scots raised only limited debate. The omission of the robust Welsh centre Scott Gibbs, the player of the tour in South Africa four years earlier, did appear to be one glaring error, along with the versatile English back-row forward Martin Corry. They would both eventually join the tour as replacements.

The selection of former rugby league wing Jason Robinson, who had not completed a full Test prior to the tour, was greeted favourably. It was to prove an inspired selection, as Robinson was one of the best-performing Lions on the tour, bamboozling and confusing defenders with his blistering pace and effective side-step. Johnson, with his seemingly permanent furrowed brow, led from the front as usual and carried the Lions' frustrations and aspirations on his considerable shoulders. The only real 'surprise' in the squad was the promising 21-year-old Scottish No. 8 Simon Taylor, with only three caps to his name. Unfortunately after a bright start on his debut in the opening game, he badly damaged his knee and was ruled out of the rest of the tour.

The main reason for the muted debate on selection was that there appeared to be an identifiable Test line-up within the squad, leaving the areas of keenest debate around those players likely to figure in the midweek fixtures. This single fact – while it appeared to be a positive at the outset – turned into one of the key reasons why the tour hit the rails in terms of player morale once the players reached Australia. For clearly certain players believed there was one tour for the perceived Test squad and another for the 'dirt-trackers' – those who had to make do with appearances in the midweek fixtures.

Keeping the balance between such groups of players, managing the four-country chemistry, and the maintenance of morale and competition for Test places has been a dilemma for every Lions management team. The importance of these aspects on a tour cannot be overstated and they need shrewd and diplomatic treatment in order for the management to harness the full potential of the squad. Sadly, evidence of such thinking was missing within the new professional framework.

Henry acknowledged at the pre-tour camp in Hampshire that the task ahead was an onerous one and that perhaps the lack of match fitness was a concern: 'Playing against Australia will be a different game to the one being played in the 6 Nations. It will be a huge step up for all concerned. We are in for a huge challenge and our playing levels have to go up if we are to beat the number-one nation. But there are one or two guys that we're keen not to play in the early part of the tour, simply because they've had so much rugby recently. Others are a little underdone: the Irish, for instance, have played very little because of the foot-and-mouth outbreak. It's a question of finding the right balance.'

▲ The Lions grew again in 2001 as 37 players were initially selected for the trip down under. The squad fine-tuned its preparations in the grounds of the team's Hampshire hotel before flying to Australia

Henry's response to his concerns over the mixed preparation and fitness levels within the squad manifested itself in a severe early training regime that pushed the players to their limits. He appeared to settle on the lowest common denominator in terms of fitness and was keen to taper off the training as the Tests approached. The large English contingent, the fittest and more hardened professionals within the squad, took exception to this approach, believing such fitness and routine skill work was unnecessary and wasteful. This created another despondent faction within the squad. Indeed, several English players, through hard-hitting syndicated newspaper columns, vented their frustration at the Lions management and caused conflict within the camp, despite Lenihan's attempts to paper it over.

One article, written by wing Austin Healey before the final Test in Sydney, undermined Henry's management and ridiculed Wallaby lock Justin Harrison, providing so much psychological ammunition to the Wallabies that it could be argued that it was almost treasonable. Nonetheless, the Lions came within minutes of securing a second successive series victory over a reigning world champion side. For the large part of the series they were the better team, playing a wonderful brand of expansive rugby, comprising a vigour and urgency up front that was never matched by the Wallabies.

The demolition of the Wallabies in the first Test was remarkable for its ruthlessness, as the Lions took every opportunity that came their way. With total dominance up front, the Test put the Lions on the front foot and put the pressure firmly on the Wallabies to win both remaining Tests. The first 40 minutes of the second Test provided more of the same – except crucially the Lions failed to convert their superiority into points. At half-time the Wallabies appeared ready for the taking, barely resembling the team that had won the 1999 World Cup.

Remarkably, however, they turned the 11–6 deficit into a record-winning margin to run out victors 35–14, turning the series around. The renowned mental fortitude of this generation of Wallabies came to the fore once again and it was the home team that snapped up the half-chances to score three second-half tries.

▲ Scott Quinnell in action during the opening game of the tour, a record-breaking 116–10 demolition of Western Australia at the WACA in Perth featuring 18 tries. The No. 8 went on to appear in all three Tests on tour

The Olympic Stadium in Sydney, fresh from hosting the most successful Games in history, provided the backdrop for the deciding rubber. Indeed, tickets were harder to find than for the Games opening ceremony a year earlier, and for sheer tension and drama it is hard to remember a more intense match.

The Lions, showing signs of fatigue (and suffering a lengthy touring injury list), trailed 29–23 with minutes to go. Searching for a last elusive score they failed to capitalise on late territorial advantage and when they lost their own throw at a lineout within the Wallaby 22, the match and the series were blown.

It was a devastating blow for the estimated 15–20,000 Lions supporters who had provided such ardent support for the tourists. At the end of the day the Lions, so ruthless in the early stages of the tour, failed to inflict a killer punch against a side struggling for form and they paid the price. The Wallabies, with fewer opportunities and a more conservative, structured game plan prevailed – finding their form late in the series.

The tour had kicked off in sunny Perth on Australia's west coast against Western Australia. The match was played at the famous WACA cricket stadium and the Lions fans were treated to a real cricket score with the visitors winning 116–10. The locals were clearly not up to the challenge despite their invitations to New South Wales players Duncan McRae and Patricio Noriega to bolster their amateur ranks.

Henry surprised everyone by selecting Irish centre O'Driscoll at full-back, in an experiment that failed to provide any clear solutions. Lock Grewcock and scrum-half Howley were two of the best on the field, while wing Luger and No. 8 Quinnell helped themselves to three tries each.

It was a ruthless win, but costly, however, as the fresh-faced Scottish forward Simon Taylor smashed his knee to end his tour. English back-row forward Martin Corry, who missed initial selection, was called from England's tour of North America to

The 116–10 victory over Western Australia remains the largest victory in Lions' history.

◄ Wing Jason Robinson signs a supporter's shirt after the Lions' crushing 83–6 defeat of a Queensland President's XV. The former rugby league star scored five of the tourists' 13 tries

replace Taylor, while Scottish hooker Gordon Bulloch was summoned as a cover for hooker Phil Greening who had failed to shrug off a pre-tour injury. He never made it onto the field and was later sent home.

The standard of competition increased slightly for the second match but the Lions disposed of a Queensland President's XV 83–6 in Townsville, North Queensland. After a sluggish start against a spirited opposition that included ten Super 12 players, the Lions scored a record 73 points in the second half.

With seven run-on debutants, the Lions scored 13 tries – with Robinson scoring five and centre Henderson three. Man of the match was flanker Charvis who was the catalyst for the second-half points avalanche. In the first half they were stopped on the gain line far too often as too much of their play was lateral, with the ball shuffling across the field with little subtlety.

Lions tour manager Lenihan declared after the match: 'There are always three or four moments that define a Lions tour and I think we saw one there tonight. They didn't panic. The team got rid of their first-half anxiousness and their character showed through.'

With 31 tries scored in just two matches, the Lions faced their first real test of the tour against Queensland at Ballymore in Brisbane. In a sometimes spiteful match, the Lions thrashed an injury-depleted Reds side 42–8. With Wilkinson kicking beautifully and controlling the match tempo and tactics, Hill, Henderson, O'Driscoll, Luger, and James all scored tries. The only concern for the Lions was adjusting to the southern hemisphere refereeing interpretations at the breakdown. The Lions gave away several penalties for slowing the ball down at the ruck and for not releasing the ball in the tackle: areas that were to prove troublesome for the rest of the tour.

The fourth match of the tour against Australia A at Gosford, north of Sydney, was basically the 'fourth Test' on the schedule, and a major hurdle for the Lions' midweek XV. Indeed, Eddie Jones' shadow Wallaby Test side held off a late charge from the Lions to claim a deserved 28–25 win, destroying the Lions' perfect record. A try-less first half saw Australia A 15–6 up at the break as Manny Edmonds exchanged

penalties with Neil Jenkins. There were four tries in the second half, with Scott Staniforth scoring Australia's only touchdown, and the Lions grabbing their three late scores from Mark Taylor, Matt Perry and Jason Robinson on the final whistle.

But the constant infringement of the Lions team at the ruck cost them dearly, and reinforced Eddie Jones' claims prior to the game of cynical play from the tourists in slowing the ball down. Lawrence Dallaglio, playing his first match of the tour, spent ten minutes in the sin-bin for repeated transgressions.

After the match Henry declared, 'Our lineout was not acceptable. We lacked basic sharpness, and a lot of negatives came out of this game. We need to put some more time into our lineout work, which needs to be quality time. But this could be the baseline we require. Reality has really set in.'

Worrying for the Lions was Mike Catt's departure from the field in his first match. He aggravated the calf injury he had been nursing from the outset and played no further part in the tour. Welshman Scott Gibbs was flown out to replace him for the remaining matches. Hooker Robin McBryde also joined the casualty list during the match and Englishman Dorian West joined Gibbs on the plane to Australia as his replacement. But there was worse to come a day later when likely Test winger Dan Luger fractured his cheekbone in training when he clashed heads with Neil Back. Luger had been looking impressive until that point but the injury put him on the plane home and he was replaced by Irishman Tyrone Howe. Without doubt several players keen to break into Test reckoning ruled themselves out of contention in Gosford. Cohen, Jenkins, O'Kelly, Young, Murray and McBryde saw their Test aspirations disappear. The pack was outplayed for most of the game with the Australia A second row of Justin Harrison and Tom Bowman dominating the lineout.

The match against New South Wales, who were devoid of their Test squad players, will be remembered for one moment of madness by full-back Duncan McRae. Inexplicably, he launched a savage punching attack on replacement outside-half Ronan O'Gara as both players lay on the ground. O'Gara left the field and needed 11 stitches in two deep cuts around his left eye. McRae was sent from the field by referee Scott Young and the incident caused deep friction between the Lions and Bob Dwyer's Waratahs team. Five other players were sent to the sin-bin in what was a stormy match – Bowman, Blades and Cannon from the home side and Grewcock and Vickery of the Lions. At one point in the second-half, 12 Waratahs played 13 Lions.

Until the distractions of these sending-offs and the sin-binnings, the Lions looked generally impressive during victory in their last major outing before the first Test. Of some concern was a dip in performance in the second half but they scored five tries to their opponents' four. Robinson helped himself to two more, Wilkinson ensured victory with his goal kicking, while a rejuvenated O'Driscoll in the centre, and outstanding performances from forwards Quinnell and Grewcock indicated that the Lions were developing into a series-winning team.

Following the match, tempers were frayed over the O'Gara incident and the Lions' management also accused home coaches of orchestrating a media campaign that attacked the Lions' methods, in order to influence referees during the tour. The Test matches were looming and the attendant psychological war of words had clearly started.

There was yet more bad news on the injury front when potential Test centre Will Greenwood suffered an ankle ligament injury that was to prevent him from playing any further part in the tour. Then, a week later, flanker Neil Back suffered a rib injury that put him out of the first Test.

Furthermore, Lawrence Dallaglio aggravated the knee ligament problem he came to Australia with, and was sent home for surgery. He should never have toured. Interestingly, his replacement – Irishman David Wallace – created a unique piece of Lions history. He became the third Wallace brother to become a Lion, following winger Richard in 1993 and prop Paul in 1997. (All three were replacement players.)

The New South Wales town of Coffs Harbour – the Wallabies' training headquarters – hosted the last match before the first Test. A mediocre midweek Lions team stuttered their way to an unconvincing 46–3 victory over the part-time New South Wales Country Cockatoos.

Captained by Tamworth poultry farmer Bernie Klasen, the Cockatoos put up a spirited performance. Prior to the match they sang the national anthem in the dressing-room and their pride in Country rugby could be measured by the tears shed.

The Lions' lacklustre performance could be attributed in part to the lengthening injury list and the shock of the death of their gear steward, Anton Toia, who died of a heart attack while swimming in the sea off Coffs Harbour. He was a popular Australian rugby official with many touring teams, and his death was marked by the wearing of black armbands in the match.

▲ Waratahs full-back Duncan McRae became the first player to be sent off against the Lions after repeatedly punching Ronan O'Gara during a fiery tour match in Sydney. McRae was banned for seven weeks while O'Gara needed 11 stitches

The selection of the first Test team produced little surprise. It had, in fact, largely picked itself following the six lead-up matches and with the major injuries to eight of the squad. The dependable Matt Perry was preferred at full-back to the below-par Balshaw, while Robinson picked himself on the wing, where Dafydd James joined him in place of Luger.

The Irish centre pairing of O'Driscoll and Henderson showed outstanding form, with halves Wilkinson and Howley clearly head and shoulders ahead of their nearest

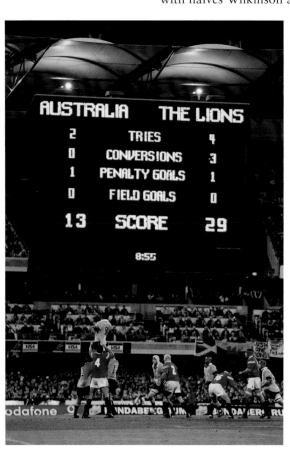

rivals. Tom Smith, Keith Wood and Phil Vickery won the front-row spots, with skipper Martin Johnson and fellow countryman Danny Grewcock packing down in the second row. Neil Back's injury left the door open for Martin Corry to claim the No. 6 jersey, following impressive form after joining the tour as a replacement. Richard Hill moved to open-side with Scott Quinnell locking the scrum at No. 8.

With Ballymore deemed too small and the larger Suncorp Stadium under redevelopment, the first Test was played at the 38,000-capacity Woolloongabba Cricket Ground in Brisbane. The scene of many an Australian cricket Test victory, the ground was filled to the rafters and the Red Army, with its singing and boisterous support, virtually turned the arena into a mini Twickenham or Murrayfield.

The Wallabies, with only a single match against the New Zealand Maoris as their preparation, started the match with Chris Latham at full-back in preference to Matthew Burke. Flanker Owen Finegan came back into the side after suspension in the Super 12, and Nathan Grey was given the inside-centre shirt ahead of Elton Flatley. The biggest talking point was the relatively inexperienced front-row combination of debut prop Stiles, hooker Paul and tight-head Panoho.

The rest of the side comprised the tried and tested, including halves Gregan and Larkham, and locks Eales and Giffin. The talented 20-year-old open-side George Smith made up the back-row contingent along with No.8 Toutai Kefu.

▲ The Gabba scoreboard makes happy reading for Martin Johnson's Lions side, who overwhelmed their slightly undercooked hosts to register a convincing win

The Lions' optimism was high, especially as they had played fast, expansive and effective rugby, had been able to unlock decent defences and up front had scrummaged better and more aggressively than any of their opposition. This optimism was not out of place, as the Lions scored four tries to two in a convincing 29–13 victory that sent shock waves through Australian rugby.

The margin could have been even greater, as the Wallabies only scored their tries in a late flourish when the Lions had been reduced to 14 men on two occasions, when referee Watson sin-binned Vickery and then Corry.

Man of the match O'Driscoll and his partner in crime Henderson cut the Wallaby defence to shreds and tackled like demons. Robinson, scoring the first try after just two minutes with a classic in-and-out swerve and step, proved electric in everything he did; Wilkinson was the rock and locks Johnson and Grewcock proved unstoppable. Hooker Wood and flanker Hill were simply everywhere, causing havoc around the ruck.

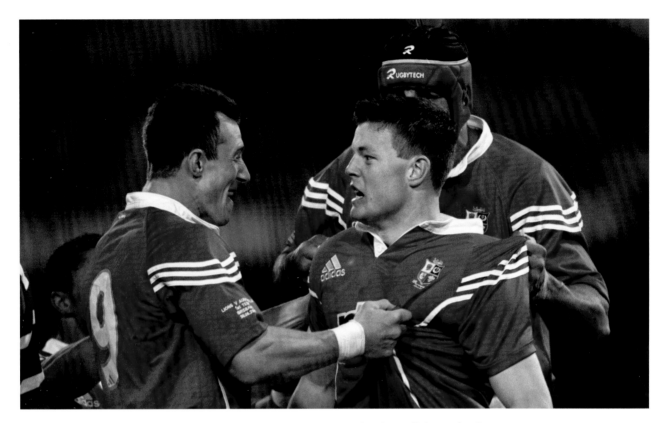

The Lions dominated the lineout and out-scrummaged a docile Wallaby eight that was clearly short of match practice and stunned by the ferocity of the Lions' onslaught. The pace at which the Lions played was impressive and authoritarian, and James' late first-half try after a sortie by Robinson made the Lions' advantage 12–3 at the break – a scoreline that flattered Australia.

The game was all but sealed two minutes into the second half when O'Driscoll waltzed his way through weak Wallaby tackling to score a superlative solo try under the posts. A Wilkinson penalty and a converted try to the ever-rampaging Quinnell after 51 minutes extended the lead to 29–3. The Wallabies replied with two consolation tries from Walker and Grey after Flatley had replaced an out-of-sorts Larkham, but they were well beaten. To make matters worse, hooker Jeremy Paul suffered a season-ending knee injury.

With the Red Army in raptures at the final whistle, the Lions strode elated but purposefully off the field. They were perhaps tempted to indulge in a lap of honour, but they resisted, knowing the series had not been decided and that victory in the second Test, as in South Africa four years earlier, would clinch the series.

The Lions' tour moved on to the Australian capital Canberra for the last midweek match against the Super 12 champions. The Brumbies, devoid of their nine Test players, fielded a mix of Super 12 squad players and young development players, and were incredibly unlucky not to inflict the tourists' second defeat of the tour. Marshalled by former Wallaby No. 8 Jim Williams and Pat Howard, recently returned from several years in England, the Brumbies stunned the tourists in the first half with coach Eddie Jones opting to take the Lions' defence on out wide. The Lions played as poorly as any time on tour and in midfield they were carved open by Howard's passing and the angled running of centres Bond and Holbeck. Three tries to the home side to a late intercept by Healey saw the Brumbies lead 22–10 at half-time.

▲ Ireland's Brian O'Driscoll (centre) was one of four try scorers in the first Test in Brisbane, turning in a man of the match performance that filled the travelling Lions supporters with confidence for the rest of the tour

➤ The eagerly awaited second Test in Melbourne attracted a capacity crowd of 56,000, many of them Lions fans hoping their side could seal the series after their victory in Brisbane the previous week

The second half proved to be a complete reversal, with the Lions enjoying far greater possession. Wallace reduced the lead with a 44th-minute try. Dawson (awarded the goal-kicking duties ahead of O'Gara) and Hall then swapped penalties through this half of the game as the Lions slowly ground down their opponents.

With the score 28–23 in the locals' favour as the clock ticked over into injury time, the Lions launched one last offensive and after numerous phases Healey side-stepped his way across the line. It left Dawson (who had been pilloried midweek for writing a derogatory newspaper column) to kick the winning conversion. He duly did so and the villain become a hero. The Lions had staged a remarkable comeback.

History was made in Melbourne for the second Test when the match was played under a closed roof at Colonial Stadium. The atmosphere was electric and the Australian Rugby Union's attempt to coerce greater vocal and visual support to offset the Red Army's included giving away tens of thousands of gold-coloured scarves and broadcasting good-luck messages from the tennis player Pat Rafter and runner Cathy Freeman.

However, the combined British and Irish choir – led as always by the Welsh – easily won the singing and they claimed their seats expectantly as the Lions took the field with only one change. Neil Back replaced a very unlucky Martin Corry in the back row. The in-form Corry moved to the bench to replace Charvis who had been suspended for two matches having been found guilty of kneeing an opponent late in the first Test. Hooker West came onto the bench too for Bulloch. Wily veteran Michael Foley replaced the injured Jeremy Paul at hooker for the Wallabies, with Brendan Cannon moving onto the bench. Prop Panoho was declared unfit and Rod Moore took his spot. Matthew Burke was preferred at full-back to Latham who moved to the bench.

The first 40 minutes of the match resembled the Gabba Test with the Lions dominating most facets of the game and breaking the first line of defence to cross the gain line on numerous occasions. But for all their superiority the Lions only led

11–6 at half-time, following a tremendous try from a lineout set piece and two penalties each to Wilkinson and Burke. Grewcock secured possession at a lineout deep in the Wallaby 22 and the Lions pack drove the maul across the line for Back to touch down.

How very different it was in the second 40 minutes. The Lions lost Howley, Hill and Wilkinson (rib, head and leg injuries respectively), conceded three tries and proceeded to lose their discipline, resulting in Burke kicking four penalties to end the game with a record 25 points against the Lions. The Wallabies won the match 35–14 by scoring 29 points in the second half.

The loss of Richard Hill at half-time after an errant elbow to the head by Nathan Grey infuriated the Lions' management but the pivotal point of the match – and perhaps the series – was Roff's first try. Wilkinson, running right, noticed he had an overlap and opted for a long, looping ball to his outside runners. Unfortunately the ever-alert Roff intercepted and galloped 30 metres to score in the left corner.

The score revived the Wallabies who were floundering badly and, shortly after this, Roff scored a second with a delightful change of pace and a left step. Surprisingly the possession had been secured when the Wallaby eight disrupted a Lions scrum, Eales secured the ball and Larkham released Roff down the left touchline.

Worrying signs started to appear in the Lions ranks. The inclusion of flanker Neil Back had seriously diminished the lineout options and he started to struggle against Wallaby open-side, Smith. The dominant scrum lost its cohesiveness and the Wallabies were not being stopped at the gain line.

When Burke crossed for his try midway through the half, the Lions lost their pattern and the match. The Wallabies had reasserted their dominance of world rugby following the humiliation of the first Test. It was a significant achievement and one that swung the series in their favour. Eales, playing his 50th match as captain, returned to his best form, Moore shored up the scrum, Gregan was dominant around the fringes while Finegan provided the hard yards up the middle. Macqueen declared after the match, 'Whenever this side has been asked questions, they have reached and found the answers.' He also announced that he would step down as coach following the third Test, adding a huge emotional edge to the match in Sydney.

The Wallabies lost Larkham for the decider (two big hits late in the second Test damaged his already suspect shoulder) along with second row Giffin. Flatley was given the No. 10 shirt while Brumby lock Harrison made his Wallaby debut.

Miraculously Wilkinson, after having his bruised leg cast in plaster for two days, was passed fit but Healey, preferred to James on the wing, withdrew with a back problem. James consequently assumed the wing position while injuries meant that Dawson replaced Howley at scrum-half and Corry replaced Hill on the side of the scrum. Such was the extent of injuries and non-availability of players that the side failed to have a complete run together in the week before the Test. Scottish scrum-half Andy Nicol, a replacement on the 1993 tour to New Zealand, was summoned from a supporters' tour to sit on the bench as reserve scrum-half after wing Healey, the scrum-half cover, dropped out.

It was a tumultuous rollercoaster of a game that saw the lead chop and change several times as the match drew towards its conclusion. In front of a record crowd for a Lions Test (84,188), the teams slogged it out until the Lions simply ran out of energy for the fight. Burke gave Australia a 9–3 lead at the quarter-hour mark, with three penalties to one from Wilkinson, before the irrepressible Robinson crossed for a try in the left corner.

The Lions had looked set to score a pushover try, only for referee Paddy O'Brien to reset the scrum because of the front rows popping. From the next scrum the ball went right before Dawson switched left, and excellent handling from Wilkinson and front-rowers Wood and Smith created the score. Wilkinson's conversion gave the Lions a 10–9 lead, but he then missed a penalty, letting the Wallabies off the hook after a period of pressure.

The Wallabies regained the lead with a try created by some deft handling by Roff, Herbert and Walker down the right-hand blind side. A last inside pass saw Herbert cross for a try, which Burke converted. The Lions responded immediately, but territorial dominance at the end of the half only led to a Wilkinson penalty, which meant the Lions trailed 13–16 at the break.

Revitalised after the break, the Lions drove deep into the Wallaby quarter with Wood, Grewcock and O'Driscoll all prominent. Finally, when the ball went right near the posts, Wilkinson scuttled past Toutai Kefu to score. He converted and the Lions' hopes soared as they once again resumed the lead.

▲ Rob Henderson (left) and Jonny Wilkinson are consoled by teammates and management after the Lions lost the third Test in Sydney to dash their hopes of a series triumph

The Lions' dreams of defending and extending their lead evaporated when some excellent driving play and recycling led to Kefu and Foley putting Herbert across for his second try. Burke's conversion was followed by a Wilkinson penalty to tie the scores at 23–all. Significantly, the penalty was for a dangerous tackle on O'Driscoll by Herbert who was sin-binned for ten minutes; unfortunately the tiring Lions failed to score any points with Herbert off the field, and as the final whistle approached the dishevelled Lions conceded two penalties which Burke kicked for a 29–23 lead.

A converted try could still have won the game, though, and in the last two minutes the Lions somehow rallied to secure a lineout well inside the Wallaby 22. Fearing a driving maul, an effective weapon in the Lions' armoury all tour, the Wallabies appeared ready to counter the tactic, which meant not contesting the throw. However, debutant Harrison decided he would contest and grabbed the ball in front of Johnson – it was cleared by the Wallabies and the Lions' opportunity was lost, along with the Test and the series. For the Lions it was despair; for the Wallabies, and the retiring Macqueen, it was jubilation.

As in previous tours, injuries once again proved insurmountable for the Lions even though it was a short ten-match tour. Losing key players at crucial times cost the Lions dearly and by the end of the tour the Test players were literally out on their feet. Dallaglio, Catt, Greening, Greenwood, Luger, Quinnell, Back, Jenkins, Taylor, Healey and Howley were either injured or carrying injuries at some point in the tour.

When asked to assess the tour and to say what future recommendations he would make, manager Donal Lenihan announced, 'In the professional era the whole tour

structure needs to be looked at. If you are going to play a tour of this intensity at the end of the domestic season you will have to look at more time between matches. Players need more time to recover. It is a question of whether you can afford so many midweek matches.'

Graham Henry added: 'We thought that maybe – and there needs to be some discussion on this – that there should be a reduced number of players: 28 or something like that, and [we should] just concentrate on having one game a week, building correctly for those games and going on from there. You are probably talking about Saturday games only, with a smaller squad.'

The post-tour analysis clearly showed that the top British and Irish players are simply playing too much rugby compared to their southern hemisphere counterparts. Therein lies the problem and it is perhaps the greatest concern for future tours. Scaling back midweek matches and further reducing the number of other matches would be calamitous for the future of Lions tours.

RESULTS OF THE 2001 LIONS IN AUSTRALIA

P 10 W 7 D 0 L 3 F 449 A 184

Western Australia	W	116–10	NSW Country	W	46–3
Queensland President's XV	W	83–6	Australia (Brisbane)	W	29–13
Queensland	W	42–8	ACT	W	30–28
Australia A	L	25–28	Australia (Melbourne)	L	14–35
New South Wales	W	41–24	Australia (Sydney)	L	23–29

MARTIN JOHNSON'S 2001 LIONS TEAM

FULL-BACKS			FORWARDS		
I.R. Balshaw	Bath	England	N.A. Back	Leicester Tigers	England
M.B. Perry	Bath	England	G.C. Bulloch*	Glasgow Caledonians	England
			C.L. Charvis	Swansea	Wales
THREE-QUARTERS			M.E. Corry*	Leicester Tigers	England
M.J. Catt	Bath	England	L.B.N. Dallaglio	London Wasps	England
B.C. Cohen	Northampton	England	J. Davidson	Castres Olympique	Ireland
I.S. Gibbs*	Swansea	Wales	P. Greening	London Wasps	England
W.J.H. Greenwood	Harlequins	England	D.J. Grewcock	Saracens	England
R.A.J. Henderson	London Wasps	Ireland	R.A. Hill	Saracens	England
T.G. Howe*	Ulster	Ireland	M.O. Johnson (capt.)	Leicester Tigers	England
D.R. James	Llanelli	Wales	J. Leonard	Harlequins	England
D.D. Luger	Saracens	England	R.C. McBryde	Llanelli	Wales
B.G. O'Driscoll	Leinster	Ireland	D. Morris	Swansea	Wales
J.T. Robinson	Sale	England	S. Murray	Saracens	Scotland
M. Taylor	Swansea	Wales	M.E. O'Kelly	Leinster	Ireland
			L.S. Quinnell	Llanelli	Wales
HALF-BACKS			T.J. Smith	Brive	Scotland
M.J.S. Dawson	Northampton	England	S.M. Taylor	Edinburgh	Scotland
A.S. Healey	Leicester Tigers	England	P.J. Vickery	Gloucester	England
R. Howley	Cardiff	Wales	D.P. Wallace*	Munster	Ireland
N.R. Jenkins	Cardiff	Wales	D.E. West*	Leicester Tigers	England
R.J.R. O'Gara	Munster	Ireland	M.E. Williams	Cardiff	Wales
J.P. Wilkinson	Newcastle Falcons	England	K.G.M. Wood	Harlequins	Ireland
A.D. Nichol*	Glasgow Caledonians	Scotland	D. Young	Cardiff	Wales
			*Replacements		

2005 TOUR KIT

2005
DOWN AND OUT IN THE SHAKY ISLES

Captain: Brian O'Driscoll (Leinster and Ireland)
Squad Size: 44 players + 7 replacements
Tour Manager: Bill Beaumont (England)
Head Coach: Sir Clive Woodward (England)
Assistant Coaches: Eddie O'Sullivan (Ireland), Ian McGeechan (Scotland), Gareth Jenkins (Wales), Phil Larder (England), Mike Ford (Ireland), Dave Alred (England)
Head Doctor: James Robson (Scotland)
Doctor: Gary O'Driscoll (Ireland)

Tour Record:	P 12	W 7	D 1	L 4	F 353 A 245
Test (Arg):	P 1	W 0	D 1	L 0	
Test Series (NZ):	P 3	W 0	D 0	L 3	

Sitting down to write the events of the 2005 British & Irish Lions tour to New Zealand was quite a challenge. For, quite simply, the tour, the most anticipated for many a year, was a curious mix of anticlimax and bizarre underachievement, not just for the ambitions of the players who boarded the plane for the Antipodes, but for the entire rugby community.

It must be recorded that the New Zealand team was a class apart from the Lions, who, for whatever reasons, failed to perform to their ability on the field. Their courage under the intense pressure exerted on them by the best New Zealand could throw at them was never in doubt, but what was apparent is that they were badly let down by a coaching staff that devised an outmoded and doomed tour strategy.

This was hugely disappointing for the hordes of immaculately behaved travelling Lions fans that once again endeared themselves to the host nation. Indeed, the tour was a great success in terms of the atmosphere and sense of anticipation it created in the towns and cities that played host to matches. This is what Lions tours are about, after all. Happily, the Lions' public face was also much improved from 2001.

The tour was always going to be fiendishly difficult, but it turned up more egos, surprises, twists and turns than arguably all the previous Lions tours put together. It can only be described as a magical mystery tour, a circus of sorts that travelled from the Vale of Glamorgan (the squad's pre-tour base) to the North and South Islands of New Zealand.

The ringmaster of the circus was the former England Rugby World Cup-winning coach, Clive Woodward, who was knighted for his achievement of 2003 and given the helm of the 2005 Lions tour. Many felt he defied logic with his selections and may have allowed personal ambition to undermine the first tour to New Zealand in the professional era. Everything about this Lions tour seemed disproportionate, from the excessive, unwieldy squad size, the overabundance of coaches and, significantly, the serious lack of sufficient match preparation – especially for the Test side. The invitation to Prince William to join the tour and wear a Lions tracksuit, the privilege of the selected tour squad, was questionable, as was the hiring of political public-relations consultant Alistair Campbell. The latter's unnecessary meddling earned the instant distrust of the media, while any professional working relationship became impossible when his misconceived 'spin-doctoring' went into overdrive once defeat

◄ After leading England to glory at the 2003 World Cup, Sir Clive Woodward was the natural choice as head coach for the Lions' tour of New Zealand two years later

became obvious. These may sound like harsh words, but the reality is quite clear: record defeats and a Test-series whitewash despite Woodward declaring prior to departure that it was the best-prepared Lions squad in history!

It all started so positively at the Hilton Hotel at Heathrow in April. With great melodrama, Woodward and manager Bill Beaumont (the likeable former England and Lions captain), announced that 44 players – 23 forwards and 21 three-quarters – had been selected for the trip to New Zealand and that Irish skipper Brian O'Driscoll would be the captain.

A slick video presentation took the assembled media through the squad of selected players under the motivational and branding theme of 'The Power of Four', representing the conglomerate of the Four Home Unions. An anthem of the same name was also commissioned by Woodward to be played before each match but it did not catch on with the fans, no one knew the words and it was far from the inspirational boost he had hoped for.

Prior to the announcement, the smart money was on Woodward remaining loyal to the experienced core of his 2003 England World Cup team and that they would form the backbone of his squad and possibly the Test team. However, the announcement of 21 Englishmen, 11 Irish, 10 Welsh and three Scots was startling given that England and Ireland had performed miserably in the Six Nations, while Wales had won the Grand Slam with some enterprising and inspirational rugby. That Ireland deserved more players than Wales was completely illogical and the overabundance of Englishmen alarming.

Sure, experience was provided by Lawrence Dallaglio, Neil Back, Matt Dawson, Martin Corry and Richard Hill, but the likes of Jason Robinson, Will Greenwood, Danny Grewcock, Graham Rowntree, Julian White and Ben Kay were widely considered to be badly out of form. Another, Iain Balshaw, became the first casualty of the tour when he pulled out through injury before the squad left for New Zealand to be replaced by promising England wing Mark Cueto.

▲ The Lions gather at the Vale of Glamorgan Hotel in Wales. With 44 players in the original squad, it remains the biggest tour party ever assembled

It may have been a bold decision by Woodward to rely on his tried-and-tested England players, but it clearly suggested from the outset that he was not going to play the expansive ball-in-hand tactics that won Wales the title and had troubled the All Blacks on their most recent tour to Europe.

It appeared as if Woodward was caught in a time warp, as two years on from the World Cup the game had noticeably changed. He was intent on taking a team to New Zealand to overpower the All Black forwards at the set piece and therefore create the platform to dominate territory via the boot. But forward attrition and set-piece dominance alone no longer held sway in Test rugby, especially as the Kiwis and Aussies were playing a fast, high-intensity, high-impact game allied with a renewed emphasis on the essential set-piece elements of forward play. Quite how Woodward planned to attack the gain line remained a mystery. Ironically, the only time the Lions have achieved success in New Zealand was in 1971, under the astute eye of Carwyn James, when the Welsh won the Grand Slam prior to the tour. Wales contributed the majority of players to the Test team.

Furthermore, it was announced that three additional players were on an injury list, with Woodward declaring that these players could also make the trip if they recovered suitably. Again all three were English: prop Phil Vickery, centre Mike Tindall and outside-half Wilkinson. Only Wilkinson eventually made the tour after surviving a couple of matches with his club side Newcastle. However, he had played no Test rugby since the 2003 Rugby World Cup final. Even more remarkable was that players including Ryan Jones, Colin Charvis, Simon Easterby, Adam Jones, Brent Cockbain, Jason White, Joe Worsley, Mefin Davies, Kevin Morgan and Chris Patterson were not selected, or if necessary given the same opportunity to prove their fitness.

It was the biggest tour party in Lions history – 44 players (which became 51) – and an incredible 29 backroom staff, including a plethora of coaches, with Ian McGeechan (on his fourth tour), Eddie O'Sullivan, Gareth Jenkins and Andy Robinson to name but some; numerous coaching technicians for fitness, defence and kicking; a medical team; a media team, including Campbell; administration management staff; and a legal expert and a chef.

With only 11 matches, the tour to New Zealand was the shortest of its kind in Lions history and to take so many players was always going to cause problems in terms of the number of matches each player was going to get. Four outside-halves

and four scrum-halves seemed an obvious extravagance. Obviously, there would be limited opportunities for a lot of the players, but Woodward's overriding philosophy was to ensure he got to the end of the tour, and the third Test, with a squad still standing. He was not prepared to get into the situation of Australia in 2001 when training for the final Test was hampered by injury. It was a commendable theory given that the Lions have won only one series in ten previous attempts in New Zealand. The irony is that the 2005 Lions reached the last week in tatters and as a result of injuries the Wednesday training session was postponed.

Despite the injury toll in Australia four years earlier, the Lions almost pulled off the series win, as the team was stable, tight and had played together as a unit for most of the tour. Woodward's sentiment may well have been commendable, but he basically threw out over 100 years of Lions history and the tour format that had seen the Lions win two out of its last four series, South Africa in 1997 and Australia in 1989.

This formula is based on the tour comprising a Saturday team and a midweek team. It is not ideal as players in the midweek team do play second fiddle to the Saturday team, which is ultimately the Test team. The management and motivation of the midweek team has always been the key to a successful tour. Its players will ideally put pressure on the Test incumbents by winning midweek games, and, of course, it is the team from which injuries will be covered. But Woodward chose a cumbersome squad with a rotation policy that quite clearly did not provide the key players with enough field time, and played no part in developing combinations and relationships on the field, so badly needed when combining players from four different national sides.

On his return, following his tragic injury in the first match, Dallaglio clearly believed Woodward had got it wrong. He stated that players need to play once a week on such a tour to maintain fitness and combinations – play one game, rest one game, play the next. Woodward did not do this, often using some players once every three or four matches and others twice in a row. At no time did we see the same team take the field prior to the Tests. Furthermore, proven combinations in the Six Nations were ignored, a classic example being the in-form Welsh centre pairing of Gavin Henson and Tom Shanklin.

The tour to New Zealand is the hardest one encountered by any Lions squad. Not only does it face the might of the All Blacks, enjoying home advantage, but also there is the constant scrutiny and criticism of their rugby-mad media and public. And to make matters worse, for this tour the All Blacks were ranked number one in the world (with Australia and South Africa right behind them), adding credence that the southern hemisphere had fully recovered from losing the World Cup to England in 2003.

The Lions also knew that at the helm of the All Blacks was Graham Henry, the former Welsh national coach, who was the Lions coach on the tour to Australia in 2001. He had an insider's knowledge of the machinations and idiosyncrasies involved in such a touring team and this probably played a large part in the All Blacks' success.

▲ Promotional posters for the series against the All Blacks revealed the levels of excitement and anticipation in New Zealand ahead of the arrival of the Lions

The Lions warmed up for their New Zealand tour with a one-off Test against Argentina in Cardiff. They escaped from the Millennium Stadium with a 25–25 draw thanks to Jonny Wilkinson's last-gasp penalty

Woodward also introduced a pre-tour match against Argentina at the Millennium Stadium in Cardiff in order to start the player-bonding process and to look at some of the players with whom he was less familiar. The Lions playing at home is a rare sight – the last occasion was in 1990 when they played a Rest of Europe XV at Twickenham and won 43–18.

The Lions had played the Pumas on six previous occasions, the last time in 1936 when they won 36–0 in South America. In that era, Argentina was not an official member union of the IRB and the Tests were not officially recognised. This was the first Test against Argentina in Britain.

It is an experiment that is unlikely to become a regular feature of Lions tours, as the players looked uncomfortable playing a pre-tour match, with injury clearly in their thoughts days before the plane left for New Zealand. This underlying atmosphere among the Lions was all too evident against an Argentine side weakened by the withdrawal of several players as a result of their French clubs refusing to release them for the match. Welsh No. 8, Michael Owen, captained a Lions side that included Wilkinson at outside-half, as he needed match time, but few of Woodward's experienced England core.

The Argentinians, delighted to have been given the opportunity to further push their credentials on the world stage, had not read the Woodward script and were far more physical, clearly more eager at the breakdown, more creative in general play and almost did the unthinkable in beating the Lions. They exploited an error-strewn opening from the Lions to race 13–0 ahead after just 15 minutes, including a try by Jose Nunez Piossek, who burst over in the corner. At the break, the Pumas led 19–16.

Centre Ollie Smith scampered over for the Lions' only try of the match, and although Federico Todeschini's immaculate 20-point haul from the boot had seemed enough to keep the Lions firmly caged, Wilkinson snatched a 25–all draw with his seventh successful kick from seven attempts eight minutes into injury time. The enduring moment from the match was the lap of honour the ecstatic Pumas enjoyed after the final whistle.

So, subdued by the lacklustre performance against the Pumas, The British & Irish Lions headed to New Zealand for the first time in 12 years and landed in hostile territory on 27 May.

First up, the Lions faced the Bay of Plenty at Rotorua. The pre-tour hype was over and the Lions had to impress on the field, as in seven days they faced the Maori, which was being billed as the fourth Test. The selected XV gave little indication in terms of Test selection, but young Welshman Gavin Henson partnered captain O'Driscoll in the centres outside the halves Ronan O'Gara and Dwayne Peel, with Richard Hill, Martyn Williams and Dallaglio forming the back row. Surprisingly, in-form Welsh centre Shanklin was selected on the wing.

Before Woodward's Lions team played Argentina at the Millennium Stadium, they were entertained by a performance from the London Welsh Male Voice Choir, which featured among their number 1971 Lions skipper John Dawes.

and four scrum-halves seemed an obvious extravagance. Obviously, there would be limited opportunities for a lot of the players, but Woodward's overriding philosophy was to ensure he got to the end of the tour, and the third Test, with a squad still standing. He was not prepared to get into the situation of Australia in 2001 when training for the final Test was hampered by injury. It was a commendable theory given that the Lions have won only one series in ten previous attempts in New Zealand. The irony is that the 2005 Lions reached the last week in tatters and as a result of injuries the Wednesday training session was postponed.

Despite the injury toll in Australia four years earlier, the Lions almost pulled off the series win, as the team was stable, tight and had played together as a unit for most of the tour. Woodward's sentiment may well have been commendable, but he basically threw out over 100 years of Lions history and the tour format that had seen the Lions win two out of its last four series, South Africa in 1997 and Australia in 1989.

This formula is based on the tour comprising a Saturday team and a midweek team. It is not ideal as players in the midweek team do play second fiddle to the Saturday team, which is ultimately the Test team. The management and motivation of the midweek team has always been the key to a successful tour. Its players will ideally put pressure on the Test incumbents by winning midweek games, and, of course, it is the team from which injuries will be covered. But Woodward chose a cumbersome squad with a rotation policy that quite clearly did not provide the key players with enough field time, and played no part in developing combinations and relationships on the field, so badly needed when combining players from four different national sides.

On his return, following his tragic injury in the first match, Dallaglio clearly believed Woodward had got it wrong. He stated that players need to play once a week on such a tour to maintain fitness and combinations – play one game, rest one game, play the next. Woodward did not do this, often using some players once every three or four matches and others twice in a row. At no time did we see the same team take the field prior to the Tests. Furthermore, proven combinations in the Six Nations were ignored, a classic example being the in-form Welsh centre pairing of Gavin Henson and Tom Shanklin.

The tour to New Zealand is the hardest one encountered by any Lions squad. Not only does it face the might of the All Blacks, enjoying home advantage, but also there is the constant scrutiny and criticism of their rugby-mad media and public. And to make matters worse, for this tour the All Blacks were ranked number one in the world (with Australia and South Africa right behind them), adding credence that the southern hemisphere had fully recovered from losing the World Cup to England in 2003.

The Lions also knew that at the helm of the All Blacks was Graham Henry, the former Welsh national coach, who was the Lions coach on the tour to Australia in 2001. He had an insider's knowledge of the machinations and idiosyncrasies involved in such a touring team and this probably played a large part in the All Blacks' success.

▲ Promotional posters for the series against the All Blacks revealed the levels of excitement and anticipation in New Zealand ahead of the arrival of the Lions

▲ The Lions warmed up for their New Zealand tour with a one-off Test against Argentina in Cardiff. They escaped from the Millennium Stadium with a 25–25 draw thanks to Jonny Wilkinson's last-gasp penalty

Woodward also introduced a pre-tour match against Argentina at the Millennium Stadium in Cardiff in order to start the player-bonding process and to look at some of the players with whom he was less familiar. The Lions playing at home is a rare sight – the last occasion was in 1990 when they played a Rest of Europe XV at Twickenham and won 43–18.

The Lions had played the Pumas on six previous occasions, the last time in 1936 when they won 36–0 in South America. In that era, Argentina was not an official member union of the IRB and the Tests were not officially recognised. This was the first Test against Argentina in Britain.

It is an experiment that is unlikely to become a regular feature of Lions tours, as the players looked uncomfortable playing a pre-tour match, with injury clearly in their thoughts days before the plane left for New Zealand. This underlying atmosphere among the Lions was all too evident against an Argentine side weakened by the withdrawal of several players as a result of their French clubs refusing to release them for the match. Welsh No. 8, Michael Owen, captained a Lions side that included Wilkinson at outside-half, as he needed match time, but few of Woodward's experienced England core.

The Argentinians, delighted to have been given the opportunity to further push their credentials on the world stage, had not read the Woodward script and were far more physical, clearly more eager at the breakdown, more creative in general play and almost did the unthinkable in beating the Lions. They exploited an error-strewn opening from the Lions to race 13–0 ahead after just 15 minutes, including a try by Jose Nunez Piossek, who burst over in the corner. At the break, the Pumas led 19–16.

Centre Ollie Smith scampered over for the Lions' only try of the match, and although Federico Todeschini's immaculate 20-point haul from the boot had seemed enough to keep the Lions firmly caged, Wilkinson snatched a 25–all draw with his seventh successful kick from seven attempts eight minutes into injury time. The enduring moment from the match was the lap of honour the ecstatic Pumas enjoyed after the final whistle.

So, subdued by the lacklustre performance against the Pumas, The British & Irish Lions headed to New Zealand for the first time in 12 years and landed in hostile territory on 27 May.

First up, the Lions faced the Bay of Plenty at Rotorua. The pre-tour hype was over and the Lions had to impress on the field, as in seven days they faced the Maori, which was being billed as the fourth Test. The selected XV gave little indication in terms of Test selection, but young Welshman Gavin Henson partnered captain O'Driscoll in the centres outside the halves Ronan O'Gara and Dwayne Peel, with Richard Hill, Martyn Williams and Dallaglio forming the back row. Surprisingly, in-form Welsh centre Shanklin was selected on the wing.

> Before Woodward's Lions team played Argentina at the Millennium Stadium, they were entertained by a performance from the London Welsh Male Voice Choir, which featured among their number 1971 Lions skipper John Dawes.

And it was a very positive start, with the Lions racing ahead 17–0 after just
15 minutes, full-back Josh Lewsey prominent with two decisive tries. But as the
match wore on, the Lions were given a sobering reminder of how much work they
had to do.

Once Bay of Plenty got itself organised defensively their aggression clearly
worried the Lions and at the interval the home side was on equal terms at 17–all. It
was a much sterner test than the West Australia opening match four years previous,
as Bay of Plenty's quick phase rugby troubled the Lions. But second-half tries to
Shanklin, Peel and Gordon D'Arcy, on top of two earlier tries to Lewsey and one to
Cueto, secured a hard fought 34–20 victory, six tries to two.

However, the Lions' first-match injury jinx struck once again with likely Test
back-row forward and England veteran Lawrence Dallaglio dislocating his ankle in
the first half. Dallaglio was ruled out of the tour that evening and his replacement
was Ireland's Easterby, which surprised many since Wales' Ryan Jones and
England's Worsley were considered the frontrunners to join the tour. Prior to the
match, Irish lock Malcolm O'Kelly aggravated a groin injury, indicating he was
never fit to tour and he too was lost to the series. England's Simon Shaw joined
Easterby on the plane over.

The second match took the Lions to New Plymouth to face proud Taranaki.
Woodward fielded a completely different 22 with the captain now Martin Corry,
who was joined in the back row by Michael Owen and Lewis Moody. Charlie
Hodgson and Chris Cusiter were the halves, with John Hayes, Andy Titterrell and
Graham Rowntree forming the front row.

The Lions demonstrated admirable composure in overcoming a half-time deficit
and ultimately cruised to a four-try victory, but were far from convincing. Full-back
Geordan Murphy scored a brace of tries and the halves were the pick of the players,

with Hodgson booting 16 points. Notably, the pack struggled and buckled under pressure in the scrum while the lineout proved a real weakness. In the end, the home side ran out of steam allowing the Lions to move away in the 48th minute following a try by Corry.

The Lions appeared to have no definitive game plan. Third- and fourth-phase ball simply became one-man rushes into the defensive line, and they allowed the opposition to commit more men to the breakdown which slowed their own ball and ensured the home team enjoyed quicker, cleaner ball when in possession. Lineout throwing and lost possession on the throw-in was also a growing concern. These worrying traits were becoming a feature of the tour, as well as a defensive system that moved up and across, allowing opposition players space and options instead of being more direct and aggressive.

The grand traditions of rugby touring were beautifully highlighted after the match, when, with transport arrangements muddled up, the Taranaki players saw the Lions waiting outside the ground and invited them onto their bus. Together they travelled to the local pub, which was being used for post-match revelry. In the stark world of professional sport, this was a welcome oasis of friendship and camaraderie that only rugby can provide.

With two games under their belt and the first Test just two weeks away, the Maori match was the first opportunity for Woodward to perhaps have a look at his Test side. But Woodward kept everyone guessing by selecting Shanklin and Lewsey out of position again and preferring D'Arcy to Henson alongside O'Driscoll in the centres. Welsh outside-half Jones got his first start after arriving on tour late, following French club duties, and there was still no sign of Wilkinson getting a run-on start in New Zealand.

No. 8 Simon Taylor withdrew on the eve of the match with a recurrence of a long-standing hamstring injury to become the third player ruled out of the tour (the second consecutive tour he has left early). Owen was called up to play his second successive match before flying back to Wales the next day to attend the birth of his second child and fellow countryman Ryan Jones, on tour with Wales in North America, was summoned to replace Taylor.

Nevertheless, All Black coach Henry was bemused at the need for the Lions to call out even more troops. 'How many is that now?' asked Henry at an All Blacks press conference. 'If we name more than 22, I get criticised by old All Blacks for cheapening the shirt.'

The Maori game lived up to its billing as the fourth Test with the Lions fielding probably its heaviest front row ever. Messrs Sheridan, White and Thompson weighed in at 54 stones 10lb. But size isn't everything, and unfortunately the Lions were again out-muscled and out-thought at the breakdown and generally outplayed by a formidable team.

Both sides scored a try apiece, but the Lions slumped to their first official defeat to Matt Te Pou's Maori XV 19–13. The Maori hadn't beaten the Lions in six previous attempts but smelt blood in Hamilton and were ferocious at the breakdown. The inspiration of veteran Carlos Spencer, on as a replacement outside-half early in the second half, proved the difference.

The Lions turned around at 6–6 but were hit by a Maori maelstrom shortly afterwards. And, alarmingly, the back row of Hill, Owen and Williams was outplayed by their counterparts, led by influential skipper Jonno Gibbes. A late O'Driscoll try was not enough to save the Lions after full-back Leon MacDonald had

◀ Prop Andrew Sheridan was yellow carded for a punch during the Lions' 19–13 reverse against the New Zealand Maori in Hamilton. It was the tourists' first official defeat against the Maori

crossed for the inspired Maori early in the second half. The misfiring Lions spent much of the game defending, and prop Andrew Sheridan was lost to the sin-bin for a punch at the end of the first half.

The midweek team got the tour back on the road four days later with a solid but unspectacular performance against a weakened Wellington side that was without its All Blacks Tana Umaga, Jerry Collins, Rodney So'oialo and Conrad Smith. It was a better balanced Lions side, with England World Cup stars Jonny Wilkinson, Jason Robinson and Neil Back (after serving a four-week suspension for foul play) among a handful of players making tour starts in the fourth game. Skipper O'Driscoll and full-back Lewsey featured for the third time in four games and flanker Easterby made his debut.

Wilkinson gave an unconvincing kicking display in breezy conditions on his first appearance. He contributed 13 points with the boot and it was two Welshmen either side of the break, prop Jenkins and centre Thomas, who scored the decisive, winning tries. The Lions failed to turn their first-half dominance into points as the three-quarters looked disjointed in their attack and made far too many errors. They only led 13–6 at half-time but held on to win 23–6.

With 20 minutes to go, Woodward pulled off inside-centre Henson and replaced him with outside-half Jones. But it was Wilkinson who slotted in at centre, with Jones taking the outside-half role. At the time it seemed a curious move but ultimately revealed Woodward's thinking for the first Test.

With another new captain, this time Scottish hooker Gordon Bulloch, at the helm, the Lions next travelled to Carisbrook, the house of pain, in Dunedin, to face Otago. Hodgson and Cusiter were the halves, O'Driscoll was rested and the centre pairing of Greenwood and D'Arcy had the responsibility of feeding wingers Shane Williams and Denis Hickie. The back row of debutant Ryan Jones, Williams and Easterby looked to be the quickest and most agile selection of the tour so far, and gave a good account as a unit.

For an hour it looked possible that Otago would add to its unmatched record against the Lions, but in the end the visitors outlasted and ultimately showed more creativity than the provincial team, again deprived of its best players by All Black duty, to win 30–19.

The Lions owed much of this creativity to the Wales duo of Jones and Shane Williams, who contrived two of the three tries between them. Jones' Lions debut was startling and will go down as one of the best in the side's history. He brought badly needed combativeness to the No. 8 shirt and competed vigorously at the breakdown, won crucially important turnover ball and scored a try in the 53rd minute – running the perfect line to receive Williams' short, subtle, perfectly timed pass about ten metres out.

Then, with the Lions leading 23–19, and with a quarter of an hour to go, Jones took a quick penalty from inside his own half, made rapid ground and found support to initiate a move that ended with Williams side-stepping the covering defence to score. It was some of the most fluid rugby the Lions had played on tour, but they conceded easy points through a high penalty count and again suffered slow ball at the breakdown.

▲ A week before the first Test, the Lions enjoyed a morale-boosting 30–19 victory over Otago courtesy of tries from Will Greenwood, the outstanding Ryan Jones (pictured) and Shane Williams

With just a week left until the first Test, post-match talk centred on whether Woodward would have the conviction to go with form and the more open tactics displayed by the Celts, or stick with the more static England game plan.

Then it happened. Woodward cracked his ringmaster's whip and in an instant the tour became 'The Power of One' – Woodward's England versus New Zealand. Prior to the announcement of the team to face Southland in Test week, Woodward stated that those playing in the midweek game would not be considered for the first Test. Quite why he should decide to shatter the confidence of the midweek players before their match and give them nothing to play for was a strange move for a normally very astute coach. And among those named in the team or on the bench to face Southland in Invercargill were Welsh backs Henson and Shanklin, Irish flanker Easterby, and Scottish scrum-half Cusiter and hooker Bulloch, all of whom would have been in many people's Test squad.

The omission of young and in-form players, while disappointing, was not totally unpredictable. But it did bring to mind the thoughts of Jim Telfer, assistant coach on the 1997 Lions tour to South Africa, who, at a selection meeting before the first Test, pondered, 'I would hate to go for experience and end up not having a go at them!' – indicating there is a fine balance between the tried-and-tested who play to their established patterns, and the ingenuity and boldness of youth and players in form.

The Southland match reflected the mood in the Lions camp, it being flat and listless. Two tries by surprising Test omission Henson saved the Lions from possible embarrassment against the weakest opponents they had met on tour so far. They struggled to beat the locals 26–16 in Invercargill.

◄ Wales centre Gavin Henson demonstrated his excellent form with two tries in the 26–16 midweek victory over Southland in Invercargill

Henson struck in the 13th and 54th minutes, on both occasions gliding his way past two tacklers to score from close range. He was by far the Lions' most effective player on a night when the team again looked as if they had never met before rather than having spent a month together in camp and on tour.

The announcement of the first Test team confirmed Woodward's obsession with his English World Cup-winning squad – 13 Englishmen were named in the 22-man squad, with Wales contributing five players and Ireland four. Not one Scotsman was deemed worthy of selection. (A tour-ending injury to three-quarter Shanklin was another blow to the squad.)

There have been such precedents before, with 11 Englishmen taking the field in 1993, and Scotland missing representation in 1950 and Ireland in 1989. Professional rugby may be about winning, but the proud traditions of British & Irish Lions tours should have been upheld, especially when Cusiter and/or Bulloch would have at least been capable replacements.

The biggest surprise was the selection of Wilkinson at inside-centre alongside captain O'Driscoll. He had been used sparingly on tour to date: his form was poor, he had not played a Test for two years and he was out of position, having last worn the 12 jersey in an international six years previous when England blew the Grand Slam against Wales.

The selection of Robinson at full-back was questionable given that Lewsey – selected on the wing – had clearly proved to be the form 15 in the squad. And the selection of prop Rowntree, centre Greenwood, lock Grewcock and wing Shane Horgan on the bench defied form shown in the previous six matches. The all-English back row in Woodward's view had withstood the challenges of the impressive Easterby and Ryan Jones, the two tour replacements whose form belied their original omission from the tour.

The XV that took to the field featured: Robinson; Lewsey, O'Driscoll, Wilkinson, Thomas; S. Jones, Peel; Corry, Hill, Back; Kay, O'Connell; White, Byrne, Jenkins. It appeared to be a team picked on reputation rather than form. Players such as Cueto, Henson, Shane Williams, Sheridan, Bulloch, Cusiter, Moody and Shaw were very unlucky to miss out.

The one outstanding problem that confronted the selected team was the fact that it had not played together at all on tour. It was a tactical flaw from which the side would never recover.

The Lions endured a nightmare start to the Test when captain O'Driscoll was injured after just 77 seconds when he was aggressively cleaned out at a ruck by Umaga and Keven Mealamu. The diagnosis was a dislocated shoulder that put an end to his involvement in the Test and the rest of the tour. He was then joined on the sidelines by flanker Hill, who limped off after 20 minutes to be replaced by Ryan Jones.

The All Blacks strangled the Lions from the kick-off, dominating territory and possession. The Lions were completely outplayed at the set piece by the All Black forwards, who had clearly been intent on proving a point. The pre-tour mantra that the Lions pack would be too powerful and aggressive for the All Blacks was shattered.

The Lions lost five of their own lineouts before half-time with All Black lock Chris Jack dominating Paul O'Connell and Ben Kay, the former not helping his side's cause by being yellow carded in the first half for a blatant offside infringement. Julian White failed to dominate in the front row to create the expected scrum platform and the All Blacks wheeled the Lions' scrum at will.

▲ Captain Brian O'Driscoll was ruled out of the series after suffering a dislocated shoulder early on during the first Test after a spear tackle by Tana Umaga and Keven Mealamu

The glut of possession led to tries for the All Blacks by lock Ali Williams and winger Sitiveni Sivivatu, and continual pressure on the Lions' ball as they scrambled desperately to make any headway with limited opportunities. Outside-half Dan Carter, enjoying clean possession on the front foot, easily won the battle of the stand-offs and he slotted 11 points with the boot. Stephen Jones and Jonny Wilkinson had their attacking influence nullified and the Englishman scored the Lions' only points through a single penalty goal. The final score of 21–3 flattered the Lions, as the atrocious conditions prevented the All Blacks from scoring further points.

The Test had a peculiar feeling of inevitability about it. The Lions, as in previous matches, did not appear to play to any pattern, and without the likes of Cueto, Shane Williams and Henson there was no one behind the scrum capable of breaking the gain line.

O'Driscoll's injury was a major blow for the Lions, but the captain himself had disappointingly not really delivered on the field to that point, like so many of the squad. His influence as a leader was also not apparent as the tour headed towards its business end. The incident involving Mealamu and Umaga appeared questionable, but independent citing officer Willem Venter deemed they had no case to answer after the Lions management cited both. Television pictures were inconclusive.

The following days were dominated by the O'Driscoll episode, with the captain himself, Woodward and Alistair Campbell all criticising the two Kiwi players. The spin-doctoring grew to immense proportions but became entirely counterproductive: Campbell's PR campaign backfired when it looked as though the incident was being

used to deflect scrutiny of the abject performance of the Lions in the first Test and it ultimately provided the All Blacks with motivational inspiration for the second. Campbell's lack of knowledge of the rugby environment was exposed.

Unfortunately for the Lions, lock Grewcock was cited and found guilty of biting in the Test, and was suspended for two months, effectively ending his tour. Welsh lock Cockbain became the 50th player on the tour as his replacement. Flanker Richard Hill, injured in the first Test, also succumbed to injury and was replaced on tour by Scotland's Jason White.

Manawatu presented the Lions with their easiest match of the tour and the scoreline of 109–6 reflected this. It was short of the record score against West Australia in 2001 when the Lions opened the tour with a 116–10 victory, but the writing was on the wall after just three minutes when Shane Williams crossed for the first of his five tries to stake a claim for a second Test spot. He became the first Welshman to score five tries in a match in New Zealand. The Lions scored 17 in all.

Ironically, just days after the set piece had been their undoing against the All Blacks, the Lions won all their lineouts in Palmerston North and managed to win five of the opposition's. Also impressing, just days before the second Test, were flanker Martyn Williams, lock Donncha O'Callaghan and full-back Murphy.

The level to which the selection for the first Test was miscalculated was reflected in seven changes for the second Test in Wellington, with another four positional changes also taking place. It hinted at desperation, with the make-up of six English and Welsh and three Irish. Once again, no Scotsman. The props remained unchanged, but O'Callaghan moved into the second row to partner his Irish colleague Paul O'Connell. The major change was the back row, with none of the English veterans retained. Woodward simply could not ignore the form and dynamism of Ryan Jones, Easterby and Moody.

Josh Lewsey swapped positions with Jason Robinson while Gareth Thomas, who became the fifth tour captain in O'Driscoll's absence, formed a new centre partnership with Gavin Henson. Wilkinson was moved to outside-half, while Shane Williams won a spot on the wing. Steve Thompson replaced hooker Shane Byrne who, along with back-rower Corry and outside-half Jones, was relegated to the bench.

It was asking miracles of the Lions to turn around the form of the first Test as again they had not played together as a unit, and although they toiled hard and were far more competitive, the All Blacks wreaked havoc and scored five tries to two. The chief destroyer was 23-year-old outside-half Dan Carter, whose performance was world-class. He directed and dictated the tempo of the match, totally outplayed Wilkinson, scored two tries and kicked nine from ten to score 33 points. Never before had a single individual dominated to this level in a Test between these two teams.

And yet the Lions had started promisingly when, after two minutes, Gareth Thomas cut back on the left-hand side of the field to find a gap close to the ruck on the 22. He scored under the posts, Wilkinson converted and for a few minutes the Lions' supporters revelled in the lead.

But that was the high point for the Lions, as the All Blacks took control as they had in the first Test. The Lions set piece was much improved, but apart from the promising opening ten minutes they had no answer to the dynamism and pace of the Kiwis. They were remorseless and the pressure led to points with Richie McCaw in the thick of everything in the loose. Skipper Umaga, spurred on by the vitriol thrown at him by the Lions management, was outstanding, adding the first try himself after 13 minutes.

The remaining two tries were scored by McCaw and Sivivatu as the All Blacks took the series 2–0 with a record 48–18 victory. Simon Easterby scored a consolation try, but it was the highest number of points conceded in a match against international opposition and left the Lions staring down the barrel of a 3–0 whitewash.

In the post-match media conference, Graham Henry was determined to enjoy the series victory and chose not to mince his words when praising his maligned captain: 'Tana has been fabulous. He has put up with rubbish from people who don't know the game nor have a passion for the game.'

Amid jubilant New Zealand media headlines proclaiming the All Blacks series win, the Lions headed for Auckland for the last provincial match and the third Test, two particularly hard matches for a demoralised tour party. However, the Auckland match was won 17–13 to maintain the unbeaten record of Ian McGeechan's midweek side. It was a small comfort to the Lions and was Auckland's first defeat by a touring team since Samoa in 1994.

Tour newcomers Jason White and Brent Cockbain made their Lions debuts in a match that was disjointed and fragmented, and failed to live up to its billing in front of the largest crowd of the tour so far: 48,000. Both sides scored one try, with Martyn Williams crossing for the Lions and Isa Nacewa for Auckland. Four penalty goals, one to outside-half Charlie Hodgson and three to his first-half replacement, Ronan O'Gara, secured the win.

The Auckland match was an abrasive affair and it contributed further injuries to a growing list of walking wounded. In the lead-up to the final Test, Woodward was forced to cancel a training run and out of selection for the match were Horgan, Wilkinson, Henson, Hodgson, Sheridan, Smith and Kay. Back and several others were struggling to overcome niggling injuries.

The result was a further four changes to the team for the third Test, all in the three-quarters. Geordan Murphy started at full-back with Josh Lewsey and Mark Cueto on the wings. In the centres, captain Gareth Thomas was joined by Will Greenwood, while Stephen Jones partnered Dwayne Peel in the halves. Thankfully, the pack was intact from the second Test.

The All Blacks also had injuries, with their two stars, Dan Carter and Richie McCaw, both unable to take to the field. Sione Lauaki replaced McCaw while young outside-half Luke McAlister replaced Carter and showed that New Zealand's depth at outside-half was impressive as he slotted into the side like a veteran once his early nerves had subsided.

The fact that the pack was playing its second match together in a week showed as the lineout and broken play improved markedly. The scrum was less impressive, however, and again the All Blacks disrupted the Lions ball by wheeling the scrum far too often. The suffering front row appeared to have very little support from the second row at the set piece and it led to very little quality ball once again. But the all-round basic skills of the team were sadly lacking and their play was ridden with mistakes.

The Lions started the stronger once again and deserved their 6–0 lead, but when lock O'Callaghan failed to use a three-man overlap and blew a wonderful scoring opportunity, the side's weakness of failing to convert pressure came home to roost.

This glaring weakness was exposed even further later in the first half when, in the space of four minutes, the All Blacks scored two tries while down to 14 men following the sin-binning of captain Umaga. The Kiwis' ability to turn their possession into points was a major factor in the series and Umaga returned to the fray to score two tries from a total of five by the rampant All Blacks.

The home side had continued their aggressive approach to the series and Collins became the second All Black in the sin-bin during the Test. Intimidated by the aggression, the Lions had no answer to the speed of the Kiwis' recycling of the ball and the sheer pace of the outside-backs, who looked dangerous with ball in hand. The Lions' response was a single try to flanker Moody.

The biggest cheer of the series as far as the Lions fans were concerned occurred in the 230th minute of the Test series when the first Scottish Lion got onto the field. Seventy minutes into the match, Gordon Bulloch replaced Shaun Byrne and acknowledged the supporters.

The final whistle at Eden Park signalled a 3–0 whitewash, the worst possible result for a team that was given every chance of success prior to the tour. In the series, the All Blacks scored 107 points to the Lions' 40. No Lions team has ever conceded a century of points in a series before. It was the first whitewash for 22 years, when Ciaran Fitzgerald's Lions had also capitulated to New Zealand. One amazing statistic is that in the 11 matches, the Lions had five different captains – O'Driscoll, Corry, Bulloch, Owen and Thomas.

▲ The All Blacks triumphed 38–19 in the third Test in Auckland to complete a tour whitewash and leave the Lions still looking for a first series win in New Zealand since 1971

The nature of the All Blacks' series performance against a hopelessly outclassed Lions made a mockery of northern media commentary which – since England's World Cup triumph – suggested that Super 12 rugby was not 'real rugby' and not suited to preparing players for Test rugby – unlike the Zurich Championship and the European Cup.

It seems Woodward had a vision (which was reflected in his tour party make-up) that his Lions were going to descend on New Zealand and show the world how rugby should be played – the northern way – by physically bludgeoning the opposition forwards to death, dominating set pieces and territory, and kicking the penalty goals that came along. Thank goodness for the future of the game that this was not the case.

In fact, his side did not come anywhere close to fulfilling these aims. The All Blacks forwards dominated the Lions over the series and, utilising superiority in possession and territory, unleashed a potent back line that was orchestrated by outside-half Dan Carter, and his deputy McAllister in his absence in the third Test.

Following the tour, an IRB statistical analysis highlighted how wide of the mark Woodward's selection thinking was in terms of the type of rugby required to win at Test level in 2005. The outcome of the Test series was decided after the first two Tests, at which point New Zealand had succeeded not only in obtaining overwhelming possession but also scoring tries more effectively. At that stage, New Zealand had gained 30 per cent more possession than the Lions and had outscored them by seven tries to two.

After the third Test, in which the All Blacks had less possession, the try gap had extended to 12 tries to three. New Zealand confirmed what had been happening in the previous year at international level. Possession was not a prerequisite to success. The analysis showed that South Africa (2004 Tri-Nations champions) scored a try for every 4.5 minutes' possession, Wales (2005 Six Nations champions) scored a try for every 5 minutes' possession while New Zealand scored a try for every 4.4 minutes' possession. The Lions, on the other hand, had required 16 minutes' possession to score each try.

The fact that the players looked unfamiliar with each other and appeared not to have any confidence in the man inside in defence highlighted a lack of preparation and a deficiency in coaching. It showed the Test-match coaching staff of Andy Robinson, Phil Larder and David Alred, under the direction of Woodward, were not up to the task. Instead, too much attention seemed to go on wrapping training fields in plastic sheeting to keep away the outside world and attempting to win a propaganda war as losses mounted.

In sport there is an old saying: 'you're only as good as your last game'. Clive Woodward thinks differently to most people, but there was still no excuse for his parting shot at his last media engagement, which indicated that his 2003 World Cup triumph surmounted the All Blacks' series win: 'Everything was in place to win the Tests. There's not many things I'd change, except win the series. But we lost and that's how I will be judged. But I don't think there is a gulf [between north and south]. The only time you can really judge teams like New Zealand is, in my opinion, at World Cups, when everyone arrives with the same preparation.'

It is sad that, following the tour, some people brought into question once again the future existence of Lions tours. What is even more disappointing is that such narrow-minded thinkers were given fuel to stoke their fire of despair following the record defeat at the hands of the All Blacks.

If the Lions are to be consistently competitive when touring the southern hemisphere, administrators need to be more united and put aside parochial attitudes and realise that there is more to rugby's well-being than success in the Six Nations. The Lions are a scratch side and they will continue to find it hard to beat New Zealand, Australia and South Africa if handicapped by an incredibly short team assembly period, lack of consistency in tour planning and no identifiable strategic plan for future tours. But the concept is unique; it provides colour and interest that other Test rugby can't match. It is a valued tradition that provides the only opportunity for British and Irish rugby players to unite under one banner, build lifelong friendships and meet the challenges of rugby in foreign lands.

RESULTS OF THE 2005 LIONS IN WALES AND NEW ZEALAND

P 12 W 7 D 1 L 4 F 353 A 245

Argentina (Cardiff)	D	25–25	Southland	W	26–16	
Bay of Plenty	W	34–20	New Zealand (Christchurch)	L	3–21	
Taranaki	W	36–14	Manawatu	W	109–6	
NZ Maoris	L	13–19	New Zealand (Wellington)	L	18–48	
Wellington	W	23–6	Auckland	W	17–13	
Otago	W	30–19	New Zealand (Auckland)	L	19–38	

BRIAN O'DRISCOLL'S 2005 LIONS TEAM

FULL-BACKS

I.R. Balshaw	Leeds Tykes	England
G.E.A. Murphy	Leicester Tigers	Ireland
G. Thomas	Toulouse	Wales
O.J. Lewsey	London Wasps	England
J.T. Robinson	Sale Sharks	England

THREE-QUARTERS

M.J. Cueto*	Sale Sharks	England
G.W. D'Arcy	Leinster	Ireland
W.J.H. Greenwood	Harlequins	England
G.L. Henson	Ospreys	Wales
D.A. Hickie	Leinster	Ireland
S.P. Horgan	Leinster	Ireland
B.G. O'Driscoll (capt.)	Leinster	Ireland
T.G. Shanklin	Cardiff Blues	Wales
O.J. Smith	Leicester Tigers	England
S.M. Williams	Ospreys	Wales

HALF-BACKS

G.J. Cooper	Dragons	Wales
C.P. Cusiter	Borders	Scotland
M.J.S. Dawson	London Wasps	England
C.C. Hodgson	Sale Sharks	England
S.M. Jones	ASM Clermont Auvergne	Wales
R.J.R. O'Gara	Munster	Ireland
D.J. Peel	Scarlets	Wales
J.P. Wilkinson*	Newcastle Falcons	England

FORWARDS

N.A. Back	Leicester Tigers	England
G.C. Bulloch	Glasgow	Scotland
J.S. Byrne	Leinster	Ireland
B.J. Cockbain*	Ospreys	Wales
M.E. Corry	Leicester Tigers	England
L.B.N. Dallaglio	London Wasps	England
S.H. Easterby*	Scarlets	Ireland
D.J. Grewcock	Bath	England
J.J. Hayes	Munster	Ireland
R.A. Hill	Saracens	England
G.D. Jenkins	Cardiff Blues	Wales
R.P. Jones*	Ospreys	Wales
B.J. Kay	Leicester Tigers	England
L.W. Moody	Leicester Tigers	England
D.F. O'Callaghan	Munster	Ireland
P.J. O'Connell	Munster	Ireland
M.E. O'Kelly	Leinster	Ireland
M.J. Owen	Dragons	Wales
G.C. Rowntree	Leicester Tigers	England
S.D. Shaw*	London Wasps	England
A.J. Sheridan	Sale Sharks	England
M.J.H. Stevens	Bath	England
S.M. Taylor	Edinburgh	Scotland
S.G. Thompson	Northampton Saints	England
A.J. Titterell	Sale Sharks	England
J.P.R. White*	Sale Sharks	Scotland
J.M. White	Leicester Tigers	England
M.E. Williams	Cardiff Blues	Wales

*Replacements

2009 TOUR KIT

2009
PRIDE, DRAMA AND DEFEAT ON THE HIGH VELDT

Captain: Paul O'Connell (Munster and Ireland)
Squad Size: 37 players + 3 replacements
Tour Manager: Gerald Davies (Wales)
Team Manager: Louise Ramsey (England)
Head Coach: Ian McGeechan (Scotland)
Assistant Coaches: Warren Gatland (Wales), Rob Howley (Wales), Shaun Edwards (Wales), Graham Rowntree (England)

Tour Record:	P 10	W 7	D 1	L 2	F 309	A 169
Test Series:	P 3	W 1	D 0	L 2		

The year 2009 opened with Barack Obama being sworn in as the USA's first African American president, while bush fires raged through the state of Victoria in Australia. The sports world was then outraged when terrorists attacked the Sri Lankan cricket team bus in Lahore, before military coups took place in Honduras, Fiji and Madagascar. General Motors filed for bankruptcy in the States and pop legend Michael Jackson died. Ireland won their first Grand Slam title since 1948.

Unfortunately, history will also record that the 2009 Lions failed to emulate the 1997 team and beat the world champion Springboks on their own turf in South Africa. But, in truth, it was one hell of a tour and the rugby played in the Test series was the most competitive, physical and absorbing in many years. Naturally, the Lions were bitterly disappointed with the outcome, but they showed great resilience and passion throughout the tour and, vitally, they restored the pride and dignity to the famous jersey.

▲ Ian McGeechan (centre) was named Lions head coach for a fourth time ahead of the 2009 tour while Gerald Davies (right) was unveiled as tour manager

Indeed, following the tumultuous events of the previous tour to New Zealand, which included record Test losses, the power brokers within the Home Unions and The British & Irish Lions Board took stock. Fearful for the future of the Lions, to their eternal credit they drew a line in the sand and made a determined effort to re-establish the quintessential tour ethos.

The Wales and Lions legend Gerald Davies was installed as tour manager, the Lions Board was chaired by Scotland and Lions legend Andy Irvine, and Ian McGeechan was once again given the coaching mantle. This blend of Lions blue blood, experience and cunning proved irresistible, and the players bought into the leadership mentality that was professional, steely, determined, proactive and allowed fair competition for selection throughout the tour. Indeed, there was no defined midweek team or Saturday side, and every player stayed in the mix for selection right up to the first Test.

Remarkably, it was McGeechan's fifth tour in a coaching capacity and seventh in total following two tours as a player: his knowledge of such tours is unsurpassed. Understandably, the year after the tour he was knighted for his services to rugby. Davies added a presidential-style leadership that bought real gravitas to the tour and

its off-field activities, while privately instilling a hard edge within the touring party. The UK media, desperate for Lions success, were brought into the fold, and the PR battle was calm and efficient and took delight in exploiting the numerous faux pas of eccentric Springbok coach Peter de Villiers.

The Lions proved to be very popular ambassadors throughout the tour. Their openness to meeting the locals, getting out and about and contributing to the tour fully endeared them to the community wherever they went. Standout events included an official welcome at Zoo Lake in Johannesburg, a visit to Masibambane College in Orange Farm, Gauteng Province, to open a new sports ground and a visit to Simondium, near Cape Town, to open school facilities.

Such an attitude translated itself into a united, courageous squad that held little fear against a highly fancied Springbok outfit that had won the 2007 Rugby World Cup. Ultimately, it was a tour that could have delivered more but was hampered in no small part by the late finish of the domestic season, causing the preparations at the pre-tour camp at Pennyhill Park in Surrey to take place without those players involved in season-ending finals.

Undeterred, McGeechan, accepting this inflexibility, selected a coaching panel that was unashamedly familiar to him. There was a strong Anglo-Welsh flavour to his team, with Warren Gatland (forwards), Shaun Edwards (defence), Rob Howley (backs), Neil Jenkins (kicking) and Graham Rowntree (technical) accepting tour roles as his lieutenants. McGeechan had worked previously with

▼ Second row Paul O'Connell (centre) became the tenth Irishman to lead the Lions when he was appointed captain for the tour of South Africa

several of the panel at the London Wasps club in England, while Gatland, Howley, Jenkins and Edwards also had Welsh Rugby Union ties. Another Lions stalwart, Dr James Robson, took charge of the medical team for his fifth consecutive Lions tour.

On 21 April, at the Sofitel at Heathrow, McGeechan unveiled his tour party of 36 players plus his captain, the towering Paul O'Connell. A proud Munster man who had led the province to European success, he became the tenth Irishman to captain a Lions tour party.

Tour manager Gerald Davies declared, 'We now have a short space of time in which to prepare for the tour and build a team that is capable of taking on the world champions. As ambassadors for British and Irish rugby, I know the players will be dedicated to the adventure and task ahead. They might hail from four different countries, but on tour they will play for the one jersey, one philosophy, one style and have one ambition: to return home as winners.'

However, as is the norm in the professional environment, injuries hit the squad prior to departure during the latter part of the season and at the pre-tour camp.

Tomas O'Leary, Jerry Flannery (both Munster and Ireland) and Tom Shanklin (Cardiff Blues and Wales) were to be ruled out of the tour through injury, while another one of Munster's Irish international forwards, Alan Quinlan, was suspended for foul play following his club's Heineken Cup semi-final against Leinster.

Furthermore, Leigh Halfpenny (Cardiff Blues and Wales) aggravated a previous injury and stayed at home to undergo medical treatment before flying out to join the tour later as the 37th squad member. Initially, the assembled 36-man party featured 12 Welsh and 11 Irish players, to reflect the success of those two nations as Grand Slam champions in 2008 and 2009 respectively, nine Englishmen and four Scots.

▲ The Lions' preparations for the Springbok series at their base in Bagshot were intense as head coach Ian McGeechan sought to ensure his squad hit the ground running in South Africa

It was one of the most inexperienced Lions teams to head overseas, with just 12 of the squad having been on a previous tour. Included were New Zealand-born centre Riki Flutey; exciting young Irish three-quarters Keith Earls, Rob Kearney and Tommy Bowe; and mobile back-row forwards such as Jamie Heaslip, Stephen Ferris and Tom Croft. Messrs Brian O'Driscoll (2005 tour captain to New Zealand), Ronan O'Gara, Simon Shaw and Martyn Williams were each on their third Tours, while Shane Williams, Stephen Jones, Gethin Jenkins, Donncha O'Callaghan, Andrew Sheridan, Phil Vickery, David Wallace and O'Connell were on their second. Naturally, this dozen formed the experienced core of the squad.

The assembly and preparation camp at Pennyhill Park was thorough and exact and included player familiarisation, tactical discussions, fitness testing and medicals. Time was short, and the fitness and conditioning team also unveiled their special

training equipment: exercise bikes and rowing machines fitted with special breathing equipment designed to simulate the effects of playing at altitude on the high veldt. The equipment became a common sight on tour and the players took to it without question.

All in all, with injury disruption and absentees in preparation week, it was not the ideal way to get ready to take on the Rugby World Cup holders, but, undeterred, the Lions boarded British Airways flight BA055, labelled Air Force Scrum, on 24 May bound for Johannesburg and a country buoyed by winning the right to stage the FIFA World Cup the next year.

In sport, there are often incredibly small margins between victory and defeat, between winning silverware or being the runner-up. In rugby, a knock-on, a missed kick at goal or a missed tackle can mean the difference between jubilation and disappointment. Yet still players keep coming back, searching for further jubilation or seeking to right any previous disappointment. This sums up the Lions spirit in South Africa. It was a ten-match tour, with just six games before the first Test to hone skills and to build partnerships and tactics.

Ultimately, the entire series came down to the last five minutes of the second Test in Pretoria when the Lions' lead was first wrenched from their grasp. Then, with the game level as the final whistle approached, one bad decision to kick possession away resulted in a dubious penalty to South Africa in injury time. The long-range penalty was kicked by outside-half Morne Steyn – and with that, the 'Boks had won the match and the series, and the rugby world was robbed of a deciding third Test.

One can only speculate what the outcome would have been, and how much a ticket to see it would have been worth, but the Lions did win the third Test and on aggregate across the three internationals won the series 74–63, scoring seven tries to five. It was a frustrating time for the Lions after the second Test, as refereeing decisions had clearly not gone their way, but their response was magnificent, and a third Test win by a significant margin highlighted the pride in this latest generation of Lions.

The tour kicked off in Rustenburg, at the foot of the Magaliesberg mountain range in North West Province, 65 miles north of Johannesburg, against a Royal XV. The venue was the Royal Bafokeng Stadium, one of the new stadiums used for the FIFA World Cup. A sparse crowd was in attendance because of a clash with the Super 14 final between the Bulls and Chiefs down the road in Pretoria, and unfortunately this set a trend for the tour.

In hot, dry conditions the Lions were understandably rusty, with little cohesion, and they were full of mistakes. The first-up partnerships looked interesting on paper, with O'Gara and Mike Blair at half-back and Martyn Williams, Joe Worsley and Wallace in the back row. Fortunately, the opposition, a composite side from the Vodacom Cup teams Falcons, Griffins, Griquas, Leopards and Pumas, while keen as mustard, were equally disjointed.

▲ A Lions training top from their South Africa tour. Despite several injuries to key players, the 2009 squad was arguably the best prepared yet and actually outscored their hosts by seven tries to five across the series

The Lions won 37–25, but allowed the opposition too much latitude in attack, reflected by the points conceded, including three tries. Royal XV actually led 18–3 early on, but a Tommy Bowe try saw the Lions trail 18–10 at the break. In the second half, the Lions began to show better promise, with Lee Byrne and Jamie Roberts leading the way. Superior fitness was another factor in the heat and, after trailing by five points with 20 minutes to play, late tries to Byrne, Alun Wyn Jones and O'Gara, the last of these enjoying the rarefied atmosphere on the veldt by slotting four conversions and three penalties, ensured victory.

▲ Midfield duo Brian O'Driscoll and Jamie Roberts celebrate after a try in the 74–10 demolition of the Golden Lions in Johannesburg. The pair were in outstanding form early in the tour

For the second match, it was back to the Johannesburg base camp at Sandton and a game against the Golden Lions (formerly Transvaal), who had sacked coach Eugene Eloff in the wake of a disappointing Super 14 campaign. In protest, a group of senior players had planned to make themselves unavailable for the match. In the end they were persuaded to play but may have rapidly regretted their decision. The Lions dominated from the first whistle at Ellis Park, and the Golden Lions were mauled by a very eager Lions team that saw 12 changes to the run-on team.

The Welsh duo of Stephen Jones and Mike Phillips were paired at half-back, while Roberts and Bowe played their second match in a row. Roberts was joined by O'Driscoll at centre, with the Irishman captaining the side for the first time since the first Test in New Zealand in 2005 when he dislocated his shoulder in a controversial 'tackle'. Croft and Heaslip joined Wallace in the back row, while the new front five comprised Nathan Hines, Wyn Jones, Vickery, Lee Mears and Jenkins.

The Roberts–O'Driscoll centre partnership was sublime on the night and a pointer to the possible Test combination. It did not take long for O'Driscoll to step past his opponent and put Roberts over for the first of ten Lions tries. The two centres scored three tries between them, and Bowe scored two, as did English wing Ugo Monye. James Hook, Ferris and Croft scored the other tries, with Stephen Jones, like O'Gara before him, showing great form with the boot.

Naturally, breakfast the next day was good-natured. The players, as was routine, underwent injury assessment by the hard-working medical staff after their daily weigh-in. Those who had not played enjoyed a light run, and the focus turned to packing for the charter flight to Bloemfontein and the third match against the Free State Cheetahs.

Bloemfontein is renowned as one of the major nurseries of South African rugby and is home to the famous Grey College, which has produced more Springboks than any other school in the Republic. It was an apt training venue and helped focus the Lions' minds on the job at hand, as Vodacom Park, 1,400 metres above sea level, is always a hard place to win.

◄ The Lions won six from six at the start of the 2009 tour, including a narrow 26–24 victory over the Free State Cheetahs in Bloemfontein which included an impressive try from Ireland's Keith Earls (pictured)

The Lions survived a severe test by the Cheetahs to remain unbeaten. It started encouragingly enough as the Lions romped into a 20–0 lead, with tries from the in-form flanker Ferris and young Munster centre Earls, both converted by outside-half Hook, who also added two penalties.

However, led by one of the few Springboks to get field time for his province, open-side flanker Heinrich Brussow, the Cheetahs surged back into the match. Ferris was sin-binned, and in the ten minutes he was off the field the Cheetahs scored tries through wing Danwel Demas and prop Wian du Preez. Thankfully, Hook slotted a penalty to make it 23–14 at the break.

The second half was a tight affair, with the sides trading penalties. Irish centre Gordon D'Arcy, the first tour replacement, took to the field as a reserve. Unfortunately, a loose pass from Shane Williams in open play with barely ten minutes left was intercepted, and the Cheetahs pounced to close the gap to two points with a converted try. Then, a minute from time, the Cheetahs' replacement outside-half Louis Strydom attempted a drop goal, but it sailed narrowly wide and the Lions held on to win 26–24.

The tourists moved on to Durban to tackle the Sharks in what was deemed to be the strongest test of their credentials so far. In the days leading up to the match, Halfpenny, who had joined the tour late, and Ferris, the in-form back-row forward, were ruled out of the tour through injury.

Missing their Springboks, the Sharks were devoid of any real attacking power, and the Lions, led by skipper O'Connell, playing his third match, outscored their hosts five tries to none in a 39–3 victory. This comprehensive win, despite a slow start, alerted the locals to the fact that the Lions were on course to more than trouble the Springboks. The Test back row, minus Ferris, was beginning to take shape and Heaslip, Wallace and Croft took to the field at Kings Park. Roberts and O'Driscoll were reunited in midfield and O'Gara was given another chance to impress ahead of Stephen Jones at outside-half.

> The Lions warmed up for the first Test with a 26–23 win over Western Province in Cape Town seven days earlier. Six Englishmen were in the starting XV, including captain Phil Vickery (centre)

Four matches down, four victories chalked up, and Western Province in Cape Town was the next obstacle for the Lions. McGeechan, once again mixing and matching while searching for his Test XV, started with Kearney at full-back and with Harry Ellis in tandem with Stephen Jones at half-back. Flutey had his first run-on start while, in the pack, Vickery was given the captaincy and Hines, Andy Powell, Worsley and O'Callaghan were also given opportunities to impress with the first Test just a week away. Despite scoring three tries to one, it took a late penalty from the replacement, Hook, with a mere three minutes left to maintain the Lions' unbeaten record at a wet and windy Newlands. It ended in a 26–23 victory, but they were pushed all the way by a committed Western Province side that made light of their missing Springboks.

Tries from wingers Bowe, his fourth of the tour, and Monye helped the Lions to an 18–12 half-time lead after they had been trailing 9–6. Flanker Williams scored a third try 15 minutes into the second half, but Province rallied to level the scores with 17 minutes left when full-back J.P. Pietersen scored in the left corner. The Lions endured some shaky moments as a first tour defeat loomed, but, significantly, their dominant scrum pulled them out of a hole. This was a facet of the game the Lions were becoming increasingly confident about.

The last match before the first Test took the Lions to Port Elizabeth to face the Southern Kings XV at the brand-new Nelson Mandela Bay Stadium, built to replace the decrepit old home of Eastern Province, the Boet Erasmus Stadium. A gastro bug hit several players prior to departure for Port Elizabeth, causing a team reshuffle, but the tour party took it in its stride. The opposition was the Southern Kings, a rebadged Eastern Province representative team that was keen to both re-establish the province as a rugby power and push for a place in Super Rugby. This ambition translated into an overly aggressive performance from the hosts. Hook and Euan Murray were among the casualties, with the latter later ruled out of the first Test and the tour. It was not a pretty match, but the Lions survived the ambush to record a 20–8 win and remain unbeaten prior to the Test series.

◄ The pre-match huddle before kick-off in the first Test in Durban. The Lions had lost at Kings Park back in 1962 but were 18–15 winners in 1997

After six lead-up matches, McGeechan waited until the last moment to announce his Test team. Byrne, Monye and Bowe formed a competent back three; the emerging talent of Roberts was picked alongside the past master, O'Driscoll, at centre; and the Welsh duo of Stephen Jones and Mike Phillips grabbed the half-back slots. There were no surprises in the back row, with Croft, Wallace and Heaslip teaming up, while O'Connell was joined in the second row by Alun Wyn Jones. In the front row, Vickery was preferred at tight-head in front of Adam Jones, the diminutive Mears beat Matthew Rees to the hooking role, and Jenkins picked up where he left off in 2005 as the top loose-head.

Some estimates put the Lions supporters numbers at over 40,000 throughout the tour, and at Kings Park, Durban, the setting for the hugely anticipated first Test, the Lions were buoyed by the sheer number of red shirts that had massed in large groups in the stadium. However, the vociferous support was not enough to quell the Springboks, who started the match far better and who totally dominated the first half. It took captain John Smit just five minutes to crash over next to the posts and for Ruan Pienaar, surprisingly selected at outside-half ahead of Morne Steyn, to add the extras. Then the Lions were guilty of blowing a golden opportunity to hit straight back. Monye, having been put clear out wide, stepped inside the defence near the left corner, but failed to ground the ball while being tackled by Jean de Villiers.

Francois Steyn and Pienaar then added a penalty apiece as the referee, Bryce Lawrence, started to penalise the Lions, particularly at the scrum, where they had enjoyed superiority on tour to date. Lawrence deemed that Vickery was using illegal tactics to manage Tendai 'The Beast' Mtawarira. However, against the run of play, Roberts surged through the Springbok defence on the right and offloaded to O'Driscoll, who ghosted into the 22 before putting Croft over. Jones added the extras to turn the tide somewhat at 13–7, but two further Pienaar penalties took the lead to 19–7.

The Lions were clearly rattled by Lawrence, who looked overwhelmed at times and as if he was being influenced by the home crowd. His handling of the scrum and ruck led to a lengthy discussion between him, Vickery and O'Connell as they left the

field at half-time. Nothing changed when the game resumed, but McGeechan turned to Adam Jones five minutes into the second half and he replaced Vickery. The scrum strengthened, but the damage had been done.

Crucially, the home team drove a lineout maul over the line minutes into the second half. Flanker Brussow scored the try and Pienaar converted; it was 26–7 and the Lions were looking out of it. But the closely bonded Lions picked up their game, and Phillips almost scored but lost the ball over the line. Then, on 67 minutes, Roberts and O'Driscoll created more havoc in the Springbok defence before Croft found a hole to score his second. Jones added the conversion and it was 26–14.

The Lions were now dominant and appeared the fitter team. It was becoming a memorable Test match, but once again Monye failed to seize a golden opportunity with ten minutes to go as he failed to touch down when pressured by replacement outside-half Morne Steyn on the left. With all to play for, the Lions pressed again and Phillips made no mistake when given a second chance: he scampered over next to the posts after several minutes of pressure. Jones again converted, and with five minutes left the Lions had surged back to 21–26. Again, they pressured, but the wily 'Boks slowed the tempo and held firm despite appearing to be out on their feet and beaten in the try count.

There was jubilation and relief for the Springboks, but it was the first defeat of the tour for the Lions. Not surprisingly,

▲ The Lions narrowly lost the first Test 26–21 in Durban and were left frustrated by the interpretation of the laws by New Zealand referee Bryce Lawrence

the hangover of disappointment affected the last provincial match of the tour against the Emerging Springboks in soggy Cape Town. Full-back Byrne was ruled out of the rest of the tour with a hand injury, and in a subdued affair, Earls scored the Lions' only try, which was converted by O'Gara, who also kicked a penalty, as did Hook. The Lions led 13–6 deep into the second half, and with few players staking a claim for Test selection, they looked safe. But a lapse in concentration led to wing Demas scoring in the corner. The Cheetahs wing obviously liked playing against the Lions, but his teammate de Waal did the unthinkable and converted from the touchline on the whistle to earn his team a 13–13 draw.

The whole tour was now on the line. The second Test was now 'do or die'. Scottish forward Nathan Hines was harshly suspended following the Emerging Springbok match for a dangerous tackle, but reserve props Tim Payne and John Hayes were in town to cover the mounting front row injuries.

Delighted by the way his players had performed and by the rugby they had played in Durban, but naturally dissatisfied with the result, McGeechan made five changes for the second Test. Kearney replaced Byrne at full-back and fellow Leinster man

◄ The second Test in Pretoria was an intensely physical affair, with both sides refusing to give an inch

Luke Fitzgerald replaced Monye on the wing. Up front was an all-Welsh front row for the first time since the 1955 tour, when Billy Williams, Bryn Meredith and Courtenay Meredith packed down against the Springboks. Some 54 years on, it was with Adam Jones in for Vickery, Matthew Rees at hooker for Mears, and Jenkins again at loose-head. Captain O'Connell was joined in the second row by English giant Simon Shaw, who was winning his first Lions Test cap after three tours and 16 matches. He had made his Lions debut 12 years earlier against an Eastern Province Invitation XV.

What transpired at Pretoria's Loftus Versfeld on the afternoon of Saturday, 27 June, was one of the most physical matches ever played by a Lions team. It was an unbelievable match, full of acrimony, controversy and physicality. The match started explosively when aggressive 'Bok flanker Schalk Burger was yellow-carded for what appeared to be a gouging attack on Lions wing Fitzgerald.

With Burger cooling his heels, outside-half Jones kicked a penalty from out wide. The teams came to blows as tempers flared, and shortly afterwards, the Lions crossed for their first try. A rapid, sweeping attack down the right led to a beautiful offload by Stephen Jones to Kearney, who scored in the corner. Jones converted. 10–0 to the Lions.

Burger's return had an immediate effect, as wing J.P. Pietersen scythed through the midfield from lineout ball to score after 12 minutes and make it 10–5. With the Lions scrum performing strongly, they were determined to play expansively, and constant pressure led to a penalty and a smartly taken drop goal by Stephen Jones to increase the lead to 16–5. Unfortunately, with the interval approaching the Springboks were awarded a penalty and Francois Steyn, taking over the kicking from Piennar, who had missed several attempts, kicked it to make the half-time score 16–8.

An hour into the game, Jones increased the lead further with a penalty as the physical nature of the game started to affect both sides. Numerous changes were made in the second half by the coaches, the most notable being at outside-half, where

Morne Steyn replaced Pienaar. Then, on 63 minutes, in what was almost a carbon copy of Pietersen's earlier try, Habana split the Lions defence to score at the posts. Steyn converted and suddenly it was only 19–15 to the Lions.

Then, in a huge blow to the Lions, both O'Driscoll and Roberts left the field injured. Stephen Jones and Bowe moved to the centres, with O'Gara coming on at outside-half. The Lions had already lost their two props, Adam Jones and Jenkins, and resources were stretched to the limit. Morne Steyn then kicked a penalty to reduce the gap to one, but Stephen Jones, who was kicking immaculately, then extended the lead to four with another penalty.

Sensing the Lions were tiring, the 'Boks pressed and pressed, and replacement centre Jacques Fourie was awarded a try in the right corner after minutes of deliberation by Australian video official Stuart Dickinson. It looked 50–50, but he awarded the try, Morne Steyn converted, and all of a sudden the home side led 25–22. Time was running out, and, with the series on the line, the Lions surged again,

▲ Wales fly-half Stephen Jones scored 20 points in Pretoria but his haul was not enough to stop the Lions slipping to a heart-breaking last-gasp defeat

and Jones kicked his fifth penalty on 78 minutes to level the scores and claim the highest individual points tally by a Lion in a Test in South Africa, with 20.

What a match! A draw seemed on the cards, which would keep alive the hopes of O'Connell's men of at least getting to Johannesburg seeking a share of the series. The outstanding Kearney then retrieved a 'Bok kick and smashed it downfield, only for Francois Steyn to launch it back into the Lions 22. O'Gara fielded the kick and ignored the pleas of his teammates to kick for touch, instead launching a high up-and-under towards halfway. He chased his own kick, but, with his eyes on the ball, he fatally stumbled into Fourie du Preez as he was attempting to catch it.

Referee Berdos decided it was a deliberate act and awarded a penalty. Up stepped Morne Steyn on his home pitch and over went a 54-metre penalty from inside his own half, to the raptures of the home fans. The Springboks had avenged their 1997 series defeat and shattered the hopes and dreams of the 2009 Lions, who collapsed exhausted and broken-hearted.

It is easy to say the defeat consigned the Lions to their third series defeat in a row, but they deserved more, each and every one of the touring party, for the rugby they played, for the attitude with which they attacked the tour, and for sheer guts and effort. Determined to avoid a whitewash, most of the tour party headed for a two-day break at a safari lodge, and others chose to drown their sorrows in the bars of Johannesburg. There was no midweek match and it was paramount that the Lions recharged their batteries for the final Test.

If the controversy and drama of the second Test had not been enough, the final week of the tour was steeped in it. Burger was vilified in much of the media and was subsequently banned for eight weeks, making a mockery of Berdos' yellow card. His

coach de Villiers tried to defend Burger, but made a clown of himself in the process. Then Bakkies Botha was hauled before the judiciary for some over-physical counter-rucking that had left Adam Jones with a dislocated shoulder. He was suspended for two weeks, despite many feeling his actions were simply part of the game.

With all the hoo-ha in the media over both players, it still came as a surprise to everyone that the Springbok squad came out for the third Test wearing white armbands with the words 'Justice 4' on them. It was clearly a reference to Botha having been, in the eyes of his teammates at least, unfairly treated. It was a disrespectful action to the game's administrators and indeed to the Lions, and it was no surprise that the IRB sanctioned the South African Rugby Union over the matter.

The post-match dressing-room at Loftus Versfeld after the Second Test had resembled a scene from the TV drama M*A*S*H, according to the Lions' medical team. The Lions had given their all, and many of the players were later ruled out of the final Test. McGeechan was forced into eight changes, one of them positional, for the final match, declaring: 'It is fair to say injuries have had an impact on the tour, as you would expect, including selection for the third Test, as we were unfortunate to lose Brian O'Driscoll (concussion), Jamie Roberts (wrist), Gethin Jenkins (cheekbone) and Adam Jones (shoulder) through injury last Saturday.

'Andrew Sheridan (prop), Riki Flutey (centre), Joe Worsley and Martyn Williams (flankers) will all be part of a Lions starting XV for the first time. Stephen Jones, Mike Phillips, skipper Paul O'Connell and Jamie Heaslip will earn the distinction of being in the starting XV for all three Test matches,' he added. The other changes saw Monye back on the wing, Shane Williams on the left wing, Bowe moving off the wing to outside-centre and Vickery back at tight-head.

▲ Nathan Hines (left) and Andy Powell take time out to play tag rugby with local children in Johannesburg the day before the Lions rallied to win the third Test

It may be a bit over the top to claim the Battle of Rorke's Drift during the Anglo–Zulu war came to mind prior to the last match. Sure, the Springboks themselves made ten changes for the last match, but stalwarts Smit, Victor Matfield, du Preez, Juan Smith, and Fourie were playing and several others from the previous Tests were on the bench. To many, there was a sense of over-confidence within the home camp.

OFFICIAL TEST MATCH PROGRAMME

10

R50 (VAT incl)

3RD TEST
-4 JULY 2009-
SOUTH AFRICA VS LIONS
COCA-COLA PARK
JOHANNESBURG

SOUTH AFRICA vs THE BRITISH & IRISH LIONS
4TH JULY 2009, COCA-COLA PARK, JOHANNESBURG

CASTLE LAGER | SOUTH AFRICA | ABSA

▲ The third Test in Johannesburg saw the Lions turn in a rousing performance to finally claim the reward their efforts deserved and give Ian McGeechan a truly fitting send off

The weakened Lions won the third Test in Johannesburg, thumping the Springboks 28–9 to equal both the highest score posted by a Lions team in a Test in South Africa and the biggest winning margin. The fact that the record was held by Willie John McBride's all-conquering 1974 side put the performance in proper perspective. *The Times* called it 'one of the most heroic performances in the history of the Lions'.

From the first whistle, they flew at the 'Boks, and after Stephen Jones and Morne Steyn had swapped early penalties, Welsh winger Shane Williams brought the game alive with two well-taken tries. Heaslip and Flutey were the providers, but Williams reminded everyone of his scoring abilities and raised the question of why he hadn't started previous Tests. Jones added one conversion to make it 15–3.

The game was once again incredibly physical, but the Lions strived to play a high-tempo game and found holes in the 'Bok defence through excellent offloading. Hooker Rees succumbed to injury after half an hour and Ross Ford took to the field to be the lone Scot to play a part in the series. Shaw was sin-binned for using his knees before Morne Steyn kicked a late penalty to make it 15–6 to the Lions at the interval.

The tourists could smell victory when Monye was on the money after 55 minutes with an interception of a Wynand Olivier pass in midfield. His try at the posts was converted by Stephen Jones and the lead stretched out to 22–6. The only response from the 'Boks was a third Steyn penalty, while Stephen Jones made sure of victory with two penalties of his own to hoist his series total to 39 points. At the final whistle the record-breaking victory was a sign of what might have been. Remarkably, it was also the Lions' first Test victory since Brisbane in 2001, nine games ago. The Lions more than enjoyed their victory lap, to the delight of their loyal supporters, who had stayed to cheer them to the end.

The Test was also the last Lions match for McGeechan, who declared he was hanging up his coaching boots. Victory in the final Test, by a record-equalling margin in the 118 years of this fixture, confirmed him as rugby's ultimate alchemist. Only a side which bonded tighter than any of its recent predecessors could have produced a performance of this calibre at the end of another exceedingly long season. Emotional before and after the Test, McGeechan was immensely proud of the victory, his players and the support of the fans.

There may have been more talented Lions squads than this one, but few have risen to the stiffest of challenges with more enthusiasm. 'Anyone who says the Lions cannot be competitive cannot possibly have seen the last three Tests,' said proud tour manager Gerald Davies.

Brian O'Driscoll reflected, 'Being a part of the 2009 British & Irish Lions squad has been one of the highlights of my career. We were unbeaten leading into the Test matches and it is a shame that the results in the Tests did not go our way, but sport comes down to fine margins at times. We could easily have won the first two Tests, but it wasn't to be.'

Phil Vickery summed up the prevailing mood: 'I can honestly say I've never been on a tour with so many good men. I think we've put a huge amount of pride back into the Lions shirt.'

▲ The Lions demonstrated incredible team spirit to regroup and triumph 28–9 over the Springboks in the third Test, only the tourists' second win at Ellis Park in seven attempts

RESULTS OF THE 2009 LIONS IN SOUTH AFRICA

P 10 W 7 D 1 L 2 F 309 A 169

Royal XV	W	37–25	Southern Kings	W	20–8	
Golden Lions	W	74–10	South Africa (Durban)	L	21–26	
Free State Cheetahs	W	26–24	Emerging Springboks	D	13–13	
Sharks	W	39–3	South Africa (Pretoria)	L	25–28	
Western Province	W	26–23	South Africa (Johannesburg)	W	28–9	

PAUL O'CONNELL'S 2009 LIONS TEAM

FULL-BACKS/THREE-QUARTERS

T.J. Bowe	Ospreys	Ireland
L.M. Byrne	Ospreys	Wales
G.W. D'Arcy*	Leinster	Ireland
K.G. Earls	Munster	Ireland
L.M. Fitzgerald	Leinster	Ireland
R.J. Flutey	London Wasps	England
S.L. Halfpenny	Cardiff Blues	Wales
R. Kearney	Leinster	Ireland
U.C. Monye	Harlequins	England
B.G. O'Driscoll	Leinster	Ireland
J.H. Roberts	Cardiff Blues	Wales
S.M. Williams	Ospreys	Wales

HALF-BACKS

M.R.L. Blair	Edinburgh	Scotland
H.A. Ellis	Leicester	England
J.W. Hook	Ospreys	Wales
S.M. Jones	Scarlets	Wales
R.J.R. O'Gara	Munster	Ireland
W.M. Phillips	Ospreys	Wales

FORWARDS

T.R. Croft	Leicester	England
S. Ferris	Ulster	Ireland
R.W. Ford	Edinburgh	Scotland
J.J. Hayes*	Munster	Ireland
J.P.R. Heaslip	Leinster	Ireland
N.J. Hines	Perpignan	Scotland
G.D. Jenkins	Cardiff Blues	Wales
A.R. Jones	Ospreys	Wales
A.W. Jones	Ospreys	Wales
L.A. Mears	Bath	England
E.A. Murray	Northampton Saints	Scotland
D.F. O'Callaghan	Munster	Ireland
P.J. O'Connell (capt.)	Munster	Ireland
T.A.N. Payne*	London Wasps	England
A.T. Powell	Cardiff Blues	Wales
M. Rees	Scarlets	Wales
S.D. Shaw	London Wasps	England
A.J. Sheridan	Sale Sharks	England
P.J. Vickery	London Wasps	England
D.P. Wallace	Munster	Ireland
M.E. Williams	Cardiff Blues	Wales
J.P.R. Worsley	London Wasps	England
*Replacements		

11

WINNING WAYS

The 2013 tour provided a fitting conclusion to the first 125 years of British & Irish Lions history. A colourful and action-packed period that finished with a long overdue series win in Australia. A period that produced some compelling and brave rugby but one that ultimately delivered just 12 series wins out of 31 played.

After a long, arduous domestic season, the Lions always travel full of hope, yet more often than not return battered and bruised, sometime victorious sometimes vanquished. The deeds of Cliff Morgan, O'Reilly, Willie John, King Barry, twinkle-toed Gerald Davies, Andy Irvine, Martin Johnson and Brian O'Driscoll, to mention just a few, providing exciting footnotes to the bravery of the Lions.

One thing is for sure, no tougher challenge exists in rugby. The Lions touring record in the professional era prior to 2013 testifies to this. It is not pretty reading. Despite some heroic attempts, notably in Australia in 2001 and South Africa in 2009, the fact remains that prior to the Australian tour in 2013 the tourists had won only once in the southern hemisphere since the sport turned professional in 1995 — and that was back in 1997.

Granted, winning is not everything, and the noble traditions and ambassadorial nature of the tour philosophy are very important in their own right, but it is nice! That is why the Australia tour victory, after so many years of heartbreak, was celebrated so keenly.

2013 TOUR KIT

2013
GUTSY GATLAND DELIVERS GOLD

Captain: Sam Warburton (Cardiff Blues and Wales)
Squad Size: 37 + 7 replacements
Tour Manager: Andy Irvine (Scotland)
Operations Director: Guy Richardson (Scotland)
Coach: Warren Gatland (Wales)
Assistant Coaches: Andy Farrell (England), Graham Rowntree (England), Neil Jenkins (Wales), Robert Howley (Wales)
Tour Doctor: James Robson (Scotland)

Tour Record:	P 10	W 8	D 0	L 2	F 387	A 121
Test Series:	P 3	W 2	D 0	L 1		

Mission accomplished! After years of near-misses, losses, 'what ifs' and disappointment, the 2013 Lions triumphed in Australia to record just their twelfth series victory in 125 years. Once again, as in the two previous series between the Lions and Wallabies, the drama was immense, with the series coming down to a winner-takes-all third Test decider. Containing numerous subplots and twists, the best Hollywood scriptwriters could not have penned a more thrilling narrative.

But let's get one thing straight from the start: this was a talented, well-coached and determined group of young players that triumphed. Only 12 of the original 37-man squad had previous Lions experience. The opposition was a very capable Wallabies side that stood as the third-best team in world rugby. It had beaten Grand

◄ Warren Gatland was named
Lions head coach after leading
Wales to the Grand Slam in 2012
and the championship the following
year. He became the Lions' second
foreign coach after compatriot
Graham Henry in 2001

Slam champions Wales 3–0 in Australia the previous year and won the last eight matches on the trot against them. It contained several world-class players, and for sections of the local media to attempt to blame defeat solely on a poor, out-of-sorts Wallabies side was ridiculous and bordering on the defamatory.

Credit should be given when credit is due. Lions tours are both unique and gruelling in today's professional sporting world. The squad comprises players from four different countries who assemble at the end of a long domestic season. The squad travelled 25,442 km, took nine flights, stayed in 13 hotels and played ten matches in the space of five weeks. It was hardly surprising they suffered injuries due to their workload. To demean in any way the achievement smacks of ignorance, especially given that the Aussies enjoyed home advantage and familiar surroundings.

The Wallabies could actually have been 2–0 up after the first two Tests... but then again, so could the Lions. Such was the drama of the first two matches in Brisbane and Melbourne. The Lions won the first Test 23–21, but Wallabies full-back Kurtley Beale missed a kickable penalty on the final whistle to let the Lions off the hook. In the second Test, the Wallabies held on to win 16–15, but not before Lions full-back Leigh Halfpenny had missed a 55-metre penalty, also on the final whistle. The fact the outcome of both games was undecided going into the 81st minute showed how tight and tense the series was.

Ultimately, the Lions' success came down to collective belief and hunger, better coaching and a burning desire to win to reward their amazing fans. The 'sea of red' that once again followed the tour was a sight to behold and almost turned the three Tests into home fixtures for the Lions. The record 41–16 third Test victory was greeted with passion and palpable emotion by the tens of thousands of Lions fans who swarmed into Sydney.

Their ultimate hero, and the man at the helm of the tour, was the Wales coach Warren Gatland. A shrewd and ambitious Kiwi, but a man who had been fully immersed in British and Irish rugby culture since 1989, his insightful understanding of the game, how such series play out and pragmatic decision-making over Test selections were key factors in the Lions' success. He emerged from the tour with his reputation enhanced, while the other Kiwi coach at the heart of the battle, Robbie Deans, was forced to exit stage left with his in tatters.

Gatland was without doubt everyone's choice as coach, with a pedigree that included steering London Wasps to multiple English and European club successes, and Wales to two Grand Slam titles (2008 and 2012) and a semi-final at the 2011 Rugby World Cup. He took some very brave decisions on tour and added a Lions series to his impressive resume. There can't now be many better coaching CVs in world rugby than Warren Gatland's!

Before the tour, the manager, Andy Irvine, highlighted another major factor in Gatland's appointment: 'Importantly, he was one of Ian McGeechan's specialist coaches on the 2009 Lions tour to South Africa so has an intimate knowledge of the Lions, the challenges they face and the processes that need to be put in place to ensure the squad has every chance of being successful.' Indeed the key factor for the Lions Board in planning 2013 was continuity.

The Lions had restored their ethos, and had come so close to beating the Springboks in 2009 that they felt there was no use dusting off the proverbial drawing board. The majority of the 2013 coaching and management team returned for the tour. But even in his early selection Gatland showed he was not a man to stand on sentiment as he preferred England's Andy Farrell to his long-standing defence coach partner Shaun Edwards.

Gatland almost ruined his chances of making the tour after a well-documented accident at home in New Zealand in mid-2012. He broke both ankles and badly fractured his heel bones falling off a balcony while cleaning some windows. His injuries led to a prolonged convalescence at home. Thankfully, he recovered, and on 12 December that year he announced Rob Howley and Graham Rowntree as assistant coaches, along with the fresh blood of Farrell. Neil Jenkins was also later appointed to complete the coaching panel.

Under the meticulous, military-like planning of tour operations manager Guy Richardson, along with Irvine and Gatland, the most important aspect of the tour was unveiled in London in the April before the tour: the squad. The composition of the team to embark on the 125th anniversary tour down under had been the talking point of the entire rugby family in Britain and Ireland for the previous two years. Everyone, it seemed, was an expert, and pubs, newspapers and radio talkback became vehicles for all manner of team selections.

▲ Flanker Sam Warburton captained the Lions in Australia in 2013, the first tour skipper from Wales since Phil Bennett wore the armband in New Zealand 36 years earlier

Gatland anointed his 2012 Grand Slam captain Sam Warburton as tour captain in a 37-man squad that included 15 Welshmen, ten Englishmen, nine Irishmen and three Scotsmen. The mix reflected Wales' two successive RBS 6 Nations titles, plus an emerging England that was on target for the 2013 title until derailed by a rampant Wales in Cardiff three months before the tour. This mix was to change the day before departure, however, when the England and Northampton Saints hooker Dylan Hartley was ruled out after being suspended for his dismissal in the English Premiership final. He was replaced by Ulster and Ireland hooker Rory Best.

With the squad announced, Gatland took his charges to the Vale of Glamorgan in Wales for an orientation and conditioning camp, then a further week of training at Carton House in Dublin. This looked like excellent preparation time on paper, but unfortunately the game's administrators had once again failed to provide enough squad assembly time. By not amending the playing season by at least one week– surely something within their remit once every four years – the whole squad could not take advantage this two-week pre-tour preparation period. Instead, the Lions had to train without 18 of the squad due to the Celtic and English Premiership finals scheduled for the weekend immediately prior to departure. Madness, and a huge ongoing problem that will continue to affect the Lions competitiveness unless something is seriously done about it.

The 20-odd players who did train for the two weeks prior to departure basically formed the side that played the first match of the tour, in Hong Kong, against the world-renowned Barbarians. The hot, humid climate in Hong Kong in late May/ early June is far from ideal for rugby matches, but with only nine matches available in Australia, the need to find a sixth match prior to the first Test saw the Lions heading to Asia. Hong Kong's expat population and Rugby Sevens pedigree made it the perfect choice, and it also assisted in breaking the long travel time to Australia.

With Warburton rested due to a knee injury picked up in training, the 2009 skipper Paul O'Connell led a team that included 18 first-time Lions, including the Scottish contingent of Stuart Hogg, Richie Gray and Sean Maitland. Young English fly-half Owen Farrell, son of coach Andy Farrell, partnered veteran Mike Phillips in the halves, while the all-Welsh back row of Justin Tipuric, Dan Lydiate and Toby Faletau looked particularly threatening.

The match was played in the evening at the National Stadium and saw the Lions arrive very late due to local traffic that had turned the narrow streets into car parks. Temperatures were well into the thirties and humidity was 85 per cent. Many critics expressed horror at allowing players to be exposed to such conditions, but it perhaps highlighted a lack of understanding of the preparation of today's professional players.

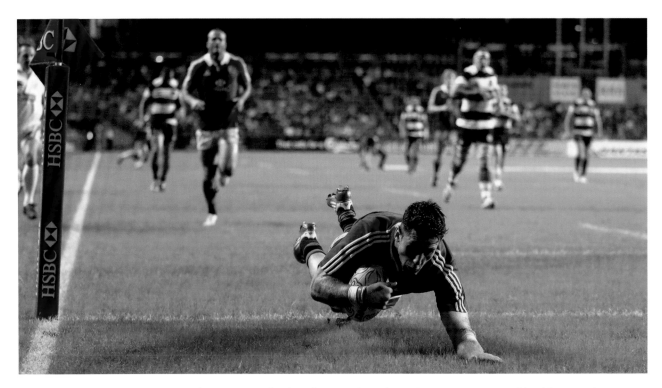

▲ Wales wing Alex Cuthbert made an early bid for a Test berth by scoring two of the Lions' eight tries in Hong Kong as the tourists overwhelmed the Barbarians four days before their first assignment down under

The Lions medical and strength and conditioning personnel had known for months that the climate would be far from ideal. Detailed planning, specific training, hydration techniques and sound recovery regimes showed that player welfare was uppermost in their thinking. Ice towels, ice vests, special drinks and ice fans were all used to good effect in training and on match night. In the end, the trip to Hong Kong proved an invaluable conditioning camp on the way to Australia.

Despite international players of the calibre of Sergio Parisse, Martin Castrogiovanni, Dmitri Yachvili, Imanol Harinordoquy, Joe Rokocoko and Nick Evans, the Barbarians were well beaten 59–8 in an eight-try-to-one display. Phillips and young Wales wing Alex Cuthbert scored two tries apiece to lay down early markers for the Test team.

A unique feature of the Lions jerseys that day was the first use of the individual player's appearance number embroidered onto his shirt. This followed the Lions Board decision to mark the Lions' 125th anniversary by honouring every player that has played for the Lions from 1888 with a playing number. Numbers were designated alphabetically for each match ever played on tours to New Zealand, Australia, South Africa and Argentina, as well as for those players who played in the games against the Rest of the World XV in 1986 and France in 1989. Salford's Jack Anderton, from the 1888 originals, took No. 1, while the Leicester Tigers hooker Tom Youngs became No. 788 when he took the field as the last of the eight replacements against the Barbarians.

The first fixture in Australia was against the Western Force, the first of five Super Rugby franchises faced by the Lions. The squad landed in sunny Perth on the west coast on 2 June and met the Force at Paterson's Stadium, a traditional AFL venue.

A completely new team took to the field, captained by four-time tourist and 2005 tour captain Brian O'Driscoll. The team comprised many of the players who had played finals ten days earlier, and another seven players made their Lions debuts including Ben Youngs, Manu Tuilagi, Geoff Parling, Dan Cole and Sean O'Brien.

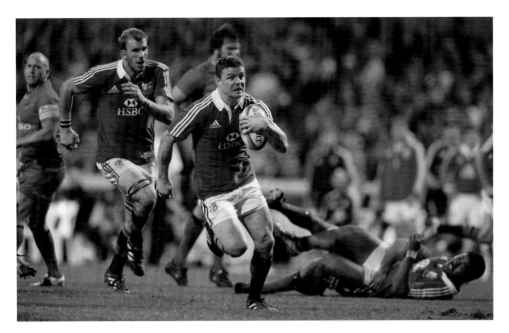

◄ After suffering tour-ending injuries in New Zealand in 2005 and South Africa four years later, Brian O'Driscoll took the armband for the 2013 game against Western Force in Perth and scored twice in a 69–17 win

O'Driscoll led from the front in the 69–17 victory, scoring two of the team's nine tries, while full-back Leigh Halfpenny, known as 'Pence' to teammates, gave a masterclass in goal kicking by slotting all nine conversions plus two penalties for a match tally of 24 points. It was an all-round performance that made many Australians sit up and take notice of the talents of the 24-year-old Welshman, who had been named as man of the tournament during the 2013 RBS 6 Nations.

However, the game was unforgettable for Leinster prop Cian Healy. First, he was cited for an alleged bite on the Force scrum-half Brett Sheehan, a spurious claim that was successfully defended by Max Duthie, the team's legal eagle. Having been exonerated, Healy then found the ankle injury he had picked up during the game was severe enough to force him out of the tour. It was the start of an injury epidemic to loose-head props on the tour and led to Gatland phoning England coach Stuart Lancaster in Argentina and asking him to put London Irish prop Alex Corbisiero on the next available flight. Not only did he do that, but he also pulled Corbisiero out of England's first Test against the Pumas in Salta.

Two from two, and the touring party was in good spirits as it headed to Brisbane and the toughest assignment to date. The players were well organised, with committees set up to handle social activities, bus music, tour fines, rooming lists and various other requirements. The player bus was a positive place to be as it headed for Suncorp Stadium.

The Reds, coached by former Wallabies World Cup winner Ewen McKenzie and the new national coach in waiting, had won the Super 15 title in 2011 and were recognised as arguably the toughest provincial test for the Lions. Disappointingly the Reds' Wallabies players were stood down for the match: a pattern often repeated on tour. Wallabies supremo Robbie Deans was keen to avoid injuries to his Test squad; however, such thinking does nothing but devalue such provincial tour matches. It had been a similar story in Perth, where the

The 2013 tour saw Warren Gatland's squad stretched to the limit thanks to injuries, with head doctor James Robson and his medical team performing miracles to restore Jamie Roberts, Tommy Bowe and Manu Tuilagi – among others – to fitness in record time. But despite the intense nature of the tour, a number of Lions racked up a truly impressive amount of minutes out on the pitch, with Wales centre Jonathan Davies leading the way with a draining 505.

Force coach Michael Foley held back a number of senior players because of a Super Rugby clash four days later against the Waratahs. Such decisions denied the players the chance of a lifetime, their fans an opportunity to see their team claim a massive scalp and the Lions the kind of quality opposition they craved in the build-up to the Test series.

Sam Warburton made his Lions and tour debut in the match in Brisbane, becoming the 800th Lion. A sore knee had seen him rested until this point, but he led

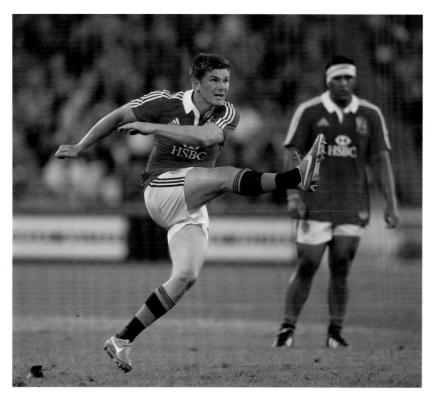

the team to a 22–12 victory that was hard fought against a young Reds side that flew at the Lions and played an enterprising brand of rugby. The Reds deservedly scored two tries to the Lions' one, with flying winger Luke Morahan scoring a sensational individual try to give the hosts an early lead.

The Lions did not panic and worked their way back into the match with a try to scrum-half Youngs and a flawless kicking display from outside-half Farrell, who kicked five penalties and a conversion. However, the Lions lost their English centre, Tuilagi, in the first half with a shoulder injury that was to keep him out of the next four fixtures. Even more of a worry was a broken hand suffered by wing Tommy Bowe. Surgery was required and his tour seemed

▲ England fly-half Owen Farrell made his first start in Australia against the Reds in Brisbane and kicked 17 crucial points as the Lions ran out 22–12 winners at the Suncorp Stadium

to be over, but the coaches decided to keep him on tour and monitor his recovery as the Test series was still a fortnight away.

An injury crisis was starting to play out, with another loose-head prop Gethin Jenkins ruled out of the tour without playing a match as he succumbed to a calf injury. The earlier call to Corbisiero was to prove invaluable as the tour went on, and Scotland and Glasgow Warriors prop Ryan Grant was summoned to join the tour from South Africa. Gatland also called for cover in the three-quarters, inviting the Munster wing Simon Zebo to fly in from Ireland's North American tour to become the third addition.

It was a short hop down the east coast from Brisbane to New South Wales and Newcastle, the venue for the match against a Combined Country XV. It was a brief 48-hour visit, as this was always going to be the weakest opposition on tour, with the Country XV comprising very few professional players.

On the morning of the match, the Lions, represented by their captain Sam Warburton, Manu Tuilagi, tour manager Andy Irvine and Lions chairman Gerald Davies, visited the grave of Robert Seddon, the Lions' first captain, in 1888 (see chapter 1). Seddon unfortunately drowned in the Hunter river near Newcastle during that tour. It was a fitting tribute to Seddon 125 years on from his untimely death, and wreaths were laid in his memory. The ARU joined in the celebrations

and members of the local Maitland rugby club worked wonders on ensuring the grave was in good order. The club have tended the grave for more than 80 years in a remarkable display of rugby respect and camaraderie.

Hunter Stadium, home to the NRL side the Newcastle Knights, had hosted Scotland's stunning 9–6 win over the Wallabies a year earlier in hurricane-like conditions, but fine weather greeted the Lions. Corbisiero and Grant made their Lions debuts, while O'Driscoll and Jamie Roberts were reunited in the centre for the first time since their memorable partnership in South Africa four years earlier.

The Lions predictably smashed Country, scoring ten tries without reply in a 64–0 drubbing. Nine different players scored tries, with wing George North scoring two as he started to hit top form ahead of the first Test.

It was a comfortable enough win, but further injury concerns surfaced. Farrell, O'Driscoll and North were carrying minor leg injuries, while Tuilagi continued to be ruled out. It meant Gatland had to call for another replacement to provide cover. This time he went for Gloucester's versatile Billy Twelvetrees, who became the fourth replacement called up in six days as he was recruited from England's tour in Argentina.

With his focus squarely on the Test series, Gatland unashamedly declared, 'The nature of a Lions tour means there will inevitably be knocks which take time to recover from. The whole squad has worked hard, but a lot of the backs have doubled up over the last two games, either starting or from the bench. We need to make sure that we rest a few players because the whole priority is making sure that we arrive in Brisbane next Saturday for the first Test fresh and ready to go.'

With a protection policy in place behind the scrum, the Lions headed to Sydney to play the NSW Waratahs, a team starting to rediscover its form following the appointment of the former Leinster and Stade Francais coach Michael Cheika after several years of disappointment. The Lions were also bemused by a ridiculous attack on them by former Wallabies coach Bob Dwyer. He called them cheats in *The Australian*, but so wide of the mark were his remarks that he was quite rightly ridiculed by the rest of the media. Gatland and his fellow coaches brushed off the attack and selected a very strong side for the match in Sydney. The pack in particular looked like the starting eight for the first Test the following Saturday.

Warburton was joined in the back row by Tom Croft and Jamie Heaslip, while in the second row the 2009 Test locks Paul O'Connell and Alun Wyn Jones were paired together. Mako Vunipola, Tom Youngs and Adam Jones comprised the front row, while behind the scrum replacement Simon Zebo made his Lions debut.

The Lions recorded an impressive 47–17 victory in what was easily their best performance of the tour. Jonathan Davies continued to impress in the centres, forcing O'Driscoll to declare post-match, 'Man, how good was Jonathan Davies tonight?'

Halfpenny was again a standout, scoring two tries, four conversions and four penalties in an individual haul of 30 points. It was a record for a Lion in Australia, bettering Ronan O'Gara's 26 against a Western Australian XV in 2001, and moved him into second place on the all-time list behind Alan Old's 37 against South West Districts in 1974. Alun Wyn Jones was a tower of strength up front, and the other try scorers were Davies, Johnny Sexton and Croft.

▲ Tour manager Andy Irvine lays a wreath on the grave of Robert Seddon, the first Lions captain who tragically drowned midway through the 1888 tour

Unfortunately, the victory came at a cost. Roberts injured a hamstring six minutes from time to add to the casualty list behind the scrum and leaving the Lions to finish the game with 14 men. Sexton was also sore after being targeted by the Waratahs, and it forced Gatland into further protection measures for the midweek match against the Brumbies.

To rest those players who were fit and in contention for the first Test, Gatland took the unusual step of calling in three further replacements. Wing Christian Wade was called from the England tour, fellow Englishman and centre Brad Barritt was invited to cut short a holiday, while the two-tour Welsh veteran winger Shane Williams was invited to play one final time in the Lions jersey. Williams, who had retired from international rugby in 2011, was already on his way to Australia to work for talkSPORT on the Test series. He was playing for a second-division side in Japan, but jumped at the chance of playing one final time for the Lions.

The Lions started their visit to Canberra, the home of the Brumbies, by visiting the famous Australian War Memorial at the heart of the Australian capital city. The Lions laid a wreath in recognition of the contribution of British and Australian soldiers during the World Wars, especially Blair Swannell, who died at Gallipoli in 1915. Swannell, who still holds with Froude Hancock the record of six wins in Test matches for the Lions, played for the Lions on two tours to Australia, in 1899 and 1904, and then went on to play for the Wallabies in 1905.

The Lions team that took to the field for the Brumbies match was underdone and underprepared. The coaches knew it, and the gamble was to protect the Test side. The team only had one short training session together due to travel commitments and featured four replacements in a makeshift back line: Wade, Barritt, Williams and Twelvetrees. Scottish recruit Grant was at loose-head prop and a further two newcomers were among the replacements, in Corbisiero and Zebo. In addition, the 2009 Test full-back Rob Kearney made his first start of the tour after a troublesome hamstring injury. In the end, it was no surprise the game was lost 14–12, just days from the first Test.

It was a hugely disappointing result, especially as Warburton had stated the ambition of his squad was to become the first Lions side since 1891 to win every game on tour, but nothing should be taken away from the young Brumbies, who, devoid of their Wallabies, relished the opportunity to play the Lions and scored the only try of the match. Marshalled by the South African World Cup-winning coach Jake White, they had a specific game plan and proved that the Brumbies' strong showing in Super Rugby was no fluke. White declared it 'one of the highlights of my career. I've got no doubt the boys sitting in the Wallabies camp would have looked at that result and the performance of some of these young boys and said: It's do-able.'

It was a definite knock to the Lions' confidence, but pre-tour Gatland had stressed he could live with some midweek losses if it meant focusing on the Test matches. Several questions were being asked. Could the Lions bounce back for the Test? They were familiar with the Suncorp Stadium, having beaten the Reds there, but did the Brumbies win provide a template for Wallabies success? Were injuries starting to count against the Lions?

Seemingly undeterred, Gatland predictably selected a vastly different team for the first Test in Brisbane. Although Tuilagi, Roberts and Bowe were unavailable, it was a team that resembled the one that had humbled the Waratahs. The back line comprised an all-Welsh back three of Halfpenny, Cuthbert and North, while the centres were O'Driscoll and Davies, and the halves were Sexton and Phillips. The

2009 veteran Heaslip won the No. 8 spot ahead of Faletau, while Warburton captained from the flank alongside Croft. Alun Wyn Jones and O'Connell were the second rows, while Corbisiero, Tom Youngs and Adam Jones provided the beef in the front row.

The importance of winning the first Test could not be overestimated, as momentum in modern rugby is vitally important. That said, in the previous two series against the Wallabies, in 1989 and 2001, the team winning the first Test had gone on to lose the series.

In a match of startling quality, speed and intensity, both teams scored two tries and there were never more than eight points between them. Sensationally, the Wallabies lost centre and goal kicker Christian Leali'ifano, a mere 50 seconds into his debut after he misjudged a tackle on opposite number Davies. He became the first of three Wallabies to leave the field on a stretcher.

It was to prove a huge loss to the home side. As well as being one of their major play-makers, Leali'ifano was also going to be their lead goal kicker. Outside-half James O'Connor had to take over and proceeded to miss two early penalties. By the end of the game, O'Connor and Beale had missed 14 points by pushing four penalties and a conversion wide of the posts. Even so, the Wallabies opened the scoring when Will Genia took a quick tap in his own 22, burst down the right touchline and created space for rugby league recruit Israel Folau to score his debut Wallabies try after just 13 minutes. O'Connor promptly converted and it was 7–0 to the hosts.

Halfpenny reduced the deficit with a penalty after 24 minutes before a badly placed kick out of defence by the full-back Berrick Barnes was fielded by George North on his own ten-metre line. Not to be outdone by his opposite number Folau

▲ The Lions cannot hide their disappointment following the 14–12 defeat against the Brumbies, although many felt Warren Gatland's decision to protect his first-choice Test side was justified in the face of the Lions' growing injury list

▲ A stunning try from on-song Wales wing George North (top) gave the Lions a 13–12 lead at half-time in the first Test in Brisbane, and although he was narrowly denied a second after the break (bottom) the team held firm for a dramatic 23–21 triumph

on his Lions Test debut, North burst past three Aussies on his way into the home half before standing up Barnes just outside his 22. All that was required then was for the Scarlets flyer to use his speed to beat the corner-flagging Genia to score one of the great Lions tries in the left corner. It was a sensational score that Halfpenny converted, and the Lions led 10–7 after 27 minutes.

Halfpenny added another penalty just after North was denied a second try in the corner by the TMO before, against the run of play, Folau embarrassed the Lions defence with some fancy footwork and a turn of speed to cross for his second try in the right corner on 34 minutes. O'Connor missed the conversion and Halfpenny missed with a penalty on the stroke of half-time to leave it 13–12 to the Lions.

Five minutes after the interval, with full-back Barnes already off the field following a sickening head clash with Folau that knocked him senseless, replacement centre McCabe, who had earlier replaced Leali'ifano, also left the field with a neck injury that brought his season to a premature end. It meant Deans had to switch open-side flanker Michael Hooper to centre, where he had played twice for club side Manly. The Lions spotted an opportunity and they brought Cuthbert racing into the back line off his wing to run a clever midfield line and split the Aussie defence asunder to score a debut try in the 48th minute. Halfpenny's conversion made it 20–12.

With the game opening up further, and both sides showing plenty of confidence to run the ball, penalties to O'Connor and Beale closed the gap to 20–18. The Lions were perhaps guilty of playing too much rugby in their own half and by this stage had lost their scrum ascendancy. A Halfpenny penalty at the 64-minute mark made it 23–18, but a Beale penalty three minutes later made it 23–21.

It was all to play for, and the Lions looked in control with a scrum deep in the Wallabies' 22 with nine minutes left on the clock. It looked like the perfect launchpad for another mesmerising midfield move, or even a drop goal, but the Wallabies wheeled the scrum and the ball squirted out and was cleared downfield. It was a crucial moment for the home side in their bid to stay in touch, and they then won a kickable penalty 35 metres out from the Lions' posts. Beale missed, but the drama wasn't over. Another scrum two minutes from time just inside the Lions' half went down and the New Zealand referee Chris Pollock awarded the Wallabies a penalty. The Lions were angry, bemused and feared the worst as Beale stepped up to win the match with a 45-metre penalty. Had he kicked it, the Lions would have been

left kicking themselves for throwing away a game they should have nailed much earlier, but Beale slipped as he ran up to kick the ball and his attempt fell short. The ball was kicked dead and the game was over – the Lions had won and taken the first, vital step on the road to registering a first Test series victory in 16 years.

It was a narrow win after some promising periods of play, but the Lions were not happy with the breakdown interpretation and felt harshly treated at the set piece by the referee, who gave the Wallabies 13 penalties in the match. It was a sobering thought that the Wallabies missed 14 points with the boot. North and Halfpenny shone, but Roberts was clearly missed in midfield. The back-row balance also appeared askew.

Gatland declared, 'It was not the prettiest performance, but we deserved to win. Our game management was not as good as it should have been and I told the players afterwards that they have to trust themselves and our systems.'

Warburton added, 'I could hear the noise the fans were making from my hotel room in the afternoon and any time you were feeling tired, they gave you a lift. When Australia had a penalty to win the game at the end it was the worst minute of my life. I thought the kick was going over and while I am delighted with the win, it was way too close for comfort.'

The big talking point after the game was the citing of Wallabies captain James Horwill. The Lions asked the citing officer to look at a stamping incident three minutes into the game. Horwill's boot clearly came into contact with Alun Wyn Jones' head and he needed stitches at half-time. However, the next day the judicial officer threw out the citing, saying it was unintentional. Horwill was free to play. The decision appeared incredibly lenient and most people had expected some form of suspension. The ensuing outcry in the British media, and a later decision by the International Rugby Board to appeal the verdict [a further hearing took place between the second and third Tests], showed the concern within the rugby family over the leniency. The Lions management shook off the controversy, accepted the decision and got on with the job at hand. The IRB appeal ultimately failed, caught up in legal argument and process rather than the fact of the incident.

With the first Test won, it was off to Melbourne for the last midweek match, against the Rebels, and the second Test. The Rebels match provided a further conundrum in terms of selection. The first Test took its toll on several players' bodies and, in a big blow, Paul O'Connell was ruled out of the tour with a broken arm. Several players were still overcoming niggling injuries that had kept them out of Test selection.

So, in another pragmatic move, Gatland called in Ireland's Tom Court to further cover the front row, as Corbisiero had picked up a calf injury in the Test. Second row Geoff Parling had been named as captain for the Rebels clash, but, when O'Connell was ruled out, he was withdrawn from the match. Ian Evans took his place and flanker Dan Lydiate took over the captaincy. Court replaced Vunipola on the bench as a protective measure for the second Test. The team included centre Tuilagi, who made only his second start of the tour after shrugging off his shoulder injury, and he was joined in the midfield by Barritt with Kearney at full-back and Maitland and Zebo on the wings. Lydiate, O'Brien and Faletau made a very useful back row that would feature strongly again before the end of the tour.

The outcome was a comfortable 35–0 victory that saw the Lions score five converted tries, one being a penalty try. Maitland, Murray, O'Brien and Ben Youngs all crossed, while Farrell slotted three conversions and Hogg two. Thankfully there

were no further injuries. The Rebels were captained by the former Wales back-row forward Gareth Delve and had their wing Lachlan Mitchell cited for a dump tackle on Zebo. His one-game ban was upheld on appeal.

The second Test at the Etihad Stadium was played under a closed roof and the match was billed as a 'do or die' match for the Wallabies. The city was awash with red-clad fans, and the Lions also knew that a win would secure the series and immortality. This was the same setting, and scenario, that the 2001 Lions had found themselves in 12 years earlier, and the air of expectation was palpable.

The Wallabies had injury concerns of their own and in the lead-up lost full-back Barnes, McCabe and wing Digby Ioane. However, battered centres Adam Ashley-Cooper and Leali'ifano were declared fit. Beale started at full-back, while Joe Tomane replaced Ioane on the wing.

To many people's surprise, Gatland made five changes in all to the Lions. O'Connell and Corbisiero were both ruled out with injuries, Parling and Vunipola replacing them off the first Test bench, while Bowe completed his remarkable comeback by taking over from Cuthbert. Ben Youngs took over from Phillips at scrum-half, as the Welshman succumbed to a sore knee, and Lydiate edged out Croft in the back row.

While the first Test was full of open and inventive rugby, the second was slower, full of kicking and defence orientated, yet remained incredibly gripping. All week in the build-up the Lions had talked openly about finishing off the job they started in Brisbane and seizing the moment. They wanted to clinch the series in Melbourne and grab their place in history. But the Wallabies tied the series by winning by a point. The Lions looked uncertain and nervous, and sat back on their lead in the closing quarter and paid the price for having to defend for so long. Their kicking game misfired, option taking suffered and confidence appeared low as the weight of expectation seemed to get to them. One bright spot was an amazing piece of play by North in his ongoing box-office battle with Folau. Taking the ball out wide on the left, he was confronted by his opposite number, and, undeterred, he ran straight into him before hoisting him onto his right shoulder, fireman's-lift style. He ran several

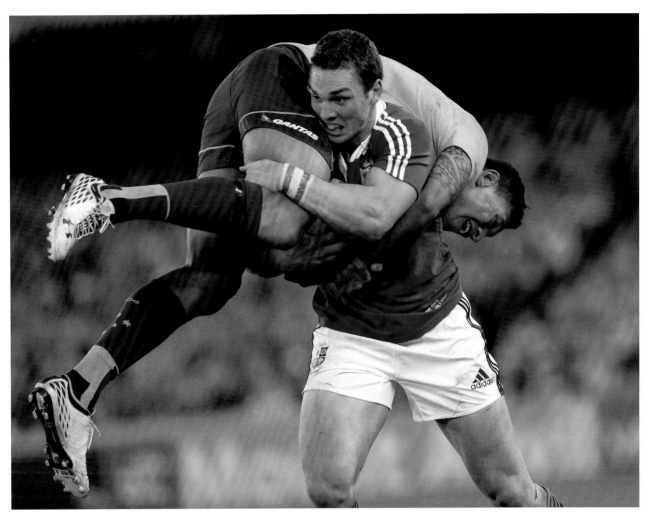

metres with ball and player in tow before finally being brought to ground. It was a clash of the two 'Supermen' in the respective teams, and it brought the crowd to its feet and instantly earned North cult status with Lions fans.

Despite not performing as they wished, the fact was the Lions could have won the match. The first half became a kicking duel between Halfpenny and Leali'ifano, with referee Craig Joubert blowing for numerous infringements especially at the scrum, where the Lions failed to dominate as expected. Halfpenny won the early duel, kicking four penalties to three, to give the Lions a 12–9 half-time lead. Indeed, the Lions were never behind until the 75th minute, when the Wallabies scored the only try of the match. After several minutes of pressure, and some stoic Lions defence, the Wallabies eventually scored when Adam Ashley-Cooper crossed to the left of the posts to tumultuous cheers from the home support. Leali'ifano was left with the conversion to steal the lead, and he hit the mark to maintain his 100 per cent record in the game, showing what the Wallabies had been missing in Brisbane after his untimely early departure.

With full-time rapidly approaching, the Lions launched a final assault that resulted in a penalty. It was a complete role reversal to the first Test, with Halfpenny now standing in Beale's boots with a shot from 55 metres to win the match and close the series. There were many within the record-breaking crowd of 56,771 at the Etihad Stadium, including the majority of the Australian team, who felt the

▲ George North's manhandling of Israel Folau was a highlight of the second Test but it was ultimately overshadowed by the Lions' agonising 16–15 defeat following a last-gasp Adam Ashley-Cooper try

Welshman was going to hit the mark. If ever there was a man you wanted to step up for such a kick, it would have been the Cardiff Blues full-back. It may have been on the edge of his range, but it was within his capabilities and he was on top goal-kicking form. But there was to be no fairy-tale ending for Halfpenny or his team as he got underneath his kick and saw it fall short of the posts. The game went to the delighted Wallabies, 16–15, and sent the series to a by now familiar decider in Sydney. To make matters worse for the Lions, Warburton, who had turned in what the onlooking 2005 head coach Clive Woodward described as one of the best performances he had ever seen by a British & Irish Lions player, so badly tore his hamstring that he had to be helped off the field in the 67th minute and was ruled out of the final Test.

Gatland was philosophical after the match but was clearly disappointed by the result: 'It's 1–1, next week's a big game, we'll look after ourselves the next couple of days then look forward to it, be excited about it. Last week was close, and again tonight. It could have gone either way.

'In fairness to Australia, they keep going for 80 minutes and it was a very tough Test. I was very pleased with the first half. Second half we didn't control territory as well. The defence dominated the game, and the breakdown, and we just weren't as accurate as we needed to be in the second half.'

What was needed was some R&R, so the Lions headed to the Sunshine Coast in Queensland. In Noosa, a 'well-to-do' tourist town with a beautiful beach, bars and cafes, they found the perfect haven. Two days away from the training pitch was perfect, with beers, lattes, surfing, jet-skis and sun the antidote for tired bodies and minds. Maitland, Roberts and Matt Stevens provided musical entertainment on guitar, numerous restaurants did a roaring trade, including one favourite pizza bar, as did the local nightclub. A fresher team trained at Noosa rugby club on the Wednesday, before arriving in Sydney on the Thursday before the third Test.

With the series locked at 1–1, Gatland rolled the dice one final time and decided to freshen up the team yet again. Key forwards O'Connell and Warburton were out of the tour, but everyone else was on deck, including the fit-again Roberts, Phillips and Corbisiero. In a bold move, Gatland made six changes. The most notable was the selection of Roberts in the centres ahead of O'Driscoll. The rugby world, especially in Ireland, went mad for several days as Gatland was castigated for daring to drop such an iconic player. From various former Lions such as Keith Wood and Willie John McBride there was unbridled outrage. They all wanted to see O'Driscoll round off his Lions career in grand style by steering the side to a series triumph in Sydney to add a long-overdue series victory to his title collection. For many other observers, the Irish legend had been fortunate that Roberts had been injured against the Waratahs, because had push come to shove, Gatland might well have done what he did for the third Test ahead of the first and gone for the Welsh midfield pairing from the start.

Quite how sections of the media and former Lions (who should know better) should determine that one player is immune to being dropped is incredible. Without question O'Driscoll was a great Lion, but at 34 his best days were probably behind him before he went on this, his fourth tour. He contributed mightily to the final outcome, starting in two of the three Tests, and can rightly claim to have played his part in helping the Lions to win the series. But Roberts would clearly have played earlier in the Test series if fit and there was never any question of dropping Davies, who was the standout centre on tour. Critics also hit out at Gatland for picking ten

Welshmen in the starting XV and another on the bench for the final Test. They claimed Gatland had showed bias, but this totally ignored the fact that eight Welshmen had started in the first Test. I am quite sure that if selecting 15 Irishmen meant winning the series he would have done that also! Gatland took it on the chin and backed himself big time: 'It's only hard because you are making the decision using your head and not your heart. Then you realise that what comes of making a decision like that is all the peripheral stuff, because it becomes a major story for 48 hours and it becomes a debate.

'I'll go back to the UK after this and say: "Did I make the decision because I believe it's the right decision or did I make it because it was politically right?" I have to put hand on my heart and say it's the right rugby decision. I would hate to think we had made calls to avoid criticism or for reasons of public popularity.'

Privately, Gatland was seething at the vitriol, but it was a mark of the man that he didn't let it show. He recalled Phillips at scrum-half, replaced Warburton with O'Brien, brought in Faletau at No. 8 for Heaslip, and beefed up the front row, where Hibbard replaced Tom Youngs and Corbisiero replaced Vunipola. A deserving Alun Wyn Jones was handed the captaincy. The ten Welshmen matched that nation's record from the first Test against Australia in Brisbane in 1950, but was still behind the 12 Englishmen who started the second Test in South Africa in 1891 or the 11 Englishmen who twice faced the All Blacks in the 1993 series.

The result? A record score in a Test for the Lions – by ten clear points! The 41–16 hammering of the Wallabies provided vindication for Gatland and complete embarrassment for his critics. Never have so many people been proved so wrong and been left to eat so much humble pie. The Red Army was delirious and the Lions had won their first series since 1997, in South Africa.

The Lions enjoyed the perfect start at the ANZ Stadium, packed full with a record crowd for the newly configured ground of 83,702, when Genia dropped the kick-off from Johnny Sexton. It gave the Lions the put-in at the game's first scrum inside the home 22. The scrum turned into a free kick for early engagement by the Aussie front row and Phillips went quickly to the narrow side. Tommy Bowe carried on and, a few phases later, Corbisiero crashed over near the posts for a try that Halfpenny converted to make it 7–0 within the opening two minutes.

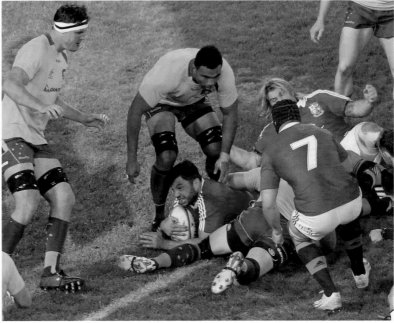

▲ England prop Alex Corbisiero scored the first of the Lions' four tries in the ANZ Stadium as the tourists thrashed the Wallabies in Sydney to seal a famous 2–1 series triumph

Could it get any worse for the Wallabies? Of course it could. The recalled veteran back-rower George Smith was knocked out in an ugly clash of heads with Hibbard and left the fray on 'snake legs' for a full five minutes before returning, clearly flustered. Halfpenny then made it ten points in seven minutes as he added three more points with a penalty off the halfway line. Leali'ifano stemmed the tide with a penalty moments later, but three more kicks from Halfpenny saw the Lions stretch

out to a 19–3 lead before the half-hour mark. Those 14 first-half points from Halfpenny's boot took his series tally past Neil Jenkins' Lions record of 41 in South Africa 16 years earlier – he ended with 49 points – and was the first of two individual landmarks he captured in the game of his life.

The Lions scrum was impressive. Corbisiero, Hibbard and Jones were dominating their opponents, and the French referee Romain Poite continually penalised the Wallabies scrum. His patience tested, he sent Wallabies tight-head Ben Alexander to the sin-bin in the 24th minute after another collapse. Alexander had celebrated his 50th cap in the Melbourne victory, but Corbisiero saw him off in quick fashion a week later as he never returned from his torrid 24 minutes, Sekope Kepu staying on for the rest of the game.

The Wallabies' woes continued when standout winger Folau left the field injured and Lions lock Parling produced a wonderful tap tackle to stop his replacement, Jesse Mogg, in his tracks as he broke open the Lions defence. But the Australians' luck changed shortly after Sexton missed with a drop-goal attempt on the half-hour mark. Then, after at last getting some possession and territory, they pressed in injury time, and O'Connor wriggled his way past Sexton and O'Brien to score a try at the posts, which Leali'ifano converted to leave the series poised on a knife-edge once more at the break, at 19–10.

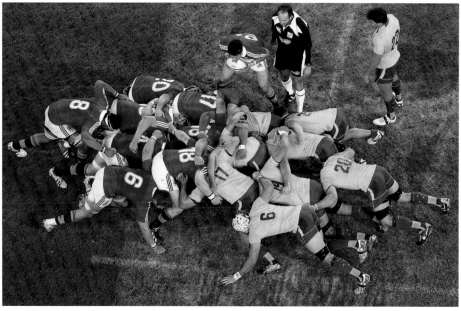

▲ The ascendancy of the Lions forwards in the third Test in Sydney was pivotal as the tourists registered a record-breaking 41–16 win over Australia

The Wallabies could sense they were back in the game and surged forward at the resumption of play. They were rewarded with two penalties by Leali'ifano that made it 13 points in 18 minutes to cut the gap to three points. Gatland had questioned whether the Wallabies could rise emotionally to the same levels they achieved in Melbourne to pull off a second win in seven days, but six minutes into the second half the momentum had swung completely their way. It was time for the Lions to dig deeper than ever before.

Thankfully, the tourists had Halfpenny's boot to rely on in troubled times, although the full-back also showed he had a running side to his game as the match broke up and the Lions went in for the kill. His fifth penalty, on 51 minutes, opened the gap up to six points and gave the Lions renewed confidence. It was at this stage of the game in Melbourne that they had fatally gone into their shells, but there was no repeat in Sydney.

Gatland began to ring the changes, backing his assertion that it would be a 23-man effort that would clinch the series, and he began to empty his bench, sending on Conor Murray, Dan Cole, Justin Tipuric and Tom Youngs to add fresh legs to the victory push.

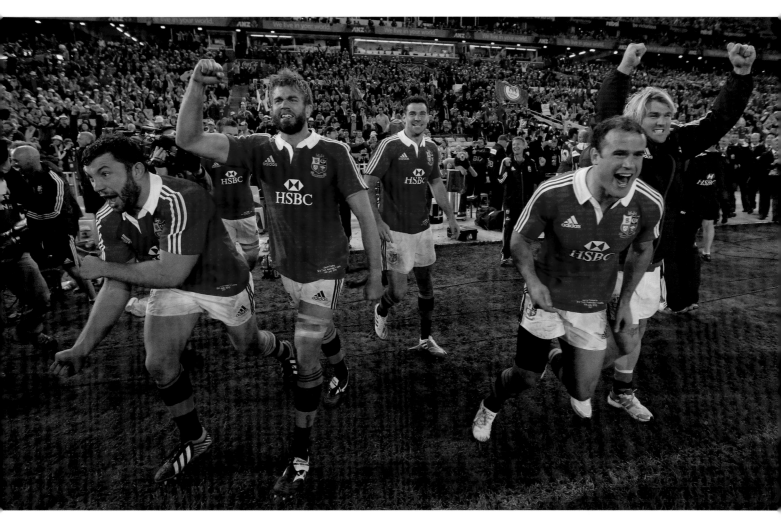

Five minutes later, Sexton scored a beautifully constructed try after great lead-up work by Davies and Halfpenny. North, always a danger on the left flank, then scored after a wonderful counter-attack from Halfpenny, who had collected a kick on touch at halfway and run it back at the Wallabies. He converted both to make it 34–16 with 15 minutes left.

The Lions fans roared their approval, and heartily sang 'cheerio' to the Australian fans, who decided to leave early. They were rewarded for their faithful support with a 'bonus point' try from Roberts, who ran a great line to receive a scoring pass from Murray off a lineout on the Wallabies' 22. Halfpenny converted and the Lions ran out comfortable winners 41–16.

It was the biggest score the Lions had posted in their 108-Test history, surpassing the 31 scored in the second Test against the Wallabies in Brisbane in 1966. Their 79 points in the series matched the record high notched in a four-Test series against the Springboks in 1974, and Halfpenny quite rightly carried off a number of records and accolades. As well as his series record of 49 points, he cracked the previous best of 20 points in a Lions Test held by Jonny Wilkinson and Stephen Jones with his 21-point match haul. He was named as the man of the match and the player of the series.

Pure elation erupted on and off the field as the entire squad and management joined forces to celebrate the first Test series win since Martin Johnson's men in 1997. Warburton and Alun Wyn Jones went up to receive the Tom Richards Trophy.

▲ The Lions celebrate as the final whistle sounds at the ANZ Stadium, signalling that the tourists had claimed their first series victory since toppling the Springboks in 1997

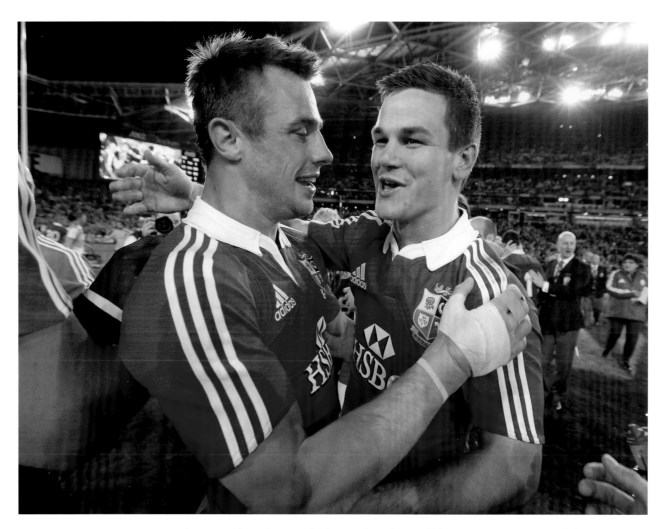

▲ Ireland teammates Tommy Bowe (left) and Johnny Sexton – who, despite being repeatedly targeted by the Australian pack, turned in a masterful performance at fly-half during the third Test – celebrate the Lions' victory

Of course, there have to be losers, but the Wallabies were gracious in defeat, waiting to clap the Lions off the field after a prolonged lap of honour. One major casualty was coach Deans, who resigned two days after the match. Copious volumes of beer and champagne were drunk over the next few days at the team hotel in Sydney: just reward. Gatland and Irvine addressed the players at a team meeting and thanked the entire tour party, from Rala the baggage master to the fellow coaches.

It would be hard to single out any individuals on such a tour, where teamwork and camaraderie prevailed across the entire management and playing staff. But special mention must be made of Halfpenny, who was voted the player of the series after three outstanding performances. He scored 114 points on tour, including a record 21 in the third Test and a record 49 points in the three Tests. He kicked 40 from 45 attempts at goal on tour at a success average of 89 per cent. To see him smile and enjoy the series win contrasted markedly with the sheer dejection written across his face after missing that penalty at the end of the second Test.

The work of the medical and strength and conditioning teams also merits recognition. To get Tommy Bowe, George North, Alex Corbisiero, Mike Phillips, Manu Tuilagi and Jamie Roberts fit for action was quite an achievement.

The Lions were hugely popular as tourists and enjoyed accolades wherever they went. ARU CEO Bill Pulver enthused about the Lions and how the tour invigorated fans in Australia once again: 'This tour that was 12 years in the making was

certainly worth waiting for. By every measure it has been a phenomenal success. We are in the process of selling out every seat in the house [for the third Test] and that will result in a total of about 390,000 spectators across nine games for this tour.'

Fly-half Sexton declared, 'It feels as though I'm standing in [a] Lions DVD. You have to pinch yourself at times. I remember watching these sorts of scenes from the video of the '97 tour and thinking I would never be a part of that, but here we are. It's a dream come true.'

And privately, Gatland carried a wry smile on his face until the day the squad departed for home. After all, he had out-coached Deans, rolled the selection dice and steered the Lions to a famous series win.

▲ Author Greg Thomas (right) and head coach Warren Gatland celebrate the Lions' seventh series victory over the Wallabies

RESULTS OF THE 2013 LIONS IN HONG KONG AND AUSTRALIA

P 10 W 8 D 0 L 2 F 387 A 121

The Barbarians	W	59–8	ACT Brumbies	L	12–14
Western Force	W	69–17	Australia (Brisbane)	W	23–21
Queensland Reds	W	22–12	Melbourne Rebels	W	35–0
Combined Country	W	64–0	Australia (Melbourne)	L	15–16
NSW Waratahs	W	47–17	Australia (Sydney)	W	41–16

SAM WARBURTON'S 2013 LIONS TEAM

FULL-BACKS/THREE-QUARTERS

T.J. Bowe	Ulster	Ireland
A.C.G. Cuthbert	Cardiff Blues	Wales
J.J.V. Davies	Scarlets	Wales
S.L. Halfpenny	Cardiff Blues	Wales
S.W. Hogg	Glasgow Warriors	Scotland
R. Kearney	Leinster	Ireland
S.D. Maitland	Glasgow Warriors	Scotland
G.P. North	Scarlets	Wales
B.G. O'Driscoll	Leinster	Ireland
J.H. Roberts	Cardiff Blues	Wales
E.M. Tuilagi	Leicester Tigers	England
W.W. Twelvetrees*	Gloucester Rugby	England
C. Wade*	London Wasps	England
S.M. Williams*	Mitsubishi Dynaboars	Wales
S. Zebo*	Munster	Ireland

HALF-BACKS

O.A. Farrell	Saracens	England
C. Murray	Munster	Ireland
W.M. Phillips	Bayonne	Wales
J. Sexton	Leinster	Ireland
B.R. Youngs	Leicester Tigers	England

FORWARDS

R.D. Best*	Ulster	Ireland
T.R. Croft	Leicester Tigers	England
D.R. Cole	Leicester	England
A.R. Corbisiero*	London Irish	England
T. Court*	Ulster	Ireland
I.R. Evans	Ospreys	Wales
T.T. Faletau	Dragons	Wales
R. Grant*	Glasgow Warriors	Scotland
R.J. Gray	Unattached	Scotland
C.E. Healy	Leinster	Ireland
J.P.R. Heaslip	Leinster	Ireland
R.M. Hibbard	Ospreys	Wales
G.D. Jenkins	Toulon	Wales
A.R. Jones	Ospreys	Wales
A.W. Jones	Ospreys	Wales
D.J. Lydiate	Dragons	Wales
S.K. O'Brien	Leinster	Ireland
P.J. O'Connell	Munster	Ireland
G.M. Parling	Leicester Tigers	England
M.J.H. Stevens	Saracens	England
J. Tipuric	Ospreys	Wales
M.W.W.N. Vunipola	Saracens	England
S.K. Warburton (capt.)	Cardiff Blues	Wales
T.N. Youngs	Leicester Tigers	England
*Replacements		

12

RECORDS & STATISTICS

SINCE 1888

Having brought to life many of the great players and characters who have played for the Lions since 1888, this section of the book aims to arm you with all the relevant facts and figures from the tours made by British and Irish teams between 1888 and 2013. These teams have been given different names down the years, but The British & Irish Lions are now bracketing them all under one banner.

As well as different names, the teams have played under different scoring systems down the years. These not only differed from tour to tour, but also sometimes from country to country, or from region to region within a country. For instance, in 1888 scoring values were:

New Zealand: Try – 1 pt, Goal – 2 pts, Field Goal – 3 pts
NSW: Try – 2 pts, Goal – 3 pts, Field Goal – 4 pts
Queensland: Try – 1 pt, Goal – 2 pts, Field Goal – 3 pts

Opposite is the points-scoring system utilised by one of the game's top statisticians, Stuart Farmer, which explains the values applied for tries, conversions, drop goals, penalties and goals from a mark down the years.

▼ The 1971 Lions in action against the All Blacks during the first Test at Dunedin. A try from prop Ian McLauchlan and two penalties from fly-half Barry John allowed the tourists to claim a 9–3 victory and got the ball rolling on arguably the most famous Lions series of all time

POINTS-SCORING SYSTEMS

Era	Try	Con	DG	Pen	GM
1890/91	1	2	3	2	3
1891/92–1892/93	2	3	4	3	4
1893/94–1904/05	3	2	4	3	4
1905/06–1947/48	3	2	4	3	3
1948/49–1970/71	3	2	3	3	
1971/72–1976/77	4	2	3	3	
1977/78–1991/92	4	2	3	3	
1991/92–present	5	2	3	3	

The A-Z Guide to The British & Irish Lions players is compiled in such a way as to give you the name of the club and country each player was playing for when selected, as well as the number of games and Tests he played.

Overall points scored are also included. For example, Rodger Arneil (see his statistics below) went on two tours. In 1968, he was playing for Edinburgh Academicals and was a Scottish international. He played 12 times, failed to score and played in four Tests. In 1971, he had moved club to Leicester and played five times in Australia and New Zealand, but didn't play in any Tests. If a player was uncapped when selected then only his club appears after his name.

ARNEIL	Rodger	Edinburgh Accies/Scot	1968	12	0	1,2,3,4
		Leicester/Scot	1971	5	0	

Down the years the Lions have played 'picnic' or 'unofficial' matches on tour. For the purpose of these records, the following matches are included:

1891 v. Stellenbosch
1930 v. Western Australia
1938 v. Western Province (Country)
1955 v. East Africa
1959 v. British Columbia All Stars XV
1959 v. Eastern Canada
1962 v. East Africa
1966 v. British Columbia
1966 v. Canada
1977 v. Fiji

Games excluded are:
1904 v. Maoris
1908 v. Maoris
1930 v. Ceylon
1950 v. Ceylon

The matches from the tours to Argentina in 1910, 1927 and 1936 are not included, although the results and some scoring details are included in the chapter on the 'Forgotten Tours'. The 2005 Test v. Argentina is included, but the 1977 Queen's Silver Jubilee match v. Barbarians and the game against a Rest of the World XV in Cardiff in 1986 are not.

BRITISH & IRISH LIONS CAPTAINS

YEAR	VENUE	CAPTAIN	N	P	W	D	L
1888	NZ/AUS	Robert Seddon	E	35	27	6	2
1891	SA	Bill Maclagan	S	20	20	0	0
1896	SA	Johnny Hammond	E	21	19	1	1
1899	AUS	Matthew Mullineux	E	21	18	0	3
1903	SA	Mark Morrison	S	22	11	3	8
1904	AUS/NZ	David Bedell-Sivright	S	19	16	1	2
1908	AUS/NZ	Arthur Harding	W	26	16	1	9
1910	SA	Dr Tom Smyth	I	24	13	3	8
1924	SA	Dr Ronald Cove-Smith	E	21	9	3	9
1930	NZ/AUS	Doug Prentice	E	28	20	0	8
1938	SA	Sammy Walker	I	24	17	0	7
1950	NZ/AUS	Karl Mullen	I	29	22	1	6
1955	SA	Robin Thompson	I	25	19	1	5
1959	AUS/NZ/CAN	Ronnie Dawson	I	33	27	0	6
1962	SA	Arthur Smith	S	25	16	4	5
1966	AUS/NZ/CAN	Mike Campbell-Lamerton	S	35	23	3	9
1968	SA	Tom Kiernan	I	20	15	1	4
1971	AUS/NZ	John Dawes	W	26	23	1	2
1974	SA	Willie John McBride	I	22	21	1	0
1977	NZ	Phil Bennett	W	26	21	0	5
1980	SA	Bill Beaumont	E	18	15	0	3
1983	NZ	Ciaran Fitzgerald	I	18	12	0	6
1989	AUS	Finlay Calder	S	12	11	0	1
1993	NZ	Gavin Hastings	S	13	7	0	6
1997	SA	Martin Johnson	E	13	11	0	2
2001	AUS	Martin Johnson	E	10	7	0	3
2005	NZ	Brian O'Driscoll	I	12	7	1	4
2009	SA	Paul O'Connell	I	10	7	1	2
2013	AUS	Sam Warburton	W	10	8	0	2
TOTAL							
29 tours				608	448	32	128

ARGENTINIAN TOURS

YEAR	VENUE	CAPTAIN	N	P	W	D	L
1910	ARG	John Raphael	E	6	6	0	0
1927	ARG	David MacMyn	S	9	9	0	0
1936	ARG	Bernard Gadney	E	10	10	0	0
TOTAL							
3 tours				25	25	0	0

THE COMPLETE BRITISH & IRISH LIONS TEST RECORD

TEST	RESULT	F	A	OPPOSITION	VENUE	YEAR
01	WON	4	0	v. South Africa	Port Elizabeth	1891
02	WON	3	0	v. South Africa	Kimberley	1891
03	WON	4	0	v. South Africa	Cape Town	1891
04	WON	8	0	v. South Africa	Port Elizabeth	1896
05	WON	17	8	v. South Africa	Johannesburg	1896
06	WON	9	3	v. South Africa	Kimberley	1896
07	LOST	0	5	v. South Africa	Cape Town	1896
08	LOST	3	13	v. Australia	Sydney	1899
09	WON	11	0	v. Australia	Brisbane	1899
10	WON	11	10	v. Australia	Sydney	1899
11	WON	13	0	v. Australia	Sydney	1899
12	DRAW	10	10	v. South Africa	Johannesburg	1903
13	DRAW	0	0	v. South Africa	Kimberley	1903
14	LOST	0	8	v. South Africa	Cape Town	1903
15	WON	17	0	v. Australia	Sydney	1904
16	WON	17	3	v. Australia	Brisbane	1904
17	WON	16	0	v. Australia	Sydney	1904
18	LOST	3	9	v. New Zealand	Wellington	1904
19	LOST	5	32	v. New Zealand	Dunedin	1908
20	DRAW	3	3	v. New Zealand	Wellington	1908
21	LOST	0	29	v. New Zealand	Auckland	1908
22	LOST	10	14	v. South Africa	Johannesburg	1910
23	WON	8	3	v. South Africa	Port Elizabeth	1910
24	LOST	5	21	v. South Africa	Cape Town	1910
25	LOST	3	7	v. South Africa	Durban	1924
26	LOST	0	17	v. South Africa	Johannesburg	1924
27	DRAW	3	3	v. South Africa	Port Elizabeth	1924
28	LOST	9	16	v. South Africa	Cape Town	1924
29	WON	6	3	v. New Zealand	Dunedin	1930
30	LOST	10	13	v. New Zealand	Christchurch	1930
31	LOST	10	15	v. New Zealand	Auckland	1930
32	LOST	8	22	v. New Zealand	Wellington	1930
33	LOST	5	6	v. Australia	Sydney	1930
34	LOST	12	26	v. South Africa	Johannesburg	1938
35	LOST	3	19	v. South Africa	Port Elizabeth	1938
36	WON	21	16	v. South Africa	Cape Town	1938
37	DRAW	9	9	v. New Zealand	Dunedin	1950
38	LOST	0	8	v. New Zealand	Christchurch	1950
39	LOST	3	6	v. New Zealand	Wellington	1950
40	LOST	8	11	v. New Zealand	Auckland	1950
41	WON	19	6	v. Australia	Brisbane	1950
42	WON	24	3	v. Australia	Sydney	1950
43	WON	23	22	v. South Africa	Johannesburg	1955
44	LOST	9	25	v. South Africa	Cape Town	1955
45	WON	9	6	v. South Africa	Pretoria	1955
46	LOST	8	22	v. South Africa	Port Elizabeth	1955

TEST	RESULT	F	A	OPPOSITION	VENUE	YEAR
47	WON	17	6	v. Australia	Brisbane	1959
48	WON	24	3	v. Australia	Sydney	1959
49	LOST	17	18	v. New Zealand	Dunedin	1959
50	LOST	8	11	v. New Zealand	Wellington	1959
51	LOST	8	22	v. New Zealand	Christchurch	1959
52	WON	9	6	v. New Zealand	Auckland	1959
53	DRAW	3	3	v. South Africa	Johannesburg	1962
54	LOST	0	3	v. South Africa	Durban	1962
55	LOST	3	8	v. South Africa	Cape Town	1962
56	LOST	14	34	v. South Africa	Bloemfontein	1962
57	WON	11	8	v. Australia	Sydney	1966
58	WON	31	0	v. Australia	Brisbane	1966
59	LOST	3	20	v. New Zealand	Dunedin	1966
60	LOST	12	16	v. New Zealand	Wellington	1966
61	LOST	6	19	v. New Zealand	Christchurch	1966
62	LOST	11	24	v. New Zealand	Auckland	1966
63	LOST	20	25	v. South Africa	Pretoria	1968
64	DRAW	6	6	v. South Africa	Port Elizabeth	1968
65	LOST	6	11	v. South Africa	Cape Town	1968
66	LOST	6	19	v. South Africa	Johannesburg	1968
67	WON	9	3	v. New Zealand	Dunedin	1971
68	LOST	12	22	v. New Zealand	Christchurch	1971
69	WON	13	3	v. New Zealand	Wellington	1971
70	DRAW	14	14	v. New Zealand	Auckland	1971
71	WON	12	3	v. South Africa	Cape Town	1974
72	WON	28	9	v. South Africa	Pretoria	1974
73	WON	26	9	v. South Africa	Port Elizabeth	1974
74	DRAW	13	13	v. South Africa	Johannesburg	1974
75	LOST	12	16	v. New Zealand	Wellington	1977
76	WON	13	9	v. New Zealand	Christchurch	1977
77	LOST	7	19	v. New Zealand	Dunedin	1977
78	LOST	9	10	v. New Zealand	Auckland	1977
79	LOST	22	26	v. South Africa	Cape Town	1980
80	LOST	19	26	v. South Africa	Bloemfontein	1980
81	LOST	10	12	v. South Africa	Port Elizabeth	1980
82	WON	17	13	v. South Africa	Pretoria	1980
83	LOST	12	16	v. New Zealand	Christchurch	1983
84	LOST	0	9	v. New Zealand	Wellington	1983
85	LOST	8	15	v. New Zealand	Dunedin	1983
86	LOST	6	38	v. New Zealand	Auckland	1983
87	LOST	12	30	v. Australia	Sydney	1989
88	WON	19	12	v. Australia	Brisbane	1989
89	WON	19	18	v. Australia	Sydney	1989
90	LOST	18	20	v. New Zealand	Christchurch	1993
91	WON	20	7	v. New Zealand	Wellington	1993
92	LOST	13	30	v. New Zealand	Auckland	1993
93	WON	25	16	v. South Africa	Cape Town	1997
94	WON	18	15	v. South Africa	Durban	1997

TEST	RESULT	F	A	OPPOSITION	VENUE	YEAR
95	LOST	16	35	v. South Africa	Johannesburg	1997
96	WON	29	13	v. Australia	Brisbane	2001
97	LOST	14	35	v. Australia	Melbourne	2001
98	LOST	23	29	v. Australia	Sydney	2001
99	DRAW	25	25	v. Argentina	Cardiff	2005
100	LOST	3	21	v. New Zealand	Christchurch	2005
101	LOST	18	48	v. New Zealand	Wellington	2005
102	LOST	19	38	v. New Zealand	Auckland	2005
103	LOST	21	26	v. South Africa	Durban	2009
104	LOST	25	28	v. South Africa	Pretoria	2009
105	WON	28	9	v. South Africa	Johannesburg	2009
106	WON	23	21	v. Australia	Brisbane	2013
107	LOST	15	16	v. Australia	Melbourne	2013
108	WON	41	16	v. Australia	Sydney	2013

BRITISH & IRISH LIONS OVERALL TEST RECORD

OPPONENTS	P	W	D	L	F	A	TF	TA	Win %
South Africa	46	17	6	23	516	600	68	95	37
Australia	23	17	0	6	414	248	57	27	74
New Zealand	38	6	3	29	345	634	41	97	16
Argentina	1	0	1	0	25	25	1	1	0
COMBINED	108	40	10	58	1300	1507	167	220	37

BRITISH & IRISH LIONS TEST MATCHES IN SOUTH AFRICA

1891
TEST NO. 1

30 July, Port Elizabeth
South Africa 0 The Lions 4
HT: 0–4 Att: 6,000

South Africa: B. Duff; M. van Buuren, C. Vigne, H. Boyes, F. Guthrie; A. Richards, M. Versfeld; B. Bisset, H. Castens [capt.], T. Devenish, J. Louw, E. Little, F. Alexander, G. Merry, F. Hamilton

The Lions: **W. Mitchell; P. Clauss, R. Aston, W. MacLagan [capt.], A. Rotherham; W. Wotherspoon, W. Bromet; J. Gould, J. Hammond, P.F. Hancock, R. MacMillan, C. Simpson, A. Surtees, R. Thompson, T. Whittaker.** Scorers: Tries: R. Aston, T. Whittaker; **Con:** A. Rotherham

Referee: Dr John Griffin (South Africa)

TEST NO. 2

29 August, Kimberley
South Africa 0 The Lions 3
HT: 0–3 Att: 3,000

South Africa: B. Duff; A. de Kock, C. Vigne, H. Boyes, J. Powell; A. Richards, M. Versfeld; F. Alexander, B. Snedden [capt.], B. Shand, W. Trenery, D. Smith, B. Heatlie, T. Smith, J. Louw

The Lions: **W. Mitchell; P. Clauss, R. Aston, W. MacLagan [capt.], A. Rotherham; H. Marshall, W. Bromet; E. Bromet, J. Hammond, P.F. Hancock, R. MacMillan, E. Mayfield, A. Surtees, R. Thompson, T. Whittaker.** Scorer: DG: W. Mitchell

Referee: Percy Ross-Frames (South Africa)

TEST NO. 3

5 September, Cape Town
South Africa 0 The Lions 4
HT: 0–0 Att: 3,000

South Africa: B. Duff; J. Hartley, C. Vigne, H. Versfeld, A. Richards [capt.]; F. Guthrie, M. Versfeld; B. Bisset, E. Little, B. Shand, C. van Renen, J. McKendrick, B. Heatlie, C. Chignell, J. Louw

The Lions: **W. Mitchell; P. Clauss, R. Aston, W. MacLagan [capt.], W. Wotherspoon; A. Rotherham, W. Bromet; E. Bromet, J. Hammond, P.F. Hancock, R. MacMillan, E. Mayfield, A. Surtees, R. Thompson, T. Whittaker.** Scorers: Tries: W. MacLagan, R. Aston; **Con:** A. Rotherham

Referee: Herbert Castens (South Africa)

1896
TEST NO. 4

30 July, Port Elizabeth
South Africa 0 The Lions 8
HT: 0–3 Att: 7,500

South Africa: D. Lyons; P. Jones, B. Anderson, F. Aston, E. Olver; F. Myburgh [capt.], F. Guthrie; C. van Renen, S. Wessels, B. Heatlie, P. Scott, C. Gorton, P. Meyer, M. Bredenkamp, F. Douglass

The Lions: **C. Boyd; L. Bulger, O. Mackie, F. Byrne, R. Johnston; M. Mullineux, L. Magee; T. Crean [capt.], A. Clinch, J. Sealy, W. Carey, P.F. Hancock, W. Mortimer, A. Todd, C. Mullins.** Scorers: Tries: L. Bulger, W. Carey; **Con:** F. Byrne

Referee: Henry Kemsley (South Africa)

TEST NO. 5

22 August, Johannesburg
South Africa 8 The Lions 17
HT: 0–5 Att: 5,000

South Africa: D. Cope; F. Aston [capt.], S. Forbes, B. Taberer, T. Samuels; G. Devenish, A. Larard; P. Scott, S. Wessels, B. Andrew, T. Mellett, A. Beswick, C. Devenish, J. Crosby, T. Smith. Scorers: **Tries:** T. Samuels 2; **Con:** D. Cope

The Lions: **J. Magee; L. Bulger, F. Byrne, O. Mackie, R. Johnston; S. Bell, L. Magee; J. Hammond [capt.], T. Crean, A. Clinch, J. Sealy, W. Carey, P.F. Hancock, W. Mortimer, A. Todd.** Scorers: **Tries:** A. Todd, T. Crean, P.F. Hancock; **Cons:** F. Byrne 2; **DG:** O. Mackie

Referee: Gordon Beves (South Africa)

TEST NO. 6

29 August, Kimberley
South Africa 3 The Lions 9
HT: 3–0 Att: 2,000

South Africa: T. Samuels; F. Aston [capt.], B. Anderson, B. Powell, P. Jones; J. Powell, B. Cotty; P. Scott, S. Wessels, P. Dormehl, T. Kelly, A. Beswick, D. Theunissen, M. Bredenkamp, T. Smith. Scorer: **Try:** P. Jones

The Lions: **A. Meares; L. Bulger, F. Byrne, O. Mackie, R. Johnston; S. Bell, L. Magee; T. Crean [capt.], A. Clinch, J. Sealy, W. Carey, P.F. Hancock, W. Mortimer, A. Todd, C. Mullins.** Scorers: **Try:** O. Mackie; **Con:** F. Byrne; **DG:** F. Byrne

Referee: William Bisset (South Africa)

TEST NO. 7

5 September, Cape Town
South Africa 5 The Lions 0
HT: 5–0 Att: 2,500

South Africa: T. Samuels; T. Hepburn, F. Aston, B. Anderson, P. Jones; T. Etlinger, A. Larard; P. Scott, B. Heatlie [capt.], P. Dormehl, C. van Renen, A. Beswick, B. van Broekhuizen, P. de Waal, P. Cloete. Scorers: **Try:** A. Larard; **Con:** T. Hepburn

The Lions: **A. Meares; L. Bulger, O. Mackie, F. Byrne, J. Magee; S. Bell, L. Magee; T. Crean, A. Clinch, J. Sealy, W. Carey, P.F. Hancock, W. Mortimer, A. Todd, J. Hammond [capt.]**

Referee: Alf Richards (South Africa)

1903
TEST NO. 12

26 August, Johannesburg
South Africa 10 The Lions 10
HT: 10–5 Att: 5,000

South Africa: H. Morkel; J. Barry, W. van Renen, J. Krige, A. Morkel; F. Dobbin, J. Powell; A. Frew [capt.], W. McEwan, J. Sinclair, K. Raaff, C. Brown, J. Partridge, P. Nel, B. Heatlie. Scorers: **Tries:** J. Sinclair, F. Dobbin; **Cons:** B. Heatlie 2

The Lions: **E. Harrison; G. Collett, R. Skrimshire, L. Greig, I. Davidson; J. Gillespie, P. Hancock; M. Morrison [capt.], W. Scott, F. Stout, A. Tedford, T. Gibson, W. Cave, J. Wallace, R. Smyth.** Scorers: **Tries:** W. Cave, R. Skrimshire; **Cons:** J. Gillespie 2

Referee: William Donaldson (Scotland)

TEST NO. 13

5 September, Kimberley
South Africa 0 The Lions 0
HT: 0–0 Att: 5,000

South Africa: H. Morkel; J. Barry, S. Ashley, S. de Melker, B. Gibbs; F. Dobbin, J. Powell [capt.]; C. Brown, J. Jackson, H. Metcalf, P. Nel, K. Raaff, G. Crampton, C. Currie, R. Martheze

The Lions: **R. Neill; G. Collett, R. Skrimshire, L. Greig, E. Walker; J. Gillespie, P. Hancock; M. Morrison [capt.], W. Scott, F. Stout, A. Tedford, T. Gibson, W. Cave, J. Wallace, R. Smyth**

Referee: Percy Day (South Africa)

TEST NO. 14

12 September, Cape Town
South Africa 8 The Lions 0
HT: 0–0 Att: 6,000

South Africa: W. van Renen; J. Barry, P. Carolin, J. Krige, B. Loubser; H. Ferris, T. Hobson; J. Anderson, A. Reid, P. Roos, C. Brown, J. Botha, W. McEwan, P. Nel, B. Heatlie [capt.]. Scorers: **Try:** J. Barry; **Con:** B. Heatlie

The Lions: **R. Neill; E. Walker, L. Greig, R. Skrimshire, G. Collett; J. Gillespie, P. Hancock; W. Cave, J. Wallace, R. Smyth, A. Tedford, F. Stout, W. Scott, T. Gibson, M. Morrison [capt.]**

Referee: John 'Biddy' Anderson (South Africa)

1910
TEST NO. 22

6 August, Kimberley
South Africa 14 The Lions 10
HT: 3–3 **Att:** 14,000

South Africa: A. Marsberg; C. Hahn, J. Hirsch, D. de Villiers, B. Loubser; F. Dobbin, F. Luyt; D. Morkel [capt.], K. Raaff, N. Howe-Brown, H. Walker, N. Crosby, C. Riordan, A. Williams, M. Davison. Scorers: **Tries:** F. Luyt, D. Morkel, C. Hahn, D. de Villiers; **Con:** D. Morkel

The Lions: S. Williams; M. Neale, J. Jones [capt.], K. Wood, A. Foster; J. Spoors, G. Isherwood; R. Stevenson, J. Webb, H. Jarman, T. Richards, O. Piper, F. Handford, D. Smith, P. Waller. Scorers: **Tries:** A. Foster, J. Spoors; **DG:** J. Jones

Referee: Reg Stanton (South Africa)

TEST NO. 23

27 August, Port Elizabeth
South Africa 3 The Lions 8
HT: 3–0 **Att:** 7,000

South Africa: P. Allport; C. Hahn, D. de Villiers, D. Luyt, W. Mills; F. Luyt, C. van Ryneveld; W. Millar [capt.], N. Howe-Brown, G. Roos, T. Moll, C. Riordan, H. Walker, A. Lombard, W. Burger. Scorer: **Try:** W. Mills

The Lions: S. Williams; A. Foster, J. Jones, J. Spoors, M. Neale; C. Pillman, G. Isherwood; T. Smyth [capt.], D. Smith, F. Handford, R. Stevenson, P. Waller, T. Richards, H. Jarman, J. Webb. Scorers: **Tries:** M. Neale, J. Spoors; **Con:** C. Pillman

Referee: Reg Stanton (South Africa)

TEST NO. 24

3 September, Cape Town
South Africa 21 The Lions 5
HT: 5–0 **Att:** 3,000

South Africa: P. Allport; C. Hahn, D. de Villiers, D. Luyt, B. Loubser; F. Luyt, C. van Ryneveld; W. Millar [capt.], D. Morkel, B. Morkel, H. Walker, G. Roos, N. Howe-Brown, K. Reynecke, N. Crosby. Scorers: **Tries:** F. Luyt, P. Allport, G. Roos, K. Reynecke; **Cons:** D. Morkel 3; **Pen:** D. Morkel

The Lions: S. Williams; M. Baker, J. Jones, K. Wood, M. Neale; J. Spoors, G. Isherwood; T. Smyth [capt.], F. Handford, H. Jarman, C. Pillman, D. Smith, R. Stevenson, P. Waller, J. Webb. Scorers: **Try:** J. Spoors; **Con:** C. Pillman

Referee: Reg Stanton (South Africa)

1924
TEST NO. 25

16 August, Durban
South Africa 7 The Lions 3
HT: 7–0 **Att:** 7,000

South Africa: J. Tindall; K. Starke, P. Albertyn [capt.], W. Clarkson, H. Aucamp; B. Osler, W. Myburgh; P. Mostert, T. Kruger, F. Mellish, B. Payn, N. du Plessis, A. Walker, M. Ellis, J. van Druten. Scorers: **Try:** H. Aucamp; **DG:** B. Osler

The Lions: D. Drysdale; I. Smith, R. Maxwell, R. Kinnear, W. Wallace; H. Waddell, H. Whitley; R. Cove-Smith [capt.], A. Blakiston, N. MacPherson, D. Davies, R. Howie, J. McVicker, D. Marsden-Jones, N. Brand. Scorer: **Try:** H. Whitley

Referee: Lionel Oakley (South Africa)

TEST NO. 26

23 August, Johannesburg
South Africa 17 The Lions 0
HT: 3–0 **Att:** 15,000

South Africa: N. Bosman; K. Starke, P. Albertyn [capt.], J. Bester, H. Aucamp; B. Osler, P. Truter; P. Mostert, T. Kruger, F. Mellish, B. Payn, N. du Plessis, A. Walker, M. Ellis, J. van Druten. Scorers: **Tries:** P. Mostert, K. Starke, P. Albertyn, J. van Druten; **Con:** B. Osler; **Pen:** B. Osler

The Lions: D. Drysdale; R. Harding, H. Davies, R. Kinnear, I. Smith; H. Waddell, A. Young; R. Cove-Smith [capt.], A. Blakiston, N. MacPherson, D. Davies, R. Howie, N. Brand, K. Hendrie, D. Marsden-Jones

Referee: Boet Neser (South Africa)

TEST NO. 27

13 September, Port Elizabeth
South Africa 3 The Lions 3
HT: 3–3 **Att:** 12,000

South Africa: N. Bosman; K. Starke, P. Albertyn [capt.], S. de Kock, J. Slater; B. Osler, D. Devine; B. Vanderplank, T. Kruger, F. Mellish, N. du Plessis, P. La Grange, A. Walker, M. Ellis, J. van Druten. Scorer: **Try:** J. van Druten

The Lions: D. Drysdale; S. Harris, R. Kinnear, V. Griffiths, R. Harding; W. Cunningham, H. Whitley; R. Cove-Smith [capt.], R. Howie, N. MacPherson, D. Davies, J. McVicker, T. Voyce, A. Blakiston, R. Henderson. Scorer: **Try:** W. Cunningham

Referee: Billy Millar (South Africa)

TEST NO. 28

20 September, Cape Town
South Africa 16 The Lions 9
HT: 7–3 **Att:** 18,000

South Africa: N. Bosman; K. Starke, J. Bester, P. Albertyn [capt.], J. Slater; B. Osler,
P. Truter; T. Kruger, M. Ellis, F. Mellish, P. Mostert, P. La Grange, A. Walker, J. van Druten,
B. Vanderplank. Scorers: **Tries:** K. Starke 2, J. Bester, J. Slater; **DG:** K. Starke

The Lions: D. Drysdale; S. Harris, R. Kinnear, V. Griffiths, R. Harding; H. Waddell,
H. Whitley; R. Cove-Smith [capt.], R. Howie, N. MacPherson, D. Davies, J. McVicker,
A. Blakiston, T. Voyce, R. Henderson. Scorers: **Tries:** S. Harris, T. Voyce; **Pen:** T. Voyce

Referee: Billy Millar (South Africa)

1938
TEST NO. 34

6 August, Johannesburg
South Africa 26 The Lions 12
HT: 13–9 **Att:** 36,000

South Africa: G. Brand; D. Williams, P. de Wet, G. Lochner, F. Turner; T. Harris, D. Craven
[capt.]; F. Louw, J. Lotz, B. Louw, R. Sherriff, B. du Toit, L. Strachan, E. Bastard, F. Bergh.
Scorers: **Tries:** D. Williams 2, T. Harris, F. Louw; **Cons:** G. Brand 4; **Pens:** G. Brand 2

The Lions: V. Jenkins; J. Unwin, D. MacRae, H. McKibbin, E. Jones; J. Reynolds,
J. Giles; E. Morgan, C.R.A. Graves, G. Dancer, S. Walker [capt.], R.B. Mayne, R. Taylor,
W.G. Howard, R. Alexander. Scorers: **Pens:** V. Jenkins 3, R. Taylor

Referee: Adriaan 'At' Horak (South Africa)

TEST NO. 35

3 September, Port Elizabeth
South Africa 19 The Lions 3
HT: 10–0 **Att:** 20,000

South Africa: F. Turner; D. Williams, P. de Wet, G. Lochner, J. Bester; T. Harris, D. Craven [capt.];
F. Louw, J. Lotz, B. Louw, R. Sherriff, B. du Toit, L. Strachan, J. Apsey, F. Bergh. Scorers: **Tries:**
G. Lochner, B. du Toit, J. Bester; **Cons:** F. Turner 2; **Pens:** F. Turner 2

The Lions: C. Grieve; J. Unwin, B. Nicholson, H. McKibbin, V. Boyle; J. Reynolds,
H. Tanner; E. Morgan, B. Travers, G. Dancer, S. Walker [capt.], R.B. Mayne, R. Taylor,
L. Duff, R. Alexander. Scorer: **Try:** L. Duff

Referee: Dr Johnny Strasheim (South Africa)

TEST NO. 36

10 September, Cape Town
South Africa 16 The Lions 21
HT: 13–3 **Att:** 18,000

South Africa: G. Smith; D. Williams, P. de Wet, F. Turner, J. Bester; T. Harris, D. Craven [capt.]; F. Louw, J. Lotz, B. Louw, R. Sherriff, B. du Toit, F. Bergh, L. Strachan, E. Bastard. Scorers: **Tries:** F. Turner, J. Lotz, J. Bester; **Cons:** F. Turner 2; **Pen:** F. Turner

The Lions: C. Grieve; E. Jones, J. Giles, H. McKibbin, V. Boyle; G. Cromey, G. Morgan; C.R.A. Graves, B. Travers, G. Dancer, S. Walker [capt.], R.B. Mayne, L. Duff, J. Waters, R. Alexander. Scorers: **Tries:** L. Duff, E. Jones, R. Alexander, G. Dancer; **Con:** H. McKibbin; **Pen:** H. McKibbin; **DG:** C. Grieve

Referee: Nic Pretorius (South Africa)

1955
TEST NO. 43

6 August, Johannesburg
South Africa 22 The Lions 23
HT: 11–8 **Att:** 90,000

South Africa: J. van der Schyff; T. Briers, D. Sinclair, T. van Vollenhoven, S. Swart; C. Ulyate, T. Gentles; C. Koch, C. Kroon, A. du Plooy, S. du Rand, J. Claassen, S. Fry [capt.], B. van Wyk, D. Retief. Scorers: **Tries:** T. Briers 2, S. Swart; **Cons:** J. van der Schyff 2; **Pens:** J. van der Schyff 2

The Lions: A. Cameron; T. O'Reilly, J. Butterfield, W.P.C. Davies, C. Pedlow; C. Morgan, R. Jeeps; W.O. Williams, B. Meredith, C. Meredith, R. Williams, R. Thompson [capt.], R. Higgins, J. Greenwood, R. Robins. Scorers: **Tries:** T. O'Reilly, C. Pedlow, J. Greenwood, J. Butterfield, C. Morgan; **Cons:** A. Cameron 4

Referee: Ralph Burmeister (South Africa)

TEST NO. 44

20 August, Cape Town
South Africa 25 The Lions 9
HT: 3–3 **Att:** 52,000

South Africa: R. Dryburgh; T. Briers, D. Sinclair, W. Rosenberg, T. van Vollenhoven; C. Ulyate, T. Gentles; C. Koch, B. van der Merwe, J. Bekker, S. du Rand, J. Claassen, S. Fry [capt.], D. Ackermann, D. Retief. Scorers: **Tries:** T. van Vollenhoven 3, T. Briers, R. Dryburgh, W. Rosenberg, D. Ackermann; **Cons:** R. Dryburgh 2

The Lions: A. Cameron; T. O'Reilly, J. Butterfield, W.P.C. Davies, G. Griffiths; C. Morgan, R. Jeeps; W.O. Williams, B. Meredith, C. Meredith, R. Williams, R. Thompson [capt.], R. Robins, J. Greenwood, T. Reid. Scorers: **Tries:** B. Meredith, J. Butterfield; **Pen:** A. Cameron

Referee: Mike Slabber (South Africa)

TEST NO. 45

3 September, Pretoria
South Africa 6 The Lions 9
HT: 0–3 Att: 45,000

South Africa: R. Dryburgh; T. Briers, D. Sinclair, W. Rosenberg, T. van Vollenhoven; C. Ulyate, P. Strydom; C. Koch, B. van der Merwe, J. Bekker, S. du Rand, J. Claassen, S. Fry [capt.], D. Ackermann, B. Lochner. Scorer: **Pens:** R. Dryburgh 2

The Lions: D. Baker; G. Griffiths, J. Butterfield, W.P.C. Davies, T. O'Reilly; C. Morgan [capt.], R. Jeeps; W.O. Williams, B. Meredith, C. Meredith, R. Williams, T. Reid, R.C.C. Thomas, J. Greenwood, R. Robins. Scorers: **Try:** J. Butterfield; **Pen:** D. Baker; **DG:** J. Butterfield

Referee: Ralph Burmeister (South Africa)

TEST NO. 46

24 September, Port Elizabeth
South Africa 22 The Lions 8
HT: 3–5 Att: 37,000

South Africa: R. Dryburgh; T. Briers, D. Sinclair, W. Rosenberg, T. van Vollenhoven; C. Ulyate, T. Gentles; J. Bekker, B. van der Merwe, H. Koch, S. du Rand, J. Claassen, S. Fry [capt.], D. Ackermann, D. Retief. Scorers: **Tries:** T. Briers 2, T. van Vollenhoven, C. Ulyate, D. Retief; **Cons:** R. Dryburgh 2; **DG:** C. Ulyate

The Lions: D. Baker; G. Griffiths, J. Butterfield, T. O'Reilly, C. Pedlow; C. Morgan, R. Jeeps; W.O. Williams, B. Meredith, C. Meredith, R. Williams, R. Thompson [capt.], R.C.C. Thomas, J. Greenwood, R. Robins. Scorers: **Tries:** T. O'Reilly, J. Greenwood; **Con:** C. Pedlow

Referee: Chris Ackermann (South Africa)

1962
TEST NO. 53

23 June, Johannesburg
South Africa 3 The Lions 3
HT: 3–0 Att: 73,000

South Africa: L. Wilson; M. Roux, M. Wyness, J. Gainsford, O. Taylor; K. Oxlee, P. Uys; F. Kuhn, A. Malan, M. Myburgh, J. Claassen [capt.], A. Malan, H. van Zyl, F. du Preez, D. Hopwood. Scorer: **Try:** J. Gainsford

The Lions: J. Willcox; A. Smith [capt.], D.K. Jones, M. Weston, N. Brophy; G. Waddell, R. Jeeps; S. Millar, B. Meredith, K. Jones, W. Mulcahy, K. Rowlands, B. Rogers, A. Pask, M. Campbell-Lamerton. Scorer: **Try:** D.K. Jones

Referee: Dr Bertie Strasheim (South Africa)

TEST NO. 54

21 July, Durban
South Africa 3 The Lions 0
HT: 0–0 Att: 40,000

South Africa: L. Wilson; J. Engelbrecht, M. Wyness, J. Gainsford, M. Roux; K. Oxlee,
D. de Villiers; F. Kuhn, A. Malan, C. Bezuidenhout, J. Claassen [capt.], F. du Preez,
L. Schmidt, H. Botha, D. Hopwood. **Scorer: Pen:** K. Oxlee

The Lions: J. Willcox; A. Smith [capt.], D.K. Jones, M. Weston, D. Bebb; G. Waddell,
R. Jeeps; S. Millar, B. Meredith, K. Jones, W. Mulcahy, K. Rowlands, A. Pask, H. Morgan,
M. Campbell-Lamerton

Referee: Ken Carlson (South Africa)

TEST NO. 55

4 August, Cape Town
South Africa 8 The Lions 3
HT: 3–3 Att: 54,843

South Africa: L. Wilson; J. Engelbrecht, M. Wyness, J. Gainsford, M. Roux; K. Oxlee,
D. de Villiers; F. Kuhn, A. Malan, C. Bezuidenhout, J. Claassen [capt.], F. du Preez,
H. van Zyl, H. Botha, D. Hopwood. **Scorer: Try:** K. Oxlee; **Con:** K. Oxlee; **Pen:** K. Oxlee

The Lions: T. Kiernan; A. Smith [capt.], D.K. Jones, M. Weston, D. Bebb; R. Sharp,
R. Jeeps; S. Millar, B. Meredith, K. Jones, W. Mulcahy, W. McBride, A. Pask, H. Morgan,
M. Campbell-Lamerton. **Scorer: DG:** R. Sharp

Referee: Dr Bertie Strasheim (South Africa)

TEST NO. 56

25 August, Bloemfontein
South Africa 34 The Lions 14
HT: 10–6 Att: 60,000

South Africa: L. Wilson; J. Engelbrecht, M. Wyness, J. Gainsford, M. Roux; K. Oxlee,
P. Uys; F. Kuhn, R. Hill, C. Bezuidenhout, J. Claassen [capt.], F. du Preez, H. van Zyl,
H. Botha, D. Hopwood. **Scorers: Tries:** M. Roux 2, J. Gainsford, H. van Zyl, M. Wyness,
J. Claassen; **Cons:** K. Oxlee 5; **Pens:** K. Oxlee 2

The Lions: J. Willcox; R. Cowan, D. Hewitt, M. Weston, N. Brophy; R. Sharp, R. Jeeps
[capt.]; S. Millar, B. Meredith, K. Jones, K. Rowlands, W. McBride, W. Mulcahy, B. Rogers,
M. Campbell-Lamerton. **Scorers: Tries:** R. Cowan, M. Campbell-Lamerton, K. Rowlands;
Con: J. Willcox; **Pen:** J. Willcox

Referee: Pieter 'Toy' Myburgh (South Africa)

1968
TEST NO. 63

8 June, Pretoria
South Africa 25 The Lions 20
HT: 16–11 Att: 75,000

South Africa: R. Gould; J. Engelbrecht, S. Nomis, E. Olivier, C. Dirksen; P. Visagie,
D. de Villiers [capt.]; M. Myburgh, G. Pitzer, H. Marais, F. du Preez, T. Naude, P. Greyling,
J. Ellis, T. Bedford. **Scorers: Tries:** F. du Preez, D. de Villiers, T. Naude; **Cons:** P. Visagie 2;
Pens: P. Visagie 2, T. Naude 2

The Lions: T. Kiernan [capt.]; K. Savage, B. Bresnihan, J. Turner, M. Richards; B. John
(M. Gibson), G. Edwards; S. Millar, J. Young, J. O'Shea, P. Stagg, W. McBride, R. Arneil,
M. Doyle, R. Taylor. **Scorers: Try:** W. McBride; **Con:** T. Kiernan; **Pens:** T. Kiernan 5

Referee: Max Baise (South Africa)

TEST NO. 64

22 June, Port Elizabeth
South Africa 6 The Lions 6
HT: 3–3 Att: 58,000

South Africa: R. Gould; J. Engelbrecht, S. Nomis, E. Olivier, C. Dirksen; P. Visagie,
D. de Villiers [capt.]; M. Myburgh, G. Pitzer, H. Marais, F. du Preez, T. Naude, T. Lourens,
J. Ellis, T. Bedford. **Scorers: Pens:** P. Visagie, T. Naude

The Lions: T. Kiernan [capt.]; K. Savage, B. Bresnihan, J. Turner, S. Hinshelwood;
M. Gibson, G. Edwards; S. Millar, J. Pullin, T. Horton, P. Larter, W. McBride, R. Arneil,
R. Taylor, J. Telfer. **Scorer: Pens:** T. Kiernan 2

Referee: Hansie Schoeman (South Africa)

TEST NO. 65

13 July, Cape Town
South Africa 11 The Lions 6
HT: 3–3 Att: 46,100

South Africa: R. Gould; S. Nomis, E. Olivier, M. Roux, G. Brynard; P. Visagie, D. de Villiers
[capt.]; M. Myburgh, G. Pitzer, H. Marais, F. du Preez, T. Naude, T. Lourens, J. Ellis,
T. Bedford. **Scorers: Try:** T. Lourens; **Con:** P. Visagie; **Pens:** P. Visagie, T. Naude

The Lions: T. Kiernan [capt.]; K. Savage, J. Turner, T.G.R. Davies, M. Richards;
M. Gibson, R. Young; M. Coulman (W.D. Thomas), J. Pullin, T. Horton, P. Stagg,
W. McBride, R. Arneil, R. Taylor, J. Telfer. **Scorer: Pens:** T. Kiernan 2

Referee: Max Baise (South Africa)

TEST NO. 66

27 July, Johannesburg
South Africa 19 The Lions 6
HT: 6–3 Att: 62,000

South Africa: R. Gould; S. Nomis, E. Olivier, M. Roux, G. Brynard; P. Visagie, D. de Villiers [capt.]; T. Neethling, G. Pitzer, H. Marais, F. du Preez, T. Naude, T. Lourens, J. Ellis, T. Bedford. **Scorers: Tries:** M. Roux, S. Nomis, J. Ellis, E. Olivier; **Cons:** P. Visagie 2; **DG:** R. Gould

The Lions: T. Kiernan [capt.]; K. Savage, B. Bresnihan, J. Turner, M. Richards; M. Gibson, G. Connell; D. Thomas, J. Pullin, T. Horton, P. Stagg, W. McBride, R. Arneil, R. Taylor, J. Telfer. **Scorer: Pens:** T. Kiernan 2

Referee: Dr Bertie Strasheim (South Africa)

1974
TEST NO. 71

8 June, Cape Town
South Africa 3 The Lions 12
HT: 3–3 Att: 45,000

South Africa: I. McCallum; C. Pope, P. Whipp, J. Oosthuizen, G. Muller; D. Snyman, R. McCallum; T. Sauermann, P. van Wyk, W. Meyer [capt.], K. de Klerk, J. Williams, B. Coetzee, J. Ellis, M. du Plessis. **Scorer: Pen:** D. Snyman

The Lions: J.P.R. Williams; W. Steele, I. McGeechan, D. Milliken, J.J. Williams; P. Bennett, G. Edwards; I. McLauchlan, R. Windsor, F. Cotton, G. Brown, W. McBride [capt.], R. Uttley, F. Slattery, M. Davies. **Scorers: Pens:** P. Bennett 3; **DG:** G. Edwards

Referee: Max Baise (South Africa)

TEST NO. 72

22 June, Pretoria
South Africa 9 The Lions 28
HT: 3–10 Att: 63,500

South Africa: I. McCallum (D. Snyman, L. Vogel); C. Pope, P. Whipp, J. Snyman, G. Germishuys; G. Bosch, P. Bayvel; N. Bezuidenhout, D. Frederickson, H. Marais [capt.], K. de Klerk, J. Williams, M. du Plessis, J. Ellis, D. MacDonald. **Scorers: Pens:** G. Bosch 2; **DG:** G. Bosch

The Lions: J.P.R. Williams; W. Steele, I. McGeechan, R. Milliken, J.J. Williams; P. Bennett, G. Edwards; I. McLauchlan, R. Windsor, F. Cotton, G. Brown, W. McBride [capt.], R. Uttley, F. Slattery, M. Davies. **Scorers: Tries:** J.J. Williams 2, P. Bennett, G. Brown, R. Milliken; **Con:** P. Bennett; **Pen:** P. Bennett; **DG:** I. McGeechan

Referee: Cas de Bruyn (South Africa)

TEST NO. 73

13 July, Port Elizabeth
South Africa 9 The Lions 26
HT: 3–7 **Att:** 55,000

South Africa: A. Roux; C. Pope, P. Cronje, J. Schlebusch, G. Muller; J. Snyman, G. Sonnekus; N. Bezuidenhout, P. van Wyk, H. Marais [capt.], M. van Heerden (K. de Klerk), J. de Bruyn, P. Fourie, J. Ellis, J. Kritzinger. Scorer: **Pens:** J. Snyman 3

The Lions: **J.P.R. Williams;** A. Irvine, I. McGeechan, R. Milliken, J.J. Williams; P. Bennett, G. Edwards; I. McLauchlan, R. Windsor, F. Cotton, G. Brown, W. McBride [capt.], R. Uttley, F. Slattery, M. Davies. Scorers: **Tries:** J.J. Williams 2, G. Brown; **Con:** A. Irvine; **Pens:** A. Irvine 2; **DG:** P. Bennett 2

Referee: Cas de Bruyn (South Africa)

TEST NO. 74

27 July, Johannesburg
South Africa 13 The Lions 13
HT: 6–10 **Att:** 75,000

South Africa: A. Roux; C. Pope, P. Cronje, J. Schlebusch, G. Muller; J. Snyman, P. Bayvel; N. Bezuidenhout (R. Stander), P. van Wyk, H. Marais [capt.], J. Williams, M. van Heerden, J. Kritzinger, J. Ellis, K. Grobler. Scorers: **Try:** P. Cronje; **Pens:** J. Snyman 3

The Lions: **J.P.R. Williams;** A. Irvine, I. McGeechan, R. Milliken, J.J. Williams; P. Bennett, G. Edwards; I. McLauchlan, R. Windsor, F. Cotton, C. Ralston, W. McBride [capt.], R. Uttley, F. Slattery, M. Davies. Scorers: **Tries:** A. Irvine, R. Uttley; **Con:** P. Bennett; **Pen:** A. Irvine

Referee: Max Baise (South Africa)

1980
TEST NO. 79

31 May, Cape Town
South Africa 26 The Lions 22
HT: 16–9 **Att:** 50,000

South Africa: G. Pienaar; R. Mordt, D. Smith, W. du Plessis, G. Germishuys; N. Botha, D. Serfontein; R. Prentis, W. Kahts, M. le Roux, L. Moolman, M. van Heerden, R. Louw, T. Stofberg, M. du Plessis [capt.]. Scorers: **Tries:** W. du Plessis, G. Germishuys, D. Serfontein, R. Louw, M. van Heerden; **Cons:** N. Botha 3

The Lions: R. O'Donnell; J. Carleton (R. Gravell 58), J. Renwick, D. Richards, M. Slemen; T. Ward, C. Patterson; C. Williams, P. Wheeler, G. Price, W. Beaumont [capt.], M. Colclough, J. O'Driscoll, J. Squire, D. Quinnell. Scorers: **Try:** G. Price; **Pens:** T. Ward 5; **DG:** T. Ward

Referee: Francis Palmade (France)

TEST NO. 80

14 June, Bloemfontein
South Africa 26 The Lions 19
HT: 16–9 Att: 60,000

South Africa: G. Pienaar; R. Mordt, D. Smith, W. du Plessis, G. Germishuys; N. Botha, D. Serfontein; R. Prentis, W. Kahts, M. le Roux, K. de Klerk, L. Moolman, R. Louw (T. Burger 80), T. Stofberg, M. du Plessis [capt.]. Scorers: **Tries:** G. Pienaar, G. Germishuys, T. Stofberg, R. Louw; **Cons:** N. Botha 2; **Pens:** N. Botha 2

The Lions: **A. Irvine; J. Carleton, C. Woodward, R. Gravell, B. Hay; W.G. Davies (O. Campbell 64), C. Patterson; C. Williams, P. Wheeler, G. Price, W. Beaumont [capt.], M. Colclough, J. O'Driscoll, J. Squire, D. Quinnell.** Scorers: **Tries:** R. Gravell, J. O'Driscoll; **Con:** W.G. Davies; **Pens:** W.G. Davies 2, A. Irvine

Referee: Francis Palmade (France)

TEST NO. 81

28 June, Port Elizabeth
South Africa 12 The Lions 10
HT: 3–7 Att: 47,000

South Africa: G. Pienaar; R. Mordt, D. Smith, W. du Plessis, G. Germishuys; N. Botha, D. Serfontein; R. Prentis, W. Kahts (E. Malan), M. le Roux, L. Moolman, M. van Heerden, R. Louw, T. Stofberg, M. du Plessis [capt.]. Scorers: **Try:** G. Germishuys; **Con:** N. Botha; **Pen:** N. Botha; **DG:** N. Botha

The Lions: **A. Irvine; C. Woodward, P. Dodge, R. Gravell, B. Hay; O. Campbell, C. Patterson; C. Williams, P. Wheeler, G. Price, W. Beaumont [capt.], M. Colclough, J. O'Driscoll, C. Tucker, J. Squire.** Scorers: **Try:** B. Hay; **Pens:** O. Campbell 2

Referee: Jean-Pierre Bonnet (France)

TEST NO. 82

12 July, Pretoria
South Africa 13 The Lions 17
HT: 3–7 Att: 68,000

South Africa: G. Pienaar; R. Mordt, D. Smith, W. du Plessis, G. Germishuys; N. Botha, D. Serfontein; R. Prentis, E. Malan, M. le Roux, L. Moolman, M. van Heerden, R. Louw, T. Stofberg, M. du Plessis [capt.]. Scorers: **Try:** W. du Plessis; **Pens:** G. Pienaar 2, N. Botha

The Lions: **A. Irvine; J. Carleton, P. Dodge, R. Gravell, B. Hay; O. Campbell, J. Robbie; C. Williams, P. Wheeler, G. Price, W. Beaumont [capt.], M. Colclough, J. O'Driscoll, C. Tucker, J. Squire.** Scorers: **Tries:** A. Irvine, C. Williams, J. O'Driscoll; **Con:** O. Campbell; **Pen:** O. Campbell

Referee: Jean-Pierre Bonnet (France)

1997
TEST NO. 93

21 June, Cape Town
South Africa 16 The Lions 25
HT: 8–9 Att: 46,100

South Africa: A. Joubert; J. Small, J. Mulder, E. Lubbe (R. Bennett 40), A. Snyman; H. Honiball, J. van der Westhuizen; O. du Randt, N. Drotske, A. Garvey, H. Strydom, M. Andrews, R. Kruger, A. Venter, G. Teichmann [capt.]. Scorers: Tries: O. du Randt, R. Bennett; Pens: H. Honiball, E. Lubbe

The Lions: N. Jenkins; I. Evans, S. Gibbs, J. Guscott, A. Tait; G. Townsend, M. Dawson; T. Smith (J. Leonard 79), K. Wood, P. Wallace, M. Johnson [capt.], J. Davidson, L. Dallaglio, R. Hill, T. Rodber. Scorers: Tries: M. Dawson, A. Tait; Pens: N. Jenkins 5

Referee: Colin Hawke (New Zealand)

TEST NO. 94

28 June, Durban
South Africa 15 The Lions 18
HT: 5–6 Att: 52,400

South Africa: A. Joubert; A. Snyman, P. Montgomery, D. van Schalkwyk, P. Rossouw; H. Honiball, J. van der Westhuizen; O. du Randt, N. Drotske, A. Garvey (D. Theron 67), H. Strydom, M. Andrews, R. Kruger (F. van Heerden 50), A. Venter, G. Teichmann [capt.]. Scorers: Tries: P. Montgomery, A. Joubert, J. van der Westhuizen

The Lions: N. Jenkins; J. Bentley, S. Gibbs, J. Guscott, A. Tait (A. Healey 76); G. Townsend, M. Dawson; T. Smith, K. Wood, P. Wallace, M. Johnson [capt.], J. Davidson, L. Dallaglio, R. Hill (N. Back 57), T. Rodber (E. Miller 76). Scorers: Pens: N. Jenkins 5; DG: J. Guscott

Referee: Didier Mene (France)

◄ Ireland's Keith Wood put in an all-action performance during the first Test of the 1997 tour, helping the Lions to a 25–16 triumph that paved the way for one of the Lions' most memorable series victories

TEST NO. 95

5 July, Johannesburg
South Africa 35 The Lions 16
HT: 13–9 **Att:** 52,400

South Africa: R. Bennett; A. Snyman, P. Montgomery (H. Honiball 53), D. van Schalkwyk, P. Rossouw; J. de Beer (J. Swart 71), J. van der Westhuizen (W. Swanepoel 80); O. du Randt (A. Garvey 63), J. Dalton (N. Drotske 69), D. Theron, H. Strydom, K. Otto, A. Venter, R. Erasmus, G. Teichmann [capt.] (F. van Heerden 3–5, 73). **Scorers: Tries:** P. Montgomery, A. Snyman, J. van der Westhuizen, P. Rossouw; **Cons:** J. de Beer 2, H. Honiball; **Pens:** J. de Beer 3

The Lions: N. Jenkins; J. Bentley, J. Guscott (A. Bateman 40), S. Gibbs, T. Underwood (T. Stimpson 30); M. Catt, M. Dawson (A. Healey 80); T. Smith, M. Regan, P. Wallace, M. Johnson [capt.], J. Davidson, R. Wainwright, N. Back, L. Dallaglio. **Scorers: Try:** M. Dawson; **Con:** N. Jenkins; **Pens:** N. Jenkins 3

Referee: Wayne Erickson (Australia)

2009
TEST NO. 103

20 June, Durban
South Africa 26 The Lions 21
HT: 19–7 **Att:** 47,813

South Africa: F. Steyn; J. Pietersen, A. Jacobs, J. de Villiers (J. Fourie 57), B. Habana; R. Pienaar (M. Steyn 65), F. du Preez (R. Januarie 69); T. Mtawarira (G. Steenkamp 65), B. du Plessis, J. Smit [capt.] (D. Carstens 65-77), B. Botha (A. Bekker 57), V. Matfield, H. Brussow (D. Rossouw 52), J. Smith, P. Spies. **Scorers: Tries:** J. Smit, H. Brussow; **Cons:** R. Pienaar 2; **Pens:** R. Pienaar 3, F. Steyn

The Lions: L. Byrne (R. Kearney 38); T. Bowe, B. O'Driscoll, J. Roberts, U. Monye; S. Jones, M. Phillips; G. Jenkins, L. Mears (M. Rees 50), P. Vickery (A. Jones 45), A.W. Jones (D. O'Callaghan 69), P. O'Connell [capt.], T. Croft, D. Wallace (M. Williams 66), J. Heaslip. **Scorers: Tries:** T. Croft 2, M. Phillips; **Cons:** S. Jones 3

Referee: Bryce Lawrence (New Zealand)

TEST NO. 104

27 June, Pretoria
South Africa 28 The Lions 25
HT: 8–16 **Att:** 52,511

South Africa: F. Steyn; J. Pietersen, A. Jacobs, J. de Villiers (J. Fourie 55), B. Habana; R. Pienaar (M. Steyn 60), F. du Preez; T. Mtawarira, B. du Plessis, J. Smit [capt.], B. Botha (A. Bekker 58), V. Matfield, S. Burger, J. Smith (D. Rossouw 58, H. Brussow 61), P. Spies. Yellow Card: S. Burger 1. Scorers: Tries: J. Fourie, B. Habana, J. Pietersen; Cons: M. Steyn 2; Pens: M. Steyn 2, F. Steyn

The Lions: **R. Kearney; T. Bowe, B. O'Driscoll (S. Williams 62), J. Roberts (R. O'Gara 67), L. Fitzgerald; S. Jones, M. Phillips; G. Jenkins (A. Sheridan 22–30, 45), M. Rees, A. Jones (A.W. Jones 45), S. Shaw, P. O'Connell [capt.], T. Croft, D. Wallace (M. Williams 68), J. Heaslip.** Scorers: Try: R. Kearney; Con: S. Jones; Pens: S. Jones 5; DG: S. Jones

Referee: Christophe Berdos (France)

TEST NO. 105

4 July, Johannesburg
South Africa 9 The Lions 28
HT: 6–15 **Att:** 58,318

South Africa: Z. Kirchner (F. Steyn 57); O. Ndungane, J. Fourie (F. Steyn 24-28), W. Olivier, J. Nokwe (P. Spies 64); M. Steyn, F. du Preez (R. Pienaar 41); T. Mtawarira (G. Steenkamp 72), C. Ralepelle (B. du Plessis 41), J. Smit [capt., D. Carstens 72–74], J. Muller, V. Matfield, H. Brussow, J. Smith, R. Kankowski. Scorer: **Pens:** M. Steyn 3

The Lions: **R. Kearney; U. Monye, T. Bowe, R. Flutey (H. Ellis 55), S. Williams; S. Jones, M. Phillips; A. Sheridan, M. Rees (R. Ford 37), P. Vickery (J. Hayes 55), S. Shaw (A.W. Jones 67), P. O'Connell [capt.], J. Worsley (T. Croft 31–35, 66), M. Williams (D. Wallace 76), J. Heaslip.** Yellow Card: S. Shaw 37. Scorers: Tries: S. Williams 2, U. Monye; Cons: S. Jones 2; Pens: S. Jones 3

Referee: Stuart Dickinson (Australia)

BRITISH & IRISH LIONS TEST MATCHES IN AUSTRALIA

1899
TEST NO. 8

24 June, Sydney
Australia 13 The Lions 3
HT: 3–0 **Att:** 27,000

Australia: B. McCowan; C. White, F. Row [capt.], L. Spragg, P. Evans; A. Gralton, P. Ward; W. Tanner, J. Carson, W. Davis, H. Marks, P. Carew, C. Ellis, G. Colton, A. Kelly. **Scorers: Tries:** L. Spragg, P. Evans, G. Colton; **Cons:** L. Spragg 2

The Lions: E. Martelli; A. Bucher, E.G. Nicholls, C. Adamson, G. Doran; G. Cookson, M. Mullineux [capt.]; F. Stout, T. McGown, W. Jarman, J. Francomb, H. Gray, F. Belson, A. Ayre-Smith, G. Gibson. **Scorer: Try:** E.G. Nicholls

Referee: William Garrard (New Zealand)

TEST NO. 9

22 July, Brisbane
Australia 0 The Lions 11
HT: 0–3 **Att:** 15,000

Australia: B. McCowan [capt.]; L. Spragg, A. Henry, T. Ward, E. Currie; P. Evans, P. Ward; W. Tanner, C. Graham, C. Ellis, H. Marks, P. Carew, A. Corfe, R. Challoner, N. Street

The Lions: C. Thompson; G. Doran, E.G. Nicholls, A. Timms, H. Gray; G. Cookson, C. Adamson; W. Judkins, G. Gibson, A. Ayre-Smith, B. Swannell, G. Evers, F. Stout [capt.], T. McGown, W. Jarman. **Scorers: Tries:** E.G. Nicholls, C. Adamson, A. Ayre-Smith; **Con:** C. Adamson

Referee: Bill Beattie (Australia)

TEST NO. 10

5 August, Sydney
Australia 10 The Lions 11
HT: 0–5 **Att:** 16,000

Australia: W. Cobb; L. Spragg, F. Row [capt.], S. Miller, A. Boyd; I. O'Donnell, P. Ward; B. Webb, G. Bouffier, P. Carew, W. Davis, C. Ellis, R. Barton, G. Colton, S. Boland. **Scorer: Try:** L. Spragg 2; **Con:** L. Spragg 2

The Lions: C. Thompson; E. Nicholson, A. Timms, E.G. Nicholls, A. Bucher; G. Cookson, C. Adamson; F. Stout [capt.], T. McGown, W. Jarman, A. Ayre-Smith, W. Judkins, B. Swannell, G. Evers, G. Gibson. **Scorers: Tries:** A. Bucher 2, A. Timms; **Con:** C. Adamson

Referee: W. Stewart Corr (Australia)

TEST NO. 11

12 August, Sydney
Australia 0 The Lions 13
HT: 0–0 **Att:** 7,000

Australia: W. Cobb; L. Spragg, F. Row [capt.], B. McCowan, A. Gralton; I. O'Donnell,
P. Ward; W. Davis, B. Webb, J. O'Donnell, C. Ellis, P. Carew, B. Hardcastle, S. Boland,
J. Sampson

The Lions: C. Thompson; E. Nicholson, A. Timms, E.G. Nicholls, A. Bucher; G. Cookson,
C. Adamson; F. Stout [capt.], W. Jarman, T. McGown, G. Gibson, A. Ayre-Smith, B. Swannell,
W. Judkins, G. Evers. **Scorers: Tries:** A. Bucher, C. Adamson; **Cons:** C. Adamson 2;
Pen: C. Adamson

Referee: W. Stewart Corr (Australia)

1904
TEST NO. 15

2 July, Sydney
Australia 0 The Lions 17
HT: 0–0 **Att:** 34,000

Australia: J. Verge; C. White, J. Hindmarsh, S. Wickham, C. Redwood; L. Evans, S. Baker;
B. Burdon, E. Dore, F. Nicholson [capt.], B. Richards, D. Lutge, T. Colton, P. Walsh, H. Judd

The Lions: C. Stanger-Leathes; W. Llewellyn, A. O'Brien, R. Gabe, E. Morgan; P. Bush,
F. Hulme; D. Bedell-Sivright [capt.], D. Trail, D. Dobson, S. Bevan, S. Saunders, S. Crowther,
B. Swannell, A. Harding. **Scorers: Tries:** W. Llewellyn 2, P. Bush; **Cons:** A. Harding,
A. O'Brien; **DG:** P. Bush

Referee: Roland Kean (Australia)

TEST NO. 16

23 July, Brisbane
Australia 3 The Lions 17
HT: 3–0 **Att:** 16,000

Australia: J. Verge; S. Wickham [capt.], P. Carmichael, D. McLean, C. Redwood; J. Manning,
S. Baker; B. Burdon, A. Oxlade, V. Oxenham, A. McKinnon, D. Lutge, T. Colton, P. Walsh,
H. Judd. **Scorer: Try:** B. Burdon

The Lions: A. O'Brien; W. Llewellyn, R. Gabe, P. McEvedy, E. Morgan [capt.]; P. Bush,
T. Vile; R. Edwards, D. Trail, D. Dobson, S. Bevan, S. Saunders, S. Crowther, B. Swannell,
A. Harding. **Scorers: Tries:** P. Bush, W. Llewellyn, A. O'Brien; **DG:** P. Bush 2

Referee: Bill Beattie (Australia)

TEST NO. 17

30 July, Sydney
Australia 0 The Lions 16
HT: 0–3 Att: 24,000

Australia: C. Redwood; F. Nicholson, F. Futter, S. Wickham [capt.], D. McLean; L. Evans,
P. Finley; J. Meibusch, A. Oxlade, B. Richards, E. Dixon, D. Lutge, J. White, H. Judd, P. Walsh

The Lions: **A. O'Brien; W. Llewellyn, R. Gabe, P. McEvedy, E. Morgan [capt.]; P. Bush,
T. Vile; R. Edwards, D. Trail, D. Dobson, S. Bevan, B. Massey, S. Crowther, B. Swannell,
A. Harding.** Scorers: **Tries:** W. Llewellyn, R. Gabe, E. Morgan, B. Swannell; **Cons:** P. Bush,
A. O'Brien

Referee: Tom Pauling (Australia)

1930
TEST NO. 33

30 August, Sydney
Australia 6 The Lions 5
HT: 3–0 Att: 30,712

Australia: A. Ross; O. Crossman, S. King, C. Towers, G. McGhie; T. Lawton [capt.],
S. Malcolm; B. Cerutti, E. Bonis, E. Thompson, H. Finlay, G. Storey, L. Palfreyman, J. Ford,
W. Breckenridge. Scorers: **Tries:** G. McGhie, S. Malcolm

The Lions: **J. Bassett; J. Reeve, H. Bowcott, C. Aarvold, T. Novis; R. Spong, P. Murray;
H. O'Neill, S. Martindale, J. Farrell, D. Parker, D. Prentice [capt.], B. Black, I. Jones,
G. Beamish.** Scorers: **Try:** T. Novis; **Con:** D. Prentice

Referee: Roy Cooney (Australia)

1950
TEST NO. 41

19 August, Brisbane
Australia 6 The Lions 19
HT: 3–11 Att: 20,000

Australia: W. Gardiner; P. Thompson, A. Walker, J. Blomley, N. Hills; J. Solomon, C. Burke;
K. Gordon, N. Cottrell [capt.], F. McCarthy, R. Mossop, N. Shehadie, D. MacMillan,
D. Brockhoff, K. Cross. Scorers: **Pens:** W. Gardiner 2

The Lions: **B.L. Jones; D. Smith, J. Matthews, B. Williams [capt.], M. Thomas; J. Kyle,
R. Willis; T. Clifford, D. Davies, J. Robins, J. Nelson, R. Stephens, W. McKay, R. Evans,
R. John.** Scorers: **Tries:** B.L. Jones, B. Williams; **Cons:** B.L. Jones 2; **Pens:** B.L. Jones 2;
DG: B.L. Jones

Referee: Lewis Tomalin (Australia)

TEST NO. 42

26 August, Sydney
Australia 3 The Lions 24
HT: 0–16 Att: 20,510

Australia: P. Costello; A. Tonkin, A. Walker, J. Blomley, N. Hills; J. Solomon, C. Burke; K. Gordon, N. Cottrell [capt.], N. Shehadie, R. Cornforth, R. Mossop, D. MacMillan, K. Cross, D. Brockhoff. Scorer: **Try:** C. Burke

The Lions: B.L. Jones; R. MacDonald, J. Matthews, B. Williams, M. Lane; J. Kyle, R. Willis; T. Clifford, K. Mullen [capt.], J. Robins, J. Nelson, R. Stephens, W. McKay, R. Evans, R. John. Scorers: **Tries:** J. Nelson 2, J. Kyle, R. John, R. MacDonald; **Cons:** J. Robins 2, B.L. Jones; **Pen:** B.L. Jones

Referee: Tom Moore (Australia)

1959
TEST NO. 47

6 June, Brisbane
Australia 6 The Lions 17
HT: 6–6 Att: 17,000

Australia: J. Lenehan; A. Morton, J. Potts, L. Diett, K. Donald; A. Summons, D. Connor; K. Ellis, P. Johnson, P. Dunn, A. Miller, J. Carroll, J. Thornett, R. Outterside, P. Fenwicke [capt.]. Scorer: **Pens:** K. Donald 2

The Lions: K. Scotland; P. Jackson, M. Price, D. Hewitt, T. O'Reilly; B. Risman, R. Jeeps; H. McLeod, R. Dawson [capt.], S. Millar, B. Mulcahy, R. Williams, A. Ashcroft, K. Smith, J. Faull. Scorers: **Tries:** T. O'Reilly, K. Smith; **Con:** B. Risman; **Pens:** D. Hewitt 2; **DG:** K. Scotland

Referee: Bryan O'Callaghan (Australia)

TEST NO. 48

13 June, Sydney
Australia 3 The Lions 24
HT: 3–5 Att: 15,521

Australia: J. Lenehan; A. Morton, R. Kay, L. Diett, K. Donald; A. Summons, D. Connor; K. Ellis, P. Johnson, P. Dunn, A. Miller, J. Carroll, P. Fenwicke [capt.], R. Outterside, J. Thornett. Scorer: **Pen:** K. Donald

The Lions: K. Scotland; P. Jackson, D. Hewitt, M. Price, T. O'Reilly; B. Risman, R. Jeeps; H. McLeod, R. Dawson [capt.], S. Millar, R. Evans, R. Williams, N. Murphy, K. Smith, D. Marques. Scorers: **Tries:** M. Price 2, T. O'Reilly, R. Dawson, B. Risman; **Cons:** D. Hewitt 2, K. Scotland; **Pen:** K. Scotland

Referee: Arthur Tierney (Australia)

1966
TEST NO. 57

28 May, Sydney
Australia 8 The Lions 11
HT: 8–0 **Att:** 42,303

Australia: P. Ryan; G. Ruebner, R. Trivett, B. Ellwood, A. Cardy; P. Hawthorne, K. Catchpole; J. Thornett [capt.], P. Johnson, A. Miller, R. Heming, P. Crittle, J. Guerassimoff, G. Davis, D. Shepherd. Scorers: **Try:** A. Miller; **Con:** G. Ruebner; **Pen:** G. Ruebner

The Lions: **D. Rutherford; S. Watkins, D.K. Jones, M. Weston, D. Bebb; D. Watkins, R. Young; D. Williams, K. Kennedy, R. McLoughlin, M. Campbell-Lamerton [capt.], B. Price, J. Telfer, N. Murphy, A. Pask.** Scorers: **Tries:** R. McLoughlin, K. Kennedy; **Con:** D. Rutherford; **Pen:** D. Rutherford

Referee: Kevin Crowe (Australia)

TEST NO. 58

4 June, Brisbane
Australia 0 The Lions 31
HT: 0–3 **Att:** 18,500

Australia: P. Ryan; G. Ruebner, J. Brass, R. Trivett, A. Cardy; P. Hawthorne, K. Catchpole; J. Thornett [capt.], P. Johnson, A. Miller, R. Heming, P. Crittle, J. Guerassimoff, G. Davis, D. Shepherd

The Lions: **S. Wilson; S. Watkins, D.K. Jones, M. Weston, D. Bebb; D. Watkins, R. Young; D. Williams, K. Kennedy, R. McLoughlin, M. Campbell-Lamerton [capt.], B. Price, J. Telfer, N. Murphy, A. Pask.** Scorers: **Tries:** D.K. Jones 2, D. Bebb, D. Watkins, N. Murphy; **Cons:** S. Wilson 5; **Pen:** S. Wilson; **DG:** D. Watkins

Referee: Dr Roger Vanderfield (Australia)

➤ Lions captain Mike Campbell–Lamerton bursts through a tackle during the 1966 Test against the Wallabies in Sydney. The 1966 tourists were dominant in Australia but struggled when the action shifted to New Zealand

1989

TEST NO. 87

1 July, Sydney
Australia 30 The Lions **12**
HT: 15–6 **Att:** 39,433

Australia: G. Martin; A. Niuqila, L. Walker, D. Maguire, D. Campese; M. Lynagh, N. Farr-Jones [capt.]; C. Lillicrap (M. Hartill 41), T. Lawton (M. McBain 41), D. Crowley, W. Campbell, S. Cutler, S. Tuynman, J. Miller, S. Gourley. **Scorers: Tries:** G. Martin, L. Walker, D. Maguire, S. Gourley; **Cons:** M. Lynagh 4; **Pen:** M. Lynagh; **DG:** M. Lynagh

The Lions: G. Hastings; I. Evans, M. Hall, B. Mullin, R. Underwood; C. Chalmers, R. Jones; D. Sole, B. Moore, D. Young, P. Ackford, R. Norster, D. White, F. Calder [capt.], D. Richards. **Scorers: Pens:** G. Hastings 2, C. Chalmers; **DG:** C. Chalmers

Referee: Keith Lawrence (New Zealand)

TEST NO. 88

8 July, Brisbane
Australia 12 The Lions **19**
HT: 12–6 **Att:** 20,525

Australia: G. Martin; I. Williams, L. Walker, D. Maguire, D. Campese; M. Lynagh, N. Farr-Jones [capt.]; M. Hartill, T. Lawton, D. Crowley, W. Campbell, S. Cutler, S. Tuynman, J. Miller, S. Gourley. **Scorers: Try:** G. Martin; **Con:** M. Lynagh; **Pens:** M. Lynagh 2

The Lions: G. Hastings; I. Evans, S. Hastings, J. Guscott, R. Underwood; R. Andrew, R. Jones; D. Sole, B. Moore, D. Young, P. Ackford, W. Dooley, M. Teague, F. Calder [capt.], D. Richards. **Scorers: Tries:** J. Guscott, G. Hastings; **Con:** R. Andrew; **Pens:** R. Andrew, G. Hastings; **DG:** R. Andrew

Referee: Rene Hourquet (France)

TEST NO. 89

15 July, Sydney
Australia 18 The Lions **19**
HT: 9–9 **Att:** 39,401

Australia: G. Martin; I. Williams, L. Walker, D. Maguire, D. Campese; M. Lynagh, N. Farr-Jones [capt.]; M. Hartill, T. Lawton, D. Crowley, W. Campbell, S. Cutler, S. Tuynman, J. Miller, S. Gourley. **Scorers: Try:** I. Williams; **Con:** M. Lynagh; **Pens:** M. Lynagh 4

The Lions: G. Hastings; I. Evans, S. Hastings, J. Guscott, R. Underwood; R. Andrew, R. Jones; D. Sole, B. Moore, D. Young, P. Ackford, W. Dooley, M. Teague, F. Calder [capt.], D. Richards. **Scorers: Try:** I. Evans; **Pens:** G. Hastings 5

Referee: Rene Hourquet (France)

2001
TEST NO. 96

30 June, Brisbane
Australia 13 The Lions 29
HT: 3–12 **Att:** 37,460

Australia: C. Latham (M. Burke 41); A. Walker, D. Herbert, N. Grey, J. Roff; S. Larkham (E. Flatley 52), G. Gregan; N. Stiles, J. Paul (M. Foley 52), G. Panoho (B. Darwin 60), D. Giffin, J. Eales [capt., M. Cockbain 64], O. Finegan (D. Lyons 73), G. Smith, T. Kefu. **Scorers: Tries:** N. Grey, A. Walker; **Pen:** A. Walker

The Lions: M. Perry (I. Balshaw 41); D. James, B. O'Driscoll, R. Henderson, J. Robinson; J. Wilkinson, R. Howley; T. Smith (J. Leonard 73), K. Wood (G. Bulloch 66-73), P. Vickery, M. Johnson [capt.], D. Grewcock, M. Corry, R. Hill, S. Quinnell (C. Charvis 62). **Yellow Cards:** M. Corry 62, P. Vickery 75. **Scorers: Tries:** D. James, B. O'Driscoll, S. Quinnell, J. Robinson; **Cons:** J. Wilkinson 3; **Pen:** J. Wilkinson

Referee: Andre Watson (South Africa)

TEST NO. 97

7 July, Melbourne
Australia 35 The Lions 14
HT: 6–11 **Att:** 56,605

Australia: M. Burke; A. Walker (C. Latham 46), D. Herbert, N. Grey, J. Roff; S. Larkham (Flatley 74), G. Gregan; N. Stiles, M. Foley (B. Cannon 78), R. Moore, D. Giffin (M. Cockbain 39-40, 68), J. Eales [capt.], O. Finegan, G. Smith, T. Kefu. **Scorers: Tries:** J. Roff 2, M. Burke; **Con:** M. Burke; **Pens:** M. Burke 6

The Lions: M. Perry (I. Balshaw 50); D. James, B. O'Driscoll, R. Henderson, J. Robinson; J. Wilkinson (N. Jenkins 71), R. Howley (M. Dawson 76); T. Smith, K. Wood, P. Vickery (J. Leonard 62), M. Johnson [capt.], D. Grewcock, R. Hill (M. Corry 34–36, 46), N. Back, S. Quinnell. **Scorers: Try:** N. Back; **Pens:** J. Wilkinson 3

Referee: Jonathan Kaplan (South Africa)

TEST NO. 98

14 July, Sydney
Australia 29 The Lions 23
HT: 16–13 **Att:** 84,188

Australia: M. Burke; A. Walker, D. Herbert, N. Grey (J. Holbeck 74), J. Roff; E. Flatley, G. Gregan; N. Stiles, M. Foley, R. Moore, J. Harrison, J. Eales [capt.], O. Finegan (M. Cockbain 70), G. Smith, T. Kefu. **Yellow Card:** D. Herbert 53. **Scorers: Tries:** D. Herbert 2; **Cons:** M. Burke 2; **Pens:** M. Burke 5

The Lions: M. Perry; D. James (I. Balshaw 70), B. O'Driscoll, R. Henderson, J. Robinson; J. Wilkinson, M. Dawson; T. Smith (D. Morris 70), K. Wood, P. Vickery, M. Johnson [capt.], D. Grewcock, M. Corry, N. Back, S. Quinnell (C. Charvis 41). **Scorers: Tries:** J. Robinson, J. Wilkinson; **Cons:** J. Wilkinson 2; **Pens:** J. Wilkinson 3

Referee: Paddy O'Brien (New Zealand)

2013
TEST NO. 106

22 June, Brisbane
Australia 21 The Lions 23
HT: 9–12 **Att:** 52,499

Australia: B. Barnes (K. Beale 38); I. Folau, A. Ashley-Cooper (N. Phipps 76), C. Leali'ifano (P. McCabe 1, L. Gill 46), D. Ioane; J. O'Connor, W. Genia; B. Robinson (J. Slipper 68), S. Moore, B. Alexander (S. Kepu 57), K. Douglas (R. Simmons 68), J. Horwill [capt.], B. Mowen, M. Hooper, W. Palu. **Scorers: Tries:** I. Folau 2; **Con:** J. O'Connor; **Pens:** K. Beale 2, J. O'Connor

The Lions: L. Halfpenny, A. Cuthbert, B. O'Driscoll, J. Davies, G. North; J. Sexton, M. Phillips (B. Youngs 62); A. Corbisiero (M. Vunipola 51), T. Youngs (R. Hibbard 64), A. Jones (D. Cole 51), A.W. Jones (G. Parling 70), P. O'Connell, T. Croft (D. Lydiate 72), S. Warburton [capt.], J. Heaslip. **Scorers: Tries:** G. North, A. Cuthbert; **Cons:** L. Halfpenny 2; **Pens:** L. Halfpenny 3

Referee: Chris Pollock (New Zealand)

TEST NO. 107

29 June, Melbourne
Australia 16 The Lions 15
HT: 9–12 **Att:** 56,771

Australia: K. Beale; I. Folau, A. Ashley-Cooper (R. Horne 77), C. Leali'ifano, J. Tomane; J. O'Connor, W. Genia; B. Robinson (J. Slipper 61, B. Robinson 78), S. Moore, B. Alexander (S. Kepu 59), K. Douglas (R. Simmons 54), J. Horwill [capt.], B. Mowen, M. Hooper, W. Palu (L. Gill 59). Scorers: **Try:** A. Ashley-Cooper; **Con:** C. Leali'ifano; **Pens:** C. Leali'ifano 3

The Lions: L. Halfpenny; T. Bowe, B. O'Driscoll, J. Davies, G. North; J. Sexton, B. Youngs (C. Murray 54); M. Vunipola, T. Youngs (R. Hibbard 56), A. Jones (D. Cole 59), A.W. Jones, G. Parling, D. Lydiate, S. Warburton (capt., T. Croft 65), J. Heaslip (S. O'Brien 64). Scorer: **Pens:** L. Halfpenny 5

Referee: Craig Joubert (South Africa)

TEST NO. 108

6 July, Sydney
Australia 16 The Lions 41
HT: 10–19 **Att:** 83,702

Australia: K. Beale; I. Folau (J. Mogg 26), A. Ashley-Cooper, C. Leali'ifano, J. Tomane; J. O'Connor, W. Genia (N. Phipps 70); B. Robinson (J. Slipper 67), S. Moore (S. Faingaa 57–62, 73), B. Alexander (S. Kepu 36), K. Douglas (R. Simmons 62), J. Horwill [capt.], B. Mowen, G. Smith (M. Hooper 5–10, S. Kepu 27–36, M. Hooper 66), W. Palu (B. McCalman 60). Yellow Card: B. Alexander 25. Scorers: **Try:** J. O'Connor; **Con:** C. Leali'ifano; **Pens:** C. Leali'ifano 3

The Lions: L. Halfpenny; T. Bowe, J. Roberts (M. Tuilagi 70), J. Davies, G. North; J. Sexton (O. Farrell 63), M. Phillips (C. Murray 50); A. Corbisiero (M. Vunipola 67), R. Hibbard (T. Youngs 48), A. Jones (D. Cole 55), A.W. Jones [capt.], G. Parling (R. Gray 67), D. Lydiate, S. O'Brien (J. Tipuric 60), T. Faletau (J. Tipuric 55–59). Scorers: **Tries:** A. Corbisiero, J. Sexton, G. North, J. Roberts; **Cons:** L. Halfpenny 3; **Pens:** L. Halfpenny 5

Referee: Romain Poite (France)

BRITISH & IRISH LIONS TEST MATCHES IN NEW ZEALAND

1904
TEST NO. 18

13 August, Wellington
New Zealand 9 The Lions 3
HT: 3–3 **Att:** 21,000

New Zealand: D. McGregor; W. Wallace, E. Harper, D. McGregor, M. Wood; B. Stead [capt.], P. Harvey; D. Gallaher, G. Tyler, P. McMinn, W. Glenn, B. Fanning, T. Cross, G. Nicholson, C. Seeling. Scorers: **Try:** D. McGregor 2; **Pen:** W. Wallace

The Lions: A. O'Brien; P. McEvedy, W. Llewellyn, R. Gabe, T. Morgan [capt.]; P. Bush, T. Vile; R. Rogers, D. Trail, D. Dobson, S. Bevan, R. Edwards, S. Crowther, B. Swannell, A. Harding. Scorer: **Pen:** A. Harding

Referee: Francis Evans (New Zealand)

1908
TEST NO. 19

6 June, Dunedin
New Zealand 32 The Lions 5
HT: 21–0 **Att:** 30,000

New Zealand: J. Colman; D. Cameron, F. Mitchinson, M. Thomson, J. Hunter; B. Stead [capt.], F. Roberts; N. Hughes, S. Casey, R. Wilson, W. Cunningham, B. Francis, A. McDonald, C. Seeling, G. Gillett. Scorers: **Tries:** F. Roberts 2, F. Mitchinson 2, J. Hunter, M. Thomson, D. Cameron; **Cons:** G. Gillett 2, F. Roberts, B. Francis; **Pen:** F. Roberts

The Lions: J. Jackett; J.L. Williams, J.P. Jones, H. Vassall, R. Gibbs; J. Davey, H. Laxon; W. Oldham, B. Dibble, F. Jackson, A. Harding [capt.], P. Down, G. Kyrke, J. Ritson, H. Archer. Scorers: **Try:** R. Gibbs; **Con:** F. Jackson

Referee: James Duncan (New Zealand)

TEST NO. 20

27 June, Wellington
New Zealand 3 The Lions 3
HT: 0–0 Att: 10,000

New Zealand: W. Wallace; D. Cameron, F. Mitchinson, F. Fryer, J. Hunter [capt.]; D. Gray, P. Burns; P. Murray, B. Reedy, R. Wilson, W. Cunningham, B. Francis, S. Paterson, C. Seeling, D. Hamilton. Scorer: **Pen:** B. Francis

The Lions: J. Jackett; J.L. Williams, H. Vassall, J.P. Jones, P. McEvedy; J.T. Jones, W. Morgan; R. Gibbs, P. Down, G. Hind, B. Dibble, H. Archer, E. Morgan, A. Harding [capt.], T. Smith. Scorer: **Try:** J.P. Jones

Referee: Angus Campbell (New Zealand)

TEST NO. 21

25 July, Auckland
New Zealand 29 The Lions 0
HT: 12–0 Att: 12,000

New Zealand: J. Colman; D. Cameron, R. Deans, F. Mitchinson, J. Hunter; B. Stead [capt.], F. Roberts; F. Glasgow, B. Reedy, C. Seeling, W. Cunningham, B. Francis, S. Paterson, H. Hayward, G. Gillett. Scorers: **Tries:** F. Mitchinson 3, G. Gillett, R. Deans, J. Hunter, F. Glasgow, B. Francis, H. Hayward; **Con:** J. Colman

The Lions: J. Jackett; F. Chapman, H. Vassall, J.P. Jones, P. McEvedy; J.T. Jones, W. Morgan; J.F. Williams, B. Dibble, E. Morgan, H. Archer, T. Smith, P. Down, G. Hind, A. Harding [capt.]

Referee: Angus Campbell (New Zealand)

1930
TEST NO. 29

21 June, Dunedin
New Zealand 3 The Lions 6
HT: 0–3 Att: 27,000

New Zealand: G. Nepia; G. Hart, F. Lucas, D. Oliver, B. Cooke; H. Lilburne, J. Mill; B. Irvine, B. Cottrell, R. McWilliams, D. Steere, B. Finlayson, B. Hazlett, W. Batty, C. Porter [capt.]. Scorer: **Try:** G. Hart

The Lions: J. Bassett; J. Morley, C. Aarvold [capt.], H. Bowcott, J. Reeve; R. Spong, P. Murray; H. O'Neill, D. Parker, H. Rew, J. Farrell, B. Black, I. Jones, G. Beamish, J. Hodgson. Scorers: **Tries:** J. Morley, J. Reeve

Referee: Sam Hollander (New Zealand)

TEST NO. 30

5 July, Christchurch
New Zealand 13 The Lions 10
HT: 8–5 **Att:** 32,000

New Zealand: G. Nepia; G. Hart, F. Lucas, D. Oliver, B. Cooke; M. Nicholls, M. Corner;
J. Hore, B. Cottrell, R. McWilliams, D. Steere, B. Finlayson, R. Stewart, B. Hazlett, C. Porter
[capt.]. Scorers: **Tries:** G. Hart, D. Oliver; **Cons:** M. Nicholls 2; **DG:** M. Nicholls

The Lions: **J. Bassett; J. Morley, C. Aarvold, H. Bowcott, T. Novis; R. Spong, P. Murray;
H. O'Neill, D. Parker, H. Rew, J. Farrell, B. Black, I. Jones, G. Beamish, D. Prentice [capt.].**
Scorers: **Tries:** C. Aarvold 2; **Cons:** D. Parker 2

Referee: Sam Hollander (New Zealand)

TEST NO. 31

26 July, Auckland
New Zealand 15 The Lions 10
HT: 5–5 **Att:** 40,000

New Zealand: G. Nepia; G. Hart, B. Cooke, F. Lucas, M. Nicholls; A. Strang, M. Corner;
B. Cottrell, J. Hore, R. McWilliams, D. Steere, B. Hazlett, H. McLean, W. Batty, C. Porter
[capt.]. Scorers: **Tries:** H. McLean 2, F. Lucas; **Con:** A. Strang; **DG:** M. Nicholls

The Lions: **J. Bassett; J. Morley, C. Aarvold [capt.], H. Bowcott, J. Reeve; R. Spong,
H. Poole; H. O'Neill, D. Parker, H. Rew, J. Farrell, B. Black, J. Hodgson, I. Jones,
G. Beamish.** Scorers: **Tries:** H. Bowcott, C. Aarvold; **Cons:** B. Black, I. Jones

Referee: Sam Hollander (New Zealand)

TEST NO. 32

9 August, Wellington
New Zealand 22 The Lions 8
HT: 6–3 **Att:** 40,000

New Zealand: G. Nepia; G. Hart, B. Cooke, F. Lucas, H. Lilburne; A. Strang, M. Corner;
J. Hore, B. Cottrell, B. Hazlett, D. Steere, R. McWilliams, H. McLean, W. Batty, C. Porter
[capt.]. Scorers: **Tries:** B. Cooke 2, C. Porter 2, W. Batty, A. Strang; **Cons:** A. Strang 2

The Lions: **J. Bassett; T. Novis, C. Aarvold [capt.], H. Bowcott, J. Reeve; R. Spong,
P. Murray; H. O'Neill, D. Parker, H. Rew, J. Farrell, B. Black, W. Welsh, I. Jones, G. Beamish.**
Scorers: **Try:** T. Novis; **Con:** B. Black; **Pen:** D. Parker

Referee: Frank Sutherland (New Zealand)

1950
TEST NO. 37

27 May, Dunedin
New Zealand 9 The Lions 9
HT: 0–3 **Att:** 35,000

New Zealand: B. Scott; B. Meates, R. Roper, R. Elvidge [capt.], N. Cherrington; G. Beatty, V. Bevan; J. Simpson, A. Hughes, K. Skinner, T. White, L. Harvey, J. McNab, P. Crowley, P. Johnstone. Scorers: **Tries:** R. Roper, R. Elvidge; **Pen:** B. Scott

The Lions: **W. Cleaver; K. Jones, J. Matthews, I. Preece, R. MacDonald; J. Kyle, A. Black; J. Robins, K. Mullen [capt.], T. Clifford, D. Hayward, R. John, R. Evans, W. McKay, P. Kininmonth.** Scorers: **Tries:** J. Kyle, K. Jones; **Pen:** J. Robins

Referee: Eric Tindill (New Zealand)

TEST NO. 38

10 June, Christchurch
New Zealand 8 The Lions 0
HT: 8–0 **Att:** 43,000

New Zealand: B. Scott; B. Meates, R. Roper, R. Elvidge [capt.], P. Henderson; L. Haig, V. Bevan; J. Simpson, A. Hughes, K. Skinner, L. Harvey, T. White, J. McNab, P. Crowley, P. Johnstone. Scorers: **Tries:** R. Roper, P. Crowley; **Con:** L. Haig

The Lions: **W. Cleaver; K. Jones, J. Matthews, B. Williams, M. Thomas; J. Kyle, A. Black; J. Robins, K. Mullen [capt.], T. Clifford, D. Hayward, R. John, W. McKay, R. Evans, P. Kininmonth**

Referee: Eric Tindill (New Zealand)

TEST NO. 39

1 July, Wellington
New Zealand 6 The Lions 3
HT: 0–3 **Att:** 45,000

New Zealand: B. Scott; B. Meates, R. Roper, R. Elvidge [capt.], P. Henderson; L. Haig, V. Bevan; J. Simpson, A. Hughes, K. Skinner, L. Harvey, T. White, J. McNab, P. Crowley, P. Johnstone. Scorers: **Try:** R. Elvidge; **Pen:** B. Scott

The Lions: **W. Cleaver; N. Henderson, J. Matthews, B. Williams [capt.], M. Thomas; J. Kyle, G. Rimmer; T. Clifford, D. Davies, J. Robins, D. Hayward, J. Nelson, W. McKay, R. Evans, R. John.** Scorer: **Pen:** J. Robins

Referee: Arthur Fong (New Zealand)

TEST NO. 40

29 July, Auckland
New Zealand 11 The Lions 8
HT: 8–3 **Att:** 58,000

New Zealand: B. Scott; B. Meates, R. Roper, J. Tanner, P. Henderson; L. Haig, V. Bevan; H. Wilson, A. Hughes, K. Skinner, L. Harvey, T. White, P. Johnstone [capt.], P. Crowley, G. Mexted. Scorers: **Tries:** P. Henderson, H. Wilson; **Con:** B. Scott; **DG:** B. Scott

The Lions: **B.L. Jones; K. Jones, J. Matthews, B. Williams [capt.], M. Lane; J. Kyle, R. Willis; C. Davies, D. Davies, G. Budge, J. Nelson, R. John, R. Evans, W. McKay, P. Kininmonth.** Scorers: **Try:** K. Jones; **Con:** B.L. Jones; **Pen:** B.L. Jones

Referee: George Sullivan (New Zealand)

1959
TEST NO. 49

18 July, Dunedin
New Zealand 18 The Lions 17
HT: 6–9 **Att:** 41,500

New Zealand: D. Clarke; B. McPhail, F. McMullen, T. Lineen, P. Walsh; R. Brown, S. Urbahn; W. Whineray [capt.], R. Hemi, I. Clarke, I. MacEwan, S. Hill, R. Pickering, B. Finlay, P. Jones. Scorer: **Pens:** D. Clarke 6

The Lions: **K. Scotland; P. Jackson, M. Price, D. Hewitt, T. O'Reilly; B. Risman, R. Jeeps; H. McLeod, R. Dawson [capt.], G. Wood, R. Williams, R. Evans, N. Murphy, K. Smith, J. Faull.** Scorers: **Tries:** M. Price 2, T. O'Reilly, P. Jackson; **Con:** B. Risman; **Pen:** D. Hewitt

Referee: Allan Fleury (New Zealand)

TEST NO. 50

15 August, Wellington
New Zealand 11 The Lions 8
HT: 6–0 **Att:** 53,000
New Zealand: D. Clarke; T. Diack, F. McMullen, T. Lineen, R. Caulton; J. McCullough, K. Briscoe; W. Whineray [capt.], D. Webb, I. Clarke, I. MacEwan, S. Hill, K. Tremain, C. Meads, R. Conway. Scorers: **Tries:** R. Caulton 2, D. Clarke; **Con:** D. Clarke

The Lions: **T. Davies; J. Young, M. Thomas, B. Patterson, T. O'Reilly; M. Price, R. Jeeps; H. McLeod, R. Dawson [capt.], S. Millar, R. Williams, R. Evans, N. Murphy, A. Ashcroft, D. Marques.** Scorers: **Try:** J. Young; **Con:** T. Davies; **Pen:** T. Davies

Referee: Cecil Gillies (New Zealand)

TEST NO. 51

29 August, Christchurch
New Zealand 22 The Lions 8
HT: 14–8 **Att:** 57,000

New Zealand: D. Clarke; F. McMullen, R. Brown, T. Lineen, R. Caulton; J. McCullough, S. Urbahn; W. Whineray [capt.], R. Hemi, M. Irwin, I. MacEwan, S. Hill, K. Tremain, C. Meads, R. Conway. Scorers: **Tries:** R. Caulton 2, C. Meads, S. Urbahn; **Cons:** D. Clarke 2; **Pen:** D. Clarke; **DG:** D. Clarke

The Lions: **K. Scotland; P. Jackson, M. Price, D. Hewitt, T. O'Reilly; P. Horrocks-Taylor, R. Jeeps; G. Wood, R. Dawson [capt.], H. McLeod, R. Williams, R. Evans, K. Smith, H. Morgan, J. Faull.** Scorers: **Try:** D. Hewitt; **Con:** J. Faull; **Pen:** J. Faull

Referee: Cecil Gillies (New Zealand)

TEST NO. 52

19 September, Auckland
New Zealand 6 The Lions 9
HT: 3–3 **Att:** 60,000

New Zealand: D. Clarke; B. McPhail, T. Lineen, A. Clarke, R. Caulton; J. McCullough, S. Urbahn; W. Whineray [capt.], R. Hemi, M. Irwin, C. Meads, S. Hill, K. Tremain, R. Pickering, R. Conway. Scorer: **Pens:** D. Clarke 2

The Lions: **T. Davies; P. Jackson, D. Hewitt, K. Scotland, T. O'Reilly; B. Risman, A. Mulligan; H. McLeod, R. Dawson [capt.], R. Prosser, R. Williams, W. Mulcahy, N. Murphy, H. Morgan, J. Faull.** Scorers: **Tries:** T. O'Reilly, B. Risman, P. Jackson

Referee: Pat Murphy (New Zealand)

1966
TEST NO. 59

16 July, Dunedin
New Zealand 20 The Lions 3
HT: 8–3 **Att:** 43,000

New Zealand: M. Williment; S. Smith, R. Rangi, I. MacRae, A. Steel; M. Herewini, C. Laidlaw; J. Hazlett, B. McLeod, K. Gray, C. Meads, S. Meads, W. Nathan, K. Tremain, B. Lochore [capt.]. Scorers: **Tries:** B. McLeod, B. Lochore, M. Williment; **Con:** M. Williment; **Pen:** M. Williment 2; **DG:** M. Herewini

The Lions: **S. Wilson; C. McFadyean, K. Jones, M. Gibson, D. Bebb; D. Watkins, R. Young; D. Williams, K. Kennedy, H. Norris, B. Price, M. Campbell-Lamerton [capt.], J. Telfer, R. Lamont, A. Pask.** Scorer: **Pen:** S. Wilson

Referee: John Pring (New Zealand)

TEST NO. 60

6 August, Wellington
New Zealand 16 The Lions 12
HT: 8–9 **Att:** 44,425

New Zealand: M. Williment; S. Smith, R. Rangi, I. MacRae, A. Steel; M. Herewini, C. Laidlaw; J. Hazlett, B. McLeod, K. Gray, C. Meads, S. Meads, W. Nathan, K. Tremain, B. Lochore [capt.]. Scorers: **Tries:** C. Meads, K. Tremain, A. Steel; **Cons:** M. Williment 2; **Pen:** M. Williment

The Lions: **S. Wilson; S. Hinshelwood, C. McFadyean, M. Gibson, D. Bebb; D. Watkins [capt.], A. Lewis; D. Williams, F. Laidlaw, H. Norris, D. Thomas, W. McBride, N. Murphy, R. Lamont, J. Telfer.** Scorers: **Pens:** S. Wilson 3; **DG:** D. Watkins

Referee: Pat Murphy (New Zealand)

TEST NO. 61

27 August, Christchurch
New Zealand 19 The Lions 6
HT: 6–6 **Att:** 52,000

New Zealand: M. Williment; S. Smith, R. Rangi, I. MacRae, A. Steel; M. Herewini, C. Laidlaw; J. Hazlett, B. McLeod, K. Gray, C. Meads, S. Meads, W. Nathan, K. Tremain, B. Lochore [capt.]. Scorers: **Tries:** W. Nathan 2, S. Smith; **Cons:** M. Williment 2; **Pens:** M. Williment 2

The Lions: **S. Wilson; S. Watkins, C. McFadyean, M. Gibson, D. Bebb; D. Watkins, A. Lewis; D. Thomas, F. Laidlaw, H. Norris, W. McBride, M. Campbell-Lamerton [capt.], N. Murphy, R. Lamont, A. Pask.** Scorers: **Tries:** R. Lamont, D. Watkins

Referee: Pat Murphy (New Zealand)

TEST NO. 62

10 September, Auckland
New Zealand 24 The Lions 11
HT: 10–8 **Att:** 58,000

New Zealand: M. Williment; M. Dick, R. Rangi, A. Steel, I. MacRae; M. Herewini, C. Laidlaw; J. Hazlett, B. McLeod, K. Gray, C. Meads, S. Meads, W. Nathan, K. Tremain, B. Lochore [capt.]. Scorers: **Tries:** M. Dick, W. Nathan, I. MacRae, A. Steel; **Cons:** M. Williment 3; **Pen:** M. Williment; **DG:** M. Herewini

The Lions: **S. Wilson; S. Hinshelwood, C. McFadyean, M. Gibson, D. Bebb; D. Watkins [capt.], A. Lewis; D. Williams, K. Kennedy, R. McLoughlin, B. Price, W. McBride, A. Pask, R. Lamont, J. Telfer.** Scorers: **Tries:** S. Hinshelwood, C. McFadyean; **Con:** S. Wilson; **Pen:** S. Wilson

Referee: Pat Murphy (New Zealand)

1971
TEST NO. 67

26 June, Dunedin
New Zealand 3 The Lions 9
HT: 3–3 **Att:** 45,000

New Zealand: W.F. McCormick; B. Hunter, B. Williams, W. Cottrell, K. Carrington; R. Burgess, S. Going; R. Guy, T. Norton, J. Muller, P. Whiting, C. Meads [capt.], A. McNaughton, I. Kirkpatrick, A. Sutherland. **Scorer: Pen:** W.F. McCormick

The Lions: **J.P.R. Williams; T.G.R. Davies, M. Gibson, J. Dawes [capt.], J. Bevan; B. John, G. Edwards (R. Hopkins 7); I. McLauchlan, J. Pullin, S. Lynch, D. Thomas, W. McBride, J. Taylor, P. Dixon, M. Davies. Scorers: Try:** I. McLauchlan; **Pens:** B. John 2

Referee: John Pring (New Zealand)

TEST NO. 68

10 July, Christchurch
New Zealand 22 The Lions 12
HT: 8–6 **Att:** 57,500

New Zealand: L. Mains; B. Hunter, H. Joseph, W. Cottrell, B. Williams; R. Burgess, S. Going; R. Guy, T. Norton, J. Muller, P. Whiting, C. Meads [capt.], A. McNaughton, I. Kirkpatrick, A. Wyllie. **Scorers: Tries:** R. Burgess 2, S. Going, I. Kirkpatrick, B. Williams; **Cons:** L. Mains 2; **Pen:** L. Mains

The Lions: **J.P.R. Williams; T.G.R. Davies, M. Gibson, J. Dawes [capt.], D. Duckham; B. John, G. Edwards; I. McLauchlan, J. Pullin, S. Lynch, D. Thomas, W. McBride, J. Taylor, P. Dixon, M. Davies. Scorers: Tries:** T.G.R. Davies 2; **Pen:** B. John; **DG:** B. John

Referee: John Pring (New Zealand)

TEST NO. 69

31 July, Wellington
New Zealand 3 The Lions 13
HT: 0–13 **Att:** 50,000

New Zealand: L. Mains; B. Hunter, H. Joseph, W. Cottrell, K. Carrington; R. Burgess (M. Duncan 65), S. Going; R. Guy, T. Norton, J. Muller, B. Lochore, C. Meads [capt.], I. Kirkpatrick, A. McNaughton, A. Wyllie. **Scorer: Try:** L. Mains

The Lions: **J.P.R. Williams; T.G.R. Davies, M. Gibson, J. Dawes [capt.], D. Duckham; B. John, G. Edwards; I. McLauchlan, J. Pullin, S. Lynch, W. McBride, G. Brown, D. Quinnell, J. Taylor, M. Davies. Scorers: Tries:** T.G.R. Davies, B. John; **Cons:** B. John 2; **DG:** B. John

Referee: John Pring (New Zealand)

TEST NO. 70

14 August, Auckland
New Zealand 14 The Lions 14
HT: 8–8 Att: 56,000

New Zealand: L. Mains; K. Carrington, M. Duncan, P. Gard, B. Williams; W. Cottrell, S. Going; R. Guy, T. Norton, J. Muller, P. Whiting, C. Meads [capt.], I. Kirkpatrick, T. Lister, A. Wyllie. **Scorers: Tries:** T. Lister, W. Cottrell; **Con:** L. Mains; **Pens:** L. Mains 2

The Lions: **J.P.R. Williams; T.G.R. Davies, M. Gibson, J. Dawes [capt.], D. Duckham; B. John, G. Edwards; I. McLauchlan, J. Pullin, S. Lynch, G. Brown (D. Thomas 60), W. McBride, J. Taylor, P. Dixon, M. Davies. Scorers: Try:** P. Dixon; **Con:** B. John; **Pens:** B. John 2; **DG:** J.P.R. Williams

Referee: John Pring (New Zealand)

1977
TEST NO. 75

18 June, Wellington
New Zealand 16 The Lions 12
HT: 16–12 Att: 43,000

New Zealand: C. Farrell; B. Williams, B. Robertson, W. Osborne, G. Batty; D. Robertson, S. Going; B. Johnstone, T. Norton [capt.], K. Lambert, F. Oliver, A. Haden, K. Eveleigh, I. Kirkpatrick, L. Knight. **Scorers: Tries:** S. Going, G. Batty, B. Johnstone; **Cons:** B. Williams 2

The Lions: **A. Irvine; P. Squires, I. McGeechan, S. Fenwick, J.J. Williams; P. Bennett [capt.], B. Williams; P. Orr, R. Windsor, G. Price, A. Martin, M. Keane, T. Cobner, T. Evans, W. Duggan. Scorers: Pens:** P. Bennett 3, A. Irvine

Referee: Peter McDavitt (New Zealand)

TEST NO. 76

9 July, Christchurch
New Zealand 9 The Lions 13
HT: 6–13 Att: 50,000

New Zealand: C. Farrell; B. Williams, W. Osborne, L. Jaffray, M. Taylor; D. Bruce, S. Going; B. Johnstone, T. Norton [capt.], W. Bush, F. Oliver, A. Haden, K. Eveleigh, I. Kirkpatrick, L. Knight. **Scorer: Pens:** B. Williams 3

The Lions: **A. Irvine; J.J. Williams, I. McGeechan, S. Fenwick, G. Evans; P. Bennett [capt.], B. Williams; F. Cotton, P. Wheeler, G. Price, W. Beaumont, G. Brown, T. Cobner, D. Quinnell, W. Duggan. Scorers: Try:** J.J. Williams; **Pens:** P. Bennett 3

Referee: Brian Duffy (New Zealand)

TEST NO. 77

30 July, Dunedin
New Zealand 19 The Lions 7
HT: 10–4 **Att:** 43,000

New Zealand: B. Wilson; B. Ford, B. Robertson, W. Osborne, B. Williams; D. Bruce, L. Davis; J. McEldowney, T. Norton [capt.], W. Bush, A. Haden, F. Oliver, G. Mourie, I. Kirkpatrick, L. Knight. Scorers: **Tries:** I. Kirkpatrick, A. Haden; **Con:** B. Wilson; **Pens:** B. Wilson 2; **DG:** B. Robertson

The Lions: **A. Irvine; J.J. Williams (I. McGeechan 1st half), D. Burcher, S. Fenwick, G. Evans; P. Bennett [capt.], B. Williams (D. Morgan 41); F. Cotton, P. Wheeler, G. Price, G. Brown, W. Beaumont, D. Quinnell, T. Cobner, W. Duggan.** Scorers: **Try:** W. Duggan; **Pen:** A. Irvine

Referee: Dave Millar (New Zealand)

TEST NO. 78

13 August, Auckland
New Zealand 10 The Lions 9
HT: 3–9 **Att:** 57,000

New Zealand: B. Wilson; B. Ford (M. Taylor 2nd half), B. Robertson, W. Osborne, B. Williams; D. Bruce, L. Davis; J. McEldowney (W. Bush 2nd half), T. Norton [capt.], K. Lambert, F. Oliver, A. Haden, G. Mourie, I. Kirkpatrick, L. Knight. Scorers: **Try:** L. Knight; **Pens:** B. Wilson 2

The Lions: **A. Irvine; E. Rees, I. McGeechan, S. Fenwick, G. Evans; P. Bennett [capt.], D. Morgan; F. Cotton, P. Wheeler, G. Price, W. Beaumont, G. Brown, J. Squire, A. Neary, W. Duggan.** Scorer: **Try:** D. Morgan; **Con:** D. Morgan; **Pen:** D. Morgan

Referee: Dave Millar (New Zealand)

1983
TEST NO. 83

4 June, Christchurch
New Zealand 16 The Lions 12
HT: 6–9 **Att:** 52,000

New Zealand: A. Hewson; S. Wilson, S. Pokere, W. Taylor, B. Fraser; I. Dunn, D. Loveridge; G. Knight, A. Dalton [capt.], J. Ashworth, A. Haden, G. Whetton, M. Shaw, J. Hobbs, M. Mexted. Scorers: **Try:** M. Shaw; **Pens:** A. Hewson 3; **DG:** A. Hewson

The Lions: **H. MacNeill; T. Ringland, R. Ackerman, D. Irwin, R. Baird; O. Campbell, T. Holmes (R. Laidlaw 31); I. Stephens, C. Fitzgerald [capt.], G. Price, M. Colclough, R. Norster, J. Squire, P. Winterbottom, I. Paxton.** Scorer: **Pens:** O. Campbell 3; **DG:** O. Campbell

Referee: Francis Palmade (France)

TEST NO. 84

18 June, Wellington
New Zealand 9 The Lions 0
HT: 9–0 **Att:** 40,000

New Zealand: A. Hewson; S. Wilson, S. Pokere, W. Taylor, B. Fraser; W. Smith, D. Loveridge; G. Knight, A. Dalton [capt.], J. Ashworth, A. Haden, G. Whetton, M. Shaw, J. Hobbs, M. Mexted. **Scorers: Try:** D. Loveridge; **Con:** A. Hewson; **Pen:** A. Hewson

The Lions: H. MacNeill; J. Carleton, M. Kiernan, D. Irwin, R. Baird; O. Campbell, R. Laidlaw; S. Jones, C. Fitzgerald [capt.], G. Price, R. Norster, M. Colclough, J. O'Driscoll, P. Winterbottom, I. Paxton (J. Beattie 54)

Referee: Francis Palmade (France)

TEST NO. 85

2 July, Dunedin
New Zealand 15 The Lions 8
HT: 6–4 **Att:** 32,000

New Zealand: A. Hewson; S. Wilson, S. Pokere, W. Taylor, B. Fraser; W. Smith (A. Stone 39), D. Loveridge; G. Knight, A. Dalton [capt.], J. Ashworth, A. Haden, G. Whetton, M. Shaw, J. Hobbs, M. Mexted. **Scorers: Try:** S. Wilson; **Con:** A. Hewson; **Pens:** A. Hewson 3

The Lions: G. Evans; J. Carleton, J. Rutherford, M. Kiernan, R. Baird; O. Campbell, R. Laidlaw; S. Jones, C. Fitzgerald [capt.], G. Price, M. Colclough, S. Bainbridge, J. Calder, P. Winterbottom, I. Paxton. **Scorers: Tries:** R. Baird, J. Rutherford

Referee: Dick Byres (Australia)

TEST NO. 86

16 July, Auckland
New Zealand 38 The Lions 6
HT: 16–3 **Att:** 53,000

New Zealand: A. Hewson; S. Wilson, S. Pokere, B. Fraser, W. Taylor; I. Dunn, D. Loveridge; G. Knight, A. Dalton [capt.], J. Ashworth, A. Haden, G. Whetton, M. Shaw, J. Hobbs, M. Mexted. **Scorers: Tries:** S. Wilson 3, A. Haden, A. Hewson, J. Hobbs; **Cons:** A. Hewson 4; **Pens:** A. Hewson 2

The Lions: G. Evans; J. Carleton, M. Kiernan, D. Irwin, R. Baird (R. Ackerman 55); O. Campbell (H. MacNeill 47), R. Laidlaw; S. Jones, C. Fitzgerald [capt.], G. Price, M. Colclough, S. Bainbridge, J. O'Driscoll, P. Winterbottom, I. Paxton. **Scorers: Pens:** G. Evans, O. Campbell

Referee: Dick Byres (Australia)

1993
TEST NO. 90

12 June, Christchurch
New Zealand 20 The Lions 18
HT: 11–9 **Att:** 38,000
New Zealand: J. Timu; E. Clarke, F. Bunce, W. Little (M. Cooper 79), I. Tuigamala; G. Fox,
A. Strachan; C. Dowd, S. Fitzpatrick [capt.], O. Brown, R. Brooke, I. Jones, J. Joseph,
M. Jones, Z. Brooke. **Scorers: Try:** F. Bunce; **Pens:** G. Fox 5

The Lions: **G. Hastings [capt.]; I. Evans, J. Guscott, W. Carling, R. Underwood; R. Andrew,
D. Morris; N. Popplewell, K. Milne, P. Burnell, A. Reed, M. Bayfield, B. Clarke,
P. Winterbottom, D. Richards. Scorers: Pens:** G. Hastings 6

Referee: Brian Kinsey (Australia)

TEST NO. 91

26 June, Wellington
New Zealand 7 The Lions 20
HT: 7–9 **Att:** 39,000

New Zealand: J. Timu; J. Kirwan, F. Bunce, E. Clarke, I. Tuigamala; G. Fox, J. Preston;
C. Dowd, S. Fitzpatrick [capt.], O. Brown, R. Brooke, M. Cooksley (I. Jones 40), J. Joseph,
M. Jones, Z. Brooke. **Scorers: Try:** E. Clarke; **Con:** G. Fox

The Lions: **G. Hastings [capt.]; I. Evans, J. Guscott, S. Gibbs, R. Underwood; R. Andrew,
D. Morris; N. Popplewell, B. Moore, J. Leonard, M. Johnson, M. Bayfield, B. Clarke,
P. Winterbottom (M. Teague temp), D. Richards. Scorers: Try:** R. Underwood; **Pens:**
G. Hastings 4; **DG:** R. Andrew

Referee: Patrick Robin (France)

TEST NO. 92

3 July, Auckland
New Zealand 30 The Lions 13
HT: 14–10 **Att:** 47,000

New Zealand: J. Timu (M Cooper temp); J. Kirwan, F. Bunce, L. Stensness, I. Tuigamala;
G. Fox, J. Preston; C. Dowd, S. Fitzpatrick [capt.], O. Brown, R. Brooke, I. Jones
(M. Cooksley 20), J. Joseph, M. Jones (Z. Brooke 73), A. Pene. **Scorers: Tries:** J. Preston,
S. Fitzpatrick, F. Bunce; **Cons:** G. Fox 3; **Pens:** G. Fox 3

The Lions: **G. Hastings [capt.]; I. Evans, J. Guscott, S. Gibbs, R. Underwood; R. Andrew,
D. Morris; N. Popplewell, B. Moore, J. Leonard, M. Johnson, M. Bayfield, B. Clarke,
P. Winterbottom, D. Richards. Scorers: Try:** S. Gibbs; **Con:** G. Hastings; **Pens:** G. Hastings 2

Referee: Patrick Robin (France)

2005
TEST NO. 100

25 June, Christchurch
New Zealand 21 The Lions 3
HT: 11–0 Att: 37,200

New Zealand: L. MacDonald (M. Muliaina 69); D. Howlett, T. Umaga [capt.] (R. Gear 74), A. Mauger, S. Sivivatu; D. Carter, J. Marshall (B. Kelleher 67); T. Woodcock (G. Somerville 67), K. Mealamu (D. Witcombe 74), C. Hayman, C. Jack, A. Williams, J. Collins (S. Lauaki 76), R. McCaw, R. So'oialo. Scorers: Tries: A. Williams, S. Sivivatu; Con: D. Carter; Pens: D. Carter 3

The Lions: J. Robinson (S. Horgan 57); J. Lewsey, B. O'Driscoll [capt.] (W. Greenwood 1), J. Wilkinson, G. Thomas; S. Jones, D. Peel (M. Dawson 72); G. Jenkins, S. Byrne (S. Thompson 57), J. White, P. O'Connell, B. Kay (D. Grewcock 57), R. Hill (R. Jones 18), N. Back, M. Corry. Yellow Card: P. O'Connell 11. Scorer: Pen: J. Wilkinson

Referee: Joel Jutge (France)

TEST NO. 101

2 July, Wellington
New Zealand 48 The Lions 18
HT: 21–13 Att: 37,000

New Zealand: M. Muliaina; R. Gear, T. Umaga [capt.], A. Mauger (L. MacDonald 38), S. Sivivatu (M. Nonu 73); D. Carter, B. Kelleher (J. Marshall 66); T. Woodcock (C. Johnstone 78), K. Mealamu (D. Witcombe 70), G. Somerville, C. Jack (J. Gibbes 74), A. Williams, J. Collins (S. Lauaki 66), R. McCaw, R. So'oialo. Scorers: Tries: D. Carter 2, T. Umaga, R. McCaw, S. Sivivatu; Cons: D. Carter 4; Pens: D. Carter 5

The Lions: J. Lewsey; J. Robinson, G. Thomas [capt.], G. Henson (S. Horgan 70), S. Williams; J. Wilkinson (S. Jones 60), D. Peel; G. Jenkins (G. Rowntree 60), S. Thompson (S. Byrne 78), J. White, D. O'Callaghan (M. Corry 75), P. O'Connell, S. Easterby, L. Moody, R. Jones. Scorers: Tries: G. Thomas, S. Easterby; Con: J. Wilkinson; Pens: J. Wilkinson 2

Referee: Andrew Cole (Australia)

TEST NO. 102

9 July, Auckland
New Zealand 38 The Lions 19
HT: 24–12 Att: 47,500

New Zealand: M. Muliaina; R. Gear, C. Smith, T. Umaga [capt.], S. Sivivatu; L. McAlister,
B. Kelleher (J. Marshall 76); T. Woodcock (C. Johnstone 54), K. Mealamu, G. Somerville,
C. Jack (J. Ryan 77), A. Williams, J. Collins, R. So'oialo, S. Lauaki (M. Holah 40).
Yellow Cards: T. Umaga 8, J. Collins 54. Scorers: **Tries:** T. Umaga 2, A. Williams, R. Gear,
C. Smith; **Cons:** L. McAlister 5; **Pen:** L. McAlister

The Lions: **G. Murphy (R. O'Gara 66); M. Cueto, W. Greenwood, G. Thomas [capt.]**
(S. Horgan 51), J. Lewsey; S. Jones, D. Peel (M. Dawson 48); G. Jenkins (G. Rowntree 48),
S. Byrne (G. Bulloch 70), J. White, D. O'Callaghan, P. O'Connell, S. Easterby, L. Moody
(M. Williams 76), R. Jones (M. Corry 68). Scorers: **Try:** L. Moody; **Con:** S. Jones;
Pens: S. Jones 4

Referee: Jonathan Kaplan (South Africa)

BRITISH & IRISH LIONS TEST MATCH v. ARGENTINA

TEST NO. 99

23 May, Millennium Stadium, Cardiff
The Lions 25 Argentina 25
HT: 16–19 Att: 61,569

The Lions: **G. Murphy; D. Hickie, O. Smith (S. Horgan 60), G. D'Arcy, S. Williams;**
J. Wilkinson, G. Cooper (C. Cusiter 60); G. Rowntree, S. Byrne (S. Thompson 71), J. Hayes
(J. White 55), D. O'Callaghan, D. Grewcock (B. Kay 71), M. Corry, L. Moody, M. Owen
[capt.]. Scorers: **Try:** O. Smith; **Con:** J. Wilkinson; **Pens:** J. Wilkinson 6

Argentina: B. Stortoni; J. Nunez Piossek, L. Arbizu, F. Contepomi [capt.], F. Leonelli;
F. Todeschini (L. Fleming 72), N. Fernandez Miranda; F. Mendez, M. Ledesma, M. Reggiardo,
P. Bouza (M. Carizza 68), M. Sambucetti, F. Genoud, M. Schusterman (S. Sanz 61),
J. Leguizamon. Scorers: **Try:** J. Nunez Piossek; **Con:** F. Todeschini; **Pens:** F. Todeschini 6

Referee: Stuart Dickinson (Australia)

BRITISH & IRISH LIONS TEST RECORDS

IN AUSTRALIA
LIONS TEAM RECORDS

MOST IN TEST MATCH

Points	41	41–16 (3rd Test) 06.07.2013
Win margin	31	0–31 (2nd Test) Brisbane 04.06.1966
Tries	5	(2nd Test) Sydney 13.06.1959
		(2nd Test) Brisbane 04.06.1966
Cons	5	(2nd Test) Brisbane 04.06.1966
Pens	5	(3rd Test) Sydney 15.07.1989
		(2nd Test) Melbourne 29.06.2013
		(3rd Test) Sydney 06.07.2013
DG	2	(2nd Test) Brisbane 23.07.1904

MOST IN TEST SERIES

Points	79	2013 (Three Tests)
Tries	10	1904 (Three Tests)
Cons	6	1966 (Two Tests)
Pens	13	2013 (Three Tests)
DG	3	1904 (Three Tests)

LIONS INDIVIDUAL RECORDS
MOST IN TEST MATCH

Points	21	Leigh Halfpenny (3rd Test) Sydney 06.07.2013
Tries	2	Several
Cons	5	Stewart Wilson (2nd Test) Brisbane 04.06.1966
Pens	5	Gavin Hastings (3rd Test) 15.07.1989
		Leigh Halfpenny (2nd Test) Melbourne 29.06.2013
		Leigh Halfpenny (3rd Test) Sydney 06.07.2013
DG	2	Percy Bush (2nd Test) Brisbane 23.07.1904

MOST IN TEST SERIES

Points	49	Leigh Halfpenny 2013
Tries	5	Willie Llewellyn 1904
Cons	5	Stewart Wilson 1966
		Jonny Wilkinson 2001
		Leigh Halfpenny 2013
Pens	13	Leigh Halfpenny 2013
DG	3	Percy Bush 1904

AUSTRALIA TEAM RECORDS
MOST IN TEST MATCH

Points	35	35–14 (2nd Test) Melbourne 07.07.2001
Win margin	21	35–14 (2nd Test) Melbourne 07.07.2001
Tries	4	(1st Test) Sydney 01.07.1989
Cons	4	(1st Test) Sydney 01.07.1989
Pens	6	(2nd Test) Melbourne 07.07.2001
DG	1	(1st Test) Sydney 01.07.1989

MOST IN TEST SERIES

Points	77	2001 (Three Tests)
Tries	7	2001 (Three Tests)
Cons	6	1989 (Three Tests)
Pens	12	2001 (Three Tests)
DG	1	1989 (Three Tests)

AUSTRALIA INDIVIDUAL RECORDS
MOST IN TEST MATCH

Points	25	Matt Burke (2nd Test) Melbourne 07.07.2001
Tries	2	Several
Cons	4	Michael Lynagh (1st Test) 01.07.1989
Pens	6	Matt Burke (2nd Test) Melbourne 07.07.2001
DG	1	Michael Lynagh (1st Test) Sydney 01.07.1989

MOST IN TEST SERIES

Points	44	Matt Burke 2001
Tries	2	Several
Cons	6	Michael Lynagh 1989
Pens	11	Matt Burke 2001
DG	1	Michael Lynagh 1989

IN NEW ZEALAND
LIONS TEAM RECORDS

MOST IN TEST MATCH

Points	20	20–7 (2nd Test) Wellington 26.06.1993
Win margin	13	20–7 (2nd Test) Wellington 26.06.1993
Tries	4	(1st Test) Dunedin 18.07.1959
Cons	2	Several
Pens	6	(1st Test) Christchurch 12.06.1993
DG	1	Several

MOST IN TEST SERIES

Points	51	1993 (Three Tests)
Tries	9	1959 (Four Tests)
Cons	5	1930 (Four Tests)
Pens	12	1993 (Three Tests)
DG	3	1971 (Four Tests)

LIONS INDIVIDUAL RECORDS
MOST IN TEST MATCH

Points	18	Gavin Hastings (1st Test) Christchurch 12.06.1993
Tries	2	Several
Cons	2	Several
Pens	6	Gavin Hastings (1st Test) Christchurch 12.06.1993
DG	1	Several

MOST IN TEST SERIES

Points	38	Gavin Hastings 1993
Tries	3	Carl Aarvold 1930
		Gerald Davies 1971
Cons	3	Barry John 1971
Pens	12	Gavin Hastings 1993
DG	2	Barry John 1971

NEW ZEALAND TEAM RECORDS
MOST IN TEST MATCH

Points	48	48–18 (2nd Test) Wellington 02.07.2005
Win margin	32	38–6 (4th Test) Auckland 16.07.1983
Tries	9	(3rd Test) Auckland 25.07.1908
Cons	5	(3rd Test) Auckland 09.07.2005
Pens	6	(1st Test) Dunedin 18.07.1959
DG	1	Several

MOST IN TEST SERIES

Points	107	2005 (Three Tests)
Tries	16	1908 (Three Tests)
Cons	10	2005 (Three Tests)
Pens	9	1959 (Four Tests), 1983 (Four Tests) 2005 (Three Tests)
DG	2	1966 (Four Tests)

NEW ZEALAND INDIVIDUAL RECORDS
MOST IN TEST MATCH

Points	33	Dan Carter (2nd Test) Wellington 02.07.2005
Tries	3	Frank Mitchinson (3rd Test) Auckland 25.07.1908
		Stu Wilson (4th Test) Auckland 16.07.1983
Cons	5	Luke McAlister (3rd Test) Auckland 09.07.2005
Pens	6	Don Clarke (1st Test) Dunedin 18.07.1959
DG	1	Several

MOST IN TEST SERIES

Points	46	Allan Hewson 1983
Tries	5	Frank Mitchinson 1908
Cons	8	Mick Williment 1966
Pens	9	Don Clarke 1959
		Allan Hewson 1983
DG	2	Mac Herewini 1966

IN SOUTH AFRICA
LIONS TEAM RECORDS

MOST IN TEST MATCH

Points	28	9–28 (2nd Test) Pretoria 27.06.2009
	28	9–28 (3rd Test) Johannesburg 04.07.2009
Win margin	19	9–28 (2nd Test) Pretoria 27.06.2009
		9–28 (3rd Test) Johannesburg 04.07.2009
Tries	5	(1st Test) Johannesburg 06.08.1955
		(2nd Test) Pretoria 27.06.2009
Cons	4	(1st Test) Johannesburg 06.08.1955
Pens	5	(1st Test) Cape Town 31.05.1980
		(1st Test) Cape Town 21.06.1997
		(2nd Test) Durban 28.06.1997
		(2nd Test) Pretoria 27.06.2009
DG	3	(3rd Test) Port Elizabeth 13.07.1974

MOST IN TEST SERIES

Points	79	1974 (Four Tests)
Tries	10	1955 and 1974 (Four Tests)
Cons	5	1955 (Four Tests)
Pens	13	1997 (Three Tests)
DG	4	1974 (Four Tests)

LIONS INDIVIDUAL RECORDS
MOST IN TEST MATCH

Points	20	Stephen Jones (2nd Test) Pretoria 27.06.2009
Tries	2	J.J. Williams (2nd Test) Pretoria 22.06.1974
		J.J. Williams (3rd Test) Port Elizabeth 13.07.1974
		Tom Croft (1st Test) Durban 20.06.2009
		Shane Williams (3rd Test Johannesburg 04.07.2009
Cons	4	Angus Cameron (1st Test) Johannesburg 06.08.1955
Pens	5	Tony Ward (3rd Test) Port Elizabeth 31.05.1980
		Neil Jenkins (1st Test) Cape Town 21.06.1997
		Neil Jenkins (2nd Test) Durban 28.06.1997
DG	2	Phil Bennett (3rd Test) Port Elizabeth 13.07.1974

MOST IN TEST MATCH SERIES

Points	41	Neil Jenkins 1997
Tries	4	J.J. Williams 1974
Cons	6	Stephen Jones 2009
Pens	13	Neil Jenkins 1997
DG	2	Phil Bennett 1974

SOUTH AFRICA TEAM RECORDS
MOST IN TEST MATCH

Points	35	35–16 (3rd Test) Johannesburg 28.06.1997
Win margin	20	34–14 (4th Test) Bloemfontein 25.08.1962
Tries	7	(2nd Test) Cape Town 20.08.1955
Cons	5	(4th Test) Bloemfontein 25.08.1962
Pens	4	(1st Test) Pretoria 08.06.1968
		(1st Test) Durban 20.06.2009
DG	1	Several

MOST IN TEST SERIES

Points	77	1980 (Four Tests)
Tries	16	1955 (Four Tests)
Cons	8	1938 (Three Tests)
Pens	10	2009 (Three Tests)
DG	2	1974 (Four Tests)

SOUTH AFRICA INDIVIDUAL RECORDS
MOST IN TEST MATCH

Points	16	Keith Oxlee (4th Test) Bloemfontein 25.08.1962
Tries	3	Karl van Vollenhoven (2nd Test) Cape Town 20.08.1955
Cons	5	Keith Oxlee (4th Test) Bloemfontein 25.08.1962
Pens	3	Jackie Snyman (3rd Test) Port Elizabeth 13.07.1974
		Jackie Snyman (4th Test) Johannesburg 27.07.1974
		Ruan Pienaar (1st Test) Durban 20.06.2009
		Morne Steyn (3rd Test) Johannesburg 04.07.2009
DG	1	Several

MOST IN TEST SERIES

Points	27	Keith Oxlee 1962
Tries	5	Theuns Briers 1955
Cons	6	Keith Oxlee 1962
Pens	6	Jackie Snyman 1974
DG	1	Several

BRITISH & IRISH LIONS TOUR RECORDS

IN AUSTRALIA
LIONS TEAM RECORDS

MOST IN TOUR MATCH

Points	116	10–116 v. W. Australia, Perth 08.06.2001
Win margin	106	10–116 v. W. Australia, Perth 08.06.2001
Tries	18	10–116 v. W. Australia, Perth 08.06.2001
Cons	13	10–116 v. W. Australia, Perth 08.06.2001
Pens	5	v. ACT, Canberra 04.07.1989 v. Queensland Reds, Brisbane 08.06.2013
DG	3	v. New South Wales, Sydney 24.06.1989

LIONS INDIVIDUAL RECORDS
MOST IN TOUR MATCH

Points	30	Leigh Halfpenny v. Waratahs, Sydney 15.06.2013
Tries	5	Jason Robinson v. Queensland Pres. XV 12.06.01
Cons	13	Ronan O'Gara v. W. Australia, Perth 08.06.2001
Pens	5	Peter Dods v. ACT, Canberra 04.07.1989 Owen Farrell v. Queensland Reds, Brisbane 08.06.2013
DG	3	Craig Chalmers v. New South Wales, Sydney 24.06.1989

MOST ON TOUR

Points	124	Charles Adamson (20 apps) 1899
Tries	16	Andrew Stoddart (15 apps) 1888
Cons	35	Charles Adamson (20 apps) 1899
Pens	19	Leigh Halfpenny (6 apps) 2013
DG	7	Craig Chalmers (7 apps) 1989
Games	21	Frank Stout 1899

AUSTRALIAN TEAM RECORDS
MOST IN TOUR MATCH

Points	36	36–41 Victoria, Melbourne 13.09.1930
Win margin	25	28–3 New South Wales, Sydney 10.09.1930
Tries	7	Victoria, Melbourne 13.09.1930
Cons	6	Victoria, Melbourne 13.09.1930
Pens	7	Australia A, Gosford 19.06.2001
DG	2	Queensland, Brisbane 12.05.1971

MOST IN TOUR MATCH

Points	23	Manny Edmonds (Australia A) Gosford 9.06.2001
Tries	3	Dave Cowper (Victoria) Melbourne 13.09.1930
Cons	6	Andy Beyers (Victoria) Melbourne 13.09.1930
Pens	7	Manny Edmonds (Australia A) Gosford 19.06.2001
DG	2	Lloyd Graham (Queensland) Brisbane 12.05.1971

IN NEW ZEALAND
LIONS TEAM RECORDS

MOST IN TOUR MATCH

Points	109	v. Manawatu, Palmerston North 28.06.2005
Win margin	103	v. Manawatu, Palmerston North 28.06.2005
Tries	17	v. Manawatu, Palmerston North 28.06.2005
Cons	12	v. Manawatu, Palmerston North 28.06.2005
Pens	6	Several
DG	2	Several

LIONS INDIVIDUAL RECORDS
MOST IN TOUR MATCH

Points	25	Malcolm Thomas v. Combined XV, Blenheim 29.07.1959
		Shane Williams v. Manawatu, Palmerston North 28.06.2005
Tries	6	David Duckham v. W Coast/Buller, Greymouth 16.06.1971
Cons	8	Malcolm Thomas v. Combined XV, Blenheim 29.07.1959
		Phil Bennett v. King Country, Taumarunui 01.06.1977
Pens	6	Malcolm Thomas v. Combined XV, Blenheim 29.07.1959
		Barry John v. Maoris, Auckland 02.06.1971
DG	2	Several

MOST ON TOUR

Points	180	Barry John (15 apps) 1971
Tries	17	Tony O'Reilly (17 apps) 1959
		John Bevan (13 apps) 1971
Cons	30	Barry John (15 apps) 1971
Pens	26	Barry John (15 apps) 1971
		Phil Bennett (14 apps) 1977
DG	8	Barry John (15 apps) 1971
Games	19	Harry Eagles (1888)
		Mike Gibson (1966)

NEW ZEALAND TEAM RECORDS
MOST IN TOUR MATCH

Points	37	37–24 Otago, Dunedin 05.06.1993
Win margin	18	26–8 Otago, Dunedin 04.07.1959
Tries	5	Otago, Dunedin 05.06.1993
Cons	3	Several
Pens	6	Auckland, Auckland 19.06.1993
DG	2	Taranaki, New Plymouth 28.05.1977

NEW ZEALAND INDIVIDUAL RECORDS
MOST IN TOUR MATCH

Points	18	Robbie Deans (Canterbury) Christchurch 28.06.1983
		Grant Fox (Auckland) Auckland 19.06.1993
Tries	2	Several
Cons	3	Several
Pens	6	Grant Fox (Auckland) Auckland 19.06.1993
DG	2	Paul Martin (Taranaki), New Plymouth 28.05.1977

IN SOUTH AFRICA
LIONS TEAM RECORDS

MOST IN TOUR MATCH

Points	97	0–97 v. SW Districts, Mossel Bay 29.05.1974
Win margin	97	0–97 v. SW Districts, Mossel Bay 29.05.1974
Tries	16	v. SW Districts, Mossel Bay 29.05.1974
Cons	15	v. SW Districts, Mossel Bay 29.05.1974
Pens	6	v. Natal, Durban 14.06.1997
DG	3	v. Western Province, Cape Town 05.07.1980

LIONS INDIVIDUAL RECORDS
MOST IN TOUR MATCH

Points	37	Alan Old v. SW Districts, Mossel Bay 29.05.1974
Tries	6	J.J. Williams v. SW Districts, Mossel Bay 29.05.1974
Cons	15	Alan Old v. SW Districts, Mossel Bay 29.05.1974
Pens	6	Neil Jenkins v. Natal, Durban 14.06.1997
DG	2	Jock Turner v. E. Province, Port Elizabeth 29.05.1968
		Mike Gibson v. E. Transvaal, Springs 29.06.1968
		Bob Hiller v. Border, East London 17.07.1968
		Ollie Campbell v. W. Province, Cape Town 05.07.1980

MOST ON TOUR

Points	156	Andy Irvine (15 apps) – 1974
Tries	31	Randolph Aston (20 apps) – 1891*
Cons	36	Arthur Rotherham (15 apps) – 1891
Pens	27	Andy Irvine (15 apps) – 1974
DG	4	Mike Gibson (14 apps) – 1968
Games	23	Dyne Smith – 1910
		Phil Waller – 1910

*Includes try scored against Stellenbosch

SOUTH AFRICAN TEAM RECORDS
MOST IN TOUR MATCH

Points	39	39–67 Northern Free State, Welkom 01.07.1997
Win margin	20	20–0 Eastern Province, Port Elizabeth 15.07.1955
Tries	6	Transvaal, Johannesburg 02.07.1910
Cons	4	Northern Province, Durban 13.08.1938 Northern Free State, Welkom 01.07.1997
Pens	5	Eastern Province, Port Elizabeth 16.07.1955 SA Invitation XV, Potchefstroom 21.05.1980
DG	2	Transvaal, Johannesburg 15.06.1974
	2	Western Province 13.06.2009

SOUTH AFRICAN INDIVIDUAL RECORDS
MOST IN TOUR MATCH

Points	20	Jannie de Beer (Free State) Bloemfontein, 24.06.1997 Casper Steyn (N. Transvaal) Pretoria 07.06.1997
Tries	3	Tallie Broodryk (N. Province) Durban 13.08.1938
Cons	4	Muray Francis (N. Province) Durban 13.08.1938 Eric Herbert (N. Free State) Welkom 01.07.1997
Pens	5	Robbie Blair (SA Invitation XV) Potchefstroom 21.05.1980
DG	2	Gerald Bosch (Transvaal) Johannesburg 15.06.1974

BRITISH & IRISH LIONS TEST SERIES RECORDS

MOST POINTS BY LIONS IN SERIES

POINTS	OPPONENTS	GAMES	TOUR
79	Australia	3	2013
79	South Africa	4	1974
74	South Africa	3	2009
68	South Africa	4	1980
66	Australia	3	2001
59	South Africa	3	1997
51	New Zealand	3	1993
50	Australia	3	1904
50	Australia	3	1989

MOST POINTS BY LIONS PLAYER IN SERIES

POINTS	PLAYER	GAMES	TOUR
49	Leigh Halfpenny	AUS 3	2013
41	Neil Jenkins	SA 3	1997
39	Stephen Jones	SA 3	2009
38	Gavin Hastings	NZ 3	1993
36	Jonny Wilkinson	AUS 3	2001
35	Tom Kiernan	SA 4	1968
30	Barry John	NZ 4	1971
28	Gavin Hastings	AUS 3	1989
26	Phil Bennett	SA 4	1974

MOST TRIES BY LIONS IN SERIES

NO.	OPPONENTS	GAMES	TOUR
10	Australia	3	1904
10	South Africa	4	1955
10	South Africa	4	1974
9	Australia	4	1899
9	New Zealand	4	1959

MOST TRIES BY LIONS PLAYER IN SERIES

NO.	PLAYER	GAMES	TOUR
4	Willie Llewellyn	AUS 3	1904
4	J.J. Williams	SA 4	1974

MOST PENALTIES BY LIONS IN SERIES

NO.	OPPONENT	GAMES	TOUR
13	Australia	3	2013
13	South Africa	3	1997
12	New Zealand	3	1993
11	South Africa	4	1968
11	South Africa	4	1980
10	Australia	3	1989

MOST PENALTIES BY LIONS PLAYER IN SERIES

NO.	PLAYER	GAMES	TOUR
13	Leigh Halfpenny	AUS 3	2013
13	Neil Jenkins	SA 3	1997
12	Gavin Hastings	NZ 3	1993
11	Tom Kiernan	SA 4	1968
8	Gavin Hastings	AUS 3	1989
8	Stephen Jones	SA 3	2009
6	Phil Bennett	NZ 4	1977

MOST CONVERSIONS BY LIONS IN SERIES

NO.	OPPONENTS	GAMES	TOUR
6	South Africa	3	2009
6	Australia	2	1966
5	Australia	3	2013
5	Australia	3	2001
5	South Africa	4	1955
5	Australia	2	1950

MOST CONVERSIONS BY LIONS PLAYER IN SERIES

NO.	PLAYER	GAMES	TOUR
6	Stephen Jones	3	2009
5	Leigh Halfpenny	3	2013
5	Jonny Wilkinson	3	2001
5	Stewart Wilson	2	1966

MOST DROP GOALS BY LIONS IN SERIES

NO.	OPPONENTS	GAMES	TOUR
4	South Africa	4	1974
3	New Zealand	4	1971
3	Australia	3	1904

MOST DROP GOALS BY LIONS PLAYER IN SERIES

NO.	PLAYER	GAMES	TOUR
3	Percy Bush	AUS 3	1904
2	Phil Bennett	SA 4	1974
2	Barry John	NZ 4	1971

BRITISH & IRISH LIONS TEST MATCH RECORDS

MOST POINTS BY LIONS IN TEST (Progressive)

POINTS	OPPONENTS	TOUR	TEST
4	South Africa	1891	1, 3
17	South Africa	1896	2
17	Australia	1904	1, 2
21	South Africa	1938	3
23	South Africa	1955	1
24	Australia	1950	2
24	Australia	1959	2
31	Australia	1966	2
41	Australia	2013	3

*Most Points v. South Africa: 28 (2nd Test 1974, 3rd Test 2009)
*Most Points v. New Zealand: 20 (2nd Test 1993)

MOST POINTS BY LION IN TEST (Progressive)

NO.	PLAYER	TOUR	TEST
2	Alan Rotherham	1891	SA 1
3	William Mitchell	1891	SA 2
4	Osbert Mackie	1896	SA 2
4	Fred Byrne	1896	SA 2
6	Fred Byrne	1896	SA 3
6	Alf Bucher	1899	AUS 3
10	Charlie Adamson	1899	AUS 4
11	Percy Bush	1904	AUS 2
16	Lewis Jones	1950	AUS 1
17	Tom Kiernan	1968	SA 1
18	Tony Ward	1980	SA 1
18	Gavin Hastings	1993	NZ 1
18	Jonny Wilkinson	2001	AUS 1
20	Jonny Wilkinson	2005	ARG
20	Stephen Jones	2009	SA 2
21	Leigh Halfpenny	2013	AUS 3

MOST TRIES BY LIONS IN TEST (Progressive)

NO.	OPPONENTS	TOUR	TEST
2	South Africa	1891	1,3
2	South Africa	1896	1
3	South Africa	1896	2
3	Australia	1899	2, 3
3	Australia	1904	1, 2
4	Australia	1904	3
5	Australia	1950	2
5	South Africa	1955	1
5	Australia	1959	2
5	Australia	1966	2
5	South Africa	1974	2

*Most tries v. New Zealand: 4 (1st Test 1959)

MOST TRIES BY LION IN TEST (Progressive)

NO.	PLAYER	TOUR	TOUR
2	Alf Bucher	1899	AUS 3
2	Willie Llewellyn	1904	AUS 3
2	Carl Aarvold	1930	NZ 2
2	John Nelson	1950	AUS 2
2	Malcolm Price	1959	AUS 2
2	Malcolm Price	1959	NZ 1
2	D. Ken Jones	1962	AUS 2
2	Gerald Davies	1971	NZ 2
2	J.J. Williams	1974	SA 2
2	J.J. Williams	1974	SA 3
2	Tom Croft	2009	SA 1
2	Shane Williams	2009	SA 3

MOST PENALTIES BY LIONS IN TEST (Progressive)

POINTS	OPPONENTS	TOUR	TEST
1	Australia	1899	4
1	New Zealand	1904	1
1	South Africa	1924	4
1	New Zealand	1930	4
4	South Africa	1938	1
5	South Africa	1968	1
5	South Africa	1980	1
6	New Zealand	1993	1
6	Argentina	2005	1

*Most Penalties v. Australia: 5 (3rd Test 1989), 5 (2nd and 3rd Tests 2013)

MOST PENALTIES BY LION IN TEST (Progressive)

NO.	PLAYER	TOUR	TEST
1	Charlie Adamson	1899	AUS 4
1	Arthur Harding	1904	NZ 1
1	Tom Voyce	1924	SA 4
1	Dai Parker	1930	NZ 4
3	Viv Jenkins	1938	SA 1
3	Stewart Wilson	1966	NZ 2
5	Tom Kiernan	1968	SA 1
5	Tony Ward	1980	SA 1
6	Gavin Hastings	1993	NZ 1
6	Jonny Wilkinson	2005	ARG 1

MOST CONVERSIONS BY LIONS IN TEST (Progressive)

NO.	OPPONENTS	TOUR	TEST
2	South Africa	1896	2
2	Australia	1899	4
2	South Africa	1903	1
2	Australia	1904	1,3
2	New Zealand	1930	2
2	Australia	1950	1
3	Australia	1950	2
4	South Africa	1955	1
5	Australia	1966	2

MOST CONVERSIONS BY LION IN TEST (Progressive)

NO.	PLAYER	TOUR	TEST
2	Fred Byrne	1896	SA 2
2	Charlie Adamson	1899	AUS 4
2	Jimmy Gillespie	1903	SA 1
2	Doug Prentice	1930	NZ 2
2	Lewis Jones	1950	AUS 1
2	John Robins	1950	AUS 2
4	Angus Cameron	1955	SA 1
5	Stewart Wilson	1966	AUS 2

MOST DROP GOALS BY LIONS IN TEST

NO.	OPPONENTS	TOUR	TEST
2	South Africa	1974	SA 3
2	Australia	1904	AUS 2

MOST DROP GOALS BY LIONS PLAYER IN TEST

NO.	OPPONENTS	TOUR	TEST
2	Phil Bennett	1974	SA 3
2	Percy Bush	1904	AUS 2

BRITISH & IRISH LIONS INDIVIDUAL RECORDS

MOST TEST POINTS

POINTS	PLAYER	TESTS
67	Jonny Wilkinson	6
66	Gavin Hastings	6
53	Stephen Jones	6
49	Leigh Halfpenny	3
44	Phil Bennett	8
41	Neil Jenkins	4

MOST TEST TRIES

NO.	PLAYER	TESTS
6	Tony O'Reilly	10
5	J.J. Williams	7
4	Willie Llewellyn	4
4	Malcolm Price	5
3	Carl Aarvold	5
3	Alf Bucher	3
3	Jeff Butterfield	4
3	Gerald Davies	5
3	D. Ken Jones	6
3	Jack Spoors	3

MOST TEST PENALTIES

NO.	PLAYER	TESTS
20	Gavin Hastings	6
16	Jonny Wilkinson	6
13	Leigh Halfpenny	3
13	Neil Jenkins	4
12	Stephen Jones	6
11	Tom Kiernan	5
10	Phil Bennett	8

MOST TEST CONVERSIONS

NO.	PLAYER	TESTS
10	Stephen Jones	6
7	Jonny Wilkinson	6
7	Stephen Jones	6
6	Stewart Wilson	5
5	Leigh Halfpenny	3
4	Lewis Jones	3
4	Charlie Adamson	4
4	Angus Cameron	2

MOST TEST DROP GOALS

NO.	PLAYER	TESTS
3	Percy Bush	4
2	Rob Andrew	5
2	Phil Bennett	8
2	David Watkins	6
2	Barry John	5

RECORDS FOR ALL LIONS GAMES

MOST POINTS

POINTS	PLAYER	GAMES
274	Andy Irvine	42
228	Phil Bennett	26
214	Bob Hiller	19
188	Barry John	21
184	Ollie Campbell	18
167	Gavin Hastings	16
152	Malcolm Thomas	32
142	Neil Jenkins	12
136	Charlie Adamson	20
127	Fred Byrne	21
124	Ronan O'Gara	15
119	Mike Gibson	68
118	David Hewitt	25
116	Jonny Wilkinson	9
114	Leigh Halfpenny	7
114	Tony O'Reilly	38
111	Tim Stimpson	7
104	Terry Davies	13
101	Percy Bush	18

MOST TRIES

NO.	PLAYER	GAMES
38	Tony O'Reilly	38
31	Randolph Aston	20
22	J.J. Williams	26
22	Andrew Stoddart	28
22	Mike Gibson	68
20	Andy Irvine	42
19	Peter Jackson	18
19	Larry Bulger	20
18	John Bevan	14
17	Arthur Smith	19
17	Tony Novis	19
16	Ken Jones	17
16	Dewi Bebb	32
16	Gareth Edwards	39
15	David Hewitt	25
15	Harry Eagles	35

MOST PENALTIES

NO.	PLAYER	GAMES
48	Phil Bennett	26
41	Gavin Hastings	16
40	Andy Irvine	42
35	Ollie Campbell	18
34	Bob Hiller	19
28	Barry John	21
26	Neil Jenkins	12
24	Jonny Wilkinson	9
22	Tom Kiernan	23
18	Doug Morgan	15
18	Dusty Hare	6
18	Stephen Jones	10

MOST CONVERSIONS

NO.	PLAYER	GAMES
44	Bob Hiller	19
35	Charlie Adamson	20
34	Andy Irvine	42
32	Arthur Rotherham	16
32	Ronan O'Gara	15
31	Barry John	21
31	Phil Bennett	26
31	Malcolm Thomas	32
30	Fred Byrne	21
27	Neil Jenkins	12

MOST DROP GOALS

NO.	PLAYER	GAMES
9	David Watkins	21
9	Ollie Campbell	18
8	Barry John	21
7	Craig Chalmers	7
5	Percy Bush	18
5	Ken Scotland	22
5	Mike Gibson	68
5	John Rutherford	10
4	Fred Byrne	21
4	Gordon Waddell	22
4	Bob Hiller	19

BRITISH & IRISH LIONS APPEARANCES

MOST TEST APPEARANCES

NO.	PLAYER	TOUR/TEST RECORD
17	Willie John McBride	1962 L L, 1966 L L L
		1968 L D L L, 1971 W L W D
		1974 W W W D
13	Dickie Jeeps	1955 W L W L
		1959 W W L L L, 1962 D L L L
12	Mike Gibson	1966 L L L L, 1968 L D L L
		1971 W L W D
	Graham Price	1977 L W L L, 1980 L L L W
		1983 L L L L
10	Tony O'Reilly	1955 W L W L
		1959 W W L L L W
	Rhys Williams	1955 W L W L
		1959 W W L L L W
	Gareth Edwards	1968 L D, 1971 W L W D
		1974 W W W D
9	Syd Millar	1959 W W L, 1962 D L L L
		1968 L D
	Andy Irvine	1974 W D, 1977 L W L L
		1980 L L W
8	Bryn Meredith	1955 W L W L, 1962 D L L L
	Noel Murphy	1959 W L L W, 1966 W W L L
	Dewi Bebb	1962 L L, 1966 W W L L L L
	Mike Campbell-Lamerton	1962 D L L L, 1966 W W L L
	Alun Pask	1962 D L L, 1966 W W L L L
	Jim Telfer	1966 W W L L L, 1968 D L L
	Mervyn Davies	1971 W L W D, 1974 W W W D
	Ian McLauchlan	1971 W L W D
		1974 W W W D
	J.P.R. Williams	1971 W L W D
		1974 W W W D
	Gordon Brown	1971 W D, 1974 W W W
		1977 W L L
	Phil Bennett	1974 W W W D, 1977 L W L L
	Ian McGeechan	1974 W W W D, 1977 L W L L
	Maurice Colclough	1980 L L L W, 1983 L L L L
	Jeremy Guscott	1989 W W, 1993 L W L
		1997 W W L
	Martin Johnson	1993 W L, 1997 W W L
		2001 W L L
	Brian O'Driscoll	2001 W L L, 2005 L, 2009 L L
		2013 W L

APPEARANCE RECORD TEST MATCHES (Progressive)

NO.	PLAYER	TOUR/TEST RECORD
3	11 Players	1891
7	Froude Hancock	1891/1896
7	Blair Swannell	1899/1904
8	Tony O'Reilly	1955/1959
8	Dickie Jeeps	1955/1959
8	Rhys Williams	1955/1959
9	Tony O'Reilly	1955/1959
9	Rhys Williams	1955/1959
10	Tony O'Reilly	1955/1959
10	Rhys Williams	1955/1959
10	Dickie Jeeps	1955/1959
11	Dickie Jeeps	1955/1959/1962
12	Dickie Jeeps	1955/1959/1962
13	Dickie Jeeps	1955/1959/1962
13	Willie John McBride	1962/1966/1968/1971
14	Willie John McBride	1962/1966/1968/1971/1974
15	Willie John McBride	1962/1966/1968/1971/1974
16	Willie John McBride	1962/1966/1968/1971/1974
17	Willie John McBride	1962/1966/1968/1971/1974

MOST CONSECUTIVE TEST APPEARANCES

NO.	PLAYER	TOUR/TEST RECORD
15	Willie John McBride	1966 NZ 3 4 5
		1968 SA 1 2 3 4
		1971 NZ 1 2 3 4
		1974 SA 1 2 3 4
12	Mike Gibson	1966 NZ 1 2 3 4
		1968 SA 1(R) 2 3 4
		1971 NZ 1 2 3 4
	Graham Price	1977 NZ 1 2 3 4
		1980 SA 1 2 3 4
		1983 NZ 1 2 3 4
10	Tony O'Reilly	1955 SA 1 2 3 4
		1959 AUS 1 2, NZ 1 2 3 4
	Rhys Williams	1955 SA 1 2 3 4
		1959 AUS 1 2 NZ 1 2 3 4

MOST APPEARANCES AS TEST CAPTAIN

NO.	PLAYER	TOUR
6	Ronnie Dawson	1959
	Martin Johnson	1997, 2001

MOST APPEARANCES ALL GAMES

NO.	PLAYER	TOUR/TEST RECORD
70	Willie John McBride	1962 11, 1966 21
		1968 11, 1971 14
		1974 13
68	Mike Gibson	1966 20, 1968 14
		1971 16, 1977 7, 1980 11
44	Syd Millar	1959 19, 1962 16, 1968 9
44	Delme Thomas	1966 17, 1968 12
		1971 15
42	Dickie Jeeps	1955 11, 1959 16
		1962 15
	Mike Campbell-Lamerton	1962 20, 1966 22
	Andy Irvine	1974 15, 1977 19, 1980 8
41	Frank Stout	1899 21, 1903 20
	Jack Jones	1908/1910
	Bryn Meredith	1955 15, 1959 12
		1962 14
	Gordon Brown	1971 14, 1974 12
		1977 15
39	Gareth Edwards	1968 8, 1971 16, 1974 15

APPEARANCE RECORD ALL MATCHES (PROGRESSIVE)

NO.	PLAYER	TOUR
35	Harry Eagles	1888
41	Frank Stout	1899/1903
	Jack Jones	1908/1910
42	Dickie Jeeps	1955/1959/1962
	Mike Campbell-Lamerton	1962/1966
43	Willie John McBride	1962/1966/1968
57	Willie John McBride	1962/1966/1968/1971
70	Willie John McBride	1962/1966/1968/1971/1974

MOST LIONS APPEARANCES BY COUNTRY

COUNTRY	GAMES	PLAYER	TOURS
ENGLAND	42	Dickie Jeeps	1955/1959/ 1962
	41	Frank Stout	1899/1903
	35	Harry Eagles	1888
	34	Fran Cotton	1974/1977/ 1980
	33	Froude Hancock	1891/1896
	32	Sam Williams	1888
		Blair Swannell	1899/1904
IRELAND	70	Willie John McBride	1962/1966/ 1968/1971/ 1974
	68	Mike Gibson	1966/1968/ 1971/ 1977/ 1980
	44	Syd Millar	1959/1962/ 1968
	38	Tony O'Reilly	1955/1959
	37	Noel Murphy	1959/1966
	32	Bill Mulcahy	1959/1962
SCOTLAND	42	Mike Campbell-Lamerton	1962/1966
		Andy Irvine	1974/1977/ 1980
	41	Gordon Brown	1971/1974/ 1977
	34	Hugh McLeod	1955/1959
		Jim Telfer	1966/1968
	30	Ian McLauchlan	1971/1974
		Robbie Burnet	1888
WALES	44	Delme Thomas	1966/1968/ 1971
	41	Jack Jones	1908/1910
		Bryn Meredith	1955/1959/ 1962
	39	Gareth Edwards	1968/1971/ 1974
	38	Rhys Williams	1955/1959
	37	Graham Price	1977/1980 1983

MOST INDIVIDUAL POINTS IN ALL GAMES (Progressive)

POINTS	PLAYER	TOUR	OPPONENTS
6	Harry Speakman	1888	Otago
7	Andrew Stoddart	1888	NSW
8	Andrew Stoddart	1888	Adelaide XV
9	William Mitchell	1891	Port Elizabeth
14	Arthur Rotherham	1891	Eastern Province
15	Arthur Rotherham	1891	Transvaal Country
19	Fred Byrne	1896	King William's Town
21	Malcolm Thomas	1950	Combined XV
21	Malcolm Thomas	1950	NSW Combined XV
21	David Hewitt	1959	Queensland
21	David Hewitt	1959	Hawke's Bay
25	Malcolm Thomas	1959	Combined XV
37	Alan Old	1974	SW Districts

MOST TRIES IN TOUR MATCH

NO.	PLAYER	TOUR	OPPONENTS
6	David Duckham	1971	West Coast-Buller Districts
6	J.J. Williams	1974	Districts
5	Billy Wallace	1924	Griqualand West
5	Arthur Smith	1955	East African XV
5	Andy Irvine	1977	King Country-Wanganui
5	Jason Robinson	2001	Queensland Pres XV
5	Shane Williams	2005	Manawatu Turbos

RECORDS AGAINST THE LIONS

MOST POINTS CONCEDED IN TEST

POINTS	OPPONENTS	TOUR	VENUE
48	New Zealand	2005	Wellington
38	New Zealand	2005	Auckland
38	New Zealand	1983	Auckland
35	Australia	2001	Melbourne
35	South Africa	1997	Johannesburg
34	South Africa	1962	Bloemfontein
32	New Zealand	1908	Dunedin

BIGGEST LOSING MARGIN

POINTS	SCORE	OPPONENTS	TOUR	VENUE
32	6–38	New Zealand	1983	Auckland
30	18–48	New Zealand	2005	Wellington
29	0–29	New Zealand	1908	Auckland
27	5–32	New Zealand	1908	Dunedin
21	14–35	Australia	2001	Melbourne
20	14–34	South Africa	1962	Bloemfontein

MOST TRIES CONCEDED IN TEST

NO.	OPPONENTS	TOUR	TEST NO.
9	New Zealand	1908	3
7	South Africa	1955	2
	New Zealand	1908	1
6	New Zealand	1930	4
	South Africa	1962	4
	New Zealand	1983	4

MOST POINTS BY INDIVIDUAL IN TEST

POINTS	PLAYER	TEAM	TOUR	TEST
33	Dan Carter	NZ	2005	NZ 2
25	Matthew Burke	AUS	2001	AUS 2
20	Federico Todeschini	ARG	2005	ARG
19	Matthew Burke	AUS	2001	AUS 3
18	Don Clarke	NZ	1959	NZ 1
18	Allan Hewson	NZ	1983	NZ 4
16	Keith Oxlee	SA	1962	SA 4
15	Grant Fox	NZ	1983	NZ 2

TEAM RECORDS IN ALL GAMES

RECORD SCORE IN ALL GAMES (PROGRESSIVE)

POINTS	OPPONENT	TOUR	VENUE
28	Adelaide XV	1888	Australia
32	Western Province	1896	South Africa
36	Bundaberg	1899	Australia
37	King William's Town	1903	South Africa
45	Transvaal Country	1910	South Africa
71	Western Australia	1930	Australia
97	SW Districts	1974	South Africa
116	Western Australia	2001	Australia

MOST POINTS IN TOUR MATCH

POINTS	OPPONENT	TOUR	VENUE
116	Western Australia	2001	Perth
109	Manawatu	2005	Palmerston North
97	SW Districts	1974	Mossel Bay

MOST TRIES IN TOUR MATCH

NO.	OPPONENT	TOUR	VENUE
18	Western Australia	2001	Perth
17	Manawatu	2005	Palmerston North
16	SW Districts	1974	Mossel Bay
	Eastern Canada	1959	Toronto
	Western Australia	1930	Perth

◄ New Zealand fly-half Dan Carter holds the record for the most points scored against the Lions in a single Test

BRITISH & IRISH LIONS RECORDS AT TEST VENUES

OPPONENTS	GROUND	P	W	D	L	WIN %
AUSTRALIA	Sydney Cricket Ground	8	6	0	2	75
	Exhibition Ground, Brisbane	3	3	0	0	100
	Sydney Football Stadium	2	1	0	1	50
	The Gabba, Brisbane	2	2	0	0	100
	Ballymore, Brisbane	1	1	0	0	100
	Sydney Sports Ground	1	1	0	0	100
	Suncorp Stadium, Brisbane (Lang Park)	2	2	0	0	100
	Etihad Stadium, Melbourne	2	0	0	2	0
	ANZ Stadium, Sydney (Stadium Australia)	2	1	0	1	50
	OVERALL	23	17	0	6	74
NEW ZEALAND	Athletic Park, Wellington	10	2	1	7	20
	Eden Park, Auckland	9	1	1	7	11
	Lancaster Park, Christchurch	9	1	0	8	11
	Carisbrook, Dunedin	8	2	1	5	25
	Potter's Park, Auckland	1	0	0	1	0
	Westpac Stadium, Wellington	1	0	0	1	0
	OVERALL	38	6	3	29	16
SOUTH AFRICA	Newlands, Cape Town	12	4	0	8	33
	Ellis Park, Johannesburg	7	2	2	3	29
	Crusader's Ground, Port Elizabeth	6	3	1	2	50
	Loftus Versfeld, Pretoria	5	3	0	2	60
	Wanderers Ground, Johannesburg	4	1	1	2	25
	EPRFU Stadium, Port Elizabeth	3	1	1	1	33
	King's Park, Durban	3	1	0	2	33
	Athletic Club, Kimberley	2	1	1	0	50
	Free State Stadium, Bloemfontein	2	0	0	2	0
	Eclectic Cricket Ground, Kimberley	1	1	0	0	100
	Kingsmead, Durban	1	0	0	1	0
	OVERALL	46	17	6	23	37
WALES	Millennium Stadium, Cardiff	1	0	1	0	0
	OVERALL	1	0	1	0	0

LIONS FIRSTS

IN NEW ZEALAND (FIRST TOUR)

First Match: v. Otago (28 April 1888) at the Caledonian Ground, Dunedin

First Win: v. Otago (28 April 1888). The Lions won 8–3 in front of 8,000 fans

First Points/Try: Thomas Kent v. Otago (28 April 1888)

First Conversion: Jack Anderton v. Otago (2 May 1888) at the Caledonian Ground, Dunedin

First Drop Goal: Harry Speakman v. Otago (28 April 1888)

First Points Conceded: D. Simpson – drop goal for Otago (Caledonian Ground, Dunedin, 28 April 1888)

First Defeat: lost to Taranaki Clubs 1–0 (16 May 1888) at the Racecourse, New Plymouth

IN AUSTRALIA (FIRST TOUR)

First Match: v. New South Wales (2 June 1888) at the Association Cricket Ground, Sydney

First Win: v. New South Wales (2 June 1888). Lions won 18–2 in front of 18,000 fans

First Points: Harry Eagles v. New South Wales (2 June 1888)

First Try: Harry Eagles v. New South Wales (2 June 1888)

First Conversion: Jack Anderton v. New South Wales (2 June 1888)

First Drop Goal: Andrew Stoddart v. University of Sydney (11 August 1888) at the Agricultural Society Ground

First Defeat: There were no defeats in Australia in 1888, so the first loss on Australian soil came in 1899 in 1st Test v. Australia (29 June 1899)

First Points Conceded: Arthur Hale – try for New South Wales (Sydney, 2 June 1888)

FIRST OFFICIAL TOUR

First Official Tour: 1891 to South Africa, sanctioned by RFU

First Captain: Bill Maclagan (Scotland)

First Match: v. Cape Town (Port Elizabeth, 9 July 1891)

First Win: beat Cape Town 1–15 (Port Elizabeth, 9 July 1891)

First Points: William Wotherspoon penalty goal v. Cape Town (Port Elizabeth, 9 July 1891)

First Try: Randolph Aston v. Cape Town (Port Elizabeth, 9 July 1891)

First Conversion: William Wotherspoon v. Cape Town (Port Elizabeth, 9 July 1891)

First Penalty Goal: William Wotherspoon v. Cape Town (Port Elizabeth, 9 July 1891)

First Drop Goal: Randolph Aston v. Cape Town (Port Elizabeth, 9 July 1891)

First Defeat: lost to South Africa 5–0 (4th Test, Port Elizabeth, 5 September 1896)

First Points Conceded: Hasie Versfeld – try for Cape Town (Port Elizabeth, 9 July 1891)

TEST MATCHES

First Test: v. South Africa (Port Elizabeth, 30 July 1891)

First Win: beat South Africa 0–4 (1st Test, Port Elizabeth, 30 July 1891)

First Points: Randolph Aston v. South Africa (Port Elizabeth, 30 July 1891)

First Try: Randolph Aston v. South Africa (Port Elizabeth, 30 July 1891)

First Conversion: Arthur Rotherham v. South Africa (Port Elizabeth, 30 July 1891)

First Penalty: Charles Adamson v. Australia (Sydney, 5 August 1899)

First Drop Goal: William Mitchell v. South Africa (Kimberley, 29 August 1891)

First Defeat: lost to South Africa 5–0 (4th Test, Port Elizabeth, 5 September 1896)

First Points Conceded: Theo Samuels with try for South Africa (2nd Test, Johannesburg, 22 August 1896)

First Sending-Off: Denys Dobson v. Northern Districts, Newcastle on 6 July 1904 for allegedly swearing at the referee. The only other Lion to be dismissed was John O'Shea for punching in game v. Eastern Province on 29 June 1968 at Springs

First Replacement: Barrie Bresnihan v. Western Transvaal on 18 May 1968. He replaced Mike Gibson, who then went on to become the first replacement used in an international match in world rugby when he took over from the injured Barry John in 1st Test v. Springboks on 8 June 1968 in Pretoria

▲ Andrew Stoddart, who took over the captaincy of the 1888 tour after the death of Robert Seddon, was the scorer of the Lions' first drop goal on Australian soil

MISCELLANEOUS

In 1888, the original Lions not only played 35 games of rugby, but also took part in 19 matches under the Victorian Rules (now better known as Australian or 'Aussie' Rules). The full list of results for those matches is listed below, along with the scorecard from the game of cricket they played while in New Zealand.

1888 BRITISH & IRISH LIONS VICTORIAN RULES RESULTS IN AUSTRALIA

16/06/88	L	Carlton	14–3	Lions	Melbourne Cricket Ground
20/06/88	W	Bendigo	1–5	Lions	Back Creek Cricket Ground
21/06/88	D	Castlemaine	1–1	Lions	Camp Reserve Ground
24/06/88	L	South Melbourne	7–3	Lions	S. Melbourne Cricket Ground
27/06/88	L	Maryborough	4–3	Lions	Prince's Park
29/06/88	L	South Ballarat	7–3	Lions	Eastern Oval
30/06/88	L	Fitzroy	12–3	Lions	Fitzroy Cricket Ground
03/07/88	L	Port Melbourne	7–6	Lions	E. Melbourne Cricket Ground
07/07/88	L	South Adelaide	8–5	Lions	Adelaide Oval
10/07/88	W	Port Adelaide	7–8	Lions	Adelaide Oval
12/07/88	L	Adelaide	6–3	Lions	Adelaide Oval
14/07/88	L	Norwood	5–3	Lions	Adelaide Oval
18/07/88	W	Horsham	0–6	Lions	Horsham Recreational Reserve
20/07/88	L	Ballarat Imperial	4–1	Lions	Saxon Paddock Reserve
21/07/88	W	Ballarat	4–5	Lions	Saxon Paddock Reserve
25/07/88	W	Sandhurst	2–3	Lions	Back Creek Cricket Ground
26/07/88	W	Kyneton	1–2	Lions	Kyneton Ground
28/07/88	L	Essendon	7–3	Lions	E. Melbourne Cricket Ground
14/08/88	L	Maitland	4–2	Lions	The Albion Ground

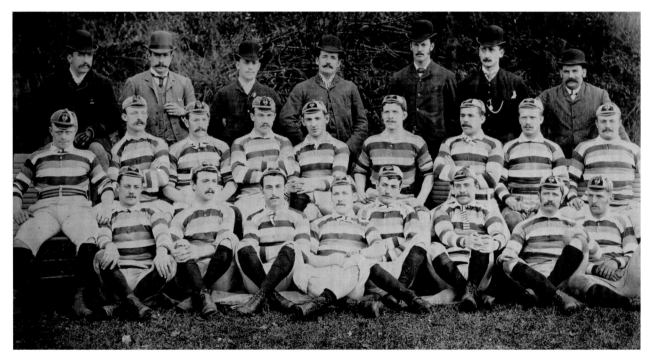

▲ The 1888 tourists turned their hands to both Victorian Rules football and cricket during their time down under

CANTERBURY V. ENGLISH FOOTBALL

LANCASTER PARK, CHRISTCHURCH, 28 SEPTEMBER 1888

The 'English Footballers', as the first Lions tourists were described wherever they went, played a one-day cricket match at Lancaster Park in aid of the Midland Cricket Club. The 'Lions' XI contained three England cricket captains in Andrew Stoddart, Arthur Shrewsbury and James Lillywhite. They also had a Lancashire first-class cricketer in their side, Arthur Paul. Many of the Canterbury team had already met Shrewsbury once or twice earlier in the year when he was at the helm of an English team touring Australasia under his own name. The 'Lions' fielded one guest in 'Matthews'.

In the home side were three expats who played cricket for New Zealand: London-born Andrew Labatt and the Welsh duo of John Fowke and Fred Wilding. Fowke was from Tenby and Wilding from Montgomery.

Stoddart captained the team, won the toss and elected to bat. He went into bat in the second innings without any pads. The game ended in a draw.

English Footballers 1st Innings

A.E. Stoddart	c H.M. Reeves b Wilding	16
A. Shrewsbury	c and b Rayner	32
A.G. Paul	b Wilding	12
J.T. Haslam	b Wilding	2
Dr J. Smith	b Rayner	8
J. Lillywhite	c and b Rayner	1
R. Burnet	b Wilding	0
A. Penketh	not out	4
W. Thomas	c Harman b Rayner	0
J. Anderton	c Fowke b Rayner	1
Matthews	c and b Wilding	3
Extras		9
Total (all out, 37.3 overs)		88

Canterbury bowling	Overs	Mdns	Runs	Wkts
Rayner	11	1	23	5
Wilding	18.3	5	33	5
Halley	8	1	24	0

Canterbury 1st Innings

W.P. Reeves	b Stoddart	1
H.M. Reeves	b Paul	11
W.E.P. Barnes	c Stoddart b Lillywhite	2
E.J. Cotterill	c Lillywhite b Stoddart	2
G.L. Rayner	c and b Stoddart	11
R.D. Harman	c and b Stoddart	2
A.B.M. Labatt	c and b Paul	12
F. Wilding	b Paul	0
J.N. Fowke	run out	1
R. Halley	c Smith b Paul	3
S. McMurray	not out	0
Extras		9
Total (all out, 46 overs)		54

English bowling

English bowling	Overs	Mdns	Runs	Wkts
Stoddart	25	11	16	4
Paul	13	6	11	4
Lillywhite	8	1	18	1

English Footballers 2nd Innings

A.E. Stoddart	run out	13
A. Shrewsbury	b Barnes	46
A.G. Paul	c Halley b Wilding	6
J.T. Haslam	c McMurray b Halley	1
Dr J. Smith	c Barnes b Halley	1
J. Lillywhite	run out	3
R. Burnet	b Barnes	0
A. Penketh	b Wilding	7
W. Thomas	lbw b McMurray	3
J. Anderton	not out	0
Matthews	b Barnes	1
Extras		7
Total (all out, 39 overs)		88

Canterbury bowling	Overs	Mdns	Runs	Wkts
Rayner	4	1	14	0
Wilding	11	1	31	2
Halley	12	2	27	2
McMurray	8	3	5	1
Barnes	3.4	1	4	3

THE A–Z LIST OF THE BRITISH & IRISH LIONS PLAYERS

SURNAME	KNOWN AS	CLUB/COUNTRY	TOUR	APPS	PTS	TESTS
AARVOLD	Carl	Headingley/Eng	1930	19	30	1,2,3,4,5
ACKERMAN	Rob	London Welsh/Wal	1983	10	4	1
ACKFORD	Paul	Harlequins/Eng	1989	8	0	1,2,3
ADAMSON	Charles	Durham	1899	20	136	1,2,3,4
ALEXANDER	Robert	NIFC/Ire	1938	14	18	1,2,3
ANDERTON	Jack	Salford	1888	29	38	
ANDREW	Rob	Wasps/Eng	1989	6	16	2,3
			1993	7	24	1,2,3
ARCHER	Herbert	Guy's Hospital	1908	18	6	1,2,3
ARMSTRONG	Gary	Jedforest/Scot	1989	5	20	
ARNEIL	Rodger	Edinburgh Accies/Scot	1968	12	0	1,2,3,4
		Leicester/Scot	1971	5	0	
ASHBY	Willie	Queen's College, Cork	1910	2	6	
ASHCROFT	Alan	Waterloo/Eng	1959	18	6	1,4
ASTON	Randolph	Blackheath/Eng	1891	20	44	1,2,3
AYRE-SMITH	Alan	Guy's Hospital	1899	17	6	1,2,3,4
BACK	Neil	Leicester Tigers/Eng	1997	8	5	2,3
			2001	5	15	2,3
			2005	3	5	1
BAINBRIDGE	Steve	Gosforth/Eng	1983	11	0	3,4
BAIRD	Roger	Kelso/Scot	1983	11	24	1,2,3,4
BAKER	Doug	Old Millhillians/Eng	1955	16	21	3,4
BAKER	Melville	Newport	1910	12	18	3
BALSHAW	Iain	Bath/Eng	2001	8	10	1,2,3
BANKS	Tom	Swinton	1888	9	4	
BARNES	Stuart	Bath/Eng	1993	8	33	
BARRITT	Brad	Sarcens/Eng	2013	2	0	0
BASSETT	Jack	Penarth/Wal	1930	15	5	1,2,3,4,5
BATEMAN	Allan	Richmond/Wal	1997	7	5	3
BAYFIELD	Martin	Northampton/Eng	1993	7	0	1,2,3
BEAL	Nick	Northampton/Eng	1997	5	20	
BEAMISH	George	Leicester/Ire	1930	21	6	1,2,3,4,5
BEATTIE	John	Glasgow Accies/Scot	1980	8	8	
			1983	9	16	2
BEAUMONT	Bill	Fylde/Eng	1977	10	8	2,3,4
			1980	10	0	1,2,3,4
BEBB	Dewi	Swansea/Wal	1962	9	6	2,3
			1966	23	42	1,2,3,4,5,6
BEDELL-SIVRIGHT	David	Cambridge Uni/Scot	1903	12	3	
		West of Scotland/Scot	1904	9	25	1
BELL	Sydney	Cambridge Uni	1896	14	9	2,3,4
BELSON	Fred	Bath	1899	7	0	1
BENNETT	Phil	Llanelli/Wal	1974	11	103	1,2,3,4
			1977	15	125	1,2,3,4
BENTLEY	John	Newcastle/Eng	1997	8	35	2,3
BERGIERS	Roy	Llanelli/Wal	1974	10	8	
BEST	Rory	Ulster/Ire	2013	4	0	0

BEVAN	John	Cardiff COE/Wal	1971	14	54	1
BEVAN	John	Aberavon/Wal	1977	12	4	
BEVAN	Sid	Swansea/Wal	1904	17	9	1,2,3,4
BIGGAR	Alastair	London Scottish/Scot	1971	10	27	
BLACK	Angus	Edinburgh Uni/Scot	1950	9	0	1,2
BLACK	Brian	Oxford Uni/Eng	1930	19	77	1,2,3,4,5
BLAIR	Mike	Edinburgh/Sco	2009	3	0	
BLAKEWAY	Phil	Gloucester/Eng	1980	1	0	
BLAKISTON	Arthur	Blackheath/Eng	1924	14	33	1,2,3,4
BONNER	Gordon	Bradford	1930	10	4	
BORDASS	James	Cambridge Uni	1924	11	0	
BOWCOTT	Harry	Cambridge Uni/Wal	1930	20	24	1,2,3,4,5
BOWE	Tommy	Ulster/Ire	2009	6	20	1,2,3
			2013	4	5	2,3
BOYD	Cecil	Dublin Uni/Ire	1896	12	0	1
BOYLE	Vesey	Dublin Uni/Ire	1938	12	18	2,3
BOYLE	Steve	Gloucester/Eng	1983	6	0	
BRACKEN	Kyran	Saracens/Eng	1997	1	5	
BRADLEY	Michael	Dolphin/Ire	1924	13	3	
BRAND	Tom	NIFC	1924	6	0	1,2
BRESNIHAN	Barry	Wanderers/Ire	1966	11	15	
		UC Dublin/Ire	1968	15	6	1,2,4
BROMET	Edward	Cambridge Uni	1891	14	10	2,3
BROMET	William	Richmond/Eng	1891	19	0	1,2,3
BROOKS	Herbert	Edinburgh Uni	1888	17	6	
BROPHY	Niall	Blackrock/Ire	1959	1	0	
			1962	8	18	1,3
BROWN	Gordon	West Of Scotland/Scot	1971	14	0	3,4
			1974	12	32	1,2,3
			1977	15	4	2,3,4
BROWN	John	Blackheath	1962	5	9	
BUCHER	Alf	Edinburgh Accies/Scot	1899	17	24	1,3,4
BUDGE	Graham	Edinburgh Wands/Scot	1950	14	0	4
BULGER	Lawrence	Dublin Uni/Ire	1896	20	57	1,2,3,4
BULLOCH	Gordon	Glasgow/Scot	2001	4	0	1
			2005	6	0	3
BUMBY	Walter	Swinton	1888	23	8	
BURCHER	David	Newport/Wal	1977	15	20	3
BURNELL	Andrew	London Scottish/Scot	1993	7	0	1
BURNET	Robert	Hawick	1888	30	3	
BURNET	William	Hawick	1888	22	1	
BURTON	Mike	Gloucester/Eng	1974	8	0	
BUSH	Percy	Cardiff	1904	18	101	1,2,3,4
BUTLER	Eddie	Pontypool/Wal	1983	1	0	
BUTTERFIELD	Jeff	Northampton/Eng	1955	12	30	1,2,3,4
			1959	9	0	
BYRNE	Fred	Moseley/Eng	1896	21	127	1,2,3,4
BYRNE	Lee	Ospreys/Wal	2009	4	10	1
BYRNE	Shane	Leinster/Ire	2005	7	0	Arg,1,2,3
CALDER	Finlay	Stew Melville/Scot	1989	6	0	1,2,3

CALDER	Jim	Stew Melville/Scot	1983	7	12	3
CAMERON	Angus	Glasgow HSFP/Scot	1955	9	44	1,2
CAMPBELL	Ollie	Old Belvedere/Ire	1980	7	60	2,3,4
			1983	11	124	1,2,3,4
CAMPBELL-LAMERTON	Mike	Halifax/Scot	1962	20	9	1,2,3,4
		London Scottish/Scot	1966	22	0	1,2,3,5
CAREY	Walter	Oxford Uni	1896	17	6	1,2,3,4
CARLETON	John	Orrell/Eng	1980	10	12	1,2,4
			1983	11	36	2,3,4
CARLING	Will	Harlequins/Eng	1993	7	8	1
CARMICHAEL	Sandy	West Of Scotland/Scot	1971	6	3	
			1974	10	0	
CATT	Mike	Bath/Eng	1997	6	13	3
			2001	1	0	
CAVE	William	Cambridge Uni	1903	19	6	1,2,3
CHALMERS	Craig	Melrose/Scot	1989	7	28	1
CHAPMAN	Fred	Hartlepool Rovers	1908	12	24	3
CHARVIS	Colin	Swansea/Wal	2001	4	10	1,3
CHILCOTT	Gareth	Bath/Eng	1989	5	4	
CLARKE	Ben	Bath/Eng	1993	8	0	1,2,3
CLAUSS	Paul	Birkenhead Park/Scot	1891	12	9	1,2,3
CLEAVER	Billy	Cardiff/Wal	1950	15	21	1,2,3
CLEMENT	Bill	Llanelli/Wal	1938	6	12	
CLEMENT	Tony	Swansea/Wal	1989	2	4	
			1993	7	13	
CLIFFORD	Tom	Young Munster/Ire	1950	18	17	1,2,3,5,6
CLINCH	Andrew	Dublin Uni/Ire	1896	21	0	1,2,3,4
CLINCH	Jamie	Dublin Uni/Ire	1924	12	3	
CLOWES	Jack	Halifax	1888	0	0	
COBNER	Terry	Pontypool/Wal	1977	11	12	1,2,3
COCKBAIN	Brent	Ospreys/Wal	2005	2	0	
COHEN	Ben	Northampton Saints/Eng	2001	4	10	
COLCLOUGH	Maurice	Angouleme/Eng	1980	11	4	1,2,3,4
			1983	11	0	1,2,3,4
COLE	Dan	Leicester Tigers/Eng	2013	9	0	1,2,3
COLLETT	Gilbert	Gloucestershire	1903	20	32	1,2,3
CONNELL	Gordon	London Scottish/Scot	1968	3	0	4
COOKSON	George	Manchester	1899	18	12	1,2,3,4
COOPER	Gareth	Dragons/Wal	2005	4	5	Arg
CORBISIERO	Alex	London Irish/Eng	2013	5	5	1,3
CORRY	Martin	Leicester Tigers/Eng	2001	7	0	1,2,3
			2005	9	10	Arg,1,2,3
COTTON	Fran	Coventry/Eng	1974	14	0	1,2,3,4
			1977	16	0	2,3,4
		Sale/Eng	1980	4	0	
COUCHMAN	Stan	Old Cranleighans	1938	11	6	
COUGHTRIE	Stan	Edinburgh Accies/Sco	1959	2	3	
COULMAN	Mike	Moseley/Eng	1968	10	3	3
COURT	Tom	Ulster/Ire	2013	1	0	0
COVE-SMITH	Ronald	Old Merchant Taylors'/Eng	1924	13	5	1,2,3,4

COWAN	Ron	Selkirk/Scot	1962	10	15	4
CROFT	Tom	Leicester Tigers/Eng	2009	6	15	1,2,3
			2013	5	10	1,2
CREAN	Edward	Liverpool	1910	4	0	
CREAN	Tom	Dublin Wands/Ire	1896	21	18	1,2,3,4
CROMEY	George	Queen's Uni, Belfast/Ire	1938	11	6	3
CRONIN	Damian	London Scottish/Scot	1993	6	5	
CROWTHER	Sidney	Lennox	1904	18	3	1,2,3,4
CUETO	Mark	Sale Sharks/England	2005	5	15	3
CUSITER	Chris	Borders/Sco	2005	6	0	Arg
CUNNINGHAM	Vince	St Mary's College/Ire	1993	3	10	
CUNNINGHAM	William	Lansdowne/Ire	1924	3	7	3
CUTHBERT	Alex	Cardiff Blues/Wal	2013	4	20	1
DALLAGLIO	Lawrence	London Wasps/Eng	1997	7	5	1,2,3
			2001	2	0	
			2005	1	0	
DANCER	Gerry	Bedford	1938	15	6	1,2,3
D'ARCY	Gordon	Leinster/Ire	2005	7	10	Arg
			2009	3	0	
DAVEY	James	Redruth/Eng	1908	13	15	1
DAVID	Tom	Llanelli/Wal	1974	9	20	
DAVIDGE	Glyn	Newport/Wal	1962	3	0	
DAVIDSON	Ian	NIFC/Ire	1903	13	22	1
DAVIDSON	Jeremy	London Irish/Ire	1997	8	0	1,2,3
		Castres Olympique/Ire	2001	5	0	
DAVIES	Cliff	Cardiff/Wal	1950	12	3	4
DAVIES	Dai	Somerset Police/Wal	1950	14	0	3,4,5
DAVIES	Douglas	Hawick/Scot	1924	14	5	1,2,3,4
DAVIES	Gareth	Cardiff/Wal	1980	4	34	2
DAVIES	Gerald	Cardiff/Wal	1968	9	9	3
		Cambridge Uni/London Welsh/Wal	1971	10	30	1,2,3,4
DAVIES	Harold	Newport/Wal	1924	9	7	2
DAVIES	Jonathan	Scarlets/Wal	2013	7	15	1,2,3
DAVIES	Mervyn	London Welsh/Wal	1971	14	9	1,2,3,4
		Swansea/Wal	1974	12	20	1,2,3,4
DAVIES	Phil	Harlequins/Eng	1955	14	24	1,2,3
DAVIES	Terry	Llanelli/Wal	1959	13	104	4,6
DAWES	John	London Welsh/Wal	1971	19	18	1,2,3,4
DAWSON	Matt	Northampton Saints/Eng	1997	6	15	1,2,3
			2001	7	21	2,3
			2005	6	0	1,3
DAWSON	Ronnie	Wanderers/Ire	1959	18	6	1,2,3,4,5,6
DEAN	Paul	St Mary's College/Ire	1989	1	0	
DEANS	Colin	Hawick/Scot	1983	7	8	
DEE	John	Hartlepool Rovers/Eng	1962	12	9	
DEVEREUX	John	Bridgend/Wal	1989	5	8	
DIBBLE	Bob	Bridgewater Albion/Eng	1908	22	0	1,2,3
DIPROSE	Tony	Saracens/Eng	1997	2	0	
DIXON	Peter	Harlequins/Eng	1971	15	6	1,2,3
DOBSON	Denys	Devon/Eng	1904	16	6	1,2,3,4

DODGE	Paul	Leicester/Eng	1980	5	4	3,4
DODS	Peter	Gala/Scot	1989	5	66	
DOOLEY	Wade	Preston G'hoppers/Eng	1989	6	8	2,3
			1993	3	0	
DORAN	Gerry	Lansdowne/Ire	1899	12	18	1
DOUGLAS	John	Stewart's Coll FP/Scot	1962	10	3	
DOWN	Percy	Bristol	1908	21	0	1,2,3
DOYLE	Mick	Blackrock/Ire	1968	11	6	1
DRYSDALE	Dan	Heriot's FP/Scot	1924	13	3	1,2,3,4
DUCKHAM	David	Coventry/Eng	1971	17	33	2,3,4
DUFF	Laurie	Glasgow Accies/Scot	1938	14	12	2,3
DUGGAN	Willie	Blackrock/Ire	1977	15	8	1,2,3,4
DUNNE	Mick	Lansdowne/Ire	1930	11	3	
DYKE	John	Penarth/Wal	1908	13	11	
EAGLES	Harry	Swinton	1888	35	24	
EARLS	Keith	Munster/Ire	2009	5	10	
EASTERBY	Simon	Scarlets/Ire	2005	5	5	2,3
EDWARDS	Gareth	Cardiff/Wal	1968	8	18	1,2
			1971	16	9	1,2,3,4
			1974	15	31	1,2,3,4
EDWARDS	Reg	Malone/Ire	1904	12	3	2,34
ELLIOT	Tom	Gala/Scot	1955	8	0	
ELLIS	Harry	Leicester Tigers/Eng	2009	5	0	3
ENGLISH	Mick	Bohemians/Ire	1959	2	0	
EVANS	Bob	Newport/Wal	1950	16	6	1,2,3,4,5,6
EVANS	Gareth	Newport/Wal	1977	18	24	2,3,4
EVANS	Geoff	London Welsh/Wal	1971	6	3	
EVANS	Geoff	Coventry/Eng	1974	8	16	
EVANS	Gwyn	Maesteg/Wal	1983	12	21	3,4
EVANS	Ian	Ospreys/Wal	2013	4	0	0
EVANS	Ieuan	Llanelli/Wal	1989	8	8	1,2,3
			1993	7	20	1,2,3
			1997	5	15	1
EVANS	Roddy	Cardiff/Wal	1959	18	3	2,3,4,5
EVANS	Trevor	Swansea/Wal	1977	14	0	1
EVERS	Guy	Moseley	1899	16	6	2,3,4
FALETAU	Toby	NG Dragons/Wal	2013	7	0	3
FARRELL	James	Bective Rangers/Ire	1930	17	8	1,2,3,4,5
FARRELL	Owen	Saracens/Eng	2013	7	51	3
FAULKNER	Tony	Pontypool/Wal	1977	3	0	
FAULL	John	Swansea/Wal	1959	20	60	1,3,5,6
FENWICK	Steve	Bridgend/Wal	1977	12	15	1,2,3,4
FERRIS	Stephen	Ulster/Ire	2009	2	10	
FISHER	John	Hull & East Riding	1904	3	3	
FITZGERALD	Ciaran	St Mary's College/Ire	1983	11	0	1,2,3,4
FITZGERALD	Luke	Leinster/Ire	2009	5	5	2
FLUTEY	Riki	London Wasps/Eng	2009	6	0	3
FORD	Ross	Edinburgh/Sco	2009	6	0	3
FOSTER	Alex	Derry/Ire	1910	17	27	1,2
FRANCOMB	John	Manchester	1899	9	3	1

GABE	Rhys	Cardiff/Wal	1904	17	15	1,2,3,4
GAISFORD	Wilf	St Bart's Hospital	1924	0	0	
GALWEY	Mick	Shannon/Ire	1993	7	5	
GIBBS	Reggie	Cardiff/Wal	1908	16	67	1,2
GIBBS	Scott	Swansea/Wal	1993	7	10	2,3
			1997	6	0	1,2,3
			2001	2	5	
GIBSON	George	Northern	1899	17	3	1,3,4
GIBSON	Mike	Cambridge Uni/Ire	1966	20	38	3,4,5,6
		NIFC/Ire	1968	14	24	1,2,3,4
			1971	16	23	1,2,3,4
			1974	7	10	
			1977	11	24	
GIBSON	Tom	Cambridge Uni	1903	20	0	1,2,3
GILES	Jimmy	Coventry/Eng	1938	15	23	1,3
GILLESPIE	John	Edinburgh Accies /Scot	1903	19	27	1,2,3
GODWIN	Herbert	Coventry/Eng	1962	9	0	
GOODALL	Ken	City Of Derry/Ire	1968	1	0	
GOULD	John	Old Leysians	1891	12	0	1,2
GRACE	Tom	St Mary's College/Ire	1974	11	52	
GRANT	David	Hawick/Scot	1966	10	0	
GRANT	Ryan	Glasgow Warriors/Sco	2013	3	0	0
GRAVELL	Ray	Llanelli/Wal	1980	11	4	1,2,3,4
GRAVES	Bob	Wanderers/Ire	1938	13	3	1,3
GRAY	Hugh	Coventry	1899	17	6	1,2
GRAY	Richie	Unattached/Sco	2013	6	0	3
GRAYSON	Paul	Northampton Saints/Eng	1997	1	0	
GREEN	Bob	Neath	1908	4	0	
GREENING	Phil	London Wasps/Eng	2001	0	0	
GREENWOOD	Jim	Dunfermline/Scot	1955	16	9	1,2,3,4
GREENWOOD	Will	Leicester Tigers	1997	6	5	
		Harlequins/Eng	2001	4	5	
			2005	5	5	1,3
GREIG	Louis	United Services	1903	17	9	1,2,3
GREWCOCK	Danny	Saracens/Eng	2001	7	5	Arg,1,2,3
		Bath/Eng	2005	4	0	1
GRIEVE	Charles	The Army/Scot	1938	9	8	2,3
GRIFFITHS	Gareth	Cardiff/Wal	1955	12	9	2,3,4
GRIFFITHS	Mike	Bridgend/Wal	1989	6	0	
GRIFFITHS	Roland	Newport	1908	7	27	
GRIFFITHS	Vince	Newport/Wal	1924	13	12	3,4
GUSCOTT	Jeremy	Bath/Eng	1989	6	4	2,3
			1993	9	10	1,2,3
			1997	7	23	1,2,3
HALFPENNY	Leigh	Cardiff Blues/Wal	2009	1	0	
		Cardiff Blues/Wal	2013	6	114	1,2,3
HALL	Mike	Bridgend/Wal	1989	6	12	1
HAMMOND	John	Blackheath	1891	20	0	1,2,3
		Richmond	1896	7	6	2,4
HANCOCK	Pat	Richmond	1903	16	3	1,2,3

HANCOCK	Froude	Blackheath/Eng	1891	17	0	1,2,3
			1896	16	6	1,2,3,4
HANDFORD	Frank	Manchester/Eng	1910	18	3	1,2,3
HARDING	Arthur	London Welsh/Wal	1904	19	11	1,2,3,4
			1908	11	7	1,2,3
HARDING	Rowe	Cambridge Uni/Wal	1924	14	9	2,3,4
HARE	Dusty	Leicester Tigers/Eng	1983	6	88	
HARRIS	Stan	Blackheath/Eng	1924	15	12	3,4
HARRISON	Edward	Guy's Hospitals	1903	20	4	1
HASLAM	Tommy	Batley	1888	29	21	
HASTINGS	Scott	Watsonians/Scot	1989	9	12	2,3
			1993	3	5	
HASTINGS	Gavin	London Scottish/Scot	1989	7	66	1,2,3
		Watsonians/Scot	1993	9	101	1,2,3
HAY	Bruce	Boroughmuir/Scot	1977	11	20	
			1980	11	8	2,3,4
HAYES	John	Munster/Ire	2005	5	0	Arg
			2009	2	0	3
HAYWARD	Don	Newbridge/Wal	1950	17	3	1,2,3
HEALEY	Austin	Leicester Tigers/Eng	1997	6	5	2,3
			2001	6	20	
HEALY	Cian	Leinster/Ire	2013	2	0	0
HEASLIP	Jamie	Leinster/Ire	2009	6	5	1,2,3
			2013	6	5	2,3
HENDERSON	Noel	Queen's Uni, Belfast/Ire	1950	14	24	3
HENDERSON	Rob	Durham Uni/Scot	1924	7	3	3,4
HENDERSON	Rob	London Wasps/Ire	2001	6	20	1,2,3
HENDRIE	Kelvin	Edinburgh Uni/Scot	1924	9	0	2
HENSON	Gavin	Ospreys/Wal	2005	4	10	2
HEWITT	Dave	Queen's Uni, Belfast/Ire	1959	18	112	1,2,3,5,6
			1962	7	6	4
HIBBARD	Richard	Ospreys/Wal	2013	9	5	1,2,3
HICKIE	Denis	Leinster/Ire	2005	5	0	Arg
HIGGINS	Reg	Liverpool/Eng	1955	9	3	1
HILL	Richard	Saracens/Eng	1997	5	0	1,2
			2001	5	5	1,2
			2005	3	0	1
HILLER	Bob	Harlequins/Eng	1968	8	104	
			1971	11	110	
HIND	Alfred	Cambridge Uni	1903	3	0	
HIND	Guy	Guy's Hospital	1908	14	0	2,3
HINES	Nathan	Perpignan/Sco	2009	5	0	
HINSHELWOOD	Sandy	London Scottish/Scot	1966	17	36	4,6
			1968	11	18	2
HIPWELL	Mick	Terenure Coll/Ire	1971	6	0	
HODGSON	Charlie	Sale Sharks/Eng	2005	4	53	
HODGSON	John	Northern	1930	15	9	1,3
HODGSON	Sam	Durham City/Eng	1962	1	3	
HOGG	Stuart	Glasgow Warriors/Sco	2013	5	23	0
HOLLIDAY	Tom	Aspatria/Eng	1924	1	0	

HOLMES	Terry	Cardiff/Wal	1980	4	12	
			1983	4	4	1
HOOK	James	Ospreys/Wal	2009	6	35	
HOPKINS	Ray	Maesteg/Wal	1971	11	3	1
HORGAN	Shane	Leinster/Ire	2005	8	5	Arg,1,2,3
HORROCKS-TAYLOR	Phil	Leicester/Eng	1959	5	5	5
HORTON	Nigel	Moseley/Eng	1977	4	0	
HORTON	Tony	Blackheath/Eng	1968	12	0	2,3,4
HOSACK	Jimmy	Edinburgh Wanderers	1903	4	3	
HOWARD	William	Old Birkonians	1938	10	8	1
HOWE	Tyrone	Ulster/Ire	2001	1	0	
HOWIE	Robert	Edinburgh Uni/Scot	1924	15	3	1,2,3,4
HOWLEY	Rob	Cardiff/Wal	1997	5	0	
			2001	4	10	1,2
HULME	Frank	Birkenhead Park/Eng	1904	6	3	1
HUMPHREYS	Noel	Tynedale	1910	5	7	
HUNTER	Ian	Northampton Saints/Eng	1993	1	0	
HUNTER	Ray	CIYMS/Ire	1962	12	16	
IRVINE	Andy	Heriot's FP/Scot	1974	15	156	3,4
			1977	19	87	1,2,3,4
			1980	8	31	2,3,4
IRWIN	David	Instonians/Ire	1983	11	24	1,2,4
ISHERWOOD	George	Sale	1910	19	0	1,2,3
JACKETT	Edward	Falmouth/Eng	1908	16	9	1,2,3
JACKSON	Fred	Leicester	1908	6	14	1
JACKSON	Peter	Coventry/Eng	1959	18	57	1,2,3,5,6
JACKSON	Walter	Cambridge Uni/Eng	1891	5	0	
JAMES	Dafydd	Llanelli/Wal	2001	7	15	1,2,3
JARMAN	Harry	Newport/Wal	1910	17	3	1,2,3
JARMAN	Wallace	Bristol	1899	18	6	1,2,3,4
JARRETT	Keith	Newport/Wal	1968	5	18	
JEAVONS	Nick	Moseley/Eng	1983	6	0	
JEEPS	Dickie	Northampton	1955	11	6	1,2,3,4
		Northampton/Eng	1959	16	4	1,2,3,4,5
			1962	15	7	1,2,3,4
JEFFREY	John	Kelso/Scot	1989	5	16	
JENKINS	Gethin	Cardiff Blues/Wal	2005	7	5	1,2,3
			2009	4	0	1,2
		Toulon/Wal	2013	0	0	0
JENKINS	Neil	Pontypridd/Wal	1997	8	110	1,2,3
		Cardiff/Wal	2001	4	32	2
JENKINS	Viv	London Welsh/Wal	1938	11	50	1
JENNINGS	Roy	Redruth	1930	9	44	
JOHN	Barry	Cardiff/Wal	1968	4	0	1
			1971	17	188	1,2,3,4
JOHN	Roy	Neath/Wal	1950	20	6	1,2,3,4,5,6
JOHNSON	Martin	Leicester Tigers/Eng	1993	4	0	2,3
			1997	6	0	1,2,3
			2001	5	0	1,2,3
JOHNSTON	Robert	Dublin Wanderers/Ire	1896	15	3	1,2,3

JONES	Adam	Ospreys/Wal	2009	6	0	1,2
			2013	6	0	1,2,3
JONES	Alun Wyn	Ospreys/Wal	2009	6	5	1,2,3
			2013	7	5	1,2,3
JONES	Elvet	Llanelli	1938	12	34	1,3
JONES	Harold	Manchester	1930	11	0	
JONES	Ivor	Llanelli/Wal	1930	20	71	1,2,3,4,5
JONES	Jack	Pontypool/Wal	1908	21	24	1,2,3
		Newport/Wal	1910	20	16	1,2,3
JONES	D Ken	Llanelli/Wal	1962	13	24	1,2,3
		Cardiff/Wal	1966	16	12	1,2,3
JONES	Ken	Newport/Wal	1950	17	48	1,2,4
JONES	Keri	Cardiff/Wal	1968	6	3	
JONES	Kingsley	Cardiff/Wal	1962	15	0	1,2,3,4
JONES	Lewis	Llanelli/Wal	1950	11	92	4,5,6
JONES	Rob	Swansea/Wal	1989	7	4	1,2,3
			1993	6	5	
JONES	Ryan	Ospreys/Wal	2005	4	5	1,2,3
JONES	Staff	Pontypool/Wal	1983	13	0	2,3,4
JONES	Stephen	Clermont-Auvergne/Wal	2005	5	22	1,2,3
		Scarlets/Wal	2009	5	65	1,2,3
JONES	Jack 'Tuan'	Guy's Hospital	1908	18	15	2,3
JONES-DAVIES	Tommy	London Welsh/Wal	1930	12	44	
JOWETT	William	Swansea/Wal	1904	6	9	
JUDKINS	William	Coventry	1899	13	0	2,3,4
KAY	Ben	Leicester Tigers/Eng	2005	5	0	Arg,1
KEANE	Moss	Lansdowne/Ire	1977	12	0	1
KEARNEY	Rob	Leinster/Ire	2009	5	5	1,2,3
			2013	3	0	0
KENDREW	Doug	Leicester/Eng	1930	11	3	
KENNEDY	Ken	CIYMS/Ire	1966	18	3	1,2,3,6
		London Irish/Ire	1974	10	8	
KENT	Tom	Salford	1888	28	8	
KIERNAN	Michael	Dolphin/Ire	1983	10	11	2,3,4
KIERNAN	Tom	UC Cork/Ire	1962	10	12	3
		Cork Constitution/Ire	1968	13	84	1,2,3,4
KINNEAR	Roy	Heriot's FP	1924	10	0	1,2,3,4
KINNIMONTH	Peter	Richmond/Scot	1950	16	0	1,2,4
KNOWLES	Tom	Birkenhead Park	1930	14	9	
KYLE	Jack	Queen's Uni, Belfast/Ire	1950	19	21	1,2,3,4,5,6
KYRKE	Gerald	Marlborough Nomads	1908	12	3	1
LAIDLAW	Frank	Melrose/Scot	1966	17	0	4,5
			1971	11	0	
LAIDLAW	Roy	Jedforest/Scot	1983	13	8	1,2,3,4
LAING	Alex	Hawick	1888	27	0	
LAMONT	Ronnie	Instonians/Ire	1966	15	21	3,4,5,6
LANE	Mick	UC Cork/Ire	1950	9	12	4,6
LANE	Stuart	Cardiff/Wal	1980	1	0	
LARTER	Peter	Northampton/Eng	1968	12	0	2
LAXON	Herbert	Coventry	1908	9	0	1

LEE	George	Rockliffe	1896	8	0	
LENIHAN	Donal	Cork Constitution/Ire	1983	2	0	
			1989	4	0	
LEONARD	Jason	Harlequins/Eng	1993	8	0	2,3
			1997	8	0	1
			2001	7	0	1
LEWSEY	Josh	London Wasps/Eng	2005	6	10	1,2,3
LEWIS	Allan	Abertillery/Wal	1966	18	3	4,5,6
LEWIS	Alun	Cambridge Uni	1977	3	0	
LEWIS	Arthur	Ebbw Vale/Wal	1971	10	6	
LEYLAND	Roy	Waterloo/Eng	1938	5	6	
LLEWELLYN	Willie	Newport/Wal	1904	14	21	1,2,3,4
LLOYD	Trevor	Maesteg/Wal	1955	6	8	
LUGER	Dan	Saracens/Eng	2001	2	20	
LYDIATE	Dan	NG Dragons/Wal	2013	8	5	1,2,3
LYNCH	Sean	St Mary's College/Ire	1971	15	0	1,2,3,4
MACDONALD	Ranald	Edinburgh Uni/Scot	1950	13	24	1,6
MACKIE	Osbert	Cambridge Uni/Eng	1896	15	34	1,2,3,4
MACLAGAN	Bill	Edinburgh Acad/Scot	1891	19	8	1,2,3
MACMILLAN	Robert	London Scottish/Scot	1891	20	3	1,2,3
MACNEILL	Hugo	Oxford Uni/Ire	1983	9	8	1,2,4
MACPHERSON	Neil	Newport/Scot	1924	15	0	1,2,3,4
MACRAE	Duncan	St Andrew's Uni/Scot	1938	11	18	1
MAGEE	Joe	Bective Rangers/Ire	1896	13	6	2,4
MAGEE	Louis	Bective Rangers/Ire	1896	15	14	1,2,3,4
MAITLAND	Sean	Glasgow Warrior/Sco	2013	5	5	0
MARQUES	David	Harlequins/Eng	1959	19	3	2,4
MARSDEN-JONES	Douglas	London Welsh/Wal	1924	12	0	1,2
MARSHALL	Howard	Cambridge Uni/Eng	1891	11	11	2,3
MARTELLI	Esmond	Dublin Uni	1899	12	7	1
MARTIN	Allan	Aberavon/Wal	1977	14	6	1
			1980	8	0	
MARTINDALE	Sam	Kendal/Eng	1930	12	14	5
MASSEY	Burnett	Hull & East Riding	1904	3	0	3
MATHERS	Charles	Bramley	1888	25	11	
MATTHEWS	Jack	Cardiff/Wal	1950	20	18	1,2,3,4,5,6
MAXWELL	Reg	Birkenhead Park	1924	7	3	1
MAYFIELD	Edwin	Cambridge Uni	1891	15	1	2,3
MAYNE	Blair	Queen's Uni, Belfast/Ire	1938	20	0	1,2,3
MCBRIDE	Willie John	Ballymena/Ire	1962	11	3	3,4
			1966	21	3	4,5,6
			1968	11	3	1,2,3,4
			1971	14	0	1,2,3,4
			1974	13	4	1,2,3,4
MCBRYDE	Robin	Llanelli/Wal	2001	4	0	
MCCARTHY	Jim	Dolphin/Ire	1950	12	12	
MCCLINTON	Arthur	NIFC/Ire	1910	8	8	
MCEVEDY	Pat	Guy's Hospital	1904	14	6	2,3,4
			1908	17	19	2,3
MCFADYEAN	Colin	Moseley/Eng	1966	23	29	3,4,5,6

MCGEECHAN	Ian	Headingley/Scot	1974	14	7	1,2,3,4
			1977	16	12	1,2,3,4
MCGOWN	Tom	NIFC/Ire	1899	19	0	1,2,3,4
MCKAY	Jim	Queen's Uni, Belfast/Ire	1950	14	30	1,2,3,4,5,6
MCKIBBIN	Harry	Queen's Uni, Belfast/Ire	1938	16	32	1,2,3
MCKINNEY	Stewart	Dungannon/Ire	1974	8	3	
MCLAUCHLAN	Ian	Jordanhill Coll/Scot	1971	17	3	1,2,3,4
			1974	13	0	1,2,3,4
MCLEOD	Hugh	Hawick/Scot	1955	13	0	
			1959	21	7	1,2,3,4,5,6
MCLOUGHLIN	Gerry	Shannon/Ire	1983	2	0	
MCLOUGHLIN	Ray	Gosforth/Ire	1966	17	0	1,2,6
		Blackrock/Ire	1971	5	3	
MCVICKER	James	Belfast Coll/Ire	1924	14	3	1,3,4
MEARS	Arthur	Dublin Uni/Ire	1896	12	6	3,4
MEARS	Lee	Bath/Eng	2009	5	5	1
MELVILLE	Nigel	Wasps	1983	2	8	
MEREDITH	Bryn	Newport/Wal	1955	15	18	1,2,3,4
			1959	12	6	
			1962	14	3	1,2,3,4
MEREDITH	Courteney	Neath/Wal	1955	14	0	1,2,3,4
MICHIE	Ernie	Aberdeen Uni/Scot	1955	11	3	
MILLAR	Syd	Ballymena/Ire	1959	19	3	1,2,4
			1962	16	6	1,2,3,4
			1968	9	0	1,2
MILLER	Eric	Leicester/Ire	1997	5	0	2
MILLIKEN	Dick	Bangor/Ire	1974	13	24	1,2,3,4
MILNE	Iain	Heriot's FP/Scot	1983	8	4	
MILNE	Ken	Heriot's FP/Scot	1993	8	0	1
MILROY	Eric	Watsonians/Scot	1910	4	0	
MITCHELL	William	Richmond/Eng	1891	20	20	1,2,3
MOLONEY	John	St Mary's Coll/Ire	1974	8	12	
MONYE	Ugo	Harlequins/Eng	2009	6	25	1,3
MOODY	Lewis	Leicester/Eng	2005	5	5	Arg,2,3
MOORE	Brian	Nottingham/Eng	1989	7	4	1,2,3
		Harlequins/Eng	1993	7	0	2,3
MORGAN	Cliff	Cardiff/Wal	1955	15	21	1,2,3,4
MORGAN	Doug	StewMelville FP/Scot	1977	15	98	3,4
MORGAN	Eddie	Swansea/Wal	1938	14	3	1,2
MORGAN	Edgar	Swansea	1908	23	0	2,3
MORGAN	Gerry	Clontarf/Ire	1938	11	12	3
MORGAN	Haydn	Abertillery/Wal	1959	20	18	5,6
			1962	14	12	2,3
MORGAN	Peter	Llanelli/Wal	1980	7	7	
MORGAN	Teddy	Cardiff/Wal	1904	13	21	1,2,3,4
MORGAN	William	London Welsh	1908	17	3	2,3
MORLEY	Alan	Bristol/Eng	1974	2	4	
MORLEY	Jack	Newport/Wal	1930	14	24	1,2,3
MORRIS	Darren	Swansea/Wal	2001	6	0	3
MORRIS	Dewi	Orrell/Eng	1993	8	0	1,2,3

MORRIS	Haydn	Cardiff/Wal	1955	8	27	
MORRISON	Mark	Royal HSFP/Scot	1903	19	3	1,2,3
MORTIMER	William	Cambridge Uni	1896	16	3	1,2,3,4
MULCAHY	Bill	UC Dublin/Ire	1959	15	6	1,6
		Bohemians/Ire	1962	17	3	1,2,3,4
MULLEN	Karl	Old Belvedere/Ire	1950	15	0	1,2,6
MULLIGAN	Andy	Wanderers/Ire	1959	15	0	6
MULLIN	Brendan	London Irish/Ire	1989	7	28	1
MULLINEUX	Matthew	Blackheath	1896	12	16	1
			1899	10	3	1
MULLINS	Cuthbert	Oxford Uni	1896	13	0	1,3
MURPHY	Geordan	Leicester Tigers/Eng	2005	7	15	Arg,3
MURPHY	Noel	Cork Constitution/Ire	1959	19	24	2,3,4,6
			1966	18	18	1,2,4,5
MURRAY	Conor	Munster	2013	7	10	2,3
MURRAY	Euan	Northampton Saints/Sco	2009	4	0	
MURRAY	Paul	Wanderers/Ire	1930	17	6	1,2,4,5
MURRAY	Scott	Saracens/Scot	2001	5	0	
NASH	David	Ebbw Vale/Wal	1962	2	0	
NEALE	Maurice	Bristol	1910	14	27	1,2,3
NEARY	Tony	Broughton Park/Eng	1974	8	8	
			1977	14	0	4
NEILL	Robert	Edinburgh Accies/Scot	1903	13	3	2,3
NELSON	John	Malone/Ire	1950	18	12	3,4,5,6
NICHOLLS	Gwyn	Cardiff/Wal	1899	19	38	1,2,3,4
NICHOLSON	Basil	Harlequins/Eng	1938	10	6	2
NICHOLSON	Elliot	Birkenhead Park	1899	7	12	3,4
NICOL	Andy	Dundee HSFP/Scot	1993	1	0	
		Glasgow/Scot	2001	0	0	
NORRIS	Howard	Cardiff/Wal	1966	17	6	3,4,5
NORSTER	Rob	Cardiff/Wal	1983	6	0	1,2
			1989	6	4	1
NORTH	George	Scarlets/Wal	2013	7	20	1,2,3
NORTON	George	Bective Rangers/Ire	1950	3	9	
NOVIS	Tony	Blackheath/Eng	1930	19	48	2,4,5
O'BRIEN	Arthur	Guy's Hospital	1904	17	35	1,2,3,4
O'BRIEN	Sean	Leinster/Ire	2013	6	10	2,3
O'CALLAGHAN	Donncha	Munster/Ire	2005	7	0	Arg,2,3
			2009	5	0	1
O'CONNELL	Paul	Munster/Ire	2005	5	0	1,2,3
			2009	6	0	1,2,3
			2013	4	5	1
O'CONNOR	Tony	Aberavon/Wal	1962	10	0	
O'DONNELL	Rodney	St Mary's Coll/Ire	1980	6	3	1
O'DRISCOLL	Brian	Leinster/Ire	2001	6	20	1,2,3
			2005	4	5	1
			2009	4	5	1,2
			2013	4	15	1,2
O'DRISCOLL	John	London Irish/Ire	1980	11	8	1,2,3,4
			1983	8	0	2,4

O'GARA	Ronan	Munster/Ire	2001	4	26	
			2005	7	49	3
			2009	5	49	2
O'KELLY	Malcolm	Leinster/Ire	2001	4	5	
			2005	0	0	
OLD	Alan	Leicester/Eng	1974	4	59	
OLDHAM	William	Coventry/Eng	1908	12	3	1
O'NEILL	Henry	Queen's Uni, Belfast/Ire	1930	17	0	1,2,3,4,5
O'REILLY	Tony	Old Belvedere/Ire	1955	15	48	1,2,3,4
			1959	23	69	1,2,3,4,5,6
ORR	Phil	Old Wesley/Ire	1977	12	4	1
			1980	5	0	
O'SHEA	John	Cardiff/Wal	1968	8	6	1
OTI	Chris	Wasps/Eng	1989	3	4	
OWEN	Michael	Dragons/Wal	2005	7	0	Arg
PARKER	Dai	Swansea/Wal	1930	17	45	1,2,3,4,5
PARLING	Geoff	Leicester Tigers/Eng	2013	7	5	1,2,3
PASK	Alun	Abertillery/Wal	1962	14	12	1,2,3
			1966	22	6	1,2,3,5,6
PATTERSON	Bill	Sale	1959	11	24	4
PATTERSON	Charlie	Malone	1904	3	3	
PATTERSON	Colin	Instonians/Ire	1980	10	4	1,2,3
PAUL	Arthur	Swinton	1888	29	33	
PAYNE	Tim	London Wasps/Eng	2009	1	0	
PAXTON	Iain	Selkirk/Scot	1983	9	16	1,2,3,4
PEDLOW	Cecil	Queen's Uni, Belfast/Ire	1955	13	58	1,4
PEEL	Dwayne	Scarlets/Wal	2005	5	5	1,2,3
PENKETH	Alfred	Douglas, Isle of Man	1888	19	1	
PERRY	Matt	Bath/Eng	2001	6	13	1,2,3
PHILLIPS	Alan	Cardiff/Wal	1980	7	0	
PHILLIPS	Mike	Ospreys/Wal	2009	6	10	1,2,3
		Bayonne/Wal	2013	5	10	1,3
PILLMAN	Charles	Blackheath/Eng	1910	16	67	2,3
PIPER	Oliver	Cork Con/Ire	1910	16	6	1
PLUMMER	Reg	Newport	1910	12	18	
POOLE	Howard	Cardiff	1930	14	3	3
POPPLEWELL	Nick	Greystones/Ire	1993	7	0	1,2,3
POWELL	Andy	Cardiff Blues/Wal	2009	5	0	
POWELL	David	Northampton/Eng	1966	15	0	
PREECE	Ivor	Coventry/Eng	1950	10	15	1
PRENTICE	Doug	Leicester/Eng	1930	11	50	2,5
PRICE	Brian	Newport/Wal	1966	19	3	1,2,3,6
PRICE	Graham	Pontypool/Wal	1977	15	0	1,2,3,4
			1980	12	8	1,2,3,4
			1983	10	0	1,2,3,4
PRICE	Malcolm	Pontypool/Wal	1959	19	45	1,2,3,4,5
PRICE	Terry	Llanelli/Wal	1966	3	17	
PROSSER	Ray	Pontypool/Wal	1959	13	3	6
PROTHERO	Gary	Bridgend/Wal	1966	9	0	
PULLIN	John	Bristol/Eng	1968	11	0	2,3,4
			1971	16	0	1,2,3,4

PURCHAS	Griff	Coventry	1938	8	3	
QUINN	Pat	New Brighton/Eng	1955	12	21	
QUINNELL	Derek	Llanelli	1971	10	3	3
		Llanelli/Wal	1977	14	8	2,3
			1980	9	8	1,2
QUINNELL	Scott	Richmond/Wal	1997	3	0	
		Llanelli/Wal	2001	6	20	1,2,3
RALSTON	Chris	Richmond/Eng	1974	13	0	4
RAYBOULD	Billy	London Welsh/Wal	1968	7	6	
REA	Chris	Headingley/Scot	1971	10	9	
REDMAN	Nigel	Bath/Eng	1997	4	0	
REED	Andy	Bath/Eng	1993	6	5	1
REES	Clive	London Welsh/Wal	1974	6	12	
REES	Elgan	Neath	1977	12	32	4
		Neath/Wal	1980	6	12	
REES	Matthew	Scarlets/Wal	2009	8	0	1,2,3
REEVE	James	Harlequins/Eng	1930	14	24	1,3,4,5
REGAN	Mark	Bristol/Eng	1997	6	10	3
REID	Tom	Garryowen/Ire	1955	13	6	2,3
REID-KERR	James	Greenock Wands/Scot	1910	0	0	
RENWICK	Jim	Hawick/Scot	1980	11	17	1
REW	Henry	Blackheath/Eng	1930	15	5	1,2,3,4
REYNOLDS	Jeffrey	Army/Eng	1938	14	19	12
RICHARDS	David	Swansea/Wal	1980	7	4	1
RICHARDS	Dean	Leicester/Eng	1989	6	0	1,2,3
			1993	6	5	1,2,3
RICHARDS	Maurice	Cardiff/Wal	1968	11	15	1,3,4
RICHARDS	Thomas	Bristol	1910	12	3	1,2
RIMMER	Gordon	Waterloo/Eng	1950	8	0	3
RINGLAND	Trevor	Ballymena/Ire	1983	9	20	1
RIPLEY	Andy	Rosslyn Park/Eng	1974	9	20	
RISMAN	Bev	Manchester/Eng	1959	14	62	1,2,3,6
RITSON	John	Northern	1908	12	9	1
ROBBIE	John	Greystones/Ire	1980	7	7	4
ROBERTS	Jamie	Cardiff Blues/Wal	2009	5	10	1,2
			2013	4	5	3
ROBERTS	Mike	London Welsh/Wal	1971	11	0	
ROBERTS	Vic	Penryn/Eng	1950	11	9	
ROBERTSON	Bill	Edinburgh Uni	1910	10	0	
ROBINS	John	Birkenhead Park/Wal	1950	15	36	1,2,3,5,6
ROBINS	Russell	Pontypridd/Wal	1955	17	0	1,2,3,4
ROBINSON	Andy	Bath/Eng	1989	6	8	
ROBINSON	Charles	Percy Park	1896	8	7	
ROBINSON	Jason	Sale/Eng	2001	7	50	1,2,3
			2005	4	5	1,2
ROCHE	William	Newport/Ire	1924	12	3	
RODBER	Tim	Northampton/Eng	1997	5	0	1,2
ROE	Robin	Lansdowne/Ire	1955	11	3	
ROGERS	Budge	Bedford/Eng	1962	12	6	1

ROGERS	Ron	Bath	1904	7	0	4
ROLLO	David	Howe Of Fife/Scot	1962	13	0	
ROSCOE	Bert	Manchester	1891	5	3	
ROSS	Andrew	Kilmarnock/Scot	1924	3	0	
ROTHERHAM	Arthur	Cambridge Uni/Eng	1891	16	81	1,3
ROWLANDS	Keith	Cardiff/Wal	1962	18	6	1,2,4
ROWNTREE	Graham	Leicester/Eng	1997	6	5	
			2005	6	0	Arg,2,3
RUTHERFORD	Don	Gloucester/Eng	1966	10	55	1
RUTHERFORD	John	Selkirk/Scot	1983	10	23	
SAUNDERS	Stuart	Guy's Hospital	1904	5	0	1,2
SAVAGE	Keith	Northampton/Eng	1966	12	21	
			1968	11	9	1,2,3,4
SCOTLAND	Ken	Cambridge Uni/Scot	1959	22	72	1,2,3,5,6
SCOTT	William	West Of Scotland/Scot	1903	22	9	1,2,3
SEALEY	James	Dublin Uni/Ire	1896	19	3	1,2,3,4
SEDDON	Robert	Swinton/Eng	1888	19	7	
SEXTON	Jonathon	Leinster/Ire	2013	7	19	1,2,3
SHANKLIN	Tom	Cardiff Blues/Wal	2005	3	5	
SHARLAND	John	Streatham	1904	7	0	
SHARP	Richard	Oxford Uni/Eng	1962	11	52	3,4
SHAW	Simon	Bristol/Eng	1997	7	10	
		London Wasps/Eng	2005	5	0	
			2009	7	0	2,3
SHERIDAN	Andrew	Sale Sharks/Eng	2005	5	0	
		Sale Sharks/Eng	2009	6	0	2,3
SIMPSON	Clem	Cambridge Uni	1891	10	0	1
SKRIMSHIRE	Reg	Newport/Wal	1903	22	59	1,2,3
SLATTERY	Fergus	UC Dublin/Ire	1971	13	0	
		Blackrock/Ire	1974	12	24	1,2,3,4
SLEMEN	Mike	Liverpool/Eng	1980	5	25	1
SMITH	Arthur	Cambridge Uni/Scot	1955	5	29	
		Edinburgh Wands/Scot	1962	14	37	1,2,3
SMITH	John	Edinburgh Uni	1888	9	0	
SMITH	Doug	L. Scottish/Scot	1950	5	11	5
SMITH	Dyne	Richmond/Eng	1910	23	3	1,2,3
SMITH	Ian	Oxford Uni/Scot	1924	6	15	1,2
SMITH	Ken	Kelso/Scot	1959	17	12	1,2,3,5
SMITH	Ollie	Leicester/Eng	2005	5	10	Arg
SMITH	Steve	Ballymena/Ire	1989	5	8	
SMITH	Steve	Sale/Eng	1980	0	0	
			1983	2	0	
SMITH	Tom	Leicester	1908	21	9	2,3
SMITH	Tom	Watsonians/Scot	1997	7	0	1,2,3
		Brive/Scot	2001	6	0	1,2,3
SMYTH	Robertson	Dublin Uni/Ire	1903	16	3	1,2,3
SMYTH	Tom	Malone/Ire	1910	18	17	2,3
SOBEY	Wilfred	Old Millhillians/Eng	1930	1	0	
SOLE	David	Edinburgh Accies/Scot	1989	8	4	1,2,3
SPEAKMAN	Harry	Runcorn	1888	27	19	

SPENCER	John	Headingley/Eng	1971	10	12	
SPONG	Roger	Old Millhillians/Eng	1930	17	15	1,2,3,4,5
SPOORS	Jack	Bristol	1910	19	21	1,2,3
SQUIRE	Jeff	Newport/Wal	1977	15	12	4
		Pontypool/Wal	1980	11	4	1,2,3,4
			1983	6	8	1
SQUIRES	Peter	Harrogate/Eng	1977	9	20	1
STAGG	Peter	Sale/Scot	1968	11	0	1,3,4
STANGER	Tony	Hawick/Scot	1997	1	0	
STANGER-LEATHES	Chris	Northern	1904	11	4	1
STEELE	Billy	Bedford/Scot	1974	9	28	1,2
STEPHENS	Ian	Bridgend	1980	5	0	
		Bridgend/Wal	1983	4	4	1
STEPHENS	Rees	Neath/Wal	1950	12	3	5,6
STEVENS	Matt	Saracens/Eng	2005	6	0	
			2013	6	0	0
STEVENS	Stack	Harlequins/Eng	1971	6	0	
STEVENSON	Robert	St Andrew's Uni/Scot	1910	15	3	1,2,3
STIMPSON	Tim	Newcastle/Eng	1997	7	111	3
STODDART	Andrew	Blackheath/Eng	1888	28	73	
STOUT	Frank	Gloucester/Eng	1899	21	12	1,2,3,4
		Richmond/Eng	1903	20	22	1,2,3
STUART	Angus	Dewsbury	1888	23	1	
SURTEES	Aubone	Harlequins	1891	14	0	1,2,3
SWANNELL	Blair	Northampton	1899	17	3	2,3,4
			1904	15	3	1,2,3,4
SYKES	Frank	Northampton/Eng	1955	14	27	
TAIT	Alan	Newcastle/Scot	1997	6	10	1,2
TANNER	Haydn	Swansea/Wal	1938	10	3	2
TAYLOR	Bob	Northampton/Eng	1968	14	6	1,2,3,4
TAYLOR	John	London Welsh/Wal	1968	5	3	
			1971	15	12	1,2,3,4
TAYLOR	Mark	Swansea/Wal	2001	5	10	
TAYLOR	Russell	Cross Keys/Wal	1938	16	53	1,2
TAYLOR	Simon	Edinburgh/Scot	2001	1	5	
			2005	0	0	
TEAGUE	Mike	Gloucester/Eng	1989	6	0	2,3
		Moseley/Eng	1993	8	5	2
TEDFORD	Alf	Malone/Ire	1903	18	15	1,2,3
TELFER	Jim	Melrose/Scot	1966	23	6	1,2,3,4,6
			1968	11	9	2,3,4
THOMAS	Alun	Llanelli/Wal	1955	5	15	
THOMAS	Clem	Swansea/Wal	1955	10	0	3,4
THOMAS	Delme	Llanelli	1966	17	3	4,5
		Llanelli/Wal	1968	12	6	3,4
			1971	15	0	1,2,4
THOMAS	Gareth	Toulouse/Wal	2005	4	10	1,2,3
THOMAS	Len	Penarth	1908	10	0	
THOMAS	Malcolm	Newport/Wal	1950	15	96	2,3,5
			1959	17	56	4

THOMAS	Will	Cambridge Uni/Wal	1888	28	3	
THOMPSON	Charles	Lancashire	1899	13	0	2,3,4
THOMPSON	Robert	Cambridge Uni	1891	19	6	1,2,3
THOMPSON	Robin	Instonians/Ire	1955	15	3	1,2,4
THOMPSON	Steve	Northampton Saints/Eng	2005	6	0	Arg,1,2
THORMAN	Will	Cambridge Uni	1891	6	0	
TIMMS	Alec	Edinburgh Uni/Scot	1899	15	36	2,3,4
TIMMS	Charles	Edinburgh Uni	1910	11	9	
TIPURIC	Justin	Ospreys/Wal	2013	6	0	3
TITTERRELL	Andy	Sale Sharks/Eng	2005	3	0	
TODD	Alex	Blackheath	1896	19	6	1,2,3,4
TOMES	Alan	Hawick/Scot	1980	7	4	
TOWNSEND	Gregor	Northampton/Scot	1997	6	13	1,2
TRAIL	David	Guy's Hospital	1904	12	0	1,2,3,4
TRAVERS	Bunner	Newport/Wal	1938	21	3	2,3
TUCKER	Colm	Shannon/Ire	1980	9	0	3,4
TUILAGI	Manu	Leicester Tigers/Eng	2013	4	0	3
TURNER	Jock	Gala/Scot	1968	10	15	1,2,3,4
TWELVETREES	Billy	Gloucester/Eng	2013	2	0	0
TYRRELL	William	Queen's Uni, Belfast/Ire	1910	10	3	
UNDERWOOD	Rory	Leicester/Eng	1989	8	16	1,2,3
			1993	7	15	1,2,3
UNDERWOOD	Tony	Leicester/Eng	1993	6	10	
		Newcastle/Eng	1997	8	35	3
UNWIN	Jim	Rosslyn Park/Eng	1938	15	31	1,2
UTTLEY	Roger	Gosforth/Eng	1974	16	8	1,2,3,4
VASSALL	Harry	Oxford Uni/Eng	1908	7	0	1,2,3
VICKERY	Phil	Gloucester/Eng	2001	6	0	
		London Wasps/Eng	2009	7	0	1,3
VILE	Tommy	Newport	1904	15	6	2,3,4
VOYCE	Tom	Gloucester/Eng	1924	12	37	3,4
VUNIPOLA	Mako	Saracens/Eng	2013	7	5	1,2,3
WADDELL	Gordon	Cambridge Uni/Scot	1959	10	21	
		London Scottish/Scot	1962	12	17	1,2
WADDELL	Herbert	Glasgow Accies/Scot	1924	14	9	1,2,4
WADE	Christian	London Wasps/Eng	2013	1	0	0
WAINWRIGHT	Rob	Watsonians/Scot	1997	8	20	3
WALKER	Edward	Lennox	1903	9	3	2,3
WALKER	Sam	Instonians/Ire	1938	20	12	1,2,3
WALLACE	David	Munster/Ire	2001	2	5	
			2009	7	0	1,2,3
WALLACE	James	Wanderers	1903	11	3	
WALLACE	Joseph	Wanderers/Ire	1903	18	0	1,2,3
WALLACE	Paul	Saracens/Ire	1997	6	0	1,2,3
WALLACE	Richard	Garryowen/Ire	1993	5	5	
WALLACE	William	Percy Park	1924	8	27	1
WALLER	Phillip	Newport/Wal	1910	23	3	1,2,3
WALSH	Jerry	Sunday's Well/Ire	1966	4	9	
WARBURTON	Sam	Cardiff Blues/Wal	2013	4	0	1.2
WARD	Tony	Garryowen/Ire	1980	5	48	1

WATERS	Jack	Selkirk/Scot	1938	9	9	3
WATKINS	David	Newport/Wal	1966	21	43	1,2,3,4,5,6
WATKINS	Stuart	Newport/Wal	1966	13	15	1,2,5
WEBB	Jim	Abertillery/Wal	1910	10	0	1,2,3
WEBSTER	Richard	Swansea/Wal	1993	7	10	
WEIR	Doddie	Newcastle/Scot	1997	3	5	
WELSH	Willie	Hawick/Scot	1930	16	11	4
WEST	Bryan	Northampton/Eng	1968	2	0	
WEST	Dorian	Leicester/Eng	2001	1	0	
WESTON	Mike	Durham City/Eng	1962	15	40	1,2,3,4
			1966	16	24	1,2
WHEELER	Peter	Leicester/Eng	1977	13	4	2,3,4
			1980	11	4	1,2,3,4
WHITE	Derek	London Scottish/Scot	1989	7	4	1
WHITE	Jason	Sale Sharks/Eng	2005	1	0	
WHITE	Julian	Leicester Tigers/Eng	2005	6	0	Arg,1,2,3
WHITLEY	Herbert	Northern	1924	10	3	1,3,4
WHITTAKER	Thomas	Manchester	1891	17	7	1,2,3
WILKINSON	Harry	Halifax/Eng	1930	13	42	
WILKINSON	Jonny	Newcastle/Eng	2001	5	72	1,2,3
			2005	4	39	Arg,1,2
WILLCOX	John	Oxford Uni/Eng	1962	15	67	1,2,4
WILLIAMS	Barry	Richmond	1997	4	0	
WILLIAMS	Billy	Swansea/Wal	1955	17	0	1,2,3,4
WILLIAMS	Bleddyn	Cardiff/Wal	1950	19	39	2,3,4,5,6
WILLIAMS	Brynmor	Cardiff	1977	12	12	1,2,3
WILLIAMS	Clive	Aberavon/Wal	1977	9	4	
		Swansea/Wal	1980	12	4	1,2,3,4
WILLIAMS	Denzil	Ebbw Vale/Wal	1966	20	3	1,2,3,4,6
WILLIAMS	Gareth	Bridgend	1980	6	4	
WILLIAMS	Gerry	Liverpool	1908	4	0	
WILLIAMS	Ivor	Cardiff	1938	7	3	
WILLIAMS	John	Old Millhillians/Eng	1955	8	15	
WILLIAMS	John (J.J.)	Llanelli/Wal	1974	12	48	1,2,3,4
			1977	14	40	1,2,3
WILLIAMS	John (J.P.R.)	London Welsh/Wal	1971	15	16	1,2,3,4
			1974	15	12	1,2,3,4
WILLIAMS	John F.	London Welsh/Wal	1908	15	12	3
WILLIAMS	Johnnie L.	Cardiff/Wal	1908	20	36	1,2
WILLIAMS	Martyn	Cardiff/Wal	2001	4	0	
		Cardiff Blues/Wal	2005	7	5	3
			2009	6	5	1,2,3
WILLIAMS	Rhys	Llanelli/Wal	1955	16	0	1,2,3,4
			1959	22	3	1,2,3,4,5,6
WILLIAMS	Sam	Newport	1910	16	15	1,2,3
WILLIAMS	Sam	Salford	1888	32	15	
WILLIAMS	Shane	Ospreys/Wal	2005	5	30	Arg,2
			2009	8	10	2,3
		Mitsubishi/Wal	2013	1	0	0
WILLIS	Rex	Cardiff/Wal	1950	12	3	4,5,6

WILSON	Dyson	Met Police/Eng	1955	15	9	
WILSON	Stewart	London Scottish/Scot	1966	20	90	2,3,4,5,6
WINDSOR	Bobby	Pontypool/Wal	1974	12	0	1,2,3,4
			1977	14	4	1
WINTERBOTTOM	Peter	Headingley/Eng	1983	12	4	1,2,3,4
		Harlequins/Eng	1993	7	0	1,2,3
WOOD	Gordon	Garryowen/Ire	1959	15	6	3,5
WOOD	Keith	Harlequins/Ire	1997	5	0	1,2
			2001	6	0	1,2,3
WOOD	Ken	Leicester	1910	9	6	1,3
WOODWARD	Clive	Leicester/Eng	1980	11	53	2,3
			1983	7	3	
WORSLEY	Joe	London Wasps/Eng	2009	6	0	3
WOTHERSPOON	William	Cambridge Uni/Scot	1891	9	22	1
WRIGHT	Peter	Blackheath/Eng	1962	8	0	
WRIGHT	Peter	Boroughmuir/Scot	1993	6	0	
YOUNG	Arthur	Cambridge Uni/Eng	1924	10	0	2
YOUNG	David	Cardiff /Wal	1989	8	0	1,2,3
			1997	6	0	
			2001	4	10	
YOUNG	Jeff	Harrogate/Eng	1968	9	0	1
YOUNG	John	Harlequins/Eng	1959	14	42	4
YOUNG	Roger	Queen's Uni, Belfast/Ire	1966	17	3	1,2,3
			1968	9	6	3
YOUNGS	Ben	Leicester Tigers/Eng	2013	7	10	1,2
YOUNGS	Tom	Leicester Tigers/Eng	2013	7	0	1,2,3
ZEBO	Simon	Munster/Ire	2013	3	0	0

THE A–Z LIST OF UNCAPPED BRITISH & IRISH LIONS TOURISTS

There have been 124 players who were uncapped at the time of going on tour with The British & Irish Lions between 1888 and 2013. Of those players, 41 went on to win caps for their countries after becoming a Lion. The last uncapped Lions tourist was Will Greenwood (Leicester) in 1997. He played for England later that year and went on two more tours.

SURNAME	CHRISTIAN NAME	CLUB/COUNTRY	TOUR	CAPPED
ADAMSON	Charles	Durham	1899	No
ANDERTON	Jack	Salford	1888	No
ARCHER	Herbert	Guy's Hospital	1908	Eng
ASHBY	Willie	Queen's College, Cork	1910	No
AYRE-SMITH	Alan	Guy's Hospital	1899	No
BAKER	Melville	Newport	1910	Wal
BANKS	Tom	Swinton	1888	No
BELL	Sydney	Cambridge Uni	1896	No
BELSON	Fred	Bath	1899	No
BONNER	Gordon	Bradford	1930	No
BORDASS	James	Cambridge Uni	1924	No
BRAND	Tom	NIFC	1924	Ire

BROWN	John	Blackheath	1962	No
BUMBY	Walter	Swinton	1888	No
BURNET	Robert	Hawick	1888	No
BURNET	William	Hawick	1888	No
BUSH	Percy	Cardiff	1904	Wal
CAVE	William	Cambridge Uni	1903	Eng
CHAPMAN	Fred	Hartlepool Rovers	1908	Eng
CLOWES	Jack	Halifax	1888	No
COLLETT	Gilbert	Gloucestershire	1903	No
COOKSON	George	Manchester	1899	No
COUCHMAN	Stan	Old Cranleighans	1938	No
CREAN	Edward	Liverpool	1910	No
CROWTHER	Sidney	Lennox	1904	No
DANCER	Gerry	Bedford	1938	No
DOWN	Percy	Bristol	1908	Eng
EAGLES	Harry	Swinton	1888	No
EVERS	Guy	Moseley	1899	No
FISHER	John	Hull & East Riding	1904	No
FRANCOMB	John	Manchester	1899	No
GAISFORD	Wilf	St Bart's Hospital	1924	No
GIBSON	Tom	Cambridge Uni	1903	Eng
GOULD	John	Old Leysians	1891	No
GRAY	Hugh	Coventry	1899	No
GREEN	Bob	Neath	1908	No
GREENWOOD	Will	Leicester Tigers	1997	Eng
GREIG	Louis	United Services	1903	Scot
GRIFFITHS	Roland	Newport	1908	Wal
HAMMOND	John	Blackheath	1891	No
		Richmond	1896	No
HANCOCK	Pat	Richmond	1903	Eng
HARRISON	Edward	Guy's Hospital	1903	No
HASLAM	Tommy	Batley	1888	No
HIND	Alfred	Cambridge Uni	1903	Eng
HIND	Guy	Guy's Hospital	1908	Eng
HODGSON	John	Northern	1930	Eng
HOSACK	Jimmy	Edinburgh Wanderers	1903	No
HOWARD	William	Old Birkonians	1938	No
HUMPHREYS	Noel	Tynedale	1910	No
ISHERWOOD	George	Sale	1910	No
JACKSON	Fred	Leicester	1908	NZRL
JARMAN	Wallace	Bristol	1899	Eng
JEEPS	Dickie	Northampton	1955	Eng
JENNINGS	Roy	Redruth	1930	No
JONES	Elvet	Llanelli	1938	Wal
JONES	Harold	Manchester	1930	No
JONES	Jack 'Tuan'	Guy's Hospital	1908	Wal
JUDKINS	William	Coventry	1899	No
KENT	Tom	Salford	1888	Eng
KINNEAR	Roy	Heriot's FP	1924	Scot

KNOWLES	Tom	Birkenhead Park	1930	Eng
KYRKE	Gerald	Marlborough Nomads	1908	No
LAING	Alex	Hawick	1888	No
LAXON	Herbert	Cambridge Uni	1908	No
LEE	George	Rockliffe	1896	No
LEWIS	Alun	Cambridge Uni/London Welsh	1977	No
MARTELLI	Esmond	Dublin Uni	1899	No
MASSEY	Burnett	Hull & East Riding	1904	No
MATHERS	Charles	Bramley	1888	No
MAXWELL	Reg	Birkenhead Park	1924	No
MAYFIELD	Edwin	Cambridge Uni	1891	No
MCEVEDY	Pat	Guy's Hospital	1904	No
			1908	No
MELVILLE	Nigel	Wasps	1983	Eng
MORGAN	Edgar	Swansea	1908	Wal
MULLINEUX	Matthew	Blackheath	1896	No
		Blackheath	1899	No
MULLINS	Cuthbert	Oxford Uni	1896	No
NEALE	Maurice	Bristol	1910	Eng
O'BRIEN	Arthur	Guy's Hospital	1904	No
PATTERSON	Bill	Sale	1959	Eng
PATTERSON	Charlie	Malone	1904	No
PAUL	Arthur	Swinton	1888	No
PENKETH	Alfred	Douglas, Isle of Man	1888	No
PLUMMER	Reg	Newport	1910	Wal
POOLE	Howard	Cardiff	1930	No
PURCHAS	Griff	Coventry	1938	No
QUINNELL	Derek	Llanelli	1971	Wal
REES	Elgan	Neath	1977	Wal
RITSON	John	Northern	1908	Eng
ROBERTSON	Bill	Edinburgh Uni	1910	No
ROBINSON	Charles	Percy Park	1896	No
ROGERS	Ron	Bath	1904	No
ROSCOE	Bert	Manchester	1891	No
SAUNDERS	Stuart	Guy's Hospital	1904	No
SHARLAND	John	Streatham	1904	No
SMITH	John	Edinburgh Uni	1888	No
SMITH	Tom	Leicester	1908	No
SPEAKMAN	Harry	Runcorn	1888	No
SPOORS	Jack	Bristol	1910	No
STANGER-LEATHES	Chris	Northern	1904	Eng
STEPHENS	Ian	Bridgend	1980	Wal
STUART	Angus	Dewsbury	1888	No
SURTEES	Aubone	Harlequins	1891	No
SWANNELL	Blair	Northampton	1899	Aus
			1904	Aus
THOMAS	Delme	Llanelli	1966	Wal
THOMAS	Len	Penarth	1908	No
THOMPSON	Charles	Lancashire	1899	No

THOMPSON	Robert	Cambridge Uni	1891	No
THORMAN	Will	Cambridge Uni	1891	No
TIMMS	Charles	Edinburgh Uni	1910	No
TODD	Alex	Blackheath	1896	Eng
TRAIL	David	Guy's Hospital	1904	No
VILE	Tommy	Newport	1904	Wal
WALKER	Edward	Lennox	1903	No
WALLACE	James	Wanderers	1903	Ire
WALLACE	William	Percy Park	1924	No
WHITLEY	Herbert	Northern	1924	Eng
WHITTAKER	Thomas	Manchester	1891	No
WILLIAMS	Brynmor	Cardiff	1977	Wal
WILLIAMS	Gareth	Bridgend	1980	Wal
WILLIAMS	Gerry	Liverpool	1908	No
WILLIAMS	Ivor	Cardiff	1938	No
WILLIAMS	Sam	Newport	1910	Eng
WILLIAMS	Sam	Salford	1888	No
WOOD	Ken	Leicester	1910	No

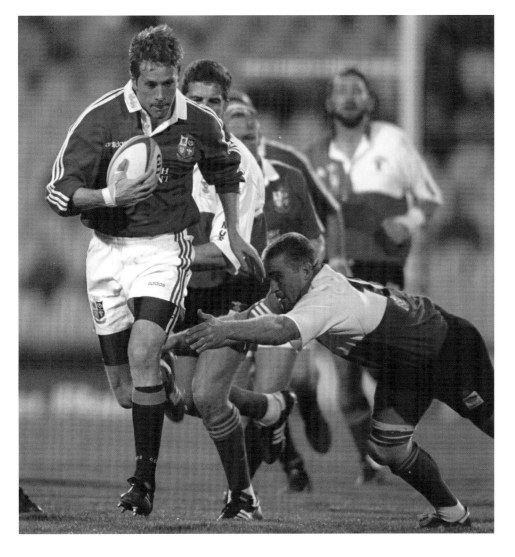

◄ Will Greenwood, the last man to be picked for a Lions tour without having played for his country first, in action during the 1997 match against Free State in Bloemfontein. The Lions won the match 52–30 but not before the young centre was carried off following a freak injury that almost cost him his life. Fortunately no lasting damage was done and Greenwood would go on to represent both England and the Lions with distinction in the future

The British & Irish Lions marked their 125th anniversary by honouring every player who has played for the Lions from 1888 with a player number. Numbers were designated alphabetically for each match played on tours to New Zealand, Australia, South Africa and Argentina, as well as for those players who played in the games against the Rest of the World XV in 1986 and France in 1989.

LIST OF BRITISH & IRISH LIONS BY PLAYER NUMBER

No	SURNAME	FIRST NAMES	CLUB	TOURS
1888 NEW ZEALAND/AUSTRALIA				
1	ANDERTON	Jack	Salford	1888
2	BANKS	Thomas	Swinton	1888
3	BUMBY	Walter	Swinton	1888
4	BURNET	Robert	Hawick	1888
5	EAGLES	Harry	Salford	1888
6	HASLAM	J. Tommy	Batley	1888
7	KENT	Thomas	Salford	1888
8	LAING	Alexander James	Hawick	1888
9	MATHERS	Charles	Bramley	1888
10	NOLAN	John	Rochdale Hornets	1888
11	SEDDON	Robert Lionel	Swinton	1888
12	SPEAKMAN	Henry Collinge	Runcorn	1888
13	STODDART	Andrew Ernest	Blackheath	1888
14	THOMAS	William Henry	Cambridge University	1888
15	WILLIAMS	Samuel	Salford	1888
16	PAUL	Arthur George	Swinton	1888
17	STUART	Angus John	Dewsbury	1888
18	BURNET	William Hewitson	Hawick	1888
19	PENKETH	Alfred Peter	Douglas IOM	1888
20	BROOKS	Herbert	Durham County	1888
21	SMITH	John	Corinthians	1888
22	MACSWAINE	David	Guest	1888
23	BRYCE	Thomas	Guest	1888
24	WADSWORTH	Deacon	Guest	1888
25	CLOWES	Jack	Halifax	1888
1891 SOUTH AFRICA				
26	ASTON	Randolph Littleton	Blackheath	1891
27	BROMET	William Ernest	Richmond	1891
28	CLAUSS	Paul Robert Adolph	Oxford University	1891
29	GOULD	John Harding	Old Leysians	1891
30	HAMMOND	Johnny	Blackheath	1891 1896
31	HANCOCK	Philip Froude	Blackheath	1891 1896
32	MACLAGAN	William Edward	Edinburgh Academy	1891
33	MACMILLAN	Robert Gordon	London Scottish	1891
34	MITCHELL	William Grant	Richmond	1891

35	ROTHERHAM	Arthur	Cambridge University	1891
36	SIMPSON	Clement Pearson	Cambridge University	1891
37	THOMPSON	Robert	Cambridge University	1891
38	THORMAN	William Henry	Cambridge University	1891
39	WHITTAKER	Thomas Sherren	Manchester	1891
40	WOTHERSPOON	William	Cambridge University	1891
41	BROMET	Edward	Cambridge University	1891
42	MARSHALL	Howard	Cambridge University	1891
43	MAYFIELD	Edwin	Cambridge University	1891
44	JACKSON	Walter	Cambridge University	1891
45	ROSCOE	Bertwine Goldsmith	Manchester	1891
46	SURTEES	Aubone Alfred	Harlequins	1891

1896 SOUTH AFRICA

47	BELL	Sydney Pyman	Cambridge University	1896
48	BOYD	Cecil Anderson	Dublin University	1896
49	BULGER	Lawrence Quinlivan	Dublin University	1896
50	BYRNE	James Frederick	Moseley	1896
51	CAREY	Walter Julius	Oxford University	1896
52	CLINCH	Andrew Daniel	Dublin University	1896
53	CREAN	Thomas Joseph Patrick	Wanderers	1896
54	JOHNSTON	Robert	Wanderers	1896
55	MACKIE	Osbert Gadesden	Cambridge University	1896
56	MAGEE	Louis Mary	Bective Rangers	1896
57	ROBINSON	Charles	Percy Park	1896
58	SEALY	James	Dublin University	1896
59	TODD	Alexander Findlater	Blackheath	1896
60	MAGEE	James Mary	Bective Rangers	1896
61	MEARES	Arthur William Devenish	Dublin University	1896
62	MORTIMER	William	Cambridge University	1896
63	MULLINEUX	Matthew	Blackheath	1896 1899
64	MULLINS	Reginald Cuthbert	Oxford University	1896
65	LEE	George William	Rockcliff	1896

1899 AUSTRALIA

66	ADAMSON	Charles Young	Durham City	1899
67	AYRE-SMITH	Alan	Guy's Hospital	1899
68	BELSON	Frederick Charles	Bath	1899
69	BUCHER	Alfred Moore	Edinburgh Academy	1899
70	DORAN	Gerald Percy	Lansdowne	1899
71	GIBSON	George Ralph	Northern	1899
72	GRAY	Hugh Grainger Stewart	Coventry	1899
73	JARMAN	John Wallace	Bristol	1899
74	MARTELLI	Arthur Esmonde	Dublin University	1899
75	MCGOWN	Thomas Melville	North of Ireland	1899
76	NICHOLLS	Erith Gwynne	Cardiff	1899
77	STOUT	Frank Moxham	Gloucester	1899 1903
78	THOMPSON	Charles Edward	Manchester	1899
79	TIMMS	Alec Boswell	Edinburgh University	1899

80	COOKSON	George	Manchester	1899
81	FRANCOMB	John Stanley	Manchester	1899
82	EVERS	Guy Vincent	Moseley	1899
83	JUDKINS	William James	Coventry	1899
84	NICHOLSON	Elliot Tennant	Birkenhead Park	1899
85	SWANNELL	Blair Inskip	Northampton	1899 1904

1903 SOUTH AFRICA

86	BEDELL-SIVRIGHT	David Revell	Cambridge University	1903 1904
87	COLLETT	Gilbert Faraday	Gloucester	1903
88	DAVIDSON	Ian Geddes	North of Ireland	1903
89	GIBSON	Thomas Alexander	Cambridge University	1903
90	GILLESPIE	John Imrie	Edinburgh Academy	1903
91	HARRISON	Edward Montague	Guy's Hospital	1903
92	HIND	Alfred Ernest	Leicester	1903
93	MORRISON	Mark Coxon	Royal HSFP	1903
94	NEILL	Robert Miln	Edinburgh Academy	1903
95	SCOTT	William Patrick	West of Scotland	1903
96	SKRIMSHIRE	Reginald Truscott	Newport	1903
97	TEDFORD	Alfred	Malone	1903
98	WALLACE	James	Wanderers	1903
99	WALLACE	Joseph	Wanderers	1903
100	WALKER	Edward Forbes	Lennox	1903
101	CAVE	William Thomas Charles	Cambridge University	1903
102	HANCOCK	Patrick Sortain	Richmond	1903
103	GREIG	Louis Leisler	United Services	1903
104	SMYTH	Robertson Stewart	Dublin University	1903
105	HOSACK	James Charles	Edinburgh Wanderers	1903

1904 AUSTRALIA/NEW ZEALAND

106	BEVAN	Thomas Sydney	Swansea	1904
107	BUSH	Percy Frank	Cardiff	1904
108	CROWTHER	Sydney Nelson	Lennox	1904
109	EDWARDS	Reginald Weston	Malone	1904
110	GABE	Rhys Thomas	Cardiff	1904
111	HARDING	Arthur Flowers	London Welsh	1904 1908
112	HULME	Frank Croft	Birkenhead Park	1904
113	LLEWELLYN	William Morris	Newport	1904
114	MORGAN	Edward	Guy's Hospital	1904
115	O'BRIEN	Arthur Boniface	Guy's Hospital	1904
116	SAUNDERS	Stuart Mackenzie	Guy's Hospital	1904
117	STANGER-LEATHES	Christopher	Northern	1904
118	TRAIL	David Herbert	Guy's Hospital	1904
119	MCEVEDY	Patrick Francis	Guy's Hospital	1904 1908
120	PATTERSON	Charles Delamere	Malone	1904
121	SHARLAND	John Thomas	Streatham	1904
122	VILE	Thomas Henry	Newport	1904
123	DOBSON	Denys Douglas	Newton Abbot	1904
124	JOWETT	William Frederick	Swansea	1904

125 ROGERS	Ronald Joseph	Bath	1904
126 FISHER	John Leaper	Hull & East Riding	1904
127 MASSEY	Burnett Staveley	Hull & East Riding	1904

1908 AUSTRALIA/NEW ZEALAND

128 DAVEY	James	Redruth	1908
129 DIBBLE	Robert	Bridgwater Albion	1908
130 GIBBS	Reginald Arthur	Cardiff	1908
131 JACKETT	Edward John	Falmouth	1908
132 JONES	John Phillips (Jack)	Pontypool	1908 1910
133 KYRKE	Gerald Venables	Marlborough Nomads	1908
134 LAXON	Herbert	Coventry	1908
135 MORGAN	Edgar	Swansea	1908
136 OLDHAM	William Leonard	Coventry	1908
137 RITSON	John Anthony Sydney	Northern	1908
138 SMITH	Thomas William	Leicester	1908
139 WILLIAMS	John Frederick	London Welsh	1908
140 WILLIAMS	John Lewis	Cardiff	1908
141 DOWN	Percy John	Bristol	1908
142 DYKE	John Charles Meredith	Penarth	1908
143 ARCHER	Herbert	Guy's Hospital	1908
144 CHAPMAN	Frederick Ernest	Hartlepool Rovers	1908
145 GRIFFITHS	Rowland Best	Newport	1908
146 JACKSON	Frederick Stanley	Leicester	1908
147 VASSALL	Henry Holland	Oxford University	1908
148 WILLIAMS	Gerald Lloyd	Liverpool	1908
149 HIND	Guy Reginald	Guy's Hospital	1908
150 JONES	James Phillips (Tuan)	Guy's Hospital	1908
151 MORGAN	William Llewellyn	London Welsh	1908
152 THOMAS	Leonard	Penarth	1908
153 GREEN	Robert	Neath	1908

1910 ARGENTINA

154 ASHBY	John Francis	Birkenhead Park	1910
155 BENNETTS	Barzillai Beckerleg (Barrie)	Penzance	1910
156 DIGGLE	Percy Robert	Oxford University	1910
157 FULLER	Edward Newman	Old Merchant Taylors'	1910
158 HARRISON	Robin	Northampton	1910
159 HENNIKER-GOTLEY	Anthony Lefroy	Oxford University	1910
160 HOLMWOOD	Ernest	Blackheath	1910
161 HUNTINGFORD	Walter Legh	United Services	1910
162 MONKS	Harold	Liverpool Old Boys	1910
163 PALMER	Alexander Croydon	London Hospital	1910
164 RAPHAEL	John Edward	Old Merchant Taylors'	1910
165 STRANACH	Whalley	Guy's Hospital	1910
166 STRANG	Peter Denny	Old Merchant Taylors'	1910
167 TWEED	Martin Baird Moore	Guy's Hospital	1910
168 WARD	Horace Evelyn	Harlequins	1910
169 FRASER	William Lovat	Merchistonians	1910

170	SMITH	Stanley	Cumberland	1910
171	FRASER	Henry John	Merchistonians	1910
172	WADDELL	Robert Bertram	Glasgow Academy	1910
173	WHITEHEAD	Henry	Manchester	1910

1910 SOUTH AFRICA

174	BAKER	Albert Melville	Newport	1910
175	ISHERWOOD	George Aldwyn	Sale	1910
176	JARMAN	Henry	Newport	1910
177	McCLINTON	Arthur Norman	North of Ireland	1910
178	NEALE	Maurice Edward	Bristol	1910
179	PILLMAN	Charles Henry	Blackheath	1910
180	PIPER	Oliver James Southwell	Cork Constitution	1910
181	ROBERTSON	William Albert	Edinburgh University	1910
182	SMITH	Dyne Fenton	Richmond	1910
183	SMYTH	Thomas	Newport	1910
184	SPOORS	John Ainsworth	Bristol	1910
185	STEVENSON	Robert	University of St Andrews	1910
186	WALLER	Philip Dudley	Newport	1910
187	WILLIAMS	Stanley Horatio	Newport	1910
188	HANDFORD	Frank Gordon	Manchester	1910
189	PLUMMER	Reginald Clifford	Newport	1910
190	WOOD	Kenneth Berridge	Leicester	1910
191	FOSTER	Alexander Roulston	Derry	1910
192	TYRRELL	William	Queen's University Belfast	1910
193	TIMMS	Charles Gordon	Edinburgh University	1910
194	CREAN	Edward O'Donovan	Liverpool	1910
195	RICHARDS	Thomas James	Bristol	1910
196	HUMPHREYS	Noel Forbes	Tynedale	1910
197	ASHBY	Willie Joseph	Queen's College Cork	1910
198	MILROY	Eric	Watsonians	1910
199	WEBB	James	Abertillery	1910

1924 SOUTH AFRICA

200	BLAKISTON	Arthur Frederick	Blackheath	1924
201	COVE-SMITH	Ronald	Old Merchant Taylors'	1924
202	DRYSDALE	Daniel	Heriot's FP	1924
203	HARRIS	Stanley Wakefield	Blackheath	1924
204	HENDRIE	Kelvin Gladstone Peter	Edinburgh University	1924
205	HOLLIDAY	Thomas Edward	Aspatria	1924
206	HOWIE	Robert	Edinburgh University	1924
207	KINNEAR	Roy Muir	Heriot's FP	1924
208	MACPHERSON	Neil Clark	Newport	1924
209	MARSDEN-JONES	Douglas	London Welsh	1924
210	McVICKER	James	Belfast Collegians	1924
211	ROSS	Andrew	Kilmarnock	1924
212	WADDELL	Herbert	Glasgow Academy	1924
213	WALLACE	William	Percy Park	1924
214	YOUNG	Arthur Tudor	Cambridge University	1924

215 BORDASS	James Harrison	Cambridge University	1924
216 CLINCH	James Daniel	Dublin University	1924
217 DAVIES	Douglas	Hawick	1924
218 GRIFFITHS	Vincent Morgan	Newport	1924
219 HARDING	Rowe	Cambridge University	1924
220 ROCHE	William Joseph	Newport	1924
221 SMITH	Ian Scott	Oxford University	1924
222 VOYCE	Anthony Thomas	Gloucester	1924
223 BRADLEY	Michael James	Dolphin	1924
224 BRAND	Thomas Norman	North of Ireland	1924
225 MAXWELL.	Reginald Bellamy	Birkenhead Park	1924
226 WHITLEY	Herbert	Northern	1924
227 DAVIES	Harold Joseph	Newport	1924
228 HENDERSON	Robert Gordon	Durham University	1924
229 CUNNINGHAM	William Anthony	Lansdowne	1924

1927 ARGENTINA

230 AARVOLD	Carl Douglas	Cambridge University	1927 1930
231 ALLEN	Arthur	Cambridge University	1927
232 FARRELL	James Leo	Bective Rangers	1927 1930
233 GUBB	Thomas Witheridge	Oxford University	1927
234 HAMILTON-SMYTHE	Arthur	Cambridge University	1927
235 HAMMETT	Ernest Dyer	Blackheath	1927
236 LAW	Douglas Edward	Birkenhead Park	1927
237 MCILWAINE	George Arthren	Cambridge University	1927
238 PAYNE	Charles Trevor	North of Ireland	1927
239 PIKE	Theodore Ousley	Lansdowne	1927
240 SOBEY	Wilfred Henry	Old Millhillians	1927 1930
241 TAYLOR	Edward Graham	Oxford University	1927
242 WAKEFIELD	Roger Cuthbert	Cambridge University	1927
243 WALLENS	John Noel Stanley	Waterloo	1927
244 WILSON	Guy Summerfield	Birkenhead Park	1927
245 COGHLAN	Granville Boyle	Cambridge University	1927
246 DOUTY	Peter Sime	London Scottish	1927
247 KELLY	Robert Forrest	Watsonians	1927
248 MALFROY	Jules Omer John	Cambridge University	1927
249 MACMYN	David James	London Scottish	1927
250 SPONG	Roger Spencer	Old Millhillians	1927 1930
251 TROUP	Donald Scott	Oxford University	1927
252 COLEY	Eric	Northampton	1927

1930 NEW ZEALAND/AUSTRALIA

253 BEAMISH	George Robert	Leicester	1930
254 BLACK	Brian Henry	Oxford University	1930
255 BONNER	William Gordon	Bradford	1930
256 BOWCOTT	Henry Morgan	Cambridge University	1930
257 JONES	Ivor Egwad	Llanelli	1930
258 KENDREW	Douglas Andrew	Woodford	1930
259 KNOWLES	Thomas Caldwell	Birkenhead Park	1930 1936

260 MARTINDALE	Samuel Airey	Kendal	1930
261 MORLEY	John Cuthbert	Newport	1930
262 NOVIS	Anthony Leslie	Blackheath	1930
263 REW	Henry	Exeter	1930
264 WELSH	William Berridge	Hawick	1930
265 HODGSON	John McDonald	Northern	1930
266 JENNINGS	Roy	Redruth	1930
267 MURRAY	Paul Finbarr	Wanderers	1930
268 O'NEILL	Henry O'Hara	Queen's University Belfast	1930
269 PARKER	David	Swansea	1930
270 POOLE	Howard	Cardiff	1930
271 REEVE	James Stanley Reeve	Harlequins	1930
272 WILKINSON	Harry James	Halifax	1930
273 DUNNE	Michael Joseph	Lansdowne	1930
274 JONES	Harold Crawford	Manchester	1930
275 JONES-DAVIES	Thomas Ellis	London Welsh	1930
276 PRENTICE	Frank Douglas	Leicester	1930
277 BASSETT	John Archibald	Penarth	1930

1936 ARGENTINA

278 BEAMISH	Charles Eric St. John	Leicester	1936
279 BOYLE	Charles Vesey	Dublin University	1936 1938
280 BRETT	John Alfred	Oxford University	1936
281 CHADWICK	William Owen	Cambridge University	1936
282 DUNKLEY	Phillip Edward	Harlequins	1936
283 GADNEY	Bernard Cecil	Leicester	1936
284 HOBBS	Peter	Richmond	1936
285 HUSKISSON	Thomas Fredrick	Old Merchant Taylors'	1936
286 PRATTEN	William	Blackheath	1936
287 SHAW	Robert Wilson	Glasgow HS	1936
288 TALLENT	John Arthur	Blackheath	1936
289 UNWIN	Ernest James	Rosslyn Park	1936 1938
290 UREN	Harold John	Waterloo	1936
291 WESTON	William Henry	Northampton	1936
292 A'BEAR	John Gordon	Gloucester	1936
293 WATERS	John Alexander	Selkirk	1936 1938
294 HANCOCK	George Edward	Birkenhead Park	1936
295 MOLL	John Selwyn	Lloyds Bank	1936
296 OBOLENSKY	Alexander Sergeevich	Oxford University	1936
297 PRESCOTT	Robert Edward	Harlequins	1936
298 HORDERN	Peter Cotton	Gloucester	1936

1938 SOUTH AFRICA

299 ALEXANDER	Robert	North of Ireland	1938
300 CLEMENT	William Harries	Llanelli	1938
301 DUFF	Peter Laurence	Glasgow Academy	1938
302 GILES	James Leonard	Coventry	1938
303 GRAVES	Charles Robert Arthur	Wanderers	1938
304 JENKINS	Vivian Gordon James	London Welsh	1938

305 LEYLAND	Roy	Waterloo	1938
306 MACRAE	Duncan James	University of St Andrews	1938
307 MAYNE	Robert Blair	Queen's University Belfast	1938
308 REYNOLDS	Frank Jeffrey	Old Cranleighans	1938
309 TAYLOR	Albert Russell	Cross Keys	1938
310 TRAVERS	William Henry	Newport	1938
311 WALKER	Samuel	Instonians	1938
312 COUCHMAN	Stanley Randall	Old Cranleighans	1938
313 CROMEY	George Ernest	Queen's University Belfast	1938
314 HOWARD	William Gordon	Old Birkonians	1938
315 JONES	Elfed Lewis	Llanelli	1938
316 MCKIBBIN	Henry Roger	Queen's University Belfast	1938
317 MORGAN	George Joseph	Clontarf	1938
318 MORGAN	Morgan Edward	Swansea	1938
319 WILLIAMS	Ivor	Cardiff	1938
320 GRIEVE	Charles Frederick	Army	1938
321 DANCER	Gerald Thomas	Bedford	1938
322 PURCHAS	Arthur Horsfall	Coventry	1938
323 TANNER	Haydn	Swansea	1938
324 NICHOLSON	Basil Ellard	Harlequins	1938

1950 NEW ZEALAND/AUSTRALIA

325 BUDGE	Grahame Morris	Edinburgh Wanderers	1950
326 CLEAVER	William Benjamin	Cardiff	1950
327 CLIFFORD	Jeremiah Thomas	Young Munster	1950
328 HAYWARD	Donald James	Newbridge	1950
329 LANE	Michael Francis	University College Cork	1950
330 MACDONALD	Ranald	Edinburgh University	1950
331 MATTHEWS	Jack	Cardiff	1950
332 McCARTHY	James Stephen	Dolphin	1950
333 MULLEN	Karl Daniel	Old Belvedere	1950
334 NELSON	James Edward	Malone	1950
335 PREECE	Ivor	Coventry	1950
336 RIMMER	Gordon	Waterloo	1950
337 ROBERTS	Victor George	Penryn	1950
338 STEPHENS	John Rees Glyn	Neath	1950
339 THOMAS	Malcolm Campbell	Newport	1950 1959
340 BLACK	Angus William	Edinburgh University	1950
341 DAVIES	Clifton	Cardiff	1950
342 EVANS	Robert Thomas	Newport	1950
343 JOHN	Enerst Raymond	Neath	1950
344 JONES	Kenneth Jeffrey	Newport	1950
345 KININMONTH	Peter Wyatt	Richmond	1950
346 KYLE	John Wilson	Queen's University Belfast	1950
347 McKAY	James William	Queen's University Belfast	1950
348 NORTON	George William	Bective Rangers	1950
349 ROBINS	John Denning	Birkenhead Park	1950
350 DAVIES	David Maldwyn	Somerset Police	1950
351 HENDERSON	Noel Joseph	Queen's University Belfast	1950

352 WILLIS	William Rex	Cardiff	1950
353 WILLIAMS	Bleddyn Llewellyn	Cardiff	1950
354 JONES	Benjamin Lewis	Llanelli	1950
355 SMITH	Douglas William Cumming	London Scottish	1950

1955 SOUTH AFRICA

356 BUTTERFIELD	Jeffrey	Northampton	1955 1959
357 DAVIES	William Philip Cathcart	Harlequins	1955
358 GREENWOOD	James Thomson	Dunfermline	1955
359 HIGGINS	Reginald	Liverpool	1955
360 LLOYD	Trevor	Maesteg	1955
361 MEREDITH	Brinley Victor	Newport	1955 1959 1962
362 MEREDITH	Courtenay Charles	Neath	1955
363 MORGAN	Cifford Isaac	Cardiff	1955
364 PEDLOW	Alexander Cecil	Queen's University Belfast	1955
365 SMITH	Arthur Robert	Cambridge University	1955 1962
366 THOMAS	Alun Gruffydd	Llanelli	1955
367 THOMPSON	Robin Henderson	Instonians	1955
368 WILLIAMS	Rhys Haydn	Llanelli	1955 1959
369 WILLIAMS	William Owen Gooding	Swansea	1955
370 WILSON	Dyson Stayt	Metropolitan Police	1955
371 JEEPS	Richard Eric Gautrey	Northampton	1955 1959 1962
372 McLEOD	Hugh Ferns	Hawick	1955 1959
373 MORRIS	Haydn Thomas	Cardiff	1955
374 QUINN	James Patrick	New Brighton	1955
375 ROBINS	Russell John	Pontypridd	1955
376 ROE	Robin	Lansdowne	1955
377 SYKES	Frank Douglas	Northampton	1955
378 BAKER	Douglas George Stanley	Old Merchant Taylors'	1955
379 CAMERON	Angus	Glasgow HSFP	1955
380 ELLIOT	Thomas	Gala	1955
381 MICHIE	Ernest James Stuart	Aberdeen University	1955
382 O'REILLY	Anthony Joseph Francis	Old Belvedere	1955 1959
383 REID	Thomas Eymard	Garryowen	1955
384 WILLIAMS	John Edward	Old Millhillians	1955
385 GRIFFITHS	Gareth Meredith	Cardiff	1955
386 THOMAS	Richard Charles Clement	Swansea	1955

1959 AUSTRALIA/NEW ZEALAND

387 ASHCROFT	Alan	Waterloo	1959
388 DAWSON	Alfred Ronald	Wanderers	1959
389 HEWITT	David	Queen's University Belfast	1959 1962
390 JACKSON	Peter Barrie	Coventry	1959
391 MARQUES	Reginald William David	Harlequins	1959
392 MORGAN	Haydn John	Abertillery	1959 1962
393 RISMAN	Augustine Beverley Walter	Manchester University	1959
394 SCOTLAND	Kenneth James Forbes	Cambridge University	1959

395	SMITH	George Kenneth	Kelso	1959
396	WOOD	Benjamin Gordon Malison	Garryowen	1959
397	YOUNG	John Robert Chester	Oxford University	1959
398	BROPHY	Niall Henry	University College Dublin	1959 1962
399	DAVIES	Terence John	Llanelli	1959
400	EVANS	William Roderick	Cardiff	1959
401	FAULL	John	Swansea	1959
402	MILLAR	John Sydney	Ballymena	1959 1962 1968
403	MULCAHY	William Albert	University College Dublin	1959 1962
404	MURPHY	Noel Arthur Augustine	Cork Constitution	1959 1966
405	PRICE	Malcolm John	Pontypool	1959
406	PROSSER	Thomas Raymond	Pontypool	1959
407	COUGHTRIE	Stanley	Edinburgh Academy	1959
408	ENGLISH	Michael Anthony Francis	Bohemians	1959
409	WADDELL	Gordon Herbert	Cambridge University	1959 1962
410	MULLIGAN	Andrew Armstrong	London Irish	1959
411	PATTERSON	William Michael	Sale	1959
412	HORROCKS-TAYLOR	John Philip	Leicester	1959 1962

1962 SOUTH AFRICA

413	C'BELL-LAMERTON	Michael	Halifax	1962 1966
414	HODGSON	Stanley Arthur Murray	Durham City	1962
415	JONES	David Kenneth	Llanelli	1962 1966
416	JONES	Kingsley Daniel	Cardiff	1962
417	NASH	David	Ebbw Vale	1962
418	O'CONNOR	Anthony	Aberavon	1962
419	PASK	Alun Edward Islwyn	Abertillery	1962 1966
420	ROGERS	Derek Prior	Bedford	1962
421	ROLLO	David Miller Durie	Howe of Fife	1962
422	SHARP	Richard Adrian William	Oxford University	1962
423	WESTON	Michael Philip	Richmond	1962 1966
424	WILLCOX	John Graham	Oxford University	1962
425	COWAN	Ronald	Selkirk	1962
426	DEE	John Mackenzie	Hartlepool Rovers	1962
427	HUNTER	William Raymond	CIYMS	1962
428	KIERNAN	Thomas Joseph	University College Cork	1962 1968
429	ROWLANDS	Keith Alun	Cardiff	1962
430	WRIGHT	Thomas Peter	Blackheath	1962
431	DOUGLAS	John	Stewart's College FP	1962
432	GODWIN	Herbert	Coventry	1962
433	McBRIDE	William James	Ballymena	1962 1966 1968 1971 1974
434	BEBB	Dewi Iorwerth Ellis	Swansea	1962 1966
435	BROWN	Harold John Catleugh	Blackheath	1962
436	DAVIDGE	Glyn David	Newport	1962

1966 AUSTRALIA/NEW ZEALAND/CANADA

437	HINSHELWOOD	Alexander James	London Scottish	1966 1968
438	LAIDLAW	Francis Andrew Linden	Melrose	1966 1971
439	LEWIS	Robert Allan	Abertillery	1966
440	NORRIS	Charles Howard	Cardiff	1966
441	PRICE	Brian	Newport	1966
442	RUTHERFORD	Donald	Gloucester	1966
443	TELFER	James William	Melrose	1966 1968
444	WALSH	Jeremiah Charles	Sunday's Well	1966
445	WATKINS	Stuart John	Newport	1966
446	WILLIAMS	Denzil	Ebbw Vale	1966
447	GRANT	Derrick	Hawick	1966
448	KENNEDY	Kenneth William	CIYMS	1966 1974
449	LAMONT	Ronald Arthur	Instonians	1966
450	MCFADYEAN	Colin William	Moseley	1966
451	MCLOUGHLIN	Raymond John	Gosforth	1966 1971
452	POWELL	David Lewes	Northampton	1966
453	SAVAGE	Keith Frederick	Northampton	1966 1968
454	THOMAS	William Delme	Llanelli	1966 1968 1971
455	WATKINS	David	Newport	1966
456	WILSON	Stewart	London Scottish	1966
457	YOUNG	Roger Michael	Queen's University Belfast	1966 1968
458	PROTHERO	Gareth John	Bridgend	1966
459	BRESNIHAN	Finbarr Patrick	Wanderers	1966 1968
460	GIBSON	Cameron Michael Henderson	Cambridge University	1966 1968 1971 1974 1977
461	PRICE	Terence Graham	Llanelli	1966

1968 SOUTH AFRICA

462	COULMAN	Michael John	Moseley	1968
463	DAVIES	Thomas Gerald Reames	Cardiff	1968 1971
464	DOYLE	Michael Gerard	Blackrock College	1968
465	EDWARDS	Gareth Owen	Cardiff	1968 1971 1974
466	HORTON	Anthony Lawrence	Blackheath	1968
467	JONES	William Keri	Cardiff	1968
468	RICHARDS	Maurice Charles Rees	Cardiff	1968
469	TAYLOR	Robert Bainbridge	Northampton	1968
470	TURNER	John William Cleet	Gala	1968
471	YOUNG	Jeffrey	Harrogate	1968
472	ARNEIL	Rodger James	Edinburgh Academy	1968 1971
473	JOHN	Barry	Cardiff	1968 1971
474	PULLIN	John Vivian	Bristol	1968 1971
475	STAGG	Peter Kidner	Sale	1968
476	TAYLOR	John	London Welsh	1968 1971
477	HILLER	Robert	Harlequins	1968 1971
478	LARTER	Peter John	Northampton	1968

479 RAYBOULD	William Henry	London Welsh	1968
480 JARRETT	Keith Stanley	Newport	1968
481 O'SHEA	John Patrick	Cardiff	1968
482 GOODHALL	Kenneth George	City of Derry	1968
483 WEST	Bryan Ronald	Northampton	1968
484 CONNELL	Gordon Colin	London Scottish	1968

1971 AUSTRALIA/NEW ZEALAND

485 BIGGAR	Alistair Gourlay	London Scottish	1971
486 BROWN	Gordon Lamont	West of Scotland	1971 1974 1977
487 DAWES	Sydney John	London Welsh	1971
488 DIXON	Peter John	Harlequins	1971
489 DUCKHAM	David John	Coventry	1971
490 HOPKINS	Raymond	Maesteg	1971
491 LYNCH	John Francis	St. Mary's College	1971
492 McLAUCHAN	John	Jordanhill College	1971 1974
493 QUINNELL	Derek Leslie	Llanelli	1971 1977 1980
494 SLATTERY	John Fergus	University College Dublin	1971 1974
495 SPENCER	John Southern	Headingley	1971
496 BEVAN	John Charles	Cardiff College of Education	1971
497 CARMICHAEL	Alexander Bennett	West of Scotland	1971 1974
498 DAVIES	Thomas Mervyn	London Welsh	1971 1974
499 HIPWELL	Michael Louis	Terenure College	1971
500 LEWIS	Arthur John Llewellyn	Ebbw Vale	1971
501 ROBERTS	Michael Gordon	London Welsh	1971
502 WILLIAMS	John Peter Rhys	London Welsh	1971 1974
503 REA	Chris William Wallace	Headingley	1971
504 STEVENS	Claud Brian	Harlequins	1971
505 EVANS	Thomas Geoffrey	London Welsh	1971

1974 SOUTH AFRICA

506 BENNETT	Philip	Llanelli	1974 1977
507 BERGIERS	Roy Thomas Edmond	Llanelli	1974
508 DAVID	Thomas Patrick	Llanelli	1974
509 McGEECHAN	Ian Robert	Headingley	1974 1977
510 MOLONEY	John Joseph	St Mary's College	1974
511 NEARY	Anthony	Broughton Park	1974 1977
512 REES	Clive Frederick William	London Welsh	1974
513 RIPLEY	Andrew George	Rosslyn Park	1974
514 STEELE	William Charles Common	Bedford	1974
515 WINDSOR	Robert William	Pontypool	1974 1977
516 COTTON	Francis Edward	Coventry	1974 1977 1980
517 EVANS	Geoffrey William	Coventry	1974
518 IRVINE	Andrew Robertson	Heriot's FP	1974 1977 1980

519	MILLIKEN	Richard Alexander	Bangor	1974
520	OLD	Alan Gerald Bernard	Leicester	1974
521	RALSTON	Christopher Wayne	Richmond	1974
522	UTTLEY	Roger Mills	Gosforth	1974
523	WILLIAMS	John James	Llanelli	1974 1977
524	GRACE	Thomas Oliver	St. Mary's College	1974
525	BURTON	Michael Alan	Gloucester	1974
526	McKINNEY	Stewart Alexander	Dungannon	1974
527	MORLEY	Alan John	Bristol	1974

1977 NEW ZEALAND/FIJI

528	BURCHER	David Howard	Newport	1977
529	COBNER	Terrence John	Pontypool	1977
530	EVANS	Trefor Pryce	Swansea	1977
531	HAY	Bruce Hamilton	Boroughmuir	1977 1980
532	HORTON	Nigel Edgar	Moseley	1977
533	KEANE	Maurice Ignatius	Lansdowne	1977
534	ORR	Philip Andrew	Old Wesley	1977 1980
535	PRICE	Graham	Pontypool	1977 1980 1983
536	SQUIRES	Peter John	Harrogate	1977
537	WHEELER	Peter John	Leicester	1977 1980
538	WILLIAMS	David Brynmor	Cardiff	1977
539	DUGGAN	William Patrick	Blackrock College	1977
540	BEVAN	John David	Aberavon	1977
541	EVANS	Gareth Lloyd	Newport	1977
542	FENWICK	Stephen Paul	Bridgend	1977
543	MARTIN	Allan Jeffrey	Aberavon	1977 1980
544	MORGAN	Douglas Waugh	Stewart's Melville FP	1977
545	WILLIAMS	Clive	Aberavon	1977 1980
546	SQUIRE	Jeffrey	Newport	1977 1980 1983
547	REES	Harold Elgan	Neath	1977 1980
548	BEAUMONT	William Blackledge	Fylde	1977 1980
549	FAULKNER	Anthony George	Pontypool	1977
550	LEWIS	Alun David	Cambridge University	1977

1980 SOUTH AFRICA

551	BEATTIE	John Ross	Glasgow Academy	1980 1983 1986
552	DAVIES	William Gareth	Cardiff	1980
553	GRAVELL	Raymond William	Llanelli	1980
554	HOLMES	Terence David	Cardiff	1980 1983
555	LANE	Stuart Morris	Cardiff	1980
556	MORGAN	Peter John	Llanelli	1980
557	SLEMEN	Michael Anthony	Liverpool	1980
558	RENWICK	James Menzies	Hawick	1980
559	BLAKEWAY	Philip John	Gloucester	1980
560	CARLETON	John	Orrell	1980 1983

561 COLCLOUGH	Maurice John	Angouleme	1980 1983
562 O'DONNELL	Rodney Christopher	St Mary's College	1980
563 O'DRISCOLL	John Brian	London Irish	1980 1983
564 PATTERSON	Colin Stewart	Instonians	1980
565 PHILLIPS	Allan John	Cardiff	1980
566 RICHARDS	David Stuart	Swansea	1980
567 TOMES	Alan James	Hawick	1980
568 TUCKER	Colm Christopher	Shannon	1980
569 WOODWORD	Clive Ronald	Leicester	1980 1983
570 CAMPBELL	Seamus Oliver	Old Belvedere	1980 1983
571 WILLIAMS	Gareth Powell	Bridgend	1980
572 STEPHENS	Ian	Bridgend	1980 1983
573 WARD	Anthony Joseph Patrick	Garryowen	1980
574 ROBBIE	John Cameron	Greystones	1980
575 DODGE	Paul William	Leicester	1980

1983 NEW ZEALAND

576 ACKERMAN	Robert Angus	London Welsh	1983
577 BOYLE	Stephen Brent	Gloucester	1983
578 EVANS	Gwyn	Maesteg	1983
580 HARE	William Henry	Leicester	1983
581 JONES	Stephen Thomas	Pontypool	1983
582 KIERNAN	Michael Joseph	Dolphin	1983
583 LAIDLAW	Roy James	Jedforest	1983
584 MILNE	Ian Gordon	Heriot's FP	1983
585 NORSTER	Robert Leonard	Cardiff	1983 1989
586 RINGLAND	Trevor Maxwell	Ballymena	1983 1986
587 RUTHERFORD	John Young	Selkirk	1983 1986
588 WINTERBOTTOM	Peter James	Headingley	1983 1993
589 BAINBRIDGE	Stephen	Gosforth	1983
590 BAIRD	Gavin Roger Todd	Kelso	1983
591 CALDER	James Hamilton	Stewart's Melville FP	1983
592 IRWIN	David George	Instonians	1983
593 MACNEILL	Hugh Patrick	Oxford University	1983
594 DEANS	Colin Thomas	Hawick	1983 1986
595 PAXTON	Iain Angus McLeod	Selkirk	1983 1986
596 JEAVONS	Nicholas Clive	Moseley	1983
597 MELVILLE	Nigel David	Wasps	1983
598 LENIHAN	Donal Gerard	Cork Constitution	1983 1986 1989
599 McLOUGHLIN	Gerald Anthony	Shannon	1983
600 SMITH	Stephen James	Sale	1983
601 BUTLER	Edward Thomas	Pontypool	1983

1986 IRB CENTENARY MATCH

602 CARR	Nigel John	Ards	1986
603 DEVEREUX	John Anthony	Bridgend	1986 1989
604 DOOLEY	Wade Anthony	Preston Grasshoppers	1986 1989 1993

605	FITZGERALD	Desmond	Lansdowne	1986
606	HASTINGS	Andrew Gavin	London Scottish	1986 1989 1993
607	JEFFREY	John	Kelso	1986 1989
608	JONES	Robert Nicholas	Swansea	1986 1989 1993
609	MULLIN	Brendan John	London Irish	1986 1989
610	UNDERWOOD	Rory	Leicester	1986 1989 1993
611	WHITEFOOT	Jeffrey	Cardiff	1986
612	DACEY	Malcolm	Swansea	1986

1989 AUSTRALIA

613	CALDER	Finlay	Stewart's Melville FP	1989
614	DEAN	Paul Michael	St Mary's College	1989
615	DODS	Peter William	Gala	1989
616	EVANS	Ieuan Cennydd	Llanelli	1989 1993 1997
617	HASTINGS	Scott	Watsonians	1989 1993
618	MOORE	Brian Christopher	Nottingham	1989 1993
619	SOLE	David Michael Barclay	Edinburgh Academy	1989
620	TEAGUE	Michael Clive	Gloucester	1989 1993
621	WHITE	Derek Bolton	London Scottish	1989
622	YOUNG	David	Cardiff	1989 1997 2001
623	CHALMERS	Craig Minto	Melrose	1989
624	ACKFORD	Paul John	Harlequins	1989
625	ARMSTRONG	Gary	Jedforest	1989
626	CHILCOTT	Gareth James	Bath	1989
627	GRIFFITHS	Michael	Bridgend	1989
628	GUSCOTT	Jeremy Clayton	Bath	1989 1993 1997
629	OTI	Christopher	Wasps	1989
630	RICHARDS	Dean	Leicester	1989 1993
631	ROBINSON	Richard Andrew	Bath	1989
632	SMITH	Stephen James (2)	Ballymena	1989
633	HALL	Michael Robert	Bridgend	1989
634	ANDREW	Christopher Robert	Wasps	1989 1993
635	CLEMENT	Anthony	Swansea	1989 1993

1989 FRENCH REVOLUTION BICENTENARY MATCH

636	CRONIN	Damian Francis	London Scottish	1989 1993
637	EGERTON	David William	Bath	1989
638	MATTHEWS	Philip Michael	Wanderers	1989
639	PROBYN	Jeffrey Alan	Wasps	1989

1993 NEW ZEALAND

640	BARNES	Stuart	Bath	1993

641 CLARKE	Benjamin Bevan	Bath	1993
642 GALWEY	Michael Joseph	Shannon	1993
643 HUNTER	Ian	Northampton	1993
644 LEONARD	Jason	Harlequins	1993 1997 2001
645 REED	Andrew Ian	Bath	1993
646 WEBSTER	Richard Edward	Swansea	1993
647 WRIGHT	Peter Hugh	Boroughmuir	1993
648 BURNELL	Andrew Paul	London Scottish	1993
649 BAYFIELD	Martin Christopher	Northampton	1993
650 CARLING	William David Charles	Harlequins	1993
651 GIBBS	Ian Scott	Swansea	1993 1997 2001
652 MILNE	Kenneth Stuart	Heriot's FP	1993
653 MORRIS	Colin Dewi	Orrell	1993
654 POPPLEWELL	Nicholas James	Greystones	1993
655 UNDERWOOD	Tony	Leicester	1993 1997
656 WALLACE	Richard Michael	Garryowen	1993
657 CUNNINGHAM	Vincent John	St Mary's College	1993
658 JOHNSON	Martin Osborne	Leicester	1993 1997 2001
659 NICOL	Andrew Douglas	Dundee HSFP	1993

1997 SOUTH AFRICA

660 BEAL	Nicholas David	Northampton	1997
661 DALLAGLIO	Lawrence Bruno	Wasps	1997 2001 2005
662 GREENWOOD	William John	Leicester	1997 2001 2005
663 HILL	Richard Anthony	Saracens	1997 2001 2005
664 HOWLEY	Robert	Cardiff	1997 2001
665 JENKINS	Neil Roger	Pontypridd	1997 2001
666 QUINNELL	Leon Scott	Richmond	1997 2001
667 SHAW	Simon Dalton	Bristol	1997 2005 2009
668 SMITH	Thomas James	Watsonians	1997 2001
669 TOWNSEND	Gregor Peter John	Northampton	1997
670 WEIR	George Wilson	Newcastle	1997
671 WOOD	Keith Gerald Mallinson	Harlequins	1997 2001
672 WILLIAMS	Barry Hugh	Neath	1997
673 DAVIDSON	Jeremy William	London Irish	1997 2001
674 BACK	Neil Anthony	Leicester	1997 2001 2005
675 BATEMAN	Allan Glen	Richmond	1997
676 BENTLEY	John	Newcastle	1997
677 GRAYSON	Paul James	Northampton	1997
678 HEALEY	Austin Sean	Leicester	1997 2001
679 MILLER	Eric Roger Patrick	Leicester	1997

680 REGAN	Mark Peter	Bristol	1997
681 ROWNTREE	Graham Christopher	Leicester	1997 2005
682 STIMPSON	Timothy Richard	Newcastle	1997
683 WAINWRIGHT	Robert Ian	Watsonians	1997
684 TAIT	Alan Victor	Newcastle	1997
685 DAWSON	Matthew James	Northampton	1997 2001 2005
686 WALLACE	Paul Stephen	Saracens	1997
687 RODBER	Timothy Andrew Keith	Northampton	1997
688 CATT	Michael John	Bath	1997 2001
689 REDMAN	Nigel Charles	Bath	1997
690 DIPROSE	Anthony James	Saracens	1997
691 BRACKEN	Kyran Paul Patrick	Saracens	1997
692 STANGER	Anthony George	Hawick	1997

2001 AUSTRALIA

693 COHEN	Benjamin Christopher	Northampton	2001
694 GREWCOCK	Daniel Jonathan	Saracens	2001 2005
695 LUGER	Daniel Darko	Saracens	2001
696 MORRIS	Darren Raymond	Swansea	2001
697 O'DRISCOLL	Brian Gerald	Leinster	2001 2005 2009 2013
698 O'GARA	Ronan John Ross	Munster	2001 2005 2009
699 O'KELLY	Malcolm Eamonn	Leinster	2001
700 TAYLOR	Mark	Swansea	2001
701 VICKERY	Philip John	Gloucester	2001 2009
702 TAYLOR	Simon Marcus	Edinburgh	2001
703 BALSHAW	Ian Robert	Bath	2001
704 HENDERSON	Robert Alexander	London Wasps	2001
705 McBRYDE	Robin Currie	Llanelli	2001
706 CHARVIS	Colin Lloyd	Swansea	2001
707 CORRY	Martin Edward	Leicester Tigers	2001 2005
708 JAMES	Dafydd Rhys	Llanelli	2001
709 MURRAY	Scott	Saracens	2001
710 PERRY	Matthew Brendan	Bath	2001
711 ROBINSON	Jason Thorpe	Sale	2001 2005
712 WILLIAMS	Martyn Elwyn	Cardiff	2001 2005 2009
713 BULLOCH	Gordon Campbell	Glasgow Caledonians	2001 2005
714 WILKINSON	Jonathan Peter	Newcastle Falcons	2001 2005
715 HOWE	Tyrone Gyle	Ulster	2001
716 WALLACE	David Peter	Munster	2001 2009
717 WEST	Dorian Edward	Leicester Tigers	2001

2005 WALES/AUSTRALIA

718 BYRNE	James Shane	Leinster	2005
719 COOPER	Gareth James	Newport Gwent Dragons	2005
720 D'ARCY	Gordon William	Leinster	2005 2009

721	HAYES	John James	Munster	2006 2009
722	HICKIE	Denis Anthony	Leinster	2005
723	MOODY	Lewis Walton	Leicester Tigers	2005
724	MURPHY	Geordan Edward	Leicester Tigers	2005
725	O'CALLAGHAN	Donncha Fintan	Munster	2005 2009
726	OWEN	Michael James	Newport Gwent Dragons	2005
727	SMITH	Oliver James	Leicester Tigers	2005
728	WILLIAMS	Shane Mark	Ospreys	2005 2009 2013
729	CUSITER	Christopher Peter	Borders	2005
730	HORGAN	Shane Patrick	Leinster	2005
731	KAY	Benedict James	Leicester Tigers	2005
732	THOMPSON	Stephen Geoffrey	Northampton Saints	2005
733	WHITE	Julian Martin	Leicester Tigers	2005
734	CUETO	Mark John	Sale Sharks	2005
735	HENSON	Gavin Lloyd	Ospreys	2005
736	JENKINS	Gethin David	Cardiff Blues	2005 2009 2013
737	LEWSEY	Owen Joshua	London Wasps	2005
738	O'CONNELL	Paul Jeremiah	Munster	2005 2009 2013
739	PEEL	Dwayne John	Scarlets	2005
740	SHANKLIN	Thomas George	Cardiff Blues	2005
741	STEVENS	Matthew John Hamilton	Bath	2005 2013
742	SHERIDAN	Andrew John	Sale Sharks	2005 2009
743	HODGSON	Charles Christopher	Sale Sharks	2005
744	TITTERRELL	Andrew James	Sale Sharks	2005
745	JONES	Stephen Michael	Clermont Auvergne	2005 2009
746	EASTERBY	Simon Henry	Scarlets	2005
747	THOMAS	Gareth	Toulouse	2005
748	JONES	Ryan Paul	Ospreys	2005
749	COCKBAIN	Brent John	Ospreys	2005
750	WHITE	Jason Philip Randall	Sale Sharks	2005

2009 SOUTH AFRICA

751	BLAIR	Michael Robert Leighton	Edinburgh	2009
752	BOWE	Thomas John	Ospreys	2009 2013
753	BYRNE	Lee Martin	Ospreys	2009
754	EARLS	Keith Gerard	Munster	2009
755	JONES	Adam Rhys	Ospreys	2009
756	REES	Matthew	Scarlets	2009
757	ROBERTS	Jamie Huw	Cardiff Blues	2009 2013
758	WORSLEY	Joseph Paul Richard	London Wasps	2009
759	FLUTEY	Riki John	London Wasps	2009
760	HEASLIP	James Peter Richard	Leinster	2009 2013
761	JONES	Alun Wyn	Ospreys	2009 2013
762	PHILLIPS	William Michael	Ospreys	2009 2013
763	MEARS	Lee Andrew	Bath	2009
764	CROFT	Thomas Richard	Leicester Tigers	2009 2013

765	HINES	Nathan John	Perpignan	2009	
766	KEARNEY	Robert	Leinster	2009	2013
767	MONYE	Ugichukwu Chiedozie	Harlequins	2009	
768	FERRIS	Stephen	Ulster	2009	
769	HOOK	James William	Ospreys	2009	
770	ELLIS	Harry Alistair	Leicester Tigers	2009	
771	POWELL	Andrew Thomas	Cardiff Blues	2009	
772	FORD	Ross William	Edinburgh	2009	
773	MURRAY	Euan Alister	Northampton Saints	2009	
774	FITZGERALD	Luke Matthew	Leinster	2009	
775	HALFPENNY	Stephen Leigh	Cardiff Blues	2009	2013
776	PAYNE	Timothy Adam North	London Wasps	2009	

2013 AUSTRALIA

777	CUTHBERT	Alexander Charles Gordon	Cardiff Blues	2013
778	DAVIES	Jonathan James Vaughan	Scarlets	2013
779	FALETAU	Tangaki Taulupe	Newport Gwent Dragons	2013
780	FARRELL	Owen Andrew	Saracens	2013
781	GRAY	Richie James	Sale Sharks	2013
782	HIBBARD	Richard Martin	Ospreys	2013
783	HOGG	Stuart William	Glasgow Warriors	2013
784	LYDIATE	Dan John	Newport Gwent Dragons	2013
785	MAITLAND	Sean Daniel	Glasgow Warriors	2013
786	TIPURIC	Justin Charles	Ospreys	2013
787	VUNIPOLA	Mako Wanangarua	Saracens	2013
788	YOUNGS	Tom Nicholas	Leicester Tigers	2013
789	HEALY	Cian Eoin James	Leinster	2013
790	MURRAY	Conor Gerard	Munster	2013
791	SEXTON	Jonathan Jeremiah	Leinster	2013
792	NORTH	George Philip	Scarlets	2013
793	BEST	Rory David	Ulster	2013
794	COLE	Dan Richard	Leicester Tigers	2013
795	EVANS	Ian Richard	Ospreys	2013
796	O'BRIEN	Sean Kevin	Leinster	2013
797	TUILAGI	Manusamoa Etuale	Leicester Tigers	2013
798	PARLING	Geoff Matthew Walter	Leicester Tigers	2013
799	YOUNGS	Ben Ryder	Leicester Tigers	2013
800	WARBURTON	Sam Kennedy	Cardiff Blues	2013
801	CORBISIERO	Alex Richard	London Irish	2013
802	GRANT	Ryan	Glasgow Warriors	2013
803	ZEBO	Simon Robert	Munster	2013
804	BARRITT	Bradley Michael	Saracens	2013
805	TWELVETREES	William Wesley Frederick	Gloucester Rugby	2013
806	WADE	Christian	London Wasps	2013
807	COURT	Thomas Gordon	Ulster	2013

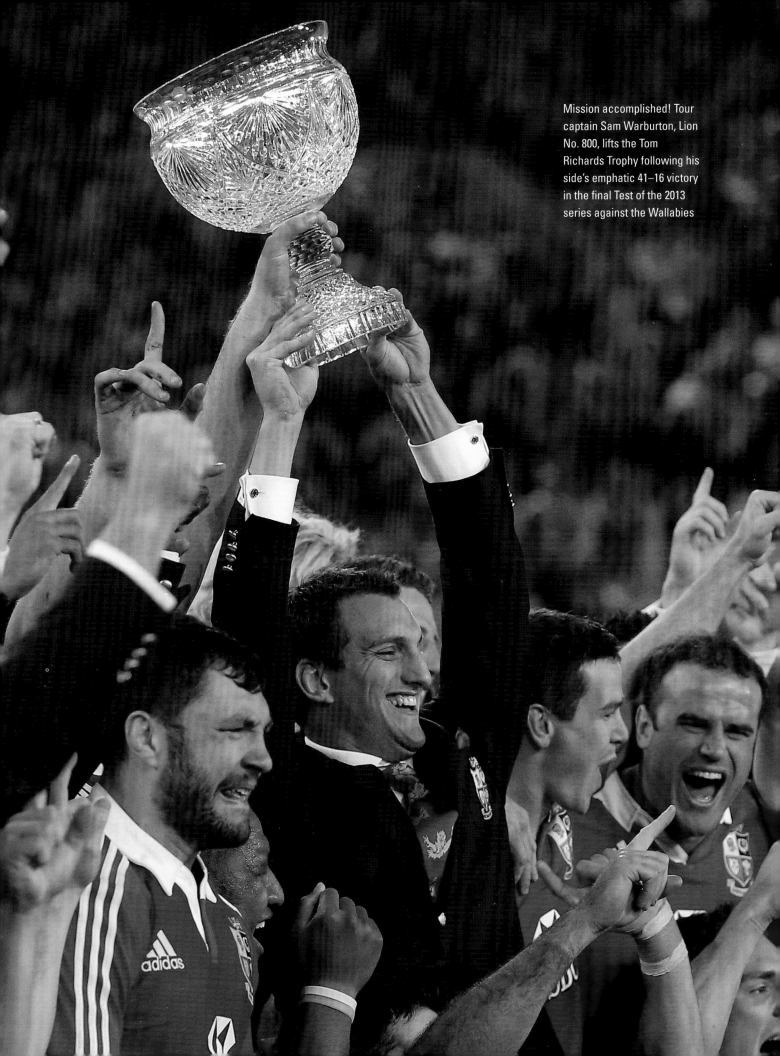

Mission accomplished! Tour captain Sam Warburton, Lion No. 800, lifts the Tom Richards Trophy following his side's emphatic 41–16 victory in the final Test of the 2013 series against the Wallabies

ACKNOWLEDGEMENTS

The authors would like to thank many people for their unstinting assistance, support and encouragement, including John Griffiths, Terry Godwin, Alan Watkins, Geoff Cooke, Sir Ian McGeechan, Gavin Hastings, Hermas Evans, Clive Rowlands, John Lawrence, Bob Weighill, Harry Bowcott, Mike Burrows and the countless Lions, such as Tommy David, who provided such wonderful first-hand accounts of their tours.

▲ Authors Greg (left) and Clem Thomas at Sydney Football Stadium prior to the third Test of the 1989 Lions tour

If any errors have been made in fact or memory it was through no lack of effort or intention on behalf of Clem and Greg Thomas. Many years of history are crammed into this book and naturally some stories, anecdotes and escapades did not make the final cut. However, such omissions have not harmed the objective of this book which is to chronicle and celebrate the unique concept of The British & Irish Lions, at a time when professionalism in rugby is infringing on many aspects of what makes rugby such a wonderful sporting endeavor both on and off the field.

Co-author Greg Thomas would particularly like to thank: Toby Trotman, Jim Drewett, Ed Davis, Iain Spragg and the team from Vision Sports Publishing for appreciating the special role of the Lions in British and Irish sport and publishing this latest and greatest edition; former Lions Gerald Davies and Andy Irvine who were the tour managers in 2009 and 2013 respectively, who were brilliant to work with and continue to be champions of the traditions of the Lions; British & Irish Lions Ltd and the various board members and staff, including Ellie Yeates, Luke Davis and Anna Voyce, who have supported the book throughout its various editions.

A special mention of thanks also to Rob Cole (and his colleagues at Westgate PR) for his ongoing contribution to *The British & Irish Lions: The Official History* and whose enthusiasm, passion and knowledge of all things Lions continues to be an inspiration.

The authors are extremely grateful for the references and assistance from the following publications:

Beaumont, Bill, Andy Dalton, Terry McLean and Ian Robertson, *Lions v. All Blacks 1983*; Bennett, Phil, *Everywhere for Wales*; Chester, R.H. and N.A.C. McMillan, *Men in Black: 75 Years of New Zealand Rugby, Centenary: 100 Years of All Black Rugby*; Clayton, K. (ed.), *The Legends of Springbok Rugby, 1889–1989*; Craven, Danie, *Springbok Annals, 1891–1958*; Dobson, Paul, *Rugby in South Africa: A History 1861–1988*; Edwards, Gareth, *An Autobiography*; Frost, David, *Lions '83*; Gallaher, D. and W.J. Stead, *The Complete Rugby Footballer* (1906); Godwin, Terry, *The Complete Who's Who of International Rugby*; Greyvenstein, Chris, *Springbok Saga: 100 Years of Springbok Rugby*; Griffiths, John, *British Lions*; Harding, Rowe, *Rugby Reminiscences and Opinions*; Hastings, Gavin and Clem Thomas, *High Balls and Happy Hours*; Hopkins, John, *British Lions 1980, Life with the Lions*; James, Carwyn and Colin Welland, *Tommy David*; James, Carwyn and John Reason, *The*

World of Rugby; Jenkins, Vivian, *Lions Rampant*; Marshall, Rev. E, *Football: The Rugby Union Game* (1892); McLean, Terry, *The Lion Tamers, The Best of McLean*; O'Connor, Terry, *How the Lions Won*; Parker, A.C., *The Springboks 1891–1970*; Raeburn, Wallace, *The Lions*; Rea, Chris, *Rugby*; Reason, John, *The 1968 Lions, The Victorious Lions, The Unbeaten Lions, Backs to the Wall*; *Rothmans Rugby Union Yearbooks*; *The Rugby Almanack of New Zealand, 1951*; Starmer-Smith, Nigel, *The Barbarians, Rugby: A Way of Life*; Thomas, J.B.G., *Lions on Trek, The Lions on Trek Again, The Roaring Lions, Trial of Strength, Wounded Lions*; Williams, Bleddyn, *Rugger: My Life*

This updated version of Clem Thomas' original work has benefited hugely from the explosion of content online, particularly access to old newspapers at trove.nla.gove.au in Australia, paperspast.natlib.govt.nz in New Zealand and The Times Digital Archive 1785–2006 in the UK, and the following titles:

WEBSITES: bmj.com; durhamrugby.com; edunirugby.co.uk; espnscrum.com; findmypast.co.uk; irb.com; jottingsonrugby.wordpress.com; militarian.com; paperspast.natlib.govt.nz; rugbyfootballhistory.com; The Times Digital Archive 1785–2006 (find.galegroup.com); trove.nla.gov.au; venn.lib.cam.ac.uk; Wikipedia

BOOKS: Bennett, Phil and Martyn Williams, *Everywhere for Wales*; Chester, R.H and N.A.C McMillan, *The Visitors: The History of International Rugby Teams in New Zealand, Men in Black*; Collins, Tony, *Rugby's Great Split: Class, Culture and the Origins of Rugby League Football*; Cotton, Fran, *Fran: Fran Cotton – An Autobiography, My Pride of Lions: The British Isles Tour of South Africa 1997*; Coughlan, Barry, *The Irish Lions 1896–2001*; Craven, Danie, *Springboks Down the Years*; Davies, Gerald, *An Autobiography*; Delaney, Trevor, *Rugby Disunion: Volume One – Broken-Time*; Evans, Alan, *Lions Down Under: 1950 Tour to New Zealand, Australia & Ceylon*; Frost, David, *No Prisoners*; Griffiths, John, *International Rugby Records*; Hopkins, John, *Life with the Lions: The Inside Story of the 1977 New Zealand Tour*; Jenkins, Neil with Paul Rees, *Life at Number 10: An Autobiography*; Labuschagne, Fred, *Goodbye Newlands, Farewell Eden Park*; Lewis, Steve, *Ken Jones: Boots and Spikes, Last of the Blue Lions – The 1938 British Lions Tour of South Africa*; Malies, Jeremy, *Sporting Doubles: The Colourful Characters Who Represented Their Country at More than One Sport*; McCarthy, Winston, *Listen... It's a Goal!*; McWhirter, Ross and Sir Andrew Noble, *Centenary History: Oxford University Rugby Football Club, 1869–1969*; Mortimer, Gavin, *Fields of Glory*; Nepia, George and Terry McLean, *I, George Nepia*; Nicholls, E.G., *The Modern Rugby Game and How to Play It*; Owen, O.L., *The History of the Rugby Football Union*; Palenski, Ron, *All Blacks v Lions*; Parker, A.C, *W.P. Rugby: Centenary 1883–1993*; Parry-Jones, David, *The Dawes Decades, Prince Gwyn – Gwyn Nicholls and the First Golden Era of Welsh Rugby*; Roderick, Alan, *Newport Rugby Greats*; Quinn, Keith, *Lions '77*; Sharp, Richard, *Winning Rugby*; Slatter, Gordon, *Great Days at Lancaster Park*; Titley, U.A. and Ross McWhirter, *Centenary History of the Rugby Football Union*; Watkins, David, *An Autobiography*; Westgate Sports Agency Ltd, *The Lions Official Tour Guide, New Zealand 2005*; Williams, J.P.R., *J.P.R: The Autobiography of J.P.R. Williams*; Williamson, John, *Football's Forgotten Tour: The Story of the British Australian Rules Venture of 1888*; Wynne-Thomas, Peter, *'Give me Arthur': A Biography of Arthur Shrewsbury*

➤ Brynmor Williams (left), Tony Neary (centre) and Fran Cotton get into the party spirit during the 1977 tour to New Zealand

PHOTOGRAPHY

A key element in this book is the high quality of the photography it contains; many of the images are appearing in print for the first time. Vision Sports Publishing are most grateful to the past and present generations of talented photographers who have contributed to the images published. They include the work of Getty Images and 3 Objectives Photography who have so superbly photographed all the historic memorabilia. A special thank you must also go to Phil McGowan and Deborah Mason at the World Rugby Museum for all their painstaking help in uncovering the memorabilia featured here.

Every effort has been made to contact the copyright holders of the photographs used in this book. If there are any errors or omissions the publishers will be pleased to receive information and will endeavour to rectify any outstanding permissions after publication.

▲ An undated rosette celebrating the Lions, currently in the possession of the World Rugby Museum at Twickenham

PICTURE CREDITS & MEMORABILIA

WORLD RUGBY MUSEUM: p2, 6, 7, 14, 15, 16, 17, 18, 24, 25, 42, 51, 52, 53, 54, 55, 56, 57, 60, 61, 62, 63, 64, 65, 69, 71, 72, 73, 80, 81, 85, 87, 89, 91, 92, 93, 95, 96, 97, 98, 101, 103, 104, 105, 106, 108, 109, 111, 114, 118, 119, 124, 132, 133, 136, 137, 138, 139, 142, 144, 145, 146, 148, 149, 150, 152, 153, 154, 156, 158, 159, 160, 162, 163, 164, 165, 166, 167, 168, 169, 170, 171, 179, 180, 181, 182, 185, 186, 187, 189, 190, 191, 192, 194, 195, 199, 201, 202, 206, 208, 213, 215, 216, 218, 220, 221, 223, 224, 226, 230, 231, 233, 234, 236, 237, 238, 239, 240, 243,

World of Rugby; Jenkins, Vivian, *Lions Rampant*; Marshall, Rev. E, *Football: The Rugby Union Game* (1892); McLean, Terry, *The Lion Tamers, The Best of McLean*; O'Connor, Terry, *How the Lions Won*; Parker, A.C., *The Springboks 1891–1970*; Raeburn, Wallace, *The Lions*; Rea, Chris, *Rugby*; Reason, John, *The 1968 Lions, The Victorious Lions, The Unbeaten Lions, Backs to the Wall*; *Rothmans Rugby Union Yearbooks*; *The Rugby Almanack of New Zealand, 1951*; Starmer-Smith, Nigel, *The Barbarians, Rugby: A Way of Life*; Thomas, J.B.G., *Lions on Trek, The Lions on Trek Again, The Roaring Lions, Trial of Strength, Wounded Lions*; Williams, Bleddyn, *Rugger: My Life*

This updated version of Clem Thomas' original work has benefited hugely from the explosion of content online, particularly access to old newspapers at trove.nla.gove.au in Australia, paperspast.natlib.govt.nz in New Zealand and The Times Digital Archive 1785–2006 in the UK, and the following titles:

WEBSITES: bmj.com; durhamrugby.com; edunirugby.co.uk; espnscrum.com; findmypast.co.uk; irb.com; jottingsonrugby.wordpress.com; militarian.com; paperspast.natlib.govt.nz; rugbyfootballhistory.com; The Times Digital Archive 1785–2006 (find.galegroup.com); trove.nla.gov.au; venn.lib.cam.ac.uk; Wikipedia

BOOKS: Bennett, Phil and Martyn Williams, *Everywhere for Wales*; Chester, R.H and N.A.C McMillan, *The Visitors: The History of International Rugby Teams in New Zealand, Men in Black*; Collins, Tony, *Rugby's Great Split: Class, Culture and the Origins of Rugby League Football*; Cotton, Fran, *Fran: Fran Cotton – An Autobiography, My Pride of Lions: The British Isles Tour of South Africa 1997*; Coughlan, Barry, *The Irish Lions 1896–2001*; Craven, Danie, *Springboks Down the Years*; Davies, Gerald, *An Autobiography*; Delaney, Trevor, *Rugby Disunion: Volume One – Broken-Time*; Evans, Alan, *Lions Down Under: 1950 Tour to New Zealand, Australia & Ceylon*; Frost, David, *No Prisoners*; Griffiths, John, *International Rugby Records*; Hopkins, John, *Life with the Lions: The Inside Story of the 1977 New Zealand Tour*; Jenkins, Neil with Paul Rees, *Life at Number 10: An Autobiography*; Labuschagne, Fred, *Goodbye Newlands, Farewell Eden Park*; Lewis, Steve, *Ken Jones: Boots and Spikes, Last of the Blue Lions – The 1938 British Lions Tour of South Africa*; Malies, Jeremy, *Sporting Doubles: The Colourful Characters Who Represented Their Country at More than One Sport*; McCarthy, Winston, *Listen... It's a Goal!*; McWhirter, Ross and Sir Andrew Noble, *Centenary History: Oxford University Rugby Football Club, 1869–1969*; Mortimer, Gavin, *Fields of Glory*; Nepia, George and Terry McLean, *I, George Nepia*; Nicholls, E.G., *The Modern Rugby Game and How to Play It*; Owen, O.L., *The History of the Rugby Football Union*; Palenski, Ron, *All Blacks v Lions*; Parker, A.C, *W.P. Rugby: Centenary 1883–1993*; Parry-Jones, David, *The Dawes Decades, Prince Gwyn – Gwyn Nicholls and the First Golden Era of Welsh Rugby*; Roderick, Alan, *Newport Rugby Greats*; Quinn, Keith, *Lions '77*; Sharp, Richard, *Winning Rugby*; Slatter, Gordon, *Great Days at Lancaster Park*; Titley, U.A. and Ross McWhirter, *Centenary History of the Rugby Football Union*; Watkins, David, *An Autobiography*; Westgate Sports Agency Ltd, *The Lions Official Tour Guide, New Zealand 2005*; Williams, J.P.R., *J.P.R: The Autobiography of J.P.R. Williams*; Williamson, John, *Football's Forgotten Tour: The Story of the British Australian Rules Venture of 1888*; Wynne-Thomas, Peter, *'Give me Arthur': A Biography of Arthur Shrewsbury*

➤ Brynmor Williams (left), Tony Neary (centre) and Fran Cotton get into the party spirit during the 1977 tour to New Zealand

PHOTOGRAPHY

A key element in this book is the high quality of the photography it contains; many of the images are appearing in print for the first time. Vision Sports Publishing are most grateful to the past and present generations of talented photographers who have contributed to the images published. They include the work of Getty Images and 3 Objectives Photography who have so superbly photographed all the historic memorabilia. A special thank you must also go to Phil McGowan and Deborah Mason at the World Rugby Museum for all their painstaking help in uncovering the memorabilia featured here.

Every effort has been made to contact the copyright holders of the photographs used in this book. If there are any errors or omissions the publishers will be pleased to receive information and will endeavour to rectify any outstanding permissions after publication.

▲ An undated rosette celebrating the Lions, currently in the possession of the World Rugby Museum at Twickenham

PICTURE CREDITS & MEMORABILIA

WORLD RUGBY MUSEUM: p2, 6, 7, 14, 15, 16, 17, 18, 24, 25, 42, 51, 52, 53, 54, 55, 56, 57, 60, 61, 62, 63, 64, 65, 69, 71, 72, 73, 80, 81, 85, 87, 89, 91, 92, 93, 95, 96, 97, 98, 101, 103, 104, 105, 106, 108, 109, 111, 114, 118, 119, 124, 132, 133, 136, 137, 138, 139, 142, 144, 145, 146, 148, 149, 150, 152, 153, 154, 156, 158, 159, 160, 162, 163, 164, 165, 166, 167, 168, 169, 170, 171, 179, 180, 181, 182, 185, 186, 187, 189, 190, 191, 192, 194, 195, 199, 201, 202, 206, 208, 213, 215, 216, 218, 220, 221, 223, 224, 226, 230, 231, 233, 234, 236, 237, 238, 239, 240, 243,

247, 248, 249, 250, 256, 258, 270, 275, 277, 281, 288, 291, 298, 299, 302, 311, 314, 322, 324, 328, 329, 334, 354, 377, 393, 402, 488, 534

GETTY IMAGES: p4, 5, 6, 8, 9, 10, 11, 12, 19, 20, 21, 22, 23, 28, 30, 34, 38, 40, 49, 79, 83, 112, 122, 123, 125, 126, 128, 129, 146, 162, 171, 176, 177, 195, 196, 203, 211, 212, 214, 218, 224, 225, 227, 228, 234, 235, 244, 245, 246, 252, 253, 254, 256, 259, 260, 261, 263, 265, 266, 268, 269, 272, 273, 274, 278, 279, 282, 283, 284, 285, 286, 290, 292, 293, 294, 295, 296, 301, 303, 304, 305, 306, 307, 308, 309, 312, 315, 316, 317, 319, 320, 321, 324, 325, 326, 331, 332, 334, 339, 340, 341, 342, 345, 346, 348, 350, 352, 354, 356, 357, 358, 359, 362, 363, 364, 365, 366, 367, 368, 369, 370, 372, 375, 376, 378, 379, 381, 382, 383, 384, 387, 388, 390, 391, 392, 394, 395, 396, 397, 398, 399, 400, 401, 403, 404, 405, 407, 408, 409, 410, 411, 412, 413, 415, 416, 418, 419, 421, 422, 423, 424, 426, 427, 428, 447, 454, 485, 487, 511, 531, 534, 535

NIGEL WRAY/COLOR SPORT: p35, 58, 86, 117, 161, 288, 353

CLEM AND GREG THOMAS: p136, 137, 198, 207, 280, 425, 532

THE BRITISH & IRISH LIONS: p7

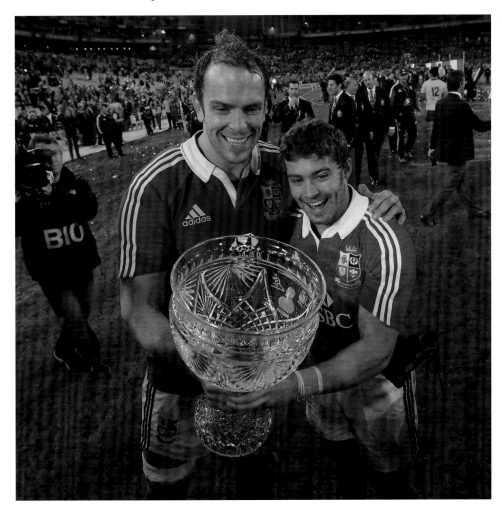

◄ A delighted Alun Wyn Jones (left) and Leigh Halfpenny show off the Tom Richards Trophy following the Lions' 41–16 triumph over the Wallabies at Sydney in 2013, which sealed a memorable series victory for Warren Gatland's side

Published by Vision Sports Publishing in 2016

Vision Sports Publishing
19-23 High Street
Kingston upon Thames
Surrey
KT1 1LL

www.visionp.co.uk

ISBN: 978-1909534-65-0

Authors: Clem Thomas and Greg Thomas, with Rob Cole
Editor: Ed Davis
Editorial Production: Paul Baillie-Lane
Designer: Neal Cobourne
Editorial: Iain Spragg
Sales and Marketing: Toby Trotman
Print Purchasing: Ulrika Drewett

British Lions Ltd
1st Floor
Simmonscourt House, Simmonscourt Road
Ballsbridge, Dublin 4
Ireland
www.lionsrugby.com

Official Licensed Publication
Trademark and Copyright of the Lions Badge is owned by British Lions Ltd

A CIP record for this book is available from the British Library
Printed and bound in Slovakia by Neografia